ROBERT WIGHT AND THE
BOTANICAL DRAWINGS OF RUNGIAH & GOVINDOO
BOOK I

Robert Wight and the
Botanical Drawings of Rungiah & Govindoo

BOOK I

THE LIFE AND WORK
OF ROBERT WIGHT

H. J. NOLTIE

Royal Botanic Garden Edinburgh

MMVII

FOR
EMD & MED
1947–1992

ulmus erat contra speciosa nitentibus uvis:
quam socia postquam pariter cum vite probavit,
'at si staret' ait 'caelebs sine palmite truncus,
nil praeter frondes, quare peteretur, haberet;
haec quoque, quae iuncta est, vitis requiescit in ulmo:
si non nupta foret, terrae acclinata iaceret.

First published 2007
by the Royal Botanic Garden Edinburgh
© all rights reserved

ISBN 978 1 906129 03 3

Designed and typeset in Verdigris by Dalrymple
Printed in Belgium by Die Keure

Frontispiece: Robert Wight, aged 36,
crayon drawing by Daniel Macnee.
© Royal Botanic Gardens,
Kew

7 FOREWORD

9 INTRODUCTION

PART I · BIRTH & EDUCATION

13 Forebears

19 School 1807–13

21 University 1813–18

PART II · FIRST INDIAN PERIOD
1819–31

29 Early Days in India 1819–26

31 Madras Naturalist and Botanist 1826–8

37 Garrison Surgeon of Negapatam 1828–31

PART III · ON FURLOUGH
1831–4

45 Return to Britain

PART IV · SECOND INDIAN PERIOD
1834–53

59 Bellary, Palamcottah and Courtallum 1834–5

63 The Horticulturist

71 The Economic Botanist 1835–6

83 Madras and Work on Economic Plants 1837

89 Marriage and Family: The Eventful Year of 1838

93 Wight the Taxonomist: 'indagator acerrimus'

109 Roving Botanist and the Nilgiri Hills 1839–42

117 The Madras Cotton Experiment

147 Life in Coimbatore 1842–53

153 Calcutta Connections (Wallich and Griffith),
and Departure from India

PART V · THE LATER YEARS
1853–72

161 Retirement to Reading

169 Domestic and Family

173 The Final Years and Last Scientific Work

179 ACKNOWLEDGEMENTS

181 REFERENCES TO MANUSCRIPT SOURCES

183 BIBLIOGRAPHY

189 NOTES AND REFERENCES

203 INDEX

Foreword

In the Preface to Henry Noltie's magnificent *The Dapuri Drawings* published in 2002, I asked the question 'who knows what other wonders lie in the archives awaiting discovery?' This three volume set on Robert Wight by the same author provides a more than satisfying answer. These works continue the exploration of the extraordinarily rich collections of botanical specimens, illustrations, correspondence and other archival materials held at the Royal Botanic Garden Edinburgh, together with related collections in India and elsewhere in the United Kingdom. They explore the life and impact of Robert Wight, a Scot who travelled widely in South India during the early nineteenth century, contributing enormously to our knowledge of the plants of the Subcontinent and creating a legacy of some 23,000 specimens in the Edinburgh herbarium.

The author confesses to a 'mania for connections' and in researching Wight's life he has followed every trail to its end, establishing linkages and relationships that might never otherwise have been rediscovered. He notes that 'The bare facts of Wight's life were known, largely from an excellent obituary'. Now we have a much deeper understanding of Wight, one that is set, of course, in the context of his lifetime (1796–1872) but that nevertheless connects with present-day Scotland and the wider world. Writing in the third volume – *Journeys in Search of Robert Wight* – about the proximity of his New Town flat to the very places where Wight and the other principal players lived, one has a sense that Henry Noltie is writing about his neighbours. His own botanical work, both in the field and in the collections, does indeed continue the tradition of Wight. The same meticulous documentation of plant diversity is as necessary as it ever was. Today, in a time of biodiversity loss and climate change, the endeavours of Wight, and the inheritors of his tradition, acquire a greater urgency than ever before. Many of the scientific challenges recognised by Wight, such as how to describe and illustrate plants with sufficient clarity that others can identify them accurately, are still unresolved. We may have new tools such as digital images and the internet but the core scientific quest remains the same! If you wish to understand how such research is actually done, I know of no better account than this.

Stephen Blackmore FRSE
Regius Keeper
The Royal Botanic Garden Edinburgh

Introduction

This trilogy has had a long gestation. It forms the second in a series of monographs documenting the more important collections of Indian botanical drawings in the library of the Royal Botanic Garden Edinburgh (RBGE), and is successor to one describing a collection commissioned by Alexander Gibson from an anonymous Portuguese-Indian artist in the Bombay Presidency made at Dapuri in the late 1840s. The present work concerns a much larger collection of drawings, and the vast herbarium collections they are intimately connected with, commissioned by Robert Wight, another Scottish East India Company (EIC) surgeon, made in the other great Peninsular Presidency – Madras – between 1826 and 1853. There are many similarities between the two bodies of work, and numerous parallels in the lives of Wight and Gibson who brought them into being; but there are also significant differences. Perhaps one of the most striking of the latter is that the names of the two artists employed by Wight are known: Rungiah and Govindoo.

Like Gibson, Wight has never been entirely forgotten – both were thought deserving of entries in the first edition of the *Dictionary of National Biography*, and both figure in the published annals of Indian botanical history and in the growing literature (both Western and Indian) on nineteenth-century environmental history. Wight's enormous contribution to descriptive botany is constantly in the eye of those who study the Indian flora, either in the field or in the herbarium, both for the large number of species with epithets that commemorate his name, and for the even larger number of genera and species he described; likewise his contribution to the illustration of the Indian flora has never been forgotten. However, not all of the little that has been written about either Wight or Gibson has been entirely accurate. Social historians in particular have not always fully understood the process of taxonomy, and have not infrequently projected less than idealistic motives (of the 'knowledge equals power' variety) on the vast taxonomic effort that, as I hope will be seen in the case of Wight, is only a small part of the truth. To over-emphasise this controlling or financial motivation is to deny intellectual curiosity as an end in itself – and one that individuals like Wight were prepared to go to huge personal lengths to satisfy, in terms of time, expense and even risk. This academic cynicism also fails to take into account the passion for natural history that seems

to be a deeply ingrained British characteristic expressed, for instance, in its love of gardening, membership of organisations such as the RSPB, and, in subverted form, its love of field sports.

Both Wight and Gibson were Scottish surgeons belonging to the period at the tail end of the Scottish Enlightenment, when intellectual curiosity demanded the completion of the primary documentation (cataloguing – the 'Statistical' tradition) of what would now be called 'biodiversity', started by predecessors such as William Roxburgh and Francis Buchanan. As employees of the EIC there was, of course, a powerful economic agenda, and both Gibson and Wight subscribed to the ideal of 'improvement' – forestry in Gibson's case, and agricultural botany in Wight's. Both of these involved experimental work, for example, Gibson's manipulations of teak forests, and Wight's American cotton trials. Neither was a theoriser, and, by accident of birth, their active periods in India predate Darwin's great unifying theory of biology. Although certainly Wight knew of this in due course, his upbringing in a tradition of natural theology (which saw evidence of a Creator in the beauty and adaptations of plants in nature), prevented him from accepting it. It nonetheless seems worth examining and recording the lives of these foot soldiers of nineteenth-century science to whom we owe (as did Darwin) so much in terms of the accumulation of primary data and specimens. For Wight this is of particular importance in the context of the collections entrusted to the care of RBGE – for the 710 drawings, and 23,000 herbarium specimens, made under his guidance by Indian artists and collectors, represent a treasure of incalculable scientific and cultural value. The statistics also explain the rather long genesis of the book, since the taxonomic and curatorial part of the work took on a life of its own that resulted in an unillustrated, sister volume.[1] It will be apparent that it has been possible to find out much more about Wight than was the case for Gibson – this is due in part, at least, to the fact that his ancestors, based in and around Scotland's capital, were in some ways more distinguished, but also to the vagaries of surviving documents, above all the richness of Wight's correspondence with Sir William Hooker at Kew.

There were, however, other more immediate reasons why Wight was chosen to succeed Gibson. The Dapuri project was generously funded, in memory of her husband, by Mrs Mehroo Dinshaw, whose support covered the complete cost of conserving the drawings, and designing and printing the book. She attended the launch of the book at an exhibition of the paintings held at Inverleith House in May 2002, but only a few weeks later was found to have cancer and died a few months later. She faced her illness with quite incredible bravery and lack of fuss, but one of the things she asked me during this time was if I couldn't 'do something on cotton'. The

reason being that her grandfather, the industrialist Sir Homi Mehta, had, among his many other business enterprises, owned cotton mills in Bombay in the 1930s, and, as a young man, been sent to learn about cotton in Lancashire. Even then I was aware that Robert Wight had devoted more than ten years of his life to a largely unsuccessful attempt to persuade Indian tenant farmers (*ryots*) to grow long-staple American cotton instead of their own native 'oopum', and this added weight to the idea that Wight should follow Gibson, and that this project should be dedicated to the memory of Mrs Dinshaw.

Other, more personal, reasons were also a factor. I had first come across Wight's name while writing the *Flora of Angus*, in which the first reported occurrence of each species in the county was cited.[2] The relevant, and somewhat cryptic entry, reads:

Carex ×grahamii Boott (*C. stenolepis* non Less.) Mountain Bladder-sedge. Dr. [R.] Wight, 1832. Graham *et al.* (1832).

When this was written I had no idea of how unlikely it was that at this point in his life Wight should have been in Britain, far less scrambling on a cliff high up in Corrie Fee. The story behind this, and the connections between Wight, Robert Graham (then Regius Keeper of the RBGE), and Francis Boott (Secretary of the Linnean Society, who described Wight's find as a new species), will all be explained in due course, but this link with one of the most beautiful and enigmatic of Scottish alpine sedges was another influence. A decade later I came across Wight's name again – once more in an alpine context, though a rather more elevated one, and on the other side of the world. This took the form of *Rhododendron wightii* (its late, monsoon-sodden flowers decidedly undistinguished) growing at 4000m in the Prek Chu valley in western Sikkim, where it was discovered by Joseph Hooker in 1848, and named by him after a man he had known since he was a 14 year old schoolboy, when Wight was a guest of his father in Glasgow in 1831.

Then, one day in July 2002, shortly after preliminary work on the project had been started, though nobody outside of the RBGE knew of it, I was taken aback to receive an email entitled 'Robert Wight' from a sender whose name I did not recognise. It ran:

My name is Lindsey Moore and my family has recently been reading up on my great, great, great, great grandfather Robert Wight, and we believe that there may be some of his botanical work at the botanical gardens … .

This persuaded me, not only of the power of modern information technology, but that fate was on the side of the project, and clinched the decision to produce these books.

THE LIFE AND WORK
OF ROBERT WIGHT

PART I
BIRTH AND EDUCATION

Forebears

Robert Wight was born on 6 July 1796, at a house called Milton in the parish of Pencaitland, East Lothian, Scotland. His father Alexander was an Edinburgh lawyer (a member of the Society of Writers to His Majesty's Signet – 'WS'), and his mother Jean Maconochie the daughter of an Edinburgh builder. Both parents came from rather interesting families, whose genealogies have proved hard to unscramble, mainly because of the incompleteness of the relevant parish records from the early eighteenth century – even the original record of Wight's own baptism from 1801 can no longer be found. Nevertheless, by digging deep into Kirk Session Minutes, Registers of Hearth Tax, Sasines and the Court of Session, and other arcana, the genealogist Diane Baptie has built up a fascinating picture of this background for which I am extremely grateful. What this reveals is an example of what can be termed the eighteenth-century 'middle-classes' of Edinburgh and the Lothians, and one of considerable social mobility – the Wights were prosperous tenant farmers in East Lothian; the Maconochies prosperous Edinburgh burgesses. Both sides could be described as enterprising 'improvers' – the Wights by improving the land they farmed, the Maconochies by building up capital, which they invested in property and land. On both sides the brightest members of the family went into the Law: on the Maconochie side one branch led to election to the judiciary and the establishment of a landowning dynasty; in the case of Wight's father the Law gave him opportunities for financial wheeling and dealing that nearly caused his downfall. To start with the Wights, whose agricultural activities would, curiously, be echoed in Robert Wight's own work in India from 1835 to 1853.

THE ORMISTON WIGHTS

The parish of Pencaitland marches with that of Ormiston, a name familiar to every Scottish schoolboy as the cradle of the agricultural revolution in Scotland in the early eighteenth century. At the end of the previous century Andrew Fletcher of Saltoun (just across the burn from Milton) had berated Scottish landowners and blamed the dreadful state of Scottish agriculture on the short leases they gave to tenants, and the excessive rents they charged. Fletcher's neighbour Adam Cockburn of Ormiston, Lord Justice Clerk, was one of the first to take this criticism on board, and in 1698 'granted Robert Wight, son of Alexander Wight one of his tenants in Ormiston village, a lease of the farm of Muirhouse [= Murrays], to endure for eleven years. It was the first enclosed'.[1] This work was carried on and greatly extended by Cockburn's son John,[2] who gave Robert Wight's son, another Alexander, the lease of the farm of Murrays for 38 years at a rent of £40, and when this expired on payment of a fee of £64 it was to be renewed in periods of nineteen years 'in all time coming, or as long as "wood grows and water runs"'. There was now an incentive for farmers to improve the land, and Cockburn sent extensive and detailed letters from London to his manager Charles Bell,

and tenants such as Alexander Wight, on matters such as 'planting and enclosing, making public roads, sowing fallow wheat, raising turnips, ryegrass, and clover, planting potatoes, feeding cattle and sheep'. This Alexander Wight was the first to raise turnips in drills and 'brought the culture of them to such perfection that in 1736 a turnip of his raising, which weighed 34¾ lbs, was sent to Edinburgh, and exhibited in John's Coffee-house, Parliament Square'. Cockburn encouraged Alexander Wight to set up a brewery and a distillery, and in 1736 he established a Farmer's Club in Ormiston. 124 years later 'our' Robert Wight lectured to such an organisation in Reading, and it is interesting to note this pioneering precursor from the days of his great grand-uncle, to which no fewer than eight Wights belonged, as did George Broun of Coalston (grandfather of Wight's correspondent Christian, Lady Dalhousie) and, to show that these networks continue to the present day, Sir Hew Dalrymple, ancestor of the designer of this book. In a curious foretaste of Wight's work on the introduction of American cotton to South India using American cotton planters, Cockburn encouraged the growing of flax and 'experienced workmen were imported from Holland … to instruct the natives of the district' on its processing and manufacture. This Alexander Wight's son, Andrew (1719–1792) became well known as a writer on agricultural improvement. Despite the huge success of the improvements that Cockburn had set in motion, it is sad to have to relate that they bankrupt him, and in 1747 he was forced to sell the estate to the Earl of Hopetoun.

The difficulties of working out an exact genealogy have been immense, due partly to the incomplete parish records already mentioned, but also to a superfluity of Wights and the limited number of their Christian names – a problem that will again be encountered in disentangling Wight's school and university careers. For example there were at least three Alexander Wights in Ormiston in 1738.[3] However, it seems that the Alexander (tenant of East Mains of Ormiston) who was 'our' Robert Wight's great grandfather was son of David Wight, tenant of West Byres, and brother of the Robert, tenant of Murrays, mentioned above. Alexander (of East Mains) married Mary Walker on 19 November 1724 and they had four sons and four daughters.[4] He was a prosperous man and it may have been he (rather than either of the other Alexander Wights of Ormiston) who was made a burgess and guild brother, gratis, by the town council of Edinburgh in October 1735.[5] When he died in 1777 or 1778 he left £400 sterling to each of two of his daughters, the lease of East Mains to his second son Robert, and the lease of the Mill of Ormiston to his wife.[6] That his eldest son James is not mentioned in this will is perhaps the origin of the family myth that he was disinherited because of sailing 'around the world with Lord Anson';[7] but the will merely deals with moveable estate.

James, Wight's grandfather, born in 1725, had in fact been very well provided for by his father, with the heritable lease of the farms

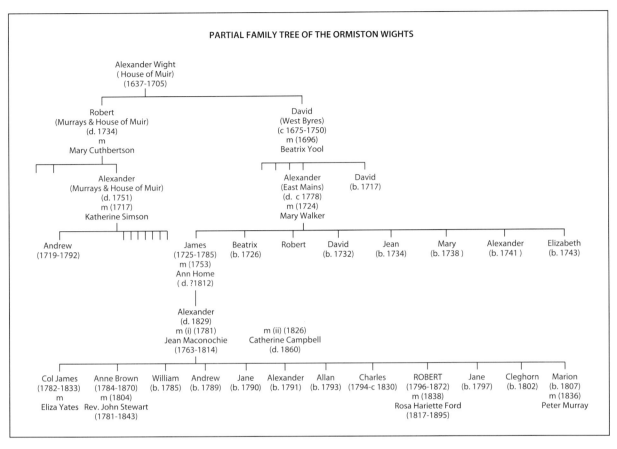

PARTIAL FAMILY TREE OF THE ORMISTON WIGHTS

Alexander Wight
(House of Muir)
(1637-1705)

Robert
(Murrays & House of Muir)
(d. 1734)
m
Mary Cuthbertson

David
(West Byres)
(c 1675-1750)
m (1696)
Beatrix Yool

Alexander
(Murrays & House of Muir)
(d. 1751)
m (1717)
Katherine Simson

Alexander
(East Mains)
(d. c 1778)
m (1724)
Mary Walker

David
(b. 1717)

Andrew
(1719-1792)

James
(1725-1785)
m (1753)
Ann Home
(d. ?1812)

Beatrix
(b. 1726)

Robert

David
(b. 1732)

Jean
(b. 1734)

Mary
(b. 1738)

Alexander
(b. 1741)

Elizabeth
(b. 1743)

Alexander
(d. 1829)
m (i) (1781)
Jean Maconochie
(1763-1814)

m (ii) (1826)
Catherine Campbell
(d. 1860)

Col James
(1782-1833)
m
Eliza Yates

Anne Brown
(1784-1870)
m (1804)
Rev. John Stewart
(1781-1843)

William
(b. 1785)

Andrew
(b. 1789)

Jane
(b. 1790)

Alexander
(b. 1791)

Allan
(b. 1793)

Charles
(1794-c 1830)

ROBERT
(1796-1872)
m (1838)
Rosa Hariette Ford
(1817-1895)

Jane
(b. 1797)

Cleghorn
(b. 1802)

Marion
(b. 1807)
m (1836)
Peter Murray

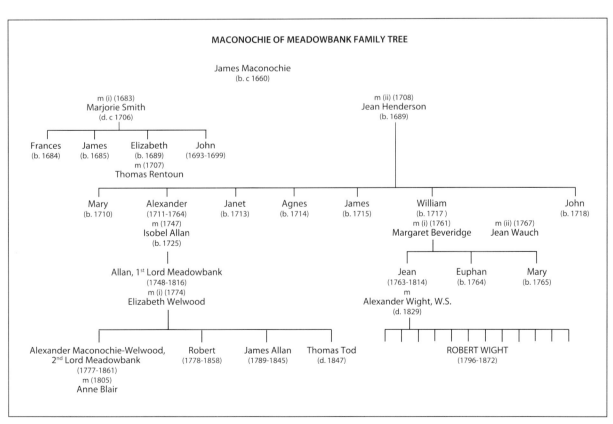

MACONOCHIE OF MEADOWBANK FAMILY TREE

James Maconochie
(b. c 1660)

m (i) (1683)
Marjorie Smith
(d. c 1706)

m (ii) (1708)
Jean Henderson
(b. 1689)

Frances
(b. 1684)

James
(b. 1685)

Elizabeth
(b. 1689)
m (1707)
Thomas Rentoun

John
(1693-1699)

Mary
(b. 1710)

Alexander
(1711-1764)
m (1747)
Isobel Allan
(b. 1725)

Janet
(b. 1713)

Agnes
(b. 1714)

James
(b. 1715)

William
(b. 1717)
m (i) (1761)
Margaret Beveridge

m (ii) (1767)
Jean Wauch

John
(b. 1718)

Allan, 1st Lord Meadowbank
(1748-1816)
m (i) (1774)
Elizabeth Welwood

Jean
(1763-1814)
m
Alexander Wight, W.S.
(d. 1829)

Euphan
(b. 1764)

Mary
(b. 1765)

Alexander Maconochie-Welwood,
2nd Lord Meadowbank
(1777-1861)
m (1805)
Anne Blair

Robert
(1778-1858)

James Allan
(1789-1845)

Thomas Tod
(d. 1847)

ROBERT WIGHT
(1796-1872)

of Duncrahill, Havestries and Keithbank which Alexander had obtained on a 58 year lease in 1742.[8] James also inherited the annual rents to be collected on some houses in Portsburgh in Edinburgh,[9] on which Alexander had purchased a heritable bond of £100 in 1773 from George Norrie (of the notable family of Edinburgh artists).[10] A witness to this transaction (and to his grandfather's will) was Alexander Wight, Robert's father, who was thus inducted early into the deals and speculations that would later land him in trouble. James is recorded as tenant of Duncrahill in 1756 and 1765,[11] when it was part of the Saltoun estate, belonging to Andrew Fletcher, Lord Milton, but it was sold to the Earl of Hopetoun in 1768. In 1772 James sublet Duncrahill and leased the nearby farm of Milton from John Sinclair of Broomrig.[12] Wight's grandmother was Ann Home youngest daughter of the Hon. George Home of Whitfield, whom James married in 1753. After her husband's death she moved to Whitefield at the bottom of Leith Walk,[13] but although her son Alexander paid her an annuity of £50 secured on a property in North St David's Street that had been purchased by James,[14] when she died in 1812 she left him nothing in her will.[15] She had remarried in 1789, and that she left her plate, jewellery and a property in Rose Street to members of the Home family suggests some sort of rift with her son.

Wight's father, Alexander Wight ws, was an intriguing and entrepreneurial figure. There is no record of his birth, which doubtless took place at Ormiston or Duncrahill in the 1750s. He trained as a lawyer ('writer', in Scotland) and became a member of the Society of the Writers to the Signet in 1783, having been apprenticed to James Chalmers.[16] He was heir to his father James's property, which, as already noted, included the lease of Milton, and also part of a tenement in North St David's Street in Edinburgh.[17] That Wight took a serious interest in farming, is to be found in the account of the parish of Pencaitland in the *Statistical Account*:

> Upon two farms … where the soil is fit for raising turnips, that system is adopted, and in the execution of it, there appears a great degree of skill and attention. One of them, possessed by Mr ALEXANDER WIGHT, writer to the signet, has exhibited, for some years past, a state of cultivation not surpassed, if equalled, in any part of this country.[18]

It is not known how much time Alexander Wight devoted to the farming of Milton, which might have been something of a weekend hobby and left largely to a grieve.

THE MACONOCHIES

On 7 August 1781 Alexander married Jean Maconochie. This was an astute move as Jean was an heiress, both of her maternal grandfather James Beveridge, an Edinburgh merchant, and of her father William a wright (or builder). In 1779 her father made a disposition to her and her heirs of his property in Edinburgh consisting of:

> Houses at the head of Robertson's and Macconochie's Close, Cowgatehead.[19]

> House, stables, wright shop and yards in Allison's Close, immediately west of the above.[20]

> A tenement of houses in Fishmarket Close in the Cowgate.[21]

> A four storey plain stone land fronting the High Street, at the head of Blackfriar's Wynd with a cellar and garret.[22]

The Maconochies[23] were an interesting family of a rather different sort to the agricultural Wights, who can be traced back to James Maconochie, a highly successful tailor based at 'the head of the Canongate'. As James married Marjorie Smith in 1683 he is likely to have been born around the year 1660.[24] In the August of the year of his marriage Maconochie was made a burgess of Edinburgh,[25] and seems rapidly to have built up a fortune, which he invested in land. The source of this fortune is obscure, but the nineteenth-century story is possibly a gentrification myth.[26] According to this the money was compensation for land forfeited by James's (supposed) grandfather Dougall Campbell, alias Maconochie of Inverawe, who was tried for high treason with the Marquess of Argyll in 1661 and executed with his son at Carlisle.[27] Whatever the truth of this James bought and sold land in Perthshire, then in Fife,[28] and in 1703 bought land in the parish of Kirknewton, Midlothian from Sir Alexander Dalmahoy of that Ilk, which he developed as an as estate that he named Meadowbank. The initial purchase consisted of 'the 5 merklands of Leithshead, the 5 merklands of Newlands, the 3 merklands called the House of the Muir, the lands … of Easthaugh, the 4 merklands of Loanhead, the town and lands of Whytmoss and … a whole lot of acres divided among tenants which had been taken in from the muir [i.e., reclaimed from moorland]'.[29] Three of the children (including both sons) of this marriage seem to have died, as must Marjorie some time after 1703, and James married for a second time, on 10 July 1708, Jean Henderson, daughter of another Edinburgh tailor,[30] though by this time he must have been around 50 years old. His relatively advanced age explaining why in 1714 he made a disposition to his three-year old son Alexander of the Kirknewton properties (by now also including the lands of Boghead, Lawries Dyke, Edgehead, Greenburn, Townhead, Whitemoss, Templelands, West Bank and Crossgates) with the liferent of these to his wife Jean.[31] This eldest son, Alexander (born 1711) turned to law becoming a writer, a profession followed by his son Allan, later the first Lord Meadowbank (1748–1816), whom as will be seen, would witness the baptism of Robert Wight (his cousin once removed).

In 1717, from his second marriage, James Maconochie had another son, William, 'our' Wight's maternal grandfather. Unlike his ambitious elder brother, William stayed in trade, becoming a 'wright' or builder; but he too was successful and acquired property – both by his own efforts, and through his marriage in 1761 to Margaret Beveridge. They had three daughters, Jean, Euphan and Mary, all baptised in Old Greyfriars Church, the last certainly, the others probably, by the redoubtable William Robertson, Minister of Greyfriars and Principal of Edinburgh University, who according to Brougham,[32] was a kinsman of the Maconochies. Robertson was a distinguished historian, and in view of the locus of the botanical labours of Jean's son, it should be noted that his last book was an *Historical Disquisition Concerning the Knowledge which the Ancients had of India* (1791). Lest we think that the Starkey/Schama school of celebrity historians is anything new, it is noteworthy that Robertson was paid £3500 for the copyright of his *History of the Reign of Charles V* (and an additional £500 for a second edition) being the largest sum paid up to that date for a single work, and equivalent to about £200,000 in today's terms. Of these three daughters, only Jean survived and it was she who married Wight's father Alexander in 1781.

WIGHT'S PARENTS

Alexander and Jean Wight had 12 children, six of whom died either young or childless. The eldest was James, fourteen years Robert's senior, who joined the Madras Army, in which he rose to be a Lieutenant Colonel and left a large family that proliferated greatly in following generations. Next came Anne Brown, who in 1804 married the Rev John Stewart, minister of Blair Atholl, a union also productive of a large number of descendents. Wight seems to have been especially close to Anne, though she was his senior by twelve years. Two brothers, Allan (born 1793) and Charles (born 1794) went to Jamaica and died childless. Wight's youngest sister Marion (born 1807), also went to Jamaica, married an Army surgeon called Peter Murray, and left family including a daughter Zena who much later would visit her uncle at Grazeley.

Wight's parents must have spent some time at Milton, as that is where he was born, but probably more in Edinburgh attending to Alexander's business activities. Although nothing is known of his legal career, Alexander's property deals are recorded, and his frequent flittings around houses or flats in Edinburgh can be tracked in the contemporary street directories.[33] At the time of Wight's birth, and until 1804/5, the family's address was 23 North Hanover Street, but unfortunately the street numbering has changed so it is impossible to say exactly where this was. Being an odd number it was on the east side of the street, and as at this time Alexander was a prosperous WS it is at least possible that it was in the handsome double-bowed tenement block on the south side of Thistle Street very similar to the one into which another prosperous WS, Walter Scott, moved in 1802, in the corresponding block two streets to the west. Alexander is not listed in the street directories for 1805/6 or 1806/7, but in the remaining 23 years of his life he had no fewer than six addresses – four years in London Street (two different numbers) and a year in Dublin Street, before moving out of the New Town. In 1814

Alexander (by now a widower) was living in Buccleuch Place, which must have been convenient for his son, then attending the nearby University, and he moved flat within the same street before finally, in 1822, ending up in a place called Society where he died in 1829. This final address is of interest: the site was that on which the Museum of Scotland would later be built, and it took its odd name from the 'Fellowship and Society of Ale and Beer brewers of the Burgh of Edinburgh' that existed from 1598 to 1619. Since 1697 this property had belonged to the Cleghorn family,[34] with whom Alexander Wight must have been friendly as he gave their name to one of his sons, and his eldest son James, in turn, named one of his sons (who would later send Wight specimens from China) Arthur Cleghorn Wight. Hugh F. C. Cleghorn would become a friend of Wight's in Madras, and (indirectly) a great donor of Indian material to the library of the RBGE.

The property his wife Jean brought to the marriage was not sufficient for Alexander's ambitions and he indulged in property speculation in the New Town both independently, and with his father-in-law William Maconochie. A revealing example of Wight's solo speculations has recently come to light in a fascinating account of the evolution of the central section of the Queen Street Gardens.[35] In 1788 a builder-cum-architect called John Brough went bankrupt, which caused the sale of a plot of rough ground immediately to the east of Howe Street (opposite what would later be Robert Louis Stevenson's house in Heriot Row). This was land that the Town Council of Edinburgh had leased from Heriot's Hospital in 1769 as ground for builders working on the first New Town, but subleased to Brough in 1786 on condition that it was used as a park or garden; Brough did nothing with the land, and at his bankruptcy was sold with an upset price of £40, though how much above this it fetched is not recorded. The plot was split into two strips, of which the eastern one was bought by Alexander Wight (his name appears

Fig.1. Sir William Miller, Lord Glenlee.
Etching by John Kay, 1799.

GEORGE STREET, ST ANDREW'S CHURCH, & LD MELVILLE'S MONUMENT.
EDINBURGH

Fig.2. George Street, Edinburgh, looking east – showing St Andrew's Church and the Melville Monument. Etching by Thomas Barber after a drawing by T. H. Shepherd from Shepherd's *Modern Athens* (1829–31).

over it in Ainslie's 1804 map of Edinburgh). As Wight lived in Hanover Street this was obviously bought purely as an investment rather than to form a garden, and he made a killing, selling it after five years, back to its original owner, Heriot's Hospital, for £150 (the other strip was sold for £200). Wight also speculated in land to the south of the city, and some time prior to 1811 purchased a 'Park called Boswells Bogg, the lands of Peakeshole and the lands of Millhaugh with the Mill of Kevock' near Lasswade, which he sold in 1813.[36] He had also rented a farm called Cousland Park in the parish of Cranston in 1806, which he sublet in 1808. Wight's major speculative venture, however, was in the Drum Coal Company at Gilmerton, and it was this that was to prove his undoing. In 1808, along with two brothers, William and Adam Armstrong, Alexander Wight bought the right to coal on the lands of Drum, 'with the colliers' houses in the village of Gilmerton' for the enormous sum of '£17,000 Sterling'.[37] Like many mining speculations, this ended in disaster. In 1784 Wight had purchased 'two merk land of Whitehill in the Burrowfield of Ayr' for £800,[38] which proved a spectacular investment, as he sold it in October 1812 for £12,000.[39] This was doubtless immediately swallowed by the coal mine, but was unfortunately not enough and in 1813 the company (which had been in operation for 11 years) went into liquidation and Wight made bankrupt.[40] His assets at this time were listed and included houses in Hanover Street, Thistle Street and Niddrie Street, ground on the east side of Leith Walk, and no fewer than three farms in Ayrshire.[41] This must have been a difficult time for Alexander, and not only financially, for the year after his bankruptcy his wife died. His circumstances were severely reduced, and he had to take a job as clerk to Sir William Miller, Lord Glenlee [fig.1]. According to Henry Cockburn, Glenlee (1755–1846), who was a judge for 45 years from 1790, was the last to appear in the streets wigged – his practice, before becoming so feeble as to require a sedan chair, being 'to walk to court in his wig and long cravat, his silk stockings, and silver buckles, and his cocked hat in his hand'.[42] He was also subject to strange nervous tics – his whole frame was disturbed 'by little jerks and gesticulations, as if he was under frequent galvanism'.

Alexander Wight was evidently a survivor and weathered the storm, continuing to live in Edinburgh, but he must still have been keen on agriculture, as he leased a farm at Greenfoot in the parish of Lasswade. In 1826 when he must have been at least 70, he remarried, this time the 55 year-old daughter of a baronet, Catherine Campbell. They were married for only a short time as Alexander died at Society on 22 February 1829, though his place of burial is a mystery. By the time of his death Alexander had managed to restore his finances as his inventory amounted to just over £1,164 with only two small debts.[43] In his will he recorded that he had already provided for his four sons, and so made provision for his daughters Anne and Marion, but offered James the Greenfoot lease should he return from India.[44]

Alexander had armigerous pretensions, and his son Robert, at the time of his furlough, started to seal letters with a signet ring, most likely inherited from him. These arms were described by the Rev J.S. Roper as: 'gules, a chevron between three boar's heads couped argent'; the crest a 'dexter arm and dagger pointing down'; and the motto 'Fortiter'; but, as the family discovered when they wanted to use it on Ernest Wight's memorial in 1915, this was not registered at the College of Arms in London. Neither is it at the Court of the Lord Lyon in Edinburgh.[45] The use of the fake arms

demonstrates Alexander's social aspirations, but also that he had a sense of humour – the shield is very close to one used by various people of the name Whitelaw and it can therefore be read as a rebus – as 'Wight – Law'.

There was once a portrait, taken by family tradition to depict Alexander Wight, which the Rev J. S. Roper knew in the possession of his son Robert's widow Rosa, and was described (from memory) in a letter from Marjorie Cosens to her niece Joan Wilkinson written about 1950. As in the same letter is a cock and bull story about Wight's father being a country doctor and peppering the behind of a coal thief with shot, the source cannot be taken as entirely reliable, but nonetheless the description of the portrait is intriguing. Alexander Wight is a Colonel in the local Yeomanry and the picture shows him reviewing the troops:

> sitting on a horse on a hill top & they are manoeuvring in red coats on the plain below – No – he is standing by his horse, but you can see on the horse a ghost form which is how he was first painted & then painted out by the artist. He is bare headed but holding up a large sunshade, the story being that his daughter, for whom the picture was painted, was so proud of his noble brow that she wouldn't let him have it covered.[46]

The sunshade hardly sounds appropriate for the Lothians, so was this picture really of Alexander Wight or, perhaps, something his son acquired in India? In any case one would love to know its whereabouts, last heard of in 1931 in the possession of Janet ('Jenny') Wight, widow of Robert Wight's youngest son Ernest, at 'Paddocks, Newton, Newbury'.

ROBERT WIGHT

It has taken some time to reach the subject of this book (hereafter 'Wight'), but it seems worthwhile to have described his origins, and the relevance of the agricultural part of the story will become clear later on. From legal documents something is known about Wight's inheritance, but there is no way of knowing anything of the influence of his aspirational father, other than the wording of the dedication of his doctoral thesis, to 'the author's first and most trusted friend' – words that seem heartfelt and slightly more than a conventional platitude. Wight saw his father for the last time on leaving for India in 1819, as he was to die in 1829, two years before Wight returned for his first home leave. His father's financial troubles must surely have had a profound affect on the young Wight, as, perhaps, can be seen in the discussion of economics in his 1836 agricultural report, and his dislike of debt.[47] He seems not to have gone in for rash speculations, and while in India invested significant sums from his salary in idealistic botanical activities and publications that can have brought little in the way of profit. Wight certainly amassed enough to set himself up with a 60 acre property in England on his retirement, but in this he seems to have overstretched himself and Grazeley had to be sold immediately after his death.

What of Wight's inheritance? As already mentioned he had been 'provided for' by his father, but there were also properties that came to him from the Maconochies. These included a '5/6th part of a perpetual annuity of £70/16/6 9/12d in the Bond and Disposition' that had been made by James Smith, merchant in Leith, to his mother on 24 December 1800,[48] though one does wonder how a penny could be divided into twelfths! Just before returning to India in 1834 Wight executed a Commission referring to a 'Disposition and

Settlement' of his maternal grandfather William Maconochie, and appointing his brother-in-law the Rev John Stewart of Blair Atholl and William Hunter Campbell ws to act on his behalf while abroad.[49] It is also recorded that while on leave (in 1831 and 1832) Wight had sold his share of properties that had come from his grandfather to his sisters Anne and Marion.[50]

As we have seen Wight was born at Milton, but there is no record of his birth in the Pencaitland parish records, doubtless explained by the information that 'since the date of tax upon the registration of baptisms [people] do not register the births in their families'.[51] Neither can any trace of his baptism be found in any of the surviving Edinburgh parish records, though it must once have existed since, fortunately, an extract of it was made when Wight applied to join the EIC in 1819.[52] This shows that, somewhat surprisingly, he was not baptised until the age of five, in 1801. The family was then living in North Hanover Street and the parish is given as that of 'St Andrew Church'. The witnesses were both lawyers – Allan Maconochie and James Thomson ws, connections of his mother and father respectively. Maconochie was in fact the first Lord Meadowbank, and at this time his Edinburgh house was at 20 Fredrick Street – he was stated by Roper to be his mother's uncle,[53] but was in fact her (rather older) cousin. Thomson must have been a friend of his father's as they both trained under the same lawyer, James Chalmers. The place of baptism is not given, but as Meadowbank was certainly a Presbyterian it is most likely to have taken place in the beautiful elliptical church of St Andrew on George Street [fig.2].

Allan Maconochie, first Lord Meadowbank, was an important figure of the Scottish Enlightenment and a distinguished judge, though by some thought eccentric.[54] An amusing example of what might be taken for eccentricity (or was it merely rational pragmatism?) was recorded by his friend and colleague Henry Cockburn in the *Memorials of his Time*: an hour after Maconochie's marriage 'the bridegroom disappeared; and, on being sought for, was found absorbed in the composition of a metaphysical essay "on pains and penalties"'.[55] As an undergraduate at Edinburgh University Maconochie had been a founding member of the influential debating club, the Speculative Society, and from 1779 to 1796 held the regius chair of Public Law at his *alma mater*. This chair (which he effectively purchased from its incumbent, James Balfour, for £1412.18.2) was a reward for his support of Principal Robertson and Henry Dundas over the policy of Catholic relief in Church Courts.[56] Maconochie, whose lecturing followed 'the type of unified Enlightenment social project' along the lines of Adam Smith, resigned the chair when he became a Lord of Session in 1796, taking the title Lord Meadowbank, and in 1804 he was made a Lord of Justiciary. As a friend of luminaries such as Sir Walter Scott and Cockburn, Maconochie figures in their journals and biographies, and the latter described him as 'a curious and able man' whose 'true merits were obscured … by certain accidental oddities which obstructed the perception of them … His knowledge reached every subject – legal, scientific, historical, and literary … and he seemed to me to be equally at home in divinity or agriculture, or geology, in examining mountains, or demonstrating his errors to a farmer, or refuting the dogmas of the clergyman'.[57] He was the subject of an interesting biographical memoir by Henry Brougham.[58] Meadowbank died in

1816, but his character and interests may well have influenced his young cousin. He was an active member of the Royal Society of Edinburgh, being Vice-President 1812–6, and chairing the committee that prepared a new charter for the Society, which received Royal Assent in 1811.[59] Of particular relevance to the Wight story in 1788 Maconochie read the Society a paper on 'Observations respecting the country, religion, political institutions, and sciences of the Hindoo', but unfortunately this was not published in their *Transactions*. That Meadowbank's agricultural interests were deep and well informed can be seen from a fascinating booklet that he published (anonymously) in 1815, the first part of which deals with the use of a mixture of peat and farmyard dung as a manure; the second a set of 'Instructions for Foresters', which demonstrates his knowledge of plant physiology and phenomena such as that of apical dominance. Despite his Tory politics, it also shows Meadowbank's social awareness and includes a diatribe against Highland landowners, who, were they to improve their estates in the way he suggested 'would no longer suffer the disgrace of urging emigration' on 'that high-spirited and noble race of men, who, by their intrepidity and self-devotement [sic] to national glory, have raised their reputation to a level with Spartan fame'. Maconochie practised what he preached on his estate at Meadowbank, and, as with the East Lothian Wights, adopted an 'enlightened attitude, planting trees on the more unfertile parts of the land and encouraging a positive policy of agriculture among his tenants'.[60] His house, now renamed Kirknewton, was greatly extended in 1835 by his son, another judge, Alexander, the second Lord Meadowbank (1777–1861) to designs by W. H. Playfair.[61] The Playfair wing, which was demolished in 1947, seems to have been somewhat curious architecturally, perhaps designed in an archaic style to harmonise with James Maconochie's small laird's house of 1703, which still forms the core of the present building.

Alexander Maconochie (Wight's second cousin) was also a notable character,[62] whose official posts included spells as Sheriff-Depute of Haddingtonshire (1810), Solicitor General for Scotland (in Lord Liverpool's administration, 1813), and Lord Advocate (1816). He became a Lord of Session and Lord of Justiciary in 1819, and it was he who, famously, at a theatrical dinner in Edinburgh in 1827, publicly announced the by then financially embarrassed Scott's authorship of the Waverley novels:

> The clouds have been dispelled – the darkness visible has been cleared away – and the Great Unknown – the minstrel of our native land – the mighty magician who has rolled back the current of time … stands revealed to the eyes and the hearts of his affectionate and admiring countrymen.[63]

In more lurid vein, it was the second Lord Meadowbank who in 1828 pronounced sentence on the body snatcher William Burke. The trial of Burke and his accomplice William Hare (who saved himself by giving King's evidence) was a sensation – they had murdered 16 people to supply, as corpses for dissection, to Robert Knox the anatomist and former school mate of Wight's. It was therefore an ironic twist with which Meadowbank ordered that after being executed 'his body thereafter be given for dissection'.[64] This was duly performed by Monro Tertius and a gruesome memento of the event is to be found in the museum of the Royal College of Surgeons in Edinburgh – a pocket book bound in a piece of Burke's skin.

School 1807–13

Nothing is known of Wight's childhood beyond what he later told J.H. Balfour – that he 'was educated at home till 11 years old',[1] but it was doubtless divided between Edinburgh and East Lothian. After this Wight 'was sent to the High School Edinburgh' where he remained for 'five years'. The archival records of this venerable school are sadly incomplete, but Wight's progress can be tracked in the Student Library Subscription Register 1806–19.[2] He enrolled in Mr Ritchie's class in March 1807, in which he remained until 1811. Three other Wight boys (Andrew, Alexander and James) were with him throughout, but, confusingly, a second Robert arrived in Ritchie's fourth year class of 1810. In March 1811 all these Wights entered the Rector's class in which it was normal to stay for two years; however, only one Robert did the second year and if Wight's later memory of spending five years at school is correct, then it was not him.

The High School of Edinburgh was then a world famous establishment, and is well documented in print – in an excellent and detailed history,[3] and in the personal memoirs of contemporaries of Wight such as those of Sir Robert Christison, later professor of Medical Jurisprudence at Edinburgh and expert on poisons.[4] It is from these sources that the following details have been taken. The School is a medieval foundation, but in 1777 had been rehoused in a handsome new building [fig.3] designed by Alexander Laing, that still stands in Infirmary Street (now occupied by the University's Department of Archaeology). The school was run by the Town Council, and Alexander Wight would have paid £2 12s 6d annually for his son's education. Several factors gave the school its characteristic social strengths. One was its inclusiveness, such that one pupil could record that 'I used to sit between a youth of ducal family and the son of a poor cobbler'. Another, which it shared with the University, was its international nature, and in the class of this same pupil were boys 'from Russia, Germany, Switzerland, the United States, Barbadoes, St Vincents, Demerara, besides England and Ireland'. All this in a single class, though the classes were huge, of 150 or more, so that the teaching consisted mainly of rote learning. Lastly, at least 'as compared … with the great English schools, was its semi-domestic, semi-public constitution', and the 'constant intercourse … [this allowed] at home, with our sisters and the other folks of the other sex, these too being educated in Edinburgh'.[5]

The dominant academic features of the school were its entirely classical syllabus and the excellence of its masters, several of whom went on to University chairs. It was to the masters' 'zeal, ingenuity, learning, industry, and perseverance [that] the advancement of the cause of good letters in the northern division of our island, is in a very peculiar degree to be ascribed'.[6] Considering the size of the school (595 pupils in Wight's first year), the staff was tiny, consisting only of the Rector, four Classical Masters and a teacher of Writing & Arithmetic. Instruction was conducted entirely in Latin, though the Rector, James Pillans [fig.4], was at this time encouraging the teaching of Greek. The syllabus was formidable and that of the Rector's class included 'the Hexametrical works of Horace, with the exception of the treatise de Arte Poetica, and some of the more indelicate satires; the Andria of Terence, with part of the Heautontimorumenos [also Terence]; the Oration of Cicero pro Archia Poeta, his first and fourth in Catilinam, and his Cato Major de Senectute, with lessons in Greek and Ancient Geography, in the former three times, and in the latter twice a week, for one hour each day, after the ordinary business of the class was over … and indeed yielded abundant employment for the most ardent votary of study'.[7] It was a deeply held belief that this exclusive use of the Classics was the best method of training the intellect, and that there was time enough for learning facts and modern subjects at University and thereafter. Nevertheless it would hardly be surprising if Wight could take only a single year of such a regime, and much later, in India, he wrote of the limitations of his Latin: 'Classical attainments unfortunately never having been very bright & now much less so than formerly … often I fear commit sad blunders'.[8] At some point (perhaps at home) Wight would also appear to have learnt one modern language, as he was later able to read the French botanical literature, such as the *Annales des Sciences Naturelles* to which he subscribed.

It was not all hard slog, however, and Christison recorded the boys' games, and the significant role that rambles over the surrounding countryside played in their lives. Ten years later George Bentham walked up one of the most popular venues for such rambles, Arthur's Seat, and was amazed to find himself in a:

> wild, sequestered valley, so completely silent and solitary that I might have fancied myself in the midst of the Cevennes or Pyrenees, many leagues from the habitation of man, instead of being within half a mile of so flourishing a city as Edinburgh.[9]

Years later in India, in a 'home thoughts from abroad' moment, nostalgically ruminating on the primrose, Wight recalled a scene from just such an excursion: 'the delight experienced in our juvenile days on beholding, in early spring, sunny banks bedecked with tufts of fragrant yellow flowers when all around was still held in the cold deadly grasp of winter'.[10] On these jaunts Wight must have excavated and consumed the pignuts, which he still remembered in Negapatam twenty years later when he compared their taste with the tubers of *Aponogeton natans* (Book 2 plate 123). One can also picture the young Wight at 'the row and the frolic [that] were reserved for the wind up on the 1st August, the annual examination-day before the autumn holidays, when the Town Council of the city, robed and halberdiered, walked from the gate to the hall between two dense rows of several hundred schoolboys, showering from all sides handfuls of papes [cherry stones] at the processionists, and especially at the Lord Provost'. The only other boyhood activity of which

Wight left any record was an early interest in ornithology. In India, half a century later, when writing of the holly tree he (somewhat pompously) recounted that it provided a bird-lime 'to which I can myself testify, having often, when a boy, prepared it, sometimes by the very primitive operation of mastication, at others by bruising the bark between stones and washing out the parenchymatous matter'.[11]

Wight's two schoolmasters were both distinguished and he was certainly fortunate with his Classical Master, William Ritchie (1756–1822), with whom he spent four years. Ritchie was a kindly bachelor whose 'instructions had fixed in [his pupils'] minds many a useful lesson, and his gentleness and urbanity of manner had formed many a valuable habit'.[12] His own principle when it came to teaching was that 'I like to make my class happy; I don't like to torment children by puzzling their brains'.[13] Ritchie's Continental walking tours, undertaken during the vacation, were famous and on return he perhaps regaled pupils with tales of following the British troops in Portugal during the Peninsular War, or of his 1812 tour of Sweden undertaken with Dr Thomas Thomson the chemist, and father of the eponymous Indian botanist whom Wight would meet much later in life.

The Rector whose class Wight joined in 1811 was Dr James Pillans (1778–1864), who had assumed office only in January 1810.[14] Wight was fortunate to escape Pillans's first year when he had been forced to use extreme physical punishment ('*summum supplicium*') on a boy, as an example in order to regain control of the school after a lax interregnum. Thereafter he substituted translation exercises for corporal punishment, introduced the composition of Latin verse and developed the teaching of Greek and of Classical Geography. It was for the teaching of the latter that he is reputed to have invented the pedagogical tools of blackboard and coloured chalk. Brother-in-law of the Rev John Thomson of Duddingston (1778–1840), the pioneering painter of romantic Scottish landscapes, he lived at 43 Inverleith Row, and in 1820 became Professor of Humanity (i.e., Latin) at Edinburgh University.

Of Wight's High School contemporaries Robert Christison has already been mentioned, but unfortunately he neglected to refer to Wight in his memoirs. They must certainly have known each other for 60 years later Wight would tell J.H. Balfour he 'was glad to see Dr Christison's name in the Gazette as Sir Robert Bart.'.[15] Other contemporaries included George Walker-Arnott (of whom much more anon) and Robert Knox. Knox, who won the school Greek prize in 1810, was to earn fame as a 'foppish … flamboyant, one-eyed, gold-vested' anatomy lecturer,[16] but also an unfortunate notoriety as the receiver, for dissection, of Burke and Hare's victims. In a contemporary verse:

> Down the close and up the stair
> But and ben wi' Burke and Hare
> Burke the butcher
> Hare the thief
> And Knox the boy that buys the beef

In the summer of 1813 Wight 'commenced studying medicine in the shop of the late Mr Kenneth McKenzie an old and highly respected Apothecary in Edinburgh'.[17] Wight was evidently grateful to Mackenzie as he was one of the dedicatees of his doctoral thesis, where, somewhat strangely, he is described as 'chirurgo' (i.e., surgeon). Mackenzie was made a burgess of Edinburgh in 1781 and had been apprenticed to Duncan McDonald.[18] From the Edinburgh Directory of 1812–3 it is found that the shop where Wight undertook his earliest medical studies was at 114 High Street, and that McKenzie lived in [St] James Square.

Fig.3. The High School, Edinburgh in 1820. Anonymous wood engraving from Cassell's *Old and New Edinburgh* (1882).

Fig.4. James Pillans, Rector of the High School. Mezzotint by Charles Turner (1823), after a painting by Sir Henry Raeburn. Scottish National Portrait Gallery.

University 1813–18

As with his school career, it is possible to discover something of Wight's time at University, not from his own writings (which record merely that he matriculated as a medical student in the autumn of 1813), but from detailed publications relating to Edinburgh University,[1] fleshed out from the memoirs of Robert Christison,[2] a medical contemporary. Like the High School, Edinburgh's world renowned University was run by the Town Council (it was often known as the 'Tounis College'). Wight's education was thus undertaken within a very circumscribed geographical area, for the College lay to the west of the High School, and between them was the baroque palace that was William Adam's Royal Infirmary. At this period the University was flourishing, despite the fact that its Principal (since 1793) George Husband Baird [fig.5] has been described as a 'bearded non-entity whose sole qualification for the office was that he was the Lord Provost's son-in-law'.[3] The buildings, however, were in a state of chaos as a result of the cessation of construction work on Robert Adam's magnificent new double-quadrangled College. This had been started in 1789, but had ground to a halt in December 1793 following Adam's death the previous year, and chronic financial difficulties. In Wight's time part of the entrance front (east range) had been built, and the north-west quadrant block that included the Anatomy theatre and classrooms for the Theory and Practice of Physic, and for Moral Philosophy, was complete. The rest of the classes were conducted in the crumbling old buildings (in some of which candles had to be used even during hours of daylight), which included a seventeenth-century wing that then still stood in front of the site eventually occupied by the north side of the present quadrangle. Building work resumed while Wight was still a student, in 1816, to modified plans by W. H. Playfair,[4] as financial circumstances improved following the end of the Napoleonic Wars, but he would have had to wait until his return to Edinburgh in 1831 to see the whole of Playfair's magnificent conception. Wight left the University in 1818 and the handsome Museum occupying the centre of the west side of the quadrangle, built to house Professor Robert Jameson's natural history collections, was not completed until 1820, and the stupendous library, occupying the upper floor of the whole of the south wing, not until 1827. Despite the physical problems (and old-fashioned teaching) student numbers were booming and in Wight's first year 1849 students matriculated, who came from an even wider geographical range than his school mates.

The medical curriculum of Wight's time was virtually unaltered since the *Statuta Solennia* had been laid down in 1767.[5] To gain a medical degree it was necessary to study for a minimum of three years, at least one of which had to be spent at the University of Edinburgh, and to have studied Anatomy and Surgery, Chemistry, Botany, Materia Medica, Theory (or 'Institutions') and Practice of Medicine, and 'the lectures in Clinical Medicine given in the Royal Infirmary'. In addition to these there were optional subjects such as Midwifery and Clinical Surgery. These subjects were all taught by University professors, but it was also possible to study with 'extra-mural' or 'extra-academical' lecturers. The contrast between the teaching of these two groups has been stressed by Janet Browne in her outstanding discussion of Darwin's time at Edinburgh, but dating (and significantly so) from a few years after Wight had left. The professors in Wight's time were extremely conservative and:

> the most important aspect of their work was the way in which higher learning reinforced and justified the system of natural theology popular in the upper reaches of British society and the academic context in general: a natural theology that sought to use the characteristics of the external world to establish the existence of a divine creator, and to provide proofs of its benevolence, wisdom, and power. Natural theology provided the rationale for most of the scientific work of the first half of the nineteenth century in Britain, explicitly fusing the domains of nature and religion in supporting a stable moral and social order by its marked emphasis on "natural law".[6]

This intellectual background seems never to have left Wight, and natural theology underpins his taxonomic work in India. The extra-academical courses that he may have attended in Anatomy and Clinical Medicine seem not to have been of the radical, continentally inspired, sort that were available in Darwin's time.

In order to graduate as MD the candidate was:

> examined more minutely by two Professors, in the presence of the Faculty [in one of their houses], on the different branches of Medicine ... Then two of the Aphorisms of Hippocrates were to be given him for explanation and illustration. He was to make his comments in writing, and defend them before the Faculty ... Next he was to have two cases (*morborum historiae*) given him, with questions attached. He was to return answers in writing, and defend them before the Faculty ... Then, if all had previously gone well, he was to have his Thesis printed by the University printer, and present copies to each member of the Faculty of Medicine. And on the Graduation day he would defend his Thesis, and then receive the Doctor's degree ... All the above-mentioned exercises, both oral, and written, were to be in the Latin language [English not being allowed until 1834].[7]

Christison adds an interesting gloss on these formidable rules, pointing out that it was usual practice for a student to employ someone called a 'grinder' to prepare him for the exam, and that as the written parts were all done at home 'they were actually often the composition of the candidate's grinder'! Christison, whose thesis topic, like Wight's, was fever, proudly, and evidently exceptionally, noted that 'I even composed the Latin of my thesis'.[8]

It is not possible to be completely certain which subjects Wight studied each year, or, indeed, for how many years Wight matriculated, despite the fact that such information would seem to be easily

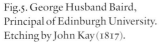

Fig.5. George Husband Baird,
Principal of Edinburgh University.
Etching by John Kay (1817).

Fig.6. Surgeon's Square, Edinburgh – showing (left) the hall of the Royal College of Surgeons and (right) John Barclay's extra-academical anatomy school. Etching by Thomas Barber after a drawing by T.H. Shepherd from Shepherd's *Modern Athens* (1830).

ascertained from the University Matriculation Rolls and from the class lists given in the Medical and General Registers, which survive almost intact for Wight's period. One difficulty comes from curious anomalies and inconsistencies in the student's place of birth as given in the Matriculation Roll (where it was written by the student when he signed up and paid £10 at the start of each academic year), and which is sometimes (but not always) also given in the class lists. Unfortunately the matriculation ticket number, which would make an incontrovertible link, is not always recorded in the class lists, making correlations problematic. An even greater difficulty comes from a positive plethora of Robert Wights, whose signatures are not distinguishable with certainty, and who all came from Midlothian or East Lothian. While at the High School there had been a mere two, at the University there seem to have been four Robert Wights – all there at the same time![9] In the year before 'our' Wight matriculated there were two different Robert Wights studying Humanities, one from Midlothian, the other from Dunbar. In Wight's first year (1813–4) there are two different Robert Wights – one from Pencaitland in the Arts Faculty, the other from 'Ormiston' in the Medical, who took the Chemistry class and seems to be our man, and can be tracked for the following two years. In 1814–5 he took Institutions of Medicine, Chemistry (again), Moral Philosophy and Midwifery, and in 1815–6 Materia Medica, Practice of Physic, Clinical Surgery, Midwifery (again), and Botany in summer 1816. In the years 1816–7, 1817–8, and 1818–9 appears a Robert Wight who signs himself as from 'East Lothian', but this seems likely to refer to someone else as it would not have been necessary for Wight to matriculate for more than three years. In the years 1813–4 to 1815–6 'our' Wight is not recorded as having taken the compulsory subjects of Anatomy or Clinical Medicine, but one explanation for this could be that he studied these subjects with extra-academical lecturers – anatomy possibly with John Barclay, and Clinical Medicine almost certainly with James Sanders. This interpretation of the confusing

records leaves a gap between summer 1816 and 1818, the year in which Wight submitted his thesis, but this was doubtless the period when he was taught by Sanders and gained the experience acknowledged in his doctoral thesis, and when he attended the extra-academical classes of John Stewart in botany. There thus seems no time when Wight could have undertaken the 'several voyages as surgeon to a ship, one of which was to America' mentioned in Cleghorn's obituary, but which puzzlingly (given that if they really happened, they must surely have been exciting and interesting) are not mentioned in the autobiographical information Wight gave to Balfour? This question is never likely to be resolved.

That Wight matriculated for the minimum three years, is supported by the regulations governing the awarding of Diplomas by the Royal College of Surgeons where it is stated that 'no candidate can be admitted to examination before the third Tuesday of March of his last year's course of study'.[10] From the minute book of the College it is known that Wight received this Diploma on 25 March 1816,[11] providing circumstantial evidence that the East Lothian Wight(s) of 1816–7 is someone different; it should also be noted that yet another Robert Wight from East Lothian (but an apprentice, rather than a University student) received a College Diploma in November 1816. To obtain a Diploma, Wight had to prove that he had attended the University, and present himself at the Surgeon's Hall for an examination in which he was 'required to translate into English, some portion of a Latin medical author' having paid the treasurer his fee of '100 merks Scots (£5: 11: 1⅓)'. This took place in the old Surgeon's Hall [fig.6] built in 1697 and which still stands.

What of the University classes that Wight attended? The huge numbers have already been noted, and can be quantified:

Chemistry 1813–4: 515 students
Institutions of Medicine 1814–5: 191 students
Materia Medica 1815–6: 242 students

Midwifery summer 1815: 261 students
Practice of Physic 1815–6: 360 students
Clinical Surgery 1815–6: 126 students
Botany summer 1816: 157 students

The professors ranged from the youthful Thomas Brown (30) to the elderly Andrew Duncan (70) and exhibited a pronounced hereditary tendency, no fewer than four of them (Hope, Gregory, Hamilton and Monro) being the offspring of professorial fathers, holders of either the same, or a different, chair. The most extreme case of this was Alexander Monro, the last of three generations who collectively held the chair of Anatomy for 126 years! They were an assemblage of rather remarkable characters, nearly all meriting entries in the *Dictionary of National Biography*, their eccentricities caricatured by the engraver John Kay, with contemporaneous written cameos appearing in Christison's memoirs. It is from the last source that the following quotations have largely been taken.

The only non-compulsory class Wight seems to have taken, in November 1814, was that of Moral Philosophy given by the charismatic Dr Thomas Brown. Brown (1778–1820) was something of a prodigy. It was from his 'acid pen', that in 1798 had come 'the most violent, lasting attack' on Erasmus Darwin's *Zoonomia*.[12] He stood in for Dugald Stewart, first lecturing on Moral Philosophy in 1808–9, and his lectures were popular not only with students, but with 'distinguished members of the bench, of the bar, and of the pulpit' and with academics such as John Playfair, professor of Natural Philosophy. Brown was a member of the influential Academy of Physics (along with Sydney Smith, Henry Brougham, Francis Jeffrey and Francis Horner) from which sprang the *Edinburgh Review*.[13] Brown was a bachelor of poetic bent, whose 'affections were devoted to his mother, his sisters, nature, books, studies, literary fame … [who] seemed to have none for "the [fair] sex"', so perhaps one detects a whiff of homophobia in Christison's comment that he 'never became reconciled to [Brown's] affected feminine delivery, through which I was unable to discern the excellence which his lovers found in his matter'. Brown became ill and in 1819 the versatile John Stewart (see below) was employed to give his lectures, and it fell to

him to edit Brown's *Lectures on the Philosophy of the Human Mind* in four hefty volumes after his death in 1820, the effort of which was said to have brought about the editor's own premature demise.[14]

The Chemistry lectures Wight attended in 1813–4 and 1814–5 were given by Thomas Charles Hope (1766–1844), son of John Hope, Professor of Botany and Materia Medica, and the Regius Keeper of the Royal Botanic Garden who had moved the garden to Leith Walk in 1763. The second year Christison was also in the class and described Hope as follows:

> [although] his manner and his diction were, indeed, somewhat pompous [this] violation of correct taste as might strike a fastidious ear, was more than counterbalanced by uncommon clearness of expression, and unexampled splendour and success in experimental demonstration. To be visible to a class of 500 students … his experiments required to be performed on a very large scale … [yet] in 1814, there was not a single failure to attain exactly what he announced.[15]

It is thus perhaps not surprising that Wight had returned for a second helping. Hope, in early life, had shown 'skill as an analyst and ingenuity as a discoverer, – as shown in his discovery of strontia [sic, element 38: strontium], and his inquiry into the temperature of water at its maximum density', but he abandoned this and devoted his life to perfecting his 'admirable class experiments' while failing to 'encourage experimental enquiry among his students'.

As already note there is no record of Wight's taking a University class in Anatomy, but this may be due to a missing class list, as, in order to graduate, he must have attended the lectures of Alexander Monro, *tertius* (1773–1859). Monro, however, was unpopular and Wight doubtless shared Christison's 'constant disgust at the odour of the anatomical theatre'. Given this, and Wight's wide interests, it seems likely that he may have attended the anatomy classes of the charismatic and witty extra-academical lecturer Dr John Barclay (as certainly did his botanical colleague R.K. Greville). As well as human anatomy, Barclay also taught comparative anatomy, which was not then taught in the University. His attempt to persuade the Town Council to make a chair of comparative anatomy in 1817, however, was unsuccessful, being opposed by the old guard of Hope, Monro

Fig.7. The Craft in Danger, etching by John Kay (1817) showing left to right: James Gregory, T.C. Hope, John Barclay (on elephant), Alexander Monro tertius, Robert Jameson and Robert Johnson. I.W.J. Rolfe.

Fig.8. Dr Andrew Duncan, etching by John Kay (1797).

Fig.9. Dr James Gregory, etching by John Kay (1797).

and Jameson (professor of Natural History, and editor of the *Edinburgh New Philosophical Journal* to which Wight & Arnott would later contribute). The argument over this chair is the subject of an amusing caricature by John Kay featuring the elephant skeleton that was a conspicuous feature of Barclay's distinguished teaching collection, which in 1828 was given to the College of Surgeons [fig.7].

Andrew Duncan, senior (1744–1828), professor of the Institutions of Medicine [fig.8], was described by Christison as:

> an aged, most amiable, but by this time rather feeble-minded man. He chose his lectures *stare super vias antiquas*, and, "by some devilish cantrip slight", contrived to make it appear as if the physiology, pathology, and therapeutics of Gaubius and the previous century were the physiology, pathology, and therapeutics of the present day, and the existing doctrines those of the historical past. Little, therefore, was to be learned from him. But he was so kindly and warm-hearted a man in manner, had done so much practical good in his day, and was so attentive to his students, whom he invited in succession once every week to a dull enough tea-and-talk party, that he was universally respected, and respectfully listened to.[16]

Duncan also had botanical interests, and in 1809 had been one of the founders of the Caledonian Horticultural Society.

The lectures on Materia Medica given by James Home (1760–1844) were popular and Christison described the class-room as 'so crowded every morning in the dark winter season, that notwithstanding his early hour of 8AM, some twenty students had to stand'. Although the lectures were 'not enlightened by well-defined general principles, or illustrated as now by experiment and demonstration, or enlivened by any of the flowers of oratory – they were a mine of useful facts, laboriously collected, sifted with care, and well together. His delivery was quiet, but earnest; and his whole soul was evidently in his duty'.[17]

The greatest character, and ablest lecturer, among Wight's teachers was James Gregory (1753–1821), professor of the Practice of Physic [fig.9]. Given his interest in 'fevers and inflammations', which he always treated whatever other subjects were omitted through lack of time, Gregory would seem to have had a particular influence on Wight – as this was the subject of his doctoral dissertation. Given this it is worth quoting Christison's account of Gregory at some length:

> a lecturer of the highest order ... his expression, voice, and manner,– all betokened the vivacity, self-reliance, boldness, and determination of a powerful intellect. Equally in fluency as in choice of language, he surpassed all lecturers I had ever heard before. His doctrines were set forth with great clearness and simplicity, in the form of a commentary on [William] Cullen's 'First Lines of the Practice of Physic'. His measures for the cure of disease were sharp and incisive ... he somehow left us with the impression that they [diseases] must of necessity give way before the physician who is early and bold enough in encountering them ... the consequence was that Gregorian Physic – free blood-letting, the cold affusion, brisk purging, frequent blisters, the nauseating action of tartar-emetic – came to rule medical practice for many years, in all quarters throughout the British Islands and the Colonies.[18]

Christison judged Gregory as in advance of his time 'in treating of blood-letting in fever, which was about to break out as a mania with our profession, he briefly but emphatically cautioned us that it does not answer at all in some types of epidemic fever'. However, there was another, more combative side to Gregory, and his works on infirmary management were deemed 'unworthy of his social as well as professional position' and led to lifelong feuds with many of his colleagues. One such feud actually led to violence and the use of the stout cane that Gregory always carried when walking: a quarrel with Professor Hamilton 'was wound up by that formidable belligerent with "the cane"', for which Gregory was fined £100, but who, incorrigibly, offered to pay double for an opportunity to repeat the thrashing'! Another recorded feud was with none other than Wight's cousin Lord Meadowbank, at one time 'his intimate friend' who had actually assisted in the composition of Gregory's doctoral thesis – this squabble, however, was eventually made up.[19]

The unfortunate recipient of Gregory's irascible temper was James Hamilton (1767–1839), Professor of Midwifery, whose three month courses were given thrice yearly in the Lying-in Hospital. Christison described him as:

> a little man, frail-looking, but strong, uncommonly fair, not at all comely, and undeniably wigged. He had a quick, short, nervous step, and a slight stoop and downward look, as if his eyes took account always of what his feet were doing. His voice was harsh, and his intonation Scotch, pure and unsophisticated ... a powerful lecturer ... his information inexhaustible, drawn as it was from stores of vast experience ... a snarling, unfair, unfeeling critic he was ... always in the right – dissentients ever in the wrong ... his language was apt to be unmeasured.[20]

That this could lead to trouble has already been seen, but it evidently appealed to the students. Despite not being compulsory his classes were popular (Wight appears to have attended twice), though Christison suspected that the popularity was due at least partly to the 'pugnacity with which his information was spiced'

The professor of Clinical Surgery was James Russell (1754–1836), a permanent consulting surgeon at the Infirmary who accompanied attending surgeons on their visits, and, having no patients of his own, lectured on the cases of others. Given this he could not be too critical, but nevertheless 'piloted his way skilfully among these quicksands, and gave much useful information to well-attended classes'. Christison found him 'a somnolent lecturer,– a quality fomented by an evening class-hour, and betrayed by an inveterate habit the professor had of yawning while he spoke, and continuing to speak while he yawned'.[21]

The other compulsory subject, Clinical Medicine, was in Wight's time taught in rotation by Dr Duncan senior, Dr Home and Dr Rutherford in the wards of the Infirmary. Although Wight's name does not appear on any of the lists of this class between 1813 and 1816, he must have attended this compulsory course at the Infirmary, but from the wording of the dedication of his doctoral thesis it appears that he also studied Clinical Medicine with James Sanders, an extra-academical lecturer.

Wight informed Balfour that he 'first began the study of Botany under Professor Rutherford in 1817 and continued it under Mr John Stuart [sic] who commenced lecturing that or the subsequent year I now forget which Dr Arnott being a fellow student'.[22] It seems likely that Wight mis-remembered the date of his year with Rutherford and that he is the Robert Wight of the summer 1816 course, and that it was in 1817 that he studied with Stewart, an extra-academical lecturer. Little is unfortunately known of John Stewart other than his philosophical work with Thomas Brown mentioned above. Of his

botanical interests we have only glimpses – he discovered the rare moss *Buxbaumia aphylla* in Selkirk-shire and in the account of this species in Hooker's *Flora Scotica* Stewart was described as 'a gentleman of high botanical attainments … He died at an early age, while on the eve of a voyage to South America, a victim to intense application of literary pursuits'.[23] Greville, in a paper on the same moss, gave the date of his death as '3d November 1820' and stated that he 'promised to hold a conspicuous place in the pursuit not only of natural history but of general literature'.[24] Stewart wrote the article on mosses ('Musci') for Brewster's *Edinburgh Encyclopaedia*, illustrated by Greville, and a footnote by Brewster adds that the projected expedition was to 'Chili, where he proposed to spend three or four years in examining the natural history of that interesting country'.[25] In 1819 Stewart issued the first part of a projected series of exsiccata entitled *Hortus Cryptogamicus Edinensis* , 'a collection of the cryptogamic tribes … indigenous to Scotland', of which a copy survives at Kew. Stewart's enthusiasm for cryptogams was evidently inspirational, as Arnott's earliest botanical work was on mosses, and Wight was to collect cryptogams extensively in India.

Christison's information on the botany course, and on Professor Daniel Rutherford (1749–1819) [fig.10], is of particular interest and relevance. These lectures took place in the Botanic Garden, then in Leith Walk. Rutherford was best known as an 'inventive chemist', (arguably a discoverer of nitrogen), and when teaching botany:

> always seemed to lecture with a grudge, and never contributed a single investigation to the science which he taught. He was a little, sluggish-looking man, who, through the inroads of frequent gout, moved slowly, although not over sixty-three. He had a large, placid face, sunk between his shoulders, heavy eyes, and a great mouth and jaw, in harmony with the credit he got for being fond of the good things of the table. His words seemed to be squeezed out of his chest; and his accents and manner, unless he happened to be cross, were mild, kindly, and dreamy. His lectures were extremely clear, and full of condensed information, and his pronunciation pure and scarcely Scotch; and consequently his class – a large one, in spite of the early hour of eight in the morning, and the long distance to the garden – always listened to him attentively, and treated him with respect. He depended very much for his demonstrations in the class-room on his excellent head-gardener, [William] M'Nab … and he often subjected his aide-de-camp to rather rough usage by his crossness … The doctor had a detestation of foul smells, yet was fascinated by an irresistible necessity when an ill-smelling plant came in his way. "Gentlemen", said he one day, "this is the henbane plant,– the *Hyoscyamus niger* of Linnaeus. It is known by," &C., &C. "It may be also known by a very peculiar, disagreeable odour, – a most offensive odour". Whereupon, raising the nosegay to his nostrils, and whiffing it slightly, he went off in a fit of spasmodic movements as if choking, and called out with a cross air "Take it away, Mr M'Nab! take it away!".[26]

In Christison's eyes, with the benefit of hindsight gained from observation of Rutherford's successors Robert Graham and J. H. Balfour in such matters, he took it as 'a great blot' in Rutherford's teaching that 'he gave no encouragement in any way to practical training in the field', but allowed that this may have been due to his gout.

Although Christison stated that in 1813 the Leith Walk garden 'was thought very fine', a somewhat different view comes from a contemporary, and professionally more reliable, source. The 63 year

old William Roxburgh had returned to Edinburgh from Calcutta in September 1814, as a very sick man, to a house in Park Place.[27] As Robinson pointed out it was an unfortunate winter for a man with 'an old Indian constitution' to return to Edinburgh, with winter temperatures of 20°F, but as he related in a letter to Robert Brown shortly after his return Roxburgh had visited the garden 'where I met a very exclusive collection of Tropical plants; many of them my old Indian friends, but they are miserably lodged, & every way hampered, tho' the Gardener, Mr McNabb, seemed to spare no pains to make the most of such accommodation as the Garden affords'.[28] It is fascinating to think, not only that this was where Wight got his first glimpse of living Indian plants, but that he might even have seen this elderly veteran, the Father of Indian Botany, to whom he would later dedicate his *Icones*, walking the streets of Edinburgh.

As a balance to Christison's perhaps jaundiced view of Rutherford, it should be remembered that the variety of living material demonstrated as witnessed by Roxburgh (and apparent from Rutherford's lecture notes, admittedly from an earlier period), and his advocacy of the Natural System of classification, were certainly influential with Wight,[29] as they had been with Robert Brown rather earlier.[30]

Of Wight's social activities as a student we know nothing, only that in 1818 he was a fellow of the Royal Physical Society, a society that had been established (as the Physico-chiurgical Society) in 1771 and given a Royal Charter in 1778. The University's prestigious

Fig.10. Professor Daniel Rutherford. Stipple engraving by William Holl after a painting by Sir Henry Raeburn; published in Thornton's *New Illustrations of the Sexual System of Carolus von Linnaeus*. (1804).

Wernerian Society was not open to him, as it was only for graduates. Of his classmates, Christison and Greville have already been mentioned, but it is interesting to note that in Duncan's Institutions of Medicine class of 1814–5 was a student called Samuel John Borthwick from Tanjore. One is tempted to speculate on whether he might have talked to Wight about life in southern India, upon which he would embark some five years later. Of Wight's other classmates the one who would become by far the most significant was George Arnott Walker-Arnott (1799–1868). At this stage Arnott was orientated much more towards the Arts, starting university the same year as Wight, but in the Arts faculty, taking classes in Latin and Greek. Arnott took an Arts degree (A.M. in 1818) before turning to Law, but at University, as noted by Christison, was best known for his exceptional mathematical ability. We will return to Arnott in the role of Wight's great botanical collaborator in 1832, but the gratitude we feel for him in this context was not shared by his maths teacher, John Leslie. On hearing of his pupil's 'melancholy change' in deserting maths Leslie is said to have exclaimed despairingly that 'a man with so fine an intellect for mathematics' should 'desert it for botany! – botany! the lowest exercise of the reason of man!'.[31] We have Wight's testimony, already quoted, that Arnott and he studied botany together under John Stewart, and Cleghorn gave the dates of Arnott's studies with Stewart as 1817 and 1818.[32] Cleghorn also quoted a letter of Wight's, referring to Arnott, that 'Here it was our friendship began, in a friendly rivalry in the formation of our herbaria'.

WIGHT'S DOCTORAL THESIS

In order to become an EIC surgeon it was not necessary to obtain an MD – many did not,[33] and the fact that Wight took the trouble of the necessary additional time and expense must reflect a certain intellectual ambition. As already noted, to obtain a doctorate it was necessary to publish and defend a thesis, and it is the resulting publication that provides the one piece of direct surviving evidence relating to Wight's medical studies. The title of Wight's thesis is *De Febrium Natura, Scalpello Quaesita* – 'On the nature of fevers', 'by surgical investigation' or, more literally, 'dissected with a scalpel', and was published in August 1818. Fortunately a copy has survived in the library of Edinburgh University. This 18–page pamphlet was printed by Patrick Neill, also a noted horticulturist, whose press was in Old Fishmarket Close, just off the Royal Mile close to the University and Law Courts; and it would be to Neill that Wight returned for the printing of his major publications with Arnott in the early 1830s. The thesis is headed by an improving epigraph from Terence's *Andria*, which he must have studied at school: 'devotion, with sound judgement, bringeth understanding'. There are three dedicatees – his father, Kenneth Mackenzie and James Sanders. Little can be discovered of Sanders (1777–1843): in 1805 he was president of the Royal Medical Society, and the same year he received an MD from Edinburgh, his inaugural dissertation being entitled *De Hernia Crurali*. Sanders also published on consumption and the properties of *Digitalis* (1808), on smallpox (1813), and in 1821 applied for the chair of Practice of Physic at Edinburgh. Wight recorded that Sanders instructed him 'in matters of medicine and the investigation of diseases', and from the designation given in the dedication ('Med. Prax. Praelect.' of this town) he would appear to have been an extra-academical lecturer.

It is worth looking at this short document in some detail, not least as an antiquarian exercise, it being doubtful that it has been read by anyone since 1818. However, it is somewhat hard to put oneself back to a mindset that knew nothing of the microbiological cause of the fevers with which Wight was trying to get to grips, and as a result is somewhat hard to interpret. The first thing to be said is that, despite Christison's comments on the authorship of such theses, from some curiously disingenuous phrases, it would seem to be Wight's own work, though given his difficulties with Latin, he doubtless had it translated (as did the present author in the reverse direction). An example of such a phrase, which serves also to reveal Wight's belief in the power of observation that would be essential for his later botanical work, may be cited:

> though my own inspiration may fail me, what nature itself teaches I shall reveal truthfully.

The thesis begins with a historical review: firstly Galen, whose theories of humours are dismissed as 'thoughtless and insane'; then those of the Renaissance medics J.B. van Helmont (1579–1644), Paracelsus (1493–1541) and Georg Ernst Stahl (1660–1734) to whom Wight ascribed a belief in 'some innate capacity [of the body] to protect itself' or the 'healing power of nature' (doubtless what we now know as the immune system). Wight then briefly mentioned Thomas Willis (1621–73) and Friedrich Hoffmann (1660–1742) who thought that muscles played an important role in attacking diseases. Two theories to which Wight took exception, as not agreeing with symptoms observable in the progress of fevers, follow. The first was that of the influential Edinburgh physician William Cullen (1710–90), who proposed a three stage process, with fever first sedating the body with cold, this promoting the action of a protective force, the force finally attacking the action of the disease. The second theory discussed was that of John Brown (1735–88) who thought in terms of external influences on the body and reactive forces from within, with disease occurring when these forces were unbalanced, but Wight considered that his theories contained 'more ingenuity than truth'.[34] Of Erasmus Darwin's theory of fever,[35] Wight disarmingly stated that while Darwin 'sets out much that is right and true … it proved too much for my clouded intellect [and] I therefore pray you would excuse me if I say no more of this theory'. In concluding this section Wight accepted Cullen's description of 'Pyrexia' (enunciated in *Synopsis Nosologicae Medicae*, 1785) as the best definition of fever as 'the disruption of many bodily functions and in particular the loss of strength from the limbs'.

The following part of the thesis is of some interest, as it deals with the taxonomy of fevers and elicits an explicit espousal of empiricism and the experimental method with the statement that 'the knowledge and remedies we desire are sought and discovered not by argument, refutation, and skilful debate, but by experimentation, observation and proper surgical investigation'.[36] Here Wight again cited Cullen, but disagreed with his classification of fevers as of two distinct types – intermittent and continuous, the latter including three kinds: '*synocha*' (or inflammatory), '*typhus*' (decaying or putrid) and '*synochus*' (symptoms various). In an interesting comment, of relevance to his later taxonomic work in botany, Wight wrote that there were no absolute distinctions between continuous and intermittent, and that 'fevers are much less easily categorised in terms of their general properties than many people think'. Wight considered that the symptoms of fever developed depended largely on the state of the body when attacked – if the body was healthy (its essential parts, which he still considered in terms of the humours, in balance)

then the fever would be of the inflammatory type, and if the essential body parts were in disarray then the fever would be of the typhoid (or putrid) type. It is also noteworthy that Wight took into consideration the importance of environmental factors stating that 'each case of fever varies depending on the victim's sex, age, lifestyle, the area and climate in which they live, as well as the strength of the infection and part of the body … affected most'.

The final part, curiously, given that it is the most relevant to the title of the thesis, is the shortest, and, whilst interesting, comes as something of an anticlimax. It is here that Wight discussed the dissection of fever victims, to determine if fever (as opposed to other diseases the victim might be suffering from, but which might be hard to disentangle) affected the appearance of internal organs, and if different types of fever had different effects. Wight credited his teacher James Sanders with the initial ideas on these matters, which he then investigated for himself. He proposed that the effect of fever on organs was mediated by the muscles, but that the origin must be in the marrow of the spinal column, and it is therefore there that symptoms should be sought. The results Wight claimed to find were that in *synocha* or inflammatory fevers 'the surface and muscles around the spine are red in colour', whereas if 'the fever is of a typhoid nature, these muscles and the surface of the spine are blackened'. Somewhat tautologously, and rather unconvincingly, his conclusion was that

the causes of disease first attack the muscles around the spine thus disturbing the flow of blood. When the muscles are assaulted in this way, the functions of the body are upset. Therefore, have we not shown the nature of all fevers, and at the same time their cause?

Mark Harrison, who has worked on such matters, kindly read the thesis and made the following comments:

The dissertation seems pretty standard in its main themes and discusses most of the works one would expect in a dissertation of the period on this subject written by someone with an Edinburgh training (e.g., the importance of morbid anatomy, and a respect for Cullen). However, what is unusual is the special emphasis on the spinal cord and surrounding muscles as the seat of fever [doubtless this came from Sanders]. Although most contemporary treatises on fever emphasised the role of the nervous system, I have never seen the spinal cord singled out in such a specific way, nor can I recall other writings on the pathology of the spinal cord.

The reason for Wight's interest in fever can be found in the fact that in 1817–20 Edinburgh, along with many other British towns, was in the grips of an epidemic. This epidemic was described by Christison, who studied the outbreak in detail (and caught the disease himself on three occasions), and was attributed by him to the 'crop failure of 1816 and period of little employment and defective food among labouring classes in 1817'.[37] Although Wight did not discuss the treatment of fevers in his thesis, it is of interest to note those then in use.[38] The traditional treatments were those of Cullen, 'by nauseating or diaphoretic doses of tartar emetic', and 'that of Currie by cold affusion', but as neither of these worked, bloodletting was coming into vogue and was rapidly to be 'employed universally and lavishly'. One of the proponents of this gory treatment was Benjamin Welsh (Jane Carlyle's uncle), who was in charge of the fever hospital in Queensberry House that would later become part of the Scottish Parliament.

PART II
FIRST INDIAN PERIOD
1819–31

Early Days in India 1819–26

Wight had obtained his MD, and as all hope of a substantial inheritance from his father had by now evaporated, like many young Edinburgh-trained medics, he sought employment as an Assistant Surgeon with the East India Company. The papers required for his application are in the India Office Collections at the British Library, and include a copy of his baptismal record, a letter from W. F. Chambers who had examined and judged him qualified in Physic, one from John Borthwick Gilchrist confirming that he had attended a course in 'Hindoostanee' in London in May 1819, and another that he had attended Charles Maclean's lectures 'on the diseases of hot climates'[1]. To obtain this prestigious and highly sought after post,[2] it was necessary to be over twenty-two years old, and to be nominated by one of the Company's Directors. Wight is described as a protégé of Sir Robert Preston, who had recommended him to Joseph Cotton, a Director who had a surgeon's position in Bengal available in his gift. Preston (1740–1834) (known as 'Floating Bob') had made a fortune in the East Indies and, in addition to the house in Downing Street from which he wrote the letter about Wight, had a fishing cottage on the Thames at Dagenham where he instituted the Ministerial Whitebait Dinner that marks the close of the Parliamentary Session.[3] Preston was related to Wight by marriage, being uncle to Lord Meadowbank's wife, Elizabeth (née Welwood). In 1800 Floating Bob inherited the estate of Valleyfield in Fife (along with a baronetcy) from his brother Sir Charles Preston, on which he developed salt panning and coal mining. To landscape historians, however, Preston is known as the commissioner of Humphrey Repton's only Scottish garden, of which only fragments now remain. Wight evidently asked Preston to change the appointment from Bengal to Madras as he had 'friends at that place', and so he became what was known as a 'Mull'(see p.111) rather than a 'Qui-hi'. The friends in Madras doubtless included his brother James who was already in the Madras army, but it is interesting that at about this time his second cousin Robert Maconochie was Master of the Madras Mint. There is a curious request in Preston's letter – that Wight 'may be sent out as soon as possible, as it may be of Consequence to him'. Was this just a natural impetuosity to start a new and exciting career, or is something interesting hidden here? In the end it was not Cotton, but another Director, George Abercrombie Robinson who sponsored Wight's application for Madras. Robinson (1758–1832), son of a Calcutta merchant, was at this time MP for Honiton.[4]

THE VOYAGE TO INDIA

It must have been with great excitement that Wight boarded the ship 'Almorah' at Gravesend on 25 May 1819. As an Assistant Surgeon his passage cost £95 and it would be over four months before he reached Madras. The log of this East Indiaman under the command of Thomas Winter survives and Wight's travelling companions to Madras were as follows: chief, second and third officers, a surgeon, carpenter, boatswain, steward and cook. Of the 23 seamen, seven deserted (one at Madras, the others on the onward journey to Calcutta) and one drowned.[5] There were eleven passengers (one other Assistant Surgeon, six in Company service and one cadet), and 40 recruits to the EIC army (Infantry: one senior sergeant, three sergeants, 31 privates (and 3 wives) and one corporal; Artillery: four privates). Little of interest is recorded in the log other than the ritual crossing of the equator on 29 June, on which day 'Neptune boarded the ship'. Unless exempt by his medical status, Wight must have been one of the 'several strangers' whom Neptune ritually 'passed … into the south side of the Line'. On Friday 17 September the ship 'came to with the chain cable in Madras Roads' and the passengers and their luggage went ashore in the traditional manner of 'Madras landings' (that is, through the violent surf in *massulah* boats, then borne on the shoulders of natives). Wight would not leave India again for twelve years.

THE NORTHERN CIRCARS · 1819–24

Wight's first period in India is poorly documented other than the bare bones of his military career as recorded in his service record,[6] and the annual volumes of the *Madras Almanac* and *East India Register*. This military service was undertaken in the Northern Division of the Madras Presidency, the area of the Godaveri delta, where William Roxburgh had worked 50 years earlier, now in the Telugu-speaking state of Andhra Pradesh. In October 1819 it was recommended that he be attached to the Garrison Surgeon of Masulipatam, and in April 1820 he was assigned to the 21st regiment of Madras Native Infantry at the same place. Wight remained with this regiment (Second Battalion in 1821; First Battalion in 1823), later renamed the 42nd, in which his brother James was already serving and of which he later became Colonel.

Much later Wight would tell Balfour that 'from the time of my arrival in India … I devoted nearly all my leisure to Botanical pursuits', though these first steps were somewhat faltering. Cleghorn in his obituary explained the difficulties Wight faced – 'frequent marches of his regiment and the entire want of books'. Those eventually obtained were Willdenow's *Species Plantarum* (1797–1806), Persoon's *Synopsis* (1805–7), and 'the Lichfield Society's translation of the *Genera Plantarum* of Linnaeus' (1787),[7] with which aids Wight 'proceeded joyously to investigate the Botany of the Madras Presidency',[8] an investigation he would prosecute for the next thirty years. Some of these early specimens, collected at Samulcottah, Rajahmundry, Masulipatam and Cocanada, between July 1821 and May 1823 survive at Edinburgh, mounted on small sheets of what appears to be Indian paper (Book 3 fig. 7). Given the limitations of his library (and, in fact, little else of relevance was then available) it is not surprising that these are not very well identified, and that they

bear the names of the artificial Linnaean orders and classes. It has been suggested that this collection represents the 5–600 specimens sent by Wight in 1823 to Robert Graham,[9] who had by then replaced Daniel Rutherford as Regius Keeper at Edinburgh, and it was perhaps a case of wishful thinking that these 'miserable scraps'[10] were stated to have 'perished in the wreck of the vessel in which they were embarked off the Cape of Good Hope'.[11]

The difficulties of identifying plants in India at this time were later eloquently described by Wight:

> The naming of its objects from definitions only [i.e. written descriptions] has always been a difficult department of Natural History. This difficulty is daily increasing from the increased number of objects to be named and in this Country it is greater than in most others from their being no separate descriptive Catalogue of its natural productions [i.e., a Flora of India], and from the number of nondescript species which it contains. The want of such a Catalogue renders it necessary to select the name of each plant from among forty or fifty thousand [in works such as Willdenow, effectively a world Flora], in place of from four to five thousand the estimated number of described Indian plants.[12]

THE MYSORE VET · 1824–5

In the 1825 *Madras Almanac* Wight is listed, somewhat improbably, as being stationed at the 'Public Cattle Depot in Mysore'. Such a posting was not mentioned by Cleghorn, but turns out to be true.

The background lies with the defeat of Tipu in 1799 and the annexation of his Mysore territories and assets by the EIC, among which was the Amrit Mahal, Tipu's cattle breeding establishment.[13] Cattle, originally brought to Karnataka in ancient times by people of the Hallikar tribe from northern India, started to be improved in the late sixteenth century by the Vijayanagar viceroys. In the following two centuries the Wodeyar rajas of Mysore developed the breed, both for milk and draft power and assigned pasture lands ('kavals') for ranching them and had a breeding establishment called the 'Benne Chavadi'. This was taken over by Hyder Ali, whose son Tipu renamed it the Amrit Mahal ('from Amrutha – Nectar' meaning the Department of Milk), and developed it not only for dairy purposes, but to build up a herd of 60,000 bullocks, used in his campaigns for hauling military baggage and weapons. In 1813 the Madras Government took over the administration of this cattle breeding department (then amounting to 14, 399 cattle and 900 calves, but which by 1823 had doubled in number) together with the 143 kavals. Soon afterwards, in 1815, in a long an interesting letter William Scot, secretary of the Madras Medical Board, raised the question of veterinary research on the cattle (also elephants and camels) because of their importance as pack animals for the Indian army.[14] While valuing the traditional knowledge about the diseases of the cattle passed on from generation to generation by their native 'attendants', Scot recommended appointing someone to be put in post 'in the vicinity of some of the great depot of cattle, in order to become acquainted with their habits in the domesticated state, to study their diseases, to have the opportunities of dissecting carcases, and so forth' that they might establish 'rational principles' on diseases 'grounded on the basis of anatomy, first of the sound parts, then, of the parts altered by disease, and, on a comparison of the healthy and morbid actions of the animal machine'. The importance of the health of the human part of this large and valuable military establishment (2 Europeans and 700 Indians) had been recognised by the appointment in 1818

of a 'Native doctor', but the 'subject of investigating the diseases of Cattle … [had been] lost sight of', and was raised again under the governorship of Sir Thomas Munro in 1824. Munro's permission was sought to 'select one whose attention has been already directed to comparative anatomy and whose pursuits are otherwise such as specially to qualify him for the task'.

Wight was the man recommended for the appointment on 22 June 1824.[15] He must have seemed the ideal candidate, with his agricultural ancestry, the comparative anatomical studies he probably made under John Barclay, and his dissection of fever victims under James Sanders. This would be the first time that Wight's wider interests and abilities were recognised, causing him to be taken away from doctoring sepoys and into what could be termed 'applied biology'. We know little about Wight's time at Seringapatam other than his pay, and the staff of whom he had charge. Of these latter the most interesting was a 'Native Draftsman', to be discussed later (Book 2, p.15), and besides this he had two 'Senior Medical Pupils' and the 'Native Doctor' already at the farm. Over and above his usual Assistant Surgeon's pay Wight was allowed to draw a Zilla [district] allowance of Rs 65, a Palankeen allowance of Rs 70, a sum of Rs 105 for Medical expenditure and servants, and an 'additional allowance in lieu of salary for vaccination' of Rs 52, 8 pice.[16] It is doubtful that the job can have been an attractive one and Scot had predicted that it would require 'great labour, as well as many circumstances of a disgusting and unwholesome nature … in a climate of very questionable salubrity'. It is perhaps not surprising, therefore, that on 8 June 1825 Wight wrote a letter of resignation to the Medical Board not, he assured them, for 'any hope of getting another appointment more to my liking – but purely and solely – on account of my Health which suffered very severely all the time I resided at the Farm' and doubtless somewhat disingenuously trusting that the Board 'will feel satisfied that in so doing, I make a sacrifice which nothing but bad health could have induced me to make'.[17] In the Board's covering letter recommending that the Governor accept Wight's resignation, they assured Munro that 'we are fully sensible from our own observation of Dr Wight's case that his constitution is quite unable to withstand the climate of that part of Mysore where the Depot is situated' but at the same time regretted that 'his researches would have been productive of advantage in the department'.[18] The job was given to Dr A.E. Best, who had a stronger constitution having been stationed at Manantoddy, and also near Seringapatam, 'without suffering from it'. It seems likely that Wight had been struck down with malaria, which must then have been endemic in the low-lying land next to the Cavery River at Seringapatam.

INTERLUDE IN VELLORE · 1825–6

Wight did not return to the 21st regiment of Native Infantry, but was appointed Assistant Surgeon to the 33rd on 1 July 1825,[19] and it is at this period that he appears to have made 'a considerable collection partly at Vellore, and partly at Madras (where he spent three months for the recovery of his health)'.[20] During this illness Wight stayed with Dr James Shuter, then the Madras Naturalist, who at this very time received a letter from W.J. Hooker requesting Indian specimens.[21] Shuter accordingly took a collection of plants back to England when he went there on sick leave in 1826, which reached Hooker in Glasgow via Robert Barclay. Though Hooker was not to know it, this collection included specimens collected by Wight.

Madras Naturalist and Botanist 1826–8

'Peregrinator Indefessi'

One of the most interesting and important periods of Wight's life was his period as Naturalist on the Madras Establishment, and one that, as a welcome change, is relatively well documented. The importance Wight attached to this time is perhaps indicated by the wording on his monument at Grazeley, where it is stated that he was 'for many years' the Company's Naturalist. In fact the job he loved so much was abolished in a period of retrenchment after only two years.

By Wight's time Madras had an almost fifty-year tradition of Company-funded research into Natural History, with an official post called 'Naturalist and Botanist' whose holder was to investigate the natural resources of the country with a view to commercial exploitation. In parallel with this, and with important overlaps of personnel, was the botanical work undertaken by the Christian

Fig.11. Dr Patrick Russell. Soft ground engraving by William Daniell, after a drawing by George Dance (1811).

missionaries and doctors based at the Mission run by the University of Halle at the Danish colony of Tranquebar. The stories of the Company Naturalists and the Tranquebar missionaries are well documented,[1] but it is appropriate to summarise them here.

EARLY HISTORY OF THE POST

The first holder of the Naturalist's post, in 1778, was Linnaeus's pupil J.G. König (1728–85), though it should be noted that it was the Nawab of Arcot who in 1774 had first employed König in such a position. König was a medic who had gone to Tranquebar in 1768, and embarked on botanical research with a group of like-minded naturalists who called themselves the 'United Brethren', and included the Rev C.S. John. Though König collected extensively and accumulated manuscript descriptions and drawings of plants little of this was published (though some specimens that got back to Europe were described by Linnaeus (and his son) and Retzius). König was also in close touch with two Edinburgh trained medics, William Roxburgh who first went to Madras in 1776, and Patrick Russell who arrived in 1781. König died in 1785, but Russell had persuaded him to bequeath his notes to Sir Joseph Banks. It was Russell (1727–1805) [fig.11] who succeeded König as Naturalist, a post he held from 1785 to 1789, and although better remembered as a pioneering herpetologist, played a major role in persuading Banks and the EIC to publish an illustrated work on the plants of the Coromandel Coast, to be edited and printed in London based on specimens, descriptions and drawings sent from India, for which it would fall to his successor, Roxburgh, to provide the materials. Russell also collected plants seriously in the Northern Circars. The story of William Roxburgh, the father of Indian Botany, has often been told – most recently by Robinson:[2] his setting up of experimental plantations at Samulcottah in the Northern Circars to investigate spices, medicinal, dye and food plants; his commissioning of Indian artists to paint plants to accompany his written descriptions, 300 of which were eventually published, at the Company's expense, through the mediation of Banks as the lavish folio *Plants of the Coast of Coromandel* (1795–1819). Roxburgh succeeded Russell as Company Naturalist, but resigned in 1793 when he went to superintend the Company's Garden at Calcutta.

After Roxburgh's departure for Calcutta, the post of Naturalist lapsed, but Benjamin Heyne (1770–1819), who had gone to Tranquebar as a medic in 1793, took over supervision of the Samulcottah plantations. In 1800 he was appointed botanist on Colin Mackenzie's Mysore survey, and when the Samulcottah plantations were abandoned this same year he had responsibility for moving the interesting plants to a garden at Bangalore (possibly the Lal Bagh). In Madras at this time Dr James Anderson had a large private botanic garden (66–67 cawnies in area), and it was he who had been responsible for setting up the Nopalry, a garden for

growing cacti of the genus *Opuntia* as host plants for the cochineal insect, under the charge of his nephew Andrew Berry. By 1799 the Nopalry had effectively turned into a botanical garden,[3] but it was closed down shortly thereafter, and the species of interest also transferred by Heyne to Bangalore. Heyne was appointed to the Naturalist's post in 1802 and held it, with various periods of interruption, until his death in 1819. In addition to wide ranging natural historical activities (including geology) he employed a botanical draftsman, and collected plants assiduously. The whereabouts of his botanical drawings is not know, though according to Mildred Archer many 'passed to the second Lord Clive',[4] who was Governor of Madras 1798–1803. It is just possible that some survived in the Madras Naturalist's collection inherited by Wight, now at Kew (see Book 2, p.23). Heyne, on a period of leave to Europe (1812–5), gave his botanical specimens to the German botanist A.W. Roth, who published two hundred of them as new species in his *Novae Plantarum Species Praesertim Indiae Orientalis* in Halberstadt in 1821, though this book was hard to obtain in India and it was only in 1830 that Wight obtained a copy via W.J. Hooker.[5]

Two other Tranquebar botanists, some of whose plant specimens would come into Wight's hands, must also be mentioned – J.G. Klein and J.P. Rottler. Klein was born at Tranquebar in 1766, and returned there in 1791, having studied medicine at Halle and Copenhagen. Thereafter Klein travelled extensively in South India and collected specimens as far afield as Ceylon, Courtallum, Quilon, Mysore and Nundydroog. Shortly after Klein's death in 1821 James Shuter bought collections from his estate for the Naturalist's collection.[6]

J.P. Rottler (1749–1836) went to Tranquebar as a missionary in 1776, and from 1803 was based at Madras. He collected plants extensively, making two trips to Ceylon (one in 1796 being in the company of Hugh Cleghorn,[7] grandfather of Wight's friend), and publishing an account of a botanical trip from Tranquebar to Madras taken in 1799–1800.[8] Rottler was the last of the line stretching back to Linnaeus and Wight borrowed copies of works by Sprengel and Steudel from him as an old man.[9] Wight knew of Rottler's herbarium (which he estimated to contain 6000 species, two thirds of them Indian),[10] but probably did not study it any detail until early 1831 while in Madras *en route* for his furlough, on which occasion Wight anticipated that Rottler would 'perhaps allow me to select such specimens as I may require to complete my own, which he can for the most part well spare having abundance of duplicates of most of his Indian plants'.[11] This would seem to have happened, and be the 'valuable collection of Klein's and Rottler's plants … procured by purchase a short time before he left India'.[12] Rottler bequeathed his herbarium to the Vepery Mission (run by the British Society for Promoting Christian Knowledge), of which he had charge from 1817 to his death, and from where it was sent to King's College London, but it has ended up split between Kew and Liverpool Museum. The Berlin botanist C.L. Willdenow based many new species on Rottler's and Klein's specimens in his monumental *Species Plantarum*.

THREE SHORT LASTING NATURALISTS

W. S. Michell (d. 1819) and George Hyne (1800–26)

After Heyne's death the post of Naturalist was briefly held by William Somervell Mitchell, another Edinburgh trained medic, who obtained an M D in 1800 (the title of his thesis was *De Phthisi Pulmonali*). Mitchell went to Madras in 1801 as an Assistant Surgeon, and in 1805 was at Tanjore, where he taught medicine to Raja Serfoji II;[13] he was appointed Naturalist on 2 October 1819, but died in Madras the next month on 24 November.[14] Evidently thinking it unlikely to find a replacement locally the Madras Government wrote to the Court in March 1820 asking them to select and appoint a Naturalist for them in England, who would be attached to the Medical Board.[15] In the meanwhile a local candidate cropped up in the form of George Hyne who had arrived as an Assistant Surgeon in March 1820 and applied for the vacant post in December of that year.[16] By 5 January 1821 Hyne had been appointed by the Governor, Sir Thomas Munro,[17] but Madras had jumped the gun, and in June came a letter from the Court dated 21 February, appointing James Shuter to the job, which took effect from 26 June 1821.

Hyne was therefore in post for less than six months, but seems to have been an interesting character.[18] At Edinburgh he had studied Botany, Chemistry, Mineralogy and Natural History (the latter two doubtless under Professor Robert Jameson), but was evidently more orientated towards the arts and natural philosophy bringing references from Dr Thomas Brown and Professor Christison (Sir Robert's father, one time Rector of the High School). He was evidently not lacking in self confidence, and in a flowery letter of application announced that in the course of summer excursions to almost every part of Scotland and England he had made collection of plants, minerals and natural history objects 'not surpassed in beauty by any private collection in Britain now in the possession of a young nobleman to whom I presented them'. Hyne seems to have been justified in his self-belief and the letter he wrote to the Medical Board announcing what he intended to do and outlining the equipment, travel arrangements and assistance he required, is impressive.[19] The equipment was to include barometers, thermometers, a microscope, hygrometer, eudiometer and ganiometer, a 'quadrant for ascertaining altitude and geographical position of mountains', a rain gauge, a hammer and chisel – and more besides. He was to employ Peechee Antonio, previously in Mitchell's service, as a travelling assistant, and would keep specimens in the Medical Board Office, where Russell's collections already were, to be looked after by a second assistant. It must therefore have been a great disappointment to him when Shuter turned up, and Hyne was to die only a few years later (at Tanjore) aged only 26.

James Shuter (c. 1779–1826)

In February 1821 Shuter was appointed Assistant Surgeon, and must have gone to India especially for the Naturalist's job, as in November of that year he was noted as 'being unacquainted with official forms in this country'.[20] That he started this Indian career 'too far advanced in life' to have the 'advantages of promotion … and of finally retiring on a liberal pension' was the reason for the Governor's awarding him a monthly salary of Rs 1000.[21] In this Munro was being both supportive and extremely generous and, in fact, Shuter at this time was only about 42 years old. This enormous salary (the equivalent of about £50,000 per year in today's terms) was the same as that of the Superintendent of the Calcutta garden, and double that of his predecessor, Hyne, whose monthly salary was 150 pagodas (= Rs 525),[22] and in König's time had been 40 pagodas.[23]

Shuter evidently took the job seriously and set about finding accommodation, employing assistants, and collecting and purchasing

specimens. Up to Shuter's time the Naturalist's collections had been kept in the Medical Board in Fort St George, but Shuter evidently found the conditions unsuitable and in February 1822 asked for a house and garden 'at least a mile from the sea, both on account of the preparations [i.e. museum specimens] as well as the plants that it may be required to cultivate'.[24] The house and garden rented for him was known as 'Mooniapillay's', but turns out to be none other than the old Nopalry at Saidapet, for which the owners C. Parasooramah Pillay and C. Senevassa Pillay asked a monthly rent of Rs 300 in March 1822.[25] On this they were beaten down, to Rs 210, following advice from William Ravenshaw, the Civil Architect.[26] It is clear that Sir Thomas Munro continued to be very supportive of the post, and seems never to have quibbled with matters of expenditure, such as the Rs 1219 spent by Shuter in March 1822 on 'specimens for the formation of a Museum of natural curiosities'.[27] From the start, however, Munro made it clear that he did 'not contemplate the establishment of a Botanical Garden at this Presidency' and that he would sanction no further expenses after the initial 'cleaning the Garden … of brushwood, repairing watercourses, Pacottahs[28] &c' undertaken by Shuter in December 1822.[29] Munro, however, seems to have relented on this and sanctioned the expenditure of Rs 846 on 2 in April 1825 'for work done during the last five months in the Botanical Garden'.[30]

In a letter of February 1824, Shuter described the establishment he required, 'framed upon the most economical scale'.[31] These included 'gardening & Carpenters' tools … medicines & spirits for preserving specimens, a pair of oxen for drawing water, boxes & baskets for packing & conveying seeds, plants &ca &ca, drawing and packing paper'. And the monthly expenses were as follows:

	Rs Anna Pice
1 Head Gardener	35 – –
1 Second do.	17 8 –
1 Draftsman	28 – –
1 Writer	21 – –
12 Gardeners (men) at Rs 5¼ each	63 – –
6 Do (women) at Rs 4 each	24 – –
2 Police Peons	4 – –
Total	202 8 –

These were duly approved by Munro and show the establishment inherited by Wight. It is also worth quoting some extracts from the rules drawn up for the use of the Naturalist (by the Medical Board) at this time, including as they do the formation and maintenance of a 'Museum', being the rules under which Wight must have operated:[32]

> The Functions of the Naturalist will be comprehended in the investigation of the Animal, Vegetable, and Mineral Kingdoms within the Peninsula of India …
>
> The first treating of the names, structure, food, clothing, habits or instincts; the means of preservation, geographical distribution and uses of animals in the œconomy of nature.
>
> The second treating of the names, structure, qualities, uses, the art of rearing and preserving, the geographical distribution, and the uses in the œconomy of nature of vegetable productions [for this reason 'botanist' was no longer to be appended to the job title of 'Naturalist'].
>
> The third treating of

> 1. Mineralogy, or the description of all inorganic substances situated in the Earth, or on its surface, the composition of the Earth itself, and the uses of mineral bodies in the arts; of 2– Hydrology, or an account of the qualities and distribution of Water over the Earth; and of 3. Meteorology or an account of the Phenomena of the Atmosphere, with the relations in which these stand to the general œconomy of nature' …
>
> 5. As the objects of the Naturalist can only be accomplished by his traversing and exploring the regions which are to form the field for his observations, under this Presidency, he will accordingly employ such portions of his time in this manner, as may be determined upon, in communication with the Medical Board – And as the fruits of his labours can only be rendered of full effect to the Public interests by the formation of a museum, or Collection of Specimens of Natural History, he will bend his constant endeavours to the formation, and enlargement of the Museum, which is clearly understood, and recognized, as in all respects, the property of Government.- Where there are Duplicates, the Naturalist may, under authority from the Board, reserve certain specimens for his own use.

Travel was to be 'within the limits of the Madras Territories, under a passport from the Civil Department'; he was to provide 'sketches of his intended tours', and while on tour to provide 'from time to time his progress, and Operations, and make, at least, a Monthly Report' to the Medical Board.

The Museum was 'in the first instance [to be] in a room in the Medical Board Office and a Catalogue will be immediately begun and lodged there, of which a Duplicate will be kept by the Naturalist'. There would be two assistants (one travelling, the other at the Museum). While travelling coolies were to be provided by 'the nearest Medical Storekeeper'. There follow items about supply of materials, stationery, equipment and apparatus, and how these are to be supplied via indents. In conclusion, the Naturalist was:

> required and enjoined to keep a regular Journal of his Proceedings, which Journal is to be the property of the Government and may at any time be called for.– This is not only a rule most especially indicated in the Department of the Naturalist, but it is also fully provided for in the Articles of Covenant of Assistant Surgeons, whereby all papers or writings, in any manner of way connected with the public Service, are declared to be the property of the Honorable Company.

That the word 'Museum' was used for the Naturalist's collection is significant and has not previously been remarked on. It comes only ten years after the formation of a museum by the Asiatic Society in Calcutta (1814), generally recognised as the first such institution in India. Although the Madras collection was initially restricted to natural history specimens (the Calcutta one from its inception included man made artefacts in addition to geological and botanical/zoological items), as will be seen later, Wight planned to broaden its scope to include what would now be called ethnographic, artistic and archaeological artefacts. Some of the main functions of a museum – collecting, storage, and documentation by means of a catalogue – are clearly enunciated in the Medical Board rules. Display is not mentioned as this was no more a public museum, in the modern sense, than the Calcutta one, but the Madras collection was certainly an official institution supported by Government funds. That this first 'Madras Museum' has previously escaped notice is, as will become apparent, due to its short duration and despatch to London, and Madras would have to wait another 25 years (until

1851) for a fully inter-disciplinary public museum, though interestingly this too would start with a strong natural history bias, and be run by a (Scottish) surgeon.

Shuter held the Naturalist's job for five years, but according to Wight his 'good natured procrastinating habits, that always wished to do everything, and serve everybody, but seldom did either effectually'. He was doubtless 'an indifferent Botanist', but Wight excused his lack of attention to botany on account of the rules (given above) which meant that 'a great part of whose time was taken up with other branches of natural history', and that because of these 'more was expected of him … than six men could do justice to'.[33] Despite this Wight & Arnott would honour him in the name of a leguminous genus (as had the French botanist Choisy in one in Convolvulaceae). Shuter returned to England on sick leave in January 1826, generously leaving a varied assortment of botanical books with Wight;[34] he took botanical specimens with him (including Wight's Vellore ones), which eventually reached Hooker, but died later that year, being buried at Wareham in October when he was said to be 47 years old and to have come originally from Dungannon (in Northern Ireland).[35]

ROBERT WIGHT

In a letter dated 31 January 1826 Wight was appointed by the Honourable the Governor in Council, Sir Thomas Munro [fig.12], 'to succeed Dr Shuter and officiate as Naturalist and Botanist, from the date of his embarkation for England' and to 'take immediate charge of the Department'.[36] As we have seen the Naturalist's salary had been hiked for the benefit of the 'aged' Shuter, but nonetheless the Madras Government appointed Wight on the same monthly salary of Rs 1000.[37] Wight, of course, was in the prime of life, and when the Court discovered this anomaly they ordered that his salary should revert to what it had been before Shuter's time, i.e. Rs 525.[38] However, the letter with this news was dated 30 April 1828, and cannot have reached Madras before August 1828, by which time the post had been scrapped and Wight was back doctoring sepoys at Negapatam. The bonus of a hugely inflated salary for two years must have been of enormous benefit at this stage in his career, and Wight doubtless salted much of it away.

Wight took over Shuter's flourishing establishment, but was determined to devote more time to botany than his predecessor. He specifically asked Munro 'if it was the wish of Government that a Botanical Garden should be formed'? This was 'answered in the negative, because the Premises taken for the Naturalist were rented, not Company's property'. The garden was therefore maintained 'in order and [for] rearing such ornamental or useful plants as may appear advantageous to introduce from the provinces into the Madras gardens'. Wight's ambitions on this front cannot be hidden when he stated that while these were as yet few, they were 'daily increasing in number',[39] and one such introduction – *Hedychium flavescens*, cultivated from material collected at Dindigul – was painted by Rungiah.[40] The staff inherited by Wight were Pechee Antonio as 'travelling assistant' (monthly salary Rs 35, travel allowance of Rs 1 per day),[41] and George Haldwell as 'second assistant' (monthly salary Rs 24 8 -). Soon afterwards Haldwell took over from Antonio who was transferred 'to the Field Hospital at Wallajahbad'.[42] The question of such an assistant was an important one, for it is clear that right from the beginning Wight had big ideas about travelling and collecting. Munro continued to be supportive and in July 1826

approved the provision of a Subaltern's tent and Carriage 'for the use of the Naturalist whenever he may proceed upon a professional tour', and agreeing to expenses providing that these were 'not in any degree to be a source of personal emolument'.[43]

The summer of 1826 was spent planning a great expedition, upon which Wight probably embarked at the end of August, accompanied, it should be noted, by a draftsman. It is worth reproducing Wight's letter to the Medical Board outlining his plans and the equipment required for what would be a nine-month journey.[44]

> Sir,
> I have the honor herewith to transmit for the sanction of the Medical Board an Indent for travelling equipment required for the tour on which I am about to set out.
> Allow me to take this opportunity of submitting for the consideration and I trust approval of the Board the route which I propose to follow.
> On leaving Madras I intend proceeding south probably as far as Cape Comorin traversing the low country backwards and forwards from the sea Coast to between fifty and sixty miles inland. In returning to Madras I should wish to confine myself entirely to the examination of the natural productions of the central range of hills; if I can reach them at a favorable season of the year. If not, I will then return along their outskirts making what Collections I can there. By following this route I expect to be able to Collect as much as is possible in a single tour.

Fig.12. Sir Thomas Munro. Stipple engraving by Henry Hoppner Meyer after a painting by Martin Archer Shee (1841).

During this tour I should wish to be permitted to devote the greater portion of my time and attention to Botany, for the purpose of drawing up a descriptive catalogue of the plants collected which might afterwards be published if the Board approved of it.

In a tour of such length and with objects to be accomplished so varied there must necessarily be a variety of incidental expences which it is impossible to avoid and difficult to include in a contingent charge, but which I cannot suppose it is the intention of Government should be borne by me – such for example, as the purchase of curious or valuable zoological or mineral specimens, or specimens illustrative either of the Mythology of the Arts or of the antiquities of the Hindoos occasionally for extra assistance required for Collecting curiosities or for conveying them from station to station lastly for guides and many other contingencies which it is impossible to foresee or provide for, in anticipation; otherwise than by placing a sum of money at my disposal for that purpose. In these circumstances, I trust, I shall be excused for suggesting for the consideration of the Board, the propriety of making me such a monthly allowance, as may appear to them sufficient to cover these expenses and provide native Collectors for the Tour.

In conclusion I may observe in reference to the articles indented for that

No 1 are Boxes for packing dry plants and are each calculated to hold from 700 to 800 specimens.

No 3 are for Insects and zoological specimens.

No 5 are for spirituous preparations and shells.

No 6 are for drying plants and are of the simplest construction. They consist of two thin pieces of board strengthened with cross bars and joined with strong straps and buckles. They will each contain from 80 to 100 plants laid in blotting paper.

I have not indented for package for minerals, a basket and some old gunny to wrap the specimens in to prevent friction being all that is necessary for them. Nor have I included carriage as I cannot ascertain what is required until I know what part of this Indent is complied with

I have &c (Signed) R. Wight, Naturalist.

Madras, 1st July, 1826

Indent on the Commissary General for Travelling equipment required for the use of the Naturalists' department

	Wanted
1 Box lined with tin two feet eight inches long by two feet two inches broad, and Eighteen inches deep	No.2
2d Painted canvas covers for ditto	No.2
3d Boxes lined with tin two feet four inches long by twenty inches broad and eighteen deep	No.2
4th Covers for ditto	No.2
Remark – One of them to be fitted up with a series of moveable shelves one and half inches apart, made of deal or other soft wood. The other plain.	
5th Boxes plain deal wood of the dimentions of the last	No.2
6th Portable Presses for drying plants, eighteen by twenty four inches a pattern will be given	No. 2
7th Covers for ditto	No. 2
8th A tent for preserving and drying the Collections made Carriage for ditto	No. 1
Remark. For this purpose I would recommend a Captain's tent which would afford not only ample room for the above purpose but wd. also accommodate both the Draftsman & Travelling Assistant	

(Signed) R. Wight, Naturalist. Madras 1st July, 1826

The journey took place as planned and the route is shown on the beautiful map of the journeys of Indian botanists made by Wallich for *Plantae Asiaticae Rariores*.[45] The first few pages of Wight's 'descriptive catalogue' of the plants has miraculously survived at Edinburgh, and must once have been in the possession of H.F.C. Clegorn. On the front page is written 'R. Wight M.D., P.C.D.' evidently a memento of the previous year and his days in the Public Cattle Depot. The first entries were made in Madras in July, and on 1 September he was at Pallavaram. Later in the month, from data on specimens collected, we know that Wight had reached Gingee; the route then took him through the French enclave of Pondicherry, where he possibly met the young Charles Bélanger, who at this very time had been sent to establish a botanic garden there. From Pondicherry Wight headed south through Cuddalore and Chidambaram before turning inland (and therefore missing out Tranquebar) to Tanjore and Trichy. At Tanjore might Wight have visited Raja Serfoji II? There is no record of such a meeting, but with Serfoji's interest in western science and culture, his outstanding library (including botanical illustrations) and links with Tranquebar, it seems a strong possibility. An interesting visitor to Trichy (where he died) in 1826 was Bishop Reginald Heber, and, again, one would love to know if his and Wight's paths might have crossed? In the absence of Wight's diaries we will unfortunately never know the answers to such tantalising questions. From Tanjore Wight went to Dindigul and Palani (which he called 'Piney') and must have been there in December, since Cleghorn quoted extracts from Wight's diary written in the Palni Hills dated between 11 and 16 December 1826.[46] Wight continued a criss-cross route southwards taking in the great temple city of Madurai before returning to the Western Ghats at Kambam, skirting their eastern edge to Courtallum, the place that ten years later would become his most productive source of specimens. From here, via Tinnevelly and Palamcottah, Wight reached Cape Comorin, the southernmost tip of India. From Cape Comorin he headed northwards up the Malabar Coast through Trivandrum, Quilon and Allepey turning eastwards at Trichur, reaching Coimbatore via the Palghat gap. By this stage Wight must have been short of time, otherwise he would surely have gone into the Nilgiris, rather than merely skirting their eastern flank on the way north to Mysore and Seringapatam. The return to Madras was by way of Bangalore, Vellore and Wallajabad. It was with some justification, based on this journey alone, that Wallich could call Wight an 'indefatigable traveller', though in fact Wight would never again make anything like such an extensive journey. A noteworthy feature of the route is the number of sites it took in that would become of great importance to Wight in his second Indian period (1834–53). The achievements were spectacular. Of the 10,000 specimens that were in the Naturalist's collection in 1828, nearly half had 'been collected since my appointment'. As will be seen below, these consisted not only of plants, but of birds, insects, geological specimens and botanical drawings, most of which must have been collected during the 1826–7 expedition.[47]

SCRAPPING OF THE POST

Wight evidently saw this expedition in terms of a reconnaissance, and was planning a second, longer trip, to last almost two years, in which he hoped to 'double or perhaps treble my Collections … with as Complete a series of specimens in every branch of Natural History as I may find possible to prepare'.[48] However, in January 1828

'on the eve of departure' for this expedition, in the course of which 'I would have visited all the richest botanical districts in the south of India' taking the *Hortus Malabaricus* and Buchanan's 'Travels in Mysore' for guides, tragedy struck.[49] This came about from the deliberations of the 'Committee for the revision of Civil Establishments'. The name says it all, and in looking for ways to save money the committee's eye fell on the Rs 15,549 annual cost of the Naturalist's Department. They recommended its abolition, having been asked to look for ways of reducing expenses 'as far as possible without injuring the Public interests'.[50] The Governor of Madras, by now Stephen Rumbold Lushington (Munro having died in 1827), was therefore given a choice: that 'the Office of Botanist and Naturalist should either be abolished, or put upon a more efficient scale'. His conclusions were that:

> we have no choice at this moment but to do it altogether away & therefore I propose that all expenses on this account shall cease at the end of this month and that the Collection of Curiosities be sent to the Museum in Leadenhall Street, if they shall be found on inspection worthy of a place there. By this means a saving of 15,000 Rupees will be effected.

Lushington recommended that 'the office of Botanist and Naturalist be abolished; that all expenses on account of it shall cease at the end of this month; excepting the salary of the Botanist and Naturalist, which will be continued until the end of March'.[51] The irony of this is that this was the very time (see above) that the accountants in London noticed the anomaly of Wight's inflated salary. Wight had already explained that the cost of maintaining the garden was minimal, so the vast bulk of the departmental budget consisted of his salary, and the cost of the Department could therefore quite legitimately have been almost halved. That Lushington did not do this was probably that he was as yet unaware of the anomaly, but given his dismissal of the collections as 'Curiosities', and a subsequent peevish incident, there is at least the suggestion that he regarded Natural History as a waste of money, and perhaps even had a personal grudge against Wight. This is also suggested by the indecent haste with which the orders were carried out: 'the Governor was in such a hurry that only 14 days from the receipt of the order was allowed for the removal of the contents of the Museum and my own furniture, books, apparatus etc., from the house they occupied'.[52] Lushington was a rather unattractive character, who did very well for himself under the patronage of his father-in-law Lord Harris, and with justice was accused of 'jobbery and nepotism, instances of which stood out all the more against the background of stringent economies he introduced in order to reduce Madras's deficit before the Company's charter came up for renewal in 1833'.[53] Lushington also made a point of ridding the Madras establishment of supporters of his predecessor Munro, and Wight was therefore unfortunate in being in the wrong place at the wrong time.

One spinoff of the debacle, for which we can be grateful, is that it resulted in an inventory of the material sent to London, dated 31 March 1828, which provides a testimony to the efforts of Wight and his predecessors: [54]

> Case No. 1 | Contains a Collection of plants purchased by the late Dr Shuter from the Estate of Dr Klein a Danish Missionary. This collection amounts to about 2400 species of plants, the greater part of Indian growth. The specimens are generally very perfect and in good state of preservation.

> Case No. 2 | Contains a Collection of Insects purchased at the same time and forming part of the same Collection with the former. The specimens are numerous, packed in six small boxes: some of them in perfect preservation, others are much injured by insects.

> Cases No. 3 & 4 | In these are packed a collection of plants from the Northern Circars presented to the Honorable Company by the late Dr Patrick Russel. This Herbarium contains about 1,000 Specimens all pasted on the papers and in a good state of preservation.

> Cases 5, 6 & 7 | In these are packed the plants and Minerals which I collected while officiating as Botanist and Naturalist. Of the former there is about 2,500 species, and numerous duplicates. [There follows an apologia on the state of their identification]. These three cases likewise contain a number of Minerals, a series of Drawings [presumably botanical] and four packets of plants belonging to the Collection contained in No. 1 for which there was not room in that case.

> Case No. 8 | Is filled with zoological specimens principally Birds and Insects. It contains in all about 400 specimens. The exact number is not known. I have nothing further to remark regarding them; what has been said concerning the plants being equally applicable to the animals.

Wight was canny and 'asked to keep an old damaged collection of plants to go through and keep the best for himself' – this was Klein/ Rottler/Heyne material, and he was generous with it, and on giving duplicates to Hooker stated their importance as being what we would now call types of some of Willdenow's species.[55] He, of course, kept many for himself, duplicates of which he later gave to Arnott, on which were based many species in their *Prodromus*.

Another benefit of this dispersal was that Wight's collection reached London and was added to the existing EIC herbarium collections in time for the great work of curation and distribution on which Wallich embarked in 1828, which would not have been the case had Wight stayed in post. Nor, as will be seen, would it have been of any use to Wallich had it come back with Wight himself in 1831. The result of this is that the material was worked on and at least given names in the *Numerical List* of the EIC herbarium produced and published by Wallich, though it fell to others to provide descriptions and therefore 'validate' these names. Although they were widely distributed in Britain and Europe, taxonomists were slow to do this, with the ironic result that Wight & Arnott ended up validating many names based on Wight's specimens (even those named by others as 'wightii') during the work on their *Prodromus* between 1832 and 1834.

From this great dispersal the Medical Board wanted to retain the Naturalist's botanical books, which included some extremely valuable works: Redouté's *Les Liliacées*, Rheede's *Hortus Malabaricus*, Rumphius' *Herbarium Amboinense* and Roxburgh's *Flora Indica* [i.e., the two volumes of Wallich's edition of 1820–4]. However, doubtless on the orders of Lushington, the Secretary to Government ordered that these books be sent to his own office – a matter that will be returned to.

Thus ended, for the sake of some penny-pinching, 'the only establishment … under the Madras Presidency solely devoted to the cultivation of Science',[56] an institution that in its fifty-year history from 1778 to 1828 was held by eight men – of whom five were Edinburgh-trained medics, with a Scottish Enlightenment background, and two German surgeon/missionaries from a north-European, Linnaean tradition.

Garrison Surgeon of Negapatam 1828–31

Wight was ordered back to medical duties with the 13th regiment of Madras Native Infantry, as Garrison Surgeon of Negapatam.[1] Situated in the province of Tanjore, in the region of the Cavery delta, Negapatam in mediaeval times had been one of most important international ports of the Coromandel Coast. It was taken over firstly by the Portuguese, then by the Dutch, and in 1781 by the British, but by Wight's time had declined in importance other than as a military station – he described it as being 'in a sequestered part of the country'.[2] Nothing is known of Wight's social or military life for this period, except for the fact that in 1830 his nephew Alexander (his elder brother James's eldest son) had been staying with him for eighteen months, Alexander was another surgeon and took charge of his uncle's Hospital 'while he was busily engaged in his favourite study'.[3]

Despite the disappointment at the abolition of the Naturalist's post, a salary slashed by half, and the arduousness of his medical-military duties, this was a very important period, when Wight really took off as a botanist, due in a great part to his contact with W.J. Hooker in distant Glasgow. The particular difficulties faced by taxonomic botanists in India at this time have not been fully or accurately appreciated by many writers on the history of colonial science with backgrounds in the social sciences. To progress it was essential to have close links with Europe, where the named voucher specimens (including what are now called 'types') and large libraries were located. Given the methodology of taxonomic botany established by Linnaeus – based on the principle of priority of publication – this was inevitable, and botanists in India were almost helpless without return trips to Europe or the existence of a reliable collaborator there.

Wight was unfortunate in his earliest choice of such a hoped-for-collaborator. Though perhaps not consulted before being sent gifts of herbarium specimens by Wight, for which a more active taxonomist would have paid substantial sums of money, Robert Graham [fig.14], Rutherford's successor as Regius Keeper at Edinburgh, proved both useless and ungrateful. He was clearly more interested in his medical practice (of which, while his hospital work benefitted the poor, much was devoted to private work that brought him a large income later lost in unwise investment in Australian stock), summer field trips to the Scottish Highlands, and as host of lavish dinner parties. This left little time for botanical work beyond his summer teaching, and Graham published only a few articles describing novelties flowering in the Botanic Garden, and he consistently failed even to acknowledge receipt of the specimens with which Wight showered him.[4]

Graham did, however, perform one great service for Wight, for it was he who recommended that Hooker [fig.13], his counterpart as Regius Professor of botany at Glasgow, start a correspondence with Wight. Hooker did so in March 1828, evidently asking Wight to

send him cryptogamic specimens (especially bryophytes and ferns), his great interest at that time, and Wight replied from Negaptam in October, the start of a correspondence that would last until Hooker's death at Kew in 1865. The sixteen lengthy and rambling letters from Negapatam ('my style is not the most condensed in the world',[5] being something of an understatement) written over the next two years give a fascinating insight into Wight's development as a botanist during the period when most of his botanical projects were first clearly enunciated.

It is worth quoting at this point a succinct account that Wight gave of the difficulties he faced in undertaking such work, which makes clear why Hooker's assistance was of such crucial importance:

> While Naturalist here [i.e., 1826–8], I could not find a single Botanist with whom to open a correspondence on the Madras establishment.– This at first sight appears rather extraordinary; but when we recollect how unsuitable a tropical climate is for any occupation requiring much exposure in the open air, that everyone has his official duties to perform, & that these are generally done in the morning & evening, the only times he could with safety devote to botany, our wonder begins to diminish. Besides we have but little encouragement, to induce us to undertake the advancement of science, opposed as we are, by the enervating effects of climate and the difficulty which every one must lay his account with meeting in his first attempts, from want of Books, and of the incalculable advantage to be derived from the … assistance of a friend somewhat advanced in the same pursuits. The expense required by the student of natural history for books alone, is also a very serious draw back, as there are no libraries scattered over the country, in which he can consult the more expensive books of reference. These he must either purchase for himself, or do without.– And the expenses of living in this country is so great in proportion to the income, that few indeed can afford that, and still less to carry a well stocked library from place to place when removed from one situation to another – a species of discipline that we Doctors are very subject to and lastly, the want of a local flora is a very great obstacle to the study of Indian Botany.[6]

Here we have it – isolation, lack of like-minded colleagues, the climate, long official working hours, repeated upheavals and lack of books, to which could be added periods of sickness. Wight also faced ridicule from his boorish fellow officers, who were 'more likely to laugh at than join me in my Botanical pursuits', and it was no doubt such attitudes that, years later, made him hope that his own sons would not go into the army.

There were other hurdles to be overcome, such as the cost and difficulty of obtaining paper. It is not often appreciated, until one is in a place where it is in short supply, that paper, of various types, is an essential commodity for the botanist – low quality paper for drying plants and packing them up for postage; high quality for mount-

ing herbarium specimens, and for use by artists. Locally made paper was available in India (such as that used by Wight for mounting his Northern Circar specimens), but fine paper was all imported from England at enormous expense. Paper suitable for mounting purposes cost 4 to 5 guineas per ream in Madras,[7] explaining at least partly why Wight used sheets half the size of those employed by his European colleagues for mounting his herbarium specimens. As will be seen later, the drawings Wight commissioned are also on atypically small pieces of paper, and from the watermarks, much of it probably acquired in the 1820s. Hooker's offer to supply Wight with both mounting and drying paper was therefore of greater importance than would appear at first sight. Although the latter, being of lower quality and more absorbent, could usually be obtained in Madras, at reasonable cost, Wight was still grateful for the 'large brown [drying] paper' that Hooker sent out in 1829, which amounted to 'a very heavy load for the cooly who brought it from Madras'.[8] Which raises another problem – the difficulties and cost of transport and postage, not only within India, but between India and Britain. Ships took four months, and could not operate from the storm-tossed Coromandel Coast between October and February; a letter from Madras to Negapatam took four days; a packet that Wight sent to Hooker for which he assumed the ship postage would be 5 or 6 shillings (the charge between Madras and London) ended up costing Hooker 'more pounds than I calculated shillings'.[9]

It was impossible to purchase botanical books in India (unless someone was disposing of them on leaving the country), though it was possible to consult some in collections in Madras – for example Rottler's library, and semi-public collections such as that of the Madras Literary Society, which owned the only copy known to Wight of Roxburgh's *Plants of the Coast of Coromandel*.[10] Wight also subscribed, via Parbury & Allen in London, to various periodicals, and new works such as the Wallich's expensive *Plantae Asiaticae Rariores*, the first part of which he received in June 1830.[11] Providing books was therefore one of the greatest services that Hooker was to provide, and one can detect a hint of embarrassment in Wight's slightly gauche comment that it was 'not less gratifying to me to receive than it is to you to give books'.[12] Hooker's generosity in this matter to Wight, as to an extensive network of other colonial botanists, has not always been adequately stressed, but was spectacular, and shows how greatly Hooker appreciated the specimens received in return. Books sent to Wight included not only Hooker's own publications such as the *Icones Filicum* and *Botanical Miscellany*, but A.P. de Candolle's *Théorie Elémentaire de la Botanique*, and works on cryptogams by Agardh and Sprengel, Roth's *Novae Plantae* (invaluable being a Flora, even if only very partial, relating entirely to Benjamin Heyne's South Indian collections), and various journals and loose botanical plates.[13] The depth of gratitude Hooker felt for Wight's drawings and specimens is shown by his gift of one of the

Fig.13. William Jackson Hooker, aged 28. Etching by Mary Dawson Turner after a drawing by John Sell Cotman (1813).

Fig.14. Professor Robert Graham. Lithograph by Frederick Schenck (c.1840).

most beautiful and costly of hand-coloured folio volumes ever produced, Roscoe's *Monandrian Plants*, which Hooker had to urge Wight to accept.[14] In 1829 Wight sent Hooker a list of books in his botanical library, the 'strange selection' of which he attributed to the fact that most were those generously left behind by Shuter in 1826. The list is strong in medical botany, but also includes some (even then) extremely rare and valuable illustrated works such as Catesby's *Natural History of Carolina* and Linnaeus's *Hortus Cliffortianus*, and some fine Floras of areas that would have been of little relevance in South India. As is to be expected there is a large section of 'Linnaeana', including later editions by other authors, and by proselytisers such as J.E. Smith. More significant, as will become apparent in discussions of 'Wight the Taxonomist', is the large number of works employing the natural system (Jussieu's *Genera Plantarum*; Brown's *Prodromus Novae Hollandiae*, Gray's *British Plants*; no fewer than five works by Candolle, and the Edinburgh translation of Sprengel's German edition of Candolle's *Théorie*). Of Indian Floras Wight had only the first volume of Wallich's edition of Roxburgh's *Flora Indica*, Roxburgh's posthumous catalogue of the Calcutta garden – *Hortus Bengalensis*, Don's *Prodromus Florae Nepalensis* (also arranged by the Natural method), and Moon's *Catalogue* of Ceylon plants. Of illustrated works, from the date, the Wallich reference must be to his lithographically illustrated *Tentamen Florae Napalensis*. Also noteworthy is the range of plant groups covered, including as it does many of the standard early texts on lichens, mosses, fungi and seaweeds. It is impossible to say which books Wight had before Shuter's generous gift, but it seems highly likely that the 'Principles of Botany' translated anonymously from Willdenow's *Grundriss der kräuterkunde*, published in Edinburgh in 1805 and dedicated to Rutherford, was a text he had had with him since student days.[15]

A shabby little incident concerning Wight's access to books, noted by others,[16] is worth relating here, as it is one of the incidents that suggests a personal and petty antagonism on the part of Governor Lushington towards Wight and his botanical work. This was over the copies of *Hortus Malabaricus* and *Herbarium Amboinense*, the two fundamental texts of tropical S E Asian botany of the late seventeenth and early eighteenth centuries, which Wight had got the Government to purchase for use by the Naturalist in 1826.[17] When sent into what must have seemed like exile to Negapatam, but still anxious to continue his botanical work, in particular on 'a work illustrative of the plants of India comprising their figures, descriptions, and uses, Medical and economical', Wight on 5 November 1829 wrote to the Governor requesting that he be allowed to borrow the books 'for a few months should they not be required for other purposes'.[18] Wight submitted the letter to the Medical Board, who endorsed it, before passing it on to the Governor whose curt response was that 'the Right Honorable the Governor in Council declines complying with Mr Assistant Surgeon Wight's application for the botanical works therein mentioned'.[19] Wight lamented this deplorably niggardly action to Hooker, the more so as the books were almost certainly merely 'rotting in the secretary's office'. Given the use to which Wight would have put them it is hard to see this as anything other than a purely spiteful action on the part of the Governor. Is it possible that Lushington resented Wight's botanical work, and perhaps took exception to the fact that Wight's nephew was looking after his hospital while Wight got on with botany? This might partly explain Lushington's subsequent actions.

From his arrival in 1819, as is still the case with any botanical novice encountering a tropical flora for the first time, Wight was faced with the daunting task of identifying Indian plants. The problem was twofold: first the sheer difficulty of the work, and one that it is impossible to overemphasise to those who have not tried it, of matching real plants with written descriptions. The dependency on written description was a particular concern of Wight's, and the one that fired his missionary zeal to publish illustrations to overcome this limitation – in 1829 the only, pitifully inadequate, illustrations of Indian plants he had beside him were the crude uncoloured engravings in N.L. Burman's *Flora Indica* (1768) and those of fruits in J. Gaertner's *De Fructibus et Seminibus Plantarum* (1788–92).[20] However, it was not only that written descriptions were hard to interpret: the second problem was that those relating to Indian plants were embedded in encyclopaedic works such as Willdenow's *Species Plantarum*, a world Flora, largely devoid of 'finding aids' such as keys. For this reason Wight at this stage considered producing a 'Synopsis' of descriptions abstracted from such works on the lines of Persoon's *Synopsis Plantarum*.[21] This work was to be in English, which meant that the majority of the descriptions would have to have been translated from Latin. Given Wight's ambitions one feels the heart-felt nature of his appeal to Hooker – 'I will never be able to accomplish what I have begun without your assistance: for I know none else to whom I can apply'.[22]

Books were all very well, but given the limitation of words and the primacy of specimens (though the type concept was then unnamed and embryonic in formulation), the most valuable practical resource as an identification aid was a set of named vouchers. In 1828 Wight complained of 'not having a set of named specimens to compare with their descriptions'.[23] Rottler's herbarium in Madras, collected 'during the last 30 years at least, almost every plant of which has been examined & named by many of the most eminent Botanists in Europe',[24] was obviously of huge significance, but oddly Wight did not see it properly until 1831.[25] Given this problem another of the other invaluable services Hooker provided was that of returning lists of identifications made in Britain, using his own extensive herbarium and library, so that Wight could label the duplicates retained in his own herbarium, which, therefore became progressively more useful. Wight deemed such identifications as 'the greatest compliment you could have paid'.[26]

Although Hooker was Wight's major botanical collaborator and confidant in Britain, it was at this point, in July 1828, that Nathaniel Wallich reached London, on furlough from his job as Superintendent of the EIC's Botanic Garden at Calcutta. Wight had started to correspond with Wallich as early as 1826, while occupying the Madras Naturalist's post, and on arriving in London Wallich had tried, unsuccessfully, to canvas for the re-establishment of the recently abolished post.[27] One of the purposes of Wallich's leave was to sort, name and distribute the vast herbarium collections that he had assembled in Calcutta and taken to London, along with those already at India House, among which were the Madras Naturalist's collection including Wight's specimens. Wight was evidently thrilled to learn that Wallich was working on his collections – Wallich sent him the first 59 pages of the lithographed catalogue of the EIC herbarium, but Wight wanted him to write a proper Indian Flora, with descriptions, rather than a mere list of names.[28] Wight asked Hooker if he could get Wallich to abstract a named set of his specimens and send them to India, even if these had to be returned, to

enable him to update the names on his herbarium specimens,[29] but Wallich regretted that he was not able to do this.[30] As will be seen, the need for this was overtaken by events, and Wight would unexpectedly join Wallich in London in 1831.

Another of Wallich's occupations in London was the compilation of his sumptuous illustrated work, *Plantae Asiaticae Rariores*, to which Wight, with some trepidation given its cost, subscribed. However, he was thrilled with the revelation as to what was possible by means of lithography, and flattered by Wallich's promise of commemorating him in a genus: 'the highest honours of Botany'. Modest as ever Wight worried in case 'such encomiums will be turning my head and puffing me up with vain pride'.[31]

WIGHT'S USE OF COLLECTORS

In the letters from Negapatam interesting information is to be found about Wight's use of Indian plant collectors. This was necessary partly because 'I am myself confined to one spot which I can't leave even for a day, I being the only Company's Mediciner within 50 miles of this place'.[32] Wight evidently did make the odd short local excursion, but the flora of the coastal region around Negapatam is far from exciting, and it was necessary to travel far to reach the areas that, from his 1826 expedition, he knew to be rich – an added difficulty being that 'the expenses of travelling in this country are incalculable'.[33] The botanical interest of the local countryside improved at monsoon time, and one morning in October 1829 Wight rode out in search of the tiny water fern *Azolla*, noting that 'the whole of this country (Tanjore) is now under water, & tanks on all sides with in a month or so will be full of the finest plants'. He also found some interesting aquatic flowering plants including three then placed in the genus *Vallisneria* (*V. alternifolia*, *V. octandra* and *V. spiralis*) and commented on their interesting pollination biology.[34] A few days later he described a projected excursion with the painter (un-named, but certainly Rungiah), a collector he was training, 'a porter or cooly' and '2 Bullocks to carry a tent, paper &c'.[35]

Hooker had evidently made the suggestion that a group of European subscribers, like the German society called the 'Unio Itineraria' (who employed a collector called F. Metz in the Western Ghats), might club together and pay for a collector to obtain specimens under Wight's direction. Wight initially thought such a scheme might be possible – if 20 subscribers could be found who would pay £1 per 100 specimens, they might each expect to receive between 150 and 200 per quarter.[36] After experiencing some, doubtless temporary, difficulties with collectors Wight got cold feet about any such 'pecuniary agreement to supply plants' and decided to pay for the collectors himself and supply Hooker and Graham with plants 'from time to time … for distribution among your … friends in the hope of diffusing knowledge of Indian botany' to be 'so divided as to make them as extensively useful as possible'.[37] This shows two of Wight's most endearing and valuable characteristics – his diffidence, and his outstanding generosity in the cause of botanical science. Wight later specifically asked that 'my old school fellow and brother student of Botany, Arnott' should be included among the recipients.[38] The subscription scheme having been turned down, Hooker later offered Wight a sum of £100 on which he could draw to help with collecting expenses, but this too was refused and Wight saw sending specimens as the least he could do in return for Hooker's having already 'loaded me with the most costly presents such as I am ashamed to receive', while assuring him that this refusal was not 'in any way connected with false pride'.[39] This personal investment on Wight's part meant there was no question of ownership of the specimens, which gave him a free hand in what he did with them. This was probably due to an inherent streak of Scottish parsimony, but it left him free from any problems such as had been earlier encountered by Francis Buchanan, and that would shortly be raised over the distribution of the EIC herbarium.

Who were these collectors? In a letter of 30 August 1830 Wight told Hooker that having failed to get 'qualified collectors' he engaged 'two coolies (Anglice porters) of good character' whom he taught 'to dry plants'.[40] The first mention of these collectors in action had been the previous October when Wight had two on trial, 'both anxious to be employed'. Of these one made 'no pretensions to a knowledge of plants, but he is most industrious in collecting them. I propose shortly to send him & the painter to Courtallum, a most noble field … if the result answers my expectations, their excursions will be continued in different directions'.[41] A few days later Wight mentioned sending a man to collect cryptogams – firstly lichens and seaweeds, and if this worked he was to be sent to the hills for ferns and mosses.[42] By February 1830 Wight described his Botanical establishment as consisting of 'an artist, a collector for supplying him and myself with plants procurable in the vicinity, & another with his assistant for collecting at a distance'; he was also attempting 'to establish a collector in the Neilgherry Hills'.[43] The next month Wight had 'two among the Tinnevelly [i.e., Courtallum] Hills & Travancore Mountains & one in Ceylon' and was still hoping for a fourth in the Nilgiris.[44] A picture thus emerges of the collectors going out on their own, or 'under the direction of the painter'.[45] Wight continued this method certainly until 1836 (including the period during which he was back in Britain), but thereafter there seems to have been a tailing off, though he still had one collector in the Nilgiris in 1845. The painter, who must have been Rungiah, was evidently deeply trusted and was described in 1829 as having 'been long in my service'.[46]

It would clearly be interesting to know more of these collectors, who Wight thought of as 'coolies'. Is this merely a pejorative racist stereotype? Would unskilled Indians with no plant knowledge really have put themselves forward for such work? Perhaps, and this seems more likely, they were people with a background of indigenous plant knowledge – for example, collectors of plants for medicinal purposes, such as those of the toddy tapping caste used by Rheede on the Malabar Coast in the seventeenth century. Here is another mystery that is likely to remain unresolved.

There were, of course, problems in using collectors in this way, outwith Wight's own immediate supervision. That of recording vernacular names will be discussed below, but a more serious one is the quality of the field data they collected. Although by no means atypical of collections of this time, from a modern perspective this data is extremely poor, usually amounting to no more than a generalised locality, with no notes on colour or habit, or anything about the habitat.

PLANT DRYING

Wight provided Hooker with a description of his interesting method of drying plants, which consisted of using hot sand as a kind of natural silica gel. The plants were arranged on drying paper and 'laid in the sun & covered with a layer of sand about half an inch thick; the same process is repeated daily till they are dry, which is

usually in two or three days; without ever requiring to change them. In this way the colours are preserved nearly as fresh as when first gathered'.[47] Wight correctly realised that the quicker the drying the better the result, though this method can only have been used in dry weather, and the area of ground required by the vast number of duplicates he collected stretches the imagination somewhat! Wight later published a detailed paper on drying techniques, in which he described the more traditional method of drying by changing papers between the folded sheets containing the plants – though he still recommended the hot sand method when possible.[48]

WIGHT'S ATTITUDE TO THE 'NATIVES'

The question of Wight's attitude to Indians is hard to ascertain from surviving evidence – he was certainly profoundly grateful to, and admiring of, his artists Rungiah (and later Govindoo). But with regard to less skilled Indians, his view seems to have been more ambiguous, and Hooker's innocent question as to whether or not Wight could find a keen native collector, elicited a common racist stereotype:

> there is no such animal as a native keen collector in India unless made so by <u>self interest</u>. It will further be necessary to make it worth his while to be honest in case he should take it into his head to walk off entirely with perhaps a hundred or two rupees as I have little or no hold on any of them.[49]

In Wight's publications are very few references to 'natives', though as will be seen in the discussions of his agricultural work, he undoubtedly felt sympathy for the plight of the poor farmers in thrall to money lenders, and unable to take financial risks in trying new crops if not guaranteed sale for the produce. There is almost nothing on the private lives, or what he thought of native religious beliefs, a rare exception being a comment on *Capparis divaricata* of which he noted 'the natives seem to associate some sacred idea with this tree, as I have frequently seen swammy idols under its shade'.[50] There is also the odd reference to plants growing near temples, or 'pagodas' as he called them (doubtless from the gopurams of the Tamil variety), for example *Casearia elliptica* occurred in 'old "bowries" near pagodas', perhaps a reference to sacred groves.[51]

On a related subject it is worth saying something about Wight's attitudes to indigenous plant knowledge. Once more it is hard to discover much about this, and the only evidence is in the form of annotations on herbarium specimens and drawings. Wight's artists were Telugu speakers, but the collectors are more likely to have been Tamils and both languages occur on the specimens and drawings – doubtless information obtained on field trips. The annotations on the drawings were almost certainly written by Rungiah (and later Govindoo), but the Telugu script often represents transcriptions of Tamil localities and plant names, doubtless provided by the collectors or by locals. The plant names and localities on the specimens are almost entirely Tamil. Wight was suspicious of such information, for reasons clearly given in the *Prodromus*.[52] Walter Elliot in his *Flora Andhrica*, a dictionary of Telugu plant names from what is now Andhra Pradesh, castigated Wight for this, but their interests were different – Elliot was much more interested in archaeology (including numismatics), ethnography and what would now be called ethnobotany, though he was certainly correct in saying that some plants have reliable and consistent vernacular Indian names.[53] However, it is necessary to stand up for Wight here, and to sympathise with his critical approach and the difficulties of obtaining reli-

able vernacular plant names in the days before rigorous ethnobotanical methodologies had been worked out. It should also be noted that Wight pointed out the equal limitations of English vernacular names.[54] The difficulties of vernacular names cited by Wight (and the dangerous consequences of misapplication that can follow in the case of medicinal plants) still apply in pre-scientific cultures, where only useful plants tend to have unique names. Examples justifying Wight's suspicions are to be found among his specimens, such as a single vernacular name covering more than one species (which might all have similar properties, or might simply not be distinguished in folk-taxonomy). For example 'seeroocoorooja' and 'munjul kulokulopay nother kind', both of which are applied to what is scientifically known as *Crotalaria longipes*. The latter smacks of another problem referred to be Wight – that of locals making up names on the spur of the moment so as not to disappoint a Western enquirer (or his representative). This is not to deny that some of this is probably the fault of relying on unskilled collectors, but it is unthinkable that there are unique Tamil names for, say, the 57 species of *Crotalaria* recognised by Wight & Arnott. Despite these reservations, it should be noted that in the introduction to the *Illustrations* Wight invited contributions of lists of vernacular names along with collections, 'with a view to the formation of a comprehensive catalogue and index', and to 'fix these vacillating vernacular names'.[55] Another problem he drew attention to was that of transliteration:

> it is next to impossible to convey to one unacquainted with them, the sounds of one language, by the symbols of another. This is an almost insurmountable obstacle to their use, rarely adverted to by those, who strongly advocate the introduction of vernacular names into Botanical works.[56]

From this it can be seen that Wight was not against the use of native names as a matter of racist principle, but was merely applying the same caution as he did to his scientific botanical nomenclature. When he was certain of their application, he included Tamil and Telugu names on the plates of the *Illustrations* and *Icones*.

Wight was certainly interested in local medicinal uses of plants, as will be seen later in the case of the Mudar (p.59). But his views were not uncritical and in a letter to Hooker is found an instructive and amusing example of a clash of cultures relating to indigenous versus western plant lore/medicine (to say nothing of Wight's lamentable grammar and punctuation), writing of a species of *Corchorus* in which:

> The fruit grows in circles [i.e., whorls] some looking down some up of course. The former when prepared in some manner are said to possess wonderful medicinal virtues which those looking towards heaven are of no use. This statement got the better of both my philosophy & gravity. This is one of many instances not less ridiculous which I have heard & leads me to fear that I will never learn any thing valuable in regard to medicinal properties of plants tho' something may perchance be learned of their economical application. If a plant is said to possess medical properties & it is asked how do you use it? take so much of this so much of that so much of a third & so forth until 7 or 8 articles are enumerated these are to be mixed together in some way or other and administered or sometimes externally applied, a particular regimen, often the most valuable part of the prescription, enjoined and from this most heterogyinious [sic] mess the desired effects will result.– To my sorrow however be it said their prescriptions are too often as unsuccessful as unscientific and my house is almost daily visited by people labouring

under diseases altogether incurable owing to the progress they have made under such trifling treatment but enough of this subject seeing you don't belong to the learned faculty.[57]

TAXONOMIC PROJECTS

What was the purpose and outcome of this extensive plant collecting? Wight clearly felt that he had a part to play in the major taxonomic project of the time, the cataloguing of the plant biodiversity of the world, a project that, for reasons described above, had to be centred in Europe. The realisation that he could contribute to this grand project seems to have come to Wight when, purely by chance, he was staying with Shuter in Madras in 1825. This was the very time when Shuter received a letter from Hooker requesting specimens from South India towards a 'general system of plants' that he then had in mind (but which never came to pass, the mantle being assumed by Candolle in Geneva). From Negapatam, four years later, Wight told Hooker how he had 'felt an inclination from the first to render what assistance I could', which he did by means of the specimens sent home via Shuter. However, it was by now 'in my power … to contribute much more largely to a work so much wanted [i.e., a new world Flora]. On this account therefore, even more than on my own, I rejoice in having it in my power to send these plants' and assured Hooker that 'few indeed take a deeper interest in, or would more willingly contribute to the success of your useful & truly Herculean labours than your … most sincere admirer R. Wight'.[58]

By 1830 Wight already had upwards of 3000 species in his herbarium, and was hoping to have 4000 by the end of the year;[59] it is interesting that as early as June 1829 he was already 'looking anxiously for the conclusion of De Candolle's Prodromus' as he wished 'to adopt the natural arrangement' for arranging his herbarium.[60] It is not known how Wight became aware of Candolle's work, which could have been through Hooker, or through the English translation of Sprengel's German version of Candolle's *Théorie Elementaire* published in Edinburgh in 1821, which was certainly in his library in 1829. Until this point there had been no choice in India but to use the Linnaean system for classifying and naming species, and Wight had 'attempted to follow Sprengel in nomenclature'.[61] Wight had been sending large numbers of duplicates of his most interesting herbarium collections to Hooker:

> October 1828: 150 species of cryptogams.[62]
> October 1829: 350 species of [higher] plants.[63]
> March 1830: 140 species of [higher] plants.[64]
> June 1830: 200 species of [higher] plants.[65]
> September 1830: 40 species of mosses, numerous algae; lichens; zoological specimens – sponges; corallines.[66]

Here, as elsewhere in the letters, is to be seen an interest in numbers of species – the approach of a cataloguer, or, pejoratively, that of the maligned 'stamp collector'.[67] There undoubtedly was an element of this in Wight, and one of the outcomes he wished of Wallich's great curatorial work was that it would produce 'characters sufficiently minute to discriminate between many related species' for the want of which it was impossible to make 'a perfect collection of the plants of this country'.[68] The numerical size of the Indian flora was a matter of importance to Wight, and he observed the futility of estimating the number of species occurring in a mountainous country 'by the number of species gathered in the open cultivated part of it' – all that was available to Humboldt (1817) when he estimated the total

Indian flora at about 4500 species.[69] Wight was correct in thinking that this number 'will be found to fall short, by nearly a half, for the country included between the latitudes of Madras and Cape Comorin alone', and in 1834 estimated the Peninsular flora at 9000.[70] This was based on his 1826 experience of the Western Ghats, from the Palni Hills southwards, in which grew 'many of the most curious & valuable products of the Vegetable Kingdom; & in such abundance that it is impossible to form an adequate idea of it without visiting them'.[71] This quotation shows that Wight was interested in more than mere numbers, and in 1830 he longed to go on tour again, with greater knowledge and a 'well stocked portable herbarium', to acquire information on 'habitats, geographical distribution, elevation above the sea, and geological characters of the country on which the plants of limited distribution are produced, all of which are but little known in connection with the Indian flora'.[72] Sadly in his remaining time in India he was never able to do this, and published almost nothing on these interesting topics, other than occasional altitudes – even the distributional data that can be taken from his specimens comes from notably few collecting localities.

Publication projects: Illustrated Floras

Wight wanted not only to contribute to grand European projects, but to publish works that would be available in India – to encourage others to study botany, and to make life easier for them than it had been for him. The idea of abstracting already published descriptions into a 'Synopsis Plantar: Ind: Orient' on the model of Persoon was abandoned,[73] and Wight's ambition evolved into the idea of publishing illustrated works that, unlike those of Wallich and Roxburgh, would be affordable.

In his very first letter to Hooker, in 1828, Wight announced his plan of 'attempting to establish a work to illustrate the Indian flora; on the plan of [Sowerby & Smith's] English Botany, or [Hooker's] Exotic Flora'. With this letter he sent five of Rungiah's drawings as examples and said that he could 'furnish from 100 to 150 per annum with descriptions'.[74] These descriptions were 'all taken from recent plants [i.e., rather than copied from books], which they correspond as nearly as my command of language can make them',[75] and by June 1830 he had sent Hooker 100 drawings.[76] Hooker evidently caused Wight consternation by pointing out the expense of such a publication, and Wight was impressed by Hooker's 'public spirit in making such vast sacrifices for the advancement of your favourite pursuit', not least as this came at a time when 'Medical Allowances' in India had been reduced 'to the amount of from 25 to 30 per cent'. Had Wight still had his large Naturalist's salary he would happily have paid £100 or £150 towards botanical publications, but given his present salary 'could scarcely give £20'.[77] Wight, as a true Scot, understood that 'people must pay for their hobby' and was 'most willing to pay for mine', both in terms of expense and labour 'for the attainment of so desirable an object, as that of illustrating the comparatively little known plants of the Coromandel coast', but Hooker came to the rescue and offered to publish the descriptions and plates on Wight's behalf. Wight would have preferred this to be in a separate publication, for which Rungiah could 'easily supply 10 or 12 drawings monthly', but, worried at the expense to which this would put Hooker, would be 'equally well pleased to see them as an appendix to the [Botanical] Miscellany'.[78] This in fact is what happened – the drawings were engraved by Joseph Swan in Glasgow, and appeared as 'supplementary plates' in Hooker's *Botanical Miscellany*,

the first ten appearing in November/December 1830 (when Hooker was under the misapprehension that Wight's Christian name was Richard). Altogether 41 plates were published in this way over the next three years (and as a 'separate' called *Illustrations of Indian Botany* published in Glasgow in March 1831). When the *Miscellany* folded in 1833 the series was continued by Hooker in his *Journal of Botany* (8 plates in 1834), after which the series was continued in collaboration with Walker-Arnott in Hooker's *Companion to the Botanical Magazine* (18 plates, 1835–7). The last two of the series to appear in Britain were in the *Annals of Natural History* in 1838, at which point Wight started publishing his own *Icones* and *Illustrations* in Madras.

Monographic interests

In botany today a distinction is commonly made between 'floristic' and 'monographic' studies – the former relating to the plant biodiversity of a particular geographical area, the latter to in-depth study of a particular plant group (usually a genus or family). Such distinctions were unknown to Wight, and while his and Arnott's *Prodromus* could be described as a Flora of Peninsular India, his own solo publications are really hybrid in style. Wight became interested in certain groups (what could be termed monographic interests) at this time, and was certainly not afraid to tackle taxonomically difficult genera and families. In January 1830 he announced to Hooker the intention of studying the tricky genera *Barleria* (Acanthaceae) and *Phyllanthus* (Euphorbiaceae), in which groups he thought Sprengel's circumscriptions too broad. He also intended to have as many drawings as possible made of the family Asclepiadaceae, in which, despite Robert Brown's work, he correctly thought there were still many new genera to be described.[79] Wight was to make major contributions to our knowledge of all of these families – of Asclepiadaceae in his *Contributions to the Botany of India*, and Acanthaceae and Euphorbiaceae in the *Icones*.[80]

A projected local Flora

It was also at this early stage (1830) that Wight first contemplated a book on the flora of the Nilgiri Hills, a project that would eventually come to fruition in the *Spicilegium Neilgherrense* of 1845–51. He was aware of the richness of the Nilgiri flora, and thought that the collectors he hoped to send there would collect 1000 species in six months. This book would effectively be a Flora of a discrete montane region, and was evidently inspired at least partly by David Don's *Prodromus Florae Nepalensis* (1825), a rather inadequate book devoted to a section of the Himalaya based on collections made by Wallich and Buchanan(-Hamilton), but one which, interestingly considering its early date, was arranged according to the Natural System. Wight's book was also to have a social function:

> for the benefit of convalescents who might wish to employ their time on the hills in the amusing and healthful study of their plants, an occupation that I dare say would prove more salutary than the physic in the doctor's surgery; while at the same time they might be adding to our stock of knowledge, while they were not diminishing the stock of medicines.[81]

Wight's time at Negapatam came to as abrupt a close as had his job as Madras Naturalist. This was perhaps no mere coincidence, as, once again, Governor Lushington lay behind it. The reasons have been found in a letter Wight wrote to Wallich on 20 October 1830, recently discovered by Christopher Fraser-Jenkins. Lushington had scrapped several minor Garrison Surgeons' posts, and in the case of Negapatam used the resulting change of designation to 'serve his own friends'. Wight was to be replaced, and on 8 October 1830 was posted to the regiment from which his replacement was removed,[82] the 6th regiment of Madras Native Infantry, then stationed at Quilon on the Malabar Coast.[83] The sensitive Wight thought that this substitution by someone nine years his junior in the service would indicate to those unfamiliar with the case that he had been 'guilty of some misdemeanour meriting the severest censure of government short of a court marshal'. Rather than face this Wight decided to take 'advantage of the regulations of the service which allows a man to amuse himself for three years at the expense of the Govt',[84] but in the meantime he told Hooker that he intended to apply for leave for the following three months (i.e., until he could leave India) so that he could be the 'entire master of my own time … which I have not enjoyed for the last 12 years at least'.[85] This change of plan had other advantages. It meant that Wight would be able to meet up with Wallich in London, but he also admitted that there was a medical reason causing him to take greater umbrage at Lushington's treatment than he would otherwise have done: 'I allude to a hernia under which I have laboured for many years & for which I cannot get a proper truss in this country'.[86] Wight left India in February 1831, and by time he returned three years later Lushington had left the country for good, though leaving behind a brother, Charles, who would remain a thorn in Wight's side for the rest of his time in India.

On 28 January 1831 Wight was writing to Hooker from Madras, expecting to be on the high seas within two or three weeks,[87] and his leave on 'Private Affairs' was granted on 8 February.[88] The time in Madras was eventful – it was then that Wight saw the little that he ever did of 'dear old Dr Rottler's herbarium',[89] and purchased Missionary specimens additional to the duplicates he had kept from the Naturalist's collection. It was also at this time, on 22 February, that, after 12 years' service, Wight was promoted to Surgeon (equivalent in rank to an army Captain).[90] The purpose of Wight's furlough was no mere holiday, but (as with Wallich's) to continue and develop his botanical work using the collections and expertise available in Britain, but he retained the services of Rungiah and the collectors in India while he was away. Wight left on the ship 'Zenobia' around the end of February.[91] From specimens that he later gave Hooker it is known that Wight collected plants at the Cape of Good Hope and on St Helena on the way home,[92] though only one of these has come to light. Personal acquaintance with the Cape flora is hinted at in a discussion in the *Illustrations* of *Mesembryanthemum* and its allies as 'being met with in that promontory',[93] and the single extant specimen from this voyage is an *Oxalis* collected at Longwood, the place of Napoleon's incarceration on St Helena.

PART III
ON FURLOUGH
1831-4

Return to Britain

It must have been with a sense of great anticipation that Wight returned to Britain after an absence of 12 years, and he wrote to Wallich before he had even touched land, from his ship 'off the Lizards'.[1] The letter no longer survives, but it doubtless concerned arrangements for meeting up, as it was from Wallich's 'workshop' at 61 Frith Street that he informed Hooker, on 25 June, of his arrival from Hastings late the previous night. Wight did not return home lightly laden; his luggage consisted of eight boxes, 'probably rather better than 2 tons of cargo',[2] containing his herbarium, botanical books and 'nearly 200 drawings'.[3] Wallich must have helped him find accommodation at 9 Queen Street, just around the corner from his own premises, where Wight was shortly established with his vast collections. These Wallich had helped to clear through customs, with the result that Wight had to pay duty only on Rees's *Cyclopaedia*,[4] the only work he did not plan taking back, in due course, to India. It was from this Queen Street base that Wight would sort and distribute his collections 'among such botanists as may require specimens. [For] with the exception of a single, named set I do not intend to take any back to India'.[5] Wallich was greatly preoccupied with his own massive distribution of the EIC collections, helped by botanists such as R.K. Greville who was then with him. However, the work on Wight's collections was put on hold, and he gave himself a well earned summer holiday in Scotland, catching up with family, friends, business matters, botanising – and meeting both Graham and Hooker in the flesh for the first time.

IN LONDON, AND THE DISTRIBUTION
OF THE EIC HERBARIUM

Although much discussed elsewhere,[6] it is necessary to say something about the distribution of the EIC herbarium here – not only as it provided a model for Wight's distribution of his own specimens, but because it raises interesting issues about the relations between botany in Europe and India. The undertaking was a vast one and of incalculable importance in the history of Indian botany. It involved not only the collections brought back by Wallich from Calcutta, but ones already at India House including those of Wight, the Tranquebar Missionaries and Patrick Russell that had reached London shortly before Wallich's arrival, with the dispersal of the Madras Naturalist's collection. Wallich and his collaborators (including George Bentham, Robert Brown, John Lindley, and – somewhat ironically given his neglect of the material Wight sent him directly – Robert Graham) therefore had a wealth of South Indian material on which to work. This curatorial work involved giving names to the plants (almost 8000 numbered species), but there was no time to write descriptions of the vast majority of them, and appeals for a second extension of Wallich's leave fell on deaf ears. The names of the species, many of them new to science, were thus published in a catalogue ('*Numerical List*') that Wallich reproduced by lithography (which he had used in Calcutta several years earlier to reproduce his illustrations of Nepalese plants), but devoid of descriptions. The duplicate sets of specimens were widely distributed, along with the catalogue, and many of these *nomina nuda* were taken up and validly published by authors such as Candolle in Geneva, George Don in London, and as will be seen later, by Wight & Arnott. Wight had already received the first 59 sheets of the 'Wallich Catalogue' before leaving India, at Negaptam in June 1830.[7]

A list of 66 individuals and institutions to receive duplicates was drawn up, Wallich believing that the specimens should be dispersed as widely as possible. It has been stated that some British botanists were not best pleased about this, for example, according to Satpal Sangwan:

> The project took off under clouds of suspicion created by so many individuals and institutions in Britain and other continental centres 'competing for the donation of specimens' that the common Englishman felt alarmed by the possibility of 'others' stepping in to 'steal the glory of international scientific discovery' from India.[8]

Sangwan did not cite a source for this dissent, but it may be an impression based on Candolle and Radcliffe-Smith's statement that '[Robert] Brown in particular, disapproved of Wallich's generosity to foreign botanists'.[9] The depth, or truth, of Brown's view on this matter, however, seems somewhat uncertain and may lie in comments of Alphonse de Candolle who was renowned for being 'unduly interested in gossip and his fears were, in all possibility, born out of his own imagination about the self-interest of 'English' botanists'.[10] Brown was one of Wallich's most assiduous helpers, and as Mabberley did not elaborate on what would be a curmudgeonly stance of the European-minded Brown,[11] his dissent seems likely to have been exaggerated. The labour of distribution has often been referred to as 'Herculean', and that this is no exaggeration can be seen from the fact that 226,000 specimens were sent out in some 641 parcels.[12] What is surprising is the fact that the Calcutta Botanic Garden was not on the list to receive a duplicate set. This may have been an oversight, because in October 1832, almost as soon as Wallich had returned to Calcutta, he wrote to the Linnean Society and requested them to send him 'the best set obtainable'.[13] This was not acted upon and it was still a 'source of regret' to Thomas Thomson in Calcutta in 1856 that 'one of the foundations of Indian Botany' did 'not form a part of our collection', and so he renewed the request for a set from the Linnean Society.[14] When Calcutta finally received the 11,000 Wallichian sheets that were reported to be in the Calcutta herbarium in 1977 is unclear;[15] Panigrahi gave the date as 1853–69, but the oft repeated story that they were taken back by Thomson in 1855 is by Thomson's own authority untrue.[16] It is more likely that Joseph Hooker eventually managed to prise a set out of the Linnean Society at the time he was distributing the Griffith and

Falconer material from the India Museum in the late 1860s and early 1870s. Calcutta also received some Wallich duplicates from Geneva in 1958–9.[17]

In addition to the distribution of the EIC herbarium Wallich's other great work during his fertile four-year furlough was the publication of the three large folio volumes of his *Plantae Asiaticae Rariores*. This work includes species descriptions by Wallich himself, and monographs of particular families by George Bentham, C.P. von Martius, C.F. Meisner and C.G.D. Nees von Esenbeck, illustrated with 300 superb hand-coloured lithographs by the Maltese-born artist Maxim Gauci based on illustrations commissioned by Wallich from the Calcutta Garden artists. A single plate (*Gardneria wallichii*) is based on a drawing by Rungiah (Book 2, fig.6).

RETURN TO SCOTLAND · SUMMER 1831

Wight's return to Edinburgh in July 1831 must have been tinged with melancholy; his father had died two years previously, and he therefore had no home in Edinburgh to return to. Although his father had remarried in 1826, it is doubtful if Wight would have paid more than a social call on a step mother he had probably never even met. It would therefore be his elder sister Anne's house at Blair Atholl that became the nearest thing he had to a home during his period in Britain. Despite this the return to Edinburgh must also have been exhilarating as the city had undergone dramatic changes with increasing prosperity during the 1820s. For example, the recent completion of great new public buildings by W.H. Playfair (the Royal Scottish Academy, St Stephen's Church) and Thomas Hamilton (the Royal High School), Thomas Telford's Dean Bridge, and Playfair's dramatic completion of the University. Less successful had been the National Monument to the Napoleonic Wars, intended as a replica of the Parthenon to designs by C.R. Cockerell and Playfair: the twelve skeletal columns that still dominate the east end of Princes Street were in the same state then as now, work on the project having been abandoned in 1829. There had also been extensive domestic building activity and in 1827 George Bentham had noted the changes since a visit of four years previously.[18] The Old Town remained the same, and Bentham graphically described the sort of properties that Wight inherited from his grandfather:

> houses piled upon houses, streets crossing each other at right angles, one at a great perpendicular height above the other, the narrow closes and common stairs, well-named perpendicular streets, dark and filthy, the miserable black holes more like dungeons or dens of wild beasts than lodgings for human beings … black and smoky and picturesque.

Bentham contrasted these with the 'regular beauties of the new town', and how as 'new streets continue to spring up with the usual rapidity. The upper classes move further and further to the north and northwest … Many fields that had only a few foundations marked out when I was last here are now become fashionable streets'. It was in this northern New Town that Wight stayed, with Robert Graham, in one of the largest houses in one of the grandest of the new streets, 62 Great King Street.[19] Although it has been noted earlier that Graham contributed little in the way of botanical research, he was, however, responsible for another of the most dramatic changes that greeted Wight – the move of the Botanic Garden from Leith Walk to Inverleith, and it was under Graham's care (with the help of his curator William McNab, whom he inherited from Rutherford) that 'the beautiful botanic garden was brought to a greater state of perfection than any other one in the country'.[20] Graham was a popular lecturer (if old fashioned in terms of his taxonomy), and renowned for the botanical explorations he undertook with favoured undergraduates and botanical friends in the Scottish Highlands from 1821 onwards. That Graham felt somewhat guilty towards Wight on account of his negligence is likely, and he would let him down even more seriously later on, but in the meanwhile he was able to make amends in terms of hospitality. Graham was renowned as a host, and the great ornithological artist John James Audubon recorded one of the lavish, rather formal, dinner parties given by Graham on 19 November 1826. The affair started at 6 pm: 'ladies after ladies came in, and each brought with her a gentleman. My outlandish name was called out and I entered the salon also. I was introduced only to Mr Graham, and I bowed to the rest of the company'. Fortunately Audubon was rescued by a lady in blue satin slippers who put him at ease, and when 'the shrill ringing of a bell ordered us to dinner. I accompanied the blue satin lady … and sat by her opposite another young daughter of Venus'.[21] Audubon portrayed himself as an American backwoodsman and found that 'the sumptuous dinners of this country [i.e., Britain] are quite too much for me', but it is likely that Wight, after three years of garrison life at Negapatam, would have felt similarly ill at ease in such grand surroundings.

It was therefore probably a relief when Wight set out with Graham for the Highlands on 29 July 1831.[22] The excursion this year was to the hills around Braemar in Deeside, Aberdeenshire and over the watershed into upper Glen Clova in the county of Angus; the other members of the party were H.C. Watson, R.K. Greville, Dr A.J. Macfarlane, W.H. Campbell, William Brand, Martin Barry, James Macnab,[23] and William Christy. The noteworthy alpine plants found on this trip were published by Graham, but a much more entertaining account of this Highland ramble, and its most exciting discovery, was written in the highest of spirits by Greville to Wallich (who was stuck in London):

> <u>if</u> you had been present, instead of vegetating in your dusty workshop – bad man that you are – you would have been present at the discovery of <u>Phaca astragalina</u> [now *Astragalus alpinus* – see Book 2 fig. 1] – the first time that <u>Phaca</u> has made its bow to a british audience – our friend Wight performed wonders, and to the gazers at the foot of the precipice, seemed Wightia <u>scandens</u> rather than <u>gigantea</u> [Wallich had just described the new genus and species *Wightia gigantea*]; especially as being seen in perspective little more than his anonymous end was visible. He & I however really, having less regard to broken bones or the sighs & tears of those we left behind, carried off most of the specimens. And just in this place, I beg that you will not turn up your nose at so much being said about a new british species.– Man of a thousand discoveries deign to recollect that to find a new phaenogamous plant in this exhausted receiver, as it were, of vegetation, is like finding a new species of Elephant or a Palm tree in Nepal – ahem! [24]

From Braemar Wight walked the twenty-five miles down Glen Tilt to the manse of Blair Atholl for a reunion with his sister Anne, who was married to the parish minister, the Rev John Stewart. This was to be only a brief visit, but Wight returned for a longer one the following month after a trip to Glasgow and Edinburgh. From Blair Wight took the scenic route to Glasgow, via Killin, Callander (where he was two years too late to visit the great Dr Francis Hamilton), Loch Katrine, and Loch Lomond.[25] He was accompanied by the

17 year old William Campbell, who later, as a lawyer, would act for him in business matters, and whose brother James was a colleague at Negapatam but also currently on furlough in Britain.

The long anticipated meeting with Hooker in Glasgow was planned for 20 August. Wight, after the genteel life of Edinburgh, and some weeks of 'pure Highland air',[26] was probably shocked by Glasgow, as Bentham had been slightly earlier, 'a great, black, smoky, dirty town, full of shabby, ill-looking fellows, girls of all ages going about bareheaded and barefoot'.[27] There is no record of this visit, but one can imagine the excitement of their meeting for the first time in the flesh after three years of correspondence and mutual botanical assistance, and the enthusiasm with which they must have discussed Indian botany and future publications. Wight must have been thrilled at seeing his botanical work in print for the first time in the *Botanical Miscellany*, and spared a thought for his faithful artist in India writing 'how proud my friend Rungiah will be' when he sees his drawings reproduced.[28] This must have been the occasion when Hooker discovered that the man whose work he had published under the name 'Richard Wight' was actually called Robert, and it seems likely that he kept quiet about the fact that he had already issued (in March) the whole series of four *Botanical Miscellany* articles in a separate volume entitled *Illustrations of Indian Botany*, which bore the wrong name on the title page.

Hooker was eleven years Wight's senior, and well established in Glasgow, where he had held the Botanical chair since 1820, delivering lavishly illustrated (thanks to W.H. Fitch) lectures to huge popular acclaim, and writing and editing prolifically on botany. Hooker was well known for (as Bentham put it) his 'unpretending liberality … contrasted with the petty closeness and exclusiveness of some London collectors, a liberality which was one of the chief means by which … [he] was enabled to accumulate in so comparatively short a time the finest herbarium in the country'.[29] This liberality also extended to hospitality and his household was large and welcoming and Wight, as a sensitive bachelor, must have felt embraced by its warmth. At this time the household at 7 West Bath Street included Hooker's wife Maria and their children William (aged 15), Joseph (14), Maria (12), Elizabeth (11), Mary Harriet (6); Hooker's 77 year

Fig.15. Blair Atholl, showing the castle beneath Carn Liath and Beinn a'Ghlo. Lithograph by C. Hullmandel after a drawing by D.O. Hill, from *Sketches of Scenery in Perthshire* (1822). Trustees of the National Library of Scotland.

old father Joseph; Gurney Turner, Maria's eighteen-year old brother then a medical student,[30] and Johann Friedrich Klotzsch, a young German mycologist, who between 1830 and 1832 was employed to curate the ever expanding herbarium housed in the laundry.[31] There was another guest at Bath Street at this time, a 'Miss Turner', almost certainly Maria and Gurney's twenty-year-old sister Eleanor. From an uncharitable comment in a letter written by Wallich many years later it is found that Wight had 'proposed to Miss Ellen Turner – to the utmost astonishment of herself and her sainted mother'.[32] It is not known why Wallich was so surprised by this overture, but it must have taken place around this time. Poor Wight, however, was rejected, and had he not been, would have become Hooker's brother-in-law, and Joseph Hooker's uncle! This first visit of Wight's to Bath Street must have been short, as in a summer of frenetic travel he had to visit Edinburgh before returning to his sister in Blair Atholl, whence on 19 September he was sending specimens for young Willie Hooker's ornithological collection.

Blair Atholl

On this occasion Wight spent at least a week at Blair, and he would return there for longish periods at several points during his furlough.[33] The parish formed part of the vast estates of the Murray dukes of Atholl. It was the fourth duke who proposed John Stewart as minister to the parish. This was the 'Planting Duke', who is reputed to have planted 27 million trees (especially European larch and Norway spruce) over 16,500 acres in the fifty years he held the title. He also assisted nature in beautifying some of the more picturesque spots on his estate, such as the Hermitage at Inver, beloved of travellers in search of romantic landscapes with Ossianic overtones, such as Felix Mendelssohn and Carl Klingemann who visited the area two years before Wight's visit.[34] At the falls of Bruar the duke had responded to the Burns' request (penned on its behalf by the eponymous poet in 1787) to make the scene more romantic, and in order to defy 'saucy Phoebus' scorching beams' – to 'shade my banks wi' tow'ring trees, / And bonnie spreading bushes'

About 1820 a beautiful citrine coloured serpentine ('marble') was discovered in Glen Tilt and the duke 'worked the quarry with that vigour and spirit which characterized all his undertakings';[35] The duke's forestry and geological activities were combined to spectacular effect in the marble-topped, larch-wood commodes he commissioned from the great Liverpool cabinet maker George Bullock, still to be seen in his fortified chateau of Blair Castle [fig.15].

According to his gravestone, the then newly married John Stewart, was admitted to the parish on 20 February 1805. Stewart and the duke evidently got on well, and together they 'improved' the parish ecclesiastically. They succeeded in building a large new church at the gates of the castle, seating 650 people, designed in rustic style by Archibald Elliot and opened in 1825,[36] and a new manse at Baluain (completed in 1828), a handsome Georgian box with a near-contemporary side wing. They were not, however, successful in trying to close the second church of the parish (at Struan) in which proposal they incurred the wrath of the powerful neighbouring Robertson clan.[37] The fourth duke had died a year before Wight's visit, and was succeeded by his son the Marquess of Tullibardine, who had lost his mind while in the army in Portugal, in consequence of which he was confined to a padded room in St John's Wood, London. At the time of Wight's visit the estate was therefore run by a younger son of the fourth duke, Lord Glenlyon;

it was his son (also Lord Glenlyon) who hosted Queen Victoria and Prince Albert on a famous visit in 1844 and became sixth duke on the eventual death of his incapacitated uncle in 1846.

The parish was a very different place culturally from that of today – the crofters still spoke Gaelic, and the services in Struan church were all in that language (at Blair they were in both English and Gaelic). Stewart penned an account of the parish for the *New Statistical Account* in 1838,[38] which reveals a story of highland depopulation and changes in landuse, with a very different slant to that of Wight's cousin Lord Meadowbank. While the fourth duke was not one of the worst offenders in such matters, his idea of improvement of the Highlands favoured sheep and deer over people and to make the parkland of Blair had evicted 24 families from Strathgarry; it is thus perhaps not surprising that one of these should have attempted to shoot him.[39] The result was that between 1755 and 1814 the population of the parish had declined from 3257 to 2333 souls, and Stewart considered this change to have resulted in 'a system of more beneficial management [that] has converted these dreary and comfortless habitations into sheep-walks'. In a statement of breathtaking arrogance (revealing his subservience and indebtedness to the duke) Stewart thought this to have been 'greatly to their own interest, though not perhaps at first so congenially to their feeling' of the people who had 'emigrated to the large towns of the south, or to America'.

While at Blair Wight made excursions collecting plants for his herbarium. Dominating the scenery of this part of the Highlands is the massive rounded peak of Beinn a'Ghlo (1120m) and its satellites. It comes as no surprise that Wight explored this mountain, and it was surely he who provided the botanical information later published by Stewart:

> Of the rarer Alpine plants [of Blair Atholl parish] the botanist can scarcely meet with a more productive field than Beinn-ghlo itself. Upon its west side *Saxifraga oppositifolia*, *Silene acaulis*, *Dryas octopetala*, *Azalea [Loiseleuria] procumbens*, *Betula nana*, grow abundantly; and it has been said that the *Rubus arctica* [sic] is to be found there.[40]

The last of these plants remains an elusive enigma that many botanists have sought in vain. It is not known if Wight was one of those who saw it, as almost none of his British herbarium specimens have been located, but there are other early-nineteenth century specimens from Beinn a'Ghlo and the modern view is that it 'may be sterile in Britain … [and] brought here as seeds in the droppings of wintering birds'.[41] Wight visited other notable local sites such as the Falls of Fender, Loch Tummel, and Glen Tilt, in the last of which he found the now very rare whorled Solomon's seal (*Polygonatum verticillatum*). It was William Gardiner, the Dundee umbrella-maker and botanist, who must have been visiting these parts at the same time, who told Wight where to find the latter.[42]

What of the Stewart family with whom Wight stayed? It must have been something of a squash in what is not a particularly large house, as Anne and the Minister had four daughters and five sons; but life in Blair Atholl must have been healthy, as only one of these (Maria) had died by the time of Wight's first visit.[43] The eldest son John Ramsay Stuart,[44] born in 1811, must by this time have embarked on his distinguished military career – service at Alma, Balaclava, Inkerman and Sebastaopol, ending up as General in command of the troops in Scotland. The other seven children, however, were probably all still at home: of the three surviving daughters

two – Jane M'Conochie (b. 1805) and Ann (b. 1810) – would marry ministers. Jane wed the Rev Duncan Campbell in March 1833; he was the minister of Moulin but had earlier been their family tutor,[45] and Wight attended the wedding.[46] Later on, in 1841 Rebecca (b. 1808) would marry James Campbell, who had been her uncle's colleague at Negapatam whom Wight had encouraged to collect plants, and was now in the 50th Madras Native Infantry; Rebecca must therefore have gone out to India and joined the growing Wight clan in the Madras Presidency. The remaining Stewart sons were James (b. 1813, who died in the West Indies), Atholl (b. 1818), Alexander (b. 1824), and the youngest, Robert, doubtless named after his uncle, born in 1826. Of these Alexander also went to India (to the 31st Madras Native Infantry), but it was probably Atholl to whom Wight was closest and taught to dry plants. Atholl must have appeared young for his age, for when he accompanied Arnott to look for *Phyllodoce caerulea* on the Sow of Atholl in 1835 Arnott thought he was about 14 or 15.[47] Atholl Stewart followed in his father's footsteps, but this was a time of disruption in the Presbyterian church, in which father and son were caught up. The by-now decrepit John Stewart, on 13 February 1843, allowed a group, of which his son Atholl was leader, to meet in the parish church, where they resolved to form a congregation of the Free Church. Lord Glenlyon found out, was not amused, and became 'the prime mover in trying to eradicate the presence of the Free Church in Atholl'. In this he failed: freedom of religious expression prevailed, and Atholl Stewart remained minister of the Free Church in Blair for nearly 40 years, building a large church in 1857 having earlier been forced to operate in the open air from 'preaching tents', then in a flood-prone wooden building on an island outwith Atholl territory. Lord Glenlyon (after 1846, 6th Duke of Atholl) seems to have been a rather unpleasant character and when John Stewart was laid to rest in 1843 beside the church he had built twenty years earlier, a wall had to be built to prevent his grave collapsing into the stony alluvium. Three days later the grieving family were served with a writ instructing them that if they failed to remove this wall Glenlyon would have it demolished and the family would have to pay for the work! Fortunately 'such was the general uproar and indignation at the prospect of the minister's grave being disturbed, that the attempt was given up'.[48] It was this same proprietorial and bellicose character who in 1847 came to blows with J.H. Balfour and his botanical students from Edinburgh in the famous 'battle of Glen Tilt'. Wight's sister Anne long outlived her husband and Wight would visit her several times after his return to Britain (when she seems to have lived at Killiecrankie), dying aged 86 in 1870.

LONDON · WINTER AND SPRING 1831–2

Wight intended leaving Blair Atholl for Edinburgh on 26 September, but told Hooker that on the way he intended going to St Andrews 'to see a friend'.[49] There are intriguing links between St Andrews and Madras, most obvious today through the town's secondary school, Madras Academy, founded by the Rev Andrew Bell (1753–1832), one time chaplain to Fort St George, who amassed a fortune with which he endowed various Scottish schools to perpetuate the 'Madras system' – a monitorial one, with older boys teaching the younger, which Bell had developed at the Madras Military Orphan Asylum.[50] This is no more than an aside as Bell, though still just extant, lived in London. Given the last residence of Wight's father, it is possible that this visit was to Hugh Cleghorn senior, who

had retired to Stravithie, an estate just outside the town, which he had purchased in 1806. It seems perhaps slightly doubtful that Wight would have described a 79-year-old as a 'friend', but his grandson Hugh, who did become a friend, was at this time only 11 years old, and not even certainly in Britain. There could easily have been old friends from school or university days, or people met in Madras, who might have been in St Andrews at this time, so the reason for the detour is likely to remain a mystery. After a few days in Edinburgh 'on account of some business I have to transact there' (doubtless concerning his father's estate and the property inherited from his mother),[51] Wight went by steam boat to London where he remained based at Queen Street until July 1832, working extremely hard on his herbarium collections.

In London this winter Wight mixed with the upper echelons of metropolitan botanical society, and it was at this point (17 January 1832) that he was elected to fellowship of the Linnean Society, whose president was then Lord Stanley (later 13th Earl of Derby). It was a distinguished group that signed Wight's proposal, the first five of whom have already been encountered: Robert Brown (like Wight a former botanical student of Rutherford at Edinburgh), W.J. Hooker, R.K. Greville, Robert Graham and Nathaniel Wallich. The other proposers were John Lindley, Francis Boott, George Bentham, A.B. Lambert and Archibald Menzies. Of these, Lindley (1799–1865) was Assistant Secretary of the Horticultural Society, Professor of Botany at University College, London, and the acknowledged British expert on orchids;[52] he worked on Wight's orchid specimens, and later edited the *Gardeners' Chronicle*, in which Wight would publish towards the end of his life. Though American-born, Boott (1792–1863) was another Edinburgh medical graduate, who would shortly become Secretary of the Linnean Society; an expert on the genus *Carex*, it was he who would later describe a discovery made by Wight in Corrie Fee in the summer of 1832. Bentham (1800–84), nephew of the utilitarian philosopher Jeremy Bentham, was one of the greatest of nineteenth-century taxonomists, who would take up and work on Wight's Labiatae and Scrophularia-ceae.[53] Lambert (1761–1842), Vice-president of the Linnean Society, was the owner of an important private herbarium curated by David Don, and author of the sumptuous *Description of the Genus Pinus* (1803) illustrated partly by Ferdinand Bauer. The last of the group, the venerable Menzies (1754–1852), makes a link with a previous generation, as he had studied at Edinburgh under John Hope, though is best remembered as naturalist on Vancouver's circumnavigation of the globe, from which he introduced the Chilean monkey-puzzle. At this point the admission fee for the Society was £6, and the annual contribution £3,[54] but in 1839 Wight paid the 'composition fee' of £30, a subscription for life.[55] Wight must also have met John Forbes Royle at this time, as he gave Wight his specimens of Himalayan Asclepiadaceae to work on.

Herbarium curation and distribution

As noted above, Wight's herbarium collections were prolific, and his main work of the winter 1831–2 involved sorting them into sets of duplicates, then identifying the species as best he could – from books and by comparison with specimens in other collections in London, primarily those of the EIC, Sir Joseph Banks, and the Linnean Society. Queen Street was an ideal base for these activities: the EIC's herbarium being (temporarily) literally around the corner in Frith Street; the Linnean collections a few hundred yards away in

Soho Square, under the care of David Don; and the Banksian ones, under Brown's charge, at Montague House in nearby Bloomsbury. It appears that the bulk of this vast work was carried out by Wight himself, and the only help he mentioned was with sorting the cryptogams – the seaweeds ('fuci') were to be sent to Dawson Turner (Hooker's father-in-law, who lived in Yarmouth); the mosses and lichens were sorted by a 'Mr Blyth' prior to sending to Hooker for naming;[56] and young Klotzsch had visited him from Glasgow to look at the fungi (one of which, a bizarre bracket fungus resembling a wasp's nest, he named after Wight as *Polyporus* (now *Hexagona*) *wightii*).[57] Work continued slowly over the winter, but progress improved in spring 'now that we have both longer & clearer light, & what to me is of some consequence warmer weather, for truly I cannot work when cold' and by March Wight had 1100 species ready to distribute.[58] This he did in April, sending with the sets of specimens a lithographed letter.[59]

Sir

The accompanying specimens of Plants from the Peninsula of India, are part of a herbarium collected for my own use, and for occasional communication of specimens to my immediate friends: But having observed since my return to Europe. the great advantages that have accrued to the science of Botany, from the extensive and liberal distribution among Botanists of the vast collections of the Honble. East India Company, I have resolved to extend my plan, and by imitating, though in a humble way, that noble example set before me by these munificent patrons of natural science, endeavour to render my herbarium more extensively useful, by dividing it into several sets for distribution, in the manner now practised by the Honble. Company; under the direction of that most able and indefatigable naturalist Dr Wallich.

In the hope that you will aid me in extending their usefulness, I now take the liberty of requesting your acceptance of these specimens, and trust, that they may be made still further useful to science, by being rendered as accessible as your avocations will permit, to all Botanists who may wish to consult them either for the purpose of comparing other specimens, or for publication.

I embrace this opportunity of mentioning, that the period I am permitted to remain in this country, being much too short to enable me to finish the publication of my herbarium, I am under the necessity of leaving that most desirable consummation of my previous labours, to be performed by others; and therefore request, if you have undertaken to elaborate any of the natural orders [families] of the Honble. Company's herbarium, that you will comprise in such monographs, the materials afforded by my collection.– I am anxious for many reasons, that the entire orders of both herbaria should be undertaken by the same persons; the least of which, perhaps, is the saving of time that will result, owing to the greater number of my plants being found in the larger collection; and included in the monographs now in course of preparation. Under these circumstances I trust you will not consider me unreasonable in proposing to limit the time of publication, to three years from the receipt of the specimens; and for requesting that those marked "to be returned" be examined and sent back as quickly as possible, so that I may have them in time to take with me to India.– The numbers attached to the specimens correspond with a list to be afterwards forwarded.

As I think it easier to correct errors arising from multiplication, than from excessive condensation I have in all doubtful cases, preferred

attaching a separate number. Acting on this principle, I now find, that I have in several instances numbered the same species more than once.– These errors I shall endeavour to correct in the catalogue.

In conclusion I have to request that a list of the numbers be returned, which may, perhaps, enable me to fill up some of the vacancies in the series, from specimens which I expect to receive from India before the distribution is finished. If you have particularly studied any natural order, and could, without inconvenience, communicate a list of the names along with the numbers; I would esteem it a particular favour, as it might be the means of saving me much time, and greatly contribute to the correctness of my Catalogue.

All favours of this kind will be carefully acknowledged.

9 Queen Street, Soho	I have the honour
London	to be Sir
25 April 1832	yours very obediently
	Robert Wight.[60]

This letter was Wight's first use of lithography, and in using it to re-produce manuscript text (as he would again for his herbarium catalogue the following year), he was following the example of Wallich's *Numerical List*. It is a characteristic Wight production – in its generosity of spirit no less than its long-windedness. It also shows that he was still keen to flatter the EIC and he notably desisted from relating the fact that while these 'munificent patrons of natural science' may have assisted Wallich in his work, they had turned down Wight's own request for help, as will be seen below. Despite the generosity and plea for help with naming, Wight was to be disappointed – with the signal exceptions of George Bentham and the Breslau-based botanist Christian Nees von Esenbeck.

Fortunately at this point a saviour appeared on the scene in the person of George Walker-Arnott, though the first steps towards this were decidedly faltering, and Wight would not actually meet Arnott for another four months. As mentioned earlier Wight had asked Hooker, and evidently also Graham, to send specimens to Arnott, his old school mate and fellow botanical pupil under John Stewart, from the copious material he sent them from Negapatam. These had not been acknowledged by Arnott, and Wight was therefore diffident to the point of paranoia in sending him a packet of this most recent set of duplicates. He did so via Hooker with a covering letter that is almost painful to read, begging discretion in delivery of the package 'because I am uncertain whether I do right in asking him to accept of it'. Wight was worried that Arnott's failure to acknowledge 'either our former acquaintance or the receipt of plants' might show that:

> he has no wish to know me, and that therefore my presenting him with plants now may be construed into a fawning to regain his favour; or perhaps, should he chance to be out of humour at the time, to a wish to insult him, by offering what his former conduct should have informed me, would not be accepted.[61]

Hooker's diplomatic skills were well known, but in this case proved superfluous, as it turned out there had simply been a breakdown in communication. Arnott had taken the specimens to be gifts from Graham, and not realised that any thanks were due personally to Wight. Wight's discovery of this explanation unleashed a torrent of self-abasement, which provides the deepest insight we have into his (at least at times) morbidly sensitive nature:

I have heard so much of his [Arnott's] oddities that I did not know how he would receive them or what he might think of me for doing so after the neglect with which he had treated me, supposing it to be intentional, which it evidently appears now was not the case.– Had it been intentional he might naturally and very properly too, have considered me a low mean spirited fellow anxious to gain friends at whatever sacrifice of honorable feeling, of pride, and of that respect for myself, which ought to guide every gentleman in his intercourse with the rest of the world.– Now it so appears that that kind of pride forms too large an ingredient in my constitution & often prevents me doing what I think is right and what I wish; for fear of being thought officious or sycophantish [sic] – so sensitive indeed am I to that feeling that I truly believe it has exerted a considerable influence over my fate through life. It has made me shun society where I am now confident I would have been most welcome, and from which I would have derived both pleasure & profit, merely because on some occasion something was said or done, which alarmed this foolish pride, and made me think that my absence would be more agreeable than my presence & immediately I withdrew – & what makes the thing a great deal worse is that I detest the notoriety so much which an occurrence of the kind is but only too apt to give rise to that I cannot bring myself to complain or ask an explanation what would at once set all right & so strongly is this failing implanted, that once when I had serious thoughts of becoming a benedict ['a confirmed bachelor who marries' OED. Could this have been Eleanor Turner?] something interfered which led me to suppose that my attentions were not quite agreeable & I forthwith flew off at a tangent tho' at the cost of so much internal suffering & vexation as makes me still think of the circumstance with horror.– In short this feeling with me amounts to a constitutional infirmity and will explain to you more clearly than I could otherwise do what it was that dictated the sentiments expressed in my last letter with regard to Arnott.[62]

Arnott has been described above as Wight's saviour, and this designation barely does justice to the services he would perform, both collaboratively, and on Wight's behalf, over the next 15 years, starting with their jointly authored publications, and, after Wight's return to India, as the main receiver and distributor of his specimens. That this reintroduction was effected through Hooker, is just one more cause for gratitude to him, over and above the liberal help he had already provided to Wight.

Publications

Hooker was still continuing to perform one of the greatest of his initial services – the publication of Rungiah's illustrations and Wight's descriptions in the *Botanical Miscellany*. Despite these publications, and given the wealth of material at his disposal, Wight was, not surprisingly, anxious to publish on a larger scale – no less than an illustrated Flora of southern India. Towards this he had discussions with the London publishers Parbury & Allen. Wight also sought the opinion of the great Robert Brown as to whether or not he thought the drawings worth publishing 'in that expensive form' – as a favourable opinion from Brown would have carried great weight in seeking help from the EIC. Brown certainly merited his contemporary adulation (Humboldt: '*facile botanicorum princeps*'; Martius: '*Jupiter Botanicus*'), but was probably the worst person to ask for any sort of opinion. Notorious for procrastination and sitting on other people's work (one of the worst cases being that of the manuscript of Roxburgh's *Flora Indica*), Wight, as one might have expected, found

it impossible to get Brown to pronounce. As Hooker had already warned Wight, when writing to him at Negapatam, the costs of such a publication were prohibitive and Parbury 'was alarmed and stood agast [sic] at the immense sum of money … [for] such a … flora with plates. He calculated that 500 copies of such a work with lithograph plates would cost £4000 in Royal 8vo size, [and] consequently could not be thought of, unless the certainty of an extensive sale could be procured'.[63] Wight applied to the EIC for financial help with his scientific work – both for curatorial help and with publishing costs, but the reply received in March 1832 was 'bad news from end to end – that is they have refused me all assistance.– I must therefore work through my herbarium single handed and lay aside all thought of a flora'.[64] Hooker generously offered to provide Wight with an assistant to help with the collections,[65] but Wight stalled on this and the offer became redundant when contact was made with Arnott shortly thereafter.

IN SCOTLAND AGAIN · SUMMER 1832

When, after a botanising trip to Gravesend, collecting orchids and the beautiful wild sage *Salvia pratensis* in May,[66] Wight headed north in July it must have been with a light heart – his first set of specimens distributed, the prospect of another highland expedition with Graham, of seeing his sister and her family again, and of meeting up with Arnott in the autumn. Work was also going well in India and he had received a letter from Rungiah who reported that he had collected 'much plants in Trichinopoly', but that the collectors had not got as much as they might in the mountains, being inhibited by 'a great fear of the wild beasts'.[67]

Though Wight must have been looking forward to his northern trip, it seems ironic that, having been exposed to the diseases of India for 12 years, and survived at least one serious attack of malaria, the Scotland to which he should return in July 1832 was in the grips of a cholera epidemic. In January Graham had been working in a district of Edinburgh of which he had 'undertaken the charge of in preparing for the expected attack of Cholera'.[68] The disease had reached Edinburgh by May, when Graham wrote to Wallich with an exuberant account of his extraordinary method of treating victims, which concludes like a recipe for a savoury meringue! Given Wight's interest in fever it is worth quoting this, quite apart from its interest in terms of medical history:

> We are producing here the most marvelous [sic] effects on the worst states of Cholera by injecting marvelous quantities of salt water into the veins. I saw a man today who was far on to the grave yesterday. Into his veins there have been since that time 49 pounds of salt water injected, & his eye & feeling & general appearance are now like a man in perfect health– I saw at the same time a woman who was brought into the Hospital without pulse or voice, her skin cold & her cramps severe, & her age 70.– The pumping as soon as possible was commenced, & before 6 pounds were thrown in, which was done in abt. ¼ of an hour, her pulse became good, her voice, countenance & eye natural, tho' the last had been previously swollen, the cramps almost entirely ceased, & she was cracking her jokes with the Hospital clerks who were assisting in the operation– I was obliged to leave her when she had received 7 pounds, & on returning an hour after I found her in a calm sleep. She again sunk however & the operation was renewed; I did not see her during her last injection nor have I since, but I am convinced from another case which I have seen that she will again come round – whether

permanently is a different question.– Ten pounds (I do not write pounds for grains or drachms) ten pounds are generally thrown in during one operation & in the space of 40 minutes, but I have known 6 pounds thrown in in 12 minutes, without the least inconvenience or any unpleasant effect whatever, but the most miraculous & instant improvement. To the ten pounds there are four drachms of muriate of soda [i.e. sodium chloride] & four scruples of bicarbonate of soda & the solution is injected at a temperature varying form 112 to 115 or even as high as 120 but this generally produces flushing – if at a lower temperature than 110 it generally produces a rigor.– It is positively worth your while to come & see this before you return to India – Assure Wight that it is more miraculous than the contagious nature, & more marvelous than any of the phenomena of this enigmatic disease.

> PS. The ten pounds of water injected with the old woman today contained besides the salts – the whites of three eggs – It does not appear however that this is of any use.[69]

Wight avoided cholera and once again joined what turned out to be a highly successful Highland expedition. The party consisted of two groups, the first composed of Graham's 'most elastic friends [who] could not be compressed so long this year, and, exploding during the summer heat, carried them to Forfar on the 12th July'.[70] This first group, who explored Glen Clova, Braemar and the Cairngorms in poor weather, included Hewett Cottrell Watson, who on his own continued northwards as far as Caithness recording detailed ecological information on the altitudinal distribution of plants using an Adie sympiesometer.[71]

Watson is an intriguing character who, in addition to his important ecological work, was at this stage interested in phrenology, a pseudoscience that attempted to deduce psychological characteristics (for example, criminal tendencies) from the relative sizes of parts of the brain (organs of Individuality, Causality, Tune, Wit, etc.) as revealed externally as bumps of the skull. These two interests were combined in a bizarre and unique paper: 'On the relation between cerebral development and the tendency to particular pursuits; – and on the heads of botanists'.[72] The botanists were classified as falling into one of three groups: Descriptive, Physiological and Philosphical (Watson included himself in the last category, in which the aims of the first two were seen as a means to the greater end of explaining 'the influence of soil and climate over vegetation, with the mutual relations between the vegetable kingdom and the rest of creation'). In general Watson had a masochistically low opinion of botanists, and observed that 'the average of botanical heads is smaller than will be found in those of several other sciences, as Geology, Moral Philosophy, or Political Economy'. While Watson found that it was not possible from the head to infer that an individual would be predisposed to Botany, the heads of the eight (anonymous) individuals he studied showed largest development of the organs of Individuality, Eventuality/Form/Locality/Constructiveness and Language. He did, however, consider that the bumps revealed into which of his three groups an individual botanist would fall. The botanists are unfortunately not named (though from the descriptions Hooker and Greville can be safely identified) and one can only speculate as to whether or not Wight might have been one of his subjects. Watson noted characteristic national differences between English and Scottish botanists, which would certainly provide an explanation for Wight's prolific collecting activities in India:

The inhabitants of Scotland have larger brains, larger reflective, but relatively smaller observing, organs than the people of England ... the national character of England is unquestionably better adapted to this science than is that of Scotland; yet are there one or two points in which the latter country excels. Its inhabitants are more philosophical and more acquisitive. Accordingly, they have most urged the paramount importance of the Philosophy of Botany, even while the individuals urging it have not had sufficient knowledge of the details to effect much [perhaps referring to Graham]. They also collect specimens with treble zeal and assiduity. Often I have heard Scottish botanists remark, that the English know not how to collect plants; the meaning of which is, that they fail in the quantity gathered, for the eye of an Englishman probably detects and distinguishes plants more readily than does that of his brother botanist in Scotland.

This tendency to prolific collecting certainly holds good in the case of one Scottish botanist – Robert Wight!

Graham had to wait until his summer course at the Botanic Garden was over before heading north with Wight to Kirkton of Clova on 28 July. They stayed in this vicinity until 7 August, then crossed over to Glen Isla, proceeding on the ninth to Glen Callater and Castleton of Braemar. From here Graham had to return to Edinburgh, and Wight seems to have retraced his steps of the previous year to Blair Atholl. The finds were once again spectacular, and Graham was particularly pleased to be able to contribute to the restoration of the good name of George Don (one time curator of the RBGE, and father of David), who had first explored these mountains, but whose veracity had been subsequently doubted. Of the party, in addition to Greville and James McNab, was Dr Benjamin Daniel Greene (1793–1862), a visitor from Boston (USA). The plants specifically attributed to Wight in the report were: alpine fleabane (*Erigeron alpinus*), the minute, jewel-like, snow gentian (*Gentiana nivalis*) and alpine sowthistle (*Sonchus* (*Cicerbita*) *alpina*) at five new stations.[73] Conservation was already becoming an issue and at its original site this handsome blue thistle 'from being constantly plundered ... is becoming weaker every year. Fortunately some of the new stations are wholly inaccessible', so Wight once again would seem to have lived up to his scandent reputation. The best find, however, was Wight's alone – what Graham identified as a large form of *Carex pulla* (now known as *C. saxatilis*):

> in one station, on wet places among the rocks on the south side of the Fee. Dr Wight first gathered it, of such unusual size ... that it was with difficulty I could believe in the identity of the species ... till I visited the spot, and found among the larger specimens others gradually coming down nearly to the size I had found it on other mountains.

This beautiful sedge was later identified by Francis Boott as a new species, which he described as *Carex grahami* in a paper read to the Linnean Society on 19 December 1843.[74] There is still argument about the nature of this plant, but it is now commonly regarded as a hybrid between *C. saxatilis* and *C. vesicaria*.[75] Because these two species are never now sympatric (the former being an alpine species occurring between 750 and 960 metres, the latter a lowland one occurring up to 455 metres), E.C. Wallace doubted that *C. vesicaria* was involved,[76] though it is conceivable that the two species might have grown together in immediately post-glacial conditions. The plant is currently known from about seven sites in the Scottish Highlands (750–900m), based mainly around Ben Laoigh, in

vegetatively spreading colonies that are clearly extremely long lived: Wight's clump in Glen Fee can still be seen today (Book 3 fig. 11).

While Wight was at Blair, Graham's patronage – doubtless the result of a guilty conscience from having done so little with his Indian specimens – took unexpected shapes in two rather distant localities. The first was a valuable gift for Wight in the form of a microscope, built by Andrew Ross (then at the start of his distinguished career), designed to John Lindley's specifications, which cost the enormous sum of £26 – 5 shillings, delivered to Wallich's care in London.[77] The second result was Wight's election to the oldest, and one of the most prestigious, continental academies of natural science – its prestige reflected in the length of its name: the Academia Caesareae Leopoldina-Carolinae Naturae Curiosorum, known for short as the 'Leopoldina'. Graham had been a member since the previous January, and it was doubtless therefore he who proposed Wight. Wight's citation reads '*plantarum in India orientali indagator acerrimus*'. On election, and smacking slightly of freemasonry, members had to adopt a botanical surname or 'cognomen': Graham had chosen that of the English apothecary-gardener, and King's Herbarist, John Parkinson (1567–1650), and it comes as no surprise that Wight should have chosen 'Roxburgh'.

THE WIGHT & ARNOTT COLLABORATION

After about a month at Blair Wight, after a gap of 15 years, met up with Arnott, at the latter's estate of Arlary, in the shadow of the Lomond Hills near Kinross. The purpose was 'to arrange ... our plans for working together during the winter',[78] and Wight was expected for breakfast on 11 September.[79] Earlier doubts and fears must have been entirely dispelled and the outcome exceeded Wight's greatest hopes, for it was on this occasion that Arnott 'most kindly and liberally volunteered to assist me in the preparation of my then contemplated 'Peninsular Flora of India', an offer most thankfully accepted and acted upon'.[80] This is something of an understatement as Wight must have realised that with, at most, 18 months of leave left, there was no way on earth he could have even begun to write such a work on his own without the aid of a much more experienced botanist. The enormous consequences ensuing from this brief visit (which lasted no more than a few days) will be described below, but Wight was on the move again. He had to be back in London by 20 September to see Wallich before he sailed back to India. Before this, however, Wight fitted in a visit to Hooker, who had taken a house at Helensburgh for the autumn having been 'driven by Cholera from Glasgow; some highly respectable people & our very near neighbours having within these 2 or 3 days fallen victims to it'.[81] Despite this contagion Hooker braved a visit into the city to meet up with Wight.

Wight's stay in London this autumn of 1832 was spent 'determining my plants by comparison with the Linnean and Banksian herbaria',[82] with evenings devoted to working on Asclepiadaceae, his great interest of the time. He wanted to write a monograph of the 'East Indian' species of this family, based not only on his own specimens, but those in the EIC herbarium, which included many specimens from Burma and the Malay Peninsula, the collections made by J.F. Royle in the Himalaya and northern India, and those in Lindley's herbarium. It was initially intended that this account be published in the *Botanical Miscellany*, but after much editing by Arnott, the monograph appeared in 1834 in the *Contributions to the Botany of India*. The flowers of this family are complex, and the criti-

cal pollen and anther structures of many are tiny. Graham's microscope doubtless proved its worth, but Wight complained to Henslow [fig.16] that he found evening work 'most troublesome & tedious … owing to the minuteness of parts & the bad light which candles afford for such work'. Wight attended Linnean Society meetings and a radical side to his character is perhaps to be read into a gleeful report to Hooker that 'a most gratifying part of the business was the reading of some 10 or 12 petitions for suspension [for unpaid subscriptions] – among which were a duke & an earl or two'.[83] An important business transaction that took place at this point was with the publisher Parbury – Wight had evidently given up hope for an illustrated Flora, and settled for what would become the *Prodromus*. The options were either that Parbury would publish the book on Wight's behalf, with Wight paying for it himself; or that it would be published by Parbury. The publisher struck a hard bargain, and in the latter option Wight would have to persuade the EIC to take 40 copies, find 100 subscribers and receive 25 copies as his share of the profit.[84] Wight decided to go for the former 'taking all risk & responsibility on my own shoulders, if it pays well & good, if not the loss will not much hurt either my peace of mind or my pocket'.[85]

About the middle of October Wight had the melancholy task of bidding farewell to Wallich [fig.17], whom he would not see again in person for another 21 years. Despite the enormous achievements of the previous four years, the distribution of the EIC herbarium had still not been completed (and, despite Bentham's efforts, would not be until after 1846 when Wallich retired to England). Wallich had been unable to get his leave extended any further and was therefore forced to return to his duties superintending the Calcutta Botanic Garden. Wight accompanied him to Deal and saw him off on the 'Exmouth', 'in exceedingly low spirits harrassed [sic] in both mind and body with the load of business which he had to go through to the very last moment of his stay on shore', leaving behind his wife and family.[86]

In the middle of November Wight returned to Scotland, and spent four or five days with Hooker in Glasgow in the first week of December. It was on this occasion that he sat for Daniel Macnee, who drew his portrait in coloured chalk [Frontispiece]. Hooker sent all his eminent botanical visitors to Macnee, and the resulting collection (rather badly foxed) is at Kew.[87] Anne Stewart also wanted a portrait of her brother, and Hooker generously sent her the original (which arrived with a broken glass due to sloppy packing by the 'carver and guilder'), and had a copy made for himself. It must have been from Hooker's copy that an often reproduced lithograph was made,[88] in which Wight appears older and more serious than in the handsome, Darcy-esque, drawing. Macnee evidently charged two guineas for these rapidly executed works, and framing cost a further guinea.[89] What happened to Anne's copy is unknown, but one hopes that it might survive somewhere, perhaps lurking unrecognised in a Perthshire house.

Fig.17. Nathaniel Wallich. Drawing in coloured chalk by Daniel Macnee, *c*.1830. Royal Botanic Gardens Kew.

Fig.16. Wight's handwriting – a letter written to Professor J.S. Henslow in November 1832.

Wight went to Blair in December where he remained over Christmas, corresponding with Hooker over the purchase of American herbarium specimens, but concerned not to over-stretch himself financially as he hated getting into debt (shades of his father?) 'a contingency which I always have, and I trust ever will, dislike, owing to my funds in this country being limited in extent and from being derived from a species of property which does not always pay well (houses)'.[90] It seems that Wight must at this point have taken the bulk of his herbarium north, and to have given up the Queen Street premises. Arnott joined him at Blair in January 1833, the real start of their fruitful collaboration, and it was doubtless at Arnott's instigation that they began by sorting sets of specimens of grasses (220 species) and sedges to send to Nees von Esenbeck, and spurges (Euphorbiaceae) to J.A.C. Roeper.[91] While Roeper failed to do anything with the specimens, Nees was a match for Arnott in the eagerness and productiveness with which he set to work on Wight's rich material. Sadly, however, Nees's extensive work on the grasses was never to see the light of day in print.

George Arnott Walker-Arnott (1799–1868)

It is appropriate to provide here some biographical information on Arnott, whose importance in Wight's life and work would from now on supersede that even of Hooker, but whose enormous abilities and contributions to botany have been almost entirely forgotten.[92] The most important source of biographical information about Arnott is the obituary written by Cleghorn, on which the following summary is mainly based.[93]

Arnott's stuttering name has caused confusion, but is easily explained.[94] He was born in Edinburgh (probably at 7 St John Street) on 6 February 1799, son of David Walker and Emilia Stewart, and baptised George Arnott Walker. However in 1807 his father inherited the 681 acre estate of Arlary from his maternal uncle Robert Arnott, and adopted the surname Walker-Arnott. It was in this same year, along with Wight, that Arnott entered William Ritchie's class at the High School of Edinburgh. The year 1813 saw the pair matriculating for the first time at Edinburgh University, but, as already noted, Arnott studied mainly arts subjects (taking the degree of A[rs] M[agister] in 1818) his forte being mathematics, but from which he was wooed away by John Stewart's botanical lectures. Arnott bowed to parental pressure and studied Law, becoming a member of the Faculty of Advocates in 1821, but disliked public speaking and 'only appeared in his advocate's gown three times'. On the death of his father in 1822 Arnott inherited Arlary, but this small estate yielded a tiny income, about which he would complain in letters to Hooker, as it limited his ability to purchase books and herbarium specimens. This twin background in maths and law lies behind the considerable rigour Arnott applied to botany, a rigour matched among his British contemporaries probably only by his friend George Bentham. Arnott's earliest work, doubtless inspired by Stewart, was on mosses, some of which was done in collaboration with Greville. Another strength that Arnott shared with Bentham was the extent of his personal contacts with European botanists, starting with a visit to Paris in 1821, when he worked for two months in the herbarium of Baron Benjamin Delessert. It was on this occasion that Arnott took part in the last expedition (to the Etang de St Gracieu) led by the great but elderly Antoine-Laurent de Jussieu (though then aged 73 he would live for another 15 years). Jussieu was, effectively, the originator of the practical system of

natural classification, developed by Candolle, that would be used by Wight & Arnott. In 1825 Arnott returned to France, visiting the Paris herbaria once again, before joining Bentham in the south for an expedition to the Pyrenees.[95] Arnott had first met Bentham at Patrick Neill's house, Canonmills Lodge, Edinburgh in 1823. It was Neill who had printed Wight's doctoral thesis, and would print Wight & Arnott's joint publications. Neill was also noted as a horticulturist, one of the founders of the Caledonian Horticultural Society, and for his remarkable garden and menagerie, which included a tame soland goose (gannet), a cormorant, various duck and seagulls, an ichneumon,[96] a parrot and two cats 'all living in perfect harmony'.[97] After the Pyrenean expedition Arnott spent three months in Geneva working in Candolle's herbarium, which, added to his earlier experience, gave him an unparalleled first-hand knowledge of the Natural System duly reported to Hooker in letters. The last foreign expedition Arnott undertook (until a trip to France in 1866) was to St Petersburg in 1828, in the company of his future father-in law, Arthur Barclay a merchant in Russia, and it was there that he met J.D. Prescott (another merchant with an important private herbarium, who later committed suicide), F.E.L. von Fischer, director of the St Petersburg botanic garden, and C.F. von Ledebour, professor of botany at Dorpat.[98]

This unique botanical experience, and Arnott's synthetic abilities, were demonstrated in the article on 'Botany' he wrote for the seventh edition of the *Encyclopaedia Britannica*, published in Edinburgh and edited by Macvey Napier. This article did much to popu-

Fig.18. George Arnott Walker-Arnott. Copy photograph by R.M. Adam after an original probably made in Glasgow, *c*.1860.

larise the Natural System in British botanical circles (in previous editions the article had been written by the arch-Linnaean J.E. Smith) and was 'often cited by his contemporaries'.[99] When published, however, it was effectively anonymous (attributed to 'U.U.'), and has been omitted from the standard reference work on botanical literature.[100] Authorship of the article was not generally revealed until 1842, where the attribution to 'Mr Walker Arnott' is hidden in the text of Napier's Preface added to vol. I, but, confusingly, 'U.U.' in the key to the 'signatures' is given for John Gillies! The authorship, however, was known from the start by the botanists to whom Arnott sent reprints, including (on 10 March 1832) Hooker.[101]

Arlary: 'the fog and the bogs and the whiskey toddy'

To reach Arlary from Edinburgh it was necessary to cross the Firth of Forth from Newhaven to Burntisland, then to drive by horse-drawn gig 'seventeen miles up the country, at first over high hills, then through a bare, barren, dreary, bleak country'. Bentham described the house (in 1827) as:

> small, and like many Scottish country houses, uncomfortably situated in the middle of an open grass lawn or court yard, the garden and what plantations there are being separated by it from the house, but the interior was comfortable and pleasant … The inmates consisted of Mrs Arnott, my friend's old mother, an old, tall lady … who looks like one of those who never lent against the back of her chair.– Miss Arnott, his younger sister [Jane], too much like her brother to be pretty, … and Miss Walker, an old maid … – a relation, perhaps an aunt.[102]

By the time of Wight's visit the household had been augmented, as Arnott had married Mary Hay Barclay the previous year and at this point she was heavily pregnant with their first son David, born in October 1832. The house had also been enlarged, with 'a room for my books, and another for my herbarium' added in the summer of 1831.[103] This is not the place to elaborate on Arnott's social life – he was a staunch Tory, and took his duties as a laird extremely seriously. His county activities (magistrate, church-related, turnpike roads, jails etc.) were, in fact, the major distractions he allowed himself from his botanical work. Arnott was a near neighbour of the Adam family of Blair Adam, but differed from them politically, as they were Whigs. From 1825 Arnott was Deputy Lieutenant of Kinross-shire, and he was also an active freemason, ending up as Depute Grand Master of Scotland. Bentham has left an amusing description of the hospitality at Arlary, but it should be noted that this dates from Arnott's bachelor days:

> evenings were spent in the true style of country Scottish landlords. Whiskey toddy circulated in abundance after dinner till teatime, when an hour or two was spent in the drawing room till supper – more a pretext for drinking than a meal. The toddy was again produced, and by bedtime some of the gentlemen began to appear puzzled how to find their way to their bedrooms.[104]

Arnott was also in the habit of taking visitors to the picturesque sights of the neighbourhood – the castle of Loch Leven ('the celebrated prison of the unhappy Mary'), and the spectacular gorge and waterfalls of the River Devon at Rumbling Bridge. However, given the work that Wight & Arnott achieved, it seems doubtful if there was much time either for such excursions or for excessive carousing.

By the time that Wight met Arnott in autumn 1832, the latter was willingly, but nonetheless firmly, in the clutches of Hooker for whom he provided the services of an unpaid botanical workhorse. For example, Arnott did the majority of the work on the *Botany of Captain Beechey's Voyage*, though his name appears only as second author. Arnott's motivation, and devotion to botanical science for no financial reward, match those of Wight in his generosity with his specimens, but it seems that this was all seen as necessary groundwork for the eventual reward of a botanical chair, one of the few professional posts then available to botanists. Arnott's failure, for political reasons, to get Hooker's chair when he left Glasgow for Kew in 1841 came as a catastrophic blow, not least as he had been standing in for Hooker lecturing and editing his journals while Hooker was swanning around London canvassing for the Kew job. What followed would now be called a nervous breakdown, and all mention of this terrible period is tactfully omitted by Cleghorn; this, however, was in the future and our concern here is with the remarkable achievements of the period between January 1833 and September 1834.

During this period two parts of Wight's herbarium *Catalogue* (May 1833, September 1834), the *Prodromus* (August 1834) and *Contributions* (September 1834) were all published. Further details of these publications and their production have been provided elsewhere,[105] so there is no need to say much here. Suffice it to say that there seems no doubt that the majority of the work was done by Arnott at Arlary: he was the widely experienced systematist, Wight being at this stage more of a field botanist, good at recognising species, whose main role was to check identifications by comparing with the collections in London, and, in February 1833, with the collections that Francis Hamilton (né Buchanan) had bequeathed to the University of Edinburgh.[106] Arnott described the process of writing the account of the legumes to Bentham, but this was doubtless typical of the whole enterprise: 'Wight making notes in London; I dissecting, comparing and methodising them here [at Arlary] and keeping the printer's devil [in Edinburgh] in as good humour as I could'.[107] The reason for the last comment is that it is apparent that the *Prodromus* was written in a white-hot fury, and typeset and printed as sections were completed (with no time for second thoughts). Wight was the first to acknowledge the primary role of Arnott in their joint works, but here again Arnott appeared as second author, and seems to have found adequate recompense in the opportunity to work on Wight's rich materials. Wight's and Arnott's letters of the period to Hooker are full of the details of their work together, and tell of the toings and froings of books, specimens and manuscripts between Arlary and Glasgow.

By late February 1833 Wight was panicking about his leave, which was due to run out in November or December. There was doubt about whether he would obtain an extension as the Court of Directors had 'of late most determinedly refused compliance with all applications for leave unless on sick certificate' and Wight was therefore anxious to have enough of the *Prodromus* printed to prove that the extension was needed for 'the advancement of science' and therefore backed by the 'recommendation of scientific men'.[108] After a visit to London in March–April Wight was back in Scotland for the summer, and in Edinburgh for the publication on 28 May of the first part of his herbarium *Catalogue* printed lithographically in Edinburgh. This is no more than a list of numbers and species names, with no descriptions, which was often cut up by recipients of the herbarium specimens and used as labels. Nevertheless Wight

was clearly proud of this first proof of his botanical labours, and on sending Hooker a copy hoped that it would 'please your critical eye and also Mrs Hooker's.[109] It was the only work to be printed before Wight had to leave the country.

Wight still kept in touch with Rungiah and botanical activities in India, and it was in May 1833 that he was thrilled to receive his first ever botanical letter from the Subcontinent. This came from William Griffith, a pupil of John Lindley, who had gone out as an Assistant Surgeon to Madras the previous year, and reported the 'failure of rains at Madras' and the disastrous result that 'crops of all kinds had failed'. On a more positive note he had been teaching Rungiah 'the use of the microscope & in the delineation of Microscopic views from which I hope he will derive much benefit'.[110] Griffith's early postings and travels in Madras (i.e., until he went to Bengal in 1835) are shadowy – according to the *East India Register* for 1833,[111] he was initially attached (like Roxburgh before him) to the Madras General Hospital, and his military service record gives him as being attached to the 8th Light Cavalry in 1833 and to His Majesty's 41st Regiment of Foot in 1834.[112] Cavalry regiments were more swashbuckling than Infantry ones, and British regiments had greater kudos than Native, which indicates something of Griffith's social status, or at least that he had influential friends. The question remains did Wight and Griffith ever meet? This all depends on where the 41st were in 1834 when Wight returned from leave. It has not been possible to discover this, and it is conceivable that their extremely important botanical friendship was entirely a literary one.

Back in Scotland, Arnott and Wight intended doing virtually all of the work for the first volume of the *Prodromus* on their own, with one exception: the largest family Leguminosae, which Graham had promised to write.[113] Yet again Graham would let Wight down and in July announced, to Wight's 'sad mortification', that he could not do the legumes, having been sitting on them for six months and 'as yet scarcely put pen to paper on the subject'.[114] Wight was just about to go to London bearing 'a sufficient quantity of print of our Prodromus to lay on the table of the Honorable personage called "John Company" as a peace offering to sense his compliance with my request for an extension of leave of 6 or 7 months'.[115] He was also taking with him sets of specimens to send to specialists who were to work on groups for the projected second volume of the *Prodromus*, such as Labiatae for Bentham, Orchids for Lindley, and Acanthaceae, Solanaceae and Lauraceae to be sent to Nees.[116] Wight stayed in London from July to mid-September 1833, working furiously on Leguminosae, but also on Vitaceae and Balsaminaceae. Despite the circumstances under which the legumes were written, 'the most hurried part of our whole volume',[117] Bentham adopted important parts of the treatment, such as the subgeneric divisions of *Crotalaria*, and praised the great learning of the work and the fact that, in contrast to most Floras, the characters of the genera had not been copied from other books.[118]

Graham, however, was not the only botanist to let Wight down. Greville had promised to name the non-flowering plants (with the exception of ferns, which Hooker was to do), but in fact a few seaweeds were all that Greville ever published of Wight's rich cryptogamic collections,[119] and Wight took a dim view of Greville's being 'so much taken up with slaves & temperance',[120] which had made him grow 'lukewarm to Botany'.

'So much for Edin[bu]r[gh] botanists' was Wight's frustrated cry,[121] referring to Graham and Greville, but we can be grateful to the latter for the revealing (if jaundiced) picture he painted for Wallich of Wight & Arnott's working habits, written at the very end of Wight's time in Britain:

> He [Wight] lives almost entirely at Blair working in a most exemplary manner at his Indian plants. He & Arnott are the deadliest fags at a pile of dried specimens I ever saw among all my botanical friends. As for Arnott I verily believe he prefers a dried plant to a living & looks with a sort of pity upon those inferior spirits who enter into the beauty of a living, breathing, glowing flower. A plant is to him what the <u>subject</u> is to an Anatomist; he can cut & carve & lecture upon it, & the associations are all with the dead specimen & dead subject – the living representatives are not half so amiable in their eyes. In fact Arnott is <u>abstract</u> in his botanical feelings & altogether the oddest <u>specimen</u> himself in real botany I ever met with.[122]

Greville did, however, have the grace to add that the *Prodromus*, of which he had seen a few sheets, would be 'a highly useful work', but in the light of his comments it is perhaps not surprising that Arnott should end up working on that most abstract of groups, the diatoms.

Wight's view of Greville must be tempered, as their relationship seems to have resembled the proverbial one between the pot and the kettle. This led to an interesting and unique light on Wight's susceptibility to feminine charm, expressed by Greville to Wallich at a time when Wight was in Edinburgh in July 1832. Greville wrote of Wight: 'I have not seen him for several days – His lady friends took him in tow – & farewell to botany'.[123] McNee's portrait shows that Wight was far from deficient in looks, but it would be another six years before he married. Wight seems to have been of a serious and studious bent, and stated that 'in Botany, as in everything else, there can be no medium between hot & cold, a truth taught us by the highest authority ever seen on earth'.[124]

THE LAST STRETCH · AUTUMN TO SPRING 1833–4

Little is known about the final period of Wight's furlough because of a shortage of letters to Hooker, partly because for some of this time Wight was apparently staying with him in Glasgow, and later because he was desperately trying to finish as much work as possible before the end of his leave. Wight returned to Scotland in autumn 1833, where he must have heard the good news of a six month extension of his leave granted on 9 October.[125] The plan had been to quit London and go to Glasgow via Liverpool at the end of August.[126] This appears to have happened, resulting in the longest of Wight's stays with Hooker, working on legumes and grasses, before returning to Arlary in the first week of November.[127] It is likely to have been at this point that Wight 'occupied himself with the practice of lithography', as reported by Cleghorn,[128] a subject that will be dealt with in Book 2. If the pattern of the previous two years was repeated, then Wight probably had a long stay at Blair over Christmas until March, though probably with forays to Arlary. A flavour of these last frantic weeks is glimpsed in the last letter Wight wrote to Hooker before returning to India, when on 25 February he was 'getting ready for a fresh start to the east. In military phrase I "strike my tent and march away" about this day fortnight, and most heartily do I wish the day was come, and myself on the road again, for I may truly say I have now no peace day or night'.[129] Arnott described Wight at this period as 'in terrible confusion',[130] and it fell to him to sort out the mess, including 'the whole burden of the <u>Prod[romus]</u>'.[131] Wight

stayed with Arnott for a few final days, then went to Edinburgh where he saw to business affairs. He appointed W.H. Campbell and his brother-in-law, the Rev John Stewart, to act for him while abroad,[132] and sailed from Newhaven to London on 22 March. During his final month in London Wight made preparations for his return to India, which must have included sorting his books and a set of named herbarium specimens to take back with him. During this period Wight met Robert Brown, whom he told Arnott he found 'a dry stick': be this as it may, it would later emerge that Brown had already performed a great service on Wight's behalf. Sir Frederick Adam, when about to go out as Governor of Madras in 1832, had asked Brown if he 'had any one to commend to his notice' botanically, and Brown had told him that the only one (Wight) was presently in England.[133] Adam would remember the advice in 1836, a demonstration of continuing Scottish patronage within the Madras Government, for Adam was brother of William Adam, Whig M P for Kinross, Arnott's near neighbour. Despite his politics Arnott rated 'Sir Fred.' a 'good fellow'.[134] On 30 April 1834 Wight was given permission to sail to India on the ship 'Royal William';[135] as a Surgeon his passage cost £110, and he returned to military duty in Madras on 31 July 1834.

ARNOTT'S TIDYING UP

After Wight's return, Arnott was left with the unenviable job of tidying up his unfinished business, to which he applied himself with characteristic vigour. The details of the resulting publications and Arnott's role in distributing Wight's specimens have been given elsewhere,[136] so only a summary is necessary here. The first result was the publication of the first volume of the *Prodromus*, describing 1365 species. The publisher, as already described, was the London firm of Parbury & Allan, but it was printed by Neill in Edinburgh, and Arnott sent Hooker his free copy on 14 August 1834,[137] and quoted

from it in a paper read to the British Association in Edinburgh that September. Arnott must have realised that with Wight's return the immediate pressure to produce the second volume had been removed, and in fact it was doomed never to appear. There seems to have been a general jinx on attempts to produce a Flora of India – the complete text of the flowering plant parts of Roxburgh's *Flora Indica* did not appear until 17 years after its author's death (1832);[138] Wight & Arnott's *Prodromus* did not reach a second volume; and neither did Hooker & Thomson's *Flora Indica* (1855). Only with Hooker's *Flora of British India* (1872–97) did this finally happen. Despite its incompleteness the *Prodromus* was a benchmark; Bentham's comments on the treatment of Leguminosae have already been quoted, and Joseph Hooker and Thomas Thomson characterised the work as:

> the most able and valuable contribution to Indian botany which has ever appeared, and as one which has few rivals in the whole domain of botanical literature, whether we consider the accuracy of the diagnoses, the careful limitation of the species, or the many improvements in the definition and limitation of genera and the higher groups of plants.[139]

Substantial works on three of the largest families that would have been included in the second volume (Compositae, Asclepiadaceae and Cyperaceae) had been completed, and Arnott published these as a small booklet *Contributions to the Botany of India* printed by Neill in September 1834. Arnott was again modest, and only Wight's name appears on the title page. The Compositae were written by Candolle and the Cyperaceae by Nees von Esenbeck. Sadly the latter's work on Gramineae was never published by Arnott, though he put a great deal of work into editing it. The Asclepiadaceae was jointly by Wight & Arnott, but although this family was one of Wight's great interests, in the confusion at Blair, he left the manuscript in a mess and Arnott had a substantial job of re-writing, to save, as he put it, his friend Wight's reputation.

VIEW FROM NORTH WEST CORNER OF BLYTHSWOOD SQUARE, GLASGOW
Allan & Ferguson, Lithographers, Engravers & Draughtsmen, Glasgow

Fig.19. The 'new town' of Glasgow. Steel engraving by Allan and Ferguson, after a drawing probably by Robert Carrick, from *Views in Glasgow* (1843). Bath Street, where Hooker lived during Wight's visit, lies to the right of the picture, and Woodside Crescent, where he moved in 1834 lies behind the detached house at the centre. Glasgow University Library, Department of Special Collections.

PART IV
SECOND INDIAN PERIOD
1834-53

Bellary, Palamcottah and Courtallum 1834–5

Wight will do great things, if his life be spared, when he gets back to India
GREVILLE TO WALLICH[1]
Dr Wight … will have brought back from Europe a renewed order in pursuit of this most captivating study
THE REV. BERNHARD SCHMID TO WALLICH[2]

Botanists in Britain, notably Arnott and Hooker, were anxious that the EIC might be 'induced to place Wight in such a station as he may collect plants without having to attend to medical service',[3] and, as has been seen, Robert Brown had already put in a word on his behalf with Sir Fred Adam, who by now was Governor of Madras. For the time being, however, Wight had to return to military duties and on 16 August 1834 he was appointed Surgeon to the 33rd Regiment of Madras Native Infantry – a travelling position. Having been promoted to Surgeon at least his salary had increased – to about £900 per year,[4] and although this 'necessarily implies more [medical] work … still I find time to do a good deal in the Botanical department & if I am left here for a year or two will certainly do much'.[5] This Wight certainly did and the following two years were a time of unparalleled activity on the part of his collectors, and the period when he embarked upon the series of solo scientific works, *published in India*, that would continue in an unbroken stream until he eventually left the country 19 years later.

Wight returned to India full of plans, having gained vastly from his experience in Britain, and especially from his collaboration with Arnott. His missionary zeal was announced in the very first of his publications in the newly established *Madras Journal of Literature and Science*. Ostensibly a review of Royle's *Illustrations of the Botany of the Himalayan Mountains* its purpose was that of 'agitating the subject of Botany on this side of India';[6] no less than an exhortation:

> to aid, to the utmost of our power, the diffusion of a science, so worthy of our attention, and in that way assist in removing, the not altogether unmerited reflection cast upon us, that with all India under our sway, we know little of its natural history beyond what enterprising foreigners have taught us.[7]

Beyond such articles, which had 'to combine the *utile* with the *dulce*',[8] Wight also intended to revive his plan of publishing 'outline drawings and dissections … to be lithographed in the same way as our [i.e., Wight & Arnott's] catalogue'.[9] The initial intention was that these illustrations would be of medicinal plants, but the scope grew and, after a gestation of four years, would emerge as the *Icones*. Wight confided to Arnott that one reason for writing such articles was 'the disgust I feel for the eternal frivolous conversation about hunting, shooting, dogs, horses, &c., to which I am exposed in the limited society of this place'.[10]

Wight's military duties took him firstly from Madras to Bellary, a town with a large military cantonment in the east of present day Karnataka, a 300 mile march to the north-west where he arrived in early October 1834. He collected specimens at Cuddapah on the way, and around Bellary (for example, at the 'Copper Mountains'[11]), amounting to 4–500 species in little more than three months, about which he wrote enthusiastically to Arnott.[12]

ON MUDAR AND NUTH GRASS

While at Bellary Wight wrote two papers for the *Madras Journal*: the first of these, being medico-botanical, reflected his current posting; the second, agri-botanical, was a foretaste of things to come. The former concerned the medicinal uses of plants of the family Asclepiadaceae and Wight urged its publication in an early number of the *Madras Journal* as an example of a projected 'Indian Medical Botany', the purpose being 'to give figures and descriptions of Indian medical, and otherwise useful plants grouped according to their natural affinities'. A further objective was to elicit contributions from others as:

> we still have much to learn; which is only to be obtained from the united efforts of many, as no man, however diligent, can accomplish everything, particularly at a time like the present, when even to keep pace with the stream of discovery, required application of no ordinary kind. It has been my wish in that part of my essay, to endeavour to direct that stream into new channels, by collecting what is known into one view, and requesting others to come forward with their discoveries and observations on *a subject so deeply interesting to us all, as the alleviation of human suffering*.[13]

A large asclepiad known as 'mudar' (*Calotropis procera*) had been shown in Bengal to have medicinal properties, but a similar looking plant tested in Madras had produced negative results. Wight concluded that two different species must be involved and provided characters to distinguish them. The plant that grew around Madras was the pharmaceutically inactive *C. gigantea*,[14] but Wight discovered the active *C. procera* to be the commoner in the 'Ceded Districts' around Bellary. He summarised the literature on the medicinal uses of mudar, for example against elephantiasis, which, while discovered by medical officers working in India, was mainly published in Britain. Wight also consulted 'native Doctors in this part of the country' on their use of the plant, commenting critically on the Indian love of 'polypharmacy', and the 'criminal employment' of *mudar* as an abortifacient. Also in this article is a rare example of Wight's own medical practice – an unsuccessful use of what turned out to be *C. gigantea* against elephantiasis. He next raised the question of the possible usefulness of other members of the family Asclepiadaceae, but here, as in many other cases, Wight merely flew a kite, leaving it 'in the hands of those who have better opportunities of following it out, to supply what I have left defective'. He pointed out that although 'plants of the same natural order are generally found to possess properties similar in kind', there could be exceptions. As a basis for further investigation Wight therefore listed the uses of other asclepiads reported in the works of Roxburgh and Whitelaw Ainslie, and drew attention to nomenclatural inconsistencies. Roxburgh had quoted an interesting tale told him by Patrick

Russell (like Roxburgh, one of Wight's predecessors as Madras Naturalist): James Anderson, Physician General at Madras, had found that native doctors were much more successful in treating dysentery with *Tylophora asthmatica* than he had been using Western medicines, but 'was not ashamed to take instruction from them' – a tradition that Wight seems to have followed, though not uncritically.

The second of the Bellary papers concerned the 'nuth grass' (*Ischaemum pilosum*), a pernicious arable weed that covered large tracts of agricultural land in the Ceded Districts.[15] He had been asked to investigate this question by J.G. Malcolmson, a Madras surgeon who later had a hand in Wight's transfer to economic botanical work. This would tend to suggest that a better use of Wight's talents was already in the air before he left Madras in 1834. In a revealing statement Wight had to check himself from expressing an aesthetic response to this evidently handsome grass, which he took to be a new species (though unknown to him it had been previously described by Willdenow):

> this plant is a most conspicuous object, growing to the height of nearly four feet, and remarkable for its peculiar, I had almost said showy spikes of flowers; clothed as they are with much pure white hair, contrasting strongly with the very black ground in which they grow, which is rendered still more striking, by the foliage of the plant being a pale whitish green colour, altogether different from the other plants with which it may happen to be associated.

The insistence on an objective approach was doubtless thought appropriate for a scientific paper, but alerts us to the fact that Wight was not indifferent to the picturesque, an aspect of his character largely unknown due to the bias of his surviving writings and publications. Remission of rent on land covered by this weed was allowed by the Madras Government, and Wight made enquiry of the Collector of Cuddapah on the financial and practical details of this allowance, and found, rather surprisingly, that the *ryots* had not been taking advantage of it, usually preferring to cultivate non-affected land. This caused Wight to consider the possibility that there might be a useful aspect to the plant balancing its obviously negative ones. This he found in the fact that the grass was a useful cattle fodder, which could possibly 'be the means of saving the cattle of the country during dry seasons, by producing a regular crop when other less deeply rooting grasses had failed'. Wight here brings in natural theology – the grass might represent a boon put there:

> by the hand of a bountiful Providence, willing and doing all things for our good: knowing much better than we do, our real wants, and often conferring blessing, when we in our short sighted wisdom and philosophy, are repining at them as curses.

In a conspicuous piece of lateral thinking, Wight made an analogy with the woodpeckers that had recently been almost annihilated from London's parks in the belief that they were destroying trees. Just before it was too late it was discovered that the birds were actually 'the most indefatigable enemies of the real destroyer; a caterpillar'.[16] Here is a good example of Wight's investigating a subject from several angles, and urging caution before taking what at first sight might appear to be the obvious solution: that of attempting to eradicate the grass. As usual, however, his remarks were 'not intended to prejudge the question, but are thrown out as hints, to induce those who may have the power to weight well ... the consequence of causing its total destruction'. It is also revealing in showing that Wight

was aware of potential conflicts of interest between the *ryots* and Government, and that on such matters the former might be the better judges:

> perhaps the natives are aware of this [the positive benefits of the nuth grass], and to not claim cowle so often as they might, lest they should be called upon effectually to destroy, what to them is a useful plant, but to the Government an expensive encumbrance.

PALAMCOTTAH AND COURTALLUM

It has been reported that Wight marched with the 33rd to Palamcottah, 700 miles to the south, in January 1835, but in fact he appears to have started the journey earlier and broken it at Mysore, as there are specimens of *Ceropegia mysorensis* collected there in December 1834. To some the thought of such a long march might have been offputting, but for Wight it provided an opportunity 'to add greatly to my collection ... I think I shall get a host of new things, as the greater part of it is through countries I have not traversed before'.[17] He was also looking forward to being reunited with his books and herbarium, his 'silent monitors', at Palamcottah, which had been left behind in Madras. At this stage it required 'more than six carts to carry my books and *kit*, when reduced to the smallest possible dimensions'![18]

Although the Palamcottah posting was 'considered an inferior appointment',[19] and accommodation under canvas, the great advantage was that it was close to some of the botanically most interesting mountains of the south, to which Wight had doubtless been keen to return since discovering their riches in 1826. By now his knowledge was vastly greater and he was better equipped with identification aids. According to Cleghorn Wight had with him tracings of Roxburgh's Coromandel plates 'in portable form',[20] and it was probably at this stage that he also had reduced copies made of the plates from Rheede's *Hortus Malabaricus* (some of which survive at Kew) and the *Herbarium Amboinense* of Rumphius, as he contemplated producing 'cheap and useful editions' of these pioneering works of tropical botany.[21] By March Wight had three collectors at work, one locally around Palamcottah, and two in the Courtallum and Malabar hills.

However, it was at this point that an exciting possibility arose, and in April 1835 he wrote to Hooker of his 'lively suspence [sic] owing to an anticipated appointment to proceed along with Wallich to investigate the natural history and capabilities of Upper Assam, owing to its having recently been found to produce the tea plant as a native'.[22] This, however, was not to be:

> The present Governor General (Lord W. Bentinck) has at length decided that the Company cannot afford to send a full surgeon to Assam along with Wallich (but only two Assistant surgeons who have been only a few weeks in the country) – so that Wight is not to accompany the expedition to Wallich's annoyance ... Penny-wise and pound foolish ought to be the motto of all such ridiculous economisers.– The Botany of the Peninsula will be all the better for it; that is one comfort.[23]

The two Assistant Surgeons eventually sent were William Griffith (who had actually been in the country for three years) and John McClelland, and – from the personalities involved – the consequences disastrous. It will be necessary to return to the resulting feuds, which echoed through Indian botany for the next decade.

In the end Wight was 'very well contented' to remain where he

was.[24] In May and June he made a trip southwards along the coast collecting seaweeds at Tuticoreen and Cape Comorin some of which were later described by Greville in Edinburgh, and others in Lund by the Swedish botanist Jacob Georg Agardh. At Palamcottah Wight was able to sort his herbarium and send vast quantities of new specimens to Arnott mainly from Courtallum.[25] Courtallum was a military sanitarium, and Wight went there to visit patients on two short trips, each of eight to ten days in July and August, publishing extensively on its climate and spectacularly rich flora.[26] Wight was tantalised by the brevity of these trips, being 'lost and perplexed by the endless variety of forms at once presented to the eye',[27] – a sensation familiar to anyone working on a tropical flora. Braving a wild elephant and the lair of a wild hog, he explored the area, especially a mountain of 4350 feet that he christened 'Botany Peak' – its orchids and balsams, aroids, ferns and gingers, and its particular richness in nettles and euphorbs. Wight estimated the flora of this 'mere speck of ground' of about 20 square miles at about 2000 species, or a quarter more than that of the whole of the British Isles. The resulting papers in the *Madras Journal* set a pattern used later in the *Illustrations* and *Spicilegium*: plants arranged by family according to Candolle's Natural System, descriptions of distinguishing characters and distribution (world-wide) of the families, with notes on uses and properties of species. These papers demonstrate a remarkable knowledge of the contemporary literature, and are imbued with Humboldtian ideas on vegeto-statistics, such as how the representation of different families varied in regional floras, a subject Wight might, perhaps, have discussed with H.C. Watson while on their walks in Glen Clova. As a result of the Courtallum experience Wight estimated the total number of species of flowering plants in India as 14,000,[28] which is certainly nearer the mark than Humboldt's of 4500.[29]

The climate of Courtallum, in which Wight took a great interest, differs markedly from that of the Coromandel Coast (e.g., that of Palamcottah) only a short distance to the east. He wrote a paper on this subject (in response to criticisms of remarks in one of the Courtallum papers by J.G. Malcolmson): 'On the cause of the land winds of Coromandel'.[30] Due to local topography Courtallum receives two monsoons, the south-west in summer, and north-east in winter.[31] The summer monsoon penetrates through a gap in the hills from the Malabar Coast, and the result between June and August is that:

> all is green and lively ... the scenery is rich and varied, and enlivened by a series of beautiful cascades, the fall of the lowest of which, though 200 feet in height, is so broken it the descent as to be a favorite bathing place, where the visitors enjoy a shower-bath on the most magnificent scale. The surrounding scenery is, I think, the richest I have seen anywhere in India ... [the] shelves and slopes are densely clothed with a vegetation highly varied, and of truly tropical luxuriance, the whole presenting to the view a mixture of delicate verdure, dark forests, and black, almost perpendicular, naked cliffs, forming together, a rare combination of beauty and grandeur.[32]

This was written in a letter to the artistically minded R.K. Greville (with whom he had evidently not completely fallen out), and so Wight did not on this occasion repress the urge to a full-blown romanticism that he had felt it necessary to constrain in his paper on the nuth grass. The tropical luxuriance was contrasted with the treeless hills of Clova. The spectacular natural phenomenon of the Courtallum Falls was already well known, having been painted by Thomas and William Daniell in 1791 (and reproduced in 1807 in their *Oriental Scenery*).

Given that it was the Palamcottah posting that allowed Wight access to the plants and landscape of which he was so appreciative, it comes as a surprise to find that he did not like the uncertainty of a job in which the next post might 'bring me an order to hold myself in readiness for a march'. In fact he told Arnott that he longed for a garrison appointment in which he could supply himself 'with those comforts and conveniences which are so essential to a domestic character like me, who never wishes to go from home'.[33] At this point we learn of a 'factotum, *alias* butler' called Veragoo, who no doubt assisted with Wight's domestic comforts.[34] This reveals another side to Wight, who was clearly not always a '*peregrinator indefessi*', and perhaps shows why he preferred to use collectors, despite his low expectation of 'their exertions, as natives are always timid explorers of the jungle, unless led by an European, when they will cheerfully follow'.[35] All was about to change and in November 1835 the Madras Government asked Wight to start working on what would today be called 'economic botany'.[36] As a lead into this Wight's horticultural work, which began seriously around this time, will be discussed.

Fig. 20. Seal of the Agri-Horticultural
Society of Madras

The Horticulturist

Wight must always have had some interest in horticulture as he had taken seeds home in 1831 of what he doubtless thought would be ornamental additions for the British greenhouse. These included what is now called *Hydrocera triflora*, an aquatic balsam, which, had it germinated, Arnott considered would have been 'a great ornament to our stoves'.[1] Later, however, Wight would complain of the trouble of collecting seeds and described them as 'the pests of my life', being aware that he had 'broken so many promises on that point'.[2] In May 1849 he would employ two collectors for a two month period – the result of which was 'a quantity of jungle seed' for Kew, sent to Hooker along with artefacts for his Museum.[3]

THE AGRI-HORTICULTURAL SOCIETY OF MADRAS

In July 1835, while Wight was at Palamcottah, an Agri-Horticultural Society was started in Madras, which he joined on 1 October.[4] This elicited a horticultural article for the *Madras Journal*, in which he expressed gratitude that:

> Madras, the proverbially benighted presidency, in the short space of two years, [should have produced] two such vast improvements, as the successful establishment of a scientific journal, and the formation of a Horticultural Society; the one fitted, *inter alia*, to diffuse a knowledge of the useful discoveries made by the other.[5]

He congratulated the 'society of this presidency' in using horticulture ('a science both useful and ornamental') as a start for such reforms that would 'augment ... individual comforts, by extending the commercial resources of the country, and thereby augmenting national prosperity'. Horticulture, moreover, had the benefit of transcending political differences between individuals, and could provide a model for shaking off 'lethargic indifference to local improvement'. The paper itself is of interest, not least in advocating an experimental approach to the investigation of questions such as the introduction of new plants (especially fruit trees) – that is, rather than doing nothing beyond blaming the uncongenial, and inalterable, climate. Wight believed that soil was at least as important as climate in such matters, and that the establishment of a garden would allow experiments to be made. He suggested that a way of overcoming the reluctance of certain trees to produce fruit might be found by grafting a scion of the desired plant onto the stock of a well established native species of the same genus or family (for example mangosteen, *Garcinia mangostana* onto the 'Pinny marum' – *Calophyllum inophyllum*, both being members of the family Guttiferae), and urged the undertaking of such experiments. With such 'suggestions for the practical application of botanical science to our daily wants' he anticipated 'in the course of a few years [to be able to] enjoy the luxury of drinking cocoa for breakfast ... of having our deserts enriched with mangosteens, fine oranges, and figs, and perhaps olives', all home grown, 'as the principle which I advocate

becomes better known and the practice founded on it generally adopted'. Wight was thus a true believer in the possibility enshrined in the utopian motto of the new society: 'every land will bear everything' [fig.20].[6]

Wight identified the publication of a scientific journal *in India* as a matter of great importance, and during the rest of his time in the country would contribute extensively to four such works. As already noted, he published in the very first volume of the *Madras Journal*, under its founding editor, J.C. Morris FRS, and regularly thereafter. Wight was evidently pleased when Robert C. Cole took over the editorship of this journal in 1836, and told Arnott that he had a hand in this change and therefore felt obliged to publish in it. He boasted that by encouraging Griffith to contribute, and the fact that it included extracts of relevant articles from the Bombay and Calcutta periodicals, it would contain 'a nearly perfect record of the progress of Indian Botany'.[7] Wight later expressed the hope to Hooker that 'the matter and manner also of that work [the *Madras Journal*] pleases you and proves to your satisfaction that we are not quite in the dark'.[8] By this time (1837) sales, from an initial 250, had reached 400 and Cole had asked Wight 'to take charge of the Botanical department', to which he agreed, noting that 'editing a work of the kind in India where compositors are "striking bud" is a most laborious task & he [Cole] well deserves assistance'. In 1840 there was an interruption in publication of the *Madras Journal* (perhaps due to the state of Cole's health – he died in 1842, aged 52) and thereafter Wight published his taxonomic articles in McClelland's *Calcutta Journal of Natural History*, of which, after Griffith's death in 1845, he had taken over the botanical editing with his friend George Gardner (see p.155). Wight's horticultural papers were published in the Agri-Horticultural journals in Madras and Calcutta. The large circulation of such journals in India has been noted, but copies were also sent to Britain where they were read with more than cursory interest. Important articles, however, gained a wider circulation by being abstracted for periodicals such as those edited by Hooker, and the *Annals of Natural History*. This was of particular importance in establishing priority of names of new species, which might otherwise have been overlooked in Europe. One of the most fruitful uses made of such seemingly obscure works was by Charles Darwin, who combed them for facts and evidence that he wove into his magisterial works. One such Wightian example will be cited later. The topic of scientific publishing in India will also be returned to in connection with the Griffithian affair.

Since nothing has been written about the Agri-Horticultural Society of Madras, of which Wight was a prominent member, and at various points an office-bearer, it seems worth providing some details here. Although the Society still exists, it is in a state of apparently terminal decline and none of its archives appear to have survived. All that exists in the way of contemporary documentation

is Wight's own incomplete copy of the edition of the Society's *Proceedings* that he brought out in 1842,[9] and a summary made by Shaw of the proceedings of the Society from 1835 to 1870,[10] doubtless based on material then available in the Society and since destroyed. Further information is given in the contemporary Madras Almanacs. Madras was, in fact, the last of the Presidencies to have an Agri-Horticultural Society – the national Society, founded by the Rev William Carey in 1820 was based in Calcutta, and that of Western India was founded in 1830 in Bombay.

The following brief history of the Madras Society has been abstracted from Shaw's work. The first meeting was held in the hall of the College of Fort St George[11] on 15 July 1835, when it was named the 'Madras Horticultural Society'. The name was changed later in the year to the 'Agricultural and Horticultural Society [of Madras]', before finally (certainly by 1853) ending up as the 'Agri-Horticultural Society of Madras'. The first secretary was a Mr Baynes, and like the Calcutta and Bombay societies, the Patron was no less a figure than the Governor – in this case Arnott's one time neighbour, Sir Fred Adam. An interesting feature, in common with the other societies, was that from the start it was 'open to gentlemen of all nations', and Indian landowners feature prominently in the early *Proceedings*. The entrance fee was Rs 10, the quarterly subscription (payable in advance) Rs 7, and subscription and donation books were placed in the Madras Club, Mr Pharoah's Library and the College Hall. On 31 May 1836 the Madras Government granted land to the Society as an experimental garden, near St George's Cathedral, at an annual rent of Rs 5, and as early as 1837 the committee was authorised to raise funds to purchase a further piece of ground on the south side of the Society's garden.

The Society was always small (92 members in 1840), and in 1837 was given an annual grant, for three years of Rs 1000 for its garden, and to award as 'premiums' (i.e., prizes) to encourage enterprise in relevant fields. In 1839, and unlike its sister societies, which then received Rs 100 per month from their respective Governments, the Madras one was still receiving no regular Government funding, but in 1844 it succeeded in obtaining a monthly grant of Rs 150 (and a one-off payment of Rs 500 to buy 7½ tons of African guano!). This financial boost was largely as a result of interest taken by George Hay, 8th Marquess of Tweeddale, who became Governor in 1842, and was well known for his agricultural interests in his native East Lothian. In 1842, at Wight's instigation the Society published, or more accurately reprinted 'records previously accumulated', its first volume of *Proceedings*,[12] a project first mooted in 1839. After this volume it appears that no more *Proceedings* were published until 1862, when printing in 'pamphlet form' was resumed, with a regular series from 1870. By 1846 the Society was running the flower shows that were a feature of Madras social life until well after Independence.

The first known Superintendent was a Mr J. Stent, who produced a catalogue of the 607 species then growing in the garden. No copy of this has been seen, and although Gleeson believed it to have been printed in 1848,[13] it was probably the one received by the Calcutta Society on 13 May 1846.[14] Under the combined care of Stent and Colonel Francis Reid, the Garden became a 'well-stocked Botanic garden'.[15] Stent was succeeded by Andrew T. Jaffrey, who was recruited from the Caledonian Horticultural Gardens in Edinburgh and took charge in April 1853.[16] A second garden catalogue, entitled *Hortus Madraspatensis*, was issued by H.F.C. Cleghorn in 1853 by which time the number of species cultivated had increased

to 996. This catalogue was something of a phoenix, as the initial manuscript had been destroyed, along with almost all of Cleghorn's property, in a fire at Messrs. Oakes, Partridge and Co in July 1852.[17]

The Society's Administration

A list of the Office bearers for the year 1841 serves to demonstrate the Society's semi-official status, and a list of the Secretaries during Wight's period shows the rapid turn over of military personnel, reflecting the 'frequent change of place' of which Wight complained.

OFFICE BEARERS IN 1841.[18]

PATRON. The Right Honorable Lord Elphinstone

VICE PATRONS. His Highness the Nabob [i.e., Nawab], Sir R.B. Comyn, Kt.

PRESIDENT. The Hon. Sir E.J. Gambier, Kt.

VICE PRESIDENTS. His Excellency Lt. Gl. Sir Samuel Ford Whittingham, K.C.B. and K.C.H. Commander in Chief, Maj. Gl. Sir R. Dick, K.C.B. & K.C.H., The Hon. J. Bird Esq., The Ven. Archdeacon H. Harper.

MEMBERS OF THE GENERAL COMMITTEE. Lieut. Colonel A. Tulloch, C.B., J. Wylie, Esq., M.D., Reverend F. Spring M.A., Major J.J. Underwood, J. Arathoon Esq., A.F. Arbuthnot Esq, Major Moberly, Colenda Moodelly, Walter Elliot Esq., Captain G. Mackenzie, J. Shaw Esq., J.C. Morris, Esq., R. Wight, Esq. M.D. Secretary.

SECRETARIES OF THE SOCIETY IN WIGHT'S TIME.[19]

Mr Baynes	15 vii 1835
Mr Onslow (temporary Secretary)	12 viii 1835
Lt. Thomson	25 × 1835
Mr Liddell	10 v 1836
Mr W.E. Underwood	6 vi 1838
Captain T. Lavie (temporary Officiating Secretary)	11 i 1839
Dr R. Wight	1 ii 1839
J. O[u]chterlony & Captain G.E. Underwood (acting during Wight's absence)	6 v 1840
Dr R. Wight	back by 7 × 1840
Captain G.G. Mackenzie (while Wight absent)	19 v 1841
Dr Wight & Captain Mackenzie made Secretaries [no doubt Mackenzie did the work in Madras]	15 xii 1841
Captain (during tenure became Major) F.A. Reid	6 ii 1843
Captain F.H. Sansom	15 xi 1844
Mr G.M. Swinton	3 ii 1845
Captain F.S. Gabb	22 iv 1845
Captain Hayne	25 iii 1846
Captain Worster	acting, prior to 11 v 1848
Major Reid	11 v 1848
Captain Worster	acting for six months v 1850
Dr H.F.C. Cleghorn	acting for six months iv 1852
Dr Cleghorn & Colonel Reid (joint Secretaries)	25 i 1853

WIGHT'S HORTICULTURAL INTERESTS

Rather than treat them chronologically, Wight's other primarily horticultural interests will be dealt with at this point. As already mentioned he had at least some interest in introducing plants to British hothouses, and doubtless continued occasionally to send seeds,

along with herbarium specimens, back to Hooker and Arnott. None of these introductions is likely to have persisted in cultivation, and Wight's name in British horticulture is known only through *Rhododendron wightii*. This species was first collected in Sikkim by J.D. Hooker, and has had an important role in hybridization and the production of cultivars. Tropical gardens and British conservatories owe another debt to Wight, in the form of the magnificent liane with pendent racemes of golden flowers – *Thunbergia mysorensis*, which he described (in the genus *Hexacentris*) in 1844–5. Wight's major horticultural interests, however, were in India, and largely concerned the introduction and acclimatisation of temperate plants.

Interesting information on plants already grown in Indian gardens, and potentially valuable additions, is to be found scattered through the notes in Wight's *Spicilegium* and in the 'properties and uses' section of the *Illustrations*. These include many suggestions of native species that might be suitable for taking into cultivation. One example that Wight recommended to the attention of W.G. McIvor, superintendent of the Ooty Horticultural Garden, but which would require particular efforts, were the showy parasitic orobanchs such as *Christisonia* 'the colour of their flowers being to the full as deep and bright as those of the deservedly much-prized *Torenia asiatica*'.[20] To grow these a suitable host plant would first have to be raised, but, as Wight pointed out, what had initially seemed to be similarly insuperable difficulties had been overcome in the case of orchid cultivation.[21] A particular favourite of Wight's was 'the magnificent Dahlia', which 'takes unquestioned precedence of all others [Compositae]; the finer varieties of which can scarcely be excelled, when well cultivated, for richness of colouring and ornamental effect in the well disposed parterre'.[22] Some native plants would require improvement to make them garden-worthy, for example *Anemone wightiana*, if its flowers could be made double. Wight had what would now be considered bizarre ideas on how it was possible to change the phenotype of a plant: in this case he thought it might be possible to make the flowers double by digging up a plant and transferring it to rich garden soil, preventing it from flowering for a season or two by 'stopping' (presumably pinching out its inflorescence buds, in order to 'strengthen' its roots), digging it up again and keeping it in a dark place for a few weeks, and finally replanting it. After a few seasons Wight believed this treatment would probably 'effect the desired change'![23] Wight recorded two recent exotic introductions of ornamentals. The Rangoon creeper (*Quisqualis indica*), 'now so deservedly a favourite in Madras gardens' on account of 'the profusion and magnificence of its flowers'.[24] The myrtle (*Myrtus communis*), that favourite of Victorian wedding posies, was 'now to be met with in almost every garden in Madras, a fact worthy of attention, as going far to prove that arboreous plants of the south of Europe may become acclimated in even the South of India'.[25] Which brings us to acclimatisation.

THE HOMÖOTHERMAL PAPERS

Two of the strangest, and certainly the most oddly titled, of Wight's scientific papers concern acclimatisation,[26] a topic of great interest to homesick Britons pining for lettuce and strawberries.[27] It was also a matter of substantial economic importance in the British Empire, and on which there is a large contemporary literature. This makes for difficult reading today because it involves putting oneself into a pre-Darwinian mindset, and one that knew very little either of plant physiology or genetics. One has constantly to check oneself from being patronising of ideas that now seem strange, and Wight's papers on his 'homöothermal method of acclimating extra-tropical plants within the tropics' have to be read with these caveats in mind. At times one is tempted to think that the thin atmosphere of the Palni Hills, where he first thought the theory up, must have affected his powers of reasoning. In struggling to understand Wight's meaning and arguments, his comments (in his doctoral thesis) on the difficulties he had with the works of Erasmus Darwin (p.26) are brought vividly to mind.

The theory was inspired by reading accounts of two acclimatisation trials in the *Transactions of the Agricultural and Horticultural Society of India*. The first by William Anderson, of growing Jumla rice (a temperate variety, from high altitudes in Nepal)[28] at the Chelsea Physic Garden. The second of cultivating celery (another temperate crop) in Calcutta, by G.T.F. Speede. To the seeds of both species heat had been applied, the first by germinating and growing in a hot house; the second (rather surprisingly given that this was in Bengal) by sowing the seed in a hot bed. The first experiment failed when Anderson transferred the healthy plants to a 'bason' of water where they died in the autumn, which Wight and Anderson both attributed to the plant's inability to withstand low temperature. The celery, by contrast, germinated and grew well, when all previous attempts, with germination in cool shade, had failed. In order to explain these, which Wight took to be contrary, results, he applied a philosophical (or perhaps religious) belief that there were universal vital principles common to both plants and animals, in particular the property of 'excitability', a concept originating in the theories of the eighteenth century Edinburgh medic Dr John Brown and his controversial Brunonian system of medicine. Wight explained 'excitability' as a property 'equivalent to privation of stimuli', with an opposite property 'excitement', equivalent to an excess of stimuli (or, in other words, excitement was the process by which excitability is reduced). The result is that when the state of excitability is high, then a slight stimulus will cause a violent reaction, and when low, a strong stimulus will produce a small reaction. The examples Wight cited were (using modern parlance): a hungry man, a case of hypothermia, and a drug addict.[29] The hungry man has increased excitability, and so will respond to a slight amount of food with violent excitement; the frozen man will die if brought into even moderate heat; the drug addict cannot bear privation. Moreover the same amount of a drug will have a far greater effect on a temperate man than on an addict. From this we can immediately see a problem invisible to Wight – that of mixing up physiological and psychological conditions in animals, and fundamental differences between plants and animals, most notably the lack of a nervous system in the former. Unaware of such problems he tried to explain the results of the plant trials by applying the same principle. The temperate rice variety was germinated under heat, which exhausted its excitability and so it was unable to withstand the cool autumn. (Had it been sown in autumn, then, through lack of heat in the winter, its excitability would have been kept high, and it could have responded with growth in the warmth of spring). The celery was also germinated in heat, which exhausted its excitability, and modified its constitution so that it could not only withstand high temperature, but made its continuance necessary for survival. (Had it been germinated in a cool atmosphere, the traditional method in Calcutta, its excitability would have been maintained and so would not have grown in a hot climate).

With the benefit of hindsight it is easy to pick holes in the logic and the facts, and some of these were apparent even to Wight's contemporaries. When this paper reached the Agricultural and Horticultural Society in Calcutta, its Secretary, John Bell, pointed out that the reason the Jumla rice died in the autumn is that it is a *dryland* variety, and death was therefore due to inundation rather than low temperature.[30] However, Wight was not claiming that his hypothesis (that seeds germinated at high temperature 'will produce a plant endowed with properties suitable for its growth in a hot country' as an undisputed truth, but was once again flying a kite and asking for experimental testing of it.[31] On the question of whether or not such a transition would be maintained in future generations he admitted there was no evidence, but he could see no reason for the character not appearing 'in the second, if not in the first generation', hinting strongly at Lamarckism, but also at something uncommonly like Mendelian segregation. If this were to be proved, however, it would be perhaps the 'most important and valuable discovery ever made in the science of agriculture, in connection with vegetable physiology' and he looked forward to a rosy future when not only 'the plains of India, but of the whole torrid zone, [were] covered with the highly nutritious grains and roots of Europe, in place of the very inferior ones now in use'. This could also be extended to the 'products of the farm and kitchen garden … [and] of the forest and orchard'.

The second of Wight's homöothermal articles was based on two further papers that he thought had a bearing on his theory. The first of these was by his friend Nathaniel Bagshaw Ward on what became known as the Wardian Case,[32] and to whom Wight promptly wrote enclosing a copy of the first paper suggesting the sending of 'Tropicalized' plants such as oaks, elms, ash, apples, pears, plums &c' germinated in a British hothouse to H.J. Chamier, Secretary to the Madras Government.[33] The second paper to which Wight referred was published in a French periodical, and concerned the growth of European cereals under high temperature (both in France, and in the Tropics).[34] These references are interesting in showing not only that, even in India, Wight kept up with the contemporary scientific literature, but also his ability to read French. The second paper concerned experiments sowing winter and spring wheat varieties at different times of year and their comparative survival, and also included long quotations from Humboldt on observations of the very different altitudes at which European cereals were grown in Mexico, the Caribbean and South America. The question of cereals vegetating then flowering after a delay was also raised, but nothing was then known of factors such as daylength on the induction of flowering. These matters can now all be explained in terms of separating phenotypic and genotypic effects, and the existence of genotypically distinct physiological races. Indeed Wight more or less concluded as much: that 'culture can produce varieties suited to different climates'. This, however, did not stop him from torturing himself trying to apply vital principles, and attempting to determine if these observations could help to prove his homöothermal theory.

It is perhaps not surprising that Wight's theory was ignored by physiologists; but Darwin, who commented on the same French paper, shed the required light, at least on the inheritance part, but not until 1868:

> the attempt to acclimatise either animals or plants has been called a vain chimaera. No doubt the attempt in most cases deserves to be thus called, if made independently of the production of new varieties

endowed with a different constitution. Habit, however much prolonged, rarely produces any effect on a plant propagated by buds; it apparently acts only through successive seminal generations.[35]

According to Professor Kurt Fagerstedt, plants can, in fact, make short term phenotypic (perhaps in Wight's parlance 'excitable'?) responses to short bursts of heat with the production of heat stress proteins. However, these do not act throughout the life cycle, least of all at the sensitive sexual phases, and are more likely to have evolved to allow survival through sudden heat waves. If Wight's method worked at all, it can only have been because the only seeds that germinated in the hotbeds were those already genetically adapted to grow at high temperature, in which case there was the possibility of this being passed to the next generation. In the end it seems that Wight agreed with Darwin on the chimerical nature of acclimatisation, concluding later that 'there seems little chance of successfully cultivating any of the extra-tropical species within the tropics, except during the coolest season of the year',[36] but presumably also at high altitudes in places such as the Nilgiris (see below).

Mention has been made of the use made by Darwin of Indian periodicals. An example relating to breeding systems and physiology spotted by his eagle eye is a comment by Wight, buried in one of the Courtallum papers, to the effect that plants repeatedly propagated by cuttings or other vegetative methods loose the ability to produce seeds.[37] Sharp as always Darwin was unwilling to express an opinion, on grounds of insufficient evidence, as to 'whether the long continuance of this form of propagation is the actual cause of their sterility'.[38] The examples Wight gave were plantains (i.e., *Musa* spp.), 'Portia' (i.e., *Thespesia populnea*[39]) and '*Plumeria alba*' (either *P. rubra* or *P. obtusifolia*). Darwin was right to be cautious, and here is another case of Wight making an incorrect inference from an observation through lack of knowledge, in this case of breeding systems. In the case of plantains parthenocarpic varieties have deliberately been selected, because the seeds render the fruit more or less inedible, and so the plants can only be propagated vegetatively.

HORTICULTURE AND TRANSLOCATIONS

Wight complained of there being 'so few tolerable [dessert] fruits in India'.[40] By this he can only have meant European ones and it seems that he and his fellow 'exiles' were unable to accept the rich tropical productions as adequate substitutes. The result was a eulogy on what is really a very humble, but then recent, introduction – the Brazil gooseberry (*Physalis peruviana*) – in a contribution to a moderately substantial, but previously overlooked, horticultural publication. This contribution takes the form of a series of notes he added to a *Treatise on the Culture of Several Plants* by W. Ingledew, published as a pamphlet by the Madras Agri-Horticultural Society in 1837.[41] The original treatise dealt with the cultivation of plants such as roses, strawberries, peaches, mangoes and grapes, and the notes consist of original comments and information abstracted from contemporary publications including those of the British horticultural encyclopaedist John Claudius Loudon. Perhaps the most interesting part, however, is a diversion that demonstrates Wight's deeply held belief in a Divinely ordered scheme of life. The occasion is a note on the lizard *Calotes versicolor* (known from its colouring as the 'bloodsucker') that Ingledew had taken to be injurious to the Brazil gooseberry. Wight corrected this misapprehension and pointed out that:

There must surely be some mistake or oversight in attributing to bloodsuckers (lacertae) such propensities, being wholly at variance with the insectivorous habits and economy of these animals. That rats should relish so delicious a fruit is not much to be wondered at, the more so, as the procumbent disposition of the plant affords them such excellent cover under which to carry on their depredations; but that bloodsuckers should join them is quite incredible. These lizards not only prey entirely upon insects, but unless the insect, the instant before being taken, shows signs of life it will not be touched. So far from treating them as enemies, we ought to hail their visits, as those of our best friends, since their whole lives, however unconsciously to themselves, are devoted to our service in the persevering destruction, the most numerous and subtile, of the host of enemies the horticulturist has to encounter. The facts here stated show in a striking point of view the advantages to be derived from the study of natural history, as well as the serious injury an ignorant and unobservant cultivator may inflict on himself by mistaking, among the lower grades of animals, friends for foes. But they *show still more strikingly, with what providential care an all-wise and beneficent Creator has provided for our wants by the establishment of a system of checks, of the most simple but effective kind, against the undue increase and consequent supremacy of any tribe of the myriads of created beings, with which he has stored* [sic] *the earth,* the most minute and, individually, insignificant of which, from their numbers and rapid propagation become, when opposed to man, his most unconquerable enemies and the most appalling destroyers of those hopes which, but a few hours before their attack, gladdened his heart and enlivened his future prospects. Well indeed may such atomic beings be called the "armies of the Lord" for surely if any thing will, the irresistible power of these almost invisible creatures ought to impress us with a due sense of our own insignificance in the sight of the Almighty Architect of the universe.[42]

As Wight's religious beliefs underlie his approach to taxonomy and evolution, it seems appropriate to quote here his only other, rather poetic, hymn to the Creator and man's place in Creation, prompted by an examination of the humble fumitory flower:

By the contemplation of such beautiful, though almost imperceptibly minute, arrangements of the Divine Artist, we are more surely led to form a just estimate of His infinite power, wisdom, and foresight, than even by the contemplation of the boundless vault of heaven, illuminated with the light reflected from its thousands of stars; because in the one case, the immeasurable distance and magnitude of the objects viewed, are too great for the limited powers of the human mind properly to comprehend them, and is but too apt to lead man into the error of under-estimating his own importance in the eye of his Creator. The apparent insignificance of the other is calculated to produce the very opposite effect, while it is equally suited to display the Creator's unerring wisdom and power, by teaching him, that the same power, that filled the universe with thousands of worlds, and made and endowed him with a reflecting mind, equally made the humble fumatory [sic, *Fumaria* sp.], and so nicely adjusted the arrangement of its minute organs, as to prevent the loss of even a grain of pollen, thus certainly ensuring its due fecundation, and with that, the equally certain preservation of the species. If then, so much care is bestowed on the formation and preservation of the most minute objects of creation, how much more, have we not a right to infer, is appropriated to the preservation of the Being [sic], formed in his own likeness, gifted with reason, and endowed with an immortal soul?[43]

Nothing more is known about the particular shade of Wight's Christian belief than can be inferred from these quotations, but he evidently discussed such matters in letters to William Griffith.[44] Griffith was a self-confessed High Churchman and was also an admirer of the zoologist William Swainson. David Knight[45] has written on the influence of High Church theology on Swainson's promotion of cyclical systems of classification,[45] which Griffith supported, and that Wight also attempted to apply (see p.98). Despite his high churchmanship Griffith thought it profane even to speculate on matters such as transubstantiation and the immaculate conception, discussions of which were then splitting the Anglican church, and clearly shared Wight's belief in natural theology: 'give me Nature, where a study does not lead to irreconcilable differences, but the unity of opinion'.[46]

In the Agri-Horticultural Society's *Proceedings* Wight frequently wrote notes or letters commenting on horticultural specimens despatched or received, such as fruit bushes, hill oranges,[47] nut trees and hop roots, and on vegetables such as the 'Pois noire',[48] and the mangel wurzel, and in 1841 he was delighted to have discovered in the Nilgiris a native contribution to the dessert menu in the form of a species of *Vaccinium*. In 1843 Wight wrote a letter on the treatment of stiff and bad soils that, perhaps, takes us back to his East Lothian roots. To improve such soils he recommended planting sweet potatoes in April, letting them grow until September or October, then lifting the roots and ploughing in the tops. Alternatively he suggested a green manure, sowing plots 'pretty thick with tholum [sic, probably misprint for cholum = *Sorghum bicolor*] or cumboo [= *Pennisetum glaucum*]' and when 'half ripe, too young for the seed to grow, quietly bury the whole alive at least ten inches or a foot under ground'.[49] As will be seen later Wight, somewhat perversely, never attempted the use of such methods for his contemporaneous cotton experiments.

While at the Agri-Horticultural Society, Wight also played a role, if mainly a distributive one, in the introduction of tea into South India. His role in forwarding tea plants from Wallich in Calcutta to J.A. Stewart-McKenzie in Ceylon will be discussed later. Before this (probably in July 1838), as a result of detailed climatic data received from Trivandrum, Wight had considered that the Malabar Coast was a suitable place for tea trials and William Huxham a suitably enterprising person to undertake them and accordingly recommended that cultivated tea plants from China (rather than wild Assamese ones) be sent to Huxham.[50] However, it was Assamese plants of which Wallich sent Wight 18 boxes in November 1839, and Wight seems to have forwarded six of these to Huxham the following January. Wight also sent tea seed (of unrecorded provenance), packed in two boxes with dry earth, which were so precious that Huxham actually counted the 1635 seeds.[51]

In Calcutta fragments of Wallich's correspondence with Wight have survived, which give just a taste of some of the other economic and potentially ornamental plants they exchanged in 1839–40.[52] Transport was a problem, resulting in a paper Wight wrote on 'a better transmission of plants from one part of India to another'.[53] The problem was especially acute in the case of short lived seeds, and required the services of sympathetic sea captains such as Captains Hodson and McKellar who would take care of young plants during the 15 day voyage from Calcutta to Madras. The material Wallich sent to Madras consisted of tree seeds and ornamentals – the trees clearly for their potential use as timber. These included 'acorns' sent

in February 1840, some of which Wight sowed in the Agri-Horticultural Society's garden, the rest were sent to the Nilgiris, the Bangalore garden and Salem. Some of the trees had military uses, such as the making of gun carriages, explaining the sissoo (*Dalbergia sissoo*) seedlings sent in November 1839, and sal (*Shorea robusta*) seeds collected at Gurruckpore, Bengal by Captain Goldney. Wallich gave detailed instructions on how to treat the difficult sal seeds: soak them for 24 hours, 'take out the kernels of a portion – and sow them all rather superficially'. Wallich noted that 'of all obstreperous [what are now termed 'recalcitrant'] seeds the Dipterocarpeae are the shortest lived; one might be tempted to say that they endure only so long as their quasi-wings will serve to waft them'. The seeds of 'Clematis Cadmia Hamilt.', also from Gurruckpore, were doubtless sent for trial as an ornamental. In return Wight sent Wallich seeds of *Schrebera* [presumably *Cassine albens*] and *Decaschista* [presumably *D. crotonifolia*], and, in February 1840, plants of *Dichrostachys cinerea* and *Guettarda speciosa*, with seed of *Vachellia farnesiana*, and the fruit of a cucurbit 'said to be a new vegetable between vegetable marrow and cucumber or aligator [avocado] pear or some other fellow which I have forgot but, be that as it may, it is truly a curiosity here … In growing give them the benefit of a Purdah [screen] to spread on, to keep them off the ground – and the shady side of a tree will no doubt be advantageous during the hot season'.

Griffith, while he had charge of the Calcutta garden in 1843, continued Wallich's practice of sending seeds to Wight. These included plants collected at the Cape of Good Hope by Baron Ludwig, which Griffith recommended for growing in the Nilgiris.[54] Griffith also put Wight's name down for seed of sissoo (*Dalbergia sissoo*) 'certainly a handsome and valuable timber', and a 'set of tree and shrub seeds' including the famous *Poinciana* [now *Delonix*] *regia*,[55] the flamboyant or gulmohur, originally from Madagascar but introduced via Mauritius, which had been setting fruit at Calcutta since 1840. In return, in 1844, Wight sent Griffith a collection of orchids (that arrived in Calcutta 'barely in resuscitable order'), ceropegias, and a ginger,[56] and it must have been Wight who asked E. B. Thomas (Collector of Coimbatore) to send Griffith seed of the palm *Bentinckia*, a group on which Griffith was then working.[57] Griffith also requested senna seed,[58] doubtless the form grown at Tinnevelly that Wight had investigated and published on.

THE AGRICULTURAL & HORTICULTURAL SOCIETY OF INDIA

Wight and the Madras Agri-Horticultural Society were in close touch with the senior Society in Calcutta, to which he was elected on 9 November 1836.[59] Over the rest of his time in India Wight sent the Calcutta Society seeds, objects for its museum, and communications for information or publication, all of which are recorded in the extant minute books of the Society. The bulk of these donations and communications related to cotton, but other economic plants, such as senna, were included. For example, in 1837 Wight sent the Society 14 quart bottles of tobacco seed, and in 1845 and 1848 seed of the dye plant *Wrightia tinctoria*. Material also travelled in the opposite direction, for example some hemp seed for trial in 1843. Nine of Wight's communications relating to economic botany were published in the Society's *Journal* between 1838 and 1854, the last of which was a copy of Wight's report on the Ooty garden.

THE BANGALORE AND OOTY GARDENS

In Wight's time, other than the garden of the Agri-Horticultural Society in Madras, there were two others in the Presidency supported (at least partly) by the Madras Government. The first was the Lal Bagh at Bangalore, a garden first established by Hyder Ali, Tipu's father, in 1760. It is not entirely certain that this is the Bangalore garden to which Heyne had transferred the plants from Samulcottah and the Nopalry in 1800, but it is probable; certainly responsibility for the Lal Bagh passed to the Chief Commissioner of the Princely State of Mysore in 1831.[60] It seems that at this point it was in the hands of a Colonel Waugh, and that from about 1836 it was run by the Horticultural Society of Mysore, with the involvement of Wight's friend Lieutenant William Munro,[61] who in this same year wrote an unpublished 'Hortus Bangalorensis'.[62] From references in letters written to him by Wallich from Calcutta,[63] it is known that Wight was based in this garden in the summer of 1840, but no further details of what he was doing there can be gleaned. From some dated drawings of figs by Rungiah (NHM nos 427–9) it can be established that Wight was again at Bangalore in May 1841, taking an interest in roadside trees. References to the Bangalore garden also occur occasionally in Wight's publications – for example, the illustration of *Thunbergia grandiflora* in the *Icones* was made from plants growing there,[64] and Wight commented on the fact that the loquat (*Eriobotrya japonica*) bore fruit at Bangalore (at 3500 feet), but not at sea-level.[65] The great development and expansion of the Lal Bagh, however, occurred from 1856 onwards, under Wight's friend Hugh Cleghorn, the first Conservator of Forests for Madras.

The third of the Madras Presidency gardens was the Horticultural (later Government) Gardens at Ootacamund, situated at about 7300 feet in the Nilgiri Hills. Towards the end of his time in India Wight was asked by the Madras Government to comment on a report made by its superintendent W.G. McIvor, and these comments were later published.[66] The following brief history of this still beautiful garden is based on the works of Price,[67] and Grigg.[68] A small Public Garden for growing vegetables was started in 1845, run by subscription, and was visited by a typically unimpressed Richard Burton in 1847:

> upon the side of a hill … formerly overrun with low jungle, now bearing evidences of the fostering hand of the gardener in the shape of many cabbages and a few cauliflowers.[69]

The more ambitious scheme of a Horticultural Garden under the auspices of the Ootacamund Horticultural Society was launched in April 1847, with a donation of Rs 1000 by the Governor, the agri-horticulturally minded Lord Tweeddale. The 40 acre site was a valley to the north of Lushington Hall;[70] it ranged steeply over about 150 feet, the lower part being 'little better than a peat bog', the upper covered in dense shola woodland. A committee was set up, which included two of Wight's friends, the German missionary the Rev Bernhard Schmid (who was probably the driving force – see p.111) and Captain Frederick Cotton; the monthly subscription was Rs 2. The aims, as given in the prospectus, were primarily to grow vegetables and flowers, but also to provide a pleasant place for recreation, however, it was further hoped that it would provide 'satisfaction to men of science and amateurs in Great Britain'. The intention was also that a beneficial interchange of plants could occur with Britain, in return for specimens of attractive members of the native Nilgiri flora. The committee sought help from the Court of Directors in

London, who consulted Hooker, with the result that his protégé William Graham McIvor was sent out as gardener on a five year contract, with an annual salary of £150. McIvor arrived in March 1848, and Wight, who happened to be in Ooty, met him two months later, and was able to help in the way of local introductions. Wight reported back to Hooker of his young disciple and the task that faced him:

> He has got a splendid piece of ground on which to exhibit his artistical talents, if he has them, but I fear he will find himself stinted in means. I asked him what they would give for such a mountain-side to work upon in Kew if he could by any Hocus pocus business transfer it to that locality! He glanced over the magnificent scenery before us and for a moment seemed quite lost in the contemplation of the idea & then replied: If they had such ground as that for their Gardens they would indeed have gardens worth looking at: they are fine now but they would become magnificent. And beyond all question a nobler site could not well exist, but it will never be made much of for want of funds, the population being not only limited in extent, and what [there] is of it very fluctuating. Sick officers, Civil & Military, go there for periods varying from a month to two years, [but] very few of the latter, and it is only those who are there over six months who are likely to contribute towards its support. It was at one time reported that the Court had sanctioned an expenditure of about £40 monthly, but that I understand was a mistake. It has recently been reported here that a private individual had put in a claim for the land, which had partially arrested operations, though it is the general belief he had as much title to it as either you or I, but as he was a worthless fellow & abundantly litigious he might have given trouble. He is since dead, which will facilitate the situation, as his executors will be at once called upon to establish his title & failing to do so the land belongs to the Government.[71]

Wight was right to be gloomy about the finances, as shortly after this the new Governor, Sir Henry Pottinger, allowed a monthly grant of only Rs 100 (i.e., £10). Undaunted McIvor drained and levelled the boggy lower part, and cleared the upper which, in Wight's words, he 'intersected with gravel walks, grassed neatly, laid out in flower plots and planted with ornamental shrubs'.[72] By 1852 the total spent on the garden (excluding McIvor's salary) was Rs 15,122, or about Rs 3000 per year, but receipts from the sale of produce were far from negligible (Rs 1903 in 1852). All was not well, however, between McIvor and the committee that ran the garden, which consisted of three military gents – Colonel L.W. Watson, and Majors F. Minchin and D. Babington. At this point Wight was asked, in a professional capacity, to comment on McIvor's third report on the garden. Price made much of the difference in opinion between Wight and the members of the committee ('a most violently worded correspondence'),[73] but Wight played this down ('my views [on the present condition of the garden and its resources] are at variance with those of others') as did the Madras Government when they sent McIvor's and Wight's reports to London ('We do not consider it necessary to discuss the merits of the differences between the members of the Committee and Dr Wight').

The McIvor Report

McIvor's Report, dated 23 June 1852, is terse and business-like, consisting mainly of a table showing the results of his labours in introducing, propagating, and distributing an impressive number of plants.[74] The largest group consisted of fruit trees, amounting to 30

species, of which the apple represented by far the largest (67 varieties maintained from 75 originally received), and ranging downwards to a single medlar tree. From these stocks huge numbers of plants had been propagated, including 1600 apples, 1200 figs, 3000 peaches and 16,000 strawberries. The list of 'Useful and ornamental trees, shrubs and flowers' was arranged under geographical headings: British, American, Cape [of Good Hope], Australian, Chinese and Himalayan. Of these by far the greatest number (165 species, including trees) were Australian, which McIvor thought peculiarly suited to the Nilgiris, and of which *Eucalyptus* continues to this day to have profound ecological consequences; the nine Himalayan species were mainly 'pines', but probably included the huge *Cupressus* that still dominate the garden. McIvor continued his report with the 'present state … and future prospects' of the garden, concerned mainly with the success of propagation and sale of produce. Proceeds from sales were then covering about a third of the running costs, but it was hoped that the garden would become self-supporting in a year or two.

Wight's Comments on McIvor's Report

Wight's comments, written in Coimbatore on 8 July 1852 are, typically, far from terse.[75] They were based on numerous visits made to the garden while Wight was in Ooty visiting his wife and their youngest son Charles, who had been there for five months during the hot weather in the first half of the year. The overall conclusion was that McIvor was doing a good job 'and no drone',[76] especially given the problems he had to overcome, such as an inadequate water supply – a particular problem in the winter, the poor quality of the seeds available, and the weakened state in which young trees arrived from Britain. Wight considered that 'the unassuming writer has done himself less than justice' and earnestly solicited the Court to renew McIvor's tenure, not as a personal favour to McIvor, 'but as a boon to be conferred on Horticultural Science in India'.

In some matters Wight considered McIvor to have been, perhaps, over-optimistic – such as the quality of the fruit trees and flower and vegetable seed he would be able to raise for distribution. Another concern was whether or not McIvor would be able to change the habits of fruit trees so as 'to induce spring flowering trees to flower in Autumn and ripen their fruit in spring', a change Wight took to be necessary given the climate of the Nilgiris with its summer and winter monsoons.

Two interesting digressions occur within Wight's comments: firstly, some detailed remarks on the climate of Ooty, a great interest of Wight's; secondly, an anecdote relating to plant pathology. Further details of the latter were given in a letter to Hooker written at the same time.[77] At this period the Golden Pippen apple was apparently almost extinct in Britain due to having been 'inveterately attacked with canker'. A plant, which Wight stated to be diseased, had been sent to India, and of the many plants obtained by grafting onto native Indian stocks, none showed symptoms of the disease, so that 'now there seems reason to hope that India will in a year or two send back to England this favourite fruit cured of its inveterate disease'. Canker is caused by a bacterial infection (*Xanthomonas* spp.), which spreads slowly through a tree,[78] so Wight was wrong in taking the act of grafting as having effected a 'cure'; the observed 'cure' can only have been because the disease had not yet spread to the particular buds used for grafting. However, even if Wight's idea of a 'cure' was wrong, if a disease-free stock could have been built up in what

might be called a plant sanatorium, this could certainly have formed a useful reserve of healthy trees for eventual reintroduction should the disease ever become extinct in Britain.

Wight's conclusion was that the Committee had formed:

an exaggerated conception of the capabilities of Horticulture ... principally in the error of comparing small ornamental gardens with the perhaps, too large public one.– They seem in short to expect that a garden occupying an Area of 42 Acres ... all reclaimed for the first time, from waste can in the short space of four years be as fully stocked and rendered as ornamental as a flower plot scarcely, if at all, exceeding one acre, of previously cleared ground, can be in one year, and that too while hampered with very limited funds.–

The Madras Government agreed with Wight, and accepted that McIvor had done an excellent job in achieving 'the first object of the garden ... to introduce and acclimatize the valuable productions of other countries [and] the next, to diffuse them over the country', and that 'if he was not provided with sufficient means to render it also ornamental, he cannot with any justice be censured for any deficiency in that respect'. In other words a triumph of scientific horticulture over aesthetics (and possibly also over military interference). The result was the abolition of the existing committee, and its replacement by an *ex-officio* one consisting of the Collector of Coimbatore, and the Commanding Officer and Senior Medical Officer of Ooty, with McIvor being made 'practically the Superintendent of the Gardens'. McIvor had won the day, but, lest it go to his head, he was warned 'to observe a greater degree of respect and deference than his past conduct exhibits in his future communication to the officers appointed to supervise his proceedings'.[79]

It seems that such a ticking off was in order, since, as will become apparent, there was a nasty side to McIvor's character. At this point he was certainly ambitious: with his brother he went in for property speculation in Ooty, and ended up marrying a Colonel's daughter. After Wight retired to Britain McIvor continued to have difficulty with the Military. The pair kept in touch and in a letter to Hooker in 1854 Wight reported that McIvor had 'lately been in great trouble thro' an accident to a pet dog which is said to have happened in the Garden & for which he is blamed tho' not in the Garden at the time – He appealed to the Commander in Chief for protection against the insulting conduct of his officers one of them an Acting Magistrate in the Hills!'[80] In 1857 McIvor sent Wight a copy of the Garden's 1856 report with news of the building of a £430 Conservatory, and the information that Cleghorn had been asked to write a report on the Madras gardens.[81]

There is, however, an unpleasant end to the relationship. When Wight was looking for a job for his 19–year old son Robert in 1864 he wrote to McIvor, who offered the boy a job on the successful cinchona plantations he had by now set up, assuring Wight that he had 'not forgotten your kindness when I was much in need of it, and will not fail to do my best to start your son in the world'.[82] The monthly salary was to be Rs 125 (or £150 per year) with a free house, and after some initial training young Robert was to take charge of a plantation at Mail Koondah. However, the episode did not turn out well, as we find from a rather pathetic letter Robert wrote to his father two years later. Robert may have been something of a lame duck (the solitude of the Nilgiris 'increased my self confidence in which I used to be very deficient while at home'[83]), but he had worked hard, and successfully learned how to care for, and propagate, cinchona. At this point McIvor showed his nasty side. The promised plantation did not yet exist and Robert had to clear it from the jungle, with almost no supervision, and 'after a few months' trial under these adverse circumstances McIvor:

affected to discover that the "poor" boy though very "willing" was little better than a fool and quite unfit to hold an independent charge & removed him to a subordinate situation, at the same time reducing his salary from 125 to 70 rupees a month, thus actually pocketing 55 monthly of the "poor Robert's" money!![84]

Wight remonstrated, 'which however only made bad worse by adding choler to cupidity'. So much for gratitude. In the end Robert resigned and in 1867, through his father's contact Thomas Anderson, obtained a job as an assistant in the Bengal Forest Department.

The Economic Botanist 1835–6

*Science, in modern times, is not made up of abstract speculation and
recondite theory, but is applied, in a practical manner, to the every day purposes of life,
for the general good of mankind and the advancement of civilization.*[1]

In November 1835, the Madras Government answered Wight's
prayers, and put him 'into a situation more congenial to my tastes,
and more suitable to my habits, than that of Doctoring Sepoys'.[2]
Wight attributed help in achieving this to John Grant Malcolmson,
a fellow Scot, then Secretary of the Madras Medical Board.[3] The
Governor who appointed Wight to the new job with the Revenue
Department was Sir Fred Adam [fig.21], so it would appear that the
seed sown by Brown three years earlier had at last sprouted. This
appointment was certainly not the answer to Wight's hope of a set-
tled post, as the next year was to be spent in a frenzy of travel and re-
port writing, taking him as far afield as the Shevaroy Hills to the
north and Ceylon to the south.

This was an important appointment, indicative of the Madras
Government's appreciation of the value of applied science, and was
hailed as such within Madras scientific circles, as can be seen from
the following florid note by Robert Cole in the *Madras Journal of
Literature and Science* that he edited. The start of the quotation given
as an epigraph continues:

> A visionary search for the philosopher's stone has been discontinued,
> and the industrious cultivation of the natural faculties, has taught the
> true secret of transmuting the sordid things of the earth into gold, by
> that knowledge, an alchemy worth knowing, which multiplies and
> improves the arts and manufactures, and with them the rational
> enjoyments and the comforts of life … While the labours of Dr Wight
> are thus mainly directed, as a public servant, to the improvement of
> agriculture and commerce, and to the acquisition of a knowledge of the
> statistics of our empire in India, botanical science is, at the same time,
> incidentally advanced; for wherever the foot of this ardent botanist is
> planted, new additions to our flora are made known, and, independent
> of the advantages enumerated above as accruing to agricultural and
> commercial operations, the Government is bestowing a great and
> lasting benefit on science by his employment in his present capacity –
> which, we earnestly hope, he will be permanently fixed in. This
> expression of our desire we know will be responded to by the world of
> Science in Europe, where the exertions of Dr. Wight are most eagerly
> watched and duly appreciated.[4]

In a paper dating from this period Wight noted the correlation be-
tween the advancement of science and extension of commerce, con-
cluding that 'whatever tends to extend the one, must give a forward
impulse to the other'.[5] Wight fully realised the scope of his commis-
sion and in January 1836 wrote to Henry Chamier, Secretary to the
Madras Government, explaining how long it would take to do such
a job and the expertise required:

> a more or less perfect knowledge of so many sciences (namely Agricul-
> ture viewed as a science, Statistics, Natural Philosophy, Chemistry,
> Geology, Botany, the principles of Commerce and political economy)

> must necessarily require much time to enable me to complete their
> examination in a manner creditable to myself or satisfactory to my
> employers. – The more so, as the difficulties and delays necessarily
> attendant on scientific inquiry even in the most favorable circumstances
> are greatly increased by the difficulty of procuring scientific books in this
> Country rendering it necessary to obtain from England the most
> essential works of reference.[6]

The new job, no less than a roving commission to investigate agri-
culture and natural resources, and to summarise reports already re-
ceived on such matters from the District Collectors, must have
seemed an ideal combination of Wight's talents and interests. Even
to condense the reports already received, however, could 'scarcely
require less than a year diligently employed', and Wight also wanted
to make journeys to seek new information. The terms of Wight's
brief were thought important enough to publish in the *Fort St George
Gazette*, and are of such interest that they will be given here in their
entirety:

> 1st. The circumstances in which the experiments with the American
> Cotton and Tobacco seeds sent out by the Hon'ble. Court of Directors
> were made, are to be stated in detail.

> 2d. The causes which led to their failure should be ascertained; and
> those which may appear to have been accidental, and not such as to
> justify an unfavorable opinion in more advantageous and skilfully
> conducted trials, are to be pointed out, with a view to their being
> avoided in future.

> 3d. When any thing in the soil or climate appears to be unfavourable,
> attention should be paid to the opinions expressed regarding them; but
> when these are only founded on analogy with other products supposed
> to require the same soil, or on the failure of the first trials from the
> apathy of the Natives, injurious modes of culture and preparation, or
> from inadequate encouragement, additional enquiries should be
> instituted, to ascertain as far as possible the real value of the facts; and
> whatever may remain doubtful should be pointed out as a matter to be
> hereafter investigated.

> 4th. When, notwithstanding the great difficulties attending first
> experiments, success either partial or complete has attended them, the
> information communicated on the following points cannot be too
> minute, viz. the kind of seed, as Sea Island, &c; the time of its being
> received in India, and sent into the District; the season when it was
> sown, &c.; the nature of the soil and method of agriculture adopted; the
> quantity and quality of the produce and its adaptation for the Foreign
> and Home markets; its value, and the expenses incurred in the first
> instance, and as far as can be ascertained, those likely to be incurred
> when the management is better understood, with the returns that may
> be then expected to be obtained. In this investigation the methods of

gathering and preparing the produce should be clearly explained, and such suggestions communicated as are calculated to improve those at present practised. This will necessarily lead to the description of the mode of cultivating the country plants, the defects in the manner of gathering and preparing their produce, the causes of superiority of the Coimbatore and Tinnevelly *Country Cottons*, with the history of the introduction of the Bourbon cotton plant into these Districts.

5th. With respect to Tobacco, the methods of preparation and the qualities for which it is valued in some parts of this country are by no means the same as those that will render it a lucrative article of trade with Europe; the statements on this subject founded on Native opinions are, therefore, to be received with some reserve, and the real extent to which they apply must be ascertained by personal enquiry. As this is an article nearly unknown in Indian foreign trade, and which from the great success that has attended the few experiments yet made in a proper manner, promises to be very advantageous to the country, it will be requisite to attend to the effects of any regulations now in force, by which the extension of the cultivation, its manufacture, consumption and export may be obstructed or embarrassed; and to the most eligible means by which the extension of the cultivation may be secured. This being an object of almost equal public importance with that of the introduction of the finer kinds of Cotton, it is probable that, the result of the enquiries now in progress may point out the propriety of granting liberal encouragement, in the shape of moderate remissions for a certain number of years, the removal or modification of taxes at present levied either on the production or transport of the improved products, or by other methods; and it is expected, that the examination of the reports and the additional enquiries founded on them, where the information they afford is imperfect, will enable Government to do so, in the most effectual and economical manner.

6th. The condensation and correction of the information contained in the reports and replies on the above subjects will necessarily contain references to the nature of the soils in which the various productions are most advantageously cultivated; and as the Natives have long been familiar with these distinctions, it is believed that much benefit would result from a careful comparison of the information regarding the products usually raised on the several soils, with their nature as ascertained by an examination of the samples furnished by the Collectors. For this purpose, they should be arranged into classes, the differences in physical and chemical qualities of each of which should be clearly stated. Under each principal division, the varieties should be arranged and their differences stated; and from a careful comparison of all the soils, their local names and qualities over the whole of the territories under this Presidency, will easily be referred to those whose characters have been ascertained. An abstract statement can afterwards be constructed, so as to exhibit in one view much important information on the various products for which they are severally best suited, on the returns received from each, the expenses of cultivation, and the value which should be assigned to lands of different kinds in revenue surveys. It will not only be useful to Officers in the Revenue Department and to the public to have exhibited in one view the names, characters, qualities, and productions of the numerous kinds of soil, on which the nature of the agriculture of particular districts depends; but it will materially assist individuals engaging in raising any of the staple productions of the country, to know without the expense and disappointment of unsuccessful experiments, the kinds of soil in which they may expect to cultivate particular plants with success. For example; the Bourbon Cotton plant, which produces the finest kind of Cotton wool, is most successfully cultivated in a soil similar to that most congenial to Coffee in Malabar and Wynaad; but that the rich black "Cotton soils" in which the annual plant is cultivated cause it to shoot into luxuriant branches which do not produce a crop. In this comparison, however, the nature of the climate as to temperature, and the quantity and distribution of moisture, must be held in view.

7th. In estimating the amount of the several kinds of produce from the different soils, the expenses of cultivation and the profits of the cultivator, many sources of error will have to be considered, and different statements will probably be furnished by the Ryot and the servants of the Collector. To guard as much as possible against these, in addition to the abstract statements to be prepared from the whole of the documents, a copious selection of the original detailed statements will be given in an appendix, to each of which, such remarks as may appear necessary are to be annexed; regarding the sources from whence the information was obtained and the degree of authority which they may appear to possess, when anomalous or contradictory statements occur, their investigation will lead to the correction of the tables or to the elucidation of facts of importance

As these statements will exhibit the various kinds of grain and other produce raised on different soils, and will embrace the results of unconnected enquiries made over the whole of this Presidency, it may be confidently expected that the documents, when subjected to the proposed scrutiny, will afford data, from which the real profits of the occupiers of land may be more correctly estimated than has yet been done.

8th. Similar principles are to be attended to in the examination of the answers to the queries regarding Coffee, Senna, Dye-stuffs, &c.; and to prevent misapplication of capital or enterprise that might be more advantageously employed, it will be useful to record such facts as may appear to show, that any article, supposed to deserve attention in commerce, is not likely to succeed, either from some defect in its quality, or the expense and difficulty in producing it in sufficient quantity and of good quality.

9th. It has long been considered of great importance to ascertain the causes on which the remarkable difference in the quality of the cattle of different provinces under this Presidency depends, with a view to their improvement in those Districts in which the soil and climate are not unfavourable; and to their preservation in seasons of drought, which are of such frequent occurrence and, under the present management, so destructive to agricultural stock of all kinds. A careful comparison of the information contained in the reports, with the specimens furnished by the Collectors, of the most remarkable grasses and other plants used as food for cattle, cannot fail to lead to some important general conclusions of a practical kind.

10th. For a full illustration of the subject, it will be necessary to ascertain the scientific names and characters of the various plants, with the native names by which they are familiarly known in different Provinces, their qualities as stated by the Ryots, and the soils in which they are found to thrive. It will be convenient to give this detailed information in a separate report, to be accompanied with drawings of the most valuable plants, which, if thought expedient, may hereafter be lithographed for general use, and to enable those ignorant of botanical science to prosecute the enquiry.

11th. The Districts in which the proposed enquiries are to be conducted, contain several ranges of hills of great elevation, and possessing many natural advantages for the cultivation of other valuable productions, besides those above adverted to, a scientific examination of which, would develop their capabilities to furnish additional articles of commercial importance, and by increasing the general resources of the country, indirectly promote the cultivation of the finer kinds of Cotton, Tobacco, &c.; of these, the Courtallum and Pulney hills appear to afford the greatest facilities for successfully prosecuting the inquiries referred to in the preceding paragraphs, as their examination can be conducted at the same time, with those relating to the cultivation of Cotton, Tobacco, &c. on the plains.

12th. The principal objects to be attended to in this survey are the history of the Spice gardens of Courtallum and the probability of these valuable productions being profitable cultivated in that soil and climate; the facilities for the production of Sugar in the neighbourhood of Bulsumdrum and other places in the Pulney Hills where it has long been raised with success for the supply of the neighbouring country; and the measures necessary to improve the quality of the cane, and to introduce more productive varieties, such as that of the South Seas. Attention should also be paid to the manufacture of Saltpetre carried on in the same neighbourhood; the facilities for the growth of Coffee in the hills; the quality of the hill pastures resorted to by the Ryots of Madura, and the character of the more valuable breeds of cattle brought to Pulney for sale from Dorpoory and other places; and the state of agriculture generally in the neighbourhood and on the hills, with the probability of the successful culture of the productions of colder climates, such as Tea, Madder, Cinchona, &c. on the more elevated tracts where Wheat and Flax are now grown. The characters and qualities of the timber trees with which the hills are covered, and the facilities of turning them to account, are also to be ascertained by personal enquiry, and by collecting specimens of the woods, for examination by the superintendent of the Gun Carriage Manufactory or other competent judges. Should any of the woods not generally known, and having valuable qualities not possessed by others found in India, be discovered, drawings should be made of the trees, and the native and scientific names and characters detailed.

13th. The examination of these objects of immediate utility, will afford opportunities for the investigation of others of a more speculative character, but bearing more or less directly on questions of practical interest. It is only requisite to refer to the important additions to science, particularly to geographical botany, on which success in experimental husbandry in a great measure depends, that will result from the examination, in detail, of the geological structure and of the climate (as ascertained from meteorological observations and an examination of the distribution of various families of plants), of a District of a moderate extent and well defined geographical limits; in which the transition from the vegetable forms characteristic of the plains of the Carnatic, to those found at great elevations or in more temperate climates, can be conveniently observed.

14th. This information is the more desirable as the state of the atmosphere and the specific effects of each variety of soil and climate as modified by elevation or other local causes, on vegetation and the productions that may be profitably raised on the hill ranges of the Peninsula, cannot be inferred from the observations made in those of Hindoostan, which from their higher latitude enjoy two seasons, during one of which European and during the other tropical plants can be cultivated.

15th. The prosecution of these enquiries, however, is not to interfere with the earliest practicable completion of the examination and condensation of the important information contained in the reports of the Revenue Officers and to be collected by a personal examination of the Cotton Districts of Tinnevelly and Coimbatore.

Hy. Chamier, Chief Secretary.[7]

This brief clearly demonstrates the depth of background knowledge, and attention to detail, of which at least some members of the Madras Government were capable, and is doubtless the 'series of queries' referred to by J.F. Royle as 'promulgated by order of Sir F. Adam' but actually drawn up by J.G. Malcolmson.[8] The underlying purpose is clearly economic: to identify existing agricultural practices, find ways of improving these and maximise resulting revenue, and to establish the potential for growing new crops (American cotton and tobacco) for export. The paragraphs of particular interest in relation to Wight are 10–12 and one cannot help but think that he must have collaborated with Malcolmson in writing his own job description in the paragraph seeking information on useful native plants – especially when it is suggested that lithographs be made of them.[9] The emphasis on the hill regions of Courtallum and Palni, their agricultural potential and timber resources, also suggests Wight's hand. It is, however, the extraordinary paragraph 13 that most clearly demonstrates the broad-mindedness of the Madras administrators (in comparison, as will be seen, to those in Calcutta), giving Wight the freedom to investigate matters of a 'more speculative character', appreciating the potential usefulness of geology, climate, and, even more surprisingly, geographical botany.

The Revenue Department had already (in June and July 1835) sent out circulars to the District Collectors seeking information on the subjects of paragraphs 1–9, and, as emphasised in paragraph 15, were looking in the first instance for someone to condense the resulting mass of information. A minute by Adam specifically addressed the question of how such replies could be 'turned to best account',[10] but in appointing Wight 'a gentleman of distinguished scientific acquirements, and whose pursuits have been directed to these subjects',[11] they doubtless realised that he could do far more, and therefore added the remaining paragraphs on subjects particularly suited to his talents and interests. The Court of Directors eventually approved Wight's appointment as an exception to their general aversion 'to the practice of employing our medical officers on subjects foreign to their professional duties'.[12] Wight's brief was, of course, wildly over ambitious for a single man in what was initially to be a one year appointment, but Wight set to his task with considerable energy.

In January 1836, still based at Palamcottah, Wight embarked on the first of his travels for the new job, going firstly to the Malabar Coast at Quilon to enquire into 'the cultivation and commercial value of cinnamon, and examining the kinds and qualities of timber produced on that coast'.[13] This was probably the occasion when he first visited William Huxham's spice plantations at Pathanapuram.[14] Not neglecting the opportunity for some taxonomy on the side, Wight took along two plant collectors, whom he probably left at Quilon, as in early August he was able to send Arnott 15,000 specimens collected there, which he shipped from Tuticoreen. Although

labelled 'Quilon' these specimens almost certainly came more generally from the western slopes of the Ghats, then still richly forested, rather than from the town or its immediate surroundings, which even by then must have been almost entirely cultivated. From the Malabar Coast Wight headed through the mountains for Courtallum, this time not to visit patients, but to report on the spice gardens first established there by the EIC in 1798.[15] No report on the spice gardens by Wight has been found, but in the *Illustrations* he mentioned having seen there several 'very thriving' young trees of cocoa (*Theobroma cacao*), and recommended an extension of its cultivation in the potentially suitable climates of Malabar and Mysore.[16] At Courtallum, where they thrive to this day, Wight also saw two or three young mangosteen trees that 'annually ripen their fruit';[17] there were also cloves (*Syzygium aromaticum*), allspice (*Pimenta dioica*),[18] and loquat (*Eriobotrya japonica*) that Rungiah painted (RBGE WI22). Wight arrived at Courtallum in early March and spent ten to fifteen days there before being 'regularly floored by a severe attack of jungle fever [i.e., malaria]'.[19] Wight attributed the cause of the attack, to which his whole party of more than twenty succumbed, to the climate (rather than to mosquitoes) – in particular to a change in wind direction from north to south; his attack was so severe 'that some of my Palamcottah friends predicted that it would be my last'. The European constitution won out, and while in Wight's case recuperation was helped by a six week visit to Ceylon, the natives 'were all slow of recovery, and one of the strongest men of the party is still [in June] an invalid'.

SIX WEEKS IN CEYLON · MARCH–APRIL 1836

Ceylon was not the most obvious place to convalesce from a severe attack of malaria, and Ootacmaund in the Nilgiris, by then well established as a sanitarium for the Madras and Bombay Presidencies, would have been a more obvious destination. Which suggests that Wight's visit had another purpose, perhaps a continuation of his work on spices, as Ceylon was renowned for its cinnamon. It should be noted that despite its proximity, Ceylon was not administered by the EIC, and, since 1798, had been a Crown Colony.[20] The island had its own Royal Botanic Garden, first established (with advice from Banks) in 1812 on various sites around Colombo on the southwest coast. The first 'Superintendent and Chief Gardener' was William Kerr, who died in 1814, and in 1817 he was replaced by Alexander Moon. Moon was a man of great ability, who started a herbarium, and set up a new botanic garden at Peradenyia, near Kandy in the central highlands. Despite limitations due to lack of reference books Moon, in 1824, published an important *Catalogue of the Indigenous and Exotic Plants growing in Ceylon*, including their native names set in beautiful Singhalese type, to which Wight frequently referred. It was also Moon who first employed the botanical draftsman Harmanis de Alwis Seneviratne, who worked at Peradeniya from 1823 to 1861 (see Book 2). James Macrae, Superintendent 1827–30, continued to develop the Garden's herbarium, but his successor James George Watson, who was in charge at the time of Wight's visit, was described as 'an ignoramus who could not read the language of botany'.[21]

Almost no details have come to light about Wight's 'run over to Ceylon for 6 weeks' other than what he wrote in a letter to Arnott,[22] and from the specimens (representing 5–600 species) he collected. Wight had taken his collectors with him and returned to India 'as stout as ever'. The route must have been by boat from Tuticoreen to Colombo, and at some point Wight met up with Colonel and Mrs Walker whom he accompanied on a botanical trip. The Walkers had for some time been corresponding with Graham in Edinburgh and Hooker in Glasgow. Professionally George Warren Walker was a soldier, and at this time on the Governor's staff as Adjutant-General of Ceylon, but he was also a keen botanist. In his botanical pursuits he was enthusiastically joined by his wife Ann Maria (née Paton), who was particularly interested in orchids; she was also a competent botanical artist and a lively correspondent, and Hooker had recently published her account of an ascent of Adam's Peak.[23] Wight had been corresponding with the couple since the previous autumn, when they sent tracings of some of Mrs Walker's orchid drawings, which Wight would later publish in the *Icones*.[24] Wight's Ceylon specimens are poorly localised, and the only localities mentioned by him, either on the specimens or in publications, are the Mahaweli Ganga (a river), and the settlements of Nuwara Eliya, Pussellawa and Ramboda. These, however, are enough to show that Wight reached the central highlands around Kandy, which had then only recently been made accessible.[25] It seems highly likely that Wight also met Sir Robert Wilmot-Horton, Governor of Ceylon 1831–7, and his wife Anne. Lady Horton was the subject of her cousin Byron's poem 'She walks in beauty, like the Night', and in dedicating a genus to her Wight recorded 'the lively interest she takes in botany and her extensive knowledge of Ceylon plants'.

There seems to have been a particular friendship between the Walkers and Robert Graham, but it has not been possible to establish the basis of this.[26] Graham, true to form, let them down badly over the outstandingly rich collections they sent him, and it fell to Arnott to publish many of their discoveries in a substantial paper entitled 'Pugillus Plantarum Indiae Orientalis' in the journal of the Leopoldina. This originated as notes 'copied out for Wight to guide him when prowling about',[27] and by 1838 Wight was getting more ambitious about the still incomplete second volume of the *Prodromus* in which he now wanted Arnott to include Ceylon plants. Arnott, however 'could not accomplish this without going to London and examining all Hermann's and Koenig's plants, which it will be scarcely in my power to do'.[28]

THE SOURCE OF GAMBOGE

It was on the excursion with the Walkers that Wight became interested in the source of the yellow pigment gamboge, a resin that in the *Prodromus* Wight & Arnott stated came from a tree they called *Xanthochymus ovalifolius*. The Walkers had sent relevant specimens and drawings to Graham, and the result was a minor botanical spat.[29] Graham disagreed with Wight & Arnott over the source of the dye, which led to Wight (in what he considered a 'racy' paper[30]) accusing Graham of having 'drawn a wide inference from insufficient data'. The riposte by Graham was a model of decorum, in which he was highly complimentary about Wight's work and abilities. The plants concerned are all now placed in the genus *Garcinia*, but the generic limits were by then by no means clear, and characters such as number of sepals and petals (4 or 5), and the number of bundles in which the stamens were arranged (1, 2, 4 or 5) had been used to separate genera such as *Xanthochymus* and *Stalagmitis*. Also in dispute was how many of the Ceylon species produced gamboge (which also has medicinal properties), and which of these were native. There were also nomenclatural tangles of the sort typical of

species of economic importance described by Linnaeus and other eighteenth-century authors; but in this case there was a final twist. Graham correctly identified the source of the best Ceylon gamboge as the plant Gaertner had described as *Mangostana morella*, but when trying to understand the synonymy had asked Robert Brown to examine the type of a plant described by Murray as *Stalagmitis cambogioides*, which had been sent to Joseph Banks by J.G. König. Brown discovered that this specimen was a botanical hoax, consisting of the leaves of one species skilfully attached to the inflorescence of another by means of sealing wax! The flowers belonged to Wight & Arnott's *Xanthochymus ovalifolius* (today known as *Garcinia spicata*), but the leaves belonged to Gaertner's species, for which Graham provided an un-necessary, and rather naughty new name – *Hebradendron cambogioides*. Today this would be regarded as the height of political incorrectness, but Graham perhaps meant it strictly medically or anthropologically, his 'Jew-tree' being named for the circumscissile dehiscence of its anthers.

The matter is now resolved: the best Ceylon gamboge comes from the tree known as *Garcinia morella*, which is native to the island. Colonel Walker had commented on its excellence and permanence – used as a 'colour on the figure of Buddho painted centuries ago'. A recent treatment of this species for Sri Lanka states that 'the brilliant yellow latex is an excellent gamboge or gummigut, but only used locally for painting and dyeing. The juice of *Feronia* is used as a mordant. Trees can be tapped when they are 10 years old by making a spiral incision and collecting in small bamboo containers'.[31] However, *Garcinia xanthochymus*, a native of N India, also occurs as an introduction in Ceylon, but is used more for its fruits (in preserves, for flavouring curries, and medicine) than for its inferior gamboge. The native species *Garcinia quaesita* is used for similar purposes to *G. xanthocyhmus*. It should be noted that Robert Christison, Wight's contemporary at school and university, undertook a detailed chemical analysis of the various producers of gamboge, doubtless at the instigation of Graham, and based on collections made by Colonel and Mrs Walker,[32] in a paper extensively quoted by Wight in the *Illustrations*.[33]

CINNAMON AND CASSIA

In 1839, under instruction from the Madras Government, Wight investigated the plants that produced various spices and oils belonging to the family now known as Lauraceae. Specifically he had been asked to discover whether or not 'the common Cassia Bark of the markets' was merely a 'thicker and coarser portion of the bark of the genuine cinnamon plant or tree'. Wight sought information on the Malabar Coast,[34] but it is likely that his investigations had begun during his visit to Ceylon. Given his Courtallum investigations on spices, Wight must surely have visited the cinnamon gardens in the vicinity of Colombo, run originally by the EIC who had a monopoly on the production and sale of the spice until 1823. The results of this study were published in the *Madras Journal*,[35] and in a mini-monograph that formed the seventh part of his *Icones*, in which was reproduced 21 plates of various *Cinnamomum* species (and one of a related genus) based on his own collections and reproductions from historical sources.[36]

The genus *Cinnamomum* and its relations are notoriously difficult taxonomically, and suffer from the same sort of nomenclatural problems as gamboge and other commercially important species

first described in pre-Linnaean literature. As Wight aptly put it, many of the earlier botanists:

> were but indifferent describers of plants, and often very loose in their quotations of figures [illustrations] as synonyms, a sin of which Linnaeus was often about as guilty as any of his contemporaries.

Up to Wight's time the assumption had been that the source of 'cassia' was the species described by Linnaeus in his *Species Plantarum* as *Laurus cassia*. But the truth was not so simple, because under this name Linnaeus had cited several different names, descriptions and illustrations. The main basis of the Linnaean name (on which it has since been fixed) was a plant from Ceylon in Hermann's collection, now known as *Neolitsea cassia*. However, it was pointed out by Henry Marshall that this species was non-aromatic, and therefore could not be the source of 'cassia'.[37] Marshall (1775–1851) was another Edinburgh surgeon, who had worked as assistant to the EIC's cinnamon inspectors on Ceylon, ending up as Deputy Inspector-General of Hospitals. Marshall's surprising conclusion had, significantly, been arrived at from the Singhalese vernacular name of the tree 'dawal kurundu'. Somewhat ironically (as Wight was notoriously wary of this source of potentially useful information), this was confirmed by Wight, who then investigated the nomenclatural history closely, and identified the problem as arising from the other elements included by Linnaeus. One of these was Rheede's 'carua', of *Hortus Malabaricus*, certainly an aromatic species, and now identified as the true cinnamon. In matters of identification and nomenclature, Wight largely followed C.G. Nees von Esenbeck who had made a detailed study of the family Lauraceae, and named many of Wight's own specimens. Both Nees and Wight were correct in their main conclusion – that the true cinnamon, from Ceylon and SW India, came from *C. zeylanicum* (which has subsequently been found to have an earlier name: *C. verum*), and that the 'Chinese Cinnamon … considered among European druggists the genuine of first sort [of] Cassia of commerce' came from the Chinese *C. aromaticum*. Wight's identifications of the other related species have since been somewhat modified, but he was almost certainly correct in thinking that other lower grade spices exported under the name 'cassia' came from up to six species of the genus collected in Ceylon and Malabar.

MORE ON CEYLON: TEA AND TAXONOMY

Wight had dealings with Horton's successor as Governor of Ceylon, James Alexander Stewart-Mackenzie over the important matter of the introduction of tea to the island. Stewart-Mackenzie was an interesting character who married the widow of Admiral Sir Samuel Hood, whose maiden name he added to the Stewart with which he had been born. Lady Hood was the heiress to the Seaforth estates, which included the Hebridean Isle of Lewis, but these were in dire financial straits following the collapse of the kelp industry.[38] The trustees of the estate put Lewis on the market, and, by borrowing heavily, Stewart-Mackenzie was able to purchase it. His ensuing efforts to 'improve' the island and make it profitable led to extreme acts such as printing his own bank notes, and driving people off the land to make room for sheep and fishing stations. Stewart-Mackenzie's time in Ceylon (1837–41) was not notably successful, but did involve significant agricultural activities, including the introduction of tea, of which he received Assamese plants in 1839 from Wallich.[39] It was on this topic, the same year, that Stewart-Mackenzie wrote to Wight in Madras, asking for tea plants from the Agri-Horticultural

Society to be sent via the artist De Alwis.[40] De Alwis was at this point returning to Ceylon from Madras where he had been undergoing a spell of tuition by Rungiah, and drawing some plates for the *Icones*. In this same letter Stewart-Mackenzie also asked Wight to send him some cotton seed for an experiment he wanted to conduct in the Jaffna district, and promised to try to obtain some plants of ebony and satin wood to send in return. The tea introductions were eventually highly successful and led to an industry in which Wight's great grandson Henry Cecil Cosens would participate a century later.

It was on the 1836 visit that Sir Robert Wilmot-Horton had suggested that Wight produce a new edition of Moon's *Catalogue*,[41] and to this end the Peradeniya herbarium, including Moon's and Macrae's specimens, was sent to Madras in August 1837.[42] It may have been to obtain further materials for this project that Wight sent two collectors to work with the Walkers in early 1837,[43] though, doubtless due to Wight's other activities, no new edition ever appeared. In 1843 George Gardner, a pupil of Hooker's at Glasgow, after productive travels in Brazil, was appointed to the job of island botanist and Superintendent of the Peradeniya garden.[44] Gardner set his considerable talents to setting Ceylon botany on a modern footing – putting the garden in order, and commencing the scientific investigation and publication of the flora. On his arrival in Ceylon Wight had written offering Gardner help and suggesting that he visit him in Coimbatore. This would allow him to retrieve the old herbarium and obtain recent, accurately named, specimens from Wight's herbarium. In 1844 the Governor of Ceylon (by now

Fig.21. Sir Fred Adam, watercolour and pencil by W.D. [?]T., 1817, after a painting by 'J. Edridge' [sic, but probably a mistake for Henry Edridge]. Janet Adam.

Sir Colin Campbell) duly allowed Gardner both time and expenses to do this.[45] Getting from Peradenyia to Coimbatore was no easy matter, and to make matters worse Gardner contracted malaria before he had even left Ceylon, having been forced to spend the night at a rest house in one of the most unhealthy places on the island, where he 'imbibed the seeds of a jungle fever'.[46] Gardner persisted and in December 1844 reached Point de Galle where he boarded the ship 'Precursor' on which happened to be William Hooker's brother-in-law Gurney Turner, bound for Calcutta as a surgeon. The connections continued and in Madras, which he reached after a three and a half day voyage, Gardner stayed with a nephew of Thomas Thomson, his Glasgow chemistry professor. Here the professor's son Gideon Thomson, younger brother of the eminent botanist Thomas junior, joined them shortly.[47] To travel the 320 miles to Coimbatore Gardner decided to travel 'post' which meant purchasing a palankeen, and giving eight days notice to the Post Master General to arrange 'relays of bearers placed at different stations along the road' – in this way the journey took five days and cost £20. Palankeen journeys were not comfortable, and such was the hurry that Gardner did not even take time to sleep overnight in rest houses.

When Gardner arrived at Coimbatore he 'received a most hearty welcome from Dr Wight', who had just come down from Ooty and was 'quite delighted to meet with a brother Botanist'. This must be an understatement as Gardner was an outstanding botanist compared with locals such as the Rev Bernhard Schmid. Throughout January 1845 the pair worked together on the old Ceylon collections, and Gardner's new ones, in the large herbarium room in Wight's house:

> grouping them into their Natural Orders and Genera, and then comparing them, species by species, with those in the Doctor's Herbarium, together with the use of his valuable and extensive botanical library, we were enabled to ascertain which are new species, and to name those that had already been described.[48]

Although the old collections were in a poor state Gardner was impressed with Moon's work – he seemed to have been 'a most indefatigable collector, for among his plants we found most of the species detected by subsequent Superintendents of the Garden, and other collectors'. Wight and Gardner also found time for some short local excursions, on one of which they decided that *Azima tetracantha*, which had been 'bandied about from Order to Order, and, wandering-Jew-like, has been hitherto unable to find a place of rest' was actually the type of a new family, which they jointly described as Azimaceae. This was one of only two new families described by Wight, though is no longer recognised, the single species being now placed in Salvadoraceae. Gardner's continuing attacks of malaria prompted a visit to the Nilgiris, described elsewhere (see p.113), after which they returned to Coimbatore and worked for a further ten days in Wight's herbarium, 'from 6am to 12 pm',[49] with Gardner given leave to take copious duplicate specimens for himself (many of which ended up in Hooker's and Bentham's herbaria and are now at Kew).

Gardner had to return to Ceylon, but he continued to correspond with Wight, and following Griffith's death, they collaborated as botanical editors for McClelland's *Calcutta Journal of Natural History*. Gardner worked hard, encouraged by Sir Emerson Tennent, Secretary to the Ceylon Government, and published

several important papers on Ceylon botany, but in 1849, at the age of only 38, he shared Griffith's fate and was cheated of his desire to publish a 'Flora of the island worthy of the richness and beauty of its vegetation'.[50] It fell to his successor G.H.K. Thwaites, appointed in 1849, to achieve such a work. Joseph Hooker had written to Wight from Sikkim (such by now were the tentacles of the Kew botanical empire) introducing Thwaites, and Wight intended to perform the same service for him as he had for Gardner – to initiate him 'so far as I am able, in the mysteries of Tropical Botany' and with that view wrote to Tennent.[51] The projected visit to Coimbatore appears not to have happened, and Thwaites seems to have taken the easier option of sending Wight some 2000 specimens for naming in 1852.[52]

INDUCING THE NATIVE OF INDIA TO THE CULTURE OF MERCANTILE PRODUCE

From Ceylon Wight returned to Palamcottah and sat down at his desk with the reports submitted by the Collectors on the state of agriculture in their districts, and with some sort of written instructions (the 'Context' mentioned in the 'Notes' that follow the report). Wight's report 'On the means of inducing the Native of India to devote more time and attention to the culture of commercial or mercantile produce than they have hitherto done', has been overlooked, but, while verbose, is of great interest.[53] It is, however, almost entirely devoted to matters of political and agricultural economy that lie outwith the competence of the present author to analyse; comments will therefore be restricted to matters that throw light on Wight's interests, sympathies and character.

One might start by asking why Wight was chosen for this task? As already noted Sir Fred Adam, when appointing him to the job, described him as 'a gentleman of distinguished scientific acquirements, and whose pursuits have been directed to these subjects'. But Wight's pursuits had been directed to botany, not to economics, and the question at issue was bound, rather rapidly, to lead him into waters ('political economy' and 'revenue matters') in which he was at pains to stress that he had 'limited acquaintance', and certainly no knowledge of literature of immediate relevance. At this stage, with his army, medical, and botanical background, (nothing is known of his linguistic abilities in Tamil), Wight can certainly have had no idea of the awe-inspiring complexities of the indigenous agricultural systems documented by David Ludden for the Tinnevelly District (which surrounds Palamcottah).[54] Wight's main strengths were therefore: an analytical mind; the probability of an at least superficial knowledge of the work of Adam Smith; and his Scottish legal and agricultural background, of which the Madras administrators were doubtless aware. It is somewhat doubtful, however, as to what, if any, notice the hard-nosed Revenue Board officials ever took of his recommendations, which were entirely economic rather than agri-horticultural. As the only copy seen is in the Tamil Nadu Archives, it is not even certain if they sent copies of it to Calcutta or London.

The first thing to say is that Wight was a loyal employee of the EIC, and Company policy at this time was to increase the export of raw materials (especially cotton, sugar and tobacco) from India, and certainly not to invest in the country's industrialisation. Wight seems to have been convinced that these policies were not only desirable, but fair, though the odd qualm is, perhaps, occasionally hinted at. Underlying the report is a deep sympathy for the plight of the Indian *ryot*, and a desire to find means 'for the relief of the distress which now prevails in India'. It should be remembered that these were difficult times, as a result of wars and political instability in the late eighteenth century, which had led to breakdowns in infrastructure such as a lack of attention to maintenance of vital irrigation systems. There had also been serious famines in the Madras Presidency in the years 1811–3 and 1831–3.[55] Wight's realistic view was that the *ryot* was too poor to be expected to try out potentially risky non-staple crops. In particular they were too heavily in thrall to money lenders (who charged interest rates of 12½ to 25%) from whom they had to borrow to cover the expense of sowing their food crops, and as long as this practice continued 'poverty and want must be the lot of a large proportion of this industrious and deserving proportion of the population'. The risk of trying new crops was, he therefore believed, best left to men with capital – presumably the sort of rich Indian merchants and landowners whom he knew through the Agri-Horticultural Society.

Before going any further is seems appropriate to give Wight's four conclusions on how to encourage such men of capital to come forward to subsidise the growth of commercial crops:

1. Reduce (moderately) the land tax on areas devoted to mercantile crops, which would encourage their growth 'by diminishing the risk of loss, and placing it on a more equal footing' with that of food crops.

2. Reduce or repeal export duties, which would increase both foreign trade and trade between Indian ports ('coasting trade').

3. Remove or modify the mode of collecting of transit duties (revenue raised when commodities were transported), which would 'set free internal trade'.

4. Establish strict usury laws, with fixed rates of interest, which would establish credit 'on a more secure footing' and bring more capital into circulation and enable both merchant and producer to 'borrow on reasonable terms'.

Wight regarded himself as an 'Indian' and had the best interests of the country that provided his livelihood at heart, but as a product of the Scottish Enlightenment, he believed in the Smithian benefits of 'a skilful division of labour, aided by machinery' and contrasted these with the 'the slow and operose methods pursued by the native workman'. In Wight's view the most appropriate role for India, as a non-manufacturing country, was as a producer of raw materials, which could be processed to the highest standards in Britain and sold back, for example as cloth, at a price cheaper than it would cost the 'Hindoo weaver' to produce. Wight considered such native crafts as inferior in quality to British produce, and also believed in a sort of globalised utilitarianism: that it was as wasteful to attempt to grow exotic raw materials in Britain, as to encourage 'manufacture by native artisans' in India. The resulting exchange he considered 'equally beneficial to both parties', while being honest that in this schema the vast share of the profit, which allowed 'thousands to live not only in comfort, but in affluence', occurred in the period between the raw cotton leaving India and its return as woven cloth. This he presumably accepted as Britain's just reward for its enterprise, and the investment and research, which had put it in such a position. In one place, however, Wight lets slip that the reason India had been 'nearly reduced' to that of an agricultural producer was because of the 'competition of British piece goods'.

The question of India becoming a larger consumer of British

manufactures was discussed by Wight at a later period, in the context of his cotton work, in a revealing analogy using his own professions – medic turned economic botanist:

> An ancient maxim, applicable to the living frame, informs us that where irritation exists, thither you will find a determination of blood. The same maxim, thus modified, is equally applicable to the body politic; "Where wealth is, there you will find shops;" and, in like manner, as a sore on the finger may affect the general health, so may the enticing contents of a few well-stocked shops affect the industrial habits of a whole community, by creating new wants and exciting new desires, suited to stimulate the industry of both the ambitious and the indolent. Such would soon be the effect in India of the unlimited introduction of British manufactures in exchange for our raw material.[56]

Wight had been picked up on the subject of the decline of Indian manufactures by the anonymous critic to whom he showed his 1836 report, as a result of which he appended an extensive series of notes, explaining and elaborating his views. This anonymous critic had pointed out that it was only the opening of trade in 1814 (i.e., following the renewal of the EIC's charter in 1813) that had stopped India being a manufacturing nation, and also told Wight that the number of looms in India was currently increasing. Wight refused to believe that the traditional manufactures ('trinkets and jewellery excepted') were of any value, and offered, as somewhat disingenuous proof, the fact that imports by India increased when the choice of finer articles became available. On the other matter, Wight would be happy if it were shown that Indian looms really were increasing, and if so they should be improved technologically by introduction of the 'fly-shuttle' in order to reduce production costs. Another of Wight's beliefs, typical of his background, was in the value of free trade and 'external commerce', without which it was impossible to enrich a country or 'stimulate industry beyond a certain point'. He was therefore pleased that 'our exchange with England has … risen from 20 to 30 percent in favour of India in little more than four years', but increasing this would require a change in British law, to 'place our commerce on the same footing in regard to duties as that of the more favoured colonies of the West Indies and Demerara'. Wight also believed that 'non-interposition of Government is always desirable in matters appertaining to trade and commerce'.

On the question of credit Wight strongly backed the use of usury laws, with fixed interest rates, which he thought benefitted the 'welfare of the community at large' rather than 'a few holders of capital … [with] a monopoly of the money market'. Another reason for wanting to change the credit system in India, other than freeing the *ryot* from his burden, was to encourage European speculators to settle there. While it goes without saying that Wight thought that 'India has much to learn from Europe', if such Europeans with 'their capital, credit, knowledge of business … skill in arts and political influence as a professional body' went there, they could show:

> the natives the advantages of European science and arts, which judging from their quickness and intelligence in following, when unqualified to lead, there is little reason to doubt they would soon avail themselves.

While this repeats the usual racial stereotype (Indians as followers not leaders), Wight had earlier in the report stood up for the natives on charges of apathy and aversion to innovation, on grounds of their poverty, and regretted the 'want of confidence in us and our good wishes towards them' that such charges indicated, admitting that India 'has much to give in return for the knowledge she may receive from [Europe]'. Wight, however, believed that Indians could only learn by 'example not precept … because their language, even were we perfect masters of it, does not possess [the means] to convey to their minds our abstract ideas. – This language, therefore, has still to be formed, and must be derived from visible things, not from imaginary conceptions'.

Wight's solution to increasing the growth of mercantile crops was by decreasing the production of food crops (of which, rather remarkably, he thought there was an excess, but for which there was no export market) and the question was how this could be made economically possible. Given his care for the welfare of the *ryot*, Wight seems curiously unconcerned that decreasing the area under food production would inevitably push food prices up, and comforted himself with the thought that 'consumption becomes steady in proportion as the number of consumers increase, and producers diminish'. And that, with developing expertise, the cost of producing commercial crops would decrease, and put competition in foreign markets on a more equal footing.

Another concern of Wight's was how to improve trade within India. He believed that 'indirect taxes on consumption are always the most productive and least felt by the payer' and thought this sort of tax on goods in the market (whether food or manufactured articles) fairer than taxing land or the manufacturer of goods. In the former case money had to be borrowed by the farmer or producer for his initial outlay, which increased the cost to the purchaser. On the other hand, if it were the product that were taxed then 'each consumer thus pays his exact share and no more, depending altogether on the quantity he consumes' and that 'only amounting to a fraction on each meal he eats throughout the year'. This would also have benefits in years when crops failed, when the farmer lost out all round: having already paid tax on the land, he also lost all the money he had spent (or borrowed) on seed and labour.

Wight pointed out that internal trade in India was currently hampered by duties on coastal trade, collected by often corrupt Native collectors of Customs duties. One reason for wanting these abolished was also a philanthropic one – that in times of famine it restricted the bringing of grain to places where it was needed. Other restrictions on trade were in place. For example, cheaply produced salt was one of the few commodities that Madras had to offer for trade, but its import into Calcutta was either banned or heavily taxed. The cost of production of rice in Madras (due to 'unfavourable soils' and the expense of irrigation and transport) was higher than in Bengal, and Wight thought that if internal trade were easier, then it would be more efficient to develop commercial crops in Madras, and import rice from Bengal when necessary. Related to this was the need for better internal transport, and his early, and enthusiastic, advocacy of the development of rail roads.[57] One of the few agricultural matters on which Wight touched in the report were the soils of Madras, and how these might be suited to the growth of commercial crops. Of these there were two main types, 'red' and 'black', the latter being the more highly valued. Preliminary evidence obtained from Ram Singh, the 'principal cultivator' of American and Bourbon Cottons, and Tobacco, in the Tinnevelly District, however, had suggested that the red soils might actually be the better for commercial crops, which would have the benefit of freeing the black soils for food production. These matters will be returned to in chapter 15.

Reference has been made to the Notes appended to Wight's report as a result of criticism by 'a gentleman much more conversant with such subjects than the author'. The identity of this individual is unknown, though is likely to have been a local Revenue Department official in Tinnevelly, rather than one of Wight's military colleagues. The most interesting of these is Note IV, a result of the observation that high agricultural rents were not unique to India, but were also a feature of British life. This provoked a long essay on the 'fluctuation of prices in England [sic, but actually Scotland]', which has to be read in the light of what is known of the finances of Wight's father. Wight attributed the fluctuations following the Napoleonic wars primarily to irresponsible printing of paper currency by Scottish provincial banks, and also a 'rage for speculation'. This paper money had led to inflation, exacerbated by poor harvests in 1810–2, but a crash had come with a good harvest in 1813 and resulting fall in crop prices, when 'many farmers holding farms at exorbitant rates failed'. Alexander Wight certainly 'failed' in 1813, and this digression by his son suggests that the blame was put on the failure of one of his farms. This suggests that Wight *pater* had not revealed the full extent of his coal mining speculation (the real reason for his bankruptcy in 1813) to his family.

After this 1836 report, Wight hardly ever returned to broader economic issues. However, in the *Illustrations* is to be found one example of a botanical commodity Wight believed could be useful in Britain, were it not prevented by prohibitive import duties.[58] This was a kind of candle made from the resin of the dammer tree (*Vateria indica*) that burnt with 'an agreeable fragrance' and gave a 'fine clear light, with little smoke, and consumes the wick so as not to require snuffing'. Some such candles had been sent home, where they were highly prized and sold for high prices, but 'the protective duties on made candles imported into Britain is so high as to amount to a prohibition, and put a stop to this trade'.

FIELD EXCURSIONS AND STATISTICAL ACCOUNTS: MALABAR AND THE MOUNTAINS

Wight assured Arnott that it did 'not take long to write one of these reports when the pen is once fairly in hand, yet it takes no little time to prepare and arrange the materials for them', but, given Wight's laboured and repetitive style, this boast seems more than somewhat disingenuous.[59] In any case it must surely have been a relief when the digest of the agricultural returns was complete, and in June Wight was back in the field – at Quilon on the Malabar coast, where he took time off from his economic duties for 'a day's excursion to the salt-water swamps' to look at mangroves (Book 2 Plate 43), finding seven species 'in the course of a forenoon'.[60] This expedition must have required a certain bravery on Wight's part, as he would later note the dangers of this habitat from the 'constant exhalation of noxious vapour from [mangrove] roots',[61] showing him to have been a believer in the miasmic theory of disease.

In order to obtain the information sought by the Government on the hill regions, Wight planned a great autumn journey, but before this he returned from Quilon to Palmcottah by way of Courtallum, 'a near cut home, but at present not a safe one, on account of the unhealthy season, and also on account of a man eating, *alias philanthropic* tiger, which infests that road'.[62] It was while at Palamcottah that Wight wrote a prescient article urging the development of the harbour at Tuticoreen from which to export the produce of the

Tinnevelly District. He had visited this part of the coast in May and June 1835, and realised that Tuticoreen had the huge advantage over Madras of having:

> a safe roadstead with good anchorage, in which vessels can ride at all seasons of the year, and take in their cargoes during the prevalence of the north east monsoon.

In the article Wight also called for the improvement of roads to take produce (cotton and the other new crops he was trying to promote, such as mangosteen, coffee and potatoes) to Tuticoreen, and also for the development of railways and the use of 'locomotive steam carriages', which could be powered by sacrificing the 'trees of smaller growth' from the Western Ghats, converting them into 'coke'. Like Alexander Gibson in Bombay,[63] Wight had no illusions about the value of forests *per se*, and thought that such forest clearance would be beneficial: 'opening, to the labours of the cultivator, an immense tract of country, which has hitherto been the refuge of wild beasts [like the 'philanthropic tiger'], and a generator of that most pestilential miasma which produces jungle fever [the Courtallum experience speaking here]'.

On 5 August 1836 Wight set off from Palamcottah on his longest expedition since that undertaken as Madras Naturalist almost exactly ten years earlier. During this expedition he intended to 'travel over nearly 1000 miles'. The purpose was to answer the questions of paragraphs 11 and 12 of his brief, but one can sense his excitement at the prospect of a trip in which he intended to take in all of the highest hills of southern India: the Sivagiris ('Shevaghury, between 5000 and 6000 feet … reported by the natives as intensely cold'), the Palnis ('Pulney hills, said to exceed 7000 feet'), the Shevaroys ('Shewarries, between 5000 and 6000 feet') and the Nilgiris ('Neilgherries, above 8000 feet'), intending to visit Coorg ('a country unexplored by naturalists') before descending to Cannanore on the Malabar coast.[64] Although the trip was curtailed (from the Shevaroys he returned to Madras where he had arrived by mid-November), the results of this excursion were spectacular, not only in terms of information satisfactory to his masters, but in terms of his own botanical work and the substantial herbarium collections he made.

The initial idea had been to go straight to the Palni Hills, which Wight had first visited in 1826, but having heard of some interesting hills to the west of Sivagiri said to be of 'greater elevation than those either to the North or South', he made a detour of a few days. The hills were not as high as reported (only about 4580 feet), but the geology proved interesting, and he submitted a report of this visit to the Madras Government that was unfortunately never published. Wight then continued north to the Palni Hills where he spent 'the better part of three weeks' in September, in poor weather, and on which he wrote a second report.[65] Wight had a low opinion of the lower tiers of the Madras administration and was anxious that his work should be seen by the Government both in Madras and Calcutta. He complained of having to send reports:

> through Revenue Boards and such like impediments to improvement, by which our system is beset in all directions, and the ears of Government kept close to every suggested improvement … many is the good suggestion that is strangled in the passage through these Boards, of which the Government never hears a syllable.[66]

In fact both reports duly reached Calcutta, and the Governor General himself (Lord Auckland) recommended publication of the

Palni one, which duly appeared in the *Madras Journal of Literature and Science*, under the title 'Statistical Observations on the Vurragherries, or Pulney Mountains'.[67]

As suggested by this title, these reports are in the tradition of the *Statistical Account of Scotland*. The importance of this work as an inspiration for similar surveys in India is worth looking at in a little more detail. Sir John Sinclair, originator and editor of the pioneering Scottish survey, explained the rationale, and the then unfamiliar term 'statistical' that he had first encountered on a tour of Germany in 1786, as follows:

> in Germany they were engaged in a species of political inquiry, to which they had given the name of *Statistics*; and though I apply a different idea to that word, for by Statistical is meant in Germany, an inquiry for the purpose of ascertaining the political strength of a country, or questions respecting *matters of state*; whereas, the idea I annex to the term, is an inquiry into the state of a country, *for the purpose of ascertaining the quantum of happiness enjoyed by its inhabitants, and the means of its future improvement*; yet, as I thought that a new word, might attract more public attention, I resolved on adopting it, and I hope that it is now completely naturalised and incorporated with our language.[68]

Sinclair achieved his monumental task (21 volumes covering the whole of Scotland) in a mere seven years, by sending questionnaires to the Ministers of the Church of Scotland parishes. An illuminating account of the methodology was provided in vol. 20, with a list of the 166 minutely detailed questions under the headings of: 'Geography and Natural History', 'Population', 'Productions', 'Miscellaneous' and 'Addenda'. These cover a quite extraordinary range, aimed at providing a precise documentation of the country – its geography, and its human and natural resources. Of the more surprising questions, two will suffice to show Sinclair's insatiable curiosity: 'Are there any remarkable echoes?', 'Have any murders or suicides been committed?' Needless to say, not every minister answered every question.

The account by the Rev Henry Sangster for Pencaitland, the parish of Wight's birth, is a typical example, and includes descriptions under the headings:

Form, Extent, River and Surface
Soil, Cultivation, and Produce
Farms and Rents
Minerals and Mineral Waters
Climate and Diseases[69]
Woods (150 acres, and 191 of plantations)
Villages
Provisions and Wages
Industry[70]
Ecclesiastical State
School
Poor
Character and Mode of Living

The total population was 1033, among which the following trades and professions were listed:

Minister 1	Tailors 5
Heritors[71]: 3 resident, 4 non-resident	Weavers 9
Farmers 9	Smiths 3
Masons 4	Dyer 1
Carpenters 4	Bleacher 1
Colliers and their families 110	Teacher 1
Shoemakers 2	Inn keeper 1

Wight's reports on the Shevagherries and Pulneys follow Sinclair's pattern rather closely, covering topography (including altitude and temperature), geology and soil, vegetation and botany, productions (crops and irrigation), climate and health, population, people (habits, clothes, transport), and possibilities for improvement.

The list of castes and professions quoted by Wight came from an earlier survey of the Palnis, made around 1820 by Benjamin Swain Ward, and is somewhat more colourful than that for Pencaitland: the villages of Pautchoor and Perryur will be given as an example. Together these had a combined population of 560 occupying 119 houses. Of religious edifices there were three Shaivite and three Vaishnavite temples, and 18 'sundry petty temples'. The agricultural resources consisted of 68 ploughs, 137 oxen, 145 cows and 112 buffalo. These two villages were the most diverse in terms of the castes of the inhabitants, having within them 13 of the 18 given for the hills as a whole:

Kunavar Vellalers [farmers]	247
Vullayen [?coolies]	12
Vellam Chettys [merchants]	20
'Artificers'	41
Kongu Chettys [merchants]	9
Washermen	5
Tellunga Chettys [merchants]	60
Barbers	6
Kamplears [farmers]	1
Tottyars [farmers]	4
Osleakauren [government servants]	7
Pelian ['tribals']	124
Chucklers [shoemakers]	9

The most approximate of British equivalents, kindly provided by Professor A.L. Dallapiccola, are given in square brackets. But when it is discovered that the Tottyars claimed descent from the eight thousand gopastris (milkmaids) of Krishna, and the original profession of the Karakat Vellalers (listed for some of the other villages) was 'saving or protecting the clouds', the diversity can be seen to be something altogether more exotic and colourful than the trades and professions of Pencaitland. This vividly demonstrates the richness and complexity faced by Scots such as Wight in their encounter with India – be it of the people and their languages, their history and archaeology, or its native flora and fauna. By juxtaposing the two, it also shows such detailed documentation in its true historical context – that of categorising human and natural resources, not *only* as a means of imperial control, but as part of an enlightened agenda of improvement, with a view (as explicitly stated by Sinclair) to improving the lot of the people and the productiveness of the land, and not just for the benefit of a ruling elite. It should, however, be noted that the Shevagherry and Pulney reports are unique in Wight's output.

Although largely devoted to 'statistical' matters, these reports cannot help but betray some of Wight's personal interests. In the Shevagherries it was geology that particularly intrigued him,[72] an interest not recorded elsewhere in his work, and one that has been overlooked by historians of Indian geology. Wight thought

his discovery of 'an immense primary sandstone formation' that formed the eastern face of these hills to be especially significant. The minerals he identified as occurring in this formation (quartz, feldspar, mica, hornblende and garnet) show a reasonably detailed knowledge of the subject, perhaps suggesting an influence from Robert Jameson, Professor of Natural History at Edinburgh, though Wight does not appear on any of his class lists. This is also the only place other than Courtallum where Wight recorded an appreciation of the picturesque value of landscape – in a description of the general appearance of the country as:

> exceedingly agreeable ... low hills with rounded grassy tops, and their bases skirted with belts of wood, in some places so regular, that they looked like plantations ... hills ... clothed with verdure and ... most inviting, only wanting, to complete the picture, a few hamlets and smoke.

Botany, of course, also featured and Wight took the Shevagherry Hills to be what would now be called a centre of endemism (the flora was 'peculiarly local and distinct from the rest of India'). Despite wet weather, and the swarms of 'jungle leeches, which rendered botanizing most disagreeable',[73] in only three or four days Wight collected 250–300 species, including six balsams that were new to him. Ten years later he would write that this was 'the richest station, in proportion to the extent explored' that he had ever encountered,[74] and it therefore seems curious that he never returned.

The Palni visit was something of a pioneering excursion. Unlike, for example, the Nilgiris, these hills were at this point little known to Europeans, with the exception of a single report made around 1820 by B.S. Ward, and the short visit Wight himself had made in 1826.[75] It was not until 1845 that Kodaikanal was founded by American missionaries, and in Wight's time the highest permanent settlement was at Shembaganur (which he recorded as at 5600 feet). Wight briefly described the vegetation – forest on the lower slopes; the upper parts (reaching 8000 feet in the peak of Permamallie) covered in grassland. At these higher altitudes Wight noted European families and genera of flowering plants, and that this perhaps occasioned a little homesickness is shown by the fact that, while in the reports Latin names were exclusively given, in a letter to Arnott some were given in Scots – *Rumex* spp. were 'dockens', and *Juncus* spp. 'thrashes'.[76] The flora Wight found extremely rich, collecting 500 species in under three weeks, including many novelties that he would describe gradually over the next 17 years. The people of the Palnis lived in 'extreme poverty', their main cash crop being garlic, and Wight recommended that attempts be made to 'ameliorate the condition of the hill population', not by remissions on taxes (lest 'what was first received as a boon might afterwards be claimed as a right'), but by application of the revenue raised there (a mere Rs 3300 per year) to items of direct local benefit. These would involve providing better varieties of grain seed, improving the roads, building rest houses (*choultries*) and bunds to enable the collection and storage of rain water. Wight noted that the population had declined by almost a half (from 3299 in *c.*1820, to 1648 in 1836), which he could not explain, but is likely to have been due to water shortages

in the dry years of 1831–3. He also suggested trying new crops such as coffee, which he had seen growing in the Kandy region of Ceylon,[77] and, at lower altitudes, sugar cane.

From the Palnis Wight went to the Shevaroy Hills, but no report on these hills has been found, and from there he appears to have returned to Madras. The Shevaroys had evidently been suggested as a sanitarium, but Wight pointed out that looking at the botany would have shown this to be a bad idea. Plants could be indicators of 'salubrity', and families such as the predominantly temperate Ranunculaceae, which in India grow only above the 'fever zone', were absent from the Shevaroys.[78] This was the end of Wight's first year as an economic botanist, and when submitting the Palni report (from Salem, at the base of the Shevaroys) Wight asked for an extension to be allowed to continue such work:

> of investigating the seemingly unbounded resources of this country ... the productiveness of which probably from absence of due exploration has up to the present period been so utterly disproportioned to its immense extent ... [entreating the Government to] consider whether the vastness of the benefits which might thus be derived ought for a moment to be balanced against the loss of the services during a period of almost profound peace of a single individual in a department already abundantly provided with able and efficient officers.[79]

The Madras Government, not surprisingly given Wight's huge productivity in 1836, was pleased with the results, which they accepted were 'for the good of the country', but they had to seek approval from Calcutta to extend the period of Wight's employment after the end of his first year. The reaction of the Supreme Government was not unqualified, as expressed in a minute by the Governor General, Lord Auckland. Auckland was a great supporter of Griffith's botanical travels,[80] encouraged Wallich's work at the Calcutta Botanic Garden in a spirit of warm friendship,[81] and would later subscribe for two copies of Wight's *Illustrations*. In light of this it therefore comes as rather a surprise that Auckland, while allowing a further year's employment from December 1836, was not uncritical of Wight's efforts. Although 'decidedly in favor of encouraging such enquiries as those on which Dr Wight has recently been engaged' Auckland considered that Wight had not done enough in the way of 'condensation of the existing materials',[82] and that 'he be instructed to act upon a more specified and definite plan rather than upon the sort of roving commission of philosophy under which he seems to have been lately engaged'.[83] Auckland did, however, consider that some of Wight's work should be made available to a wider audience, and, as already noted, recommended the publication of Vuragherry [Palni] paper. Attitudes in Calcutta were thus less enlightened than in Madras, but more importantly Wight's work was appreciated in London as revealed by an anonymous annotation, which can only have been written by one of the Directors or a Company official:

> the measures adopted by the Govt. of Madras [i.e., Wight's work] as an example worthy of imitation. There the true spirit of inquiry is shed abroad, and without waiting in doubt as to eventual success we earnestly trust that similar measures may immediately be put in train throughout the Presidency of Bengal.[84]

PLAN
of the
TOWN of MADRAS
AND ITS LIMITS.

Wight's House

Lacy Grey Ford's
House

Agri-Horticultural Society

Site of the Nopalry

Moubray's
Cupola

St Mathias, Vepery

St Mary's Cemetery

FORT ST GEORGE

Sir Thomas Munro
Statue

J B Pharoah's House
and Asylum Press

St George's Cathedral

BLACK TOWN

Fig. 22. Madras in 1840.
Lithograph transferred
by E.A. Rodrigues,
published in Marsden's
*Madras Almanac &
Compendium of Intelli-
gence for 1840.* Various
sites associated with
Wight have been added.

Madras and Work on Economic Plants 1837

The sensitive Wight was deeply hurt by the mixed response of the Governor General, which he took as a 'hint … that I am making a Job [i.e., a public service turned to private advantage] of an appointment I now hold, though well known to them that I am actually making sacrifices for the benefit of the country and the advancement of science'.[1] He sounded off in a letter to Hooker stating that he was considering asking for the next vacant medical posting 'worth holding' (i.e., well paid), saving as much money as possible, and retiring. However, he clearly did not really want to go back to medicine and wrote a spirited letter of self-defence to the Madras Government. The letter is revealing, not least in the perhaps oversensitivity to what was only a rather slight criticism; it also shows the difficulties Wight faced in doing a near-impossible job, some of his future plans, and the breadth of his views on what might be possible.

As the concluding clause of paragraph 2nd of the letter of the Government of India [which claims there is no evidence of Wight's condensing of existing materials i.e., the Collectors reports, during the previous year] seems to imply that His Lordship in Council is of opinion that I am unnecessarily protracting the enquiry, I trust I may be permitted briefly to allude to the subject, as the supposition that such an opinion exists is a source of much uneasiness to me, conscious as I am that it is unmerited.–

In replying to your letter No – of January 1836 I stated my belief that the Collectors reports might be condensed in the course of a year, but that the enquiry could not be considered finished until the facts collected could be reduced to general principles applicable with slight modifications to suit local peculiarities, to all situations.– In collating the reports I found so many discrepancies and conflicting statements, in circumstances, apparently, nearly similar, that no such principles could be deduced, or even themselves always clearly understood without personal examination of the grounds on which they rested: a contingency which I certainly did not contemplate when I wrote that letter.– The, at that time, equally unforeseen publication of my instructions [in the *Fort St George Gazette*] has added greatly to my difficulties by leading the public to expect, so much more from the enquiry, than I undertook to accomplish, or indeed could be accomplished within so short a period in a manner compatable [sic] either with the respect due to the Government, which had so highly honored one by selecting me, unsolicited on my part, for the performance of this important duty, or with the slightest regard for the maintenance of my own character and reputation.

To these I beg leave to add with due respect and difference [sic, deference], for his Lordship's in Council consideration, that the small addition of 150 rupees to the staff allowance of my rank so far from being an inducement to procrastinate and thereby render myself so much longer a homeless wanderer, exposed alike to the pestilential [missing word] of our jungles and the insalutary [sic] heats of a tropical climate with no better protection than a tent, does not even cover my mere travelling expenses.

I entreat therefore his Lordship in Council, before he forms so unfavorable an opinion, to compare my situation with that of men similarly employed in Bengal and say whether such a sum affords even a suitable regard for the laborious nature of my duties, or the acquirements requisite for their performance, leaving altogether out of sight my previous length of service in India [17 years] and the personal risks to which I am exposed.– To my mind it is so far from being so, that only the sanguine hope of being useful to a Country to which we owe so much, combined with a partiality for scientific pursuits induced me to accept the office in the first instance and still induces me to wish for its continuance.

If in thus strongly expressing my feeling I have in any degree departed from the decorum due to the head of the Government I trust I shall be excused as the fault is most unintentional, and from no want of respect on my part.

With reference to the past the large tract of Country already explored, the still larger in course of being examined; the various Official communications to Government, which have all been favorably received and more or less acted upon; the extensive correspondence carried on with persons in all the presidencies; and the number of papers published in both the Madras and Calcutta scientific periodicals; all bearing on this enquiry, will I trust completely exculpate me from blame on account of both negligence and procrastination.– But should any doubt on this point remain on the mind of his Lordship in Council, I beg respectfully to request him to ask the opinion of Dr Wallich, or any other man conversant with scientific researches, whether the duties assigned in my published instructions are such as can be hurriedly performed either usefully to the Government or creditably to my own reputation.

For the future, as heretofore, my plans are all directed to the attainment of one grand object, the extension and improvement of our agricultural and commercial productions. With this view I am now engaged in superintending the constructions of an improved sugar boiling apparatus and a light plough suited to this Country but on the best English Model. To the same end I am preparing a series of papers for circulation embodying the most improved methods of cultivating the more valuable articles of commerce, cotton, coffee, sugar, tobacco &c with such suggestions for further improvement as a careful study of vegetable Physiology may supply.– While these are in course of trial, my tour of the southern provinces will be completed, numerous specimens of soils collected from nearly all parts of the peninsula analysed, and the Collector's reports condensed and deficiencies supplied from the personal experience I am daily acquiring.

In addition to the occupations whatever leisure I may have, will be devoted to such collateral subjects of enquiry as may from time to time present themselves.– Thus conducted it is difficult to determine the period to which this enquiry will extend as its completion does not depend on my individual exertions.– But should the plan appear

circuitous or dilatory to his Lordship in Council, I shall willingly endeavour to shorten it to the utmost by nearly [sic, merely?] the materials already in my possession.– In deciding however on this point, I would again respectfully beg leave to solicit the attention of his Lordship in Council, to the question whether or not my Services are employed more profitably to the state in such pursuits, than in a department already amply supplied with able and efficient Officers … '.[2]

This is also of interest as a pre-echo of events ten years later, over the cotton experiment, on which occasion it would be the Madras (rather than Calcutta) Government who accused him of spinning out a job.

Wight, as he would on several later sticky occasions, stuck to his guns and did not return to medicine. Despite the Supreme Government's quibbling he had the support of the Court, and that of Elphinstone and at least most of the Madras Government, who continued to employ him working on economic botany. It appears that Wight was based in Madras from early 1837 until 1840, followed by a two year period of travel when Madras was still 'home', until moving to Coimbatore in 1842. During this period Wight lived at Keelpaukam (now Kilpauk), which then formed the extreme western fringe of the city, in a garden house on what is now called Mandapam Road [fig.22]; the garden was bounded to the north by a drainage channel, now called the Otteri Nala, and one rather wonders about the 'salubrity' of its situation.[3] It was in this garden that Wight must have undertaken the small-scale agricultural experiments on which he reported to Wallich in August 1837:[4]

> Since writing the note on the culture of the vine[5] I have commenced their culture with a view to reduce principles to practice. I hope in a few months to have all my walks trimmed with them – very fine I guess.– A bed of Senna is nearly ready to transplant – & then what next?[6]

Almost no details are to be gleaned from Wight's publications about his gardens in Madras, Ooty or Coimbatore, but he once wrote of having to take down a 'handsome arbour' of a convolvulus called 'snake creeper' (possibly *Argyreia speciosa*), since, far from scaring off snakes as the natives believed, Wight found that these creatures positively took 'shelter under the abundant cover it affords for their concealment';[7] perhaps this arbour was at Kilpauk.

It is clear that Wight was on very good terms with Lord Elphinstone [fig.26], who supported and took a personal interest in his botanical and agricultural work. However, as has been seen there were differences of opinion between Madras and Calcutta, and, as will be seen later, also within the Madras Government. It must have been on Elphinstone's orders that appeal was therefore made on 3 February 1837, to the Court of Directors, seeking approval for Wight's continued agricultural employment 'to enquire and report on the cultivation of Tobacco, Cotton and other articles of Agricultural and exportable produce',[8] and in April of the same year further approval was sought, to which the Court agreed – supporting Wight's researches 'for such time as you may consider desirable', though this positive reply cannot have reached Madras before December 1838.[9] Meanwhile, in March 1837, Calcutta was still quibbling, and while grudgingly allowing Wight's enquiries to be 'valuable' these were deemed 'still exceedingly indefinite' and they asked for half-yearly reports of his work, the first of which was submitted on 1 November 1837. This lithographed report, if short, is extremely interesting, telling of the circulars on senna and cotton Wight had

drawn up and distributed via the Revenue Department, and of his own experiments on the yield of wool from various types of cotton seed. However, as always, Wight procrastinated over the sending of the report, in this case so that he could enclose one of his earliest lithographic efforts, the lichen plate to be described below. Also reported were the lithographic schemes that would shortly emerge as the *Illustrations* and *Icones*.[10]

This was not enough, and receipt of Wight's report in Calcutta precipitated another crisis. On 26 February 1838 Ross D. Mangles, Secretary to the Government of India, wrote to Henry Chamier reiterating the earlier doubts of the Supreme Government about 'the expediency of creating an appointment of so desultory a nature as that which has been assigned to Mr [sic!] Wight' and that the 'President in Council' considered it desirable that 'measures should be taken to bring the operations conducted by Surgeon Wight to an early termination'.[11] Although Elphinstone cannot at this point have known that he would be backed up by the Court in London, he wrote a passionate letter to Calcutta, stressing the importance of Wight's work based on information not apparent from Wight's brief report, and pointing out something that would appeal to their economical minds, namely that 'the whole amount of the charge of Dr Wight's Office is but 215 Rupees *per mensem*, out of which he pays his own Writers and Draftsmen'. And that, in contrast to Calcutta, in Madras 'there is no Officer [other than Wight] to whom Government can apply to for information on subjects of a scientific nature connected with the productions of the Country and the development of its natural resources' and that 'persons of every rank and calling are in the habit of consulting him on all matters appertaining to agriculture and horticulture, his various publications on these sciences having made known his qualifications … regarding them'.[12] Elphinstone then asked Charles M. Lushington of the Madras Revenue Department to write a minute on the value of Wight's work to be sent with his plea to Calcutta. It is clear that Elphinstone cannot have read this minute before it was enclosed with his letter of support, as in it Lushington was extremely antagonistic, agreed with Calcutta, and concluded that 'Dr Wight should be immediately directed to resume the proper duties of the situation to which he stands appointed [i.e., doctoring Sepoys]'.[13] This was an amazing piece of skulduggery, and it is surely significant that this Lushington was none other than brother of Wight's old enemy Stephen Rumbold Lushington, who had done exactly the same in the case of the Naturalist's post 10 years previously. Does this merely indicate philosophical/fiscal differences of approach, or does a personal feud lurk in the background here? Fortunately in this case Lushington's advice was not acted upon – the Court's support was received, and Wight continued with economic botanical work for the rest of his time in India.

Wight's Cotton work undertaken during this period will be treated later (see Chapter 15), but that on other, lesser, crops made at this time will be discussed here.

SUGAR

Sugar cane was first mentioned by Wight in a letter penned on his productive trip of the previous year, and sent to the Madras Government from Salem on 1 November 1836.[14] The occasion was the equalisation of duties on East and West Indian sugar imported into Britain, which meant that it became worthwhile to try to improve Indian sugar, which for centuries had been produced from native (or

at least long-established) varieties of *Saccharum officinarum* – the locally produced sugar being known as 'ganjam'. In 1792 William Roxburgh had first investigated its cultivation (with a view to improvement) around Samulcottah, and in 1796 imported to the Calcutta Botanic Garden a better Chinese form that he described as *Saccharum sinense*.[15]

Wight stressed his inexperience in the matter, but urged trial by experiment, and the introduction of better yielding varieties from Mauritius, which he hoped it would be possible to grow unirrigated on red soils (in contrast to the indigenous varieties that were grown, irrigated, on black soils).[16] Wight rode out from camp and, despite a drought, was impressed by the contrast between the lushness of the native grain crops and the state of the sugar cane.[17] The cane, 'though nearly four months old, [was] small and puny' and to account for the difference Wight came up with the explanation that:

> from the long continued practice of cultivating the sugar cane as a wet crop it has lost the power of resisting drought, with which, in common with most tropical land plants it is endowed by nature to a very great degree, and has acquired the habits and peculiarities of an aquatic plant.

The (to us astonishing) logic is similar to that used in the 'homöothermal' papers: if Wight thought such conditioning, and alteration of physiology, was possible within the lifespan of a plant, then he was making a false analogy with animals; or, on the other hand, if he thought that it happened over generations, then he must have believed in a Lamarckian inheritance of acquired characters. Wight recommended that the *ryots* try growing a few canes among the grain crops, but met resistance as this was 'so diametrically opposed to their own constant practice and preconceived ideas'. Nevertheless Wight urged continuing such experiments to see if the native cane could be improved 'by a progressive change in the mode of culture', as this would be cheaper than the alternative – importing the Mauritius variety. The Governor, Sir Fred Adam, who considered Wight's analogy sound, supported the former method, and reasonably argued that the natives would not 'readily undertake experiments the results of which would appear to them uncertain without some strong inducement'. Adam therefore recommended a total remission of tax on land put to such purposes for a period of two or three years.[18] This took place, but was later retracted on instruction from the Court, and, in a belt and braces approach, canes were at the same time requested from Mauritius. When these eventually arrived, two years later, Wight, as secretary of the Agri-Horticultural Society, wrote a circular to the District Collectors on how to cultivate the Mauritius cane, and soliciting requests for plants to be supplied by the Society. Wight later published a pamphlet on sugar cane cultivation, which was widely distributed (both in English and 'vernacular languages'),[19] and even reprinted in the 1842 *Madras Almanac*. The response was overwhelming, and requests amounting to a total of 83,600 canes were received by the Society, which could not be met; in the end 1860 canes were distributed to the districts of Salem, South Arcot, Chingleput and Karur.[20] Other varieties of cane were tried, including the 'Otaheite 190 in 10 bundles; Singapore 50 in two bundles … and 10 striped Java canes in 1 bundle' sent to Wight by Wallich in October 1839.[21]

The Mauritius cane certainly proved superior to the native one in yield, but despite this, according to Ratnam, the *ryot* continued with his low-yielding, native varieties because of a failure of 'the Government of the day … [to] offer any economic benefit from putting in extra labour'.[22] As will be seen, Wight's sugar work was in every way (trying to persuade the *ryot* to grow an exotic form of a traditional crop, differing soil preferences of the native and exotic, and the offering, or not, of economic inducements), an uncanny foreshadowing of the American Cotton experiment. Wight was correct in believing that the better varieties could be grown, and the problems were largely economic. As with cotton, real improvement in sugar in South India did not occur until into the twentieth century – with breeding programmes, tariff protection, and capital investment in sugar factories.

SENNA

Senna was another of the crops specified in Wight's 1836 brief. The dried leaflets of this legume were then in wide use as a purgative, and imported into Europe to the astonishing value of £4,000,000.[23] According to Wight 3–400,000 lbs were imported into India, of which 200,000 were re-exported to England; but this still left 100,000 lbs consumed in India. In 1837 Wight published two papers on senna, which, given the size of the trade, and the desirability of India's becoming self-sufficient in this commodity, he thought promised 'a very large return to the speculator'.[24]

Wight's first senna publication took the form of an addendum to a paper reprinted from the *Transactions of the Medical Physical Society of Calcutta*. The original paper was by Wallich, whom Wight charmingly referred to as the 'Magnus Apollo of Indian Botany', and concerned the species of senna then known as *Cassia lanceolata* (now *Senna alexandrina*). This was an important export of the Tinnevelly district, where it had first been introduced (apparently from Arabia, some time prior to 1826) by George Arthur Hughes of Palamcottah.[25] In this paper Wight described the method of cultivation and drying encountered when examining the plantations in early 1836. The crop was grown as an annual, three gatherings being made from each plant, and the leaflets dried in 'a current of air in a dark room', with the scarcely surprising result that 'acetous fermentation' occurred. As he had for herbarium specimens, Wight recommended rapid drying in the sun, the method adopted in Egypt. Once again Wight urged an experimental approach – for example, to determine if the lesser activity of the Tinnevelly leaves, as compared with Egyptian, was due to the drying method, soil type, or even the possibility that the activity of the Egyptian drug actually lay in materials with which it was adulterated.

The second paper came about in response to a government request, issued by the 'Drug Committee', that India should become more 'independent of foreign aid in the medical store department'. Wight realised that the 'Hindoo Materia Medica … embraces many medicines of vast activity', one such being what he took to be a native plant known to him as '*Cassia Burmanni* Wall[ich]' (now *Senna italica*), the subject of this paper.[26] However, Wight believed that the native pharmacopoeia – as had the European one two centuries earlier – also contained many 'unworthy articles' and again urged 'repeated experiment and observation, carefully distinguishing, at every step, between the jarring coincidences of *post hoc* and *propter hoc*'. Such experimentation was to be carried out 'not by one man, or in one place, but by many, and in different situations, each, moreover, making sure that he is experimenting on the same plant'. Which raises the question of the need for accurate identification, and the difficulties of achieving this. Wight had long thought this best achieved by publishing illustrations, and this had been given

official blessing in paragraph 10 of his 1836 brief. With this paper was therefore issued a hand-coloured plate of *Cassia Burmanni*, based on a drawing by Rungiah lithographed professionally by 'Winchester', as a model for this long-contemplated work. It should be noted that Wight's interest in a second, bioactive species of senna was the possibility that it could be mixed with the better known one 'on the well known principle that two medicines possessing similar properties act better in combination than either separately'.[27] Given his earlier scathing comments (see pp.41, 59) on native 'polypharmacy' this comes as something of a surprise.

LICHENS

As part of a wider interest in non-flowering plants Wight had collected lichens, and sent specimens from Negapatam to Greville in Edinburgh, as far back as 1830. At this time the dye properties of lichens (such as litmus) were becoming known, and deemed worthy of investigation with a view to commercial exploitation. In 1837 imports into Britain were worth £60,000 to £80,000 and came from as far afield as Sardinia, South America, the Cape of Good Hope, the Canaries, Madeira and the Cape Verde Islands, with the 'Tartarous Moss' presumably coming from China.[28] The Royal Asiatic Society of Great Britain had written to the Governor General (Lord Auckland, who, curiously was Greville's wife's first cousin), sending samples of 13 useful species, and three useless ones that might be confused with them, to stimulate a search for dye-yielding lichens in India. This material must have been circulated, as Wight asking Rungiah to draw fourteen of the varieties sent by the Asiatic Society, and an additional one, *Usnea florida* var. *strigosa* [fig.23, top right], that he had found on 'branches of trees in the Hill jungles', but which 'did not give out any colour to Ammonia'.[29] Wight himself lithographed these drawings, which he submitted to the Madras Government in November 1837.[30] By this time Madras had a new Governor, Lord Elphinstone, but like his predecessor (and cousin) Adam, one who also realised the value of Wight's work and ordered

Fig.23. Plate of lichens, lithographed by Wight from drawings by Rungiah, issued with vol. 5 of the *Transactions of the Agricultural and Horticultural Society of India* (1838). Royal Botanic Gardens Kew.

100 copies of the plate to be made and coloured, for which Wight was reimbursed to the tune of Rs 70. No copies of these coloured versions have come to light, neither have Wight's 'observations and suggestions thereupon', and his contribution to Indian lichenology has been entirely forgotten. The intention was to distribute the plate 'for the purpose of aiding the diffusion of a knowledge of these plants throughout India, and their collection'. 500 uncoloured copies were also sent to the Agricultural and Horticultural Society of India in Calcutta, which were published in its *Transactions* along with the correspondence on the subject from the Asiatic Society.

EDUCATIONAL BYWAY: THE PULICAT FARM

Following his Government instructions, Wight's major concern in 1837 was how to encourage the growth of crops such as American cotton, tobacco and senna 'with a view to the extension of our external commerce'. But, so far, the only such crop to have had any success in India was indigo. Wight realised from information from the District Collectors (and as has been seen in the case of sugar), that the greatest block to agricultural diversification was not the 'proverbial apathy and aversion to innovation (with which the native is constantly reproached)', but the lack of 'steady and ready markets' that might induce the *ryots* to take the necessary risk in the matter of new crops that 'poverty forbids'. This led Wight into a correspondence with the Madras Chamber of Commerce, whom he realised was in a position to 'do more towards lightening the load under which the country labours than even the Government itself'. This would have a double benefit: the Chamber having it 'in its power to minister to his [the *ryot's*] wants, and do much towards ameliorating his condition, and at the same time to advance its own objects, by merely authorizing Revenue Officers to promise on its account the ready market so eagerly sought for by the Ryot'.[31] The response was better than Wight could have hoped for, and the Chamber enthusiastically suggested setting up a company to run an experimental farm in the neighbourhood of Pulicat Lake (about 25 miles north of Madras), for growing various cottons under Wight's supervision.[32]

Wight could not, of course, do this unless given leave by the Government, but he wrote a long and fascinating letter to the Chamber in reply.[33] The tone is characteristically modest ('a mere amateur', 'the subject is in a great measure new to me ... I am neither a practical farmer nor land agent'), fearful that any suggestions, for example on the costs of such a venture, might be 'rather crude', but, being a canny Scot, Wight realised that such a farm could combine several functions beyond the one he knew would most concern a Chamber of Commerce. These were:

> 1. To return 'a profit on the capital invested in the undertaking'.
> 2. As a 'nursery for introducing and acclimating the more valuable productions of foreign countries, as well as the uncultivated ones of our own'.
> 3. To form 'an agricultural school for the education of East Indians in the science and art of agriculture, for the purpose of fitting them to become useful occupants, and well qualified cultivators of the Soil, on which, in their present condition, they can be considered as little else than a burthen'.

Wight provided much interesting detail on the setting up and costs of such a farm, which he thought should initially be of only 100–150 acres, used for other crops besides cotton, and used for teaching, by example, the Hindoo (with his 'naturally docile disposition') in the

use of European-style agricultural implements. There is perhaps an echo of Seringapatam in the recommendation of using bullocks of the 'large sized Mysore breed', doubtless Amrit Mahals, a pair of which could be purchased in Madras at Rs 40–50. However, it is the third of Wight's aims that is by far the most interesting – showing a concern for agricultural education, but also in the products of mixed race unions (then called East Indians, now Anglo-Indians). What lies behind this? Without wishing to cast aspersions, is there a heavily disguised hint here that he might himself have contributed to this mixed gene pool – 'a race of our descendents daily increasing in numbers, and for whom we find it annually more and more difficult to make a suitable provision'? Wight thought that such an educational establishment would have 'strong claims on both our liberality and justice'. A body called the 'Philanthropic Association' had apparently procured grants of land for such 'East Indians' in the Nilgiris a few years previously, but the venture had failed as the individuals chosen had no knowledge of agriculture. If such people were properly trained they would appreciate 'the respectability of their calling, from the respect it would procure for them, so long as their own conduct entitled them to that mark of difference'. Despite his earlier standing up for the maligned Indian *ryot*, Wight, deep down, clearly believed that these 'East Indians' might prove more innovative than the *ryots*, and this letter provides the occasion for an interesting expression of his view on what might be called inter-racial hybrid vigour:

> To a more active and enterprising race [than Indians] therefore we must look for these changes, and where is such a race to be found unless among ourselves? The climate it is true forbids the pure European to expose himself to the sun and become a mere operative as in his own country but his, if I may so call them, acclimated descendents can stand such exposure nearly as well as the native, and is more willing to be guided by our instructions. Let us therefore instruct them, and show them how they may best employ their energies towards elevating themselves in the scale of society.

In a letter to Hooker of October 1837 (in which he asked for recommendations for books on agriculture) Wight referred to having examined 'the surrounding country ... [and] found a very appropriate spot' for the farm 'within a few miles of Madras'.[34] That this was at Pulicat, the site originally suggested and location of a large brackish lake, is suggested by the fact that there are herbarium specimens collected there by Wight at this time, but the farm never materialised.

USE OF CONVICTS IN AGRICULTURE

Similar combined philanthropic-educational interests had been revealed in a letter Wight wrote to the Madras Government on 24 November of the previous year (1836) on the more effective use of convicts.[35] Indians were notoriously unwilling to use new and im-

proved tools, such as fly-shuttles, wheelbarrows and 'Wilkie's improved friction wheel plough for two horses'. Rather than being mocked for carrying, rather than pushing, wheelbarrows, Wight thought that periods of hard labour during Government custody could be used to introduce convicts to new tools, which would not only increase their output, but would enable them to discover their superiority over traditional implements for themselves.

> Acting on these principles we might at no distant period fairly expect greatly to improve the domestic arts in India, and at the same time to restore delinquents to their families better men and better artists, thereby removing a strong inducement to a repetition of crime, by placing in their hands the means of attaining a livelihood honest in itself and productive to the state.

This was evidently one step too far even for the liberally minded Sir Fred Adam, and although he took the letter to be 'highly creditable to Dr Wight', and forwarded it to Calcutta for consideration of a Committee enquiring into Indian jails, he thought that such suggestions 'may not be altogether expedient'.

TAXONOMIC WARM UP

While in Madras Wight continued his taxonomic work, and his extraordinary capacity for hard work is revealed in a letter to Wallich written in August 1837, complaining of having been 'working since 6 o'clock this morning, it is now 10½ pm ergo high time to close the labours of this busy day, the more so as my eyes ache with looking through the microscope all day examining a lot of Ceylon plants wh[ich] I recently got to name'.[36] It was at this time that Wight started to correspond with the 19 year old William Munro, a lieutenant in Her Majesty's 39th Regiment of Foot, who was then involved with the garden at Bangalore, but whom the previous year had started collecting in the Nilgiris. Wight named specimens for him, and encouraged his collecting activities.[37] Munro's handwriting was execrable, and Wight ribbed him on this account, providing a rare glimpse of a lighter side to Wight not apparent in the vast majority of his letters and publications: the wigging was 'meant as a jeu d'esprit in a small way, for I can see no good in our continuing to write in starch and Buckram merely because we have not the good fortune to be personally acquainted'.[38] This year Wight published papers in the *Madras Journal* on balsams and convolvuli, and described two new genera (*Dictyocarpus* and *Nimmoia*), but these were a mere foretaste of his major botanical productions, which began to bloom the following year, 1838, and will be described in Chapter 13. It should be noted that, despite Wight's long established and deep interest in taxonomy, it was his Economic appointment that gave him the necessary spur to embark on his taxonomic works, as appreciated by J.F. Royle who took Wight's publications as evidence of 'the extensive practical applications of the scientific investigations of the present day'.[39]

Fig. 24. The Wight family, 1849. Oil on canvas, 937.5 × 775 mm; artist unknown. N.J. Wilkinson.

Marriage and Family: The Eventful Year of 1838

That Wight loved children and family life is evident from the affection he felt for two botanical families he got to know during his furlough in Britain – the Hookers in Glasgow, and the Wards in London. Three years after returning to India he wrote to Nathaniel Bagshaw Ward, inventor of the Wardian Case, 'delighted to hear of the continued health of your family particularly Steven & Nat – but most of all of my little friend Charlotte, who I presume is before this time grown so big that I should scarcely know her again'.[1] Ward was closely associated with the Society of Apothecaries and its garden, now known as the Chelsea Physic Garden, and was at one point the Society's 'examiner for the prizes in botany'.[2] It must therefore have been Ward who was responsible for Wight's being awarded the Society's bronze medal still in the possession of his family. The medal was designed by William Wyon, and although it bears the date 1830 this example must have been struck after 1838 as the initials 'RA' follow Wyon's name, and it was in that year that he became a Royal Academician. Links between the families remained strong, and Wight's two elder children would spend Christmas 1849 with the Wards, at their house in Wellclose Square near the West India Docks in London's East End.[3]

Wight probably knew the Hooker family even better than the Wards. On learning of the death of two of the Hooker children (William aged 24 in Jamaica in January 1840 and Mary Harriet aged 16, in June 1841) he wrote to Hooker: 'how altered the happy circle I left in 1834 deprived of two of its brightest ornaments. The remembrance of the happiness you then enjoyed in the midst of a happy family often contrasts sadly in my mind with what I now imagine must be the feeling of both Lady Hooker and yourself'.[4]

From a wry comment of Greville, we also know that Wight was fond, at least on occasion (as in Edinburgh in July 1832) of female company: 'Wight I suppose is off … His lady friends took him in tow – & farewell to botany'.[5] This, however, was probably mere banter and Wight chafed Greville for the anti-slavery work that was the cause of his being lured away from botany. As already noted it appears that Wight had been turned down as a suitor by Eleanor Turner during his furlough, and he remained a bachelor until the age of 42. This changed on 17 January 1838, when Wight married Rosa Harriette Ford in a ceremony in the Anglican cathedral of St George in Madras conducted by the Rev. F. Spring.[6] Rosa was only 21, literally half her husband's age, having been born in India on 10 November 1816, and baptised at Mangalore on the Malabar Coast.[7] Sadly we know almost nothing about Rosa, and the only contemporary description of her is banal:

> the match Wight has made promises to be productive of great domestic happiness. His lady is possessed of a most amiable temper & disposition & is altogether a very nice person.[8]

Two images of Rosa in her prime have survived, a grand painted conversation piece, where a good deal of artistic licence doubtless lies behind her almost Spanish looks [fig.24]. A photograph taken by Maull [fig.38] shortly after 1853, when Rosa was in her mid-thirties, is more reliable and is scarcely recognisable as the same person – showing her as plain, almost Quakerish, with piercing eyes and a firmly set mouth, hair drawn back from a centre parting, severely restrained and demurely covered in a lace cap. By contrast, her clothing is elaborate – a richly textured dress, fussily trimmed shawls and lace cuffs. The face, while of no beauty, tends to confirm the opinion of her great-niece Louisa, who was partly brought up by her, and who never forgot the 'goodness & kindness … of "dear" Aunt Rosa'.[9] The bride's father, who witnessed the wedding, was Lacy Grey Ford, a senior Madras medic, at this point an acting Superintending Surgeon, and the two families were already connected as Rosa's younger sister Helen Julia (another witness of the wedding) had married Wight's nephew Arthur the previous September. Also present as witnesses were Jane Sophia Routledge, presumably a friend of Rosa's, and a Major Bevan, doubtless a colleague of Wight's.

It is not known how much interest Rosa took in her husband's botanical work, but from some paintings that have survived from an album that clearly belonged to her, she appears to have had at least the floral interests expected of a young Victorian lady. One of these is a yellow rose that Rosa almost certainly painted herself as the name 'Miss Ford' is inscribed on the back. That she shared her husband's interests, at least to some extent, is shown by the rose apple she got Govindoo to paint as part of a series of exotic fruits, and the painting of the Indian and American cottons with which her husband was so greatly concerned in the 1840s. Rosa's 'rather happy knack' with difficult handwriting also came in handy when trying to decipher the appalling scrawl of young William Munro, already alluded to. Wight teased him:

> you want a work on Indian Gramineae which was translated after much exertion of eyesight into Indian <u>ham</u> but the remaining half of the word remained in obscurity, and it was not until <u>lyper</u> was converted into <u>C</u>yperaceae that association of ideas cleared away the obscurity by converting h into Gr. that the former could be made out.[10]

Ironically, this is an excellent description of the process necessary for the deciphering of Wight's own hand.

Shortly after his marriage, on 6 March 1838, Wight was promoted to Garrison Surgeon of Fort St George. Cole reported to Wallich that this promotion was conferred 'not as a mark of consideration for his talents and usefulness, as should have been; but merely to serve the present acting incumbent.– It is satisfactory to him & to his friends nevertheless, to know, that in case of his present employment [i.e., on economic botany] being discontinued, he has a tolerably lucrative appointment at his option'.[11] Wight,

however, was retained in his 'present duties', and Assistant Surgeon John Richmond acted for him as Garrison Surgeon.[12] At the very end of this year Wight was transferred from the 48th to the 40th regiment of Madras Native Infantry.[13]

The couple started a family the following year and their first child James Ford was born in Madras on 20 May 1839, the names commemorating his late (paternal) uncle the Colonel, and his mother's family, respectively. The proud father occasionally mentioned young James in letters to Hooker – for example, aged two, 'our little fellow' was described as 'a vigorous shoot & a keen Botanist [in] so far as being excessively fond of pulling flowers & [?ferns] can entitle him to that designation'.[14] These interests were encouraged and when James was eight, and with his mother in England, Wight asked Hooker to show them around Kew: 'she will I am sure be delighted to visit the Gardens as she is fond of Horticulture and my little son not less so. I can fancy how the little fellow will be delighted if he sees in any of your stoves a flower he knew in India. – He was an attentive observer of flowers of all sorts here, but I think it probable he will have forgot most of them before this time'.[15]

Illness was a constant worry for parents who kept their children with them in India and James contracted whooping cough in January 1842,[16] and cholera in January 1844,[17] from both of which he recovered. The couple's next son, in 1840 was still-born, but three more children followed, born either in Ooty or Coimbatore: Eliza Anne on 30 January 1842; Rosa Augusta on 19 April 1843 and Robert Stuart on 23 May 1845. Of these nothing is heard until much later, apart from poor little Eliza who was not so lucky as her brother, and succumbed to cholera in Coimbatore, aged four, on 27 December 1845. The loss of their eldest daughter must have devastated Rosa and Robert ('sadly cut up at the loss, and I do not wonder that he is so' was the way Gardner described it to Hooker[18]), and on 13 November 1846 Wight sent his wife back to London with their three surviving children, in what turned out to be a vain hope that their next child would be born in a more healthy climate. Wight intended to accompany the family as far as Ceylon to visit the botanist George Gardner,[19] but for some reason this did not happen. Travel had changed a great deal since Wight had returned from England by sailing ship in 1834, and Rosa, the children and a 'native servant', travelled by the Peninsular and Oriental Navigation Company's steam ship 'Precursor'.[20] The route was no longer round the Cape, but involved a three week voyage to Suez, crossing Egypt over-land, then taking another ship onward to Southampton – the cost of a berth 'for a Lady' was a hefty £140 – to be paid in rupees, which included transit through Egypt, the Steward's fees, 'a liberal Table, Wines and Beer, and use of Cabin Furniture, bedding and linen'; costs for the children and servants were additional. On reaching England the family was initially to stay in Bayswater with her sister Helen, but Rosa intended renting a house nearby, in 'Chapel Terrace, Petersburg',[21] and at this point Wight was thinking of retiring and joining his family in 1848.[22] Although Wight would by then have completed almost thirty years of service, he realised that by retiring at this point he would lose £65 a year in pension, which, being a careful Scot, and with young children to be educated, he evidently decided he could not afford. It must have been a comfort to Wight when his wife eventually returned on 4 May 1849, after an absence of two and a half years, in improved health after a restorative voyage on the 'Bentinck'. Rosa had distinguished company on the return voyage, including Sir Charles James Napier,[23] 'Old Fagin',

conqueror of Sind (who sadly did not report his success telegraphically with the word *peccavi* – 'I have sinned'), now on his way back to Calcutta to take command of the Indian Army. However, the reunion must have been tinged with melancholy, for Rosa returned alone. The girl who had been born in London, Jane Ellen (on 27 April 1847), had lived for only three months, and the others, James, by now ten, Augusta (six) and Robert (four) were left behind in England – James at school in London, the others perhaps in the care of relations. The painting Rosa brought back Wight thought 'very excellent … but a poor substitute' for the children themselves;[24] this magnificent, but slightly puzzling, painting will be discussed in Book 3. Robert and Rosa would stay in India for another four years, and compensation for the absence of their children came with the birth of a third son, Charles Field, in Coimbatore on 7 April 1851.[25]

It has not been possible to discover anything of the Wights' social life in Madras, any more than for that of any other period of his long Indian sojourn – if only those letters to Blair Atholl had survived. His long working days have already been mentioned, and such long established habits must have died hard, but Rosa and his young family must have made certain demands and it can't have been all work – so what else did Wight do? The Agri-Horticultural Society must have had an at least partly social function, but did he, for example, frequent the Madras Club? Was he (like Arnott and Hooker) a Freemason? Did he attend any of the functions to which the Governor issued (on the front page of the *Fort St George Gazette*) open invitations to Company employees, such as the ball celebrating the accession of Queen Victoria in January 1838? And who were his friends? The list of subscribers to the *Illustrations* may provide a hint, but only of those with titles or official designations (military, medical or clerical) can we tell anything. Botany certainly did lead to friendships, but given the size of the Madras Presidency and the unremitting demands of duty, these must have been conducted largely by correspondence, with only very occasional meetings. We have seen an example of this with the Walkers in Ceylon. By this time William Munro had gone to Agra, and Griffith was embarked upon his great travels. Also from the north Christian, Lady Dalhousie, had sent Wight specimens from Simla, where she went with her husband, Commander-in-Chief of the army in the East Indies, but she had long since returned to Scotland, where she died in 1839. A new Himalayan correspondent, however, emerged in the late 1830s in the person of Michael Pakenham Edgeworth. Closer to home Thomas Caverhill Jerdon, a recruit to the Madras Medical Service, became a botanical friend around this time. Born near Jedburgh, and Edinburgh-trained, he arrived at Madras in 1835 and in 1841 married Flora Macleod, a general's niece, in Ooty. The Jerdons had similar interests to the Walkers – both wives painted and both were particularly keen on orchids. Although interested in botany Jerdon took animals more seriously and went on to make an outstandingly important contribution to Indian zoology, especially ornithology. The first of his bird books was published in Madras in 1848, and has parallels with Wight's own work, being illustrated by lithographs made from drawings by Indian artists.

There was also an extended family, a close-knit clan of Wights and Fords, in the Madras Presidency. The links were particularly close as within this expatriate community there was a tendency towards multiple marriages both within and, in Wight's case (because his brother was fourteen years his senior), between generations. Although the husbands were almost entirely in the military, their

FORT SAINT GEORGE

References.

1. Arsenal
2. Clothing Board Office.
3. Chief Engineer's... do..
4. Lithographic Press.
5. Conductor's Quarters.
6. Town Major's House.
7. Medical Board Office.
8. Officer's Quarters.
9. Colingaroy Moodelly's House.
10. Garrison Bazars.
11. Park
12. Adjutant General's Office.
13. Prize Committee Office.
14. Mint... do.... do..
15. Government Lottery Office.
16. Sup.t Engineer's Office.
17. Records of the Accountant General's Office.

18. Stables
19. Military Board Office
20. Accountant General's Office.
21. Medical Stores
22. Main Guard.
23. Out Offices Queens Barracks
24. Solitary Cells
25. Queens Barracks
26. Magazine
27. General Treasury and Bank
28. Charity School
29. Queens Barracks School Rooms
30. Ball Court
31. Fives Court.
32. Cadets Quarters
33. Soobaroy Chetty's House
34. Mess-house Queen's Barracks

35. Occupied by the Officers
36. of the Queen's Regiment
37. Arsenal Stores
38. Records of the Revenue Board
39. Stables
40. Revenue Board Office.
41. General's Quarters
42. Private Buildings
43. Paymaster's Office
44. General Post Office
45. Barrack Serjeants Quarters
46. Serjeant Major's do...
47. Statue
48. Government Office
49. S.t Mary's Church
50. Military Auditor's Office
51. Army Clothing Stores
52. Q.r M.r General's Office

53. Garrison Dispensary
54. ...do.... Surgeon's House
55. Deputy Commissary of Stores' House
56. Magazine.
57. Officer Commanding the Garrison's House
58. Navy House.
59. Civil Auditor's Office
60. Flag Staff
61. Town Major's Office
62. Pension Office
63. Magazine

Fig.25. Fort St George in 1841. Lithograph from the Marsden's *Madras Almanac* for 1841. Shown here are the locations of the Medical Board (no. 7) and the Government Lithographic Press (no. 4).

wives and families must surely have formed a social network. James Wight, Robert's elder brother had been Colonel of the 21st (later 42nd) Regiment of Madras Native Infantry, but had died in 1833 on a voyage home while Wight was on furlough.[26] Two of James's sons, however, were still in the Madras Army in the 1840s, and three of his daughters married into it. The eldest son Alexander (born 9 August 1806) trained as a surgeon, and had helped his uncle Robert in his hospital at Negapatam before joining his father's regiment; a younger son, James (born 1814), also became a medic but escaped the army's clutches and ended up in Honolulu. Alexander married Mary Ann Fitzgerald, a sister of James Fitzgerald, a brother officer of Alexander's in the 42nd who ended up a General. While stationed at Rajahmundry tragedy struck Alex and Mary on 8 November 1839:

> sailing with his wife on the Godaveri River the boat capsized in a squall. A rescue boat found him clinging to the overturned boat, supporting his insensible wife. He begged them to take her ashore first. On their return he had disappeared. She died that night (?from lack of Medical care). The three orphans [Louisa, Eliza and Arthur, all under 4] were sent by *palky dak* with no escort but a *bearer* and an *ayah* to Madras.[27]

According to the Rev J.S. Roper, the family historian and Louisa's son, the orphans were brought up in Ooty, mainly by Wight and Rosa, 'though for a time they were with their Uncle Arthur & Aunt Helen, the latter did not seem to have had so sweet a nature as Aunt Rosa'. 'Uncle Arthur' was Arthur Cleghorn Wight, another of Colonel James's sons, who, as already noted, had married Helen Julia Ford, Rosa's younger sister. It would appear that this childless couple were of the severe military type; Arthur ended up a Major General in the Indian Army, though in his young days had collected plants for his uncle in Malacca.

The ramification of the network continued with Arthur's sister Jane Wight, who married James Fitzgerald of the 42nd, brother of the Mary who had married Alexander. Fitzgerald ended up a General, and the couple had an upwardly mobile family of five children – one became Colonel Sir Charles Oswald Fitzgerald, whose second wife was the daughter of a duke, and their daughter Matilda's husband became yet another General. James Wight's military genes were certainly dominant, for another daughter, Catherine's, husband became a Colonel, and it comes as something of a relief to find that her sister Anne had the strength of character to escape from the epaulettes and frogging and eloped with a German. Needless to say she was 'disowned by her family'.

While two of the Ford sisters married two Wights (uncle and nephew), there was a third, who married James Dorward, another Madras army surgeon; in due course Dorward would retire to Haddington and be one of Wight's executors. There is yet another dimension to this complex network, as two of Wight's sister Anne Stewart's family also joined the Madras army: Alister (born 1824), who died as a young Lieutenant at Ramnad, and Rebecca (born 1808), who in 1841 married James Campbell. Wight had been a friend of Campbell's since Negapatam days, when he had encouraged him to collect plants – but there were connections further back. Both were sons of an Edinburgh ws, and James had been recommended for the EIC by Hugh Cleghorn (senior). James's brother, William Hunter Campbell, remained in his father's profession and acted on Wight's behalf in Edinburgh, but he also had botanical interests and became secretary of the Botanical Society of Edinburgh. Wight commemorated the family friendship by dedicat-

ing the genus *Campbellia* (Orobanchaceae) to the brothers, and James eventually became a Lieutenant Colonel in the 50th Madras Native Infantry.

The only pastime in which, by odd hints, we know that Wight indulged was shooting. He had collected birds for the Madras Naturalist's collection, and, while in Scotland, for young William Hooker. It was therefore perhaps from personal experience that he recorded the heartwood of *Thespesia populnea* as 'resembling that of the chestnut, and like it, adapted for the formation of gun stocks'.[28] Wight also referred to the 'pleasant acid taste' of the fruits of *Flacourtia sapida* and *F. sepiaria* as 'very refreshing, as I have more than once experienced, to the heated and thirsty sportsman'.[29] That Wight had rather expensive tastes in shotguns is suggested by the fact that when Rosa was in London in 1847 he told Hooker that her address could be obtained from Purdey of 3–4 Oxford Street.[30]

Wight has left no written record of his physical surroundings in the city of Madras, but the first impressions of his friend George Gardner, on reaching there from Ceylon, will serve to give an idea:

> There is something far more oriental in the appearance of Madras, than in any of the towns of Ceylon. The turbaned natives, their loose flowing dresses, so well suited to the hot climate, the mosques with lofty minarets, and the flat-roofed houses, on the tops of which parties of wild monkeys are not unfrequently to be seen gambolling, recall most vividly the pictures of Eastern scenes, which every boy has read with delight in the fascinating tales of the 'Arabian Nights'. That part of the suburbs where the greater number of Europeans reside, looks like one vast garden, each house being surrounded by a large piece of ground laid out with trees and shrubs. The roads which intersect them are wide, well kept, and planted on either side with a row of trees, the commonest of which are the beautiful golden-flowered *Thespesia* [*populnea*], the ash-like *Odina Wodier*, and different species of Wild Fig, the branches of the latter fantastically adorned with pendent masses of horse-tail-like roots. The hedges which surround the enclosures are either formed of *Opuntias*, *Inga dulcis*, *Lawsonia inermis*, *Euphorbia Tirucalli*, or a small species of *Bamboo*, among which twine innumerable *Convolvulaceae*, *Asclepiadeae*, *Leguminosae* and *Cucurbitaceae*.[31]

Gardner did not supply details of the famous 'Madras landing', an alarming maritime-terrestrial transmigration necessitated because construction of a harbour at Madras was not even begun until 1876, four years after Wight's death. Here Joseph Hooker's 1848 account will represent the experience undergone by Wight in 1819 and 1834, and by Rosa in 1849:

> We had anchored at a distance of two miles from the shore, and at 4 o'clock in the afternoon, a very large [massulah] boat came alongside, of the only kind fit for landing through the surf. These are about forty feet long, very high out of the water, flat-bottomed, wall-sided, and formed of planks of soft (Mango-tree) wood, sewed together with cord. They are pulled by about twenty black paddlers, who keep up a most discordant din by way of keeping time with the paddles, which are poles of some twenty feet in length, having a small round blade at the end. As we approached the shore, the whole beach, for miles, seemed alive with people, forming a moving mass of white turbans, black heads, white frocks, and black legs … Our boat, when fairly aground, was hauled a little way out of the rollers … We landed one by one, in chairs carried by black fellows, who were so quick in their motions, that all four of us were out in half a minute'.[32]

Wight the Taxonomist: 'indagator acerrimus'

*Botany, so far from being what we have heard it tauntingly called 'a frivolous pursuit',
'a profitless science', 'a pretty amusement for ladies' is in truth a science founded on philosophical principles.*[1]
Systematic Botany is the key which opens to us the accumulated treasures of the science.[2]

After Wight returned from furlough he continued amassing herbarium specimens by the hundreds of thousand and writing short taxonomic papers, but it was in 1838 that the scheme he had been hatching since at least 1828 came to fruition – the publication of a series of illustrated works, the *Illustrations of Indian Botany*, the *Icones Plantarum Indiae Orientalis* and *Spicilegium Neilgherrense*, which over the next 15 years would amount to ten substantial volumes occupying more than half a metre of library shelving. While there were enormous difficulties in producing such works in India, there was an advantage in that, had they been published in Britain, eleven copies would have to have been sent to the copyright libraries free of charge – a problem to which William Swainson, in a curious and fascinating book known to Wight, drew attention.[3] Swainson pointed out that the French Government, unlike the British, had a generous grant for the publication of scientific works, but oddly, thanks to the EIC, Wight received a degree of official support that would not have been available at home. The writing of these books and necessary co-ordination with printers (both of the letterpress and the lithographs) was made possible by Wight's now having a more permanent base in Madras. Perhaps Wight's new domestic status (the acquisition of a helpmeet) was also a consideration. It also came within the remit of his 1836 'job description', as part of which Wight had been requested to make illustrations of economic plants. Wight made this official status clear in the public announcement of the *Illustrations*, the first of the large-scale publications, where he stated that 'the work may be looked upon as part of the duties of my office; and, in this light, has received the sanction and approbation of the Madras Government'.[4]

The Governor was by now Lord Elphinstone, in whom Wight found a keen supporter for his broad-ranging economic work, prepared to argue the case of the need for such work with an antagonistic Supreme Government in Calcutta. Wight evidently personally discussed the planned illustrated publications with Elphinstone.[5] The dedication of the *Illustrations* to:

> THE RIGHT HONORABLE JOHN LORD ELPHINSTONE,
> GOVERNOR OF THE PRESIDENCY
> OF
> FORT ST GEORGE:
> THIS ATTEMPT
> TO EXTEND AND IMPROVE,
> BY MEANS OF COLOURED FIGURES
> AND
> BOTANICAL OBSERVATIONS,
> THE KNOWLEDGE OF THE VEGETABLE PRODUCTS OF INDIA,
> ESPECIALLY OF THOSE TERRITORIES
> ENTRUSTED TO HIS LORDSHIP'S GOVERNMENT,
> IS MOST RESPECTFULLY DEDICATED
> BY HIS LORDSHIP'S OBLIGED AND
> OBEDIENT HUMBLE SERVANT,
> ROBERT WIGHT.

was therefore no mere act of flattery, and it is possible to see it, at least in part, as an example of an enlightened Scottish scientific patronage – it certainly represents a U-turn on the part of the Madras Government since the disaster of 1828. Government support for Wight's taxonomic work was in the form of the purchase of 50 copies each of the *Illustrations* and the *Icones*, which started publishing almost simultaneously.[6] Having paid his debt of patronage in the dedication of the *Illustrations*, Wight was free to acknowledge his scientific debt in that of the *Icones*:

> TO
> THE MEMORY
> OF
> WILLIAM ROXBURGH,
> CHIEF OF
> INDIAN BOTANISTS.

Despite the official status, at least at the outset of the projects, this was almost certainly lost sight of after Wight started his cotton work in 1842 and in 1848 he complained that 'my public duties engage so much of … [my time] that I can scarcely continue to steal an occasional hour for Botany, and these stolen sweets I am appropriating to the *Illustrations*'.[7] The last work of the series, the *Spicilegium Neilgherrense* was started in 1845, and by the time he retired in 1853 Wight (including the earlier work with Arnott) had described 1266 new species, 110 new genera, and published illustrations of approximately 2645 species.

Extensive bibliographical details of these works, along with nomenclatural notes on the taxa described therein, have been given elsewhere,[8] but in that work no attempt was made to analyse Wight's taxonomic work in terms of his major influences, underlying philosophy, or major concerns and interests. This will be attempted here.

The first thing to say about Wight the taxonomist is that he was a passionate believer in, and promoter of, natural classification, a method that effectively started in France with Antoine-Laurent de Jussieu and the publication of his *Genera Plantarum* in 1789.[9] It should be remembered that although Wight referred to Jussieu's work, which he first learned of in Rutherford's lectures, as belonging to a 'remote period',[10] at the time he was writing in 1850 this was in fact only sixty years previously. In defining plant groups by the natural method characters are taken (using Wight's words) 'from every part of the plant commencing with the root and ascending to the perfect seed'. This is in contrast with artificial systems, which use a single, or small number of characters – the best known being Linnaeus's sexual system, based on the number of stamens and pistils in a flower. The Preface to Wight's *Illustrations* provides a (characteristically verbose) statement of the value of the natural system and its benefits over the Linnaean – the promotion of the former is, in fact, given as the primary reason for publishing the

work. The natural system allowed 'the attainment of a correct and comprehensive knowledge of the properties and uses of plants, whether as food, medicine, or in the arts', and was contrasted with 'the most laborious, but empirical, search for individual properties when entered upon without such guide as the knowledge of affinities supplies to our researches'. Wight was at pains to be fair, however, and reminded readers of the huge debt owed to Linnaeus – in particular for the 'justly admired nomenclature and precision of language appropriated to the description of plants introduced by its author, the universally acknowledged father of modern Botany'. Moreover there were occasions when the sexual system could still be useful, especially in identifying 'abnormal' plants.

Wight believed that the object of 'the philosophical naturalist' was 'to approach as nearly as our finite faculties will permit towards the realization of this one grand and sublime idea, the discovery of The Natural System of organized beings'.[11] It should be noted that there was only *one* system, and this was because it was the product of 'ALMIGHTY WISDOM'. Very little of the theory or methods used to work out their groups (species or above), or their affinities, were written down in explicit form by Wight and his fellow Christian believers, and, as Peter Stevens has pointed out, the focus of this period was 'resolutely on revisions, descriptions of new taxa, and flora writing' and 'the natural system was simply assumed to underlie these works'.[12] This applies to Wight, and it is hard to trace the means he used to discover the underlying structure of what he took to be created order. But by combing through the hundreds of pages (mostly in small font sizes) of his publications, a number of revealing fragments about Wight's methods can be found, and at least the outlines of a picture assembled. This applies especially to the *Illustrations*, Wight's most 'philosophical' work, of which he stated that 'the main object of the strictly Botanical portion of this work is to explain the principles of the science'.[13] But firstly some historical background.

JUSSIEU AND CANDOLLE: CONTINUITY VERSUS DISCONTINUITY

Stevens has provided a brilliant, original, and long overdue account of the history of natural classification – the product of an outstanding intellect coupled with an ability to understand and digest subtle, complex, and at times internally contradictory works in English, French and German.[14] His book examines in detail the work of Jussieu and how it was developed (or not, as he convincingly shows) by others in Europe and Britain in the nineteenth century, especially up to the year 1859, and therefore provides precisely the context for Wight's work. The story is complicated and it is appropriate to summarise some of the major points Stevens makes about Jussieu and Candolle, the two most important influences on Wight, and, equally importantly, on his great collaborator Arnott.

Antoine-Laurent de Jussieu was steeped in the scientific culture of eighteenth-century France (with all its parallels with Enlightenment Edinburgh), and in particular that of botany, having been taught by his uncle Bernard, who demonstrated botany at the Jardin du Roi in Paris. As already noted it was Antoine-Laurent's *Genera Plantarum* that was the pioneering work of natural classification, but what were the principles on which it was based? The most important principle was that of continuity: that there were no gaps in nature, or that if there appeared to be, then these would be filled with new discoveries in due course. Jussieu's approach was inductive

(synthetic), and he formed his genera by the gradual addition of species. The way he formed families from genera was described by Wight's friend William Griffith: 'Jussieu used to form his genera into families by consulting drawings on cards, which he used to shuffle, and then separate and associate according to their degree of resemblance'.[15] The boundaries of such larger taxa Jussieu admitted were subjective, and the 'number of species in a genus [and genera in a family] was under the control of the naturalist, not of nature'.[16] This was partly for the pragmatic reason of making it easier to memorise his system; he limited the number of families to 100 (even although this required splitting Compositae into three), and the largest family contained 99 genera.

Augustin-Pyramus de Candolle was Swiss, and although his early work was done in France, his most famous work was undertaken in Geneva. He had a very different view of nature, and believed in discontinuities between taxa. Rather than a continuous map that represents Jussieu's view, Candolle's view of nature is that of an archipelago of islands, and he was quite happy to have families and genera of widely different sizes. He believed that 'plant groups were not some totality of the variation shown by their included members, but each group had its own basic symmetry, which was a subset of this variation and which was also more or less regular – and by this he meant that the type of a family could be represented by a more or less symmetrical flower'.[17] Candolle was therefore deductive in his methods, and analysed groups looking for ways to subdivide them, using a hierarchy of characters that could be used at different levels in the system. Later in his life Candolle looked for circles of affinity of genera within his families, and these family

Fig. 26. John, 13th Lord Elphinstone. Oil on canvas (670 × 570 mm) by James Faed (1821–1911). Sotheby's Picture Library, London.

circles could approach one another at points represented by a particular pair of species: as will be seen later Wight would also attempt to make circular arrangements. Stevens rightly credits Candolle as being the greatest botanical systematist of the nineteenth century, and we now know (because evolution happens largely through a process of branching) that his picture of gaps is more accurate than Jussieu's continuum, but, despite this, the paradox that Stevens had to explain was why Candolle 'did not come to dominate botanical systematics in that century'.[18] This indeed seems to be the case in terms of Candolle's influence over both Wight and Arnott: although they used Candolle's great *Prodromus* (no less than a world Flora continued after his death by his son Alphonse) as a framework for their taxonomic works, they were critical of his methods. As will be seen below Arnott was particularly dismissive of Candolle's species concept, and Wight thought that 'good old D.C. in his later days when his mind had begun to give way under such long continued and incessant application seems to have become fond of new genera & orders rather than take the trouble to work out new affinities in those already established'.[19] In the joint treatment of Leguminosae in their own Indian *Prodromus* Wight & Arnott wrote that Candolle's 'characters of the subtribes and their divisions are not yet very well defined',[20] and they both believed in the principle of continuity.

PHILOSOPHICAL BOTANY

Systematic botanists still have to put up with jibes that their work is not truly 'scientific', and this was also the case in Wight's day. Almost at the start of his influential article on Botany in the *Encyclopaedia Britannica* Arnott quoted the Selbourne naturalist Gilbert White on the distinction between those interested in 'a mere list of names' and the botanist who studies plants 'philosophically'.[21] Wight's work (and those of his contemporaries) is strewn with protestations of the philosophical (and therefore respectable) nature of their work – the discovery of affinities, and arrangement of families accordingly – though as Stevens pointed out they almost never explicitly stated the principles on which such work was based.

INFLUENCES ON WIGHT

Wight was aware of Candolle's work in his first Indian period. As early as 1829 he had several of his works in his library (including the original edition of the *Théorie Elementaire*, and the Edinburgh-published translation of Sprengel's unauthorised edition),[22] and Wight expressed his intention to Hooker of arranging his herbarium in the order of Candolle's *Prodromus*. Later on Wight would (largely) adopt Candolle's families and their arrangement for his *Illustrations*. Wight never visited Geneva, and it is not known how much he and Candolle corresponded, but they certainly had contact over Wight's specimens of Compositae collected up to 1831. These were described and published by Candolle, firstly in the compilation that is Wight's *Contributions*,[23] and then (with some changes) in his own *Prodromus*. Wight must also have learned of Candolle and his methods at second hand from Arnott, who had worked in Geneva.

Stevens identified the key figures in the introduction and development of the natural method in Britain in the period 1810–59 as 'John Lindley, George Walker-Arnott, William Jackson Hooker, George Bentham, and especially Robert Brown'.[24] Wight had links (to varying degrees) with all of these. Although Brown, and his 'immortal *Prodromus* [*Florae Novae Hollandiae*]',[25] was the most impor-

tant Wight's personal links with him were not close. Wight found him a 'dry stick' when they met in London in April 1834, though he always took Brown's views into consideration with due respect in discussions of family affinities in the *Illustrations*.

Although W.J. Hooker was Wight's first great botanical friend and collaborator, and of enormous practical assistance to him, Hooker was, curiously, the least influential of the group on Wight in terms of practical taxonomy. Although he had arranged *Flora Scotica* according to both Natural and Linnaean systems as early as 1821, Hooker was 'disinclined to discuss such matters and wrote little on the natural method'.[26] Although Hooker's letters to Wight have not survived, nothing in the other side of the correspondence indicates that they discussed detailed matters of taxonomy.

Wight met Bentham during his furlough, and entrusted his specimens of Labiatae to him, which Bentham worked on and included in his important monograph of the family. Referring to this work, Wight paid tribute to the 'untiring labours of Mr. George Bentham, probably the most accomplished and indefatigable of living Botanists'.[27] After Wight's return to India, however, Bentham wrote to him on only a single occasion, a covering letter sent with a copy of his *Commentationes de Leguminosarum Generibus* (1837).[28] Although, as has been noted (p.56), Wight & Arnott's work on legumes was one of the most rushed parts of their *Prodromus*, Bentham, in his monograph, expressed admiration for the work that he clearly took to be Arnott's:

> his divisions of genera and diagnoses of species are in general clear and well-defined, even if he does often seem to join together several which it will perhaps be the case ought to be separated. Although perceiving the artificiality of De Candolle's system, he has judged that in a work listing the plants of a single region it is appropriate to refrain from innovation, and he has in most respects firmly followed De Candolle's ordering.[29]

Although Bentham can have had negligible influence on Wight in taxonomic matters, he was closely involved with Arnott, at an especially important time in France, and in 1825 they undertook a joint field trip in the Pyrenees.[30]

A bigger influence on Wight was Lindley, who was one of his proposers for the Linnean Society in 1832. They corresponded after Wight returned to India, and Lindley worked on Wight's orchids, but Lindley's major influence on Wight (as on many others) was chiefly through his popular and densely informative books, notably the *Natural System of Botany*,[31] the second edition of which Wight deferred to, more often than not, when discussing family affinities in the *Illustrations*. Lindley, however, was notoriously changeable in his classifications, which he saw not only as inevitable, but as a positive virtue,[32] rather disarmingly telling his students that they would probably end up doubting 'whether any one can truly define the boundaries within the … [plant and animal] kingdoms', so complete were the 'gradations between [even] *men* and *trees*'.[33] According to the German botanical historian Julius von Sachs (quoted by Stearn) this was due to the fact that Lindley, while theoretically giving high ranking to physiologically important characters (embryo, endosperm, corolla and stamens), did not follow his own theory in such matters, and 'deduced quite incorrectly the rule of system from existing and long established natural affinities'. Interestingly Stearn attributed this *modus operandi* to Lindley's strong visual sense (he was an able botanical artist). Given the value Wight placed on illustration, one might have expected him to be similarly influenced

(led astray?), but this is certainly not the case and his discussion of affinities is ruthlessly 'philosophical', based on a highly abstract comparison of characters. The result of Lindley's changes of mind is that by the time of the publication of the *Vegetable Kingdom*,[34] although Wight valued this highly as 'one of the noblest contributions to Botany of the present century',[35] he was more often inclined to disagree with Lindley's taxonomic placements.[36]

The most important influence on Wight by far was Arnott, through the close and detailed work on their *Prodromus* in the period 1832–4. This must have left a deep and lasting impression on Wight, and they certainly carried on detailed taxonomic discussions in the letters exchanged after Wight returned to India.[37] It is therefore necessary to say more of Arnott and his own botanical influences. Arnott first went to France in 1821 and was actually present at the last field trip led by the great Antoine-Laurent de Jussieu. He visited France again in 1825 to meet up with Bentham, then living near Montpellier, the occasion when Arnott got to know the Montpellier botanists Dunal and Requien, and accompanied Bentham to the Pyrenees. After leaving Bentham in November 1825, Arnott went to Geneva to work in Candolle's herbarium. Arnott's position with respect to the key figures in the development of the natural system was thus unique. The purpose of the Geneva visit was as a spy and stooge for Hooker: to obtain detailed information from Candolle's herbarium for an unrealised 'Species Plantarum' that Hooker was then contemplating. It is worth printing here an unpublished and revealing letter that Arnott wrote to Hooker at the time,[38] which shows that he had little respect for Candolle's species concepts (and even less for those of the hair-splitting Germans). It was thus for his treatment of higher levels of the hierarchy (genus and above) that Arnott admired him, and he would use these levels of Candolle's classification throughout his life.

Genève 14 Novr. 1825
My dear friend
Your very kind letter arrived this morning, that is to say came to me, but I believe it has been some days at Geneva, the bad weather not giving me any inclination to parade the length of the Post office when I have plenty else to do.– Do you think that when I have the constitution of a horse, I have also the head of an ox, or why the deuce would you tempt me to run my head against all the botanists or <u>front-de boeuf's</u> of Germany. – To encounter one or two in … small sword, sabre, or pistol would do very well to amuse me when I had nothing else to do, but I am not quite so weary of this life as to challenge the whole mechanics (from Professor to Gardener) that pretend to the name of botanist, who spin the threads in the <u>Universal German Species manufactory</u>.– If they thought that I could not agree to a man with a large nose (viz. you) & one with a snub (that's me) being <u>specifically</u> distinct, I suspect very much they would show a desire to take a slice off the little I already have.– Lord bless you, you have to learn much yet, contrary to the adage of the Prophet if you have one hair more (perhaps ½ a hair suffices) on your body today than yesterday, you are as specifically distinct from what you were before as most of the German species of plants – and as to your first <u>ideas</u> of <u>identity</u>, about which poor Locke talked such nonsense, you may sink them in the Red Sea. – My conscience! I publish a memoir, on the notes I have taken, no, no, my very dear fellow, poor GAWA has neither the time nor inclination. – You have often told me that I enjoyed highly to find faults with others (look sharp to yourself now, that you begin your species plant[arum]), but you would not wish that I proclaim myself to

the world whilst I can be of service to my friends, and return in that way the part of the many obligations I owe, it will always give me real pleasure – with my notes you may do what you please excepting copying them word for word – because when I write you, I write freely and without much attention to the style I employ, and I have little desire (altho' I love my native soil, & its language as much as your worthy Lady does hers) to see in an English work, my name figuring after a lamentable Scottish expression.– But seriously speaking, you should not advise me to publish these said notes apart – you know well that most of them are taken from DC's herbar[ium]: and it would not look very pretty to the world that I should live at Geneva for a month or two, & get permission from DC to look over his herb. – solely to have the pleasure to attack him where he is most vital.– The notes (if of use to you) may enter very well into a work like yours – but would look rather <u>black</u> if apart.– Not that I owe much to De Candolle either.– He has not granted to me more than he, or anyone else would grant to every one who wishes to see his herbarium.– Delessert, Requien &c had written to him in my favour – but as dry as an old walking stick he has scarcely deigned to speak to me twenty words.– As proud as Lucifer, he at present sacrifices any thing for his botanical fame – he wishes to be thought the first botanist in the world, and he cares not what else the world thinks of him. By the bye – he asked me the other day to take with me some small packet for you which I shall do with pleasure – but <u>ma foi</u>, you will be a lucky dog if you get plants from him.– He is perfectly right in not giving them to every one, but all here say he gives to none – and many who had given some rich collections to him begin to repent of it sadly.– His herbarium is chiefly rich in Siberian & Caucasian plants (mostly bad species) from [?Steman] & Fischer, but I suppose ere now you have thro' Fischer, got many of them.– Of common plants he has not much of each in his herb. – but of many scarce ones he has 30 or 40 specimens, & the most distinguished botanist need not attempt to ask one – perhaps thro' great generosity he may give half a petal & a cotyledon or the radicle.– But the worst of all his herb. is <u>no authority for his species</u> – when a plant is found in Switzerland it is put into his herb. with all its variations – but when a similar one comes from Caucasia, or North America – it cannot be the same (on account of his ideas of the Geography of plants), & therefore it is made a new species – not observing that the same has been formerly found say in Swissd. & already entered in his herb. Thus his species are all mixed in his herbar[ium]. – & it is only by comparing each specimen with the description that I have been able sometimes to make out what he had in view.– Almost all the families not worked by C are better done, & his herbar[ium] there better arranged, as it has been done by the author.– But I confess I am now beginning to get sick tired of the business.– Had you and Bentham allowed me to take my own way, & come to Geneva in Spring I could have been of real use to you (I hope) – as altho' I was unwilling to say any thing about it, in case I did not like the task, when in Paris, I wished nothing more than to study every species in the first & second Vol. of the Prodr[omus] with care.– The Pyrenées deranged my plans & I have now scarcely time to do anything than take a sketch of the first part.– I am heartily tired of the Cruciferae – as a study, I have [confronted?] every species in Seringe's herb. with DC's & scrutinized them well & Seringe has given me a specimen or two of all that he could as <u>types</u> to compare others by – of these many will come to you if you wish them – & as indeed Seringe gave me in so far as he could more than one specimen with that intention I assure you when I compare Seringe with DC. the last falls far behind.– What Seringe does he does tolerably well with care.– DC works

like fire – but the two ought not to be compared – Seringe is good for species – DC only for genera. Had DC behaved properly to Seringe so even a Genevese told me lately, Seringe's name should have figured with DC's on the title page of the Prodromus – that was understood – but C pretends that the bookseller would not have an inferior name to his own – at all events they share the profits, and while DC has all the credit Seringe has most of the trouble – but to give the devil his due, C has worked nearly all the Leguminosae. Have you got the 2d Vol. yet? it has been some time at Genève.– But if I do not finish this tirade, I shall not be able to commence what I took this large sheet of paper for – viz – the Cruciferae & the families before it. You will observe that my notes are extremely defective – but if I had studied each species in DC's herbarium with the same care, I should never have finished.

[There follow many pages of notes on Magnoliaceae , Papaveraceae, Cruciferae].

Interlude written on 15 Nov and finished on 16th 'Now let me tell you I am heartily glad that I have got this enormous epistle concluded – and I dare say you will be as tired before you get to the end of it. But don't flatter yourself that I have done all this for your sake alone.– I had a nobler aim in view:– to render a boon of the kind coming from the British press more perfect if possible than that of the Genevese.– It was not for you but for your book that I took these notes – I neither wish for credit to myself – nor ask for anything but your friendship.– And perhaps I may hope to show you that I can look at & comprehend more plants than mosses, & be capable of more than to find faults with Bridel and the beasts ... Adieu my dear friend – raise the war slogan against the Germans'.[39]

The reason for Candolle's aloofness is to be found in his autobiography – the visit came at a ghastly time in his personal life at:

un moment où accablé par la douleur de la perte de mon fils je n'ai pu lui [Arnott] faire aucun accueil. Il a visité mon herbier mais je dois avouer que la parfaite froideur qu'il me témoigna pendent qu'il me voyait au désespoir m'a inspiré peu de sympathie pour lui.[40]

As usual there are two sides to a story and to know all is to forgive all!

A sixth botanist, of a younger generation (and therefore not mentioned by Stevens in this context), must be discussed as a major influence on Wight – the brilliant William Griffith (1810–45). Griffith was a pupil of Lindley's at University College London, and went out as an Assistant Surgeon to Madras in 1832 while Wight was still in Britain. Despite this their correspondence began at this point, and it seems likely, though unproven, that they met when Wight returned to Madras in 1834, as Griffith was apparently not transferred to Bengal until 1835. In this latter year Griffith embarked on his short but brilliant botanical career, and, with John McClelland, went on Wallich's Tea Mission to Assam that Wight was originally intended to have accompanied; Griffith later travelled from Afghanistan to Malacca by way of fascinating and then inaccessible countries like Bhutan and Burma, making collections and astute and detailed observations the whole time. Griffith was truly a philosophical botanist, who made great use of the microscope and was also a skilled draftsman (he taught Wight's artist Rungiah such things while Wight was away); he was also a field naturalist, and keen observer of what is now called ecology. By outlook Griffith was a Jussieuan and liked large genera; he was constantly deploring the

tendency to subdivide them by analytical methods (which he sometimes called 'Methodism'):

depend upon it, that one-third of our present genera are temporary. Botanists don't know that a plurality of marks is required for a genus, a deviation from any one or two of these, will only constitute a subgenus, not a genus.[41]

So, for example, Griffith disapproved of 'Arnott's subdividing processes; what a shame to mutilate Cucurbitaceae so'.[42]

Tragically Griffith died before his great schemes came to anything in the way of a major publication. All we have to go on are his notes, as published in an act of piety after his death by his friend McClelland. This generous act earned the opprobrium (on grounds of 'style' and 'finish') of pedants such as J.D. Hooker, but this was no doubt coloured by Hooker's friendship with Wallich, and the consequences of the falling out between Wallich, Griffith and McClelland. This originated on the Assam trip in 1835, and was exacerbated when Griffith radically replanted the Calcutta Garden of which he had temporary charge while Wallich was on sick leave at the Cape in 1842–4.[43] The destructive effects of this unedifying contretemps have been discussed by Desmond,[44] and Arnold,[45] and will be raised later (see p.153).

Griffith was Wight's one and only significant botanical correspondent *within* India, and posterity owes McClelland a huge debt for printing his letters to Wight,[46] which would otherwise have been lost. These letters cover the period 1838 (when Griffith was in Bhutan) to 1844 (when he was in Calcutta, just before his fateful final posting to Malacca) and include detailed taxonomic discussions, chiefly of points raised by Wight in his *Illustrations*. Griffith frequently quoted his old teacher Lindley in these letters, but being fiercely independent-minded was commonly critical both of Lindley's, and not infrequently of Wight's, taxonomic judgements. Of Lindley he wrote 'I have my doubts as to his systems, because he has too many, the tendency of all these, however, [is] in the right direction ... [but] founding one on wood, when we don't know how wood is formed, is beginning at the wrong end',[47] and that his 'great forte is in explaining structure, and in condensing the views of others',[48] – a judgement with which posterity has generally agreed.

WIGHT'S VIEW OF NATURE

As Arnott was the most important influence on Wight, it is necessary to discuss his view of nature first. Unlike Candolle, Arnott certainly believed in the principle of continuity: 'from the highest organized plant to the lowest, all form a chain, in which a link lost or broken disconnects the whole'.[49] Arnott noted that plants and animals were linked by zoophytes, and that Brownian motion could be observed in both living ('organized') and non-living matter.[50] Like Jussieu, Arnott believed that 'orders and genera will be found entirely artificial, and existing only in our conceptions ... [though] of the greatest use'.[51] Despite this, as in the case of all nineteenth-century systematists (Lindley was by no means exceptional in this), there was a large and significant gap between theory and practice, and Arnott (a trained lawyer, with all that implies in the use of exact language and definitions) was at very great pains to draw discreet boundaries around his taxa at all levels of the hierarchy, which would tend to show that discontinuities really did exist. Something Arnott wrote to Hooker about 'making out' (i.e., identifying) species

from descriptions is of interest here, and shows his belief in the need for tight definitions, in this case at the species level:

> I know you laugh at the idea of making out species by specific characters, and what is worse by long characters, as in Schlechtendal; but a specific character need not be long, and yet contains in it every important thing about that plant that does <u>not</u> vary: and if such characters were given (I know their extreme difficulty) I think one might make out a species by them, if the specimens were good.[52]

Wight certainly adopted this method from Arnott and followed it after he returned to India in 1834. The problem lies partly in Arnott's last qualification – but not only with reference to a specimen one is trying to identify. Also crucial are the specimens on which the 'character' itself was based – did these really encompass all the variation of the species? Scarcely likely, if the character had been drawn up from a small amount of material. The question of the interpretation of such pithy 'characters' will be returned to in the section on the 'limitation of words'.

Like Arnott, Wight, at least in theory, also believed that the shape of nature was a Jussieuan continuum: a map with 'families of plants like provinces of a kingdom, [which] touch each other, not by one point only but on all sides'.[53] Wight pointed out that Candolle's larger groups (classes) (though emphatically not his families) were artificial, but were necessary and 'intended simply to facilitate the arrangement of the orders [families] in a linear series' in order to allow publication and identification. Wight used the geographical 'simile of kingdoms and provinces, to teach under what latitude and longitude we must look first for the province (the natural order) and then for the town (the genus) to which the subject of our enquiry (the species) belongs'.[54] For example, Wight regarded the families of his class Geranioideae (Geraniaceae, Lineae, Balsamineae and Oxalideae) as 'connected in so many important points and to glide into each other by such insensible gradations, that it becomes difficult to find any good ordinal [i.e., family] characters by which to keep them distinct' (though he did).[55] Another example of Wight's belief in continuity is to be found in the Preface to the *Illustrations*, where he wrote of the value of the mass of post-Linnaean species, since, without them 'innumerable breaks in the chain of affinities must still have existed, marring both its beauty and usefulness'.[56] And his reason for including Fumariaceae (which does not occur in South India) in the *Illustrations* was 'as forming a link in the chain of affinities, which it is desirable should remain as much unbroken as the Flora will permit'.[57] Despite this some very natural families were seen to be very isolated – for example Cucurbitaceae and Compositae, the latter being described in Candollean terms as standing alone 'like a large island in the midst of the ocean, with a few smaller ones in the neighbourhood, but still quite distinct from all'.[58]

SIZE OF GROUPS

As pointed out earlier Jussieu believed, largely on practical grounds, that groups should not be too large, even if this meant artificially dividing families such as Compositae. To Candolle, on the other hand, this did not matter, and he was happy to have both large and small groups. There is only a single example, the highly plastic genus *Pouzolzia*, where (from desperation?) Wight seems to have used an artificial method resulting in the suspiciously round number of 50 species. More generally he warned against such arbitrary splitting or lumping such as the 'present fashion in Botany … on barely suffi-

cient grounds to divide families that might better be kept together'.[59] When discussing *Hibiscus* (with its distinctive calyx), Wight recommended not breaking up 'even very large genera' on the basis of a 'subsidiary character', in this case the number of seeds in the carpel.[60] On the other hand he was happy to recognise monogeneric families such as Hugoniaceae,[61] and Millingtoniaceae,[62] and the bigeneric Balsamineae.[63]

CIRCLES OF AFFINITY

According to Jussieu there was an underlying symmetry to nature, and it was not coincidental that the number of major divisions of plants and animals were the same.[64] Creation had an internal geometry, an inherent 'natural system', that could be discovered by the philosophical naturalist. A well known method that sought to recognise such geometry in the form of 'circles of affinity' was the Quinarian system of W. S. Macleay, proposed in 1819 for 'annulose' (i.e., segmented) animals; and the search for circles of affinity became a common preoccupation for systematists in the early nineteenth century. Macleay's bizarre Quinarian system was summarised by Stevens as follows:

> Taxa at any one level formed five circles of relationships, each circle having five taxa, and the circles themselves were joined by "osculating" taxa. There were various patterns of relationship among taxa in this system. Relationships were shown among taxa that occupied the same relative position in each circle of relationship, among taxa in each individual circle, and among osculating taxa and taxa in adjacent circles. The entire group of five circles formed a single unit in one of the circles at a higher level, and so on.[65]

Wight was certainly aware of Macleay at least by name, as shown in a letter written from Griffith in Peshawar to Wight in Madras in 1839. The following quotation from this letter gives a flavour both of Griffith's mind, and of his mode of expression:[66]

> We shall never get at the natural system, until every leaven of the old systems is abolished. None of your single characters can ever hold good, not even the most comprehensive ones as Dicotyledones, Monocotyledones, and Acotyledones. How unphilosophical have been our systematists, they apply natural rules to the minor divisions, arbitrary ones to the grand divisions! Look at Mr. Brown's Prodromus, you will not find there any artificial subdivisions, or divisions. The more I learn the more I am convinced that MacLeay and Swainson are the only persons who have got a glimpse of the Natural System. I cannot conceive what people are about when they lose sight of the grand numerical lessons taught us by nature in the great divisions: I look on the idea that Nature has one determinate plan of operations, as highly philosophical; the same measure which she carries thro' most obviously in her primary divisions, will be traced throughout her lower subdivisions. Look at DC's list of Compositae, it is a perfect chaos, yet in no order will the natural divisions be found more plainly marked out than in this, the most perfect of her vegetable tribes.[67]

Circular classification was not unique to British systematists and Candolle had earlier proposed one for the family Melastomataceae, though it seems unlikely that Wight knew of this. In the rather faltering description of the circular method for elucidating the natural system, in the introduction to the *Spicilegium*, Wight cited two sources for his knowledge of such methods.[68] The first of these was the first edition of Lindley's *Elements of Botany*;[69] the second

'Swainson's volumes of Lardner's Cyclopaedia … easily procurable textbooks and … among the most interesting volumes I ever read on Natural History', which may have been drawn to his attention by Griffith.[70] Wight admitted to having difficulties with the method and (only too aptly) described it as 'a difficult enquiry … the whole subject … far too deeply involved in obscurity',[71] and in recommending the use of such a system (rather weakly) deferred to 'supporters of the circular method' who claim that it 'furnishes a clue to THE Natural system', and that it had to be better than a linear system, which by its nature was artificial. It:

> assumes that nature has systematically arranged all her creations in a series of circular groups, each intimately united to others by a complex but beautifully simple net-work of affinities interwoven … with a similar net-work of more remote analogies, all of which are found to exist in every perfect circle and that these circles progressively diminish in magnitude from the highest to the lowest, until we arrive at the last link of the chain, *Species*. The primary circles are three, *Animals*, *Vegetables* and *Inorganic matter*. Animals being the Typical circle, Vegetables the sub-Typical, and Inanimate matter the Aberrant; which last is made up of three minor ones the endless modifications of Earth, Water, and Air; each equally perfect, thus making together a series of five.[72]

Wight, in fact, never mentioned Macleay by name, and the method he tried to apply – in which the series of five are made up of circles of three, one of which is further subdivided into three – was the modified form devised by William Swainson. In this, as the groups are not all at the same taxonomic rank, the retention of the magical number five is only achieved by a sleight of hand, and the circles are really circles of three. David Knight has convincingly argued that this reflects the Trinitarian theology of the High Churchman Swainson.[73] In the *Spicilegium* Wight listed the three primary animal divisions: Vertebrates, Annulose animals (insects, crabs, &c) and Acreta, the last subdivided into three minor circles: Acreta proper, Mollusca and Radiata (starfish). These correspond with the three primary vegetable circles of Dicotyledons (Exogens), Monocotyledons (Endogens), and Acotyledons (Acrogens), the last composed of Fungi, Protophyta (seaweeds and lichens) and Acrobryous or Pseudocotyledonous plants (ferns and bryophytes). So far so good – 'thus far the two kingdoms advance side by side and step by step together presenting analogous groups in each. The Vertebrata represented by the Exogens … ' and so on. At which point, not surprisingly, Wight gets stuck – the Vertebrates can be divided into five neat groups (mammals, birds, reptiles, fish and amphibia), but what are the corresponding groups of the Dicots? Neither is Wight, though respectful as ever, convinced by Lindley's attempts to bring out 'the affinities and analogies of his vegetable circles so clearly as Zoologists have their animal ones'.

Seeking life principles common to plants and animals was a common preoccupation, and has been noted in Wight's physiology (p.65), but here he surely saw that such attempts could be taken too far. Furthermore, it seems astonishing that someone who believed in God the Creator should have had such a low estimate of a deity that could devise such a simplistic scheme – limited to the number of digits on a single (human) hand. As pointed out by Alfred Russel Wallace, such a system 'absolutely places limits on the variety and extent of creation'.[74] Nevertheless, Wight thought that attempts to find the groups required to make the system work should continue, as failure might be due merely to gaps in contemporary knowledge.

Wight's first published reference to the circular method was in 1841 when he wrote that the 'circular method of investigation, which is now rendering such important services to zoology, has not yet been sufficiently extended to botany, though much wanted'.[75] In this case he was suggesting that its power be tested with the vexed question of arranging species, and constructing sections and genera, in the Umbelliferae; a highly natural family, but for which no satisfactory generic treatment had yet been achieved. Eight years later Wight would still state that 'the object [of a natural arrangement] is to form circular groups, linked together by few but comprehensive characters'.[76]

There are three cases where Wight attempted to apply such a system:

1. The subgenera of the family Myrtaceae.[77] This attempt to apply a circular arrangement was tentative, it being 'impossible to determine the sequence of a genus until the whole order has been carefully analysed' and Wight had only 'imperfect materials' with which to work. Given these limitations he thought it probable that in such an arrangement *Jambosa* would be the 'typical' subgenus of *Eugenia*; *Eu-eugenia* the 'subtypical'; and *Caryophyllus*, *Acmena* and *Syzygium* the 'aberrant', with the last of these forming the transition back to *Jambosa*.

2. An arrangement of the families Orobancheae, Gesneraceae, Bignoniaceae, Pedaliaceae, Acanthaceae and Scrophulariaceae formed 'a perfect circle, all held together by their irregular unsymmetrical flowers'.[78] The succeeding families Solanaceae, Hydroleaceae, Convolvulaceae, Borragineae, Verbenaceae and Labiatae, however, Wight was able to arrange only in a linear sequence.

3. In the Introduction to the *Spicilegium* Wight described a circle of vascular plants based on vegetative organisation, consisting of Exogens (dicots) – the typical circle; Homogens (i.e., monocots) – the subtypical; and three aberrant circles consisting of Gymnogens (conifers), Rhizanths (parasites including *Rafflesia*), and Podostemaceae, the last linking back to the typical circle (though its vegetative parts are mossy Griffith had dissected the seeds and found them to be dicotyledonous).[79] There was also a monocot circle consisting of: 'the Liliaceous class, as understood by Redouté, including nearly all the gay flowering herbaceous forms'; palms; 'the Retose families of Lindley' [*Smilax* and *Dioscorea*]; aroids; and the Glumaceous plants [Gramineae, Cyperaceae].

HOW WIGHT INFERRED AFFINITIES

> It is an axiom in Botany, in the determination of natural affinities of plants that the nature of every part of the plant must be understood and explained, to enable us to compare one organ with another in different families, and in that way ascertain in what points they associate and in what they differ. This is not always an easy task.[80]

It was very largely only gross morphological characters of the flower and vegetative parts that had to be understood, and the comparisons were undertaken by the process of analogy. This was the traditional method of Linnaeus, Jussieu and Candolle. Of these, Candolle especially had been unwilling to use anatomical evidence, in which prejudice he was largely followed by British systematists, notably Bentham.[81] The only exception to this was the use of seed characters, which Jussieu had early on incorporated from the work of

Gaertner. Wight in his descriptions always included the microscopic seed characters of embryo position, presence or absence of 'albumen' (i.e., endosperm) and cotyledon type, but pointed out that 'every day's observation tends to convince me that characters taken from … [presence or absence of albumen] require to be used with caution' and that knowledge of the significance of this was 'not yet sufficiently advanced to enable us to draw useful characters from it'.[82] He later elaborated on what he meant by this: until its 'functions in the vegetable economy' were known it was not possible 'to assign a uniform value to characters taken from it',[83] suggesting that Wight believed that physiologically more important characters should be given a higher weighting. Later on in the *Illustrations*,[84] Wight reverted to his initial belief in the primary importance of 'albumen' as a character, and chided Lindley for being inconsistent in sometimes subordinating it to floral characters. But later still, over this same question, he seems to have come to agree with Lindley's stance: 'this example [Oleineae / Chionantheae] shows both the difficulty and importance of assigning a just value to characters, whether physiological or structural, and that overvaluing either inevitably leads to disruption of affinities'.[85] In the case of the family Borragineae (including Cordiaceae and Ehretiaceae) Wight supported a broad concept, on the grounds that 'relationships easily detected by external characters' should probably not 'give place to others deduced from microscopic research'.[86]

There is a somewhat purple passage, where Wight extolled the use of the microscope, but largely as a means of revealing levels of natural wonder not visible to the human eye (as did the telescope at the other end of the scale). Its use provided 'evidences of complex structure and organization in the filmy dust of the moth's wing, or the equally minute particle of matter constituting a grain of pollen';[87] but as a tool used in assessing affinities it seems that Graham's expensive present of 1832 was largely unused by Wight. An exception was his beloved Asclepiadaceae, as in order to identify members of this difficult family (even to generic level) it was necessary to have 'a moderate degree of skill in use of the instrument'.[88] Wight also stated that it was necessary to use a 'microscope of moderate power' to identify Choisy's genera of Convolvulaceae.[89] There were times when Wight evidently worried about his lack of microscopical expertise. In 1840, when he had clearly been castigating himself over this matter (and other self-perceived limitations of his *Illustrations*) to Griffith, a pioneer of anatomical work in India, Griffith attempted to reassure Wight that:

> the use of the microscope, and of keen knives, are very good adjuncts [to the study of philosophical botany], but many of the higher branches of botany do not require them, such as the distribution of vegetables, the changes induced by cultivation, etc. etc. [90]

Wight and his contemporaries could only go on overall resemblances (at whatever scale), which, given the processes of parallelism and convergent evolution, and difficulties of interpreting reductions or losses, can be misleading. Even identifying structures as homologous, without anatomical and developmental studies, is virtually impossible.[91] The process was highly subjective, and hence the endless arguments about the significance of particular characters, and alternative placements in different schemes of natural classification.

> No sooner do we find one Botanist, eminent for his knowledge of affinities of plants, distribute the orders so marked, in the way he thinks most consonant with their natural affinities, than we find another equally celebrated proposing a different arrangement.[92]

> Those departures from the usual structure which are ever crossing the path of the systematist, to the material disturbance and derangement of his arrangements, as if to keep constantly reminding him, that nature will not submit to the trammels of human systems, but will have her own way in forming family ties and relationships between families apparently widely separated.[93]

When was an analogy close enough to establish an affinity? To take just one problematic case of the countless examples discussed by Wight, whether Hypericineae should be separated from Guttiferae, and, if so, what characters should be used? Wight did separate these families, based on fruit characters and number of floral parts, but thought Guttiferae as then constructed un-natural, and that 'giving due weight … to characters derived from the number and arrangement of parts' genera such as *Stalagmitis* should be moved from Guttiferae to Hypericineae.[94] There were occasions when Wight gave up and admitted that, pending further knowledge and refinement of the natural system, families such as Ampelideae (now Vitaceae) could only be placed 'according to some convenient artificial system suited to facilitate the investigation of new plants'.[95]

Given all this it is perhaps surprising how 'natural' many (perhaps the majority, give or take marginal prunings or graftings) of the families recognised by Wight and his contemporaries have turned out to be, though the same cannot be said of their 'affinities'. The word 'relationship' was occasionally used in this context, but similarities were never thought of as being due to common descent, but as a reflection of the pattern of creation and of the mind of God. Wight was certainly a creationist, and a believer in natural theology, who could cite the pollen collecting mechanism (stylar hairs) of certain Campanulaceae as an example of 'design on the part of the Great Architect' – no mere 'curious provision of nature' but an indication of the 'wisdom and design which meet us at every step in studying his works of creations'.[96] There is a single occasion where Wight mentioned the possibility of the mutability of species. This concerned a blue pimpernel (*Anagallis latifolia*), an introduced weed of wheat and barley in the Nilgiris, and its relationship with *A. arvensis* and *A. caerulea*. Wight suggested that 'under the influence of changing climate' a species (doubtless *A. arvensis*) might have 'run into varieties of sufficient permanence to lead to their being considered so many distinct species' – not only mutability, but perhaps also Lamarckism.[97] This, however, is but a single example in Wight's vast published output.

On a related topic, that of variation with time, and the possibility of extinction, only a single example can be found, respecting the family Begoniaceae. Wight agreed with Lindley that Cucurbitaceae was the nearest family to which the begonias had any affinity (one has to restrain oneself from saying 'its nearest relation', as Wight did *not* use this terminology), but considered that:

> I am almost disposed to go so far as to say that it has no really near affinity in the living flora of the earth, and that we must seek its relationships among the fossil remains of a former world.[98]

This is an astonishing statement, and the fact that nothing like it occurs anywhere else in Wight's entire *oeuvre* makes one wonder if it is an unacknowledged reference. Even if not, did he realise its full implications? The only reference to Wight in Darwin's correspondence

is a very slight one – referring to his comments on the isolation of the family Cucurbitaceae[99] and Darwin would surely have been even more interested (if by this time unsurprised) in this far more explicit statement of the possibility of evolution and extinction.

On the question of whether character combinations found in a particular family were what would now be called 'basal' or 'derived', only a single relevant discussion occurs in Wight's publications, and relates to Euphorbiaceae. The younger Jussieu (Adrien) believed it was a family characteristic to lack petals, but Lindley took the basic state of the family to be polypetalous, and that petals had been 'lost' in about half the genera. In deciding between the alternatives Wight suggested looking at separation of sexes ('monoecy') in the family, a condition he took to be 'an indication of diminished perfection in floral development' and that it therefore occupied 'a lower grade in the series' than families with bisexual ('perfect') flowers. He therefore disagreed with Lindley, believing this to show that:

> in place of this being a polypetalous order, losing its petals in a part of its species, it is in truth a most unequivocal diclinous one, striving as it were, to raise itself in the scale. by getting them in as many of its species as it possibly can, and as if to show its inability to raise itself higher, we find in some genera petals in the male flower but wanting in the female.[100]

From the 'as it were' the anthropomorphism (that a plant family can strive for anything!) is clearly to be taken metaphorically, but it nevertheless surely indicates some admission of the possibility of evolutionary change with time.

In the light of later knowledge, and from the occasional use of what seems the inevitably genealogical word 'relationship', it seems hard for us today to understand how botanists of Wight's period could not have realised that similarity was at least partly a result of common ancestry. It seems worth giving just one example of the modern interpretation of a group that was highly problematic to Wight (and on which he merely deferred to, and quoted from, Lindley), the water-lily family, Nymphaeaceae, with its mixture of monocotyledonous and dicotyledonous characters. A powerful additional source of information is now available to throw light on relationships in the form of molecular analysis of the sequence of base pairs in DNA, and in this case the reasons for the morphologists' struggles are revealed. Cladistic analyses using molecular data place Nymphaeaceae as a small group very near the base of the angiosperm tree. Immediately above them is another small group including star anise, as well as a huge group made up of all the other angiosperms, including monocots. The similarities between Nymphaeaceae and monocots are convergences (some think that the ancestor of the monocots may have been a plant of more or less aquatic habitats) that confused even the first generation of botanists using cladistic methods. Recent studies also show that, unlike the monocots, the dicots are not a 'natural' group, something that would have shocked Wight and his contemporaries to the core – they are simply all plants left behind after the monocots have been snipped away from the angiosperm phylogenetic tree. Immediately after Nymphaeaceae, Wight, following traditional practice, treated the sacred lotus (Nelumbonaceae). However, it has been found that the similarities between the two are also convergences to the aquatic habit, and that Nelumbonaceae are, rather surprisingly, now placed in a group with the plane trees and proteas. While the new phylogenetic classification may be truly more 'natural' (in terms of reflecting evolutionary history), it is likely to be harder to use for identification (splitting superficially similar groups far apart). Such tensions between classification and identification were pointed out long ago by Lamarck, and Stevens argued that confusing the two, to the end of providing stable names for identification purposes, was a major reason why Jussieuan methods held sway for such a very long period, and long after Darwin had explained at least a large part of the basis for 'affinities'.

MONOGRAPH ON MYRTLES

Wight's most elaborate taxonomic treatment of a family, that of Myrtaceae, brings out several useful pointers to Wight's taxonomic beliefs and methods. Firstly the question of the weighting of characters. Candolle seems to have sought a hierarchy of characters that could be used to delimit groups at different levels of the system.[101] (This was in contrast to Jussieu who thought that a given character might be more or less useful at different levels). Wight seems to have been a Candollean in this matter as he once upbraided Lindley for 'assigning different values at different times to the same organs [and therefore] totally failed [in this instance] in the construction of a Natural System of Botany'.[102] The same principle was expressed when Wight was trying to find characters to delimit genera (and species) in Myrtaceae – although this was clearly a very natural family, he was forced to have recourse to 'distinctive marks to which in most other orders only a secondary character would be attached'.[103] Wight warned against using artificial characters to define genera 'barely sufficient to supply very secondary sub-divisions' and repeated the Linnaean maxim that 'the genus gives the character not the character the genus'. As with the albumen example above, the question of the functional use of an organ in giving weight to a character was also raised here, and Wight rejected the use (at generic level) of 'the mere external form of the calyx' and 'whether the petals are so caducous [deciduous] that they fall before expansion or fairly expand and prove as persistent as petals usually are in tropical climates, that is, have a duration of from 12 to 24 hours'. In dismissing the use of such trivial characters in defining natural genera he wrote:

> it is surely time we were bidding adieu to such puerilities and studying, not how far we can split and multiply genera by restricting our characters within the narrowest limits, but how we may so construct them as to include every species that naturally belong to them, and to exclude all that do not.[104]

This suggests a Jussieuan synthetic approach to the formation of genera, and the result was the recognition of a broadly circumscribed *Eugenia*, with subordinate subgenera.

Wight may, in the Introduction to the *Illustrations*, have claimed not to care whether groups above the species were created by nature, but in this case he positively stated that in the:

> structural peculiarities [i.e., 'good' characters], which pervade the whole tribe of Eugeniae we have ... conclusive evidence that nature does create genera ... being ... pervaded ... by a uniform structure in the organs most essential to the preservation of the species, shows that it is truly one of nature's own genera and, as such, ought on no account to be broken down and frittered away by the introduction of frivolous distinctions without practical value or facility of application when employed in practice [presumably for identification], since in their nature they are fluctuating and unstable.

In dividing his large subgenera, which he admitted were 'necessarily somewhat arbitrary' in their characters, Wight was forced to use a more Candollean analytical method, using inflorescence position and the despised (at generic level) characters of the calyx, and whether the petals were free or coherent before falling. The largest of his subgenera was *Syzygium*, now recognised as a genus (partly on the basis of an anatomical character, and in which Wight's subgenera *Acmena* and *Jambosa* are included), but other than promotion of subgenera to genera, Wight's treatment has stood the test of time remarkably well. It is perhaps his most significant piece of taxonomic work, and shows what he was capable of when given time and application. He treated 57 species of *Eugenia*, 28 of which were new, and of the latter no fewer than 20 are still recognised today. (Those he placed in subgenera *Acmena*, *Jambosa* and *Syzygium* are now all placed in the genus *Syzygium*, but differing opinions as to the level of the hierarchy at which a given group should be recognised merely serve to show the subjective nature of this particular game).

INTEREST IN GENERAL LAWS OF MORPHOLOGY

Wight realised the importance and usefulness of general laws of morphology in assessing affinities by analogy, and the need to understand modification and exceptions to general plans of families:

> the Botanist unacquainted with the laws which give rise to, and regulate, these metamorphoses [such as the addition or suppression of a stamen or pistil] has no guide to direct him where else in the system to look for the plant under investigation.[105]

One metamorphosis that seems particularly to have interested Wight was the 'modern Botanical doctrine [of] transformed leaves'. The was invoked in a discussion of the modification of stipules in Cucurbitaceae,[106] and when discussing the nature of the leaf whorls of *Galium*, which Candolle and Bentham took to be composed of a mixture of true leaves and leaf-like stipules, with which Wight disagreed.[107] Wight also used the theory of 'transformed leaves' in (not very satisfactory) attempts to interpret placentation in families such as Verbenaceae,[108] in his scarcely comprehensible paper on the pomegranate fruit,[109] and in his bizarre theory on the nature of the cucurbitaceous pepo.[110]

The reason these discussions arose was because Wight believed that characters of the ovary and placentation were of crucial importance, and therefore frequently featured in his discussions of affinity. On one occasion he (wisely) stressed that it was important to examine this character early on in development rather than from the mature fruit: 'if the ovary in place of the full grown fruit was examined in all the remaining species we should find but a sorry turn out of Vacciniaceae with 10–celled ovaries and solitary ovules. In the Indian ones nothing is more common than 10 divisions in the fruit (5 spurious), tho' all have only 5–celled ovaries'.[111] Earlier he had told Arnott that 'I do most cordially dislike genera, which like most of those of the Oleaceae, rest solely on the mature fruit' (and this was specifically not *only* because of the difficulties it led to in the herbarium).[112] Here, as elsewhere, however, Wight was inconsistent. For example in his observations on the *Viburnum* fruit:[113] earlier authors had taken this to be basically 3–loculed, but 1–seeded by abortion, but Wight examined all the specimens in his herbarium (which included North American and European as well as Indian species) and reported (a little self-righteously) that in fact the ovary

was universally 1–loculed and 1–seeded. In this case he seems not to have thought of the developmental stages that might have led to this, or the need for anatomical investigations (and the same applies in the case of an argument with Bentham over the basic nature of the Labiate ovary to be discussed below).

In the case of the normally dioecious pawpaw (*Carica papaya*) Wight was anxious to illustrate the 'power which vegetables possess, in particular circumstances, of developing organs that are usually suppressed' – the development of axillary buds into branches when the apical one is damaged, and the unusual production of female flowers in male inflorescences in 'the cool [sic!] and humid climate of Quilon [on the Malabar coast]' and Kandy in Ceylon.[114]

VIEWS ON VARIABILITY

The reason for examining morphology was, of course, to aid in delimiting and defining taxa, and Wight did not want to describe unnecessary species. In order to prevent species proliferation it was necessary to take variation into account, and with enormous herbarium collections at his disposal, he was in a good position to do so. Before describing new species Wight looked carefully at a range of individuals, and considered factors such as growth conditions. Proof that he was keen not to proliferate species is found in a discussion of *Polygala* where he described his method of examining 'a very large series of specimens' seeking distinctive and invariable characters 'by which to bring varying forms together'.[115] And also in his discussion of Cucurbitaceae, where 'no dependence can be placed on the form of the foliage as affording specific characters, almost every variation of form from simple, up to much divided leaves, being found in the same species and even occasionally on the same plant'.[116] Wight cautioned against 'excessive multiplication of species' in cases where there was 'difficulty of discriminating among … species and varieties', and pointed out the necessity of looking at a wide geographical range (in this case, *Sida* and *Abutilon*, both New and Old Worlds needed to be considered).[117]

A character often mentioned by Wight as being variable, and therefore to be treated with caution as diagnostic, was variation in number of floral parts such as stamens, styles, or locules in an ovary (e.g., *Hugonia*[118]) – such variation, incidentally revealing another drawback of the Linnean sexual system. On this topic of 'aberrations in the formation of parts both of excess or deficiencies', and as a warning against putting too much weight on them, in an almost unique example of humour (or at least irony) in the somewhat arid *Illustrations*, Wight asked:

> I have seen cases of an excess of toes and fingers, would it be safe to infer from such that two thumbs on each hand was the normal structure of the human hand, but that generally they were reduced to one?

The particular context of the question, however, was a serious one, over the use of monstrosities in answering questions about the 'normal' (basic?, typical?) state of a character in a particular family. Bentham had argued (from the evidence of monstrosities) that the 'normal' number of carpels in the labiate flower was five, but that this was 'constantly reduced to two'. Wight considered this a 'non sequitur in our botanical language' while admitting that 'the study of monstrosities has been … the making of structural botany; but occasionally it seems possible to overshoot the mark'.[119]

An example of habitat forms leading to species proliferation was cited by Wight in the case of *Jasminum rigidum*: 'growing in clefts of

rocks with but little soil, and stunted in its growth by the absorbed heat, it becomes *J. myrtifolium*. In rocky places, but with a larger admixture of soil it is *J. rigidum*, while in rich deep soil, sheltered and shaded by trees, it becomes diffuse with scandent branches, and is then *J. tetraphis* [this was one of his own species, but he evidently had second thoughts here]'.[120]

The vexed question of widespread and variable species was discussed by Wight, and the case of *Viola patrinii* shows his cautious approach based on examination of a large number of specimens from a wide geographical area.[121] Taking into consideration plasticity in features such as hairiness due to wet or dry conditions, and lack of constancy of features such as petiole and peduncle length, Wight thought that no fewer than five species should be sunk under *V. patrinii*. In the case of *Biophytum* he demonstrated caution in case the reason for the different appearance of extreme forms was due simply to 'local circumstances': this, however, could only be tested 'by making the two plants change places, and in that way determining whether or not their forms would alter also'.[122] Wight suggested similar testing of his Nilgiri lilies, *Lilium neilgherrense* and *L. tubiflorum*,[123] but there is nothing to show that he undertook such transplantation experiments himself.

Wight in his solo works was notably sparing in the description of formal varieties, but in the case of the variable *Gomphandra polymorpha* described and named 'five very distinct forms'.[124] While other botanists might consider these to be species, he preferred a conservative approach treating them as 'varieties of one [species]'. Later workers have agreed and the forms are now all referred to *G. tetrandra*. The fraught, but important, question of distinguishing between species and varieties, crops up in Wight's discussion in the *Illustrations* of the cotton genus, *Gossypium*. Wight attributed the difficulty of discriminating species in this genus to their 'long culture', which had 'caused them to run into every variety or form'. Although some authors had reduced these to what he thought too few species (Buchanan-Hamilton – 2) and others too many (Candolle – 13), Wight did not agree with those who thought it of little importance whether these were called species or varieties:

> since the term species implies permanency, while variety conveys exactly the opposite idea, or that of liability to change under any variation of the circumstances under which they may be produced, hence their aptitude for culture unchanged in some favoured situations and their disposition to change in others to all appearances equally favourable.[125]

A different sort of variability, the expression of sexuality and the possibility of its alteration by climate, is raised in Wight's discussions of *Ilex*,[126] and *Calysaccion* (= *Mammea*).[127]

WIGHT'S USE OF THE WORD 'TYPE'

Candolle believed that each family had a certain basic form of floral symmetry that could be 'loosely equated with "type"'.[128] Many systematists, especially French and German, extended this concept in an essentialist way to try to 'limit the extent of the variation they saw by reducing the unruliness of nature to invariant types'.[129] This approach was frowned upon by British botanists such as Brown and Bentham, though in 1856 J.D. Hooker drew attention to the fact that notions of 'types' were vague and even arbitrary:

> the ideal type being either the prevalent form of the group, or that which unites most of the peculiarities which distinguish it, or that which

possesses the fullest complement of organs united in one individual, or that in which these are most complex, as well as specially adapted to the functions they perform.[130]

Although Wight never defined it, or explained his use of it, he did on occasion use the word 'type' as, for example:

> *Bombax* the type of the order [Bombacaceae].[131]
> The orange with its numerous varieties of lemons, limes, citrons, pumplemosses, &c form the type [of Aurantiaceae].[132]
> Orobanchaceae … I presume the type of the order, unless I have misunderstood its structure.[133]

From which it seems likely that he intended it in Hooker's second sense.[134] As has been noted Wight (and Arnott) believed in continuity, and accepted broad circumscriptions of families (including aberrant forms), and therefore did not try to limit them by using a typological method. Only later did Wight, perhaps, hanker for such precision and restriction when he wrote with great enthusiasm of Lindley's use of floral diagrams. Wight saw such diagrams of 'the essential characters of orders … as the first step taken toward reducing Botany to the precision of an exact science' and the diagrams as 'being, to the Botanist, of much the same value as those of Euclid are to the Mathematician',[135] or 'atomic formulae to chemistry'.[136]

WIGHT'S NOMENCLATURE

> His [Wight's] works show a singular, and, we say with regret, a very rare love of truth, and earnest desire to reduce species to their proper limits and their *proper names*. W.J. Hooker.[137]

It has already been noted that Wight disliked the proliferation of unnecessary species, and that one way of avoiding this was by taking variability into account. Another was by studying botanical literature to see what had already been published, and by following the existing conventions of botanical nomenclature – so as to avoid the further 'burthening [of] … our Science, already overwhelmed with synonyms'.[138] Arnott too believed it 'much more important to the science of Botany to rectify synonyms, and to make out what has been done (erroneously if you will) by others, than to describe new plants, which any one who has studied botany for a year or two can do'.[139] In Wight's time, however, botanical nomenclature was in a rudimentary state and operated largely on the principles laid down by Linnaeus. It was not until Alphonse de Candolle proposed laws to the Botanical Congress in Paris in 1867, published in English the following year,[140] that botanists had anything like a formal set of rules by which to operate, and in this they were beaten by the zoologists. In his major discussion of the subject,[141] Wight could therefore only refer to the report on Zoological Nomenclature presented to the British Association meeting in 1842.[142] Wight & Arnott's nomenclatural methods have been discussed elsewhere,[143] but it is necessary to discuss two points here, in order to understand why so many of Wight's species are no longer recognised – the first relates to synonymy, the second to changing conventions in matters of nomenclature.

In a discussion over whether the correct generic name for the glory-lily was *Gloriosa* or *Methonica*, and with reference to what might be called the 'Zoological proto-Code', Wight stated his passionate belief in two principles that still lie at the heart of biological nomenclature: *priority*, and *valid publication*. The first of these is,

essentially, that the earliest validly published name for a species or genus should stand for all time. Apart from practical usefulness as a means of establishing an absolute, Wight thought that this was fair in that it allowed credit to be paid to the scientist who first recognised the species or genus as distinct:

> the naturalist prizes the honor of naming the subjects he has studied … – it is usually his only reward for his pains-taking labour – and, as the laborer is worthy of his hire, that credit ought not to be wrested from him, and still less when to be conferred, perhaps, on a person utterly incompetent either to examine or define [i.e., describe], or what is about as bad, on one too idle to do so for himself.[144]

Anything other than respecting the principle of priority would be a 'departure from the courtesies of science'. Given, even by the mid-nineteenth century, the extent of botanical literature, and the fact that names were widely scattered in often obscure publications, it required huge effort and extensive knowledge of this literature, to be able to consult all the likely places where one's suspected novelty might have already been published. Although the starting point for botanical nomenclature has been set at the publication of Linnaeus' *Species Plantarum* in 1753, in the case of *Gloriosa* Wight had to look up earlier names described by Hermann and Tournefort, to which Linnaeus himself referred back.[145] The question then followed as to what counted as 'valid publication' of a name. Wight had strict views on this – that for a name to be valid it firstly had to be *published*, and it also had to be accompanied by a 'definition' (i.e., a description), so that other botanists had some idea of what the original author meant. It should be noted that in Wight's time it was not necessary to refer to a particular specimen, as is now the case.[146] Wight therefore rejected names that appeared merely in manuscripts or as annotations on herbarium sheets, or ones that were published but lacked descriptions (for example those in his own, or Wallich's, herbarium catalogues):

> an undefined catalogue name [i.e., a *nomen nudum*] can never be allowed to take precedence of a fully defined and published one.[147]

As Wight pointed out Indian botany was plagued with such 'undefined names' and one of the purposes of his *Icones* and *Illustrations* was to 'fix by definition these floating names', which he generously (and this was not necessary) did not alter if he was absolutely sure of the plant to which the name applied. He did, however, feel at liberty to correct what he considered to be mis-spellings,[148] and one such was the occasion of an amusing anti-German tirade. This concerned the spelling of what are now called the 'Nilgiri' mountains, but which Wight stated (not entirely correctly) was always spelt 'Neilgherries', at least by English speakers, and from which the Latinised geographical epithet should be '*Neilgherrensis*'. J.C. Zenker, a cousin of the Rev Bernhard Schmid a missionary friend of Wight's at Ooty, had made a geographical epithet '*Nilagirica*' for a species of *Michelia*, but how dared someone who spoke a 'harsh and often unpronounceable tongue' take such a 'presumptuous liberty' in correcting a language that was altogether 'softer and more flexible'?[149]

The point is that, after all one's historical research in the matter of extant names, it is only too easy to have overlooked a name that applies to a plant one is about to describe as new. For example, it might have been described in a Flora of Indonesia, or some other country that one would have no particular reason for thinking it necessary to check. This is one of the reasons why many of Wight's

are no longer recognised – earlier names having come to light with subsequent study in large herbaria containing specimens from all over the world, and in well-stocked libraries. The later name would in this case have to be 'sunk' under that for the Indonesian species, or in more formal terms 'reduced to its synonymy'.

Changes in the rules of nomenclature provide the other major reason for the sinking of many of Wight's names. As already noted Wight laid great stress on priority of validly published names with descriptions; but there was one exception, which oddly neither he nor Arnott ever mentioned. This was a convention then in place, especially among British botanists, that the rule of priority only applied within a given genus, and that if one considered that a species had been described in the wrong one, it was not necessary to use the same specific epithet if it was transferred to another genus – i.e., the epithet does *not* have priority in another genus. This, from 1877, came to be known as the 'Kew Rule'. In fact Alphonse de Candolle in his '*Lois*' of 1867 stated that the oldest epithet should always be used (except where it had already been used in the genus to which one wanted to move a species: when the name was said to be 'preoccupied'), but many botanists continued to use the 'Kew Rule', until it was voted out by taxonomists at the Botanical Congress held in Vienna in 1905.[150] Under this other system, it was the epithet that had priority, so if a species is transferred to another genus the earliest epithet must be used, unless it is preoccupied. What is more surprising, and in my view inexcusable, is that this new rule has to be applied retrospectively, even to names made in good faith according to conventions of the time. When Wight & Arnott transferred a species to a different genus they always coined a new epithet, though one that very often credited the person (author or collector) who had first recognised the species. For example Wight & Arnott thought that the legume described by Wallich's teacher Martin Vahl, on the basis of collections made by J.G. König, as '*Mimosa nitida* Vahl' should be placed in the genus *Inga*. They therefore made the new name '*Inga koenigii* Wight & Arnott', which, at the time, they were entirely justified in doing. However, under the present rule they should have retained the epithet and made a new combination '*Inga nitida* (Vahl) Wight & Arnott', but as they did *not* do this their name is regarded as being both 'superfluous' and 'illegitimate', though it is validly published. Having established that the epithet '*nitida*' has priority, later botanists have decided that it should actually be placed in the genus *Thailentadopsis*, so the plant is now correctly known as '*Thailentadopsis nitida* (Vahl) G.P. Lewis & Schrire'.

MODERN CONCERNS: OR THE WISDOM OF HINDSIGHT

> Field studies were certainly no integral part of the classificatory endeavour … [and not] important or even relevant when so much had still to be described for the first time and assigned its place … there was a split between the field naturalists with their broader approach and closer contact with the realities of nature, and the literally and metaphorically more closely focused work of the closet naturalists.[151]

The distinction between field and closet naturalists is an important one, and explains something that can seem paradoxical about Wight as seen from today's perspective. It is easy looking backwards, and ignoring historical and biographical details, to make the assumption that, because Wight was based in India (i.e., 'over there') for a total of 31 years, he was a field naturalist. This is simply not the case. It overlooks the fact that Wight was a hard-working EIC

official, that his botanical work was done very largely in his spare time, and that the majority of his herbarium collections were made by Indian collectors paid from his own pocket. It also overlooks the fact that, at least some of the time, Wight liked his home comforts.[152] The noteworthy exceptions are his 1826 expedition, those of 1836 (Courtallum, Ceylon, the Shevaroy and Palni Hills), and his 1845 excursion with George Gardner in the Nilgiris. Other than these, Wight's own collecting appears to have been on a rather limited scale. In fact, as Greville's amusing comments of 1834 show, Wight, like Arnott, was perhaps most at home with piles of dry herbarium specimens,[153] and of Steven's two categories is best understood as a 'closet' naturalist. From our perspective, if seen as someone with wonderful opportunities for field work staring him in the face, it is easy to be critical or superior, but this is both unfair and unhistorical. It is only with hindsight that we know that the great breakthrough in the study of biology came through Darwin and Wallace who were both pre-eminent field workers. But this was not obvious at the time, when closet naturalists seemed equally likely to be the ones to answer questions such as the reasons for 'natural order', and the paradox is that Darwin only recognised the importance of his finches, tortoises, and the rest of what he had seen in the field, when he came home, and largely because of the work of closet naturalists. The great exception in India was Griffith, who showed that it was possible to unite the approaches and pointed out that 'botanists publish too much from dried specimens' and questioned:

> how people can work on dry plants I cannot imagine. I am daily convinced of the poverty of the study from such materials, unless a man has seen much of living structures.[154]

Griffith, however, belonged to the generation after Wight's, and early death cheated him of his great synthetic ambitions. We should therefore not be surprised if Wight's published work (and we have to bear in mind the unpublished material, especially the private diaries that, tragically, have not survived, and the sort of field observations they might, perhaps, have contained) is largely devoid of the sort of field observation that we now value – the few examples given below are widely dispersed in his vast output, and were found only by dint of substantial effort.

Being a closet naturalist in India, however, put Wight in an anomalous position, and he repeatedly had to make excuses for his lack of facilities – the encyclopaedic library and herbarium essential for the historically-based science of taxonomy. When Lindley suggested that 'some skilful Indian botanist' should make 'good observations upon the living plants of *Guttiferae*' with a view to elucidating this difficult family. Wight replied:

> European botanists … enjoy greater advantages for this work than Indian ones … Indian Botanists are few, and very remote from each other, with but little intercourse [i.e., other than by letter], and generally having other duties to engage their attention, whence Botany, in place of a professional pursuit becomes with them a mere recreation. So situated, few enjoy the opportunities required for the successful elucidation of a difficult natural order, even when well qualified for the work; each, only becoming acquainted with the species within his own limited circle, generally too few to admit of his attempting from them anything like a comprehensive examination of a complex order [i.e., family]. He therefore, in place of attempting the nearly hopeless task

here assigned to him, more frequently when possessed of a scientific friend in Europe, sends specimens there to have them examined and named, and but too frequently is disappointed in his expectations [doubtless a reference to Robert Graham]. In this way large collections of all kinds of plants, from all parts of India, have gradually found their way to Europe and been brought together in the large European collections. Let these in the first instance be well investigated by a scientific Botanist, the genera and species clearly defined, their present confused synonymy unravelled, and such descriptions as can be made from dried specimens drawn up and published, to put the less qualified Indian Botanist in possession of the information thence attainable, and then he will have a firm foundation on which to build his observations made on growing plants. It is true that equally perfect descriptions cannot be made from dried specimens, as from growing plants, but I feel assured, from my own experience, that even with this most disheartening order [Guttiferae], much more might have been done [i.e., by European botanists] than has been yet effected.[155]

Historians of science with little understanding of the taxonomic process constantly fail to understand this issue, and why it could only be in the 'metropolis', with its large collections, that taxonomists could achieve their full potential. It was not only arrogance (though he was not always devoid of this character) that made J.D. Hooker in 1853 draw attention to the need for broader species concepts, which can only be obtained by studying large collections, or, as in his own case, from the privilege of experience obtained during extraordinarily wide travels. Hooker pointed out the disadvantages, and prejudices, under which isolated local botanists worked:

> there is … an inherent tendency in every one occupied with specialities to exaggerate the value of his materials and labours, whence it happens, that botanists engaged exclusively upon local floras are at issue with those of more extended experience, the former considering as species what the latter call varieties, and what the latter suspect to be an introduced plant the former are prone to consider native.[156]

Hooker, however, continued with a statement of the positive benefits of detailed local study, concluding that 'truth can only be arrived at through their ['local' and 'general' botanists'] joint labours'. In 1844 Griffith had taken exception to the limited role allowed to colonial botanists when he wrote to Wight that they had both been 'cast off by our English correspondents', which he attributed 'to publishing on our own account; that is heresy you know. The impudence of colonials pretending to publish!'[157] This was not entirely true (see pp.63, 155 for a discussion of publishing in India), and appears to have resulted from one bad experience and a fit of the sort of paranoia that can arise only too easily from isolation and an erratic postal system, but it shows that such matters were live issues in Wight's immediate circle. Given this, it is perhaps surprising that Wight achieved as much of lasting value as he did, due largely to his thorough and skilful use of the literature, and his use of contacts in Britain.[158] It is interesting to note that the majority of the leading taxonomists of the time (notably Arnott, Lindley, the elder Hooker, Candolle and Bentham) had no tropical field experience, and yet they created taxonomies that lasted until challenged very recently by the application of molecular methods. The exceptions, as pointed out by Stevens,[159] were Robert Brown and J.D. Hooker. Brown's taxonomy was certainly influenced by his field experience on the voyage to Australia with Flinders, but the case of J.D. Hooker

(Darwin's closest confidant) is more equivocal. His Antarctic and Himalayan travels were spectacularly productive in terms of specimens collected and publications (popular, floristic and, in the case of *Rhododendron*, monographic), and they certainly influenced his views on plant geography; but their influence on his taxonomic method is harder to pinpoint. Hooker in fact 'campaigned against the use of field characters in delimiting species', and even had Wight made better field notes (and they were non-existent), given the exclusive reliance on herbarium characters 'such notes were often considered of little importance once the specimens arrived in the herbarium'.[160]

With these caveats in mind it is of interest to cite the few examples of Wight's more 'biological' observations to be found in his publications.

Ecology

What would now be called ecological information is included in Wight's 1836 reports on the Pulney and Shevagherry mountains, and at this time he seems to have been particularly aware of its relevance – not only in explaining distributions of wild species, but, in view of his job, as indicators of which introduced species it might be possible to cultivate. Fuller habitat notes are thus given for the new *Impatiens* species Wight described at this time than in any other case,[161] and were duly appreciated by the ecologically-minded Griffith.[162]

In Wight's discussion of the family Orobanchaceae is an interesting discussion on whether substances produced by one plant can have an effect on another species (now called 'allelopathy'), or even cumulatively on itself.[163] Wight noted that seed of the tobacco parasite he described as *Orobanche nicotianae* could lie dormant in soil (which he examined microscopically and confirmed the presence of the plant's minute seeds – in modern terms a 'seedbank'), surviving through a rotation of grain crops, 'lying dormant, sometimes for years' to reappear only when tobacco was re-sown. He discussed alternative explanations for the rotation that had been found essential for certain crops: whether this was due to the crop exhausting the soil of particular minerals, or to poisonous secretions that prevented its own growth in subsequent years. While stating that the first was the more likely, Wight allowed the possibility of a contribution from the second – on the grounds that it was evidently a secretion from the tobacco root that stimulated germination of dormant broomrape seed, and it was therefore at least possible that such a secretion could 'prove injurious to successive crops of itself, or one of the same genus or even order'.[164]

Pollination biology / Breeding systems

Wight seems never to have had time to make the sort of observations on living plants of the sort made by Griffith, but that he could do so on occasion is shown by his charming description of pollination in the asclepiad *Ceropegia*:

> curious plants, especially as regards the reproductive apparatus, which is situated at the bottom of a long tube, and completely secluded from external influences, of a character suited to displace the pollen masses from the sacks of the anthers. This is accomplished by insects which can easily enter in search of the honey secreted at the bottom, but once in, they cannot return till the flower fades, owing to the tube being lined with stiff hairs directed inwards and downwards, like the wires of a

mouse trap. Thus imprisoned, the restless little creature is made the medium of bringing about fertilization, which could not otherwise take place; after which the flower fades, the hairs lose their rigidity and collapse, liberating the little prisoner to repeat the operation in another flower.[165]

For the aroid *Amorphophallus campanulatus* Wight recorded what is now called sapromyophily: 'the fetor it exhales is most overpowering and so perfectly resembles that of Carrion as to induce flies to cover the club of the spadix with their eggs'.[166]

Wight knew of the phenomenon of mass flowering (now termed a 'plietesial flowering cycle') in the family Acanthaceae: 'the curious habit of only flowering once in several years. But when they flower they do so in the greatest profusion'. It is this type of flowering behaviour, in the species *Strobilanthes kunthiana*, that gives the name to the Nilgiri (= Blue) Mountains. Wight did not, however, study this phenomenon systematically and did not record what he was in such a good position to do, that is, information on the periodicity of different species.[167]

Hybridisation

Hybridisation is now known to be of widespread, if infrequent, occurrence in wild populations of flowering plants and (especially when accompanied by polyploidy) of great importance not only in explaining patterns of variation, but as an evolutionary process. However, Wight made no mention of the natural occurrence of hybrids, and no doubt followed Arnott who took hybrids to be entirely artificial productions that 'ought never to be acknowledged by botanical writers. They are contrary to nature, and ought not to be received into any system of nature. They are only fit to amuse the eye and taste of the vulgar and uninitiated'[168] Wight & Arnott would doubtless have been surprised by the modern view of *Carex* × *grahamii*.

THE LIMITATION OF WORDS

As Wight's solo publications were, at least ostensibly, intended for a general audience, he was 'anxious to avoid the introduction of any terms not absolutely required'.[169] In the proposal for the *Illustrations* he wrote of the improvement of published descriptions since the time of Linnaeus and his predecessors, and the 'precision of modern scientific language', but if one looks at the concise descriptions in works like his and Arnott's *Prodromus*, their incredible limitation is immediately apparent, and one wonders how anyone could possibly have identified plants with their sole aid – that is, without recourse to accurately named specimens in an herbarium. Works such as the *Prodromus*, and even the much later *Flora of British India*, are really masterly arrangements of herbarium material, but of severely limited use in the field in the absence of such a backup. Descriptions like these are rooted in the Linnaean tradition (followed by Jussieu and Candolle) of extreme concision, extreme limitation in the range of characters described, an obsession with floral parts (numbers, position and fusion) – and what can only be called a pathological aversion to the use of characters contributing to what is now called the 'jizz' of the plant – even characters like growth habit are rarely mentioned, colour is treated with contempt and usually totally ignored, but perhaps the most extraordinary thing to modern eyes is that absolutely no measurements are given. An interesting tirade by Wight against the methods of Willdenow is of relevance in this context:

working with dried specimens far from their place of growth, [he] seems to have fallen into the too common error, under such circumstances, of being more anxious to multiply species, taking his distinctive characters almost entirely from the foliage, (the part of all others most likely to mislead …) than to retrench existing superfluities by an attentive study of structure [presumably floral], and a careful application of structural differences to the definition and limitation of species.[170]

It is not surprising that Wight was frustrated by verbal descriptions, the near impossibility of their practical use in India, and the concomitant importance of pictures:

the insufficiency of language alone, to convey just ideas of the forms of natural objects, has led naturalists, ever since the invention of engraving, to have recourse to pictorial delineation, to assist the mind through the medium of the senses.[171]

Wight was a passionate believer in the use of illustration a theme that will be developed, and, above all, illustrated in Book 2. Being keenly aware that works such as Roxburgh's *Plants of the Coast of Coromandel* and Wallich's *Plantae Asiaticae Rariores* were 'on so magnificent and expensive a scale as to limit their usefulness to the cabinet',[172] Wight set about providing illustrations in lavish numbers, and, by using lithography, at 'the cheapest possible rate'. His own publications were therefore on a scale (Royal Quarto) more fitted to a middle class library, if not quite for use in the field.[173]

The plates in his three great solo works are arguably Wight's greatest contribution to botany, and are still in everyday use by Indian botanists. This, however, is not to say that their letterpress was not important, and Wight once warned of using illustrations (or even specimens) without the sort of background botanical knowledge that the *Illustrations* was designed to provide. Medics had apparently been using the plates without bothering to read the text in the hopes of a painless way of finding names for plants, but Wight pointed out that there was 'no royal road to science' (i.e., no short cuts), and that such people 'need never expect through an inspection of plates or specimens of medical plants to become a medical Botanist'.[174]

Fig.27. A view westwards, similar to that from Kelso Cottage. Lithograph by W.L. Walton after a drawing by Captain E.A. McCurdy, published in *Views of the Neilgherries of Blue Mountains of Coimbetoor, Southern India*, London (c. 1830). Trustees of the National Library of Scotland.

Roving Botanist and the Nilgiri Hills 1839–42

The period 1839 to 1842 would have been busy enough merely with his work on the *Illustrations* and *Icones*, but professionally Wight continued to be effectively the Madras Government's economic botanist, under the roving brief of 1836, and with a base in Madras. In January 1842 Wight referred to 'the wandering life I have led for the last two years'.[1] Little detail is known other than the horticultural activities already described – for example the summer spent in the Bangalore garden in 1840. The following summer found Wight in the Nilgiris and it was this fascinating range of hills, and its main settlement of Ootacamund that, along with Coimbatore, would provide a base for his family and his botanical activities, until he left India in 1853 – especially over the next six years.

THE NILGIRIS · 1841 AND BEYOND

The Nilgiri Hills, the highest group of the Western Ghats, were hardly explored by Europeans until 1818, though Francis Buchanan had climbed one of the eastern outliers on his Mysore journey in 1800. However, exploration and development of the hills rapidly gathered pace thereafter generating a huge volume of literature,[2] the early history being ably summarised in Sir Frederick Price's account of Ootacamund, on which the following account largely relies.[3] The development was due largely to John Sullivan, Collector of Coimbatore, who first visited the hills on a twenty-day trip in 1819 in the company of the French botanist Jean-Baptise Louis Claude Theodore Leschenault de la Tour. It was in 1822 that Sullivan first went to the gentle amphitheatre that would soon be the site of 'Ooty', as it became 'familiarly and affectionately termed by the abbreviating Saxon',[4] and where the following year he built the first bungalow, which he named Stonehouse, at an altitude of 7244 feet. Sullivan was interested in agriculture and gardening and as early as 1821, when he had a bungalow at Dimhutty, had employed a gardener called John Johnston, who came from the Cape to 'improve plants of Europe' on the Nilgiris; he also formed a large lake at Ooty, with the possibility in mind of using it to irrigate the plains below at times of drought.[5] Sullivan also started to make meteorological observations at Ooty with a view to demonstrating the healthiness of the climate, and in 1825 suggested that a military sanitarium be established there. In 1829 a military cantonment was established with Major Kelso as the 'Officer Commanding the Neilgherries', and Major Crewe as his first Chief Commissariat Officer, who as a Colonel became Commandant in 1831. Although the military sanitarium ran only until 1841, Ooty continued to be a place of resort for invalids (civilian and military), and their 'salubrity' was proved by 'the restored healths and blooming complexions of our Indian invalids, who have gone there, [and who] bear testimony to the truth of Humboldt's theory, viz: "there is a serenity existing on all table lands between the Tropics, that are of considerable elevation"'.[6] Others just wanted to escape the heat of the plains.

Wight's first visit to the Nilgiris must also have been in the 1820s, as the map in Wallich's *Plantae Asiaticae Rariores* shows the route of his 1826–7 tour as crossing the eastern part of the range. There are also specimens labelled 'Neelgherries' collected by Wight or his collectors among the material returned to London with the Naturalist's collection in 1828 and distributed by Wallich.[7]

Despite the extensive clearance of shola forests that was started in the 1820s, and the extensive introduction of Australian trees slightly later,[8] when Wight first arrived in 1841 the area around Ooty must have closely resembled Sir Thomas Munro's description of the upper plateau based on a visit made in September 1826:

> It is composed of numberless green knolls of every shape and size, from an artificial mound to a hill or mountain. They are as smooth as the lawns in an English park, and there is hardly one of them which has not, on one side or other, a mass of dark wood, terminating suddenly as if it had been planted.[9]

The 'dark woods' are the sholas, and the grassland (which may or may not be a natural climax community) the pasture grazed by the indigenous pastoralists of the Nilgiris, the Todas.[10] Although Ooty did not become the official summer seat of the Madras Government until 1870, nearly all the Governors from Munro onwards visited it, including Wight's adversary Stephen Rumbold Lushington, who in 1829 stayed with his brother Charles, who had by this time built one of the largest houses in the growing settlement.[11] It was on this visit that the Governor laid the foundation of the church dedicated, hardly coincidentally, to St Stephen. He also instigated the new road up the Coonoor (or Nellitorai) Ghat from Mettupalayam on the plains 25 miles north of Coimbatore. This road, which was usable by bullock carts was opened in 1832, replacing the earlier route from Sirumugai to Kotagiri. Somewhat surprisingly, given his scrapping of the Madras Naturalist's post, Lushington shared Sullivan's agricultural interests and, following a visit in 1830, wrote a minute on agricultural improvements which he put under the control of Colonel Crewe. The Court, however, foiled most of Lushington's developments, which included recommendations on the extensive introduction of plants and trees, though an experimental farm of sorts was established at Kaiti.

THE PICTURESQUE

From Munro's description it can be seen that the Nilgiris were viewed in a picturesque light, above all as somewhere that evoked memories of home. Thomas Babington Macaulay, on a visit to Lord William Bentinck whom as Governor-General was at Ooty in 1834, described the still thickly forested slopes on the ascent as 'the vegetation of Windsor Forest or Blenheim spread over the mountains of Cumbria', but that on approaching Ooty 'a turn of the road disclosed the pleasant surprise of an amphitheatre of green hills encircling a

small lake, whose banks were dotted with red-tiled cottages surrounding a pretty Gothic church. The whole station presented "very much the look of a rising English watering place".[12] Another visitor, who published (lithographically) a valuable pictorial record of the hills in the 1830s, wrote nostalgically:

> The Englishman is highly gratified on the first ascent of these hills, at the sight of the fern, the brambleberry, raspberry, wild rose, and strawberry which greet him at every step, and when first the blackbird starts before him, with its well remembered whistle, the thrill of delight he experiences can only be appreciated by those who have felt, and loved such trifles in their youth, and have bade adieu to them, not only for years, but perhaps for ever.[13]

Wight had botanical suggestions to strengthen such associations, and recommended the introduction of the harebell (*Campanula rotundifolia*), 'the Witch's thimbles of the Scotch peasantry ... as adding another link to the many associations with our native country which these favoured regions already supply'.[14]

Another visitor of Wight's time was Richard Burton, on sick leave from the Bombay Army, who visited the Nilgiris in August 1847 and published amusingly scathing descriptions of Ooty – its social life, amusements (or lack thereof), its 'field-sports and excursionizing'. One of his less cynical accounts is of a visit to Hullicul Droog, an old fort of Hyder Ali, near Coonoor. The view from this eminence must have been familiar to Wight, as it was here that he collected the new ginger *Elettaria* (now *Amomum*) *cannicarpum*. Burton's description provides a good impression of the forest on the southern edge of the range, and the view over the plains to Coimbatore, where Wight would shortly be based:

> The path narrows, it becomes precipitous and slippery, owing to the decomposed vegetation that covers it, and presently plunges into a mass of noble trees. You cannot see a vestige of underwood: the leaves are crisp under your feet; the tall trunks rise singly in their sylvan glory, and the murmurs of the wind over the leafy dome above, inform you that
> This is the forest primaeval –
> as opposed to a rank bushy jungle ... The foot-track is bounded on both sides by dizzy steeps: through the intervals between the trees you can see the light mist-clouds and white vapours sailing on the zephyr far beneath your feet. After an hour's hard work, we suddenly come upon the Droog, and clambering over the ruined parapet of stone ... stand up to catch a glimpse of scenery which even a jaded lionizer would admire.
> The rock upon which we tread falls with an almost perpendicular drop of four thousand feet into the plains. From this eyrie we descry the houses of Coimbatore, the windings of the Bhawany, and the straight lines of road stretching like ribbons over the glaring yellow surface of the low land. A bluish mist clothes the distant hills of Malabar ... However hypercritically disposed, you can find no fault with this view; it has beauty, variety, and sublimity to recommend it.[15]

Lord Elphinstone (Governor of Madras 1837–42) took an active interest in the Nilgiris, and in 1840 had, without asking the Court's permission, moved the Government from Madras to Ooty for eight months, for which he was severely censured. It was at this time that he bought Lushington's former farm at Kaiti and developed it as a palatial residence and garden for himself, which he retained until 1845. It is likely that Elphinstone was behind Wight's visit to the Nilgiris on agricultural matters in 1841,[16] when he was based mainly at Kotergherry.[17] Wight found time to explore the flora, but it was

primarily a working trip, the purpose being 'to concoct a plan for setting on foot an extensive series of observations and experiments on mountain climates for the purpose of endeavouring to ascertain their value as agricultural regions'.[18] From the hills Wight corresponded with the Agri-Horticultural Society back in Madras, sending seeds, and reporting on his work. It was reported in their *Proceedings* that Wight had:

> not yet become reconciled to the Hills and can't say he much likes them but still as in a public point of view it is important they should be well known especially as regards their agricultural capabilities. [He needed more time to ascertain factors such as evaporation and the strength and prevalence of winds] for it appears to him that there is so much wind during the rainy season that nothing but annuals can stand it, and then during the cold season the weather ... [is] so intensely dry that scarcely even the ordinary culinary vegetables can survive without as much water as is required in the lower country, he begins to think from his short residence that many [have] cherished and propagated most erroneous views regarding the capabilities.[19]

Wight returned to Madras in the autumn, but the intention was clearly to continue the agri-horticultural work, as on 25 November 1841 he wrote to William Munro: 'I am now on the point of leaving Madras to take up my residence permanently on the hills, with the hope of remaining there during the next three years; in the course of which time I hope pretty well to exhaust their Flora, if I am not too much tied to my desk, which however I fear will be the case, as I have much of that kind of work on hand'.[20] Wight arrived back in the Nilgiris around 12 January 1842 looking forward to the 'almost European climate' that would be good for his health, though he was 'as yet too much of a Salamander quite to relish their cold'. The hope was clearly for a settled period that would allow him to get back to botanical work on the *Illustrations* and *Icones*, and it was with this plan in view that he bought Kelso Cottage. This hope, as will be seen, was to prove short lived and, with his cotton appointment, and the need for a base in Coimbatore, Wight's plans changed dramatically.

KELSO COTTAGE

Kelso Cottage was named after the first Commanding Officer of the Nilgiris, and was built either by him, or his successor Colonel Crewe, its first recorded owner in 1831. The cottage commanded a fine view and 'except where a clearing has been made for a flower and kitchen garden, it is surrounded by native jungle'.[21] In this jungle were attractive flowering trees such as *Rhododendron*, *Agapetes arborea*, *A. rotundifolia*, *Cleyera gymnanthera*, *Turpinia nepalensis**,[22] and two hollies *Ilex wightiana* and *I. denticulata* that reached 60–90 feet. Shrubs included *Mahonia leschenaultii*, *Viburnum hebanthum**, *Coffea alpestris** and *Lonicera ligustrina**, and it was in this shola forest, in the gully behind the cottage, that Wight discovered the orchid *Disperis neilgherrensis**. On the next ridge to the north is Lushington Hall and the ancient Toda village of Manjacamund, significantly omitted from contemporary pictures of this re-creation of little Britain. Kelso Cottage, however, proved so small that Wight was 'obliged to rent another for my Botanical department, which would of itself fill my house'; the herbarium and library were evidently moved from Madras to Ooty shortly thereafter, but it seems that they were never unpacked,[23] and eventually taken to Coimbatore. Burton described just such an Ooty house:

the walls are made of coarse bad bricks – the roof of thatch or wretched tiles, which act admirably as filters, and occasionally cause the downfall of part, or the whole of the erection. The foundation usually selected is a kind of platform, a gigantic step, cut out of some hill-side, and levelled by manual labour. The best houses occupy the summits of the little eminences around the lake. As regards architecture the style bungalow – a modification of the cow-house – is preferred … almost all are surrounded by a long low verandah, perfectly useless in such a climate, and only calculated to render the interior of the domiciles as dim and gloomy as can be conceived … If the diminutive rooms, with their fire-places, curtained beds, and boarded floors, faintly remind you of Europe, the bare walls, puttyless windows and doors that admit draughts of air small yet cutting as lancets, forcibly impress you with the conviction that you have ventured into one of those uncomfortable localities – a cold place in a hot country.[24]

The situation of Kelso Cottage, and the purpose Wight had in mind for the garden, was described in a letter to Hooker:

It is somewhat remarkable that though the elevation of the plain of Ooticamund [sic] is under 8000 feet of elevation and situated in the very centre of the northern tropic the Thermometer occasionally at this season falls to 28°. Exposed to the open air at my house situated on the slope of a hill about 100 or 150 feet above the lake it stands at about 46° at sun rize [sic]. Here therefore I am able to have a well stocked garden at all seasons while below everything is cut down with the frost. Being thus advantageously situated for the purpose I intend to render a large piece of my garden a nursery for the introduction of Europe timber trees as well as those from the Himalayas. It is somewhat remarkable that tho' many attempts have been made to introduce the indigenous trees of the Hills into cultivation they have never succeeded. I intend to try them also as well as send seed for introduction into Europe.[25]

The flower and kitchen gardens were doubtless Rosa's territory and in the former were 'Wallflowers, Larkspurs, Scabiosa, Lupines, Roses, Pinks, Carnations, Dahlias, and several kinds of Pelargoniums'. Gardner, who listed these in 1845, noted that pelargoniums had already escaped and gone 'apparently wild', along with an '*Iris*, *Œnothera biennis*, *Melianthus major*, *Capsella Bursa Pastoris*, *Achillæa Ptarmica*' – a hint of trouble to come in terms of invasive alien plants, which are still a problem in the Nilgiris. The kitchen garden produced peaches, and in February the family was able to have 'strawberries on the table nearly every other day'. Wight was fond of fruit tarts, but the garden was not the only source of suitable ingredients. The fruit of *Vaccinium leschenaultii*, a native tree-blaeberry, 'when fully ripe, makes a very excellent substitute [for cranberries], with the exception of a dash of bitter with which the acid is combined, requiring an additional quantity of sugar to render it equally palatable. With this addition I can safely recommend these berries as a tart fruit, as I have eat many tarts made of them, giving them the preference to some of the preserved fruits of Europe'.[26] Another favourite was the 'Calacca' (*Carissa carandas*) and Wight had 'often treated my guests to Calacca tarts from fruits so preserved [by boiling in syrup], which were then much esteemed'.[27]

The family attended St Stephen's Church, where Eliza Anne (named for her maternal grandmother and paternal aunt) was baptised by the Rev H.W. Stuart on 28 March 1842, and in the thicket next to the church Wight noted several fine trees of the fragrant *Michelia nilagirica*.[28] The building is decidedly gloomy within – the low ceiling, with teak beams recycled from Tipu's palace at Seringapatam, bear heavily down and it was probably low in other ways – the music for the hymns came from a barrel organ, with a repertoire of only twenty tunes. The Wights' great-niece, Louisa, attended the school for European and Eurasian girls run by Miss Hale and her two nieces until she was nine, but of the Wights' own children only James was of school age at this time. Given that his cousin was sent to school, James might in 1846 have been one of the 26 'young gentlemen … sons of officers … [or] youths of respectable families' at the boarding-school at Fern Hill run by the Rev Mr Rigg, whose monthly fees were £4.[29] On the other hand, James's education was probably one of the reasons for Rosa's taking the children 'home' to England in 1846.

SPORT AND SOCIAL

The Nilgiris of the 1840s provided plenty scope for Wight to indulge his love of shooting: 'Woodcocks abound in the months of October, November, December and January'; though it is to be hoped that he showed greater self-control than the officer who in 1829 'shot no less than 34½ brace'.[30] There were also snipe, quail (red and grey), peacock, jungle and spur fowl.[31] If Wight's tastes stretched to quadrupeds these were also still abundant on the hills, including 'Neilgherry Sambur, or elk … the giant of the cervine race', Nilgiri tahr ('ibex'), hog deer ('jungle sheep'), wild dog (two varieties), leopard, wild hog, gaur ('bison'), hare and bear. It goes without saying that these were over-exploited, so that by 1879 a 'Nilgiri Game and Fish Preservation Act' was required.[32] There was also a hunt in Wight's time, a pack of fox-hounds sent out to a Lieutenant Thomas Peyton from England in 1844. The quarry was the jackal rather than the fox, but this first hunt ceased in 1846, a successor not being established until 1854.

Burton provided an amusing classification of the Mulls ('as the Madrassees are familiarly called. The cunning in language derive the term from mulligatawny soup, the quantity of which imbibed in South India strikes the stranger with a painful sense of novelty') dividing them into:

1, the very serious
2, the *petit-sérieux*
3, the unsanctified[33]

One rather suspects that if Burton did run into Wight in 1847 he would have assigned him to the first category. T.C. Jerdon, whose name appears on the list of members of the famous Ooty Club for 1842 (Wight's does not) was doubtless another of the small group of the 'very serious' who shared Wight's natural history interests. In 1845 the Jerdons had a house in Ooty called Woodside,[34] and the church records show that several of the Jerdon children, like Wight's, were baptised in St Stephen's. Another naturalist whose name appears in this baptismal register is that of the German missionary, the Rev Bernhard Schmid.

The Rev B. Schmid

It was Schmid, who worked for an evangelical British organisation, the Church Mission Society, who in 1833 had provided a list of Nilgiri plants for Dr Robert Baikie's *Observations on the Neilgherries*.[35] Schmid's botany was old-fashioned, however, and the list is arranged according to the Linnaean system. In this book, printed in Calcutta and edited by W.H. Smoult, are three hand-coloured litho-

graphs after botanical drawings attributed to a 'Mrs P', one showing the pretty blue *Anagallis* that Wight commented on in his *Illustrations* (see p.100). In 1834 Schmid was based at Mayaverum (now Mayila-duthurai) on the coastal plain near Tranquebar, whence he corresponded with Wallich,[36] but after this posting he returned to Ooty where tragedy struck. A letter to Wallich in 1836, when Schmid was about to return to Jena, tells poignantly of the traumas parents faced in India, and one of the reasons (which Wight apparently shared) for studying botany:

> I, who have been called upon to bury three beloved and most promising sons, – my only boys, in the short space of four months, can put, from happy experience my seal to the preciousness of the truth of what you write, that "He knows best what is good for us". The consolations which He has given to my dear partner and to me, in our uncommon and severe trial, were and are wonderful … . All his counsels and dispensations are worthy both of the eternal wisdom of a Creator and Governor and of the Love of a Father. He who regulates the course of the winds and of the clouds, who preserves in due balance the numberless solar systems, and makes the Planets run their immense course with astounding exactness, and who displays in the structure of the meanest moss or of the eye of a mosquito, quite as many wonders of wisdom and power, as in the systems of Worlds which fill the endless spaces of the "vacuum", will surely not overlook man … Man, who is so short-sighted that centuries passed before he discovered the circulation of the blood in his own body, or the sexual system in the vegetable kingdom. … The study of Botany shows me the Creator in every plant, and every wood or bush which I enter is to me like a Temple of the Divinity, but surely Botany could not have afforded me any consolation concerning the death of my children, but the study of the Bible … has strengthened my faith and has opened to me a sight of the mansions of Bliss and Glory.[37]

Before this calamity Schmid had sent specimens back to his cousin J.C. Zenker, Professor of Natural History and Botany in Jena, who had drawings made (or perhaps did them himself) and engraved under the cumbersome title *Plantae Indicae quas in Montibus Coimbaturicis coeruleis Nilagiri seu Neilgherries dictis, collegit Rev. Bernhardus Schmid, illustravit Dr J. Carolus Zenker* … . Ill fortune seems to have dogged Schmid: on returning to Germany, and shortly after renewing acquaintance with his cousin, Zenker died in October 1837, with only twenty plates of the work published, in two 'decades'. Schmid was philosophical about this loss – all 'sublunary things are uncertain and perishing' and, dear as his cousin was to him, he could not suppress the painful observation to Wallich that Zenker 'was more eager to search out the system and … the spirit which the Creator has laid in the vegetable Kingdom, than desirous and diligent to search out the system and Spirit of the bible.[38]

Three copies of the first decade of Zenker's work had reached Schmid in Ooty by 16 October 1835, of which he provided details to Wallich – each decade cost '4 Saxon Rix dollars', and the work was 'warmly patronized by the Grand Duchess of Saxe-Weimar, Maria Paulowna of Russia'.[39] Wight admired the 'execution' of Zenker's work, but was rightly critical of its taxonomy:

> He seems to have considered every species new, and made a new genus out of our [Wight & Arnott's] *Abelmoschus angulosus* under the name of *Hymenocalyx variabilis* – *Fragaria indica* is now *F. nilagirica* – for *Passiflora Leschenaultiana* the Professor retains its old name.– Two species of

Jasminum with new names, though I am pretty sure they are both old and I think doubtfully distinct when their characters are examined but of this I am not quite sure as they look very different.– *Parnassia Wightiana* in his hands becomes *P. Schmidii*, and *Urtica heterophylla*, *U. acerifolia*. Two species of Ferns both in my herbm. and I think both old species are decorated with the names of *Aspidium anomophyllum* and *Grammitis cuspidata* Zenker – such is a specimen of the naming of the first decade. In other respects the work appears so well executed that I requested the Professor's friend in this country who supplies the materials [Schmid] to suggest to him the propriety of sending you [Arnott] proofs of his plates before naming on the ground that you know the Peninsular flora generally and the Neilgherry one in particular … as my herbarium contains a greater number of species from that region than any other.[40]

Wight was also scornful of Zenker's spelling of the epithet 'nilagiricum' as used, for example, in the Nilgiri *Rhododendron*, which is still used – at least at subspecific rank under *R. arboreum*. Given this linguistic hypersensitivity it seems surprising that Wight desisted from commenting on the extraordinarily unwieldy title of Zenker's book. Despite Wight's disappointment with it, it is hard not to think that it was the immediate inspiration for his own *Spicilegium Neilgherrense* (though he had first thought of a Nilgiri Flora as early as 1830 – see p.43).

After eight years in Germany Schmid felt it his duty, in autumn 1845, to return to the Nilgiris as a missionary to the 'Hindoos'. He was 58 and had replenished his family to the extent of six children. The CMS had allowed him a pension but otherwise washed its hands of him, and he therefore proposed supplementing his income by collecting plants for sale, over which he had sought Sir William Hooker's advice. Schmid had also told Hooker that he wanted 'to try the experiment, in how far European plants changed their forms and appeared as new species in the Hill-climate, and that I therefore intended to begin a little Botanic garden on the Hills'. The evolutionary implications of this statement seem more than a little surprising given Schmid's devout faith, but Hooker supplied him with 'a number of European and American seeds'.[41] This is clearly the inspiration behind the Ooty Horticultural garden, but, as with the influence of the Zenker/Schmid publication on his own *Spicilegium*, one that went uncommented on by Wight. This is curious, but, as Wight named some plants after Schmid, does not necessarily indicate that he shared Arnott's aversion to missionaries.[42] This kindly cleric also had educational activities in mind 'to try to collect a few promising Hindoo boys into a Seminary to instruct them in the elements of Knowledge as History and Geography to enlarge their minds, and in Latin and Botany, that they might become either well-inclined Native physicians (in the Medical School in Madras) – or Missionaries who are both Physicians of body and soul at the same time'.[43] Schmid also prepared a 'vocabulary of the Todaver (Toda) Language of the Neilgherries for printing at Madras by subscription'.[44]

The Rev E. Johnson

Another CMS missionary, whom Wight certainly did count as a friend, was the Rev Edmund Johnson, an Irishman from Co. Tipperary. After starting in the north of India, Johnson was sent to the Malabar Coast in 1848, firstly to Allepey, then, in 1850, as Principal of the Society's College at Kottayam.[45] It seems likely that they first

met in the Nilgiris, where Johnson collected specimens for Wight at Coonoor. Johnson was interested in orchids, but also had a more discriminating taste for obscure groups with near invisible flowers. These included the genus *Pouzolzia* of the nettle family (one of which Wight named for him), and the moss-like, aquatic family Podostomaceae, and Johnson sent Wight specimens of both these groups from Kerala. When Wight was packing up to leave Coimbatore in January 1853 he apparently sent Johnson his household chattels, for which Johnson was deeply grateful as he was having to sell up his own disposables (including his 'bandy' [cart] and pony) to raise money to send his wife Eliza to the hills for the sake of her health.[46] In the letter of thanks Johnson wrote:

> Would that we could meet again? Yet how unlikely that is. May we meet at the right hand of our Saviour & sing His praises together for ever!

Such are the bizarre twists of fate that in fact they could well have met after Johnson retired to England in 1858. From 1862–7 Johnson was a curate of Melcombe-Regis, and Wight had family connections with the adjacent town of Weymouth.

F.C. Cotton

Another orchid enthusiast was Frederick Conyers Cotton of the Madras Engineers, who had an orchid conservatory at his house in Ooty, and who has the dubious distinction of having planted the first eucalyptus at Gayton Park in 1843, a practice he continued at Woodcot.[47] Wight named an orchid genus for him, and later consulted him over the testing of the strength of timbers, and on the effect of trees on runoff and climate. Cotton was the younger brother of Sir Arthur Cotton, also of the Madras Engineers, who achieved fame (amounting to a veneration existing to the present day) for his irrigation works, firstly on the Cavery/Coleroon, and later on the Godavery/Kistna rivers, which saved millions of lives at times of famine. In 1851–2 Frederick Cotton was a member of the Madras Commission on Public Works that castigated the Madras Government for its stingy attitude to irrigation and road-building, which was perpetuating poverty among the *ryots*. The resulting fall out with Sir Henry Pottinger, is, as will be seen, paralleled with Wight's experience with this same Governor, though in Cotton's case led to his being sent home in 1854 for insubordination![48]

BOTANICAL ACTIVITIES AND GARDNER'S 1845 VISIT

Wight's chief recreation in the Nilgiris was botany and at this period Gardner recorded that Wight had one plant collector 'constantly employed' there. The most active period appears to have been between 1844 and 1846 – when Wight started to publish the *Spicilegium*, and published illustrations of many Nilgiri plants in the third volume of the *Icones*. As noted in Chapter 13 Wight left almost nothing in the way of field or ecological observations, and practically all it is possible to discover of his Nilgiri botanizing are the names of the species collected, and their localities as given on the specimens, and in the *Icones* and *Spicilegium*. The most frequent localities mentioned are Sispara, the Avalanche Bungalow, the Kaitee Falls, St Catherine's Falls and Kotagherry. Only a single sketchy account of a solo trip in the Nilgiris, made in May 1844, survives from Wight's hand, related in a letter to Griffith:

> the country I explored was without exception the most beautiful I have ever traversed. I was a little too early in the season to get much, but what

> I have got [including orchids, a rattan, the palm named for him as *Arenga wightii*, a ginger, a new genus of Acanthaceae, *Ceropegia pusilla* and an orobanch] was well worth going for.[49]

Given Wight's silence, the visit of George Gardner in 1845 comes as a blessing, and, thanks to Hooker's publication of Gardner's letters, extensive details of this expedition are known – indicators of the sorts of thing with which Wight was familiar and that he shared with his 36 year old companion.[50]

Wight wrote of the start of Gardner's visit in a letter to Hooker in February 1845, a reply to the first letter he had received from Hooker in three years. Wight had interpreted the long silence as due to some unintended offence he had given, and had stopped sending Hooker the *Icones* after the second volume, being 'under the idea that I was in some measure forcing unwished for and unacceptable favours on you'.[51] Other than the trip with the Walkers in 1836, this was the only occasion in the whole of Wight's Indian sojourn when he was in the company of a fellow enthusiast and knowledgeable botanist. It was a time of great happiness and Wight told Hooker that:

> I find that two working together manage to get over much more work than one, apparently by cheering each other on. But be that as it may the fact is certain as I am confident I did more during these three weeks than I should have done, single handed, in as many months … the benefits derived from our meeting are I find pretty equally shared by both. He gets the advantage of my Indian Knowledge and I benefit by his American [i.e., Brazilian], and then, who imbued with a Botanical spirit could work with him without finding his own stores, however rich before, still further enriched by the acuteness of his observation and extent of his knowledge and being moreover a right good fellow and most agreeable companion. I consider his visit to my mansion quite an oasis in my Indian life.

On the way from Ceylon to Madras Gardner had been unfortunate enough to catch malaria, but it was this that provided the excuse for the highly successful excursion to the Nilgiris. Gardner's fever had:

> assumed the lunar form of ague – that is, has periodical returns at new and full moon which is generally a difficult form entirely to shake off. It was to try and get rid of it, by a very decided change of air just about the period of return that brought us up here a day or two before new moon and with the intention of remaining until the full is past.

They set off on horseback at the beginning of February, and Gardner's description of the ecology and plants found on the excursion,[52] is the only detailed account of any of Wight's excursions to have survived.[53] On the dry stony plains Gardner was particularly interested in the asclepiads, and on the ascent up the mountains he noted the altitudinal zonation of vegetation, with hundred-foot tall bamboos up to about 1500 feet, among which was the striking tree *Cochlospermum gossypium* covered in large yellow flowers (Book 2 Fig.15). Above this zone, for about 3000 feet, came one that could 'be called that of the Olive, from the predominance of plants of that natural family [Oleaceae]'. Gardner must have been acutely aware of the huge contribution Wight had already made to the study of the Indian flora, for in this zone alone two of the conspicuous plants bore his name – the palm *Arenga wightii*, described by the young William Griffith, and the daisy *Monosis wightiana* by the great A.P. de Candolle. 'Shortly before reaching Coonoor, about ten miles from

Ootacamund, and nearly 6000 feet above the level of the sea, the appearance of the hills becomes very much changed in the nature of the vegetation; the vast forests disappear, leaving large open campos,[54] thinly covered with stunted trees and shrubs; but still the deep ravines and hollows are well wooded'. In one of the ravines they found *Indigofera pulchella*⋆, *Desmodium rufescens*⋆, *Osbeckia wightiana* (Book 2, plate 47) and *Wendlandia notoniana*⋆. Between Coonoor and Ooty, Gardner, like the earlier, non-botanical, travellers already quoted, was struck by the number of 'European forms' – roses, barberry, brambles, mint, a rush, honeysuckle and a clematis. He also noted the cultivation of barley, wheat, onions, garlic, mustard, opium, potatoes and a 'small grain peculiar to the country' by the 'Budagars'.[55] The travellers arrived at Ooty on 4 February, and must have been enthusiastically welcomed by Rosa and the children – James, Eliza and Augusta.

Wight designed a programme to show Gardner his favourite and most productive collecting localities. From Ooty they firstly made a couple of day excursions, the first being to the highest of the Nilgiri peaks, Dodabet (2623m), about four miles away. On the way they saw a wild strawberry (now *Fragaria nilgherrensis*) and *Pimpinella leschenaultii*, the latter being one of the many species commemorating the first botanical visitor to the Hills. On the summit Gardner was 'rewarded with an old Scotch acquaintance, *Prunella vulgaris*, and *Alchemilla zeylanica* Moon, a plant so nearly resembling the *A. vulgaris* of Europe, that it has been considered as such by Dr. Arnott', altogether more exotic was the succulent *Kalanchoe grandiflora*⋆, but on this occasion the view of the Coimbatore and Mysore countries was blanketed out 'by a dense ocean of clouds which lay spread out below us'. The next short excursion was to the Kaitie Waterfalls about seven miles below Ooty, passing through Lord Elphinstone's garden, where they saw a 'remarkably healthy English Oak tree, nearly twenty feet high; and nearly opposite to it a few Cypresses [probably Himalayan] about the same height'. In the valley leading to the falls 'many of the trees and shrubs being … deciduous, the country bore a very wintry appearance', and here one of the shrubs was *Cotoneaster buxifolia*⋆. In order to give an idea of scale to his old teacher Hooker in Glasgow, Gardner compared the stream with 'the one which runs through Campsie Glen', and the fall itself was over 'a slightly inclined basaltic precipice about two hundred feet in height'. This visit took place near the beginning of the dry season, and Wight pointed out that 'many curious herbaceous plants grow on the rocks here in the months of August and September [i.e., during the sw monsoon], but of which almost no traces were now to be observed'. One of these was 'a large-flowered Lily, very much resembling Wallich's [Nepalese] *Lilium longiflorum*'.[56] Of species in flower there were the large blue gentian *Exacum wightianum*⋆, a handsome orchid *Aerides lindleyana*⋆, and the beautiful pink *Lysimachia leschenaultii* (Book 2, plate 110). Below the falls the vegetation of the jungle was 'in a more active state' – the travellers found the passion-flower *Passiflora leschenaultii*⋆ and a 'Mulberry plantation, belonging to a gentleman who is endeavouring to rear the silk-worm on a large scale'.

The third excursion was longer, taking three days, based at the Pycarrah (Pykara) bungalow on the road north to the pass leading down to the 'Mysore territory' (i.e., to Gudalur). Here they encountered *Eugenia montana*⋆, then still undescribed, belonging to a family of particularly interest to Wight – Myrtaceae. Wight and Gardner also observed some of the local archaeology that was then arousing interest – a 'large circular Cairn about four feet high, with an open well-like cavity in the centre … similar cairns … when opened have been found to contain generally from twenty to thirty urns of clay, often of very elaborate workmanship. Iron and brass utensils are also occasionally found in them'. Plants of several temperate genera occurred here – the sweet flag (*Acorus calamus*), the royal fern (*Osmunda regalis*), and a climbing groundsel, *Senecio wightianus*⋆; growing in a stream were three species belonging to an altogether stranger genus, the moss-like flowering plant *Podostemon*, belonging to a family Gardner had first seen in South America. On the stream banks were *Hedyotis verticillaris* (Book 2 plate 74) and *Photinia notoniana*⋆, and on the trees a 'very curious coral-like' parasitic mistletoe *Viscum moniliforme* var. *coraloides* (Book 2 plate 68) and the dwarf orchid *Eria reticosa* (Book 2 plate 124), with pseudobulbs covered in a 'fine fibrous network'. Also here was the 'Hill Gooseberry', *Myrtus tomentosa*⋆, from which Europeans prepared 'a delicious jelly'. In this dry season the landscape and the golden grasslands on the road to Neddawattum appealed to the traveller's sense of the picturesque, 'having the appearance of ripe corn – intersected with patches and long stripes of verdant woods, the varying tints of the foliage of which form pictorial combinations, on which the eye dwells with pleasure'.

Wight and Gardner's final excursion was their longest and most productive. Over eight days they explored the western slopes (the 'Koondahs') that sweep down to the plains of the Malabar Coast. On the way they spent three days based firstly around the Avalanche Bungalow, about 16 miles west of Ooty, named after a large landslip. From here they found *Sonerila speciosa* (Book 2 plate 46) in wooded ravines, *Hypericum mysurense* (Book 2 plate 16) in dry fields, and, higher up, several species of *Crotalaria* and *Osbeckia gardneriana*. The last was at this point undescribed, but Wight decided to call it after his friend, and it was published in the *Icones* later the same year. There was also some zoological interest and they paid their respects to:

> the residence of a Bear, but did not find him at home … [though] he had not been long gone. The selection of this spot for his den showed great wisdom; for not only was it well protected from the prevailing winds during the season of the rains, but in case of danger he had two outlets of escape. One of these, leading to a higher part of the mountain, was a very excellent ladder, formed of the gnarled stem of a large *Rhododendron*, the dense top of which serves besides as a verandah to the portico. The steps are so much worn that they seem to have been used for a long period by the progenitors of the present possessor.

From Avalanche it was fifteen miles to Sispara, through 'truly beautiful, but uninhabited country; the road winding now along the sides of high grassy hills, now over their bleak summits, and now through beautiful vallies [sic] by the sides of limpid rivulets, the margins of which are adorned with Rhododendrons, and numerous other flowering shrubs'. Here Gardner was able to note similarities and differences of the alpine flora with that of Nuwera Ellia in Ceylon. The weather, however, turned nasty: clouds rolled in and the drenched and freezing pair dismounted and walked the last two miles, passing 'what may be called in geological language, *recent deposits*' made by a large herd of wild elephant. They made a detour to see the only known locality for Wight's *Hypericum hookerianum* confined to a single clump about twenty yards square at a place known locally as 'New England'. From the Sispara bungalow short rambles were

made among the mountains for two days, during which they found *Impatiens munronii* (Book 2 plate 23) a balsam that Wight had six years earlier named after William Munro. Gardner was anxious to see a fern of the genus *Anemia* discovered by Wight in 1844, of interest in terms of its geographical distribution. Until around 1835 the genus had been thought to be restricted to South America, where Gardner had seen about six species; but recently two more had been discovered in Africa – and now this further one in India:

> To ascertain the cause why such nearly allied forms are found in such different parts of the world, is a problem of very difficult solution … [Gardner looked to a time when] the science of the Geographical distribution of plants and animals will make a nearer approach to an exact science, than it does at present. Hitherto, temperature, moisture, soil, and elevation, have been considered as the most important causes which influence the Geographical conditions of both plants and animals, but there is, no doubt, something far beyond them, which still remains to be discovered.[57]

From this one can imagine how interested Gardner would have been in the twentieth century discoveries of Gondwanaland and continental drift. To reach the fern it was necessary to clamber up rocks by means of a 'curious kind of Wild Fig, which clings … like ropes', and two years later Gardner would describe and name the fern for his friend as *Anemia wightiana*.

After this productive month the botanists descended the mountains by a different route – the old one via Kotagherry and the Seegoor Ghat – and rode back to Coimbatore. Gardner had had no recurrence of his 'lunar ague', and they were accompanied by 'the talented historian of the Chinese war', Captain John Ouchterlony, then undertaking a survey of the Nilgiris.[58] On the way they visited the Captain's brother's small coffee plantation near Kotagherry. This appears to have been Ouchterlony's first experiment with coffee and Gardner noted that it did not grow so well as in wetter Ceylon, though the product was 'of very excellent quality, being highly flavoured'.[59] Gardner thought that the western slopes of the Nilgiris would be better suited for coffee growing, and Ouchterlony, possibly following this advice, seems later to have moved his plantations to Neddawuttum, where Wight later found some curious parasitic orobanchs.

Wight and Gardner continued their work at Coimbatore for another six weeks, Gardner finally leaving on 13 April, returning via Palghat and Trichur to Cochin on the Malabar Coast. As no description by Wight has survived of the sort of colourful religious festival that he must have witnessed in India, an account by his friend will have to do as a substitute. While passing through Trichur Gardner was lucky enough to coincide with Pooram, 'the mother of all temple festivals' of Kerala, given under the auspices of the Raja of Cochin's brother:

> not less than 10,000 people were calculated to be present, among whom were only four Europeans. In this grand procession, I saw about fifty elephants, all in gorgeous trappings of silver and gold, and on the back of each stood several half-naked Brahmins, waving large fans made of the tail-feathers of peacocks under the canopy of large umbrellas of crimson silk. Among the immense mass of human beings assembled there was neither rioting or fighting; a strong proof of the gentleness of their disposition; nor did I observe more than half a dozen in a state of intoxication.

From Cochin it was only a 'run of three days' to Colombo, whence, on 14 May, Gardner sent Hooker the account of his spectacularly successful visit to Wight.

There is, however, an unfortunate post-script relating to Gardner's visit. In March 1845 the Madras Government 'retrenched' the sum of Rs 375 against Wight for being 'absent on private affairs'. Wight appealed against this, but it was upheld by the Court.[60] Nothing is said of the cause of Wight's transgression, but, given the date, it seems almost certain that it was the excursion to the hills with Gardner. If this is so, the trip – so productive and significant in botanical terms – cost Wight dear, this sum amounting to about £38 (or £1900 in today's terms).

METEOROLOGY

Since the time of Roxburgh meteorological recording had occupied an important place in the agenda of describing the physical and biological environment of India. Wight's interest in meteorology has been mentioned in the case of his paper on the Coromandel land winds (p.61), and in connection with his house and garden at Ooty; Cleghorn also noted that Wight 'was in the habit of recording meteorological phenomena in the diary which he kept during all his wanderings'.[61] In February 1842 this interest received official recognition when Wight was given 'permission to engage in Meteorological investigations at Ootacamund' and allowed Rs 120 to purchase instruments, which he apparently bought locally. At this same time he also asked for an assistant on a monthly salary of Rs 50, perhaps to help with the measurements, or with the agricultural experiments such as the one on 'the effects of Muriate of Lime on vegetation' he was also undertaking at this time.[62] The settled period at Ooty, however, was to be short-lived; the cotton part of his work, in which he was already involved, suddenly took over and in February 1842 Wight was appointed Superintendent of the Cotton Planters, based in Coimbatore. This appointment had already been made by time the Court in London heard about the request for the meteorological instruments, but as the cost was 'not great we shall according to your request transmit a set by the first convenient opportunity' and a note beside the minute records that 'Messrs. Troughton & Simms have sent an estimate of the cost of a complete set of meteorological instruments amounting to £14:10: ='.[63] The instruments were sent out in October 1843 and the meteorological observations taken on by Dr Baikie and Captain Halpin.[64]

Despite Wight's move to Coimbatore, Kelso Cottage was kept on, though it was probably used more by Rosa and the children (especially during the hot season), with Wight visiting as official duties permitted; certainly his library and herbarium was still at Ooty in 1843,[65] though a year later at least his library was with him in Coimbatore.[66] The Cottage was sold in 1847,[67] as by this time Rosa and the children were in England.[68] Wight did, however, continue to visit the Hills after 1847, and as his sister-in-law Helen was living there on one such visit in May 1848, he probably stayed with her. If not, then he must have put up at the Club, or at one of the two hotels – the Union or the Victoria – mentioned by Burton.[69] The last visit to the Hills of which we know was when Rosa and baby Charles were staying in Ooty for five months in the first half of 1852.[70] It was then, during 'occasional visits of from 10 days to 3 weeks as circumstances permitted', that Wight inspected the Ooty Garden to gather information for his report (p.69).

DIFFERENT STAPLES OF COTTON

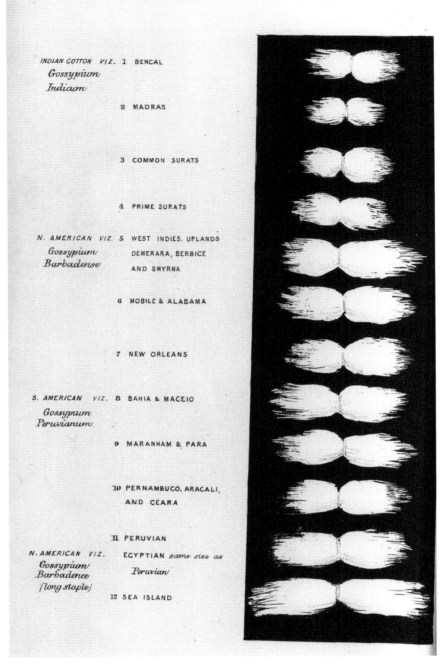

INDIAN COTTON VIZ. 1 BENGAL
Gossypium
Indicum

2 MADRAS

3 COMMON SURATS

4 PRIME SURATS

N. AMERICAN VIZ. 5 WEST INDIES. UPLANDS
Gossypium DEMERARA, BERBICE
Barbadense AND SMYRNA

6 MOBILE & ALABAMA

7 NEW ORLEANS

S. AMERICAN VIZ. 8 BAHIA & MACEIO
Gossypium
Peruvianum

9 MARANHAM & PARA

10 PERNAMBUCO, ARACALI,
AND CEARA

11 PERUVIAN

N. AMERICAN VIZ. EGYPTIAN *same size as*
Gossypium
Barbadence *Peruvian*
(long staple)

12 SEA ISLAND

Fig. 28. Diversity of cotton staples – no. 2 is 'oopum' (*Gossypium arboreum* var. *obtusifolium*), and no. 7 the New Orleans (*G. hirsutum*) the main subject of Wight's experiments. Lithograph from Talboys Wheeler's *Hand-book of the Cotton Cultivation in the Madras Presidency*, London (1863).

The Madras Cotton Experiment

So now, where Derwent rolls his dusky floods
Through vaulted mountains, and a night of woods,
The Nymph, GOSSYPIA, *treads the velvet sod,*
And warms with rosy smiles the watery God;
His ponderous oars to slender spindles turns,
And pours o'er massy wheels his foamy urns!

Erasmus Darwin[1]

The last eleven years of Wight's career as an employee of the EIC (1842–53) were spent in Coimbatore working on cotton. Whereas his earlier work on economic plants – senna, gamboge, cinnamon and sugar – had dealt mainly with native Indian species, the cotton work was rather different, as it involved the introduction of new varieties from America, and the export of the raw material for processing in England (and hence the relevance of the epigraph). Wight's job was to superintend experiments on the introduction of American cotton (primarily a variety called 'New Orleans', sometimes called 'Mexican'), and American methods of cultivating and cleaning cotton. This project also involved attempts to improve Native Cotton (the form called 'oopum'), by using American cultivation techniques and improved methods of removing the wool from the seed, and cleaning the wool. There was confusion as to the relative importance of these various aims at all levels of the complex hierarchy of those involved,[2] reflected in the confusion of Wight's (never clearly specified) title during this period, and variously given as 'Superintendent of American Planters', 'Superintendent of Government Cotton Farms' and 'Superintendent of Cotton Experiments'. Added to this confusion are difficulties inherent in the methodology of agricultural 'experiments' of this period, with no proper controls, and no statistical analysis of results. Even given this, Wight's comments on the data, tinged with excessive optimism, scarcely merit the word analysis. The result is that this is, by a long way, the most difficult part of Wight's career to deal with, being not only complex, but permeated with inconsistencies and contradictions. Furthermore, it is a period that can at best be seen as inconclusive, at worst a failure (if on an heroic scale), or, more positively, as ahead of its time.

The story is, nevertheless, not without interest, not least in trying to come to grips with ideas of complexity and failure, and the admission that for this period there is no simple story to be told. There is certainly no shortage of documentation, both published and unpublished, including much by Wight himself who was an evangelist for his work, as can be seen from the extent of his cotton publications. But the very volume of the printed material adds to the difficulties, making it hard to see the seed for the wool. There is also much related published material dating from Wight's life-time, the quantity being an indication of the huge importance placed on this research into 'white gold' both by the EIC (by 1853 the Madras experiments had cost them about £50,000 or about £2.5 million in today's terms) and by the British Government. The original documents are all in the India Office and in the Madras Archives, but the bulk of these were collected together for publication in two vast volumes for the House of Commons, the first in 1847 (557 foolscap pages, 122 referring specifically to Madras), the second, edited by the Company's 'Examiner of India Correspondence', none other than John Stuart Mill, in 1857 (921 pages, 430 devoted to Madras). These are fascinating volumes filled with the day-to-day minutiae of the Company's attempts to increase the supply and improve the quality (in terms of cleanness and length of staple) of cotton imported from India, largely as a means of reducing dependency on America. These initially off-putting tomes are not devoid of human drama, reproducing reams of original documents *verbatim*, some of which leap off the page in the extremity of their language. The problem lies in this very detail, and how to extract at least an approximation of an interesting narrative that does justice to Wight's important part in the project. At this stage it must be stressed that the author is unqualified to comment on the all-important economic aspects of the subject. Fortunately, between, and shortly after, the compilation of these weighty 'Blue Books', two contemporary authors made skilful digests of their contents, including Wight's role in the work. The first was John Forbes Royle, in his own words, 'chief of the [EIC's] Botanical Department',[3] who in 1851 published *On the Culture and Commerce of Cotton in India and elsewhere, with an account of the experiments made by the Hon. East India Company up to the Present Time*. The second was James Talboys Wheeler,[4] the result of a request by the Governor General ('Clemency' Canning) in 1861 for a 'handbook' on cotton for each of the Presidencies.[5] This small, elegant, volume was first printed by Pharoah in Madras in 1862, and reprinted the following year in London by Virtue Brothers, but is now a rare work in either edition.[6] Wight took a dim view of the Indian edition, writing that almost every page presented 'evidence of persons groping in the dark, or, as it were, attempting to navigate without chart or compass'.[7] But this is scarcely fair on Wheeler, and accurately describes the impression formed by an unbiased reader of the Parliamentary Papers: it seems that Wight after nine years of retirement could still not face the facts.

Readers with agricultural and economic interests, are directed to these volumes, and the following should be seen as no more than a broad overview of Wight's cotton work. After Wheeler, however, Wight's cotton was almost entirely forgotten. Neither his name, nor the vast Madras experiment, figures in Silver's account of Manchester's attempt to increase the supply of Indian cotton,[8] though in the 1930s Joseph Hutchinson rediscovered it through the 1847 Parliamentary Papers.[9] Although Wight is no longer remembered in

Coimbatore, in the mid-1960s two Madras-based authors did pay tribute to his work. The first was a brief review by R. Balasubramaniam in the historical section of his monograph of cotton in the Madras Presidency.[10] R. Ratnam also treated Wight's work in great detail in his excellent book on the agricultural history of Madras, based on documents in the Madras Archives, including some not printed in the Parliamentary Papers.[11]

Though Wheeler's book provided a fair summary of Wight's cotton work it dates from a period when respect for authority was greater than it is today, and when personalities were usually avoided. However, given the subject and the individuals concerned, even Wheeler was not entirely able to evade such matters. This applies to a barn-storming row between Wight and one of the American cotton planters (Thomas James Finnie) foisted by the Court of Directors on India to teach American methods of cultivation and technology, but Wheeler trod lightly over the relations between Wight and the three Governors of Madras who held office during the period, and who acted as his local bosses. The differences in characters and ethos of John, 13th Lord Elphinstone (up to 1842), George Hay, 8th Marquess of Tweeddale (1842–8) and Sir Henry Pottinger Bt. (1848–54) in relation to Wight and the cotton experiments are nonetheless highly significant. Each took a deep interest in the experiments and had very decided opinions about them (and doubtless on Wight personally); the first was strongly supportive, the other two largely antagonistic, though their antagonism would be overruled by the Company's profound commitment to the subject and their strong support for Wight, and in particular the 'scientific' expertise he was perceived to bring to bear on the experiments. It is right to mention such conflicts of approach and interests at the outset, as conflict underlies the whole subject.

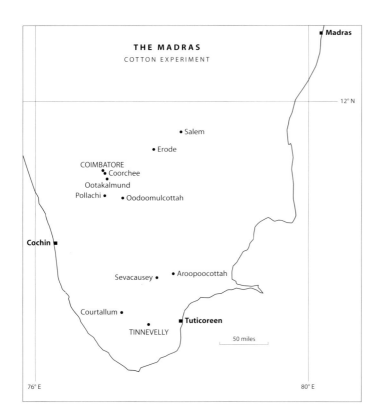

Fig. 29. Map of sites associated with the Madras Cotton Experiment

Areas of Conflict

Conflict emerges as a key element in the American cotton experiment and, at the risk of appearing simplistic, many of the issues really do seem to be reducible to alternative beliefs or practices, which it is worth identifying at the outset, so that they may be borne in mind in the following account. By looking at these stark alternatives of complex issues of politics, economics, biology and agriculture it will be apparent that 'correct' answers, or clear outcomes, were never likely to emerge.

Administrative

EIC (= Court in London) v. Madras Government (Governor and Revenue Board)
Madras Government v. local administration (District Collectors)
Wight v. Government (both local and Madras)

Economic (who should pay?)

Government v. Private enterprise (European agents or representatives of Manchester Cotton trade)
Government subsidy (remission of land tax; purchase at fixed rates) v. Market forces

Philosophical

Science v. Practice
Science and practice v. Commerce
Precept (cultivating/teaching in a Government farm) v. Example ('extension', working in the community)

Racial

British v. American Planters
Occident (British and American) v. Indian (the impoverished *ryot*, unable/unwilling to take risks)

Biological/Environmental/Agricultural

American ('New Orleans') cotton v. Indian or Native ('oopum') cotton
Soil v. Climate
Growth on red soils v. Black soils
Growth in areas with one monsoon v. Two monsoons
American cultivation (drills and deep ploughing) v. Indian (mixed crops, broadcast sowing, shallow ploughing)
Dry cultivation v. Irrigation
Rotation v. Repeat cropping
Manure v. No manure

Technological

Traditional Madras churka v. Whitney's saw-gin, or modified churka

The aims of the experiment also need to be clearly stated, and can be summarised as:

1. To introduce and establish the cultivation of American cottons, especially 'New Orleans'.

2. To improve native cotton ('oopum' in the case of Madras) by using American cultivation techniques.

3. To improve cleaning technology, by means of saw-gins and threshers, in both native and introduced varieties.

HONEYMOON UNDER ELPHINSTONE (1836–42)

Wight's early interests in cotton

The cultivation and processing of cotton has an extremely long history in India, dating back to at least 2300 BC and the Harappan ('Indus Valley') civilisation. As Royle picturesquely put it, cotton 'could not fail to be noticed by its inhabitants; first from the brilliancy of its golden inflorescence; and secondly, from the dazzling whiteness of its bursting fruit ... like wool at the birth of a lamb.[12] It was also of religious significance – as written in the Manu Smriti of the second century BC:

> The sacred thread of the Brahman shall be of cotton, of right-twisted three-ply.[13]

By Wight's time there was a huge internal market for cotton within India. Wight, in typically exaggerated mode, calculated that each Indian used 20 lbs per year, which he calculated gave a total internal consumption of 300 million lbs.[14] This was met entirely by the produce of the diploid species *G. arboreum* and *G. herbaceum* and although the wool of these species was short-stapled, it was very white in colour and ideally suited to processing by the technology available. Wool was removed from the seed by means of the *churka* [fig.32], a hand-cranked, mangle-like device, usually operated by women, which did not damage the fibre, and spinning was 'by the delicate fingers of the Hindoo'.[15] Large amounts of cotton wool were also exported, both to China and England, used in the latter for purposes such as stuffing and candle wicks, rather than spinning, but much of it was re-exported.

As summarised by Royle, the EIC had been trying to improve Indian cotton since the late eighteenth century, and Dr James Anderson of Madras had introduced seed of longer stapled varieties from Mauritius and Malta and distributed them throughout the Peninsula as early as 1790.[16] This had positive results in the Madras Presidency, and good quality Bourbon cotton (a variety of the tetraploid *Gossypium hirsutum* originating in America) was grown at Tinnevelly by George Arthur Hughes as early as 1817.[17] In 1819 large cotton farms of 400 acres each were set up at Tinnevelly, Coimbatore, Masulipatam and Vizagapatam under their Commercial Residents, the Coimbatore one being run by Josiah Marshall Heath.[18]

By 1836 imports of cotton wool into Britain had reached 407 million pounds, providing raw material for spinning and weaving in Lancashire; of this about 76 million pounds was from India, the rest from America.[19] Wight was impressed by the statistics, the 'upwards of two millions of British subjects' to whom the cotton industry gave employment, but this did not preclude sympathy both for the 'present suffering of the labouring classes' in Britain arising from mechanisation, and for the, what he considered temporary and by then largely overcome, 'great distress to our [i.e., Indian, he always used the personal pronoun in such cases, identifying himself as an Indian] manufacturing population' that had come with the concomitant decline in the export of Indian woven cotton cloth.

Fig.30. George, 8th Marquess of Tweeddale. Lithograph by [Michael & Nicholas] Hanhart from the *Journal of the Household Brigade* (1864). Glasgow University Library, Department of Special Collections.

Fig.31. Sir Henry Pottinger. Stipple and line engraving by Joseph Brown, c.1850.

Nonetheless Wight was a believer in a global economy and that, in the greater scheme, it was more efficient that weaving should take place in Britain and cloth imported into India 'and sold, after paying the expenses of a second voyage, from 20 to 30 per cent under the produce of the same quality of the native loom', and that Indian prosperity could come from increasing the supply of the raw material.[20] Wight was, above all, a loyal servant of the Company who paid his salary, and from the period of his employment as an economic botanist the Company was unswerving in its attempt to improve Indian cotton. It is important to bear this in mind when one is forced, later on, to be critical of Wight's methods and effectiveness.

In view of the EIC's aims to increase the production of exportable raw materials, cotton was one of the crops Wight had specifically been asked to investigate in his 1836 brief, and he would work on it from this point onwards, the first fruit being a substantial discourse on the genus *Gossypium* in a paper on the flora of Courtallum.[21] This early phase of Wight's cotton work involved establishing the existing state of cultivation in the Presidency from returns sent in by the District Collectors, and experimenting with, and distributing seed of, various exotic cottons in conjunction with the Madras Agri-Horticultural Society. The result was Wight's detailed 'Remarks on the culture of cotton; principally with reference to the finer foreign varieties'. This paper was first issued as a Circular,[22] and published shortly thereafter in the *Madras Journal of Literature & Science*,[23] where it was accompanied by a supplementary Circular and some letters from G.F. Fischer, Zemindar of Salem, over his experiences of growing American and Bourbon cotton.[24] These reveal the serious thought that Wight had already given to cotton cultivation at this stage, and his eagerness for experimentation, not only by Europeans, but by 'wealthy and intelligent native proprietors' and by *ryots, if suitably insured against failure*. At this stage Wight regarded it as essential to convert, by pruning, the habit of the American plant from annual to perennial. He also realised what would later become one of his major concerns: the importance of the precise time of seed sowing and plant establishment with regard to the onset of the monsoon, realising the great variability of this over the Presidency and the importance of local conditions. Already Wight was suggesting experiments on late and early sowing times. One of the experiments Wight undertook himself was to sow seed in beds, to allow earlier growth and establishment of plants that could then be transplanted at the onset of the monsoon, the traditional time for sowing seed. Wight also tried the effect of different soils on different varieties, and discussed the question of the stability and diagnostic use of characters such as seed 'fur'. He thought it likely that what were recognised as different varieties could be transformed by 'deterioration' under the influence soil and climate (for example Sea Island into Upland), but urged experiments to resolve this question. Another important factor, and one where Wight thought the traditional practice bad, was the deleterious effect of repeatedly sowing from the same stock of seed without the benefit of bringing in what would now be called new genetic material from other areas. Wight also disapproved of broadcast sowing, and pleaded 'at whatever cost [for] drill husbandry'. By this time it was known that:

> Bourbon and American varieties thrive in red sandy calcareous, also in light grey and in alluvial soils, but altogether fail in the black cotton soils, which the country variety prefers. [And that] The Sea Island and Upland Georgia have been successfully tried on the saline sandy soils of the coast.

It was also already known that the saw-gin, rather than the churka, would be required to process the seed of American cotton.

A rare glimpse of Wight's scientific philosophy is to be found in this paper:[25] when condensing the Collectors' reports, his aim was to reduce practice to principles 'under the idea that facts, however valuable in themselves, never carry the same weight as they do when combined by a leading theory into a system'. The trouble was that in the messy art of agriculture, for many of the reasons already identified, it would prove impossible to discover such general principles – leading to Wight's vacillations over the next sixteen years.

Wight's experiments on germination (boiling and homöothermalisation!) and soil preference were carried out in his own garden at Kilpauk in Madras in beds '8 or 10 feet square', using seed of Bourbon, Sea Island, Upland, Egyptian and New Orleans cotton, and he reported on them to Wallich asking him to forward the results to the Agricultural and Horticultural Society of India.[26] In his letter to Wallich Wight lamented the lack of Europeans around Madras who could extend the work, and expressed concern and understanding for the plight of the abused *ryot*:

> the natives being afraid to make the attempt for fear of failure which their poverty does now allow them to risk.– In such circumstances it is a cruel uphill work to attempt to introduce improvements.– The natives are abused for their apathy and indifference because they will not adopt our suggestions without proof and incur expenses which they are really unable to afford should failure result. How much more does the epithet belong to us who enjoy means sufficient to … [undertake] the experiments required to prove our positions and yet will not afford them that satisfactory stimulus, by cultivating a few fields at our own expense, merely to show that the chances of success are equal in both cases, and the profit in favour of the novelty.[27]

Given this Wight realised that it would be no easy matter to persuade the *ryots* to grow exportable crops such as cotton, and expressed this eloquently in 1840:

> [the *ryot*] must look to his own resources for his supply of food; and as this is always precarious throughout those districts not irrigated from streams having their sources in the Western Ghats, and fed by the southwest monsoon, he will be cautious how he engages in other than grain production. This being the character of all those [lands] most favourable for the production of cotton, and in which, were the difficulty of procuring food lessened, the production of commercial produce would be augmented, we must provide for their wants, before we can expect them to risk their existence by starvation for the love of gain by traffic.[28]

The Sea Island cotton grew luxuriantly in Madras but, in one of Wight's very few remarks on cotton pests, noted that it produced 'little or no cotton, owing to almost every pod being perforated by some insect, and rendered the nidus for its young, to the certain destruction of the produce'. The Upland Georgian did far better giving yields twice as high as Bourbon, and he considered this would 'prove by far the most productive sort in … grey loamy and clay soils'.[29] The Egyptian seed sown gave an unexpected result, producing on germination two different types, much resembling Sea Island and Upland Georgian. Wight therefore asked if the AH Society could obtain some seed of 'genuine Egyptian' cotton for him. This elicited a

learned note from John Bell, secretary of the Society, pointing out that cotton cultivation in Egypt was a recent phenomenon dating back to an interest taken by the Pasha in 1821. The first batch of imported seed could well, as it certainly was in 1827 and 1828, have been Sea Island and Bell therefore found Wight's results unsurprising, and the forms that resembled Upland could have been the result of soil and climatic effects on Sea Island.[30] The sensitive Wight took offence at this scholarly note, which he regarded as a personal slight, and though the Society's committee members could see nothing offensive in it on re-examination, rather than upset Wight, they agreed to cancel it![31]

Wight's 1837 ambitions (see p.86) for an experimental farm at Pulicat, largely devoted to cotton, came to nothing, but, in addition to practical and agricultural work, Wight had also been trawling the literature. This included Andrew Ure's 1836 work on *The Cotton Manufacture of Great Britain* and Henry Piddington's chemical analysis of the cotton soils of America, India, Mauritius and Singapore.[32] Wight also studied the fraught question of cotton taxonomy in the Indian publications of Roxburgh, Buchanan-Hamilton and Lush, and European ones by Candolle and Royle. The results were combined in an article with handsome illustrations of four American varieties in the *Illustrations*,[33] supplemented with plates of three Native cottons in the *Icones*.[34] In 1839 Wight calculated the yields of wool from seed of 'Country Cotton', Bourbon, Uplands American, Sea Island, Egyptian, Pernambuco and 'Brown or Nankeen', grown in his garden, though the sample sizes were small.[35]

Wight had thus been studying cotton practically and theoretically for four years before the next development, the arrival of the American Planters. He undoubtedly developed strong opinions during this period, which influenced him for the rest of his time in India. By 1838 Wight believed he had 'satisfactorily shown that in the southern provinces of India, the American short stapled cottons can be cultivated with equal ease and certainty, under the same course of treatment, as the indigenous kind'.[36] Wight stuck doggedly to this belief for the rest of his life, and for eleven years was paid to prove it. The results, as we shall see, would not justify his optimism, though some of the facts established at this period, for example that the American cottons grew better on soils other than the black that suited the Native, were to prove correct. Some of the facts, however, proved incorrect, and others that were correct Wight unfortunately seems later to have forgotten.

The American Planters (1839–40)

The idea of seeking advice and practical help from American planters arose in London, possibly with Joseph Hume, who met with Captain Thomas Bayles in 1838, then on furlough from the 52nd Madras Native Infantry, but who had experimented with cotton, prior to 1836, in the Southern Mahratta country.[37] As a result the Court despatched Bayles to the Southern States of America to recruit suitable planters to send to India, and wrote to the Governor General, Lord Auckland, telling him of these plans. This elicited a minute from Auckland in which were expressed many of the issues that would affect the project throughout its course.[38] Auckland was against the idea of reductions in land tax ('assessment') to encourage the growth of particular crops, which he took to be 'artificial fosterings of the devotion of capital to particular employments' and an 'improvident and unsafe speculation' that would 'make the government … responsible for the fortunes of individuals, and … un-

just to enterprise in every other department of exertion'. Auckland was also against the idea of Government experimental farms, which he thought would 'compromise some of the most legitimate means of a special kind which the Government can use in aid of the proceedings of private parties or associations', though he did agree to 'an experimental superintendence and encouragement, on a carefully regulated and measured plan'. H.T. Prinsep voiced similar concerns about the role of Government in such an enterprise. In what would prove to be prophetic words, it was:

> very probable, that the Government establishments might succeed in producing better staple and better-picked cotton than ever was produced in India before; but the grand essential of cost is always overlooked in such experiments, and the boast of success based only on the exhibition of quality is a vain and useless pretension, that can lead to no … permanent benefit, to compensate for the expenditure of money.[39]

It is clear that the American planters were wished on a largely unwilling India, and when Wight was consulted by the Madras Government on the scheme he replied in 1840 to the effect that perfectly good cotton (Bourbon in Coimbatore and Salem, Native in Tinnevelly) was being produced and that there could be 'little occasion … for the aid of American workmen to teach the growers either how to cultivate or collect their cotton', though they might have something to offer in the use of machinery.[40] Despite this, and the belief that it was British merchants rather than the Government who should 'put shoulder to wheel', Wight accepted the inevitable and recommended the setting up of 'a considerable cotton farm' under American superintendence, with power to purchase good cotton from the *ryots* at 'prices above the market'. Wight (as had Auckland) also pointed out other obstacles limiting the export of cotton from India, including problems of transport to the coast. John Sullivan of the Madras Revenue Board also made astute and prescient comments on the scheme and thought that when:

> the cotton fabrics of India had been carried to the highest perfection centuries and centuries before the cotton plant was known in America, it seems odd that we should be thinking now of importing people from America to teach the people of India how to cultivate, clean and collect their cotton.[41]

Sullivan considered that all that was required for any variety of cotton to be grown in Madras was 'a remunerating price', and that there was no reason to expect the *ryots* to grow foreign varieties – the thread was too fine for hand spinning, the seed residue of the Bourbon, unlike the Native, contained no oil, so was useless as cattle feed, and demand for the foreign varieties was fluctuating.

But by now it was a *fait accompli*, and the American Planters were on their way, the strength of their backing from the Court evident from their large salaries – £300 per annum plus a discretionary gratuity 'guaranteed … for success to a certain extent'. The Court's instructions on the Planters' operations sent to Auckland in July 1840 were deliberately non-restrictive.[42] Regarding 'the mode in which their services can best be made available on their arrival in India' the Court stated that it was 'not our wish to fetter the proceedings of your Government by giving any positive instructions on this part of the subject'. This gave the flexibility essential for a novel venture, but also led to problems. While the Court made it clear that the main purpose was to be 'by American planters with American

seed', they introduced another issue, but one they clearly denoted as an independent experiment – that of 'improving the cultivation of the cotton of the country', which they thought best done by offering Government prizes. As will be seen later both Wight, and more especially T.J. Finnie, would later twist these aims around when it suited them, but this was typical of the gulf between Court directives and practice on the ground in India found in many areas of Company work.

Bayles had an adventurous time recruiting the Planters in the slave regions of South Carolina, Georgia, Alabama, Louisiana and Mississippi.[43] His mission was supposed to be secret, but when the truth emerged he was attacked in the press and had to arm himself; he was said to be an impostor, not working for the EIC, but a private individual luring young men to a speculation that might land them destitute in India! Despite this Bayles found ten willing recruits, including Thomas James Finnie 'an intelligent young man' who ran plantations for 'two widow ladies' in Jefferson County, Mississippi. Even though the salary offered by Bayles was less than he was earning, Finnie accepted from 'a spirit of adventure, and a conviction of realizing in the East *an independence* [emphasis added] for himself'. Three of the men were intended for Madras: James Morris a planter from South Carolina, Q.N. Hawley, and Samuel Simpson. Bayles and his men sailed for England where they arrived in May 1840, Bayles travelling by the 'Great Western'.[44] The three planters arrived in Madras on the ship 'Ida' in October 1840, bringing with them two saw-gins, a model of a gin house, a rice thrasher,[45] a cotton thrasher and 100 [American] ploughs. Seed obtained in America was forwarded from London in March 1842 and must have arrived in Madras more or less simultaneously: 500 bushels of New Orleans, 250 of Sea Island and 250 of Upland Georgia.[46] The planters were sent to Tinnevelly (with an established reputation for its native 'Tinnevellies', and where Bourbon had been successfully grown), and lodged in the fort at Palamcottah under the superintendence of Captain J. Victor Hughes of the 39th Madras Native Infantry. This was disastrous: there were delays due to disputes with the Collector, W.C. Ogilvie, over who should pay the Planters' expenses, and he stalled over assigning land for the experiment until after it was too late to plant a crop that had to be picked before the onset of the land winds around 10 April.[47] A whole season was thus wasted, and with the pressure on from the Court, Elphinstone chided the Collector. In the same minute Elphinstone expressed doubt that an experimental farm was the best way to encourage the *ryots* to grow American cotton, and instead favoured its purchase at 'a certain remunerating price' or by 'granting rewards' to those raising most of 'the superior article'. It was Elphinstone who suggested involving G.F. Fischer, who had an American saw-gin at Erode supplied by means of extensive agreements with local *ryots* in the Salem and Coimbatore districts, and Elphinstone thought that 'private enterprize might come in aid of Government encouragement'.[48] Fischer was perfectly willing to help 'the patriotic views of the Honorable Court' but, like Sullivan, had astute ideas on the project, and considered the Planters an irrelevance. From practical experience Fischer knew the *ryots* to be 'skilful husbandmen', and that prize-winning Bourbon cotton could be grown at Coimbatore, but that the main problems were financial, especially:

the manner in which the trade in this article is at present carried on … [with] the medium of a succession of brokers, from the dubash of the Madras agent to the village chitty, who advances to the ryot in his hour of need, whereby but the smallest per-centage of profit remains to the ryot after each of these middle-men has made his own profit, and consequently the ryot has no sufficient inducement to bestow any other care than to reap the greatest possible quantity from his cotton field.

What was needed was 'the introduction of capital, and the immediate application of European superintendence into the interior', and (once again) better roads.[49] Fischer suggested that the Planters be moved to Coimbatore or Erode where he could give advice, and this Elphinstone authorised in May 1841.[50]

Unfortunately such joint enterprise was against Company rules, and the suggestion evoked a stinging retort from the reactionary Charles M. Lushington (brother of Wight's bugbear of 1828–31) who objected to 'amalgamate the interests of the Company with a private trader or merchant, who, of course, will look to his own interests instead of those of the Company'; furthermore, the uncharitable curmudgeon wrote that if Hughes was not competent to superintend the project he should be replaced, and that if Ogilvie had been 'remiss or supine in his duties' he should be 'removed or admonished'. Elphinstone's reasoned response to this bullishness was that it was 'impossible to disconnect the interests of the Honourable Company from that of the commercial community and of the country at large', showing him to be enlightened in terms of administration, and, on the slurs against Hughes and Ogilvie, humane in terms of personal failings.[51]

The Court was angry with Elphinstone about the disastrous first season and the move to Erode (some 200 miles north of Tinnevelly), where the Planters arrived in June 1841. In November 1841 they wrote a rebuke stating that the carefully considered location of Tinnevelly should not have been abandoned.[52] Like Lushington they disapproved of any involvement of Fischer, suggested that Wight should have been consulted (cotton coming within the remit of his employment), and ordered that superintendence of the planters be transferred from Hughes to Wight.

Hughes may have been somewhat unfairly treated, as he seems to have done his best. One of his most interesting acts, in November, being an attempt at a public relations exercise – if a somewhat tactless one. This took the form of a circular in Tamil telling the *ryots* how bad their cotton was, the purpose of the experiment, and that it was in their own interest, as well as that of the State, that they should grow the New Orleans cotton.[53]

Wight at this point was undertaking agricultural work in Ooty, but visited Hughes and the Planters at Coimbatore in September 1841,[54] that is, before the Court's orders were known. Doubtless based on his Madras experience, Wight considered the air of Coimbatore as too dry for American cotton and that at least some of the experiments should take place on the coast.[55] The changeover of Superintendents took place in February 1842 and Wight was allowed an additional monthly allowance of Rs 350 above his Surgeon's salary.[56] He would be based in Coimbatore for the rest of his time in India, though nothing is known about the location of his house, the cotton farms, or the gin-house built there in 1842.

Things had gone little more smoothly in the north than they had at Tinnevelly, as all the good land had already been let out to *ryots* whose main concern was to grow food for their own subsistence. Morris was given 100 acres at Erode of which only 30 were cultivable, the rest being too dry. Simpson was sent to Coimbatore where

he initially cultivated 70 acres and was later joined by Hawley. The areas cultivated at Coimbatore this year were 98 acres on black soil to the north of the town planted with New Orleans, Sea Island and oopum, and two smaller blocks both to the east – one of 9½ acres of red waste, the other of 15½ acres, both sown with New Orleans and oopum.[57] It rapidly emerged that results were dependent not only on the soil, but on the unpredictable monsoon, these experiments all taking place in the area receiving only the NE winter monsoon. A heavy rain came in October but was followed by drought, which caused Morris to despair: 'this is certainly the most provoking and discouraging of any thing I have ever met with in the whole course of my life',[58] though rain that fell in January fortunately revived the crops. There were also problems with 'grub worms'. The question of whether climate or soil was the more important was one to which Wight gave much thought; his vacillation between the two being a sign of their inter-dependence, the best of soils being no good if there was too much or too little rain at critical times.

By March 1842, after only a month in post, Wight was making plans for the next season, but was having trouble with the Americans expressed in a revealing letter to the Madras Government. Snobbery was involved – Mr Simpson the most 'assuming' had been a (mere, is implied) gin-wright in America, and Wight thought their pay 'exorbitant'.[59] The immediate cause of friction was a dispute about authority as to who should choose the sites for the trials, stemming from American concern about their discretionary gratuities. Wight, off his own bat, had decided at this stage that improving native cotton was, if anything, more important than introducing the exotic (on the not unreasonable grounds that it was already adapted to the climate), but the Americans were undoubtedly correct in thinking that the Court's instructions were the reverse. The Planters also believed that the American variety would grow better in wetter areas (where oopum was not grown) and that they should have the power to choose the sites, otherwise they risked losing their gratuity if forced to grow it in places they considered unsuitable. Wight planned to move some of the activities about 50 miles south of Coimbatore, to a traditional cotton growing area around Pollachi and Oodoomulcottah, but Morris, up until now, 'the most manageable of the party' threatened to leave if he were sent to such a backwater. Wight became heavy handed and thought that 'in the event of their adopting and obstinately adhering to such an insubordinate proceeding … I was prepared to forward their application for permission to retire … however … I could not recommend their passage being paid'. In the end the differences were resolved, but the incident reveals that Wight saw the Americans as a nuisance:

> uneducated, having little or no knowledge of the principles of agriculture, and doggedly attached to the routine of America, whether applicable or not to present circumstances. In America they were overseers of negroes, who understood and did the work, while they looked on.

Wight is typically inconsistent here, having earlier in the same letter praised the excellence of the American system of agriculture as 'the nearest approach to perfection yet promulgated, while the Indian practice is about the most far from that standard'. It was probably a question of personalities and Wight recommended that the Americans be replaced with more tractable 'European non-commissioned officers or steady well-behaved privates, who have been brought up to agricultural or horticultural pursuits'. Elphinstone urged concili-

ation with the Americans and 'the need of treating these persons with the utmost indulgence and consideration, and of making every possible allowance for their previous habits and education' and would not countenance the use of NCOs or pensioners lest it give umbrage to the Americans.[60] In this Elphinstone was toeing the official line – the Court was desperate to keep the Americans on board, and in due course approved of Elphinstone's implied reproach to Wight. There had been even greater difficulties with the Planters assigned to Bombay, who had already quit the country by March 1842.[61] Despite the reconciliation Hawley had had enough and moved on in June 1842,[62] to which Wight doubtless said to himself: 'one down, two to go'. The other significant issue raised for the first time in this letter of March 1842 is the question of:

> entering into agreements with the ryots to rent their lands for one or more years, on condition that they will cultivate [native] cotton for me according to the American plan on these lands; and that when I give seed they are also to sow a portion of the ground with the American plant. In return for the land, rent and part of the agricultural charges, which I engage to pay, they bind themselves according to the native practice, to give me one-half of the crop, and first refusal of the rest at the fair market rate.[63]

This was in order to extend the scheme, but brought Wight into the dangerous territory of dabbling in trade, forbidden since the Company's 1813 charter; but, as will be seen below, one that was to be allowed by the Court.

While it is not intended that this should become a book of statistics and tables, it is appropriate to give the results for Wight's first season, not least as it shows the huge variability of the results that would prove typical for the whole experiment; it also allows a discussion of Wight's highly subjective interpretation, another common feature throughout his employment.

TABULAR ABSTRACT of the Extent and Quantity of Produce of the Government Cotton Farms in Coimbatore, for the season 1841–42, as it stood on the 1st of May 1842.[64]

DESC OF SOIL	DESC OF COTTON	NO OF ACRES	AMOUNT OF PRODUCE	AVERAGE PER ACRE
Black soil	New Orleans	94	15923	169.6
	Indian	6	1340	223.5
Red Soil	New Orleans	6	160	26.1
	Indian	10	4143	414.4
Supt's Field	New Orleans	2	125	62.8
Red Soil	Indian	2	300	150
Total		120	21991	183.4
Deduct for wastage 26 acres		94		TRUE AVERAGE 233.14

Wight took these results to be good, though his analysis was curious. But for the fact that the Court were sent the figures, and could therefore have judged for themselves, one might wonder if Wight were trying to pull the (cotton-)wool over their eyes. Why did he add together the Indian and American yields, and subtract the unfortunate (but nonetheless real – the crop had simply not grown) 'wasted' acres, to produce what he called a 'true' average? Looking at these figures dispassionately the yields of Indian are clearly far higher

than the American, though the American did produce 10% more wool for a given amount of seed. The tiny acreages are also noteworthy, but allowances should be made – this was, after all, only the first year. Despite the low yields, which produced a mere ten bales of New Orleans and four of oopum,[65] Wight with what would become increasingly rose-coloured spectacles reported that 'the final outturn of American cotton has greatly exceeded the promise of the earlier stages of the experiment' and *if only* the seed and the weather had been better, 'would probably have considerably exceeded that from our best American-grown native cotton crops'.[66] In this first report another Wightian characteristic appears, his vagueness over costs: he attempted to calculate the cost of the operations, but admitted that these were 'founded on data so very imperfect, [that they] are necessarily liable to much error'. Despite this he optimistically considered that 'the profit to the farmer engaged in cotton agriculture must be very considerable'[67] However, it was not only Wight's spectacles that were tinted: Elphinstone praised Wight's 'lucid report',[68] and the Court in their minute on it had evidently not looked too closely at the table itself, and been swayed by Wight's enthusiasm, noting that the results enabled:

> Dr Wight to rely with confidence on the complete success of the experiments, and to justify the assumption than "in **ordinary** [emphasis added] seasons, a crop of American Cotton will be as certain, and prove as remunerating to the grower, as a crop of Indian Cotton, and that the latter, cultivated according to the American system, will be improved both as to the quantity and quality of the produce". Dr Wight further appears to have little doubt that cotton, both from foreign and native seed, may, with ordinary care only, and in average seasons, be produced, on the American system, with good profit to the Cultivator.[69]

The point is that there was to be no such thing as an 'ordinary' season. To build on what they perceived as a promising start the Court agreed to send an engineer to help with the saw-gins that had not been working properly, and allowed Wight's March proposal to purchase crops from the *ryots* as an encouragement, but, ever-worried about interference with trade, warned that this 'must be limited in its operation to the fair carrying out of the present experiments, beyond which object it must not be permitted to extend'.[70] But one wonders if the Court noticed that what Wight was proposing to purchase was mainly oopum and Bourbon (already naturalised in Coimbatore) cotton grown by the American method, to a far greater extent than New Orleans.

The first year's crop was processed using a saw-gin that proved cumbersome to operate, but samples of wool were sent home by the 'Overland Route' in time to be exhibited by Royle at the British Association meeting in Manchester in September 1842.[71] It was all very well demonstrating the produce to scientists, but it was the opinion of the Liverpool cotton brokers that really mattered, for it was for them that, ultimately, all this effort was being made. A report on the produce came back from Messrs. Hollingshead, Tetley & Co. in October,[72] and at least partly justified Wight's optimism since the best of the '1st sort' of New Orleans, which had been grown by Morris at Salem, was declared 'very promising', except for the damage caused by ginning, and at 5¼d per pound was worth only a farthing less than 'fair New Orleans' cotton from America. The lower quality ('2nd sort') of New Orleans from Coimbatore was coarse and also damaged by ginning and worth only 3¾d per pound, and the '1st sort' grown by Hawley and Simpson at Coimbatore was

valued at 4¾d . The staple of the New Orleans was categorised as from 'good' to 'short', but was considered fit for 'general consumption' (presumably spinning). The oopum, with its 'very short' staple, was valued at 4¼d to 4½d and praised for its whiteness and cleanness, but was rated not suitable for 'general purposes'.

ON TRIAL UNDER TWEEDDALE · 1842–8

The details and results of the first year have been given in some detail, as in their variable results they set the pattern for following years. It was at this point, in the summer of 1842, that Wight's supporter Lord Elphinstone left Madras, to be replaced in September by George Hay, 8th Marquess of Tweeddale [fig.30], a self-professed expert on practical agricultural matters. Having retired from active service in the Peninsular and Anglo-American wars he had settled at Yester and to the improvement of his East Lothian estates. George Bentham visited Yester in 1823 and noted the start of the improvements, and was amused to discover that the local farmers pronounced their laird's name as 'Twiddle'.[73] However, this temperate experience could have been of only limited application to tropical agriculture or to understanding the labyrinthine laws and practices of land tenure and agricultural fiscal systems of South India, while by this time Wight had 24 years of Indian experience, seven of which had been devoted exclusively to agricultural work.

As already described Wight had laid plans for his second season of 1842–3 (fasli 1252), and these were ambitious but careful. There were staff changes this year – Hawley, having gone to Bombay, was replaced in August by Henry Sherman. Sherman, born in Madras 'of European extraction', could read and write Tamil fluently, and became Wight's 'overseer of the cotton farms and assistant'. There were also an additional six 'Eurasian lads' sent by the Philanthropic Association (presumably of Madras) for training at their expense – four in the agricultural, two in the engineer's department. In October 1842 James Petrie arrived as engineer, having previously worked 'putting together iron steam boats for use on the Euphrates'.[74] Operations continued in and around Coimbatore with Wight himself farming 173 acres of red soil and Simpson 296 of black. Wight and Sherman jointly cultivated 129 acres of alluvium at Coorchee (now Kurichi), about five miles south of Coimbatore. And Morris had had to submit to his posting to Oodoomulcottah (now Udumalaippettai) 50 miles to the south, where he farmed 311 acres of black soil; in February 1843, however, his health conveniently failed, and he swapped places with Sherman. The crops sown were New Orleans, Bourbon, a small amount of Egyptian and oopum, and an experiment was made on one field of the previous year's New Orleans by pruning and trying it as a biennial, which on this occasion worked (though not later), and cropped better in its second than its first year.[75]

In May 1842 Elphinstone allowed Wight's request to purchase half the crops of 'indigenous [i.e., oopum] and naturalised Bourbon' cotton grown by *ryots* using the American method.[76] As well as a means of proving whether better methods of cultivation would improve the native plant, this was no doubt as a way of providing large amounts of seed cotton for the saw-gins. In July permission was given to build a gin-house and press-room at Coimbatore at a cost of Rs 6579/13/7, to be constructed under the Planters' and Wight's supervision.[77] Processing of cotton was another key part of the experiment, the British believing that the traditional churka must be ineffective and inefficient, and keen to introduce mechanisation in

the form of saw-gins. This failed to understand that ginning by churka was normally undertaken by women, and therefore at no cost to the *ryot*, for whom the time taken was not a primary concern. In fact already in June, Wight (as Finnie would later) admitted that the churka had many advantages, especially in not cutting the wool fibre, though it left more contamination from fragments of broken pod.

A glance at the construction of the two machines [figs.32, 33] is enough to show the complexity of one and the simplicity of the other. The saw-gin, the product of 'capital, ingenuity and enterprise',[78] was invented in America by Eli Whitney in 1793, and consists of a roller bearing a series of toothed blades (saws) that remove the fibres from the cotton seed (though at the risk of cutting them if brittle), the wool being removed from the saws by brushes on an opposing roller. The machines, with their revolving rollers and belts, were heavy to operate, requiring man- or bullock-power, which had to be paid for, and added to the processing costs for which the *ryots* were unwilling to pay when their family could do the work for nothing. In this first year Wight pointed out that it took eight strong men a day using a saw-gin to produce 'scarcely … as much daily as 10 or 12 feeble old women or children would do with the churka',[79] though the saw-gins worked far more efficiently after the ministrations of Petrie. After ginning the cotton wool had to be pressed into bales for transport, the reason for the building of the 'press-room'. This pressing at Coimbatore was at fairly low pressure, producing bales of 300 lbs, which were later 'screwed' at the port of embarkation (initially Madras, later Cochin) before export. At first an 'Atlas' press was used, but proved too weak and Wight asked the Court to supply a Colaba Press. When forwarding this request to the Court in June 1843, the practical Tweeddale stressed that machinery for use in the interior of India needed to be simple, robust and adequately tested.[80]

The American System and other Agricultural Matters

It is time to say something about the 'American system' of agriculture, of which Wight was initially so highly enamoured. He wrote an important account of this (and other matters) in February 1843, entitled 'Extract Notes on American Cotton Agriculture, as practised on the Government Cotton farms in Coimbatore', which was lithographed and distributed within Madras, and also sent to Calcutta for publication in the *Journal of the Agricultural and Horticultural Society of India*.[81] This Society had always taken an active interest in the cotton experiments and activities of the American Planters. Auckland had originally intended that the Society should have had a role in the management of the Planters, but this had been forbidden by the Court. Despite this its *Journal* is full of information on the subject, relating to activities in all three Presidencies, including many contributions from Wight. Wight summarised the American system as what in Europe was called 'drill husbandry', and gave a rare personal slant recalling its similarity 'to the cultivation of turnips in Scotland (as I recollect it some 30 years ago)' – this would take him back to 1813, the time he was leaving school, and doubtless refers to his father's farms near Penicuik.

The land was prepared using American ploughs to make ridges eight to ten inches high at the centre, the spacing between them depending on the soil and the variety of cotton. The aim was for the branches of plants on adjacent ridges to meet – on good soils the spacing for New Orleans was about five feet. A furrow about two

Fig.32. The Madras Churka. Lithograph by John Richard Jobbins from the EIC's *Report on the Culture and Manufacture of Cotton Wool, Raw Silk and Indigo of India*. London (1836).

Fig.33. Whitney's Saw-Gin. Lithograph by John Richard Jobbins from the EIC's *Report on the Culture and Manufacture of Cotton Wool, Raw Silk and Indigo of India*. London (1836).

inches deep was made on the ridge with an Indian plough and the seed thickly sown. When the plants had three or four leaves they were thinned, then the furrows were ploughed to bank up the roots, and this process of ploughing between the rows (to get rid of weeds and 'fertilise' the soil) repeated until the plants were two to three months old and two to three feet high. The plants took six to eight weeks to flower, and another six to eight weeks from flower fall to pod burst; weather permitting, picking could continue over a longer period for American than for oopum. This process was more labour intensive than 'the simple and indolent practice of the native agriculturist', and therefore more expensive – both in terms of hiring coolie labour and the bullocks required to pull the heavier ploughs.[82] It should be noted that there was always difficulty in getting good land for the experiments, which either had to be negotiated from the Collector (unassigned land, usually 'waste'), or subrented from *ryots* who were unwilling to give up good arable land. That it had already been established that American cotton grew better on red soils was an advantage, as this was not so desirable for food crops, though much of it had reverted to fallow ('waste') and required enormous preparation to free it from scrub and pernicious weeds such as 'couch grass' (*Ischaemum pilosum*). In this paper is a uniquely revealing admission of Wight's 'hands-off' approach to practical matters, as he stated that cultivation formed 'no part of my duty', any share he took being secondary 'to the labours of practical men'.[83]

The time of sowing *vis à vis* the rains, was a matter of crucial importance to which Wight had already given much thought. Never in a hurry, it was one that he still considered would take several more years to establish. At this stage Wight was still more or less following the traditional practice for oopum, to sow between early September and October, with the first rains of the N E monsoon, harvesting in April–May.[84] It seems that Wight was already thinking of earlier sowing, doubtless because of differences he observed in growth of the plants – oopum being deeper rooted and more resistant to drought, the New Orleans having shallower roots, and requiring moisture near the surface as found in alluvial soils or low-lying red soils that received drainage from higher up.[85] The matching of sowing regimes with plant requirements and climate (temperature, and rainfall) was to become one of Wight's major concerns. On the subject of land preparation, Wight believed in the 'fertilising effect' of the indigenous practice of repeated ploughing in preparing the soil for planting, which Indians called 'cooling', though he attributed its effectiveness to 'chemical changes brought about among the constituents of the soils through their free exposure for a length of time to the action of light and air and ready admission of moisture'.[86]

Already in February 1843 Wight was aware of a curiously parallel experiment being undertaken by the Collector of Coimbatore, J.C. Wroughton, at Ootakalmund (now Ottaikalmandapam) ten miles south of Coimbatore, which was showing promising results.[87] Simpson had given up trying to grow American cotton on black soil and asked to be moved close to Wroughton's farm, to which Wight agreed,[88] though such a move would not in fact happen until the end of 1845. Such delays in learning from experience are typical of the project, though there were probably usually good reasons: in this case perhaps a lack of available land.

Pests, and the question of deterioration in quality of plants and seed, are other important issues discussed in the 'Extract Notes'.

Throughout the project Wight recorded extremely little about the effects of pests, notorious as one of the biggest problems of cotton agriculture,[89] but here is mentioned a moth, doubtless one of the bollworms, that was most active at the time of the N E monsoon and which laid 'eggs that generate maggots in the immature bolls'.[90] The question of deterioration of plants year by year was already noted at this stage, and was rightly blamed by the Americans on faulty cultivation. It took Wight several years to realise this, and at this point he held the (Lamarckian) view that deterioration was due to poor seed 'constitutionally weakened by being the produce of unhealthy plants grown last year on black soil'.[91] The question of deterioration of quality due to what would now be called inbreeding depression, or the possibility of selective breeding, was scarcely raised by Wight while in India, though he would return to it after his return to Britain.[92] Deterioration due to repeated cropping will be discussed below.

Season 1842–3

The results of the 1842–3 season were better than those of the previous one, though again showed great variation – the best, a field of 17 acres of New Orleans on alluvial soil on Wight's own farm yielded 441¾ lbs per acre, and a much larger area (87 acres) on similar soil at Coorchee gave 394½.[93] The other New Orleans crops gave yields of between 107 and 225½, and, as with the previous year (and despite Wight's belief to the contrary), actually gave higher yields on black than red soil at both Oodamulcottah and Coimbatore. As expected the oopum greatly outperformed New Orleans on black soils (yields of 279½ and 353¾), but did worse (103) on red, though allowances must be made for the fact that the yield of wool to seed was greater (29½%) for New Orleans than oopum (22¾%). The quantity of processed wool sent back to England was greatly increased over the first year, with 131 bales of New Orleans, 61 of oopum and 10 of Bourbon.

In Wight's Report for the year he somewhat perversely expressed disappointment with these results.[94] But this was because in February and March the crops had promised to be 'probably the most abundant crop ever seen in India' that he thought might give yields of 500–1000 lbs per acre. However, rains in April had destroyed much of the crop, and for once Wight was unusually realistic and pointed out the 'futility of such anticipations'. Such reverses from initial promise, due to climate, were in fact a yearly occurrence and, as already stated, there was simply no such thing as an 'ordinary' year, other than in Wight's wishful thinking. The other consideration of the results was the costs, and although (once again) Wight was at this point unable to calculate these accurately, had to admit that:

> viewed merely as a commercial speculation, without reference to consequences, and supposed to be conducted with the most rigid economy, consistent with perfect efficiency in all its parts, [it] is a debtor.

The deficit turned out to be Rs 3177. But hopeful of higher yields in future years, and economies that would come with longer experience, Wight was still optimistic that the project could ultimately show not only that American cotton could be grown, but that it could be profitable.[95] He had also by now realised that it would be necessary to experiment with manuring and rotation, and, while still not over-enthusiastic about the remaining Americans (Morris and Simpson), he approved the award of their gratuity.[96]

Of the 219 bales of cotton produced on the Government farms 190 were shipped on the 'Lady Flora' from Madras to England

where they were reported upon by J.R. Tetley & Son. The staple of the New Orleans was pronounced 'much better than the oopum, being longer and finer, less cut with the "gin", the great part clean and of good colour'. The prices of cotton were generally lower compared with the previous year, as despite the Indian being valued the same as the 'middling fair' American New Orleans in bond, it made only between 4 and 4½d per lb when sold. Interestingly the quality of the New Orleans grown on black soil was found to be higher than that from red or alluvium; evidently a question of quantity versus quality. The brokers were gratified with Wight's work (though, of course, it had cost them nothing), and wished it to be publicised. However, they asked for information on the costs of cultivating 1000 acres by 'private enterprise' clearly trying to discover if it would be worth a British farmer's while to operate in India. The Court too was pleased with Wight's 'intelligent report' and once again pleased that, despite the 'unfavourable results of the season', Wight could speak 'with confidence of the ultimate success in all the primary objects contemplated by the experiments committed to his superintendence'.[97] In a letter to the Madras Revenue Board the Court's praise was even stronger: 'the zeal and application evinced by Dr Wight in the conduct of these experiments are very creditable to that Officer'.[98]

Season 1843–4

Cultivation in the season 1843–4 continued as in the previous year: at Coimbatore Wight worked 182 acres of red and alluvial soil and Simpson 304½ largely of black; at Coorchee Morris had 263 acres of alluvium; and Sherman at Ootamulcottah 340 acres mainly of black. The yields, however, were all dramatically down on the previous season and a great disappointment to Wight. The yield of his prize field at Coimbatore that had given over 400 lbs per acre was down to 157, which he attributed to 'partially deteriorated American seed'. The only place where the yield appeared to have gone up Wight admitted was due to fudged statistics: he omitted the acreage of a field that failed to produce, which raised the average from an actual 85 lbs per acre to the more acceptable 107⅝; he now thought it 'incorrect' to have included the acreage of this bad field the previous year as doing so had brought down the yield from in excess of 170 lbs/acre to the 124¾ he had (correctly) reported. Once again Wight was not being dishonest, as he explained what he had done, but it demonstrates his unscientific approach. This lack of method also applies to his truly lamentable style of report writing – full of repetitions, self-contradictions and digressions, and including future plans in what were supposed to be retrospective annual reports.

The three possible reasons Wight gave for the decline were:

1. Repeat cropping (discussed below)

2. Late sowing in mid-October, necessary because of a late onset of the monsoon, followed by a drought after mid-December broken only in April.

3. Too much rain at the start of the season leading to too much vegetative, and too little root growth, and therefore poor establishment when the drought came.

Once again science disappears in Wight's conclusion that none of these factors 'individually or conjointly' were enough to explain the general failure, 'which seems rather attributable to some *unknown state of the atmosphere* than to any remediable cause'.[99]

Wight was, however, anxious to learn from experience, and planned four changes to the experiment for the following season of 1844–5. The one he probably thought most important (though placed third on his list of proposed changes) was to alter the time of sowing, which he had already contemplated. He now intended to sow in May and June so that plants could be well established to benefit from the NE monsoon – Wight anticipated great advantage from this 'should the average run of seasons permit this … to become the system'. First and second on the list were less important changes: to abandon ridging (which he took to drain water from the roots); and to repeat the experiment of growing New Orleans as a biennial by pruning (which had given promising results in 1842–3). Rotation, which by now should have been the most glaringly obvious of the required changes, was discussed by Wight seriously, though did not appear on the numbered list. He knew that the *ryots* never took 'two consecutive crops of the same kind', but that in the experiments he had been '**forced** [emphasis added] to take three off most of our land'. This was presumably due to difficulty in obtaining land, but Wight knew it to be bad and so was 'progressively establishing a system of rotation'. This, however, would still take 'two or three seasons to adjust' and limit the amount of New Orleans that could be grown the following year. A question that repeatedly comes to mind when reading these reports is why it took Wight so long to effect such important changes, and to carry them out systematically, rather than piecemeal?

Another important factor emerged this year. It has already been seen that Wight realised the importance of offering incentives to the *ryots* in the form of purchasing crops, but this had been strengthened in discussions with J.C. Wroughton who 'repeatedly expressed his conviction that all that was wanted to establish the general cultivation of American cotton among the natives here was to insure to them remunerating prices for the article when produced'.[100] Wight made careful calculations as to what would be a fair price to offer, knowing that the Company did not want to make a profit, and not setting such a high price that would make difficulties for future potential speculators. He asked the *ryots* to name a price at which it would be worth their while to sell to him, to which the answer was Rs 20 per candy for 'clean well-picked New Orleans seed cotton of their own growth'. Wight therefore asked Tweeddale's permission to distribute seed and purchase the produce at between Rs 18 and 20 per candy depending on quality.[101] Such purchases were officially sanctioned by the Court in October 1845, though doubtless Wight had been going ahead in the meanwhile, but permission to purchase was initially limited to three years and that the purchases were 'limited in amount so as to be divested of the character of Commercial speculation'.[102]

The last part of Wight's 1843–4 report is a detailed table of costs for the experiment: the purchase and keep of bullocks for ploughing; costs of ginning and baling; general costs of the establishment – carpenters and smiths, 'house and godown rent', 'bandy and coolie hire to and from Madras', watchman's pay, erecting and repairing sheds, 'sacks, wax-cloth, tar-ropes and wood for ploughs', 'table, chairs, iron mounties, gear and hide lantern', 'paper, wax and gum' and the cost of the Engineer's establishment. The costs amounted to Rs 8136, but, as Wight pointed out, did not include land rent, salaries or the keep of the commissariat cattle and drivers. As the salaries and rent must have formed the major portion of the real costs of the experiment it is difficult to know if Wight was

deliberately keeping quiet about these to make his establishment look economical, or that he genuinely did not know these figures which were probably only available from the Revenue Department (some locally from the Collector's Department in Coimbatore, the salaries presumably from Madras).

Tweeddale's comments on this report are revealing, and drew attention to the absence of the important costs, which made it impossible to know the 'real price of production [of the American cotton produced]'.[103] More interesting was the comment on the absence of any input into the report from the Americans, and its implicit criticism of Wight – 'that the opinion of the American planters should always be taken when causes of failure are assigned or new schemes suggested'. This is the first place where Tweeddale's prejudice in favour of practice over what he clearly regarded as Wight's academic approach is apparent. The question of purchasing cotton from the *ryots* at fixed rates had, of course, to be referred to the Court.

Trouble with the Americans plumbed new depths this year, with Simpson making an official complaint about Wight's use of 'the Cattle of Government for private purposes'. While the Court approved a reprimand issued to Wight about this irregularity, they realised that Simpson's motives for the complaint were probably not 'pure and disinterested' as Wight had previously had cause 'to complain of the objectionable tone of Mr Simpson's Official correspondence'.[104] Relations between Simpson and Wight were to deteriorate further!

Season 1844–5

For the 1844–5 season Wight, Sherman and Morris continued farming at Coimbatore, Ootamulcottah and Coorchee respectively[105] The results for the year show that oopum still greatly outperformed New Orleans on black soils (and even on alluvium), and the only good yield of New Orleans (361 lbs per acre) was obtained by Wight on a newly cultivated six acre field of red soil, the others being down to between 66 and 159 lbs per acre. This year Wight sent home 124 bales of 1st sort oopum, 41 of 1st sort New Orleans, and 18 of Bourbon. The downward trend of yields for all varieties on repeated cropping is dramatically shown in the following table.[106]

AVERAGE [LBS] PER ACRE	1842	1843	1844	1845
Superintendent's Farm, Coimbatore[1]	–	140⅛	125⅛	105¾
Mr. Simpson's Farm, Coimbatore[2]	233	200⅝	72⅝	–
Mr. Morris's Farm, Courchee[3]	–	307½	199½	136⅛
Mr. Sherman's Farm, Oodoomulcottah[4]	–	270¾	234	229

Notes. 1. Principally American and Bourbon; soil for most part very poor, generally shallow and unsuitable. 2. Principally American and some Oopum; soil generally black, of inferior quality. 3. Principally American, some Bourbon and Oopum; soil alluvial, but poor, apparently exhausted by first luxuriant crop. 4. 1st & 2nd seasons principally American; 3rd mostly Oopum accounting for high out-turn of 3rd crop; soil black, generally of the best sort of that type.

This proved beyond doubt the damage done by repeat cropping on the 'worn out soils of India'. As early as 1843 Wight had suspected that repeat cropping would not work: 'how long the land will sustain that racking system it is impossible to say, but we have already evidence to show that our Indian lands will not bear it'.[107] It is to be hoped that by now Wight had some shame for some earlier patronising remarks:

The natives, I am aware, have some plan of rotation, but whether it has been reduced to a system or depends on the momentary fancy of the individual, I am unable to say, but suspect the latter.[108]

But why did it take Wight so long to take this matter seriously? He later attributed this to following the practice of the American Planters,[109] which (at least at this stage) was possible on the rich alluvium of the Mississippi. Many years later, from the comfort of Grazeley, and when Wight was feeling much more charitably disposed to the skills of the *ryots* and their method of cultivation with the much maligned 'crooked stick', Wight realised that the Americans, rather than practising good agriculture, had been merely living on the capital of their good soil, which became exhausted after 50 years. The *ryots*, by contrast, using careful practices lived on the interest of their land. At this point, and in nostalgic mode, Wight described the native rotation as cotton followed by two successive crops of sorghum and that the first of these was particularly abundant:

hence the floating tradition exists in some parts of the country, of a Ryot, who feeling himself dying, bitterly upbraided fate for its injustice in depriving him of what he had been looking forward to for three years, namely, his large crop of sorghum.[110]

The question of manuring had been raised by Wight in his 1842–3 report.[111] Traditionally the *ryots* relied almost entirely on rotation rather than the use of manure, which Wight described as taking 'all they can from the ground, returning as little either in labour or manure as they can'. The reason for this was that cattle dung and old cotton bushes were required for fuel, and the only small return of organic matter to the soil came from the droppings of sheep let into fields to graze the leaves after harvesting was finished. Wight's plan for the 1843–4 season was to plough in the old stalks, and on some fields to add 'a considerable quantity of village manure', but this was a question of too little and too late. In 1842 Captain J. Campbell, Assistant Surveyor General of Madras, offered muriate of lime for use as a manure,[112] and the Court eventually allowed purchase of 100 lbs for the cotton experiments,[113] but nothing is recorded about its results if it was ever used. It seems extraordinary that Wight did not think of sowing and ploughing in grain crops, as a green manure, as he had recommended as a treatment for bad soils to the Madras Agri-Horticultural Society only the previous year.[114]

Tweeddale's Later Years (1845–6 to 1847–8)

There are no annual reports for these three years, and their results are known only from the briefest of summaries. These, however, are enough to show that, with the possible exception of the first, they were very poor, a result attributed to rains falling at the 'wrong' time with respect to the growth stage of the plant, in turn depending on when seed had been sown. However, the autumn of 1845 was a critical time, with Tweeddale starting to ask awkward questions about the value of the experiment, and what sort of hands it should be under – a scientific botanist, or practical men? Wight himself also realised that changes were required.

On 1 September 1845 Wight provided what, for him, was an unusually concise summary of the experiments to date for the Madras Chamber of Commerce.[115] In this he admitted the grave mistake of repeat cropping, and by now thought that soil was much more important than climate. A spectacular yield of 1100 lbs per acre had recently been obtained by Wroughton on one of his Ootakalmund

fields,[116] but Wight could not bring himself to admit that there was anything special either about the soil on which this spectacular result had been obtained (while admitting that it had *not* been cultivated for many years, surely a significant factor) or the local climate. Later Wight disingenuously claimed that Wroughton had merely 'happened … fortunately, to pitch on [this] field',[117] clearly a question of sour grapes, and Wroughton explained that he had deliberately chosen this site because 'from local knowledge and tested experience it received both SW and NE monsoons'.[118] Even if ungracious to Wroughton, Wight had the sense, belatedly, to take advantage of his experience and some time in September 1845 abandoned Coorchee and the remote Ootamulcottah, and moved most of the activities to Ootakalmund and some surrounding villages, under the direction of Sherman, for the season 1845–6.

As this report was for the Chamber of Commerce, Wight made elaborate efforts to show that growing American cotton was not only possible, but that it was more profitable to the grower than oopum, though he had to admit that the *ryots* were still unwilling to undertake its cultivation. He gave calculations based on the latest prices of the two cottons from Liverpool, working out that the grower would have a profit of Rs 3 per candy on American over oopum. But this was based on various assumptions, of which the only truly valid one seems to be that the yield of wool/seed was greater for American. The claims that costs of production were the same for both would only be true if New Orleans could be cultivated by the native rather than American method, and Wight continued optimistically to state (against all the evidence) that 'in the average run of seasons it is my belief the [American] crops on similar soils will be found heavier', which by now was proven only for red or alluvial soil, and in most cases at a low level.

Even if the *ryots* could have been persuaded of the economic advantages of growing American cotton, it seems that there might have been cultural disincentives, if an anecdote of Wight's friend Hugh Cleghorn, as related by Royle, is to be believed. Wight had sent Cleghorn some New Orleans seed, which he distributed in Mysore; however:

> he found the Brahmins discouraging the cultivation, as it would cause the disappearance of the native plant, and that, therefore, "the evil eye" would be upon all their efforts. To ensure the truth of their prophecy, men in blanket cloaks were sent out into the fields at night, and were seen rooting up the young plants.[119]

It might have been noticed that Simpson did not appear in the 1844–5 report, the reason being that in July 1844 he had been sent to Sirsi in the Southern Mahratta country of the Bombay Presidency to report on cotton possibilities there, which he duly did despite formidable obstacles (starting with Wight's not telling him the best route, so it took him seven weeks to get there from Coimbatore!). Simpson's report included a blistering attack on Wight's methods, upon which he entirely blamed the *ryots*' failure to adopt the cultivation of New Orleans cotton.[120] Simpson thought a Government farm useful for determining limitations of soil and climate, but for absolutely nothing else: 'it will never do to exhibit a labyrinth of ways and means to the mind of a suspicious and incredulous Hindoo, as is the case with the expensive experimental cotton farms at Coimbatore'. According to Simpson the *ryots* regarded such farms as 'some public work going on for some object of the "Sircar's" [i.e., the Government], not to be understood by them, and far less did

they think it was intended for their adoption and their country's good'. Simpson realised that the actions of the poor *ryots* were controlled by the 'shroff or village merchant' who advanced them funds and 'secures to himself their crops, from the very time of sowing', but this could not be changed unless the Government took the place of the shroffs. The only way forward Simpson could see was by abandoning Government farms and taking the methods out to the people, under the charge of a 'practical person' who would supply the *ryots* with seed, and demonstrate the use of small saw-gins. Simpson also accused Wight of what might be called control-freakery over the distribution of New Orleans seed – when he had told the *ryots* to go to Wight for seed they had said '"we do not know that gentleman", and very deliberately went home'. What can lie behind this, if, indeed, it is true? The report ended with Simpson lambasting the very idea of superintendents (though not going quite so far as to name Wight) – they were:

> not … of the least use; but, on the contrary … they have signally failed to carry out the objects of the experiment, by perversely overstriding the limits of their position, and ignorantly assuming charge of what they did not understand, and had no sort of right to interfere with.

Putting himself under such people had been no part of Simpson's agreement with the EIC, and had he known in advance that such submission would be required, it would not 'have been entertained for one moment by me'.

Although the Revenue Board censured the 'tone and style' of Simpson's letter,[121] Tweeddale made no comment on this attack, and, on the contrary, was clearly on Simpson's side.[122] Tweeddale regretted that he had 'never had the advantage of personal communication with Mr Simpson', and that his 'observations impress me with a favourable opinion of his judgement'. A meeting between this Southern redneck and Scottish aristocrat is an intriguing topic for speculation, but such a thing never happened, and Tweeddale recommended that if Simpson's 'services can be spared' by Dr Wight, that he be sent to the Ceded Districts (Bellary), an important cotton growing area where his advice might be heeded. Simpson had also been causing trouble by asking for a pay rise to Rs 500 per month; Wight would not allow this and suggested that he be transferred to Bombay,[123] but it appears that Simpson gave up and left the country. Morris was also on the point of leaving in April 1845, having not been allowed a gratuity, and his salary being less than that of the Planters in Bengal or Bombay; however, he was given another year's contract and sent to Bellary in place of Simpson in October 1845.[124] Morris died at Bellary the following year, but not before offering similar views to Simpson's about Wight to the sympathetic local Collector.

Tweeddale was clearly concerned about the effectiveness of the experiments and their costs, and asked Wight to supply answers to a series of highly pertinent questions, which he did on 29 September 1845.[125] The costs of the experiment to date were Rs 111,006, but this was not a total as Wight was still not able to supply some of the most important elements 'of which no authentic records exist in my office', though this time it did include his own hefty salary. On the question of whether the experiments had been successful in introducing better methods of cultivation and cleaning Wight answered that the cleaning (i.e., by saw-gin) was successful, but that it had been necessary to adapt the American system of cultivation to local soil and climate. Despite this few Indians had followed either

example, but, ever the optimist, Wight was hopeful that 'before long these few will have many imitators'. As to the value of the Indian produced American cotton, Wight was able to report that it was worth 8% more than oopum in the English market after taking transport into consideration. Tweeddale had asked if the improved methods were 'within reach of the native cultivators' to which Wight replied that everything possible had been done to make them so in the way of offering seed, and purchasing back the produce. Free use of the now smoothly running ginning department had also been offered, but obstacles to uptake on this were due to the high costs of transporting heavy cotton seed to the gin-house by bullock cart, and the fact that 2% of the weight was lost by ginning, due to impurities and sand that were left by the churka (but for which merchants had no choice but to pay). The most searching of Tweeddale's question was 'what further object is to be gained by … continuance [of the experiment] in the Coimbatore district?' After realistically stating that the *ryots* would only adopt the new methods if shown to be to their advantage, otherwise 'they will adhere to their ancient practices', Wight urged continuance, as if it 'be now withdrawn, all that has yet been done towards the introduction of the American system and American plant will be lost', adding that:

> It is at all times a slow and difficult process to carry conviction to the uninstructed prejudiced mind, and the difficulty is increased an hundred-fold when those prejudices have been the growth of ages and are strengthened by immemorial custom.

Wight was sure that the *ryots*' prejudices were 'now beginning to give way', and that they were just on the point of being convinced that they could grow American cotton using their traditional own implements, as easily, but more profitably, than oopum, beliefs that he retained until he left the country eight years later.

Buried in this same letter of 29 September 1845, is the (for Wight) astonishing admission that the 'persevering adoption of the American plan of farms, and the exclusive use of American farming implements, have proved an insurmountable barrier to their [the ryot's] adoption of either the system or plant' – in other words, that Simpson was correct. To try to overcome this Wight planned for the year 1846–7 to 'engage lands, and enter into contracts with the *ryots* to cultivate them for us according to our method', which would allow reduction of the Government farms to 2–300 acres, using them as a 'nucleus round which others may congregate', and as a source of dependable seed.[126]

Tweeddale has already been shown as disposed to favour the 'practical man' and he nailed these colours firmly to the mast in two minutes written in October and November 1845. In the first he picked up (doubtless with some glee) on Wight's doubts about the government farms and twisted them into a firm proposal on Wight's part 'to relinquish the farming system'. The Marquess considered that there was little to show for the cotton farms and their superintendence other than their heavy expenditure, that there was little inclination on the part of the natives to follow their expensive means of cultivation and processing, and that, as the Court had only intended the experiment for five years, there were 'no grounds for renewing it'. Furthermore, the original aims would be 'far more effectually attained by the employment of practical men' – in effect, what might be called an extension system. However, it would not be fair to give the impression that Tweeddale had any intention of sacking Wight, for he asked the Court's opinion on 'the further prosecu-

tion of the experiments in Coimbatore under Dr. Wight', and in the second minute assured them that it was 'not my desire to question the abilities of Dr. Wight, or his fitness to superintend the present experimental scheme, but to point out the means which I consider the best adapted to accomplish the object in view for the benefit of this country'.[127] This may or may not have been sincere.

Another dramatic happening of the 1845–6 season was a request by the Court, which must have been received in Madras in January 1846,[128] for 5–6000 bales of saw-ginned Native cotton, in order to establish a price in Britain based on a substantial sample.[129] Oddly this request was specifically for Native, and not for the American cotton that the Court was supposed to be encouraging (and so all it was testing was the effect of the gin rather than the churka), and the Manchester Commercial Association later confused the matter by asking that the 5–6000 bales be of American cotton! Regardless of this, the vast order came as a lifeline to Wight, and justified his continuance in Coimbatore for many years to come.

The *London Mail* in November 1845 had carried an article noting the 'great rejoicings of the Americans on account of the failure of all our attempts to cultivate American cotton in India' and the advantages this would give them 'in time of peace, and power over us in time of war'. This riled Wight and prompted a patriotic outpouring addressed to the *Morning Chronicle* that was published in London on 13 March 1846. This earned him an admonishment from the Court on 'the great impropriety of addressing letters for publication to any Newspaper on subjects connected with his official duties'.[130] It tells us something, however, not only of Wight's politics, for this newspaper was famously Whig in outlook, but also gives an insight into Wight's patriotism, his hatred of war ('a horrid game, and one in which all parties always are losers, [that] ought not to be lightly spoken of'), and a very public statement of his optimism in the success of the cotton experiment. By now Wight was convinced that success was entirely dependent on sowing time (making no mention of wild and unpredictable fluctuations between years), and that when sown at the 'proper season' it was possible to get yields of 1–2000 lbs of seed cotton per acre, and even fields sown six weeks too late could yield 3–400 lbs. As we have seen such a bumper crop had occurred only once (on Wroughton's field, which Wight had been prepared to attribute to good fortune), and his own experiments had on only two occasions given yields of between 390 and 450 lbs/acre, the vast majority being between 107 and 225. When calculating the amount of cotton that could be produced in South India he did use the more realistic figure of 100 lbs/acre of clean cotton (i.e., corresponding to 300 lbs of seed), but here the vast leap of faith made by Wight was that if the price went up by only one farthing in local markets, then cultivation would go up to 4000 square miles, which (being grown on red soils) would not only have no effect on food crop production, but produce 'more than half the quantity required for home consumption by the English manufacturers'. The letter ends with a biblical rebuke to the crowing Americans:

> he who exalteth himself shall be abased *Matthew 23:12*

As already stated there is no surviving report for the season 1845–6, but some anticipatory comments on it are found in that for the previous year,[131] and there are other relevant comments from four years later.[132] Despite advice to the contrary from Morris, Wight had wisely decided to follow Wroughton's lead and move activities to Ootakalmund and three surrounding villages, where operations

were carried out under Sherman. Not only was this an area of two monsoons, but, being closer to Coimbatore, could be visited by Wight on a weekly basis.[133] The negotiations for land were complex and Sherman must have had a busy time obtaining tiny unirrigated *punjah* fields from a large number of *ryots*.[134] The agreement was for use of the land for 15 months for which the *ryots* received compensation of half the value of the Government assessment. Doing it this way Wight hoped to show the *ryots* that there 'was nothing obscure or mysterious in our proceedings', and circulated copies of accounts showing that it should be possible to make a profit of Rs 247 on an area of 22 acres – assuming a yield of 681 lbs per acre! In February 1846 Wight reported on a field of 22 acres sown in July that had so far yielded 18,000 lbs, but after July the season had become dry so that fields sown six weeks later were in expected to yield less than 100 lbs per acre.[135] The later note about this season stated that the fields prepared in May and sown at the end of July 'yielded a crop in proportion, nearly 1,000 lbs per acre', but that those sown in September 'altogether failed' and yet, in comparison to that of 1847–8, this season was deemed to have been a good one.[136]

Season 1846–7

The plan for 1846–7 was to cultivate 700 acres at Ootakalmund, and to start ploughing in April, ready for sowing in the first two weeks of July. However, this season proved 'an unfortunate one. The rains did not commence until June, and were of short duration … but from July until February no rain fell, the country generally was burned up, even the irrigated crops failed for want of water. The total fall of rain registered during 15 months in Coimbatore, was only 6½ inches' and the crop amounted to only 79 bales.[137] Despite this the American plant had apparently survived the drought better than oopum, and the few *ryots* who had been induced to plant it got better returns than they would for oopum in a good season, which 'very unlooked-for result will doubtless establish its credit beyond dispute, and stimulate its extended culture'.[138]

While Sherman was busy in Ootakalmund, Wight was active in Coimbatore addressing the issue of providing the large amounts of processed wool required for the Court's order of 5–6000 bales of saw-ginned oopum. By April 1846 this was starting to come in and Wight reckoned he could gin 3–4000 lbs of seed cotton per day. This was a typical exaggeration, and the more sober and practical Petrie later stated that the best saw-gin (with 20–25 saws) could process 1000 lbs of seed cotton per day (i.e., produce about 330 lbs of wool), being operated by 16 men in teams of four.[139] Petrie was asked to stay on for another year in order to supervise purchasing the cotton seed and completing the machinery of the gin house. It was in April 1847 that Petrie sent an improved saw-gin he had made to the AH Society in Calcutta.[140] At this same time Wight was planning a visit to Cochin, where new cotton presses were being erected,[141] the reason being that if cotton could be shipped from Cochin, rather than Madras, then huge inland transports costs could be saved.[142]

A fascinating letter from this bad season shows Wight's humanity towards the *ryots*, and the difficult job he was trying to perform, balancing the risk of chastisement from the Madras Government, the needs of the *ryot*, and the efficient running of his gins to honour his commitment to the Court's order. Although the crop was poor, and prices should have been high, the merchants would not pay above what they had contracted for at the outset of the season. The *ryots*, however, were in desperate need of money to pay their 'kist' and the costs required to start cultivation for the following year. Wight could have held out and waited for others to pay the high prices but this:

> seemed objectionable in every point of view [and] I preferred paying such prices as the lightness of the crops seemed fairly to demand. By this we lost a little, but hundreds of ryots, and, I believe, the revenue, were saved from serious injury and loss. All parties seem to have benefited by this arrangement; the ryots obtained better prices than the merchants could, as a speculation, have ventured to give; we were brought into immediate contact with them, and have ever since purchased cheaper than we could have done at second hand from petty merchants and middlemen.[143]

It was at this point (February 1847) that the Manchester Commercial Association, at the Court's invitation, offered their advice on the Coimbatore cotton experiment.[144] They praised the 'great superiority' of Wight's New Orleans cotton 'over any other of that description hitherto grown in India', but put a spanner in the works by asking that the Court's order for 5000 bales should all be of this sort, rather than the previously requested saw-ginned oopum. This was undoubtedly a tall order given Wight's actual rates of production on his own farms and lack of success in getting the *ryots* to grow it in significant quantity! Manchester also suggested that the (perceived) success of the 1845–6 crop had been due to earlier sowing, and by analogy with the plant's native growth conditions in the 'low lands of tropical Mexico', suggested even earlier sowing, in May, to take advantage of the sw monsoon. Lastly it was suggested that the staple might be improved by growing in conditions closer to that in the plant's native habitat, on lower land and nearer the coast.

Wight received a copy of the Manchester letter in April 1847 and responded to the effect that most of the recommendations had either been tried or were not possible.[145] Earlier sowing, in particular, had been tried but failed. Sowing time was largely determined by climate: it was physically impossible even to start ploughing until the ground had been softened with the onset of the rains, which did not start until mid-May at the earliest. After this Wight believed it essential to have a period of 4–6 weeks of resting, and reploughing two or three times, to clean the land and act as a substitute for manuring, before sowing, which was not possible therefore before mid-July. This meant that flowering coincided with the onset of the NE monsoon in October, which renewed the plants, and picking took place in the dry season from January onwards. On the question of staple Wight was aware of the problems; he knew that the staple of oopum grown on (wet) black soils was silkier than when grown on red. American grew better on red, so by analogy with the native he had tried growing it on lower lying alluvium to improve the staple, but this had not worked. Wight agreed that it was worth trying coastal sites, and would try to get Finnie (see below) to carry out this experiment on the east coast, but thought it would not be possible to obtain any land nearer than 60 or 70 miles from the west coast. This was formalised into a request to the Madras Government for new farms, one on each coast,[146] but nothing appears to have come of this.

Season 1847–8

This season Sherman was farming three farms at the villages of Topinpollium, Kenathkovadoo and Palatchee,[147] amounting to 'above 500 acres'.[148] Things started well, with copious rains in April,

which allowed sowing at the end of June and early July, with one field sown as early as May as an experiment.[149] The crops did well until October, but this year the trouble came from a heavy N E monsoon, which 'never ceased for three days together, until nearly the end of December' so that a large part of the harvest was 'altogether lost' and much of the rest damaged. So, once again, despite initial favourable prospects the outcome was disappointing, only 105 bales 'scarcely one-fourth of what we should have had, had the season been such as 1845–46'.[150] This, however, can refer only to the New Orleans grown on Wight's farms, as the produce from this year, consisting mainly of oopum purchased from the *ryots* and saw-ginned, amounted to 871 bales exported from Cochin on the 'Ganges', which arrived in England in January 1849. The Manchester Commercial Association was thrilled with this mixed cargo 'altogether the largest consignment of cottons from the Coimbatore district ever received by the Association',[151] which sold for £5093 16s 4d.[152]

In August 1847 Tweeddale must have received the reply to his questioning of the future of the experiments.[153] Although at this point the Court had not yet received the reply to their question about the cost of the experiments up to April 1847,[154] they expressed strong support for Wight: his reports were 'very encouraging', and the prices realised for the produce in England 'satisfactory', they were therefore:

> unwilling to sanction any measure likely to impede that officer's [Wight's] attempts to improve the quality of the cotton of Coimbatore, or to prevent the further progress and probable success of the experiment which may be anticipated from the experience which he has acquired.[155]

It is doubtful if this was what Tweeddale wanted to hear, but at this point things were ticking over at Coimbatore, the Americans gone, Sherman at Ootakalmund in closer touch with *ryots* (of which Tweeddale presumably approved) and Wight (or rather Petrie) purchasing and ginning away to meet the Court's order. The scale of the ginning operations was enormous, and in January 1848 Wroughton commented on the effect of the 'vast transactions that are carried on for Government in this staple [oopum] on the part of the Superintendent of the experimental farms'.[156] 300 bales of oopum had been sent home in 1846–7, and in 1847–8 R.N. Cuxton, by now Wight's second assistant, had purchased enough for 647 bales (at a cost of Rs 24,239).[157] At this rate it is hard to see how they could ever meet the order for oopum, let alone for the American cotton requested by Manchester.

Partly, no doubt, to try to meet the Manchester request, Wight now, in June 1847, had the idea of encouraging the *ryots* to grow American cotton by asking the Collector (Wroughton) to give a 25% remission on the land assessment for ground devoted to its cultivation.[158] This was a fraught question, going against a basic principle of ryotwary, that assessment of the land should not alter with the crops grown. Wroughton pointed out that, in any case, this method had already been tried in 1833, but had been unsuccessful even though the remission then allowed was 50%.[159] As a Collector Wroughton was not surprisingly against the 'mischief' of tampering with 'long-standing survey-settlement' and suggested that the same result could be obtained by offering to pay 25% more for the American cotton produced. When the request was submitted to the Madras Government, Tweeddale agreed with Wight that reduction of assessment (and the small loss of revenue this would entail) would

be a more effective economic means of encouragement than raising the price paid for the produce, and when he sought the Court's approval actually asked for a 50% remission.[160]

The bees in Tweeddale's bonnet were buzzing ever more busily and he wrote two more minutes before leaving Madras strongly antagonistic to Wight's efforts. The first of these of 3 September 1847 attacked Wight's confident prediction that reduction of assessment on land devoted to American cotton would result in Indian-grown product being more profitable in Britain than American-grown.[161] This was (probably correctly) dismissed as 'mere opinion, for which there do not now exist data upon which a practical farmer or merchant would rely for a moment; the fact has not been tested by anything yet done'. The attack grew stronger and more personal:

> 10. Dr. Wight's own experimental farm, and the failure of his crops, have only demonstrated this, that American cotton cannot be grown at all with profit, and with the certainty of success, excepting in particular localities, which have the advantages of the two monsoons …
> 14. … the sooner the Government relinquishes all experimental farms, and its official agency for the purpose of raising cotton and other raw produce, the better. I do not think that any adequate trial can be made … until private capital and private enterprise are embarked in the experiment … [which will not be] so long as Government occupies itself with the experiments in the mode at present adopted.
> 15. One-half of the sums now expended, if offered as a bonus to private enterprise, in the form perhaps of bounties or advances on favourable terms … I should suppose, have brought the question to issue ere this.
> 16. Nor do I think it ever can be settled by the present system of a Government farm superintended by men not practical agriculturists, and unable therefore to direct the labour of those under them; – using Government capital and commissariat cattle – of a size and power which the cultivator cannot command at any price; – and who have no direct interest in the success of the experiment, nor in limiting the expenses.[162] The sooner therefore the present system is abandoned, and private adventure and effort encouraged in substitution of it, the better, in my judgement.[163]

As if to make these criticisms even more pointedly directed against Wight, Tweeddale specifically excluded Finnie and (the by now dead) Morris from such remarks. The final minute of 11 December was along the same lines,[164] but developed Tweeddale's alternative scheme, and included a long quote from his paragon Finnie. Tweeddale was by this time not even prepared to allow Wight's scientific expertise unreservedly, referring to 'any acquirements which Dr. Wight … may possess' as a botanist.[165]

The Marquess's final action in the cotton experiment was a formal request sent to the Court in January 1848 for a 50% remission, and that the 'experimental cotton farm at present maintained at Coimbatore' [sic, but presumably including Ootakalmund] 'be relinquished for an agency confined to practical planters', 'as proposed by the majority [presumably of the Governor's Council]'.[166] The Court's reply to this (dated 4 July 1848) cannot have been received in Madras until into the following administration, and made no reference to the venomous aspects of Tweeddale's minutes, merely refusing the 50% remission, not only on principle,[167] but because they thought Wight's existing permission to purchase American cotton at remunerating prices should form an adequate incentive.[168] The Court did, however, approve the abolishing of the 'Coimbatore farm', its objectives having been 'fully attained'.[169]

Not everything was black for Wight in 1847, for it was in June of this year that he received a substantial pay rise. He had not done the prescribed two years in military service after being promoted to Surgeon and was therefore ineligible to the next rank up, Superintending Surgeon, but because he was undertaking special duties 'for which he possesses peculiar qualifications, and which it is desirable that he should continue to discharge', the Court reasonably allowed him the higher salary he had sought, which therefore went up from Rs 1239 to Rs 1540 per month.[170] Less pleasant for Wight must have been the loss of James Petrie, the highly effective engineer and supervisor of ginning operations, who had to leave Coimbatore due to ill health in July 1847.

Events in London

The British Government took a deep interest in the Indian cotton experiments, and on 7 February 1848 appointed a Parliamentary Select Committee to look into the question. This Committee had been formed under pressure from John Bright, radical M P and member of the Manchester Chamber of Commerce, who was concerned about the supply of Indian cotton as a result of the poor American crops of 1845 and 1846.[171] The Committee, which reported in July, received evidence from three people well known to Wight: J.F. Royle, James Petrie, recently retired from Coimbatore, and John Sullivan, one time Collector of Coimbatore and later a member of the Madras Revenue Board.[172] The Report is a fascinating document in which, from the questions asked of the witnesses, can be detected implicit criticism of E I C policy, on matters such as methods and levels of land assessment, and lack of investment in infrastructure. In fact neither Petrie nor Sullivan thought the levels of assessment to be a problem in Madras, but it led to a wonderful statement from the latter:

> our system acts very much like a sponge, drawing up all the good things from the banks of the Ganges, and squeezing them down on the banks of the Thames. I think the people of India have to complain of the niggardly amount which is expended in roads and other useful public works, and of the more niggardly way in which native public servants are rewarded ... beyond all other things, what the people have to complain of is, that they have no voice whatever in imposing the taxes which they are called upon to pay; no voice in framing the laws which they are bound to obey; no real share in the administration of their own country, and that they are denied those rights from the insolent and insulting pretext that they are wanting in mental and moral qualifications for the discharge of such duties.[173]

In another place Sullivan seems to condone the 'corruption' on the part of native revenue assistants that allowed the retention of at least some wealth within India. It was in the *ryots*' and native revenue collectors' interests to keep as much money in India, but although

> The Government suffers from such frauds ... the country benefits; less money goes into the public coffers, more remains in the pockets of the people; and that tends very much to the prosperity of the country.[174]

Although such sympathy for the *ryot* occurs in many places in the 1848 Report, ultimately the over-riding concern was for 'a large and regular supply of Cotton' for Manchester, and using India as a way of 'lessening the fluctuations in the market ... which have acted so injuriously on the energies of *our* [emphasis added] manufacturing population'. The conclusion was that this could best be ensured by

having British merchants based in India, advancing money to the *ryots* and purchasing the crop thereby cutting out Indian middlemen. The Report, however, was so full of the conflicting evidence that 'for many years both friends and foes of the Company drew selectively on it'. The radical Bright was disappointed and thought it 'a very milk and water thing', and continued to press for reforms in India.[175] However, the timing of the Report was certainly opportune for Wight and must have been considered by the Court of Directors before they sent their reply to Tweeddale's minute.

BRAZENING IT OUT UNDER POTTINGER · 1848–53

Sir Henry Pottinger [fig.31] took over from Tweeddale as Governor in April 1848. The two were from very different backgrounds, and though Pottinger brought with him quite different experience, he took an equally deep and personal interest in the Cotton Experiment as had Tweeddale. Pottinger was a throw back to an earlier type of Indian administrator, having joined the Bombay Army at the age of 15, but shown linguistic and administrative talent, and acted as assistant to Mountstuart Elphinstone in Poona in 1821. From this Pottinger had gone on to greater things: he was the first Governor of Hong Kong, though returned to India from a short, but disastrous, time in the Cape Colony. Despite his impressive administrative *curriculum vitae*, Pottinger could also claim a little practical horticultural experience, including the cultivation of pampelmousse in his garden at Bhuj (Kutch), where he had been Resident in 1825.

At the point Pottinger arrived in Madras its Government was still awaiting a reply to Tweeddale's query about the future of the Cotton Experiment. Although the reply (with its recommendation to relinquish the Coimbatore farm) must have arrived in September 1848 Pottinger wanted to 'look again narrowly into the whole question'.[176] In the meanwhile Wight was allowed to carry on as normal, but was asked for a report, which he duly submitted in January 1849.[177] In this particularly confusing and badly written document Wight apologised for the fact that mistakes had been 'pursued for several years', and admitted that 'our agricultural proceedings failed us as compared with the native practice'.[178]

Climate in India and Mexico vis à vis Sowing Times

One of the questions discussed in Wight's 1849 report was the question of optimal sowing time in India as compared with conditions in the American plant's 'original' home in Mexico and the Southern States. This had been first raised in the letter from Manchester,[179] which led Wight to think once again about issues of climate and sowing times, and to gather comparative climatic data. In the summer of 1847 this resulted in a paper for the Agricultural and Horticultural Society of India in which Wight stated that his deliberations had led to stating a 'self-evident truism': based on the purely pragmatic consideration of the timing of the monsoon the secret to aim for was 'a growing season of from twelve to fourteen weeks ... between the date of sowing and expected conclusion of the monsoon'.[180] For Coimbatore this meant sowing in July; for the east coast the last week of August and all of September; and for the west coast (subject only to the s w monsoon) the last week of May and the whole of June.

Theory now entered, and confused, the picture – the result of a correspondence with James Lees in Manchester, and a consideration of growing conditions in the plant's native habitat. The south-

ern states of America were (just) extra-tropical, and the American Planters, assuming the plant to come from the 'high and cool table-land of Mexico', had considered most of India as too hot for the plant except at the coolest time of year, but Lees pointed out that the part of Mexico where the plant originated was in reality the truly tropical 'Tierras Calientas', where it started growth at the beginning of the rains in May. Lees thought that, given the similar latitudes, sowing times should be the same, corresponding in India with the sowing of the spring grain crops of cholum and cumboo, so that the growing season was during the hot months of May, June and July, even for areas that received only the N E monsoon. Lees had not neglected the question of sufficient moisture, but reckoned that cotton required less moisture than cholum, and that if the latter could grow in India unirrigated, then so could American cotton. Having already tried May-sowing unsuccessfully in an area with both monsoons, it seems extraordinary that Wight should have been made (on the basis of several dubious analogies) to think that he might have made a mistake. But he did, and drew up a Circular in March 1848,[181] asking for an experiment to be carried out over a wide area, especially those the Americans had thought most unfavourable (!), with ryots sowing some American cotton with their spring grain crops of 1848–9. The results, scarcely surprisingly, were not such as Wight's 'too sanguine hopes' had led him to anticipate.

Wight had been making detailed comparisons of climatic data from America and India, and in a confusing and particularly self-contradictory paper came to the rather astonishing conclusion that 'the cultivating season of India, so far from being too hot, is actually, if anything, too cold'.[182] In America sowing took place in spring with growth under a rising temperature from April to July, whereas in India, with traditional sowing in October, growth occurred during a period of falling temperature and at the time of ripening (January–February) the temperature was 7°F below that of the equivalent growth stage in the USA. Wight stated that his idea (as it had been with apples at Ooty) was to match the growing seasons of the two countries, and that the American spring or sowing season corresponded to September–October in India. However, it was not possible, as he had discovered, to plant in May, to match the time of rising temperature, as crops planted then were likely to be ruined by the autumn monsoon. In the end, after much spilt ink, Wight ignored the question of rising or falling temperature, and returned to his 1847 conclusion, advising the Assistant Collector at Ganjam on the Carnatic coast, subject only to the N E monsoon, to sow in September–October (which was exactly when the ryots had always sown their cotton). For his own two-monsoon farms Wight again concluded that the best time to sow was July and early August, to take advantage of the N E monsoon. After this mass of badly expressed contradictions Wight, nonetheless, considered he had deduced 'clearly established' principles, and 'simplified' practice and that:

> Under the guidance of these principles to suit particular localities it appears to me American cotton may be profitably cultivated throughout the Peninsula, excepting perhaps in the high table lands where the climate is too cold.[183]

Wight based another Circular for distribution within Madras on this comparative climatic data, with additional rainfall data for Florida and Madras, from which he concluded that lack of moisture in India was no more of a hindrance than excessive heat![184] The Circular is slightly better expressed and less contradictory than the previous effort, but Wight once again changed his mind over the best planting time in the Carnatic, which he now gave as mid-August to mid-September. What is most interesting is that here, for the first time, after seven years of experiment, from which it should have been blindingly obvious that drought was a problem, is mentioned the possibility of using irrigation to make cotton cultivation 'comparatively independent of the seasons' – as was practised in Egypt. Wight undertook an experiment on a tiny area (one acre) with a well, planting at the end of January, so that growth would take place at a period of rising temperature. By March the crop was heavy, but he later reported that it was spoiled by an early summer monsoon.[185] Slightly earlier the idea of trying irrigation, so slowly and stumblingly reached by Wight, had been reached by Captain Edward Lawford, Civil Engineer at Tanjore. Lawford irrigated a crop of plants raised from seeds supplied by Wight at Srirangam in November 1848, with the result of a good yield the following March.[186] It seems extraordinary that these efforts were so belated and so perfunctory – as would be shown in the twentieth century, the great strides forward with 'Cambodian' cotton came only with growing it as an irrigated crop.

The 1848–9 season had been proceeding as normal, as reported by Wight to the Madras Government Secretary, Sir Henry Montgomery, while on a rare visit to Madras on 11 May 1849.[187] Unknown to Wight this meeting was a final checking of facts before the announcement of the drastic measures Pottinger had already decided to enact. The crop of the 1848–9 season had been 'short', but was expected to yield 700 bales when ginning was finished later in the year. The ginned oopum ordered by the Court was still being sent home, now via Cochin, and that for the year 1848–9 sold for the enormous sum of almost £3000.[188] Wight also reported to Montgomery the operations planned for the following year, 1849–50: 500 acres of puttah land worked by the farm establishment was already ploughed in preparation for planting in July with three different sorts of American cotton (including Sea Island, evidently for the first time at Coimbatore); 200 acres to be worked by native labourers on contract using their own implements, but under Wight's supervision. For the puttah land, as before, Wight was paying the ryots the assessment rate, and half as much again in compensation. However, he was also renting about ten acres of irrigated garden land, for which he gave the ryots double the assessment in compensation. While parts of Wight's confusing report of January 1849 refer to the year 1849–50, the plans outlined in it for diminishing the extent of the Government farms appear to have been intended for 1850–1. The purpose of the latter was:

> to give extension by the natives to the culture of the exotic through the formation of a number of small farms, each of from 20 to 50 acres, to be cultivated under the direction of our native maistries, by hired labour, in hope of familiarizing all classes of cultivators with it, and satisfying them that its cultivation by their own implements is just as cheap, easy, and certain as that of the native plant, while the produce is much more valuable.[189]

If this proposed down-sizing and extension system was because Wight had seen the way the wind was blowing (and he had outlined similarly vague intentions to mollify Tweeddale in 1845), he was too late; all was about to change.

Pottinger's Minute: the Scrapping of the Farms

On 4 May 1849 Pottinger wrote a minute ordering the scrapping of the Coimbatore farms and the Tinnevelly operations (to be described below), which, while respecting contracts already made with *ryots*, was to have immediate effect.[190] This had been carefully considered, and was supported by members of the Revenue Board. It should also be remembered that Pottinger could have taken this decision upon receipt of the Court's minute of July 1848, which had allowed the enactment of Tweeddale's similar recommendation.

After re-reading all the documentation Pottinger considered that the EIC and the Madras Government had given 'the experimental farms the fairest, fullest and most liberal trial … [but] that they should be forthwith discontinued', and that their continuance would be 'calculated to do great harm to the cause which they were originally intended to promote', in giving *ryots* the idea that the Government alone had the 'means and faculty of raising American cotton, or of improving the culture and quality of the indigenous plant'. Pottinger was entirely fair in saying that while American cotton could be grown, and 'may *occasionally* [emphasis added] produce heavy and sufficiently remunerating crops', he was much more realistic than Wight in pointing out that it 'will always be attended with a chance of failure, owing to the variableness and unsuitableness of the soil and climate'. Seven years had been long enough, and the experiment had now 'merged into a mere mercantile speculation'. The causes of failure seemed to Pottinger to be connected with soil and climate, and therefore beyond human control. While he gave 'Dr Wight the highest credit for his zeal and perseverance', there is a slight sting in the tail showing Pottinger's reservations about the work, for he added, that had Wight 'done far more to demonstrate his plans *than he has done* [emphasis added]', the point had still been reached where things should be left to the *ryots*, with advice from Collectors or cotton assistants.

The orders for disbanding the Tinnevelly activities will be discussed below, but at Coimbatore Wight was to 'discharge, at once, all establishments which have hitherto been employed for the experimental farms'. Sherman, Cuxton and the East-Indian lads were to be placed under the Collector, and the gin-house at Coimbatore to be placed under the Collector and given *gratis* for the use of *ryots* at least for one year. By now confident that he had 'a perfect insight into the whole matter' Pottinger ended his minute by demurring from the opinion of the Manchester Commercial Association who claimed that not enough had been done to encourage the growth of New Orleans cotton, which they believed could be produced in India 'cheaply and profitably'. Pottinger perfectly rightly stressed the 'liberality, and deep anxiety' that the Court and the Madras Government had shown 'on all and every occasion … to advance the object in view'.[191] However, the small quantities of excellent samples had been the exception and not the rule, and that the:

> merchants of Manchester must blame themselves for any inadequacy of the future supply, unless they come forward (as has been over and over again urged upon them) and apply their own agents and capital to the task in which Government have set them an example, and pointed out (according to their own showing) so easy a course.

Wight's Riposte

Needless to say Wight was furious both at Pottinger's decision, and the now-revealed Court minute of the previous July on which the Madras Government had been sitting.[192] In particular Wight thought he had been 'severely, and I think unjustly' reflected upon over the question of payment of compensation to *ryots* for the use of their land, which Pottinger thought was acting as a deterrent to their growing American cotton on their own account.[193] Wight was also rightly upset that his interview with Montgomery had, in a sense, been a trick, and, had he been allowed an interview with the Governor, might have been able to correct what he saw as misapprehensions in the views expressed in Pottinger's minute. As most of the agricultural costs for the year 1849–50 had already been incurred Wight begged for a stay of execution until the end of the year, to give time for merchants to 'establish agencies' to take over the role of his establishment, and pointed out the devastating effect such a sudden break up would have on the *ryots*. Mention is made that a group of merchants from Manchester had been planning to take over the running of the experiment, but that this had fallen victim to a commercial crisis. This was to no avail, and the break up was set for 30 June 1849.

Season 1849–50

Wight was ordered to return to military duty, and on 14 August 1849 his services were placed 'at the disposal of His Excellency the Commander in Chief'.[194] It was doubtless at this point that Wight made up his mind:

> to quit on the ground of our Governor using me as I thought rather severely and had as a preliminary measure nearly emptied my house and expected within a week or 10 days to have left Coimbatore but intending to remain a couple of months in Madras to finish off the current volumes of my Illustrations & Icones and then bid adieu to India.[195]

However, Wight had taken the step of protesting against Pottinger's decision in 'a representation … to the Government', which was forwarded to the Court in London.[196] The Manchester Commercial Association also protested.[197] Once again, as it had in 1838, the Court came to the rescue and Wight:

> was prevented carrying my intentions into effect by the receipt of a hurried note from the Secy. to Govt. ordering me to stand fast as new orders had been received from the Court regarding my appointment. Of course I had then nothing else for it but to undo as fast as I could all that I had done towards my move; beg back the furniture &c I had sold, and now I am reseated in the old chair for the next 18 months at least.[198]

The Court's minute on Pottinger's actions, dated 5 September 1849,[199] was received in Madras by 22 October, and was everything that Wight could have hoped for – not least as it allowed the termination of the troublesome Finnie's contract. The minute was, however, firm that this really should be the last 'Government season' with its 'expensive farming operations', after which the machinery should, as Wight had suggested, be made over to some (purely notional) merchants who might come forward. Pottinger was rebuked for acting with unnecessary urgency and without reference to the Court, who had no intention of stopping Wight from purchasing cotton from the *ryots* at remunerating prices, or of cultivating 'on a small scale on account of Government'. The Court was concerned that such actions would:

> produce an impression, both in India and in England, that we are become less earnest in promoting the object, important equally to both countries, of obtaining a supply of cotton suited to the requirements of the British manufacturers.

Such was far from the case and, in particular, 'it was not our wish or intention that Dr Wight should be removed from the office of Superintendent of cotton experiments'. The Court had 'repeatedly acknowledged the value of his services in that capacity' and recently given him a pay rise, equivalent to that of Superintending Surgeon.[200] Madras was therefore to undo as much as possible of the dismantling of arrangements for the 1849–50 season, with due care being 'taken to protect the interests of those *ryots* whose lands may now or hereafter be engaged for the purpose of cotton cultivation'. But what it did, above all, was to allow Wight to 'retain the position of superintendent of cotton experiments under your presidency'. The *only* condition was that, before eventually giving up the superintendency, he be asked:

> to furnish a clear and connected account of the experimental cultivation on the Coimbatore farms and elsewhere under your presidency, with such observations as his scientific and practical knowledge may enable him to offer as to the causes of success of failure. Such a report cannot fail to be a useful document as a guide for those who may be hereafter engaged in similar undertakings.

That the Court gave no time limit for the production of the report is a sign of the trust they placed in Wight, but it effectively gave him *carte blanche* to spin it out as long as he chose. And this Wight certainly did; the 'final report' not being written until May 1852. In any case the Circular of March 1849 had already summarised most of Wight's conclusions on agricultural practice and sowing times.[201]

Wight was thus reinstated as Superintendent, with permission to continue purchasing oopum from the *ryots* and supervise its ginning, and he now also had charge of the Tinnevelly activities. He was back in Coimbatore in November, trying to salvage what he could of operations there. The fields had almost all been given back to the *ryots*, but the Collector (by now E.B. Thomas) had made agreements for at least some of these to grow American cotton. Being too late in the season for normal planting, this forced Wight to undertake more extensive experiments on irrigation than the tentative ones of the previous year. For this he rented 50 or 60 acres of garden or *nunjah* land. The intention was to try the effect of irrigation both on oopum, and all the American varieties of which Wight had seed (long-stapled Bourbon and Sea Island, and shorter-stapled Mexican [= New Orleans] and 'Petty-gulph'). The *ryots*, it should be noted, believed that irrigation was 'injurious to cotton', perhaps one reason for Wight's reluctance to try it earlier. In the letter reporting these plans to the Madras Government Wight had the effrontery (after seven years of work) to claim that the report requested by the Court '*will necessarily require some time to prepare, as I am not yet in possession of all the materials required* [emphasis added]'. And ended in characteristically optimistic mood: 'I hope to show this season, that with the aid of irrigation it is nearly as certain and perhaps as profitable as either rice or sugar' and that 'American cotton will become to this part of India what indigo is to Bengal'.

The seed was sown from mid-November to mid-December, rain fell in December and (unusually) in January, and the crop was watered two or three times, but 'the tanks ran dry, so that when most in want of it we had no water'.[202] Picking started in March but on 2 April the cloud and rain of the sw monsoon arrived. This year's results, and the way he described them, are a classic Wightian mixture of self-contradiction, optimism, and regret:

> *on the whole very satisfactory ... though* owing to the ... early setting in of the spring rains, *we lost a great part of our crop ...* we realized on different fields in the course of the season from 300 to 800 lbs. of *kupas* [seed cotton] per acre ... [and] but for the injury sustained from the early and continued rains, it is my impression the yield would not have been under 1200 to 1400 lbs. per acre.[203]

The Sea Island was a total failure, producing only 200 lbs on eight acres. Ginning activities continued, and, despite much of the cotton being damaged on the way to Liverpool from Cochin, 280 bales (35 were New Orleans, the rest oopum) sold for £1753 17s 3d.[204]

In 1849 the Manchester Commercial Association had designed and manufactured a small, hand-powered saw-gin adapted for the use of, and at a price (£3) supposedly affordable, to the Indian *ryot*.[205] Two dozen of these cottage gins had been sent to Madras on the ship 'La Belle', but received a bad report when tested by the Madras Chamber of Commerce – they damaged the staple of Bourbon, and failed to separate the wool from the seed in the case of the Tinnevelly and New Orleans varieties. At a time when the cost of a traditional churka in Coimbatore was 6–8 annas,[206] they were also far too expensive for the *ryot*. Wight, by contrast, found that the cottage gins sent to him for trial in March 1850 had worked 'exceedingly well' and asked for those still remaining in Madras.[207] There had even been three applications to purchase the machines, but whether by Indians or Europeans is not stated, though if the former Wight was allowed to sell them for Rs 25.

Season 1850–1

Another characteristic of Wight was, with the passage of years, to have second thoughts about established facts – this has been seen both over the question of sowing time, and the best site for the experiments. At one stage he even expressed the idea that he might have been too hasty in dismissing black soil as unsuitable for American cotton! So here in the year 1850–1 we find him once again doing an experiment on repeat cropping, the disastrous results of which he had first suspected in 1843, and confirmed beyond question by 1845. This time Wight resowed a cotton field, comparing it with an adjacent one that had been under rice the previous season, stating 'our past experience is unfortunately adverse to the hope of success in this trial, all our former ones having tended to show that the American cotton plant is a very exhausting one'.[208] Though no record has survived, the result may safely be guessed.

This year more *ryots* than ever before applied to Wight for American seed. At last he thought he had overcome their prejudice, which he attributed to the appearance of 'two or three European merchants in the market asking for American cotton', and the results from a small field of ⅔ acre, recently cleared from forest, that had produced 1000 lbs of seed cotton (vaunted as a yield of 1600 lbs per acre). In 1850–1 Wight distributed upwards of 10,000 lbs of seed of American cotton to local *ryots*, and as much again further afield, so cultivated only about 50 or 60 acres 'on Government account'.[209] From Thomas's Collector's statement of cotton grown in Coimbatore for Fasly 1260 (1850–1) of the total of 123, 807 acres under cotton, it can be found that only 182 was of American. However, this was perhaps the best year ever, and for once justified Wight's hopes, as these 182 acres produced 46,000 lbs, or a yield of 254 lbs per acre,[210] from which Wight produced 51 bales.[211] This was considerably better than what Wight had usually achieved, though

contrarily he reported the season as 'not by any means a particularly favourable one' and yet 'American gave them [the *ryots*] acre for acre heavier and altogether more profitable returns [than oopum]'. [212] The yield for oopum this year was 163 lbs per acre, in other words, around its usual level. [213] Purchases of oopum for ginning were still being made by Wight, but on nothing like the scale of previous years.

Wight was still experimenting with technology, this year with two prize-winning 'Mather's improved churkas' that had been sent from Calcutta. In this machine the upper roller was of steel, which, by means of a 'spur wheel and pinion', performed four revolutions for every one of the lower, and a fan of 'strong whale bone brushes' removed the wool after it had passed between the rollers. [214] Wight tested these machines in September 1850, but found them an 'utter failure', requiring too much power to drive them. Two men were unable to keep them steadily at work and could barely clean from 25 to 30 lbs of seed cotton a day, whereas an old woman or half-grown boy could easily clean 20–25 lbs per day using an *unimproved* churka. [215] Wight therefore regretted that the Agricultural and Horticultural Society of India, who had sent him the machine, had been so hasty in awarding it a prize.

The only discussion of the question of seed deterioration in Wight's papers dating from the period of the experiments occurs in this same paper, written in October 1850 and addressed to the Agricultural and Horticultural Society of India, to whom he had been sending reports and samples of seed and produce since the start of the experiment. It emerges that the original stock of American plants was still being used for seed, though now in its ninth generation since being brought out by the Planters in 1840. Despite this there appeared to be no deterioration, though Wight was clearly practising some sort of selection 'bestowing the best culture, and sowing only the seed obtained from the first quality of cotton'. [216]

At this point Wight would (had he been on active service) have become eligible for a seat on the Medical Board (with equivalent rank to a Brigadier General). It seems that Pottinger disallowed this, presumably for the same reason as in 1847, because of Wight's lack of military service. Pottinger, however, seems to have gone even further as on 3 April 1851 Wight was removed from his official military posting with the 40th Regiment, which he had held since 1838. [217] Wight again appealed to the Court, and during the period of uncertainty wrote to Lindley explaining that:

> I am so peculiarly situated at the present moment that there seems reason to apprehend that I shall feel myself under the necessity of making my bow to my honorable masters somewhat sooner than I intended, and under the impression that I have been treated with injustice as the wind up to 31 years' service! As regards the local [Madras] government I look upon that as my present position, and am only waiting the decision of the Court [of Directors] to whom I have appealed. If they confirm Sir Henry [Pottinger's] orders, then I am regularly done for & must be off come what may. However I hope for better things from them. [218]

At this point Wight was ready 'to leave India without regret, or rather I should say with pleasure, as my sojourn within the Tropics has been a long one, & I long to be among my children again & in communication with old friends'. [219] In a by now familiar pattern the Court once again took Wight's side against Pottinger. While he could not be allowed a seat on the Medical Board Wight 'ought not to be debarred

from the enjoyment of the [pecuniary] advantages which that appointment would have given him'. Beside this decision on the copy of the letter retained in London are amusing annotations by three of the Directors: E. McNaghten thought Wight 'ought not to suffer for our own convenience [when] we take him from the regular line of the service'; J.A. Moore worried that it would create an extra pension at Medical Board level, and H.H. Shank that they were making an 'extra Member of the Medical Board to superintend Cotton farms'. A similar dispensation had just been made for Alexander Gibson in Bombay, who was too busy being Conservator of Forests to undertake the qualifying medical service. [220] The Medical Board normally had only three members, the Physician General, Surgeon General, and Inspector General of Hospitals, explaining Shank's comment about the extra member – the enormous monthly salary (which included all pay and regimental allowances) was Rs 2450.

Season 1851–2

And so we reach the last season of Wight's practical activities with the Cotton Experiment. The success of American cotton in 1850–1 proved to have been a mere blip and the season of 1851–2 was 'one of the most unfavourable … for several years'. [221] Despite this Wight stuck to his belief that the *ryots* were 'becoming convinced by their own experience of the truth of what we have so long laboured in vain to satisfy them, viz., that the Exotic is a less precarious and more profitable crop than the Native cotton', and in support of this cited an atypical, but favourable, example: two adjacent fields with Exotic and Native – the first had produced 1250 lbs worth Rs 50 and was still being harvested; the second 500 lbs, worth Rs 15, had finished fruiting and been ploughed up. [222] In Wight's final report he stated that the area planted with American cotton by the *ryots* in 1851–2 was, 'unless I am greatly misinformed … 1,500 to 2,000 acres'. Sadly he *was* mistaken, and the official figures for cotton grown in Coimbatore for Fasly 1261 (1851–2) tell another, doubtless more reliable, story. American cotton was, in fact, grown on 336 acres, producing 45 candies and 17 maunds (i.e., 23, 875 lbs), which Collector Thomas worked out as a yield of 68 lbs per acre seed cotton; the yield for oopum, grown on 129, 249 acres, by contrast was 149 lbs per acre. [223]

It was during this season that Wight started closing down operations at Coimbatore. [224] All the property connected with the Government farm was sold in June 1851, with the exception of the office furniture and some cotton seed, and by August all the staff had been discharged, except for one 'writer' (i.e., clerk) who was doubtless tidying up the voluminous paperwork generated by the project. The gin house was sold to a Mr D. Campbell, who apparently died shortly afterwards. [225]

Winding Up, 1852–3

On 12 May 1852 Wight eventually wrote the final report, [226] requested by the Court in 1849. The delay was explained as from a desire to incorporate the findings of the changes of the last three years (i.e., after the giving up of the Government farms), but even yet Wight thought that it could have been delayed further 'with advantage', with 'fresh information of a useful character still coming in'. Procrastination, as ever. The document extends to 49 paragraphs and about 6000 words, and as a summary of three years' work would be inadequate, but as a review of the 11 years of the project it is frankly pitiful. It is in Wight's usual digressive style and chaotic order, and therefore incredibly difficult to read, for example to discover which information

refers to which year, where new information contradicts old, and is completely lacking in statistics. It is full of blind optimism that American cotton can be grown profitably, giving higher yields than oopum, and claimed that since 1849 'a spirit of inquiry ... [was now] abroad' among the *ryots*. In the report Wight was prepared to admit mistakes, and was by now 'quite certain' that the failure of the *ryots* to grow American cotton before 1849, despite inducements, 'had some connexion with the existence of the farms'. He also admitted that a yield of 400–500 lbs/acre of seed cotton 'may be viewed as a heavy one' and that 'our crops more frequently suffer from drought'. Wight also conceded the greater difficulty and expense of processing American seed cotton, which had to be transported to gin houses.

Embedded in the text (para. 27) was a crucial admission – that what was really needed for a rapid extension was 'a steady market and moderate competition among merchants'. Wight developed this idea in the evidence he gave to the Indian Territories Committee after returning home in 1853.[227] The problem of the 6–8 month delay in the Indian product reaching England, by which time prices might have changed, made it too risky for individual merchants, so what was needed was a joint stock company. Such a body could easily raise £20,000 from shareholders each investing £500 to £1000, which if invested in Coimbatore, Madura and Tinnevelly would be enough to allow American cotton to supersede oopum. Wight was rightly critical of the 'great and wealthy manufacturing community' of Manchester who, while 'willing enough to purchase our cotton when laid down in England ... will not incur any risk themselves by occasionally purchasing in a dear market, and consuming the article in a cheaper one'. No such Company was a remote possibility in 1852, but had it been then Wight would have 'no hesitation in affirming my belief that 20,000 acres would be cropped ... within three years from this time'. Even as things stood, signs were promising and Wight believed even this year (1852–3) the *ryots* were about to plant treble the amount of American cotton that they had the previous.[228]

Cost of the Experiment

Before describing Pottinger's incandescent response to Wight's final report it seems appropriate to give the total costs of the experiment:[229]

1840–1	Rs 9549/1/1
1841–2	Rs 28,566/6/1
1842–3	Rs 54,084/4/5
1843–4	Rs 42,042/15/11
	(less Rs 649/4/2 for sales of cotton in England):
	Rs 41,393/11/9
1844–5	Rs 36,690/1/8 (less Rs 55/4/7): Rs 36,634/13/1
1845–6	Rs 31,496/12/0 (less Rs 5558/6/5): Rs 25,938/5/7
1846–7	Rs 42,605/5/8 (less Rs 10,146/5/8): Rs 32,459/0/0
1847–8	Rs 64,846/9/10 (less Rs 2695/6/10): Rs 62,159/3/0
1848–9	Rs 76,375/6/4 (less Rs 31,933/3/7): Rs 44,442/2/9
1849–50	Rs 45,922/2/0 (less Rs 2229/15/11): Rs 43,692/2/1
1850–1	Rs 66,391/14/8 (less Rs 3692/0/0): Rs 62,699/14/8
1851–2	Rs 30,338/8/10 (less Rs 5470/6/7): Rs 24,868/2/3
1852–3	Rs 28,514/5/8 (less Rs 343/14/10): Rs 28,170/6/10
Total	**Rs 557,423/14/2 (less Rs 62,774/1/7): Rs 494,649/12/7**

This total, equivalent to about £2.5 million in today's terms, shows the extraordinary lengths to which the Company (which at this stage *was* the Indian Government) was prepared to go to prosecute these experiments, and makes a mockery of the Manchester Commercial

Association's assertions to the contrary to which Pottinger had reacted so strongly in 1849. Later on the Cotton Supply Association of Manchester would continue to make public statements doubting the sincerity of the Court's efforts. These culminated in a letter to *The Times* of 5 October 1861 with the libellous accusation that 'It is pretty well known that the Government farms did not succeed because they were not intended to succeed'. James Petrie, by this time a merchant in Liverpool, responded to this, as did Wight in an unpublished letter to the press,[230] but it was this that led Wight in his old age to revisit and review his time at Coimbtore, in order to rebut the libel.[231] Even more curiously this myth of the Court/Government's inactivity has been repeated recently. Deepak Kumar in a review of nineteenth-century Indian agriculture is incorrect, at least as regards cotton, in characterising the period 1840–70 as a 'phase of "masterly inactivity" on the part of government' in terms of agricultural development work. While Kumar is right to draw attention to the (often neglected) role of the Agri-Horticultural societies in agricultural development work during this period, it should not be forgotten that in 1840 the Court had not allowed the Calcutta-based society to supervise the American Planters, which was seen as a Government responsibility.[232] The figures quoted show how very seriously this responsibility was taken by the Government of India between 1840 and 1853, and the faith they placed in Wight in carrying this out.

Pottinger's Response

When Pottinger saw Wight's report he was, quite justifiably, livid, pointing out:

> the numerous unsupported statements and the contradictory observations which pervade this report. Dr Wight exactly seems to me to speak and write as though he had just entered on his duties, instead of having done so 10 years ago.[233]

Ridiculing Wight's optimism, including the '"spirit of inquiry ... [now] abroad"', and statements such as he '"knows he is correct"', or feels '"nearly quite certain" [that American cotton can be grown]', for which 'assuredly there is no proof for these asserted facts to be found in the arguments he has brought forward'. This was all the worse as the experiment had embraced '11 years, and involving a very large outlay of public money'. In view of admissions Wight was shortly to make (see below) Pottinger was right to be cynical about Wight's optimism for future prospects, which would be carried out by 'private individuals with whom Dr Wight has no connexion whatever'. All it proved were 'the evils arising from expensive and useless experimental farms', and, all in all, it was:

> a most meagre and unsatisfactory document, from which ... neither conclusive information as to the past, nor instructive practical hints for the future, can possibly be obtained.

The only statement that, perhaps, went too far was the accusation of personal financial motivation behind Wight's persistence. Pottinger felt 'obliged to remark' that:

> had Dr Wight considered the public interests as much as he would appear to have done his private ends, he might have discovered years ago the injury of which he was the chief supporter.

A supplementary minute by J.F. Thomas, a member of the Madras Council, agreed with Pottinger, but put a slightly more positive spin

on it, stating that Wight's work had at least proved something, 'the important fact that a Government agency prohibits private enterprise'!

Wight's Apologia

It seems almost certain that Wight did not see Pottinger's minute, which, given his sensitivity to criticism would have caused him the deepest anguish. It also appears that Wight did not see the Parliamentary Report of 1857 in which the minute was published, or he would certainly have referred to it in his cotton pamphlet of 1862. What Wight was sent were the 'Minutes of Consultation' on Pottinger's document,[234] which omit the slur and concentrate on the perceived damaging effect of the Government farms. Wight's response in July was another classic case of changing goalposts, explaining that the *real* reason that *ryots* had not grown American cotton was not the Government farms *per se*, but that they believed 'all the trouble and expense was being incurred not for their benefit, but with a view to raising their rents so soon as it was ascertained that the new Cotton could be successfully cultivated by them'. [235] Wight explained the fact that he had not expressed this earlier as that he thought it reflected badly on the integrity of the EIC and the Madras Government, or at least the *ryots*' perception of it, which might, if published, 'give persons so disposed a handle for drawing conclusions disadvantageous and most unjust towards the Indian Government'. Wight ended his final apologia with another astonishing admission, that the extension of cultivation for 1852–3 seemed 'to have received a check', as shown by a decline in requests for seed, undermining all his previously expressed optimistic projections. The reason for this picks up on the comments referred to above on the need for markets for *ryot*-grown produce. After the death of Mr Campbell, there had been only one merchant prepared to buy American cotton from the *ryots*, and because the price had dropped in Liverpool, he had offered them only Rs 16–17 per candy. Wight feeling sorry for them, and not wanting to undermine the good faith that had been so painstakingly achieved, had come to the rescue, which was possible because the Court's allowing him to purchase at Rs 20 had never been revoked. But this dramatically showed that cultivation of American cotton by the *ryots* was *not* profitable, unless the price in Liverpool was favourable – a matter utterly outwith their control. The conclusion was that the Government was therefore 'premature in withdrawing [its] support'.

THE FINNIE STORY: ACTIVITIES AT TINNEVELLY

Wight had been rid of the last of his original batch of troublesome American Planters in October 1845, but at this point Thomas James Finnie, one of the Planters originally assigned to Bengal, was sent to Madras as a replacement for Simpson. The story of Finnie deserves to be told fully, as he emerges from the reams of documents that he either wrote or generated as a colourful character,[236] and provides virtually the only humour, if unintended, in the arid annals of the Cotton Experiment. Finnie's area of operation, from October 1845 to October 1849, was in the Tinnevelly and Madura districts and, as he reported directly to the Madras Government, with only an advisory input from Wight, it is appropriate to give only a summary of his work here – for the light it sheds on the attitudes of Wight, Tweeddale and Pottinger, on the Cotton Experiments, and for some vitriolic quotes to leaven this heavy chapter.

It is important to realise that, before coming to Madras, Finnie had already been working in Bengal for five years, and so brought with him strongly held preconceptions on the aims of the experiment and how these were best achieved.[237] He believed that 'we have experimentalized long enough … [and that] keeping up large and expensive establishments is not the best mode of inducing the people to follow our example', and that Wight could 'know but little practically'.[238] As is obvious these preconceptions were almost directly opposed to Wight's views, but met an appreciative audience in the person of Lord Tweeddale, who by the time Finnie arrived was also convinced of the uselessness of Government farms, and that the experiments should be in the hands of 'practical men, like Messrs. Finnie … [who] are the best, if not the only, agents calculated to carry out … the improvement and extension of the cotton trade of Southern India'.[239] Even had this not been the case, Tweeddale might well have been persuaded by the colourful and rhetorical style of Finnie's written communications (seasoned with a sprinkling of Hindi words to add authenticity), that form such a contrast with Wight's turgid effusions. Colourful as these are Finnie's writings are every bit as full of the 'tergiversations' of which he accused Wight. The very fact of Finnie's being sent to Madras was probably a tacit admission that Coimbatore was not the best place for the experiments, though by this time Wight himself was beginning to think once again of trials near the coast, which he had first recommended in 1837. In any case in choosing Tinnevelly it was a case of coming full circle, as this was where the American Planters were supposed to have been based in 1840! The ideas of Tweeddale were not, however, shared by all members of the Madras Government. For example, the Government Secretary, Henry Chamier, respected Wight's gifts and integrity and favoured his 'cooler judgement' over 'Mr Finnie's dogmatical opinions'. Chamier early on noted another significant aspect of Finnie – that 'the economy which he advocates is not intended to reach his own allowances'.[240] These allowances, which were considerable, were evidently one of many sources of irritation to Wight.

All of Finnie's prejudices are to be found in a letter written only three months after arriving at Tinnevelly.[241] The first was that his main aim was to improve Native cotton rather than to establish American. New Orleans, he wrote, would succeed only near the hills 'where it gets the benefit of the south-west monsoon'. He was prepared to try it, but 'if it succeeds [all very] well, if not, we have an indigenous article which was once celebrated in the English market; we must bring that to its pristine state'. The second was that 'to expect the adoption of the gin by the body of the people is a fallacy', due to the expense of its operation compared with the cheapness of the churka, though Finnie did admit that the gin might be used 'as an auxiliary'. The third preconception concerned economics: that the present system of the indigenous trade (purchase and export) was corrupt, the *ryot* receiving very little for his crop, being in the hands of chitties who were in turn in the hands of agents. It was these middlemen that 'eat the oyster, and he [the *ryot*] gets the shell'. To overcome this Finnie wanted to be able to act as an agent himself buying directly from the *ryots*. According to Talboys Wheeler Finnie was a man of 'sense and shrewdness' who had 'familiarized himself with the character of the Ryot'.[242] Although Finnie, on the whole, accepted the 'lazy ryot' stereotype, on occasion he could express sympathy for them, and realised (pragmatically) that if improvements were to occur the *ryot* had to see them as to his own advantage, otherwise he would consider them:

a peculiar "hickmut" of the "sahib logue", a matter in which they are not at all interested, in which they have no part; consequently, our exertions must be used among the people to induce them to apply their cheap labour to a superior mode of doing work.

As with the other Planters, Finnie came from the slave plantations of the southern states, and wrote a fascinating account of the system of cultivation used there.[243] The life of the American Planter (in contrast to the Indian one) Finnie described as one of 'incessant but pleasing labour'. The hard work, however, was undertaken by slaves for whom 'military discipline must be prescribed' and who 'receive no wages'; Finnie nostalgically recalled 'the sturdy negro's euphonious grunt' as he cleared the land of trees. Yet, despite this Finnie felt able to express sympathy for the native of India and reproach England for not having done more for those who had lifted them 'into the sunshine of prosperity', having 'deprived India of her manufactures' and not 'returned the benefit of that trade'.[244]

The complete failure of Finnie's efforts during his five Tinnevelly years, and his violent falling out with Wight, all hinge on the three issues described above, and will be discussed in turn. It appears that Finnie and Wight met only once, in the summer of 1846, in Coimbatore, when Finnie was on a reconnaissance tour and Wight was concerned about fulfilling the Court's order for 5–6000 bales of saw-ginned native cotton. Wight sent three hand-gins to Finnie, which he agreed to use to help towards meeting the Court's order. Other than this single meeting, communications were by correspondence.

Finnie's Efforts to Grow American Cotton

Having decided that it was only possible to grow American cotton in areas receiving two monsoons Finnie discovered that there were very few such localities in the Tinnevelly or Madura districts. One such was none other than Wight's old stamping ground, Courtallum, where in June 1846 Finnie persuaded some of the *ryots* to try growing some American cotton, apparently with success. Finnie painted a charming picture of this excursion, and his own powers of persuasion, writing that it was as much use trying to force the *ryots* to grow something against their will as to transplant cloves or nutmeg to the Highlands of Scotland, and that what was *not* needed were methods advocated by the:

> votaries of science … [with] their alkalis, salts, and ammonia, injected by galvanism, magnetism, or mesmerism, or some equally efficacious "ism", without reflecting for a moment upon the cost of these.[245]

The second season, 1846–7, Finnie again planted some New Orleans at Courtallum, but, to show willing, also tried some at Sevacausey (now Sivakasi) in the plains. All of the latter died of drought, with the exception of a single field that, significantly, an enterprising *ryot* had irrigated.[246] For the third year Finnie planned setting up a model cotton farm of 50–100 acres at Courtallum on Government land, but cultivated by *ryots* using their own implements.[247] However, this attempt was only half-hearted – the summer monsoon was missed, and planting did not take place until September. Courtallum is a beautiful spot, and climatically much more pleasant than the torrid plains of Tinnevelly, so Wight's accusation that Finnie spent too much of his time at the former is entirely believable.[248] Finnie once again made a token show of planting New Orleans in the lowlands, distributing seed to *ryots* in

three villages around Sevacausey and Aroopoocottah (now Aruppukkottai), some of which they cultivated in the traditional manner, inter-sown with grain crops, though some was grown on its own, and some mixed with Native cotton. Wight not unreasonably criticised this hands-off approach and made the accusation that 'so long as you stand aloof as a mere looker on you do not fulfil the obligations you have come under … as an American cotton planter'.[249] Finnie had justified the mixed planting of Native and American on the grounds that it might lead to the formation of hybrids, but Wight pointed out that this was 'at variance with the laws of nature', and, even if possible, would benefit only the native variety.[250] For the year 1848–9 Finnie decided to leave the 'oasis' of Courtallum, 'however agreeable the climate', and its cultivation to a native superintendent. 'Borne along the stream' of the 'floodtide in favour of the success of American cotton … emanating from the scientific world, and even the House of Commons', and against his better judgement, Finnie asked for a Government farm for American cotton at Aroopoocottah and Sevacausey.[251] No reply was received to this proposal, but this year Finnie had succeeded in getting some fifty *ryots*, whose names he listed, to grow small areas (between ⅛ and two chains of land) of American cotton. The results are not recorded, but in January 1849 he continued doggedly in his belief that despite his 'best attention', he could not 'give much hope of the success of the American cotton',[252] and had earlier unwisely boasted to Wight that he 'might almost undertake to *eat* all the American cotton' produced at Aroopoocottah.[253] Wight was thus probably fair when stating that, having boasted of the inevitability of failure, Finnie dare not let it succeed, as success would ruin his 'reputation as a practical planter'. Wight went further and accused the heartless Finnie of having:

> no compunction in urging poor natives to risk their little capital and labour on what you confidently pronounce a hopeless undertaking, you all the while placidly looking on doing nothing for fear of uselessly spending a few rupees of public money.[254]

Improvement of Native Cotton, and the Saw-gin versus the Churka

The second of the prejudices that Finnie appears resolutely to have prosecuted was that the main aim of the experiment was to improve the quality of Native cotton for export. He thought that the quality of cultivation could be improved somewhat (for example, by abandoning mixed cropping), but realised that there was not much to be done to improve the length of its staple. His dogged adherence to the fact that, because Tinnevelly cotton had once been highly valued in the English market, staple length could not be the prime consideration seems impossible to swallow as anything other than disingenuous. It gives just the shadow of grounds for suspicion that as Talboys Wheeler implied, his motive might have been that he did not want to run any risk of superseding American-grown cotton in the English market.[255] Whatever the truth of this Finnie put his efforts into improving the cleaning of native cotton, already convinced, given the realities of Indian labour practices, of the superiority of the churka over the saw-gin. The vast and complex correspondence on this subject is very dull, and cannot be entered into in any detail.

As already mentioned Finnie had been sent three hand-operated saw-gins by Wight in 1846, which he promised to use in order to contribute to the Court's order for 6000 bales of saw-ginned native cotton. Finnie also sold hand-gins to two local zemindars, but they found them too expensive to operate by hired labour. The same

complaints were repeatedly made by Finnie, who admitted that he did not know how to operate these machines, as they were never used in Mississippi. When James Petrie later examined Finnie's machines he discovered that the reason they were so difficult to use was that they had been tampered with! Whether this was deliberate, or merely the result of ignorance, one cannot say, but Wight doubtless inclined to the former view. The three saw-gins were set up in rented premises at Aroopoocottah, and Finnie did use them, but in addition to their slowness and expense, he was also finding difficulty in purchasing seed cotton at reasonable prices, because of competition with merchants (this area being much closer to the coastal ports than Coimbatore). The result was that only 9 bales of ginned native cotton were produced in 1846–7 and 36 in 1847–8. As early as 1846 Finnie was aware that using cattle power would improve the efficiency of ginning, and urged the purchase of some second-hand driving machinery that happened to be available in Ceylon. After enormous delays and changes of mind on the part of himself and the Madras Government this was eventually obtained, and Finnie made plans for an elaborate two-storey gin-house to be built at Sevacausey. After further delays the gin-house was eventually built in Spring 1849.

When shown the ginned cotton, the *ryots* admitted that it was cleaner than the churkaed product, but there were economic reasons for them not to attempt it themselves over and above the difference in the processing costs. It was found that brokers could get as much for dirty as for clean cotton, and that the dirty was more profitable. If the dirt was removed by ginning, then the difference in weight would have to be made up with more cotton 'and unless a much higher price could be obtained for the ginned article, they would be absolute losers by the improvement'.[256] Finnie seems to have investigated the system of native trade thoroughly, and as already described was aware of the plight of the *ryot* at the hands of the chittys and brokers, much as had been described earlier by Fischer (see p. 122):

> The chitties being monied men, make an advance to the broker; the broker advances to the ryot, and then looks sharp after him to see that he plants the land necessary to enable him to meet his engagements; otherwise the money would be spent in a big feast or wedding, or nautch (dance), or some sort of 'tumasha'.[257]

The broker, it was generally believed by the British, made his profit by adulterating the cotton. Finnie provided an extraordinary account of one such method that he claimed took place in Tinnevelly, which he called the 'devil's dust system':

> The good cotton, and ... "shocking bad" stuff, is put into little room six feet by six, which is entered by a low door about 18 inches by 2 feet. There is a little hole as a ventilator through the outer wall; two men go in with a bundle of long smooth rods in each hand, a cloth is tied over the mouth and nose to keep out the flying fibres of cotton, one man places his back so as to stop the little door completely, to prevent waste, and they both set to work and whip the cotton with their rods to mix the bad and good together so thoroughly, that a very tolerable!! article is turned out.[258]

The size of the pinch of salt that should be taken with this account is unknown – did Finnie really witness such a farrago? While Wight also cited an example of the 'roguery' of mixing good and bad cotton,[259] E.B. Thomas, at this point Collector of Tinnevelly, denied

that inferior quality cotton was the result of such 'deliberate design and system',[260] and also disputed Finnie's claim that all the best cotton went to Native States and was unavailable for export. Whatever the true state of native cleaning of cotton, Finnie pressed on with his advocacy of the churka, an instrument 'level to their [the ryots'] means of capacity', followed by hand cleaning of the wool, in order to show that it was possible to produce clean native cotton. In May 1848 (i.e., after three years) Finnie boasted of success and that:

> we have commenced a very pacific "revolution" in cotton among the democratic republicans of Hindostan!!. They are not fond of a total change, especially when unprofitable; but a little persuasive eloquence ... especially when accompanied by the consonant clink of the coin they like, will speedily bring them to compliance ... hitherto the [native cotton-cleaning houses] have been filled with rubbish and a "compound of villanous [sic] smells", and now they are clean, nicely matted. This was effected by reason, applied through the shafts of ridicule, of which the people are peculiarly sensitive.[261]

Wight was incensed by such rhetoric, and matched it with withering sarcasm – if Finnie really had been successful in persuading *ryots* suddenly to start cleaning their cotton better he must be:

> a thousand times more persuasive than was the sermon of St Peter on the day of Pentecost, the Apostles having only converted 3,000 souls [Acts 2: 41], while Mr Finnie is represented as reforming whole provinces, including a population of probably nearly half a million inhabitants.[262]

It was all very well producing a little well cleaned, churkaed, native cotton, but this was exactly what Wight thought the Cotton Experiment was *not* about, and in any case the product would never be regarded as anything other than 'Good Tinnevelly' cotton, worth in an average season 3¾ to 4½ d per lb, similar to what he had been producing, with much less labour, using the smoothly running saw-gins at Coimbatore. This opinion was confirmed by James Aspinall Turner, President of the Manchester Commercial Association: it was 'much the same as we have been in the habit of receiving for years past from Madras ... it is a perfect delusion in Mr Finnie or any one else supposing that such cottons will ever pass off to the spinners of Lancashire as a substitute for American cotton'.[263] On the use of the saw-gin, as with the growing of American cotton in India, Finnie ended as he had started, stating 'I can give no hope of its ultimate adoption by the people' and that the 'time-hallowed' churka was 'a much more efficient instrument than is generally supposed', especially if the seed cotton was threshed before being churkaed.[264]

Purchasing Cotton from the Ryots: Finnie's Agency

The last of Finnie's preconceptions, that it was necessary for him to be given power, in the form an 'agency, which will create a sure market for their improved produce, which does not now exist',[265] to purchase exportable cotton directly from the *ryots*, has been left until last. This is because, without getting into conspiracy theories, it could possibly account for Finnie's actions as described so far, though this was not a possibility considered by Talboys Wheeler.

Like many others, Finnie realised that growing cotton for export, whether Native or American, could only be undertaken by co-operative Indians. With this in mind Finnie proposed to the Madras Government that he be allowed to connect his 'official

duties with private enterprise' and set up a joint stock company of merchants called 'The Tinnevelly Cotton Agency'.[266] Tweeddale initially refused such a thing as 'not within the province of the Government', and one that should be 'left to private capital and enterprise'.[267] The ire this refusal aroused is strongly suggestive of Finnie's real motivation. He retorted that the agency was critical to his whole plan and that without it he would have 'about as much influence upon these people as the tinkling of the Jewish harp would exercise in taking a draw of wild prairie horses'.[268] At this point one recalls Finnie's original reason for going to India with Captain Bales – to achieve 'an *independence* [i.e., a financial one] for himself'.[269] It seems likely that self-interest was his primary motivation, and there is no need to ascribe any further ulterior motive. Finnie received a very generous salary from the EIC, amounting to about half of that received by Wight after 25 years of unremitting service,[270] but doubtless he wanted more, and probably didn't fully realise the strictures of Company rules. In fact, in March 1846, the Madras Government had second thoughts, later backed by the Court, that rather surprisingly allowed Finnie on an experimental basis to purchase 'cotton ginned and prepared on the American principle' from *ryots* – he was to act as a 'general agent'[271]. Even more surprisingly, this purchase was specifically *not* to be on account of Government, as this might lead the *ryots* to ask inflated prices. Despite a disingenuous claim that he would 'not wage a war of extermination upon the gin', Finnie's prejudice in favour of the churka has already been seen, and he managed to get Tweeddale to back down on the restriction of his purchasing only ginned cotton.[272] Finnie persuaded Tweeddale that the *ryots* would only gradually be brought round to use of what they considered an expensive method of processing, and he was allowed to purchase churkaed cotton, which was not only easier to obtain, but doubtless to Finnie's financial advantage.

This purchasing was another bone of contention with Wight, who as a loyal Company servant abided by its rules. As has been mentioned on several occasions, it was a strict rule of the Company not to engage in trade.[273] When Finnie pointed out that Wight himself purchased churkaed cotton, Wight replied that this was to carry out a specific order from the Court for 500 bales that could be compared with 500 bales of saw-ginned native cotton. In any case Wight threshed this wool before despatching it, in order to remove impurities normally left by the churka,[274] so in fact he was not purchasing a finally processed commodity.

The agency, however, seems to have done Finnie little good, because he soon found that he was unable to buy much cotton due to competition from Madras and Ceylon based merchants who had an established and thriving trade. Tinnevelly produced 50,000 candies of wool per year, worth £250,000,[275] which was shipped from eight Agency houses on the coast (i.e., Tuticorin), so there was never much likelihood of an incomer being able to break into such established practice. When he discovered the problems, in what amounts to a monstrous piece of cheek, Finnie asked the Madras Government if they would give him an interest-free loan of Rs 30,000 on his 'own account' to prepare and ship cotton in order to provide information for the Government on 'whether or not those now acting as agents on the spot, and possessing the same facilities that I do, by their connexion with mercantile houses, can prosecute the trade with advantage'.[276] Needless to say the request was refused.

Wight's American Conspiracy Theory

As by now must be abundantly clear Wight disagreed profoundly with Finnie's preconceptions and efforts, and accused him, with some justice, of not doing the job for which he was being paid. George Gardner, who had also fallen out with Finnie (who had made the presumption of 'poaching on my manor' over cotton in Ceylon), reported to William Hooker that Wight thought Finnie 'a most self conceited ignorant fool'.[277] That there was a racist element in this antagonism is suggested by another vituperative correspondence between Wight and Finnie. Wight had been incensed by a report in a Manchester newspaper of 17 July 1847 that two American planters who had returned to Britain had spoken to the Manchester Commercial Association to the effect that New Orleans cotton could not be grown generally in India, only in places with particular climates such as Coimbatore and Dharwar.[278] This was not the first time such an implied slur on the Cotton Experiment had been made by an American – a similar one had led to Wight's indiscretion of writing to the *Morning Chronicle*. It was clearly a point about which Wight felt strongly, having devoted five or more years of his life to proving the contrary – at least to his own satisfaction. Wight overreacted (his wife was in England, he was probably lonely, and anyone who has spent time in India knows how small aggravations can blow up out of all proportion), and in a letter to Finnie, who clearly agreed (as, more disappointingly for Wight, did the influential Royle in England), Wight told him that he intended writing to the Madras Government 'to report a "conspiracy" among the American planters to discourage the British public from perseverance in the culture of American cotton in India'.[279] That this was not self interest and worry about his own job is suggested by the fact that at this point Wight was actually thinking of retiring and joining his wife and children back in London. This led to an outburst from Finnie to the Madras Government about the 'philosophical Dr Wight'; while allowing him 'sincerity of purpose', he accused Wight of 'morbid jealousy', and painted the following wonderful image:

> Dr Wight assumes the prerogative of the gods in Homer's battles, and assails me from the clouds, and the combat is consequently unequal. Let him descend to an equal field, and we will discuss the important matter gravely; – Philosophy *v.* Common Sense.[280]

The Madras Government ignored this outburst as they had received no such letter from Wight.[281] And in the interests of fairness it is only right to point out that, on a later occasion, Finnie would admit that: 'In all points where botany is concerned, I yield with all possible deference to your [Wight's] superior knowledge'.[282] Finnie realised that Wight wanted to get rid of him, but robustly denied that there was any difference of aim 'between English or American interests'. Pottinger loftily declined to comment on this spat, and it would take another eighteen months for Wight to be free of this bumptious Southerner. As has already been seen if Pottinger had had his way both of them would have been despatched in 1849.

The End of Finnie

Despite Finnie's almost total lack of results, his contract had been extended for two years by Tweeddale in 1847, but in the end he was the casualty of Pottinger's attempt to shut down the whole Cotton Experiment in 1849. Pottinger was forced to admit that while he 'had at one time imbibed a somewhat different impression' of Wight's consistency, on re-examining the letters he found that

Wight had been consistent throughout, whereas in Finnie's he noted 'various discrepancies and assertions which were open to refutation, and many of which he has latterly vainly, in my eyes, attempted to explain away'. While Wight's views might have been 'rather acrimoniously expressed, I can find considerable palliation for his warmth'.[283] Pottinger recommended that Finnie's contract be terminated when it expired on 16 October 1849, to which the Court agreed stating that he should place himself under the orders of the Collector of Tinnevelly, devote himself to instructing the natives 'in the practical use of the gins, presses, churkas, thrashers and other implements required in the cleaning of cotton, but that he shall not interfere with the cultivation of the plant (whether American or Indian) further than offering his advice when asked for, and that he shall desist immediately from purchasing any more cotton on behalf of Government'.[284]

Finnie left with a rhetorical flourish, to the effect that he had done his best, repeating all his opinions on the impossibility of growing American cotton, or persuading the *ryots* to use the saw-gin, and stating that the Sevacausey gin-house would remain 'a cenotaph to the judgement of those who urged its purchase, after I had ascertained that it was not required'. While doing his duty to his employers, he had:

> not confined myself to the track pointed out by pseudo-scientific theory, but have launched boldly into the broad ocean of practical utility, guided by the north star of common sense.[285]

Pottinger graciously declined to dispute this, informing Finnie that the Government appreciated his efforts and 'by no means blamed him for the non-success of the measures … to induce the *ryots* to improve the methods of picking, cleaning and preparing the cotton', such a thing not being in their interest when they could get an equal price for well or ill-cleaned cotton.[286] Talboys Wheeler, however, reported a story current in Madras thirteen years later, to the effect that Finnie's last words were not those recorded above, but 'of a very different complexion; and were to the effect that he owed it, as a duty, to his country to prove that American Cotton would not grow in Southern India, and that this latter duty was the one which he considered he had fully performed'.[287]

There is a short coda to the southern experiment, for after Wight had been reinstated in 1849 he took over responsibility for the Tinnevelly operations, which he visited for six weeks in February 1850,[288] and again in February 1852.[289] Cuxton was put in charge of the Government farm at Sevacausey where he remained until the end of the 1853–4 season.[290] The final three years of this farm showed, yet again, that American cotton could not be grown profitably on unirrigated land: in 1850–1 the yield was a mere 74½ lbs per acre. However, the same year, irrigated land gave a yield of 386 lbs per acre, and a profit of Rs 5 per acre, but this was neither 'sufficient to attract Europeans to the speculation, nor to induce the native growers to devote much land to it'.[291] In Wight's final report of May 1852 he admitted that the Sevacausey experiments were going badly and that it did 'not seem to have been a good year for instituting experiments'.[292] But when was it ever?

The Court's Winding Up

On Wight's departure from Madras in March 1853, and with the last shipment of Government grown cotton on the 'Kohinoor' in September 1853, the Government ceased any activity in the experimental growth of cotton, and shortly afterwards sent instructions to Madras confirming that all purchase of cotton from the *ryots* was to cease.[293] They doubtless did this with a clear conscience as Wight had assured them that the *ryots* had by now 'taken to the culture of American cotton on their own account'. The Madras Government had told the Court that all that was needed was 'a purchaser on the spot ready to give a fair and remunerating price to the *ryot* … [which] can only be attained by affording full scope to private enterprise', and this was now being met by the Lees family who had, rather late in the day, been sent to Tinnevelly by the Manchester Commercial Association. The Court therefore instructed the Madras Government gradually to relinquish 'all direct interference in the culture of cotton of that description [i.e., American Cotton], in the hope that it has now reached a point where it may be safely left to private enterprise'.

CONCLUSIONS OF WIGHT'S CONTEMPORARIES

The dubious outcome of the Cotton Experiment had been predicted by the likes of Sullivan, Fischer and Prinsep from the start – and were hardly surprising, given the condition of the *ryots* and lack of adequate financial incentives to grow a crop they had no use for themselves. In 1850 E.B. Thomas, Collector of Coimbatore attributed the failure of the Experiment to three causes:[294]

1. To 'the native ryot's national apathy and dislike to enter on any new and untried method, or speculation (though this, of course, will eventually yield to obvious and certain profit)'.

2. That American Cotton 'required a somewhat better soil and moister atmosphere than the common native plant'.

3. To 'the absence of a certain and home market and demand for the produce, which does not now exist'. This was the biggest obstacle, as 'the Native cultivator had neither the means nor the enterprise to grow for a distant or foreign market' and the Native cotton was better adapted for local looms and manufactures. 'It therefore remained for private European mercantile agency to create a certain and ready market'. Encouragement could be given by slight and temporary reductions on land assessment, but it was only the guarantee of a market for American Cotton that would make the difference.

Nine years after Wight left India, Talboys Wheeler's four conclusions on his work were similar, that:[295]

1. American Cotton can be grown, but the profit was questionable.

2. Indian Cotton may be improved, but only to a degree.

3. American Cotton must always command a higher price than Indian.

4. The demand for Indian Cotton must always depend on the supply of American; or, more cynically, that 'Manchester looks to India for cotton, not to supply her looms, but to keep down the price of the New Orleans staple'.

Wight had shown that American cotton could be grown, but the results were extremely unpredictable, and utterly dependent on climate – in particular when rains fell with regard to the state of the crop. This was impossible to predict accurately, so all Wight's theories about matching life cycle to climate were doomed to failure. Irrigation, would of course, have helped, but without this, it could not

be said that American yielded higher than oopum as a matter of course. It sometimes did, but oopum was much less susceptible to fluctuations, as shown in the Collector's report for Coimbatore for the years 1851 and 1852:

> 1850–1: American cotton 254 lbs per acre seed cotton (based on 181 acres); oopum 163 (123, 807 acres).[296]
>
> 1851–2: American cotton 68 lbs per acre seed cotton (336 acres); oopum 149 (129, 249 acres).[297]

Ultimately, therefore, the reasons for the failure of the experiment in which the EIC had invested so heavily were to do with finance and international trade, and to growing American cotton as an unirrigated crop.

WIGHT'S FINAL YEARS

Given the failure of the Madras Cotton Experiment, and the criticisms it has been found necessary to make of Wight's over-optimistic interpretation of his results, and the inadequacy of his final report, one has to ask why he did not retire as originally planned in 1848, or resign after the differences of opinion with Tweeddale in 1848 or Pottinger in 1849 and 1851.

Firstly, with his Scottish Enlightenment, background Wight had a deeply entrenched belief in the possibility and benefit of agricultural improvement, and an equally sincere (if, from a modern perspective, misguided) belief that the most efficient use of world resources was that India should be a producer of raw materials, and purchase back woven goods of higher quality, and at cheaper prices, than they could be produced locally. Perhaps it was these that led him to be over-optimistic when faced with variable results, and to persist long after others would have given up. Secondly, it must be stressed that Wight's economic botanical work (and his optimism) was – right to the end – strongly backed by the Court in London, who on several occasions reconfirmed his appointment (and in one case rank) against the advice of the Governments of Calcutta (1838[298]) and Madras (1848[299], 1849[300] and 1851[301]). Although Wight's reports may have been badly written, he always gave the figures so the Directors could have formed their own judgement as the Madras Government clearly did. Wight was regarded both in India and in Britain primarily as a scientific botanist, and this support from the Court suggests a deep seated belief on their part of the benefits to be derived from this approach – perhaps influenced (as they had earlier been by Sir Joseph Banks) by scientific lobbying from botanists like Hooker, Royle and Wallich. Another pressure group was the Manchester Commercial Association who obtained valuable information from the Experiment at no expense to themselves.

That Wight stood up to the (at times personal) criticisms of Tweeddale and Pottinger, does perhaps suggest a certain cussidness and desire to fight what he believed to be error in the views of those in authority, as had been the case with Lushington over a similar issue earlier in his career (1828). However, there were other personal, and what might be called 'semi-professional' reasons, to maximise his stay in India. One of these was undoubtedly to continue his great ongoing taxonomic project, for which botanists will for ever be grateful, and to which he devoted enormous amounts of time, intellectual effort and personal money. In the period 1849–53 (when Wight's cotton activities amounted to no more than ginning *ryot*-grown cotton and distributing American seed)

Wight published most of vol. 2 of the *Illustrations*, the second half of vol. 2 of the *Spicilegium*, the second half of vol. 4 and the whole of vols 5 and 6 of the *Icones*. In April 1851 Wight told Hooker that his ambition was to complete the '2000 numbers [i.e., plates of the *Icones*], on which I have set my heart'.[302] In the way that people commonly justify things to themselves, Wight doubtless believed (and posterity has concurred) that, regardless of the success or otherwise of the cotton work, his taxonomic work was for the greater good of Science, as had been acknowledged under the terms of his 1836 brief. As the Madras Government had never cancelled its subscription for 50 copies of the *Icones* and *Illustrations*, Wight must still have regarded this as at least 'semi-professional' work. In his last four years he was also undertaking a limited range of other official applied-botanical activities: his work for E.G. Balfour and the 'Madras Central Committee' – on timbers and the gathering of material to send to the Great Exhibition in 1850, and in 1852 the work on railway sleepers and the report on the Ooty garden. Finally there were personal (financial) reasons. Because he had married so late Wight needed to stay in his extremely well paid job as long as possible in order to get promotion and increase his salary yet further, in order to support his still young family. He specifically gave the need to accrue a larger pension as a reason for not retiring in 1848. Even after his final promotion in 1851, Wight had to remain for two years in order to qualify for a £500 annual pension.

POST SCRIPT: THE VINDICATION OF WIGHT?

However, at the start of this chapter it was said that, rather than being seen as a failure, Wight's work could be seen as ahead of its time. After he left India, and for the remainder of the nineteenth century, almost no cottons were grown in India but the native ('desi') species *Gossypium herbaceum* and *G. arboreum*,[303] and Wight's work was forgotten. However, with the long-delayed industrialisation of India in the late nineteenth and early twentieth centuries longer staple cottons were required for the mills of Bombay and elsewhere.[304] The great development of Indian cotton in the twentieth century, however, was largely as a result of the introduction of *G. hirsutum* race '*latifolium*', which can be seen as a vindication of Wight's belief in American cotton, though with important qualifications in terms of the varieties grown, and the use of irrigation for their cultivation.

Gossypium hirsutum race '*latifolium*' came originally from Mexico, but had been introduced to the southern states of America where, under selection for long daylength, it developed into annual forms such as the New Orleans and Upland Georgia familiar to Wight and the American Planters. From the southern states it was introduced to other parts of the world where further forms, known as 'Uplands', evolved – some of which were grown in northern India, especially the Punjab. However, it was a form taken from Mexico to Indo-China and the Philippines that eventually became important in South India. Derivatives of these were introduced into the Madras Presidency via Pondicherry in 1904 and 1905, and from their source became known as 'Cambodian' cottons. These were grown at Virudunagar (a town between Sevacausey and Aroopoocottah!) with great success when some intelligent farmers (just as one had in 1846) realised they would grow better under irrigation. Serious breeding work started in India in the 1920s and '30s, and, in a curious flashback to Wight and Finnie (though their latter day counterparts could not have known it, and one of them was Indian), there were arguments at the Indian Central Cotton Committee's first

Conference in 1937 between Joseph Hutchinson (then based at Indore) who favoured development and breeding of native cottons, and Ramanathat Ayyar, based at Coimbatore, who thought that effort should be devoted to the American 'hirsutums'. Ayyar's was to prove the more profitable line of research, especially after partition in 1947, when the Upland cottons of the Punjab were no longer available to India.[305]

The huge improvements in the post-1947 period came from selections of the Cambodian cottons, by hybridising them with Uplands from various sources, and, more recently, with *G. barbadense*, much of the work being carried out in Coimbatore.[306] The other important factors accounting for the success of the new cottons have been the use of improved pesticides and irrigation, and about 25% of today's Indian crop is irrigated. The result is that in 1996–7 improved *G. hirsutum* cultivars, and newer hybrids formed 67% of the total Indian crop.[307] Wight would surely have been pleased.

Although in some aspects outdated, much fascinating and relevant information on cotton cultivation in Madras is to be found in Balasubramaniam's 1965 monograph. Many things have changed remarkably little since Wight's time, and many of the problems he faced still exist. For example:

> the indigenous crops produce fairly reliable crops even under the most adverse conditions, but the quality of cotton is entirely dependent on the severity of conditions prevailing at the boll maturation period. It is for this reason that exotic types like Luxmi and Cambodia [i.e. American Cotton] suffer both in productivity and quality, yielding wasty, weak, irregular and low grade cotton during uncongenial years.[308]

Balasubramaniam also related an interesting story about the declining quality of Cambodian cotton before the breeding programmes of the 1920s and '30s:

> Uncontrolled and hasty expansion mostly encouraged by booms of prices and good yields during the early stages … yields … slowly coming down, the quality was getting poor, damage by pests and disease was on the increase [and] fraudulent practices in trade were affecting its good name.[309]

How history repeats itself. Some things have, however, changed since 1966, for example, the much greater use of manure (organic and inorganic) and irrigation, to say nothing of breeding and hybridization programmes. Up-to-date figures for cotton production in Tamil Nadu are provided on the IKISAN website,[310] and these would certainly be of great interest to Wight. India has the largest area devoted to cotton of any country in the world (9.1 million hectares in 2005–6) and is the fourth largest producer (18.4 million bales). Coimbatore is the third largest cotton producing district in Tamil Nadu (after Virudunagar and Madurai), where 8600 tonnes were grown on 6881 hectares (17, 202 acre), giving a yield of 212 kg per hectare (being about the same as lbs per acre, this figure is directly comparison with those of Wight's day). The crop consists mainly of long staple Madras Cambodia varieties (MCU), though with some hybrids, and grown as a winter irrigated crop, sown in August–September and harvested in January–February. A variety of *G. barbadense* called 'Suvin' is also now grown in Coimbatore. In the southern zone (Madurai and Tirunelveli), similar varieties to Coimbatore are grown, but as an irrigated summer crop, sown in February and harvested in June–July.

Cotton arguments in India today revolve around the issue of genetic modification (GM), with the promotion of a transgenic Bt cotton called Bollgard developed by the Maharashtra Hybrid Cotton Seeds Company (MAHYCO) of Mumbai. In the new dispensation of global empires the patent on Bollgard is owned by Monsanto, an American firm, which has a 27% stake in MAHYCO. The genetically modified cotton is resistant to bollworm (but not to sucking insects), and thus less dependent on insecticides, and is said to have a 40% higher yield than traditional cottons. It is therefore immensely attractive to today's *ryots*, as I found during my excursion to Tamil Nadu.[311] But at what cost in environmental terms, or in terms of thraldom to multinational companies? In view of Wight's and Talboys Wheeler's conspiracy theories on America wanting to retain their cotton monopoly, one wonders what they would have thought of this new turn of events!

GLOSSARY

BALE – Wight's cotton bales weighed 300 lbs

BANDY – bullock cart (used for transporting cotton)

BULLAH – area = 3 cawnies, equivalent to 3 13/16 acres

CANDY – weight equal to 20 maunds (i.e. 500 lbs)

CAWNIE – area equivalent to 1 5/16 acre

CHOLUM – the cereal *Sorghum bicolor*

CUMBOO – the cereal *Pennisetum glaucum*

FASLY (FUSLY) – year used for the Tamil agricultural calendar (1841–2 corresponding with f.1251). The agricultural year started on 1 May

KIST – 'the yearly land revenue in India is paid by instalments … each instalment is called a *kist*, or quota'.[312]

KUNKUR (KANKAR) – lime nodules found in lower levels of both red and black soils.[313]

KUPPAS (KUPAS) – seed cotton (i.e. seed with wool attached)

MAUND (in Madras) – weight equivalent to 25 lbs

MUNNUL – red, sandy soil

NUNJAH (NUNJIE) – irrigated fields or crops (by tank or well) (correctly *nanjai*)

PUNGEE – cotton wool after removal from seed

PUNJAH – unirrigated ('dry') fields or crops (correctly *punjai*)

PURTHEE (PARTHEE) – seed cotton (i.e. seed with wool attached). The New Orleans seed cotton yields about 30% of its weight in wool, oopum about 21%

PUTTAH – grant of land to *ryots* by Government for payment of an annual fee, 'equivalent to conferring upon him [the *ryot*] a feu'.[314]

RAGAUD (RAGUD, REGUR) – black soil. The black soils of Madras (also known to Wight as 'cursel'), which can be 4 to 8 feet deep, are 'derived from granites and gneisses containing soda-lime felspar'. The colour comes from black calcium humate. Very sticky when wet, and cracks when dry.[315]

RED SOILS – the red soils of Madras (on which American cottons are still grown) are generally 'derived from the acidic component of granites and gneisses and allied rocks of micaceous type rich in alkali felspars'. The colour comes from ferric oxides.[316]

VULLUM – area equivalent to 3⅔ acre

ZEMINDAR – 'one holding land on which he pays revenue to the Government direct, and not to any intermediate superior'.[317]

Life in Coimbatore 1842–53

In the 1840s Wight's correspondence with Sir William Hooker was infrequent, so regrettably little about his life during this period is known – other than the major 'professional' (or at least semi-professional) horticultural, taxonomic and cotton activities already described. At the time Wight was living there (1847) Richard Burton passed through Coimbatore, *en route* for the Nilgiris, and described it as:

a most unpromising looking locality it is – a straggling line of scattered houses, long bazaars, and bungalows, separated from each other by wide and desert "compounds". The country around presented a most unfavourable contrast to the fertile regions we had just quitted [Malabar] … [with a] high fierce wind raising clouds of gravelly dust from the sun-parched plain.[1]

This sounds grim, but Wight did his best to make himself comfortable by building an extremely expensive house in which to live, work and indulge his favourite hobby. 'When I came here there was nowhere for me so I had to sink £1000 off hand to build one & in doing so secured for myself a good workshop. Here I am nearly all day long from early morn till dewy midnight!' This workshop was '32 feet long by 20 wide … [and] wonderfully well filled',[2] and contained all the 'needful means and appliances for carrying my business both public and private'.[3] Unfortunately no town plans of Coimbatore from this date appear to have survived, so the location of this house is unknown, and therefore whether or not it might still survive.

Coimbatore was not only an unattractive place, it was also isolated, being 300 miles from Madras – a journey that had to be made on horseback, or by palanquin.[4] This, as has been seen, led to problems over the remote-supervision of Wight's botanical publications. Although a certain amount of travel was required for his cotton work, such as a trip to Cochin in 1847, Wight's life must have been mainly divided between Coimbatore, the various cotton farms, and Ooty, and special permission had to be obtained to visit Madras, either on 'private affairs' or 'sick certificate'. The dates of such visits are detailed in Wight's military service record,[5] and were published in the *Fort St George Gazette*, from which it appears that Wight visited Madras on only four occasions during the eleven years between 1842 and his retirement in 1853! The longest visit (on 'private affairs') was between 13 December 1843 and 15 February 1844; he was granted one month's 'leave of absence' (later extended by ten days) from 1 November 1846 to see his wife and family off to Southampton, and a month (to meet Rosa on her return from London) on 24 April 1849. The last occasion was a month-long visit from 13 June 1851. That these occasions were not to be squandered on frivolous matters is suggested by the fact that he cancelled requests for a month's leave in September 1838, and a longer period from August 1849 to January 1850.

One can only guess at the effects of such isolation, but Wight must surely have felt frustrated when he knew of friends or colleagues being in Madras, but could not get leave to visit – a journey that can now be done by train in less than eight hours. During Wight's Coimbatore period there were two occasions when distinguished botanists visited Madras. The first was in June 1844 when Nathaniel Wallich called in on his way back to Calcutta from sick leave at the Cape of Good Hope.[6] The second was Joseph Hooker's visit in January 1848 on his way to the Himalaya.[7] Hooker arrived in the most opulent style imaginable, being part of the private entourage of Lord Dalhousie (son of Wight's old Simla correspondent) on his first Subcontinental landfall as Governor-General. The Scottish (more specifically Lothian) network was powerful: the Governor of Madras who welcomed the new Governor-General was the Marquess of Tweeddale whose daughter, Susan, was Dalhousie's wife, and it seems poignant that Wight, another son of Lothian, was not there to witness the spectacle. The pomp as the party made its way to Government House would certainly have been in stark contrast to the dullness of life in provincial Coimbatore:

the troops occupied a mile and a half on both sides, first the splendid Madras cavalry, then the European, and lastly the native infantry. As we passed each, the band played the National Anthem, and they kept up the salute till all the carriages had passed. It was a gorgeous and stunning sight.[8]

The Scottish connections continued after the initial introductions, for Major Robert Garstin, Tweeddale's ADC and Resident at the court of the Nawab of Arcot, was found to have stayed in the very same lodgings in Abercromby Place as Hooker when he had lectured for the ailing Robert Graham in Edinburgh in 1845. At a dinner party Hooker talked with a surgeon who accompanied General Cubbon from Mysore, who 'knew and spoke highly of Dr Wight, as did many persons'. However, there was no question of Wight and Hooker meeting up: 300 miles were no different to 3000 in this rigid, rule-ridden society, and they had to make do with letters.[9]

FRIENDSHIP WITH CLEGHORN

A new botanical friendship dating from Wight's Coimbatore period was that with Hugh Francis Clark Cleghorn (1820–95). As noted in Chapter 1 there were connections between the Wights and the Cleghorns back in Edinburgh, and the young Hugh must have borne introductions to Wight when he went out to Madras in 1842, the year in which their 'friendly intercourse' began.[10] In fact Wight could theoretically have attended Cleghorn's baptism, for he was born in Madras on 9 August 1820 shortly after Wight had arrived there for the first time. Cleghorn's father Patrick was the 'Registrar and Prothonotary' of the Supreme Court in Madras, and the baptism took place in St George's Church (not yet a cathedral) where Wight would later be married. A memento of their first meeting

has survived and gives us the date – a copy of Wight & Arnott's *Prodromus*, which Cleghorn later somewhat gushingly inscribed:

Donum mei Wightii, amici carissimi,
Botanici meretissime, liberalissimi, ardentissimi.
Receptum Dec 1842.

As there is no record of Wight being in Madras at this time Cleghorn must have paid a call either at Coimbatore or Ooty. This friendship, like most such in India, must have been largely epistolary, as Cleghorn's medical duties in the 1840s were peripatetic. Cleghorn evidently submitted to Wight the botanical drawings made for him during his Mysore travels, including one of an *Osbeckia* that he collected and had painted in 1845, which Wight described as *O. hispidissima* in the *Icones* in 1850. Wight added identifications to other of Cleghorn's drawings, but regrettably no documents from this friendship have survived in the Cleghorn archives, though the material available (especially diaries and letters) to Cleghorn are tantalisingly apparent in his thorough and largely accurate obituary of his friend. The only other surviving memento of the friendship is a copy of Plukenet's multi-volume *Phytographia* in the RBGE library inscribed 'Dr Cleghorn with the kind regards of his friend R.W.' – probably left behind when Wight left India, forseeing no further use for these antiquated tomes back in Britain. This is not the place to enter into details of Cleghorn's important educational and forest conservation activities: a summary has been given elsewhere,[11] and he will be treated in greater detail in a projected volume dealing with his own extensive collection of botanical drawings.

BOTANICAL WORK AND HERBARIUM

In the 1840s there was a reduction in Wight's botanical work, but Gardner was unfair when he implied that this was due to demands from Rosa, and that his own visit had allowed Wight to shake 'off a little of the lethargy into which he [Wight] fell after getting married'.[12] The real reason was almost certainly the demands of the 'nymph *Gossypia*' – Wight's labours on the cotton experiment. Although there was a large hiatus in publication of the *Illustrations* between 1841 and 1848, Wight did manage to keep the *Icones* (the letterpress of which was much less demanding) going throughout this period, and he touchingly described the constraints under which he operated to a new botanical correspondent of the period, Carl Philipp von Martius in Munich. As well as on Brazilian plants, Martius was the world expert on palms, and he must have written to Wight asking for specimens of this family. Wight replied in July 1844 with a typically self-deprecating explanation of his comparatively 'puny performances':

As director of a large and complex establishment, my time and studies are broken in upon with numerous details, which, added to the enervating effects of residing twenty-two years in a tropical climate, combined with the direct influence of a high temperature on a debilitated constitution, unfits me for continuous application.[13]

In this same letter Wight stated that he had only very recently unpacked his herbarium, which had been 'for nearly three years [i.e., since leaving Madras] enclosed in packing-cases'. This herbarium included 'plants from all the four quarters of the globe, besides a few from New Holland [Australia]', though by far the majority of the specimens were Indian. Interesting practical details of his herbarium are to be found in the recommendations Wight gave the following year to McClelland for the mounting and storage of Griffith's specimens to be described in Chapter 17. Insect damage was then, as now, a major threat in tropical climates and Wight's preventative method was to apply a:

solution of corrosive sublimate [mercuric chloride] in spirits, which effectively destroys any insects, whether hatched or in ova, for should the eggs afterwards hatch, the insect is immediately poisoned. For this purpose a solution of the strength of about one and half or two drachms of camphor is added. It is applied with any sort of brush, the flowers being carefully soaked, as being most liable to attack, and the most important part of the specimen. A watery solution might answer equally well, except that it does not dry so soon, and by wetting the paper is apt to cause mouldiness.[14]

Wight's herbarium, which was almost certainly arranged in Candollean sequence, was 'adapted for travelling' – probably a reference to the size of the cupboards (Reichenbach, years later, described their 'blunt edges' testifying 'to their numerous travels'[15]) and the small sheets of mounting paper, 9 × 12 inches, that he used.[16] This portability was doubtless a hang-over from army days, and by this stage any translocation was restricted to the journey between Coimbatore and Ooty. The herbarium occupied 'twenty boxes, each three feet high within, and wide enough to contain two series, somewhat in that form with double doors for facility of access'.

During the 1840s Wight's botanical collecting was undoubtedly on a more limited scale than in the period up to 1837, but continued nonetheless with the help of Rungiah, and possibly other collectors. There are specimens in his herbarium from the lowlands around Coimbatore, such as a species of *Orobanche* that was the scourge of local tobacco fields, and which he sent to Griffith for comment.[17] Another local specimen is of the gorgeously coloured tree *Spathodea* collected at Ootakalmandapam, the site of some of the cotton farms. As usual we have nothing from Wight's own pen, but when Gardner visited in 1845 he described 'evening walks or drives' and a 'large tank near Dr Wight's House' in which grew *Vallisneria spiralis* (Book 3 fig. 8).[18] The plains were botanically dull and mainly cultivated – describing the road between Coimbatore and Mettupalayam Gardner wrote:

the road is nearly level all the way; as we passed along, I observed many plantations of cotton, tobacco, and castor oil. The hedges along the road, and between the fields, are mostly formed of *Euphorbia Antiquorum*, *tortilis*, and *Tirucalli*. Sometimes *Amyris Gileadensis* is used, and while it very much resembles the hawthorn of Europe, quite equals it as a fence.

Gardner was surprised by a *Viscum* he observed parasitising a *Euphorbia*, as Candolle had stated that mistletoes did not grow on plants that produced latex.[19] He also admired the 'splendid specimens of the Tamarind and Wild Figs' that are still handsome features of Tamil Nadu roadsides, and in particular the aerial roots of the latter.

Much more interesting than the lowlands, however, were the nearby hills. The Nilgiris have already been described, but from herbarium specimens, and notes in the *Icones*, Wight seems to have visited the more accessible Iyamally Hills and Bolumputty frequently in late 1840s and early '50s.

WIGHT AND TREES

It was while Wight was at Coimbatore that the EIC began to get concerned about forestry, the initial worry being diminishing stocks of timber (especially teak) for ship building. Changes in attitude, and the growth of concern over such matters (at least as it related to valuable timber), can be tracked in Wight's own publications. In 1836, in the Tuticoreen paper, Wight had suggested that 'trees of smaller growth' could be felled and used to fuel steam locomotives, which would, moreover, be positively beneficial in terms of opening up land for cultivation, and reducing places of refuge for 'wild beasts' or 'pestilential miasma'. However, by 1850, he was drawing attention to the 'recent fearful waste and destruction' of teak, 'without a single step being taken either to keep up the stock or preserve young trees from the ruthless hands of contractors and others licensed to cut Teak timber'. He therefore welcomed new measures 'to arrest the ruinous destruction … and it is to be hoped the [Court of] Directors will succeed in their object, as otherwise the stock in hand will soon be exhausted'.[20] By the end of the 1840s the links between deforestation and environmental effects, such as climate change and increased runoff, had also become a live issue. Bombay (mainly because of its ship-building) had been the first to act, appointing Alexander Gibson as Conservator of Forests in 1847; but action was also taken in Madras, fomented by Edward Balfour and by Wight's close friend Hugh Cleghorn, who in 1856 would be appointed as the Presidency's first Conservator of Forests. It was also at this time that another large-scale requirement for timber emerged: railway sleepers. These concerns also came within Wight's ambit of interest, if in only a small way, and the accurate botanical identification of timber samples had been one of his reasons for wanting to popularise the study of botany that led to the writing of the *Illustrations* in 1838.

Teak

In the early 1840s Henry Valentine Conolly, Collector and Magistrate of Malabar, had started his pioneering teak plantations at Nilambur.[21] One of the greatest obstacles to the establishment of such plantations was the difficulty of germinating teak seed. The seeds, which are small and surrounded by an indehiscent fruit, have an inbuilt dormancy, and the germination rate is low and sporadic, such that vast amounts of fruit must be sown to obtain a small number of seedlings. As the seed is long-lived this can be seen as an adaptation to overcome predation, but one that is irritating for the silviculturist. The mechanisms are complex, and, despite much work in Thailand, Australia and India, still not fully understood – there are physical factors such as the thick spongy mesocarp and hard woody endocarp of the fruit; a germination inhibitor seems to reside in the mesocarp; and seeds vary in the time taken to reach maturity. It became apparent that some sort of treatment was necessary to overcome dormancy and to increase the germination rate. Conolly had tried burning the fruit lightly, and his sub-conservator Graham had tried removing the mesocarp with a knife, or promoting zoological assistance from the white ant. Specialist advice on the germination problem was sought by Conolly from the French botanist George Samuel Perrottet (1793–1870) and from Wight. The original documents have not been found, but the work was quoted by Cleghorn.[22] Wight thought removal of the mesocarp a bad idea, as nature had presumably provided the thick coat for a purpose. His suggestions were based on an analogy with a similar problem in germinating cinnamon seed, and by an ecological consideration – the

environment in which germination would occur in nature. The resulting suggestion was to soak the fruits, then let them ferment in a heap covered with straw or fern, with the resulting raised temperature stimulating germination.[23] Another more dramatic suggestion was to throw the fruit into nearly boiling water (180–200°F). Wight was at pains to state that his suggestions were untried, merely 'theoretical', but he thought that heat and moisture were both necessary and would simulate conditions found in nature at the beginning of the rainy season.

It appears that both Graham and Wight were on the right track, as modern pre-treatments for teak, to improve rapid and higher rates of germination, include: baking the fruit at 80°C for 48 hours; alternate soaking and drying; physical treatments with acid, or mechanical mills. Other methods include storing the fruit for 72 hours in heat traps, or sowing four weeks before the rains.[24] Irradiation with gamma rays has also been tried.

Timber

Although the collection of wood specimens and the 'turning … to account' of timber was mentioned in paragraph 12 of Wight's 1836 brief (see p.73), a renewed interest in useful and ornamental timbers came with the need to obtain samples to send to the Great Exhibition in London. To this end committees were formed in each of the Indian Presidencies, E.G. Balfour being secretary of the one coordinating activities in Madras, the 'Madras Central Committee'. Wight, a member of a subsidiary local committee in Coimbatore, was consulted, which led to his investigating the subject with characteristic thoroughness, resulting in a 25–page booklet *Observations on the Forest Trees of Southern India*, of which an apparently unique copy survives in the library of the Tamil Nadu Archives.[25] The booklet starts with a reprint of Balfour's memorandum soliciting local information and timber samples, with instructions on how to send pieces suitable for testing strength ('bars 2¼ feet long by about 1½ inch square' – to allow for shrinkage to 2 ft by 1 inch, on which the weighting / breakage measurements were made), the notes that should be made on the habit of the tree, and a statement on the importance of sending voucher specimens to allow accurate identification. Balfour also stressed the need to record native names 'care being taken that a name belonging to one language is not written in the characters of another'.[26] Balfour spelt out other problems with vernacular names, such as local variations even between places that were geographically close. In Balfour's memorandum is to be found an extraordinary quotation from Wight on the importance of extra-terrestrial events on determining felling times for timber in India, which were said to be:

> during the wane of the moon & from the second day after full moon until the day before new. Such is the native report, & I have read of a similar opinion prevailing among foresters in Europe, but do not profess to have any personal knowledge of the subject.

Next in the booklet comes a covering letter by Wight, sent to Balfour from Coimbatore with the list of timbers that forms the main body of the work. This letter contains details of the methods used for testing the strength of the woods. From the precision of the numerical details given, such mechanical engineering projects were clearly something that appealed to Wight. The tests had been carried out at the Cotton farms by the engineer James Petrie,[27] but Wight had also consulted his orchid-growing friend from Ooty, Major Frederick

Cotton of the Madras Engineers. Despite this the technique had not yet been perfected and further work was required in order to come up with a method that might:

> become a valuable addition to an Engineer's scientific apparatus as furnishing him with the means of, at any time, ascertaining the qualities of an unknown timber … and if made use of as often as opportunities offered might … become the means of saving to the State large sums of money … in the construction of public works, by showing that almost every district possesses, within itself, timber of qualities adapted for many purposes for which teak only is considered fit, and moreover remove from numbers the stigma implied in the term "jungle wood", which attaches to nearly all except that truly excellent timber.

Here is a good example of Wight's attitude to the efficient use of local resources, and a concern for economy on the Company's part. However, it was not only the absolute weight at which the timber bars broke that was important, but the nature of the fracture. This was still the days of wooden ships and cannon, and the danger of being killed by a flying wooden splinter was considerably greater than being hit by a cannon ball! Wight pointed out that woods such as teak that break suddenly would lead to splintering, but others such as *Prosopis spicigera* that was even stronger also yielded more (i.e., was more elastic), was more 'tough and cohesive', and so would not splinter on eventual breakage.

Wight was always keen on new areas of investigation but here, as elsewhere (for example as was seen in his cotton and horticultural work), a certain diffidence is apparent, and one feels that his failing to develop a subject further was due only in part to pressures of time. He happily points things out as needing further work, but then makes excuses for not undertaking these himself – leaving open questions. The question here was that of:

> specific gravity as a test of the quality of timber. The inquiry is new to myself, and my materials too limited to admit of my entering at any length on … [its] consideration … but I anticipate some useful information from this source when investigated on a larger scale under the guidance of comprehensive views, combined with practical knowledge.

Wight revealed in this work a curious aversion to the popular use of banyans (*Ficus benghalensis*) as roadside trees. This species was:

> in truth about the worst that could be chosen, for owing to their roots spreading just below the surface, they injure the roads they are intended to shelter, while the drops from their branches are often dangerous to travellers: they moreover want the height required to give shelter to the adjoining country and lastly, when they blow down … the prostrate trunk is all but useless, only fit for the lime or brick kiln. Such trees only encumber the ground and ought, as speedily as it is possible to replace them by better, to be got rid of.

The main body of the text, the 'List of Woods procurable in Coimbatore District', includes 133 species, with local names in Roman and Tamil script, Latin names, and references to illustrations and notes on matters such as strength. The substantial appendix contains statistical tables on the results of the tests on properties such as 'modules of elasticity', the weight of a sample of one cubic inch, and breaking points of some for the timbers. There is also a list of timbers from Malabar and Ceylon provided by J. Edye, and additional notes on some of the timbers with more statistics on their

strengths by John Rohde, Civil Judge of Trichinopoly; and lastly some results of wood strengths made in Guntoor and Singapore provided by Captain S. Best.

It was this list that was the model for the first section of Gibson's *Hand-Book to the Forests of the Bombay Presidency* (1857), which Gibson described as 'a descriptive list of the forest trees of India; being a commentary on, and expansion, of the list of timber trees by Dr. Wight, of the Madras Presidency'. Wight's work also had a practical outcome in the selection of timber samples from Coimbatore sent to the Great Exhibition,[28] and which were among those that received an 'Honorable Mention' (see below).

A survival of Wight's interest in timbers is still to be found in the Kew Museum of Economic Botany. This is the 'collection of small specimens of East Indian Woods' representing 90 species accessioned on 27 May 1872, the day after Wight's death – at least 20 of which are still extant.[29] Duplicates of 49 of these were also sent to J.H. Balfour in Edinburgh (which do not survive), and to Filippo Parlatore in Florence.

THE CLIMATE QUESTION

In the introduction to Wight's *Observations* is a brief, but fascinating, section entitled 'Influence of vegetation on the climate of a country', where he wrote that:

> For some time past the opinion has been gaining ground, that the climate of a country is considerably influenced by the greater or less extent to which its surface is covered with arboreous vegetation and that the dryness of the climate of the Carnatic is, in part at least, attributable to its being so generally denuded of forest. To remedy this evil extensive planting has been authorized.

Wight is equivocal on the matter, but 'even admitting, as some suppose, the theory to be erroneous', he regarded the planting of trees as a good idea 'exclusive of the augmented fertility flowing from the retention of moisture in the soil and the shelter plantations afford … from the scorching blasts of the land winds [of the Carnatic]'. The question then was what type of tree to plant: 'should large-headed, rapid growing ones … likely to produce the speediest effect on the climate, or … those furnishing the best timber and fuel, and therefore economically most valuable to the country, to have the preference?' Wight suggested a compromise, incidentally sounding a warning against what are now termed monocultures. While valuable trees would obviously be favoured on economic grounds 'they cannot be exclusively taken, it being necessary, on the known principles of vegetable physiology, towards insuring success, that the plantations should be of a mixed character and must, to some extent, include bad as well as good, but the majority should be of the latter description'.

It was in the year of Wight's tree publication that the subject of deforestation and climate change was raised in an international context – at the British Association meeting held in Edinburgh in July and August 1850 under the presidency of Sir David Brewster. It was Wight's friend Cleghorn who was asked to chair a committee of enquiry into the matter, which reported back the following year at Ipswich.[30] Cleghorn wrote to Wight seeking his views on the matter, and part of his reply, dated Coimbatore, 3 April 1851, is quoted in the Report:

> As to the destruction of forests, it appears to me that there can be but one opinion on the subject, and that is that it is most injurious to the

welfare of any country, but especially of a tropical one, and ought on no account to be tolerated, except where the ground they occupied can be turned to better account, and even then entire denudation should be avoided. I am not yet prepared to admit that trees have the property of attracting rain-clouds, and thereby increasing the quantity of rain that falls; but there can be no doubt that they increase the retentiveness of the soil; and moreover keep it in an open absorbent state, so that in place of the rain running off a scorched and baked soil as fast as it falls to the earth, it is absorbed and gradually given out by springs. I am not prepared to go so far as to say that forests, especially on high hills, have not the effect of attracting rain-clouds, but I am quite sure that if they, to ever so small an extent, have that property, the benefit is augmented a hundred-fold by their property of maintaining an open absorbent soil.

On this ground it is that I should like to see this country extensively planted, especially on all the elevated lands, because water absorbed in elevated grounds forms springs in the low ones: you truly say that short-sighted folly has already done mischief, and the Ryots have suffered to an immense amount. This is most true, but the difficulty is to put the saddle upon the right horse. Who has done the mischief?

Within about fifty miles of the spot whence I write, a tract of country has been cleared; the result is that the inhabitants are now so much distressed for the want of water that they contemplate leaving the country, their wells being all dry. On inquiry, it does not appear that the rains have fallen below the usual average, but notwithstanding, the country has become so dry that their wells no longer provide a sufficient supply of water.

Major Cotton, from whom I have this information, attributes it to the rain running off the baked soil as fast as it falls, in place of sinking into the earth and feeding springs. The subject is now attracting attention, and doubtless before long it will be ascertained whether forest has the effect of augmenting the fall of rain, or whether it results from the increased capacity of the soil for moisture. If the former, it is to be hoped that extensive plantations will be had recourse to as a means of equalizing the monsoons; and if the latter, that it will be adopted as a means of retaining the water that falls from the clouds.[31]

This is a typically Wightian response – in its verbosity and redundancy, his caution in accepting theories, and his concern for the *ryot*. However, it certainly shows his commitment to tree planting, and its value in terms of maintaining soil quality and reducing runoff of rain water.

RAILWAYS

From the Tuticoreen paper of 1836 it was apparent that Wight was an early and enthusiastic advocate for railways, particularly for commercial purposes. In 1845 the Madras Railway Company was formed in England, which began to lay the first part of the line between Arcot and Madras in 1853 (the first sod being cut by Wight's adversary Sir Henry Pottinger). This 67 mile line was opened three years later, on 1 July 1856, so Wight missed seeing the embodiment of his foresight; the terminus for the line was at Royapuram in north Madras.[32] Moves, however, had been afoot during Wight's last Indian days, and the Court had requested information on timbers suitable for railway sleepers from the Madras Board of Revenue, which they passed on to the District Collectors. A Mr Daniel had undertaken an initial investigation and seems to have suggested that only teak would be strong enough. Doubtless this would have to have been imported and the Court was evidently keen to find cheap local

timbers as substitutes. Wight was consulted by E.B. Thomas, Collector of Coimbatore, and leapt at the opportunity to contribute to this 'new and extensive field for enquiry – the quality, namely, of Indian Timbers and their adaptation for purposes demanding both strength and durability under trying circumstances' in a letter dated 10 June 1852.[33] Wight was optimistic and believed that 'in the forests of this part of India there are several kinds of Timber of great strength and durability even in their unprepared state and which, if creosoted, would I fancy, be found equal to any that has ever been tried for such purposes'. He wished that:

> Engineers and others engaged in the construction of such works would endeavour to overcome the existing prejudices against "Jungle woods" often resting on no foundation or at least on the vaguest and most untrustworthy experience, by subjecting them to a course of experimental investigation calculated to elicit their intrinsic qualities and determine their true values.

And 'that the enquiry may be entered upon' not grudgingly, but 'con amore', and 'conducted on the most comprehensive principles'.

Although the exact properties required for sleepers were as yet unknown, Wight took these to include strength, resistance to white ants, and to rotting from water – all of which he was aware of from the sorts of wood suitable as bases for his cotton ginning machines. He selected 12 from the list prepared for the Madras Central Committee, of which he thought the best would be 'Curmurdah (*Terminalia glabra*) a wood which when well seasoned is as hard, almost, as Iron and in point of tenacity for sustaining weights exceeding teak from 15 to 20 per cent'. 22 timbers were eventually authorised in 1855 for use on the Madras Railways, which included seven of Wight's recommendations,[34] but even with creosote treatment rotting was a problem, and iron sleepers were coming into use by 1860.

THE GREAT EXHIBITION OF 1851

It was J.F. Royle in London who suggested that Wight be involved in assembling the natural products of the Madras Presidency to be sent for the 'Grand Exposition', along with Captain Ouchterlony (whom Wight had met surveying the Nilgiris in 1845) and Dr Hunter (founder of the Madras School of Art) – at this stage Royle had evidently not heard of Edward Green Balfour.[35] Royle suggested preliminary lists of materials that might be sent from each of the three Presidencies: that for Madras (excluding Malabar and Travancore) shows that it was considered to be rather poor in such materials.

MINERALS
Earths & Earthy salts: Tourmaline (Madras); Metals: Wootz Steel (Madras); Iron ore (Salem).

VEGETABLE KINGDOM
Intoxicating Drugs: Tobacco (Coimbatore); Sugar: Palmyra Sugar; Gums: Keekur and Tragacanth (Kuteera) (Madras); Fatty Oils & Vegetable Butters: Sesamum Oil, Gingelly (Madras); Illiepie Oil (*Bassia longifolia*) (Madras); Dyes: Red Saunders (*Pterocarpus santalinus*) and Red Wood (*Adenanthera pavonia*); Indigo (from *Indigofera tinctoria* and *Wrightia tinctoria*) (Madras); Clothing & Cordage Material: Spiral vessels used as lamp wicks (*Nelumbium* and *Nymphaea*) (Madras); Timber & Fancy Woods: Blackwood (*Dalbergia latifolia*) (Salem).

ANIMAL SUBSTANCES
Hoofs, Horns, &c: Ivory (Madras)

In fact, as already noted, it was Edward Balfour who chaired the Madras Central Committee set up to supply suitable material for the Exhibition, with Wight as a representative on a subsidiary local committee in Coimbatore. In May 1852, after the great event was over, Wight was one of 14 individuals in the Madras Presidency (others included Hugh Cleghorn and Walter Elliot) to be sent medals by the Commissioners of the Great Exhibition for the 'superior excellence of their contributions'.[36] The handsome bronze 'For Services' medal is still in the possession of Wight's family. This medal was initially intended for the Secretaries of the 299 Local Committees who organised the materials sent, though was eventually also given to 700 'officials representing the police, military and other local [in London] public services'.[37] Like Wight's earlier medal from the Society of Apothecaries, this one was designed by William Wyon, but Wyon did not live to see it issued and it was struck by his son. Elliot also received a prize medal for a sample of 'Cattimundoo resin' from the spurge *Euphorbia cattimandoo*, a plant he collected at Vizagapatam in the Northern Circars, which was formally described and illustrated by Wight in the *Icones* in 1853.

Quite apart from its contributions to the Great Exhibition Wight suggested that the work of the Central Committee could usefully be extended as a way of tapping existing but not widely-known knowledge (both Indian and European) about useful plants, and actively exploring the Presidency for local products. Wight appeared to think that the state of knowledge in 1850 had advanced little since his own great period of investigating such matters in 1836. Wight was also still interested in the idea of edu-cating 'youths taken from the East Indian and Native communities' and in a letter to Edward Balfour suggested that the Madras Medical School could act as a focus for obtaining information and collections, and also in the teaching of Natural History.[38] While nothing seems to have come of this idea through the Committee, Balfour developed such ideas personally, resulting in major projects such as the establishment of the Madras Museum in 1851 and publications such as his *Timber Trees*,[39] and the great *Cyclopaedia of India*.[40]

Another result of Wight's interest in plant products is to be found in the material he sent for Sir William Hooker's Museum of Economic Botany at Kew. The stimulus for this came from Queen Victoria's gift to Kew in 1847 of the former kitchen garden of Kew Palace, which included a building that had been a fruit store. This was converted by Decimus Burton and opened to the public as a museum in 1848.[41] Hooker sought donations from around the world and in 1849 Wight sent him a varied assortment of plant material including wood specimens, two wooden combs, a scale and weights, a ladle, some 'Hindoo calendars', sixteen 'Hindoo Books', '5 Packages (contents unknown)', resin and bark from *Ailanthus malabarica*, kino resin (from *Pterocarpus marsupium*), pods of *Entada*, *Cassia* and *Bignonia* and flowering spikes of *Orobanche nicotianae*, the scourge of tobacco fields near Coimbatore. None of these items appears to have survived, but two that have are a lacquer box, and 'substitutes for paper & Twine, made of the petiole of the Areca Palm & strips of Musa Paradisiaca, used in Hindostan for making up packets of Coffee, Pepper &c'.[42]

Calcutta Connections (Wallich and Griffith), and Departure from India

The three most important botanists working in India between 1834 and 1846 were Wallich, Wight and Griffith. However, after Wallich's return to India in 1832 he to all intents and purposes abandoned taxonomy,[1] his time being fully occupied with running the Calcutta Botanic Garden, economic botany, and teaching at the Calcutta Medical College. As David Arnold has fairly said 'Wallich was no grand theorizer … [his] significance was as a key figure in the patronage networks that surrounded botany in the East India Company's territories, and as a scientific entrepreneur, the man who, more than any other single individual, controlled and delivered to the West, India's vast botanical "riches".[2] Wight and Wallich had first met in London in 1831, although they had corresponded since 1826. This correspondence was extensive, as can be seen from an index of Wallich's incoming letters that survives in the library of the Calcutta Botanic Garden. This lists no fewer than 224 letters and the dates on which they were written by Wight – sometimes as many as five a month. Most were in the period 1836–42, following Wight's economic appointment, and from the mere four that have survived from Wight to Wallich, and copies of eight from Wallich to Wight, these, not surprisingly, seem mainly to have concerned economic botany, and Wallich's sending of copies of the Roxburgh *Icones* (see Book 2). When it suited him Wallich's tone in correspondence could be warm, as in the somewhat toadying ones to a plethora of aristocratic British garden owners,[3] or positively backslapping in the case of some of the letters to Robert Graham. Hooker senior, he addressed as 'My most honored and valued friend', signing himself 'ever most affectionately'. By comparison the tone with Wight was never anything other than professional (if warmly so), and one suspects that there were always temperamental differences, which would surface significantly in 1845. It is important to document the ups and downs of this relationship (which, despite paranoia on both sides, never completely failed), less for the aspects of personality these reveal, than for the important scientific issues that lay behind the 1845 episode – those of publishing botanical works in India, and the keeping of a permanent herbarium in Calcutta.[4]

It was while Wight was still in Britain that the third of the triumvirate, William Griffith [fig.34], arrived in Madras as already described (see p.56). After Wight's return from furlough in 1834 he may or may not have met with Griffith, and their friendship and botanical exchanges was undoubtedly undertaken almost entirely by correspondence. Griffith, under the patronage of the Governor General, Lord Auckland, and by strategic placements as doctor on military and diplomatic missions, was allowed the opportunity to explore the botany of a quite extraordinary geographical range from 'the banks of the Helmund and Oxus to the Straits of Malacca', with significant spells in the seat of power – Calcutta. All the time Griffith was accumulating specimens, notes and drawings, with a view to writing a 'scientific Flora' of India, but a series of papers is all that

was published before his untimely death.[6] One can only wonder how things would have turned out had Wight been given similar opportunities. In fact, given Wight's abilities, it seems surprising that he was left to languish in what was then known as the 'benighted' Presidency, and in 1838 Griffith expressed a regret that Wight had never been made 'an officer of the Supreme [Indian] Government, the most liberal Government of all to those under its immediate sway. Without flattery, the Government has undergone a serious loss in not having long ago called you to Calcutta'.[7]

Tentative approaches had in fact been made to change this state of affairs – but only on a personal level, by Wallich. In 1839 or 1840, when he first thought of retiring as Superintendent of the Calcutta Botanic Garden, Wight had apparently been sounded out as a possible successor; however, Wight told Arnott that 'he had made up his mind to decline – as he would like better to finish the Peninsular flora'.[8] In September 1845 Wallich again expressed his intention of resigning the following February, and on this occasion it finally came to pass. In a letter to J.F. Royle from this time Wallich was still hoping:

> that Dr Wight might be nominated to succeed me – or he not accepting Dr Falconer. Can there be any doubt that our friend Wight has permanent claims to the post with full allowances. I fear that he would not take it without the latter, his present income being, if I mistake not, some 1100 or 1200 Rs a month – though I speak from conjecture. It would afford me extreme gratification were old Wight appointed to succeed me with full allowances, so that I had to transfer charge into his hands.[9]

Wallich was correct about the salary Wight was by now receiving as Superintendent of the cotton experiments, but as he was actually Wallich's junior by ten years, the 'old Wight' suggests a certain condescension. Having established that Wight was not interested Wallich informed Hooker of the decision of their 'dear mutual friend' as being due not only to the salary, but to Wight's growing family and immanent 'promotion to a higher grade in the Medical line'.[10] However, it was immediately following these friendly exchanges that the heat-wave from the falling out of Wallich, Griffith and McClelland reached Coimbatore, and threatened at least to singe Wight. The fire of this enmity had been ignited during the tea mission to Assam in 1835, in which Wight was originally intended to have participated, and the flames were considerably fanned with Griffith's remodelling of the Calcutta Garden while Wallich was on sick leave at the Cape in 1842. This unfortunate episode has been widely discussed,[11] but not in terms of the Mozart-Salieri light in which it is possible to view it. For some bizarre reason (though perhaps coloured by the Hookers' not uncritical view of Griffith) social historians appear to have been unwilling fully to accept the range and depth of Griffith's botanical genius, while Wallich was in a

unique position to recognise and therefore be jealous of it. A certain piquancy must have been added by the fact that, as already noted, Griffith was supported and helped, not only by the Governor General (with whom Wallich was also on good terms), but by Robert Brown (widely recognised as the greatest botanist in the world), and John Lindley (Griffith's teacher and also an international botanical giant). It is not hard to imagine the effects of such tensions on an ill and exhausted constitution. While Wallich may have been charming and affable to Hooker and the aristocracy (especially after he had retired, and in the more temperate climate of London), the irritability of his temper had been demonstrated on a previous occasion in his hounding of John Roxburgh from the post of Nurseryman.[12]

THE DEATH OF GRIFFITH

While Wight and Gardner were happily on their way from Coimbatore to Ooty, Griffith lay dying of hepatitis on the Malay Peninsula. The end came at Malacca on 9 February 1845, and Griffith was not quite 35 years old. This was a great loss not only to 'the scientific world in general, more particularly the Indian portion of it',[13] but to Wight personally. Griffith was his closest botanical confidant, and it was almost certainly Wight who organised the subscription to raise a monument to his friend in the cathedral at Madras [fig.35].[14] Wight was keenly aware of the importance of Griffith's collections and copious unpublished manuscripts and drawings, and was concerned about their publication. In his will Griffith had bequeathed 'all my collections of Natural History and all my Manuscripts and Drawings unto the Honourable the East India Company'.[15] Being in Coimbatore (more than a thousand miles away) Wight could act only vicariously through McClelland, as the collections were in Calcutta, where they had been sent by Griffith's widow Emily. Fortunately Griffith had a powerful advocate in the person of Auckland, 'one of Mr Griffith's kindest friends while in India, and the first to appreciate rightly his eminent merits, both as a scientific man, and public servant'.[16]

McClelland had started his outstanding *Calcutta Journal of Natural History* in April 1840, which, through the 'labours of Mr Griffith', had been put into 'the first ranks of Botanical Periodicals'.[17] The intention was to devote it 'exclusively to scientific objects ... [and] the applications of these to useful purposes, mental as well as commercial ... less to afford amusement than instruction',[18] but on two occasions McClelland had used it as a vehicle to attack Wallich's running of the Calcutta Botanic Garden.[19] The *Journal* was supported by the Government, which subscribed for 50 copies, and Auckland in 1845 was cited as its 'Patron'. With the shock of Griffith's death McClelland initially decided to relinquish the *Journal*, 'in the object and support of which he [Griffith] had so large a share', but:

Fig.34a & b. William Griffith.
[a] Daguerreotype, probably taken in Calcutta, *c*.1844. Image supplied by Royal Botanic Gardens, Kew.

[b] Lithographically transferred engraving by Vandendaelen (1849), after a lithograph by Edward Morton based on this same daguerreotype.[5]

the generous and kind encouragement received from Dr. R. Wight, Superintending Surgeon, Madras Service, (distinguished no less by the extent and value of his botanical works, than the independent means and exertions with which they have been accomplished) Mr. Gardner Superintendent of the Royal Botanical Garden Ceylon, and Mr. Jameson Superintendent of the Botanic Gardens, N.W. Provinces ... and other scientific friends interested in the progress of the work ... [had induced him to reconsider and] venture on its continuance.[20]

Wight and Gardner were anxious to do what they could 'towards placing Indian Botany as nearly as we are able on a par with English ... [and that they would] be able to satisfy European Botanists that the Calcutta Journal of Natural History is the proper source to which all must apply who wish to be informed regarding the progress of Botanical Science in India'.[21]

In 1845 several significant communications from Wight about how to make best use of Griffith's botanical relics were published by McClelland in the sixth volume of his *Journal*. In these an interesting tone emerges – one that can only be described as nationalistic. This was something new, but had doubtless been growing with Wight's own increasing confidence in the possibility of botanical publishing in India – in Madras his own works and contributions to the journals of the Literary Society and Agri-Horticultural Society, and in Calcutta articles in the publications of McClelland and the Agricultural and Horticultural Society of India. Things had changed greatly since Wight's early struggles in the late 1820s, when everything had to be sent back to Hooker in Glasgow. Wight was also passionate about the question of priority of publication, and that naturalists should not be beaten in such matters from purely geographical disadvantages.

PUBLICATION OF GRIFFITH'S PAPERS

Here is the revealing advice Wight gave to McClelland in a letter from 'Ootacamond', dated 4 May 1845, in which he expressed his concerns and recommended:

> printing and publishing the whole in this country before sending a single line or drawing out of it. Once published, they are at once and for ever safe, and doubtless they will be as carefully edited here as they could be in Europe, where those of his friends who are really qualified to do them justice, and would be willing for his sake to take the trouble, have for the most part occupation enough of their own ... his papers to my mind, ought beyond all question to be first published in India, especially under the existence of a proper medium for doing so in your journal, which is very fairly supported by the public.
>
> On these grounds I am strongly of opinion that an immediate application should be made to Government for them, for the purpose of publication in the journal previous to their being sent to Europe, of course giving the assurance that the utmost care will be taken of the originals, and that no pains will be spared towards having them as correctly edited as circumstances will permit. It could at the same time be urged, as you observe, that publication here does not interfere with ultimate publication in Europe of a more perfect from, accompanied with all his already published papers; nor do I think that previous publication in the Journal would at all interfere with the sale of a complete edition of all his works, should such be afterwards published. I confess I feel most anxious for the publication of his Botanical papers in this country, under the impression that, should they ever find their way to the India House before publication, the labours of the greatest

Botanist that ever set foot in India will be lost, perhaps for ever swamped, amidst the accumulated records of hundreds of men, that are daily being added to their stores.[22]

This shows Wight's concern that the Griffithian papers should be claimed as Indian by being first published there, and his anxiety about their physical safety and the fate that might befall them in Britain (rightly so, as would be proved in the case of the herbarium specimens). The Government agreed to printing the manuscripts in McClelland's *Journal* but:

> on becoming further acquainted with the nature and extent of the papers in question, the difficulty of transcribing them accurately, as a precaution against accidents by sea, such as befell the similar papers and collections of the late Dr. Jack, will probably be disposed to sanction a preliminary publication of the whole in a separate form, which will have the effect of securing these invaluable records from all risk, and of rendering them at once available to the scientific interests of the country.

This is what happened – the manuscripts were published in five octavo volumes, and the plates in five parts (usually bound in three volumes) in small folio format, printed at various Calcutta presses between 1847 and 1854, edited by McClelland. The poor quality of the editing occasioned an outcry from J.D. Hooker, who railed against the 'persevering Scotchman, without much ability, or power of perception'.[23] However, it has been seen that when Wight recommended this method, he stressed that publication in India need only be an interim measure, and they could later be republished to higher standards in Britain. Hooker did not rise to the challenge of providing a better edition, but when the opportunity eventually arose, he valiantly did what he could to save and distribute the surviving specimens.

It should be noted that when publication in the *Journal* had been contemplated Wight had generously offered financial help: 'Should further funds be wanted, I shall gladly help to the extent of 500 rupees in successive portions, or in getting his drawings printed'.[24] The latter suggesting that Wight may at one point have considered printing the drawings in his own *Icones*, as he had done in the case of the unpublished Roxburgh Icones.

GRIFFITH'S SPECIMENS

Wight was equally concerned about the fate of Griffith's dried and pickled specimens, and wrote McClelland detailed advice on how to mount and store the herbarium specimens and preserve them from the ravages of insects:

> For the same reasons that it would be wrong to send home his papers uncopied, I think it would be equally wrong to send his collections in mass.
>
> A complete set of his specimens ought, I think, to be retained for India ... [this selection need not be made by a botanist, but by someone careful to separate duplicates and able to copy] whatever remarks or labels might be attached to the original specimens, so as to make the set kept back for India, as nearly a facsimile of the other as possible ... both with a view to guard against accidents, and to preserve to India a lasting and proud memorial of the most Herculean labours of one of the most philosophical and industrious men that ever traversed its soil for the purposed of investigating its natural products.[25]

Wight offered his services to help with the preservation of the specimens, and glueing them down and arranging them into natural orders and genera, so that thus prepared 'they might then be deposited among the Garden collections for the benefit of all future Indian Botanists who might wish to consult them'.[26] Although Wight can never have seen Griffith's herbarium he knew that it was:

> grouped into natural orders following Lindley's arrangement. These groups should be most carefully preserved, enclosed in wrapper sheets (the specimens are put on half sheets) each marked on the left hand corner with the name and number of the order as given in Lindley, and finally arranged in boxes according to the numerical series, which greatly facilitates consultation, and the number at once points out the proper place of each packet in the series.
>
> I have been thus particular on the supposition that you [McClelland], not being a Botanist, might never have had an opportunity of studying the economy of a Herbarium. My own herbarium occupies twenty boxes, each three feet high within … [but] it would be more economical to make the box six feet high at once … [as it] would be a standing one never to be moved. The location of such a collection is of some moment; I would suggest that it form an appendage of the Medical College.
>
> *If sent to the Garden, it might chance some few years hence to suffer the fate of Roxburgh's, which would be bad indeed.*[27]

It was this last innocuous sentence that led to unimaginable trouble. Wight evidently regretted it and wrote a personal letter to Wallich apologising in case he might have read it as a personal accusation, an 'injustice, which I am sure I never intended'. Such an accusation could hardly have been read into the sentence alone, and suggests a guilty conscience on the part of Wight, who had been stirred up by McClelland, and knew that Wallich:

> had been writing in a way most derogatory to his own dignity in the matter of the publication of Griffith's papers which I am sorry for, as supposing my accounts true he may have lowered himself greatly in the estimation of right judging men.[28]

Wallich claimed not even to have seen the article in a journal he thought had so systematically attacked him, so Wight's (superfluous) apology and the storm in a teacup it provoked seem doubly unfortunate. Wight, however, made matters even worse by sending Wallich a letter for forwarding to McClelland for publication, which, while paying tribute to Wallich's achievement 'towards making the treasures of [India's] Flora known to the scientific world', accused him of mistaken judgement in the matter of the distribution and 'neglecting to preserve a complete set of specimens for India', especially a set of Roxburgh's specimens. Doubtless Wight thought he was being transparent in sending this letter via Wallich, giving him a chance to read it before passing it on to McClelland. As it happens Wight was quite wrong in assuming that Roxburgh material had been included in the material Wallich took home and distributed in 1828 and McClelland seems to have used Wight's letter as another stick with which to beat Wallich. He could easily have edited it into an unreserved apology to Wallich on Wight's behalf; instead, McClelland added a list of the recipients of the EIC herbarium duplicates, and the families of which they had promised to publish accounts. This supplement is sarcastic in tone, and, as most of the named botanists had failed to deliver the goods,[29] the intention was clearly to show that Wallich's reasoning over the distribution had

been faulty, and had 'tied the hands of the Botanist in India'.

Wallich wrote to Hooker expressing his hurt over the incident, enclosing copies of the correspondence, and of the letter he had written Wight explaining that there had been no Roxburgh material at Calcutta to take back to Britain:

> The atrocious act I have committed in regard to the Compy's herbaria – especially Dr Roxburgh's! Your own testimonials, Dr Wight's (in the Preface to his & Arnott's Prodr. Florae Penins.) – the testimonials loud and strong of fifty other botanists go for nought with Mr McC. That for which my humble name was applauded by all – and is still perhaps everywhere except by the Freres ignorantius, is now held up to the reprobation of that class. It is true Mr McC is only heard by an admiring multitude of his like. Still must I for ever be thus treated?[30]

The question of keeping important collections of specimens and their related drawings in what could be called a 'national' herbarium in India is an important one. Such issues had proved contentious on previous occasions, notably in the case of Buchanan's and Roxburgh's drawings, which the Company (or Governor General) insisted be kept in Calcutta.[31] The story of Wallich's taking home and distribution of the Calcutta herbarium collections between 1828 and 1832 has already been described (p.45). Despite Wallich's completely justified view on the difficulty of keeping herbarium specimens in the climate of Bengal it must, in fairness, be stressed that he did start to assemble an herbarium at the Garden after his return in 1832,[32] and as already noted had unsuccessfully requested a set of the EIC specimens from the Linnean Society. While Griffith had charge of the Calcutta Garden 1842–4 he found the herbarium collections, like the garden itself,[33] in a mess and almost certainly they

Fig.35. Monument to William Griffith, St George's Cathedral, Madras.

were not available for consultation. Griffith added to these collections and wanted to make them a 'public herbarium', which he intended housing on the top floor of the Superintendent's house.[34] As Wight never visited Calcutta it is unclear what Wight knew of the herbarium, and it is odd that in one place he suggested adding the Griffith specimens to the Garden collections, and in another that the Medical College would be a more appropriate place. As Wallich taught in the latter, this cannot be seen as another 'dig', and could have been either for the pragmatic reason that the College was more centrally situated in Calcutta than the Garden, or that Wight saw the greatest educational benefit of the herbarium as for medical students, rather than garden visitors.

That one of Griffith's sets of specimens was indeed kept in Calcutta is shown by Thomson's listing of the Garden's herbaria in 1857, though these seem to have been far from complete:

> the triplicates remained with Dr. M'Clelland during the time that he was occupied in the publication of Mr Griffith's posthumous papers, and were transferred by him to my charge in 1856.[35]

The other two sets were sent to East India House in London. The story of the priceless botanical collections that had for years been accumulating in the cellars of this institution makes for dismal reading.[36] And this despite the fact that the Superintendent of its Museum, Thomas Horsfield, had serious botanical interests, and that since 1838 the 'flatulent' (J.D. Hooker's epithet) J.F. Royle had been employed there as 'Correspondent relating to the Vegetable Productions of India', with at least partial responsibility for the plant collections. The more important of these collections, in addition to Griffith's 12,000 were those of Hugh Falconer (4–5000) from the Western Himalaya, the German Johann Wilhelm Helfer from Tennasserim (Burma – 600) and the Dane Theodore Cantor from China (200);[37] to these, in 1858, were added the collections of the Schlagintweit brothers. The neglect is even more scandalous when the human price paid for these collections is considered – Griffith died of hepatitis at the age of 34; Helfer was murdered, aged 30, by 'savages' on the Andaman Islands; Adolf von Schlagintweit was beheaded by religious fanatics in Kashgar at the age of 28. Royle was under instructions from the EIC to distribute these specimens, but had done very little, being more concerned with economic botany and, from 1849, with preparations for the Great Exhibition. However, J.D. Hooker and Thomas Thomson (who returned from their Himalayan expedition in 1851) desperately needed to see this material (especially that of Griffith and Falconer) for their *Flora Indica*. It seems that they saw almost none of it for their first (and only) volume, published in 1855, and Hooker had to wait until Royle's death in 1858 to be allowed to rescue the specimens from the vaults of India House. This included '400 bundles, largely Griffith's, mixed with Abyssinian and other collections, twenty large boxes labelled "Afghan Collections"; eight chests with more of Griffith's collections; Falconer's plants distributed among sixty-three cases'.[38] In all these amounted to eleven wagon loads, which were taken to Kew and laboriously sorted by Hooker and his staff over the next decade, though those packets left open had been destroyed by 'city dust, rats & other vermin' and among the casualties 'one half of the collections of Griffith & three fourths of those of Falconer were utterly destroyed'.[39] Coincidentally it was at this same time (the 1860s) that Hooker was distributing Wight's own copious duplicates, and, even though he kept the best of these for Kew, was still able to distribute

50,000 of the Griffith/Falconer/Helfer specimens, and 60,000 of Wight's, to the 'principal museums in Europe, North America and India'.[40]

MADRAS HERBARIA

What little we know of Wight's character shows him to have been deeply sincere, which makes it odd, given his recommendation of keeping Griffith's specimens in India, that he apparently left none of his own in the country in which he spent such a large proportion of his life. In view of his recommendation of the Calcutta Medical College as being a suitable home for Griffith's specimens, it would be good to know more of Wight's connection with the similar establishment in Madras first established under the Governorship of Sir Fred Adam, attached to the Madras General Hospital, founded on 13 February 1835. On 1 October 1850 this was awarded the status of a college and became the Madras Medical College,[41] and in a communication with Edward Balfour in December of this year Wight suggested that Natural History classes might be 'grafted' on to the curriculum of the College.[42] There is an implication in this letter that collections of natural products should be sent to the College professors, but in the end it seems that this function was passed on to the Madras Museum. A chair of Botany was established at the College in 1852, with H.F.C. Cleghorn as its first incumbent, and he must beyond doubt have had some sort of teaching herbarium of which no record has survived.

The Madras Government Museum was set up in 1851 under the Governorship of Sir Henry Pottinger, first housed in the College of Fort St George, and later moved to a building called the 'Pantheon'. This museum originated with collections accumulated by the Madras Literary Society and had first been suggested in 1846. In the 'Notification' of its establishment issued by Sir Henry Montgomery, the Government Secretary, on 14 August 1851, its scope was described as 'a Museum of Practical or Economic Geology, and a Museum of Natural History', based on 'the specimens from the Mineral, Vegetable, and Animal Kingdoms, and those of Machinery, Manufactures, and Sculptures already collected'.[43] Not surprisingly, given his involvement with the Madras Central Committee, the first officer in charge of the Museum was Edward Balfour, and an intention to include botanical collections existed from the start. The first dated botanical specimens bearing a 'Madras Museum Herbarium' label, however, are said to be from 1853, and it was Cleghorn who organised this collection, which included specimens of Sir Walter Elliot and Dr Charles Drew.[44] The great period of growth of the Madras herbarium came in the 1870s under George Bidie, and in 1873 Colonel R.H. Beddome sold it his herbarium (or more likely a duplicate set) for Rs 1500. The Museum Herbarium and that of the Government Botanist were combined, possibly by C.A. Barber who was appointed the first Director of the Botanical Survey of India for South India in 1898, and in 1909 the Herbarium moved to Coimbatore, where it remains to this day. There is no mention of Wight specimens either in the history of the Museum or of the Herbarium, and it would therefore appear that he did not leave any behind, as, given his prestige in Madras, these would certainly have been acknowledged. Despite Wight's eagerness to keep Griffith's collections in India, it seems he did not practice what he preached, and the first proof of Wight specimens going to an Indian collection are those sent to Calcutta as a result of the Kew distributions of *c*.1870.

WIGHT AND WALLICH'S RELATIONS POST-1846

The friction between Wight and Wallich over Griffith rumbled on inter-continentally after Wallich's return to England in 1846. In 1849 Wight was still referring to his disappointment over Wallich's speaking ill of the dead Griffith, when he imagined it to be the reason he had not heard from Wallich for some time.[45] Such hiatuses in communication, as we have seen, were common between British and Indian correspondents, but Wight always tended to take such things personally. In fact, Wallich cannot have held a serious grudge against Wight, as when he was canvassing for his own replacement immediately *after* his return to London, Wallich had written:

> The two candidates for the permanent situation of superintendent, are fully known to you, namely Dr. R. Wight of the Madras Medical service & Dr Falconer of the Bengal Establishment. The former distinguished Botanist cannot easily be spared, I have strong reason to believe, from his important duties at the Coimbatore Cotton farms; nor would he be willing to forego the superior pension of superintending surgeon, to which rank he is very near being promoted; unless indeed that pension were guaranteed to him on his leaving the [Coromandel] coast for the Calcutta appointment. But I beg to be understood as speaking with great caution in thus suggesting what I conceive to be the views of **my very valued friend**.[46]

Of the several references that do, however, suggest a continued friction is an obscure, but intriguing, comment in a letter from Bentham to Wallich about some sort of meeting that took place in Wallich's house in November 1847:

> I am very sorry that Wight should have heard anything about what passed in Upper Gower Street last Nov. as it was a private meeting and the understanding was that that was to be the end of all and any gossip about what then passed is sure to get strangely deformed before it reaches distant regions and knowing that it would have been far better if Wight had said nothing to you but I know he heartily wishes you well and thinks highly of your conduct and his intentions are of the best towards you so I do most sincerely hope & trust that you will keep to your resolution of neither tormenting yourself nor saying anything more to anyone on this matter.[47]

Bentham was clearly acting as a peace-maker, but what could this meeting have been about? The pair must still have been corresponding (though none of the letters survive), and in June 1848 Wight referred to having received a letter from Wallich telling him that he was 'in passing good health and going down to spend a few days with Bentham'.[48] Wallich's condescension towards Wight was still there, and, in March 1853, when going through Dawson Turner's letters, the thought of 'dear old Wight' proposing to Ellen Turner more than twenty years previously provided an excuse for a laugh at his expense.[49]

At this point Wight was about to return home and wrote 'a long letter' to Wallich.[50] In a touching replay of 1831, Wallich was one of the first people that Wight visited on his return to London after an absence of 22 years, and he was expected by Wallich on 20 April 1853.[51] Two months later, as will be described later, Wallich still thought highly enough of Wight to sign his certificate for election to the Royal Society, of which he was then a Vice President.[52]

FAREWELL TO INDIA

Wight had first thought of retiring in 1848, then again in 1849 over the troubles with Pottinger, but his 1851 promotion meant that he had to stay for a further two years for the sake of maximising his pension. During this final period Wight made preparations for returning to England, and in July 1852 wrote to Hooker asking for him to look out for suitable accommodation for his family and collections, having decided that this should be within easy reach of Kew and London:

> I have no doubt of finding myself on the high seas in the course of March next [i.e., 1853] bounding over the waves to Kew. There or thereabouts is the locality in which I contemplate to pitching my tent, but beyond asking you to keep your eyes & ears open I do no contemplate availing myself of your kind offer in the matter of finding me a house.
>
> Mrs W. is quite a connoisseur in the matter of houses so I propose letting her have it all her own way in the situation, feeling quite sure that we shall, under her management, be much better accommodated than if I interfered. If therefore you will kindly be on the look out for any pretty sizeable houses in your vicinity that may become vacant we shall feel greatly obliged.– We require a good deal of accommodation as I have a bulky store of my own and then Mrs W. and her four youngsters added to my good old sister whom I hope to be able to induce to leave the north to come & end her days with me in the more sunny south will require a good deal more.
>
> A house with anything under four available bedrooms for the family, & sundry other rooms for the stowage of my library & herbarium will not suit us. This is the nearest idea I can give you of the extent of the accommodation we shall require. Then if it has a garden "& compound" so much the better. We can afford in the way of rent about £100 per an. exclusive of taxes.[53]

In January 1853 the Wights finally left Coimbatore, and two months later quit Madras and India for good. There was a meeting at the Agri-Horticultural Society in Madras to bid him farewell on 3 March. Sadly no copy of the valedictory speeches made by Cleghorn and F.A. Reid has been found, but the fragment reproduced in the former's obituary of Wight doubtless formed part of his own contribution:

> It is recognised with gratitude, that it was your fostering care in the early days of its institution, that brought the Society into a vigorous existence. Throughout the eighteen years that have elapsed since its formation in 1835, you have ever proved its faithful and zealous friend, and have accorded to it your valuable counsel and support in every endeavour made and every measure adopted for improving the Agricultural resources of the Presidency.
>
> Much, however, as the Society owes you on this account, the Members are very sensible of the greatly superior claims upon their regard which your other and eminent labours in the field of science command. They do homage to the unshaken perseverance and unwearied industry, with which you have prosecuted Botanical researches for the last thirty-five years, amidst impediments and difficulties that it required no common zeal to surmount, and all this with a successful result, while it has gained its just appreciations in the scientific world, leaves to the members of our Society the particular gratification of seeing it associated with this Presidency. ... Our

members feel that your labours have given Southern India especially that which was so much needed, and which cannot be too highly appreciated, a standard Botanical work of reference. You have published correct figures and accurate descriptions of between 2000 and 3000 Indian plants within a comparatively limited period, and made them accessible to the public at moderate price. In fact what Sowerby's 'English Botany' is in Britain, your 'Illustrations and Figures [i.e., the Icones]' have provided for the Student of the Indian Flora.[54]

In replying Wight was not falsely modest, and did 'not ape the humility of treating them as wholly undeserved ... [but] could not venture to submit my 'Icones' to be tried by so high a standard' as Smith and Sowerby. Once again he stressed the limitations under which he operated, in terms of herbarium and library resources, whereas Smith was 'one of the first Botanists of the time, and the most classical in his style of all English writers on Botany' with access to 'the most authoritative herbarium in the world [that of Linnaeus]', and Sowerby was 'the most accomplished Artist of his day as a flower painter'. Nonetheless Wight had endeavoured to 'bring my representations up to the highest standard that the state of pictorial art in India permitted'. He ended with an expression of hope 'that my labours may not here terminate, and I am happy to assure the members that, should it please God to spare my life for a

few years, much that still remains to be done towards completing my contemplated contributions to the Indian Flora will be happily accomplished'.

Wight's annual pension from the EIC, which he was allowed to draw from 28 February, was £500,[55] and much more than the 'Lieut. Colonel's pension of £365 per annum' that Wight expected had he retired in 1849.[56] In addition he received an 'annuity for life' of Rs 3500, that is £350, from the Madras Medical Fund.[57] Wight therefore retired on a substantial annual income of £850, the equivalent of about £55,000 in today's terms. Those extra pounds of pension would, however, seem a high price to have paid for the continued separation from the three children he had not seen since November 1846, though such separations were the norm in colonial families until the middle of the twentieth century.

The voyage home started on 11 March 1853 aboard the P & O steamer 'Bentinck' bound for Point de Galle, Aden and Suez.[58] Wight and Rosa were accompanied by her mother (Mrs Lacy Grey Ford) and a 'Native female servant'. Mrs Ford had the care of two children, one of whom must have been Charles (by now almost two) and the other perhaps another of her grandchildren. Also returning to Britain on the same ship was one of Walter Elliot's children in the care of a Captain Marshall.

PART V

THE LATER YEARS

1853-72

Retirement to Reading

The Wights arrived at Southampton in April 1853 – Wight had not seen his three eldest children for seven years, and their mother had not seen them for five! As Rosa's father died in Southampton in 1844 it seems likely that she had family connections there, but Wight found the 'little English rooms' claustrophobic after 'the capacious ones of India', and after a few days of wretched weather they moved on to London. They intended staying initially at 9 Charles Street West, Westbourne Terrace – perhaps Helen Wight's house.[1] Another friend in London at this time was Octavius Adolphus Field, who lived in rather grander premises at 4 Stanhope Terrace, Hyde Park Gardens.[2] How Wight knew Field is unknown (he was neither in India nor Edinburgh trained), but the Medical Register shows that though by now retired, he had formerly been a surgeon at the Paddington Dispensary – could he perhaps have treated Wight's hernia in 1831?

INDIAN TERRITORIES SELECT COMMITTEE

By a curious quirk of timing, Wight had one last duty to perform with respect to his cotton work, when, shortly after his return, he was summoned to give evidence before the Select Committee on Indian Territories – part of the parliamentary deliberations on the renewal of the EIC's charter.[3] This committee had been convened on 15 November 1852 under the Whig-Peelite coalition administration of Lord Aberdeen, and was chaired by Thomas Baring, Tory MP for Huntingdon. It was a heavyweight body, including major figures such as Palmerston, Gladstone, Lord John Russell, Lord Stanley and T.B. Macaulay (at this point MP for Edinburgh), all of whom attended during the early days of its lengthy deliberations. Not surprisingly for a coalition government, there were numerous radicals and Whigs on the committee, including Joseph Hume, the by now elderly (76) MP for Montrose, who back in 1839 had asked Bayles to recruit the American Planters, and Henry Labouchère (uncle of the eponymous originator of the famous 'Amendment' that led to the conviction of Oscar Wilde, a later, if unwilling, Reading resident, and relation by marriage of Wight's eldest daughter-in-law). By June none of the bigwigs was attending, but among those who interviewed Wight on 6 June 1853 were Sir Charles Wood (President of the Board of Control, later 1st Viscount Halifax), and several with intriguing links to Wight's Indian past: John Elliot, Whig MP for Roxburghshire, son of a former Governor General, Lord Minto, and nephew of Hugh Elliot, who was Governor of Madras when Wight first went to India in 1819, Robert Herbert Clive (cousin of Edward Clive, 1st Earl of Powis) who had been Military Secretary in Madras in 1831, and Ross Donnelly Mangles (Whig MP for Guildford and an EIC director), who as Secretary to the Government of India in 1838 had written to tell Madras of the President in Council's recommendation of scrapping Wight's job as economic botanist! Given the strong Whig element, it comes as no surprise that, as with the 1848 Select Committee on Cotton in India, strong implicit criti-

cisms of EIC policies emerged; it is also of interest to note that three Parsees (Rustomjee Vicajee, Jevanjee Pestonjee and Ardasser Cursetjee) were interviewed. Wight's evidence, already described in Chapter 15, represented a summary of his views on 11 years of work at Coimbatore. The India Bill arising from these deliberations led, among other things, to competitive examinations for appointments to the Company's service, and, by refusing to set a time limit on the operation of the new charter, allowed for its termination if so decided by the Government.[4] This is exactly what happened, only five years later, following the Mutiny.

GRAZELEY LODGE

Over the summer of 1853 things moved quickly on the property front, and Wight must have decided to buy, rather than rent. By November the family was installed at Grazeley Lodge [fig.36] a twelve-bedroomed, house set in a 66-acre estate. A detailed description of the house was made when it was sold after Wight's death:

> The Residence … is nicely screened from the main road & approached by a broad carriage drive, and a flight of stone steps leading on to a colonnade extending along the south front, is well built, spacious, and of handsome elevation, and contains – On the ground floor, entrance hall, inner hall, principal and secondary staircases, noble drawing room 32 ft. × 18 ft., opening by French casements on to the colonnade, and communicating by folding doors with a library 21 ft. × 20 ft., including bay; well-proportioned dining room 21 ft. × 17 ft. 6 in., opening by French casements on to the colonnade, school room, lavatory, w.c. On the First Floor: capital central landing and corridor, ladies' boudoir, four spacious bedchambers, two capital dressing rooms, lavatory, and w.c.; and on the Second Floor: 8 bedrooms, cistern room, &c. The Domestic offices comprise butler's pantry, servants' hall, capital kitchen, scullery, laundry, brewhouse and bakehouse, cool dairy and larders, wine, beer, and coal cellars, &c. To the west of the Residence is the stabling and premises, and beyond these suitable agricultural buildings, with bailiff's cottage. Surrounding the residence on three sides are ornamental grounds, gardens, and shrubberies studded with well-grown trees and shrubs, greenhouse, rustic summer-houses, fernery, and a productive kitchen garden of one acre in extent partly walled-in, and abundantly stocked with choice fruit trees. The park lands are ornamentally timbered with principally oak timber, and lie to the north and east of the residence; the arable fields are beyond.[5]

This must have amply satisfied the social aspirations betrayed in the portrait of Rosa and her children, and Reading was convenient for London, which at this stage Wight intended visiting frequently. The house was only '3 miles from the Mortimer Station on the Berks and Hants line, and 4 from the County Town and Railway Stations of READING, with Three Lines of Railway affording constant and rapid communication with the Metropolis, the Sea-side, & all parts

of England'.[6] From Ealing, the nearest mainline station to Kew, there were 'two morning trains … to Reading, one at 7–12 a.m., the other 8–26 – arriving respectively at 9–10 and 9–45'.[7] Wight and Rosa would later avail themselves of the easy maritime access and would spend time on the Isle of Wight and at Weymouth.

In November 1853 the Wights headed north to Killiecrankie. This must have been where his sister Anne now lived, and she would have had to have moved out of the Blair manse on the death of her husband. She was by now 69, but Wight failed to persuade her to come to live with them in the sunny south.[8] Scarcely surprisingly the weather of their first English December came as a shock to both Wight's and Rosa's systems:

> the intense cold of the weather has exerted a conspicuous influence. Conspicuous in so far as it leads me much into the open air, where I feel much warmer, & altogether more comfortable, than when exposed in the house to the cross fire of draughts in all directions. One side roasting near the fire and the other shivering from the effects of the current caused by the fire. However, I am happy to say we all continue well. I was never better and the children have all improved in their appearance since they came here. Mrs Wight though not quite so well as I could wish has still no reason to complain as her health seems upon the whole to improve though she feels the cold much.[9]

Beside the fire, judging from an earlier diatribe, it seems likely that Wight consoled himself with a pipe or cigar. From the Stiven snuff-box still in the possession of his descendents, it is known that Wight took tobacco in another form, and in the *Illustrations* he had made a spirited defence of what, even then, was known as 'the weed':

> In spite of all that has been said and done by statesmen, moralists, divines, and physicians, to bring it [tobacco] into disgrace, it still holds its place in public estimation. This may, perhaps, be partly accounted for by the fact, that its vituperators have generally been either men whose peculiar idiocyncracies [sic] prevented their partaking of the enjoyment derived from its use, or, on the other hand, those who had abused the privilege and injured their health by excess. The testimony of such witnesses can never be admitted as trust-worthy so mankind have gone on smoking and snuffing, notwithstanding all the abuse that has been heaped on the "weed", and, it is my belief, will continue to do so to the end of time, unless, perhaps, statesmen, forgetting the lessons of experience, put it out of fashion by overwhelming it under prohibitory duties, to the manifest injury of the state exchequer, and the banishment of the peace and quiet of many good men who, being now contented to puff away their cares in the fragrant fumes of Tobacco, might become agitators for want of some better and more innocent occupation, and then become as bad and troublesome subjects as they are now good and amiable men.[10]

By 1854 the Wights must have settled into a routine, though all that is known of it is from fragmentary references in letters. Social activities in their second summer included a trip to the Isle of Wight, and in August his sister Anne, accompanied by her son and granddaughter, returned her brother's visit.[11] Existing scientific connections were developed, and new ones made, for example Wight became an annual subscriber to the British Association for the Advancement of Science, and remained so for the rest of his life. There is unfortunately no record of which, if any, of its important annual meetings he attended. It was probably also around this time that he became a Fellow of the Royal Horticultural Society.[12]

The first of the botanical visitors to Grazeley in 1854 was John Ellerton Stocks, one of the great hopes for Indian botany, who intended visiting Wight early in the year. They had been corresponding for 'some 7 or 8 years',[13] but assuming that the visit took place (though Stocks was by now ill, and would soon be dead), this would have been their first meeting as all of Stocks's Indian work had been in the Bombay Presidency and Sind. Among new botanical contacts the Dutch botanist Willem Hendrik de Vriese came to study Wight's Lauraceae in August,[14] and in September, accompanied by George Bentham, the Paris based botanist Hugh Algernon Weddell visited to look at the large collection of Urticaceae, a family on which he

was about to publish a major monograph.[15] Other visitors in August were the distinguished duo of Sir William Hooker and Robert Brown, a visit perhaps concerned with the forthcoming Royal Society elections.[16] The great German orchidologist Heinrich Gustav Reichenbach visited Grazeley on several occasions, and, from the charming and highly personal memorial notice he wrote, it is evident that his first visit must have been made around this time, a time when Wight still intended working on botany.[17]

ABANDONMENT OF BOTANY

When first planning to retire in 1848 Wight had told Hooker that he had 'no wish to spend the evening of my days in Idleness so will try to locate in a working neighbourhood'.[18] And just before leaving India reiterated this intention to Bentham:

I am now in the midst of my packing, up to the very eyes in business all day long, but hope ere the end of the week, this being Wednesday, to have made a considerable clearance. The bulk of my collections are packed, and fill between 40 & 50 bags, some of them very large, so that by the time they are all exposed again, there will be quite another Frith Street exhibition. In truth when I come to look at the numerous portly packages I feel quite horrified at the quantity of work before me ere I

Opposite Fig.36. Grazeley Lodge, *c.*1870.
Reading Public Library.

Figs 37 & 38. Robert and Rosa Wight, taken by Maull & Co., probably soon after their return from India in 1853. N.J. Wilkinson.

can expect to see them all arranged and in working order. My own impression is that there cannot be under 8000 species and of many of them no want of duplicates.

We old Indians get the credit of being a grumbling discontented set of fellows, no pleasing us when we get home again. There is a great deal of truth in that, most of us having nothing to do are like so many fish out of water. This is not likely to be my case, if I am ever destined to elaborate my Herbarium, for, I calculate, that 5 years diligent labour will scarcely suffice to enable me to get through one half of it, unless, by the way, I can induce a few more such admirable workmen as yourself and Arnott to lend a helping hand, such a work will provide ample occupation for a long time & prevent an excess of leisure hanging heavy on my hands, so that I would fain hope, in anticipation of the trial, that I may prove an exception to the general rule in the matter of grumbling & finding fault with the people & customs of the old country. We expect to be in England in April, I fancy about the time my chattels will be leaving India, a very useful arrangement as some months will be required to admit of my looking about and fixing on some plan of operations in anticipation of their arrival, for as yet I have not been able make any arrangement for there disposal on first arrival. Arnott recommends me to send the whole to Glasgow with a view to having our joint collections compared numbered & distributed so as at starting to reduce their bulk, and at the same time enable us to work conjointly though widely separated, that is, he in Glasgow & I in London thereby obtaining the benefit of the large public Herbaria there as well as those of Hooker pater et filius.– This seems a very feasible plan & so far as I can yet see the one most likely to be adopted.[19]

Wight's return to England was celebrated by his old friend Hooker in an article in the latest of his periodicals, in which it was stated that Wight intended to 'devote himself still to Indian Botany, distribut-ing his ample Herbarium, and continuing the "Prodromus Florae Peninsulae Orientalis"'.[20] Hooker praised Wight's taxonomic judge-ment, but there was a curious sting in the tail of the article:

to the general usefulness of all Dr Wight's works there is but one drawback, namely, a want of attention to style and composition.

While this is a fair criticism – Wight's style, grammar and punctua-tion are lamentable – this public wigging seems a little uncalled for in the context of a celebratory article! It shows what pedants the Hookers were in matters of 'taste', a trait noted by David Arnold: 'it was in matters of taste as much as expertise that [J.D.] Hooker often found India's botanists seriously wanting'.[21] This had emerged in Joseph's criticism of McClelland's editing of Griffith's works, and in Griffith's lack of taste in garden design, but is shown here to be an inherited characteristic.

Despite the good intentions, Wight did nothing taxonomically after his return to England. This is a puzzle, and the only thing that gives a clue as to why are three enigmatic letters to Hooker of 10 and 24 November, and 30 December 1853.[22] Wight had evidently written some papers that dealt with matters of nomenclatural priority. The result appears to have been a (doubtless prolix) rant, in which he seems to have returned to a hobby horse: the question of *Gloriosa* versus *Methonica* discussed in the *Icones*. From the incomplete cor-respondence it is clear that Wight had challenged an opinion of Wallich, whom he took to have misquoted the pre-Linnean author Paul Hermann. Hooker had apparently consulted Wallich for his opinion, but Wight protested that:

I do not think if would be right for me to permit so elaborate an article as mine to be cast aside without a word in reply on the mere dictum upon whose authority in such matters is not higher than my own. I hope on the strength of these considerations you will be able to find room at least for this paper, if not for its antecedents.

The quarrel with Wallich again! Hooker persisted and tried to make Wight see that his language had been intemperate, to which Wight replied:

You say "you think I impute motives to him" leaving of course the adjective <u>improper</u> to be understood. Now as nothing of the kind ever entered my head & nothing could be further from my wish, I say at once if my language conveys that impression to you, an impartial reader, then at once suppress the paper until I can have an opportunity of looking over it again.

Wight, sensitive as ever, took Hooker's well-intentioned interven-tion to have been an admonishment 'to the quick'. The papers never appeared and the episode would appear to have had a major effect in terms of quenching Wight's botanical ardour.

Despite this setback, the intention of continuing botanical work clearly lingered on – in January 1854 J.H. Balfour sent Wight a new microscope from Edinburgh,[23] and the next month Wight wrote to Hooker that he began 'to fancy that the polish is getting worn off the new toy [presumably his farm] and that ere long I shall find myself as heartily engaged in Botany as ever I have been'.[24] In August 1854 he wrote 'I do occasionally do some work in that [botanical] way, not so much as I ought, I now begin to feel more settled and continue to do a little almost daily and I expect the habit of application will soon become re-established'.[25] A year later the appearance of the first vol-ume of J.D. Hooker and Thomas Thomson's *Flora Indica* gave Wight a boost and promised to 'stir up afresh my Botanical ardour, and bids fair to blow into a flame the late half-dying embers of my old Botanical fire!' Reading it, however, 'proved a tedious job', 'for like Dominie Sam[p]son I could not help stopping at almost every leaf to have a read, & then a 'tother read, of its erudite contents, ever and anon pronouncing with profound admiration the word pro-di-gi-ous'[26] Wight thought that the *Flora*, if completed, promised to 'throw De Candolle the father deep into the shade as a philosophical & systematic Botanist'.[27] Sadly (largely through Thomson's inactiv-ity) like its great predecessor, Wight & Arnott's *Prodromus*, the *Flora Indica* never reached a second volume. Thomson was often invited to Grazeley, for example on 27 April 1863,[28] to look at particular families in connection with *Flora Indica*, and would later sit on the Pharmacopoeia of India Committee with Wight.

Joseph Hooker explained his understanding of the reason for Wight's giving up botany in a letter to the Melbourne botanist Ferdinand von Mueller as being bad health: 'the normal condition of [repatriated] Indian botanists', along with Thomson, Falconer, Anderson, Brandis, Wallich 'and a host of others'. Only C.B. Clarke, who helped Hooker so greatly with the *Flora of British India*, was 'the exception that made the rule'.[29] As will be seen later Wight's health until shortly before his death seems to have been only intermittently bad, and a photograph by Maull [fig.37] shows Wight to have been positively vigorous at this time, so Hooker's explanation is not con-vincing. Rather, Wight seems to have put his remaining energies al-most entirely into ephemeral agri-horticultural activities. The only

publications of his retirement are the eight letters on cotton for the *Gardeners' Chronicle* of 1861 (reprinted in pamphlet form the following year), and only the work to be described below on the *Pharmacopoeia of India* involved any new botanical research. Despite Wight's lack of active taxonomic work he maintained his links with the Hookers and with the numerous British, European and Indian botanical visitors to Grazeley.

FELLOW OF THE ROYAL SOCIETY

Then based at Somerset House the Royal Society of London was, as it still is, one of the most prestigious scientific academies of the world. In June 1853, soon after his return to England, Wight was proposed for election by Robert Brown. Wallich, one of the Society's Vice Presidents, signed the election certificate next and sent it on to Sir William Hooker,[30] but the process was slow and Wallich was dead by time Wight was finally elected on 7 June 1855. These botanists, and Lindley, another signatory, were old stagers and had all signed Wight's proposal for the Linnean Society 23 years previously.[31] However, a new generation of botanists was represented on this occasion including J.J. Bennett (Brown's assistant and botanical heir), Hooker's son Joseph, Thomas Horsfield (Keeper of the India Museum, an American-born surgeon who collected plants in Java and Sumatra), J.F. Royle (Professor of Materia Medica at King's College, London, previously superintendent of the Saharunpur Botanic Garden and later on the EIC's economic botanist), J.E. Gray (Keeper of Zoology at the British Museum) and N.B. Ward. The other names who signed the election certificate 'from personal knowledge' have less obvious connections with Wight: J. Miers, W.W. Saunders, W. Spence, and W.J. Burchell (sometime EIC botanist on St Helena, and explorer of South Africa and Brazil).

It appears that the honour came too late, and Wight was either too dispirited by the mysterious censored papers, or too keen on farming, to take advantage of it, or to make the contribution to scientific life that was clearly expected of him, for the Royal Society was no longer merely a scientific social club. Wight did, however, at least occasionally attend scientific meetings in London, for example, in August 1855 he went to one of his old friend N.B. Ward's scientific parties and on the way home dropped into the 'Society' where a copy of Hooker and Thomson's *Flora Indica* had been left for him:[32] this could refer to either the Linnean or the Royal Society. In an undated letter to Bentham Wight expressed the intention of taking his 'only specimen of *Ozodia* [i.e., *Foeniculum*] … to Burlington House where I hope to be in the Evening',[33] which could refer either to the Linnean or the Royal, as the latter had moved into Burlington House in 1857. In 1862 Wight resigned from some club or society that the Hookers had evidently put him up for in 1853 explaining that he was 'now so little in town that I could have no better object in view than the honor of the thing and that is hardly worth to me, in these latter days, the money it would cost'.[34] It has not been possible to discover to what this refers, though it was neither the Linnean Society Club nor the X Club of the Royal Society. The last record of Wight's going to London for a meeting was a Royal Society Soirée that he planned to attend on 12 March 1864.[35]

The only other record of Wight's involvement with the Royal Society is as a signatory on the election certificates for five Fellows.[36] Three of these were for botanists: in 1856 J.H. Balfour, Regius Keeper of the RBGE; the Australian botanist Sir Ferdinand von Mueller in 1860; and, in 1862, George Bentham. The two non-

botanists were George Bowdler Buckton, a chemist and natural historian (1854), and Sir Emerson Tennent in 1860. This last must have brought back memories of Ceylon as from 1845 to 1850 Tennent was Civil Secretary to the colonial government of Ceylon, in which position he had been a great supporter of George Gardner. It was to Tennent that Wight had written in 1849, asking if Gardner's successor Thwaites could visit him in Coimbatore.

KEW AND THE HOOKERS

Friendship with the Hooker family continued to be an important element of Wight's long retirement: he visited Kew from time to time, and corresponded with and sent garden produce to his old friend Sir William. In April 1854 he gave him some fruits, and a sample of the latex of *Euphorbia cattimandoo*, for his Museum.[37] In March 1864 Wight intended making a visit at a time when Sir William was laid up with gout and Lady Hooker had just recovered from scarlet fever. Given the infrequency of Wight's visits to London, this may have been the last time they met, as Hooker died in August 1865. The link, however, continued with the next generation. Joseph Hooker, whom Wight had known since his schoolboy days in Glasgow, and corresponded with while in India, had taken over from his father as Director of Kew, and persuaded the Government to purchase his father's library and herbarium, so rich in Indian specimens. Renewed contact was initially through Wight's lending herbarium specimens to help with Hooker & Thomson's still ongoing work on *Flora Indica*. This began in December 1857, when Wight took herbarium specimens of the families Cucurbitaceae, Bignoniaceae and Euphorbiaceae to Kew.[38] The detailed story of Wight's herbarium collections and their dispersal has been told elsewhere,[39] but, to summarise, Wight started giving his vast collection of duplicates to Kew in 1863 – the specimens were:

> for the most part in capital order, and plenty of them of many, enough to supply half the Herbaria of Europe with good specimens, and so distributed will probably do more good than if I had set about publishing them without subsequent distribution.– Of course you [should] distribute them as from my Peninsular Collections wh. will add to their value.[40]

The first transmission took place in April ('two biggish boxes and a large basket filled with bundles of plants'), a second followed in July, when Wight estimated four more similar would be required to get all the material from Grazeley to Kew. Wight clearly devoted great care and attention to this transportation, insisting on the return of the boxes to be refilled with the next batch of specimens. He even thought of the best way to label the bundles: 'I have simply gummed my paper address over your parchment one, so that you have merely to damp it & rub it off & yours is ready for a new bout'.[41] Clearly by now all hopes of undertaking any botanical work had gone and Wight even offered Hooker the duplicates Arnott 'was to have distributed as we went on describing, but as that day is never to be, so far as he and I are concerned, if you are willing to bother yourself with them I shall try to arrange to have them transferred to Kew'.[42] Joseph Hooker, or more probably Daniel Oliver who was appointed Keeper of the Herbarium in 1864, worked extremely hard on sorting these rich collections, resulting in a magnificent distribution like the one undertaken with Arnott in the 1830s. Another catalogue was produced for the benefit of the recipients, paid for by Wight,[43] but the numbers of the 3203 species are (confusingly) different to those

of the Arnott distributions. In 1871 Wight made a last great sacrifice and, with the help of his sons Robert and Charles, packed up his own working herbarium ('11 or 12 boxes rather tightly filled'),[44] with all its types, finally sent to Kew by the evening 'South Western goods train' on 20 October.[45] The last of Wight's botanical collections to be despatched was a 'collection of woods cut into square bars 6 inches long & 1 square, all named',[46] sent to Kew in March 1872 along with oddments including sponges.[47]

Interactions between the Wights and the Hookers were not, however, only scientific, and there is a charming undated letter (probably from 1857/8), which shows that Joseph and his wife had partaken of a tasty curry at Grazeley ('fried not stewed'), and Hooker had written to ask where Wight purchased his curry powder. The answer was a chemist called Horncastle 'nearly opposite Hyde Park Gate near Kensington Gardens', but Wight offered his wife's culinary services: 'Mrs W will have great pleasure in showing Mrs Hooker how to manipulate and explain, so far as she knows them, all the hidden mysteries of curry making'.[48] Wight's last letter to the by now great Dr Hooker – FRS, CB, Director of Kew, and emperor of the botanical world, but whom he had first known as young 'Joe Hooker of Glasgow', is full of vigour. Written in March 1872, only two months before Wight's death, it offers support to Hooker in one of his most famous fights with the Civil Service – his battle with Acton Smee Ayrton. This challenge to Hooker's authority upset Wight as he had thought that 'the Kew department in all its branches were working as smoothly as amicably adjusted and well oiled machinery could do', and assured Hooker that in dealing with such a 'pig headed mortal' he should on no account resign – 'if he is to get quit of you make him incur the obloque [sic] of dismissal, having no adequate reason to assign for his harsh & ungentlemanly measure'. In a fitting and rather touching turn, for what was to prove a final letter, the clock then turns back to the 1830s and to the scene of Wight's great labours. King's College London had just donated J.P. Rottler's herbarium to Kew and Hooker was trying to discover if Wight knew anything about it, or who had had a hand in naming the specimens. Wight replied:

for myself I saw but little of his Herbarium & none at all after my return to India in 1834 … I wish my teather [sic] was only a little longer so that I might be able to run up & see you and have a good look at dear old Dr Rottler's herbarium … but alas the length of my teather is only between two & three hours which is not enough to take me to Kew.[49]

AGRI-HORTICULTURAL ACTIVITIES

Wight had given up on taxonomy, but would seem to have acquired a taste for agriculture in Coimbatore. In this he was his father's son, and was able to indulge his hobby on the 66 acres at Grazeley. The farming was on a very small scale, with only six fields at his disposal.[50] As early as February 1854 Wight was able to tell Hooker that he was 'taken up with Agri-Horticultural operations, draining subsoil, digging some patches of ground for cultivation this season'.[51] Reichenbach provided some further details on both the agricultural and horticultural sides of Wight's later days: that his early attempts at farming were not very successful and that, because of this, he for a time 'changed his place, going to Aldershot, an adverse place, where the English [Army] training camp was'.[52] Nothing more is known of this, though the land at Aldershot was presumably only rented, and we have only glimpses of Farmer Wight in letters to Hooker. For example on 24 July 1863 he expected soon to be 'up to the eyes in harvesting, and think I am to have very passable good crops to harvest'.[53] At the age of 75 Wight was still active, though it would be his last season: on 18 October 1871 his horses were 'working double tides to get our wheat sown while this fine weather lasts and I will think myself in luck if I have my work done by this day week, and of course can't stop even for an hour so long as the weather continues so inviting'.[54]

The seriousness of Wight's farming interests is apparent from the 1862 Cotton pamphlet.[55] This started life as eight articles published the previous year by Lindley in the *Gardeners' Chronicle* reviewing the Coimbatore cotton experiments. When Wight turned them into a pamphlet, which he considered important enough to advertise as immanent in the *Times* of 24 June 1862, the articles were prefaced with long notes on two recent British agricultural phenomena – 'High Farming' and 'Pedigree Wheat'. The first dealt with matters of tillage, manuring and rotation; the second with the selective breeding of wheat from single ears to give high yielding varieties. This had been undertaken by Major Frederic F. Hallett of the Manor House, Brighton to great effect, having doubled the size of an ear in four years. Wight had clearly been following the latest agricultural literature,[56] and also taking the opportunity to observe the newest high-tech machinery such as 'Mr Smith of Woolston's steam

Fig.39. The Grazeley Lodge Estate. Hand-coloured lithograph by Hood, and photograph, 1872. Reading Public Library.

cultivator'. Since Coimbatore Wight had become much more aware of the importance of manuring – for example with ammonia, guano and superphosphates – better rotations (including legumes), and the use of green manure crops, regretting that he had not known about these when using modified American practice in India (a belated, if tacit, admission that Tweeddale's criticisms of Wight's lack of practical farming knowledge were to some extent justified).

The Grazeley Garden

Reichenbach also briefly described the garden around the gleaming white house (which he considered colossal by English standards) at Grazeley.[57] The house was 'enclosed in one of those perpetually fresh shrub gardens of *Arbutus*, *Laurus*, *Viburnum Tinus* [and] *Prunus lusitanica*' – in other words a gloomy Victorian shrubbery! Nothing is recorded of the flower garden that Rosa must have supervised. Sir William Hooker sent plants for the garden in April 1857,[58] and Wight appears to have bought seeds and plants from the Edinburgh based firm of Peter Lawson.[59] There was also a vegetable garden and in December 1857 Wight sent Hooker 'a small hamper of Jerusalem Artichokes … and a few Beetroots of a kind we think very fine'; the hamper was to be returned, if possible 'with a few snips of Weeping Willow'.[60] Gifts of produce continued after Sir William's death, and Joseph and his wife were sent a 'hamper of vegetables suited for the pot' in March 1871, though these were but a 'miserable substitute for the Herbarium' which Wight was then too ill to pack up.[61]

Address to the Reading Farmers' Club

In Cleghorn's obituary is mentioned a 'spirited address' given by Wight to the Reading Farmers' Club. Such clubs ran in Wight's East Lothian blood, but he took a dim view of this particular specimen in a talk entitled 'The uses and advantages of Farmers' Clubs'. This was given in the Club-room in the High Street on 9 June 1860 and reported the following week both in the *Berkshire Chronicle* and the *Reading Mercury* where an explanation for Cleghorn's euphemistic description is to be found.[62] The meeting was to have taken place a week earlier, but had been cancelled for lack of interest (the 'trial of Woods' mowing machine on Mr. G. Shackel's farm, at Earley, during the same hour' proving a bigger draw) – a slight that might, in part, account for the tone of Wight's address. He had been asked to suggest how the Club might be improved, but the talk is really an attack on what Wight considered 'a spectre, such a mere skin and bones of a Farmer's club'. This he attributed to a shortage of funds, and lack of support from its aristocratic President, the Marquess of Downshire (not a character from Thomas Hardy, but an Irish peer), and the landed proprietors who were its Vice Presidents. Although this was perhaps interpreted by Cleghorn as anti-establishment, Wight in fact excused their lack of interest as being due to the low subscription rate and that members might make more effort if the subscription were raised, on the principle that 'people are almost invariably given to estimate the worth of an article by its cost'. However, from the ensuing discussion it seems that Wight had been unfair, and jumped to hasty conclusions without knowing the Club's history. In any case Wight was being contradictory – surely raising the subscription would limit numbers even more? The Club had in

fact been started by incomers (liberals and what might be called do gooders), with landed proprietors each giving five guineas, and had never been much attended by farmers. It seems that what the farmers really wanted was a social club with refreshments in a local pub, and that one of the problems was that they did not want their landlords to know too much about improvements they were up to – presumably as this might lead to rent increases. It is impossible not to notice a certain parallel here with the final reason Wight gave for the Indian *ryots* not wanting to grow American cotton!

SCOTTISH CONNECTIONS

Although London was by now the centre of the botanical world, Wight maintained links with Scotland and went on a month long visit from 12 March to 14 April 1857, which must have brought back nostalgic memories of his furlough a quarter of a century previously. He (and doubtless Rosa and at least some of the children) visited the Highlands, most probably to see his sister Anne, but the weather was severe and on one occasion nine inches of snow fell in 3½ hours.[63] During this visit the Wights also spent two or three days with Arnott in Glasgow, who was 'as usual busy with his Diatoms'. Wight disapproved and considered these 'pretty enough little toys … but scarcely meriting so much of a profound Philosopher's attention'. They also spent an evening with Daniel McNee 'a most amusing fellow', who had drawn Wight's portrait in 1832.[64] In Edinburgh Wight met up with his old sparring partner R.K. Greville, by now living in reduced circumstances, and drawing and painting landscapes for a living. He also dined at the Royal Society Club with J.H. Balfour,[65] who since 1845 had been Regius Keeper of the RBGE, appointed amid much acrimony following Graham's death. Among botanists Joseph Hooker was the favoured candidate for this job, and, as a loyal member of the Hooker fan club, Wight had initially been antagonistic to Balfour, but this had evidently been long forgotten. Wight's last recorded visit to Scotland was in July 1861, which he thought would be the last time he would see his sister, who was by now 'past treating'.[66] The correspondence with Balfour continued from time to time, and in September 1868 Balfour asked Wight to take an interest in his *alma mater* and vote in an election at the University of Edinburgh that was expected to be contested.[67] This almost certainly refers to the 1868 General Election, when, for the first time, an MP was to be elected to represent the Universities of Edinburgh and St Andrews: Gladstone won the election, in which, for the first time, voting had been extended to all male householders, and the Chemist Lyon Playfair, was elected as the Universities' Liberal MP.[68] In November 1871 'an old worn out brother' Wight, still trying to offload collections, offered Balfour some wood samples for the RBGE herbarium. Wight must have kept up with Edinburgh news, for he also asked Balfour to see if Mr Archer would like some wood samples 'for the great Museum'. This was the Edinburgh Museum of Science and Art, in its splendid building in Chambers Street, designed by Captain Francis Fowke, which had opened in 1866. Thomas Croxon Archer (1817–1885) was the museum's first director, originally a surgeon, but with botanical interests and like Balfour, a one time president of the Botanical Society of Edinburgh.

Fig.40. The Wight family at Grazeley, photograph by G. Everitt and Son, ?1872. Behind Robert and Rosa,
from left to right, are James, Charles, Robert, Ernest and Augusta. N.J. Wilkinson.

Domestic and Family

The Grazeley mansion, and its proximity to London, enabled Wight and Rosa to entertain, and they were evidently very hospitable. Some of the botanical and family visitors have already been noted, and an idea of the scale of this hospitality is found in a letter to Hooker in April 1863 when Wight told him that 'our house has never been free from visitors from the time I last saw you until Thursday last'.[1] A three week lull in the guests in July 1863, however, allowed an opportunity for painters to move in – 'not quite such agreeable guests, but yet such as must occasionally be endured'.[2] On occasions the Wights travelled further afield; the Scottish visits have been described, but in summer 1861 they went to Paris. This was probably Rosa's idea, and retrospectively Wight was less than enthusiastic, having enjoyed it only 'moderately well' and 'glad to get home again. No place like Old England for an Englishman!'; his Caledonian roots by this stage evidently well and truly forgotten.[3] Wight had complained of the English cold, but after ten years Rosa (still only 46) had evidently become acclimated as in late April 1863 she went for 'a fortnight's warm [sic!] sea bathing' at West Cowes on the Isle of Wight.[4] A final, and somewhat surprising, temporary relocation came in 1868, when, from January until at least September, Wight lived at 3 Augusta Place, Weymouth.[5] According to Arnott the occupation of this house was 'to prevent some family disputes'.[6] Weymouth had been an extremely fashionable resort in Georgian times, and Augusta Place is on the seafront, but how it came into the possession of Rosa's family is unknown. Until 1867 the Rev Edmund Johnson, Wight's friend from Kerala, had been rector of the adjacent Melcombe Regis and it is intriguing to think that Wight might have met him on earlier visits to Weymouth.

THE GRAZELEY HOUSEHOLD

Details of the establishment Wight kept at Grazeley are to be found in the 1861 Census and are surprisingly modest, both by the standards of the time and the size of the house, and in stark contrast to the levels of staffing the Wights must have been accustomed to in India. The indoor servants consisted of a cook – Catharine Beck; a housemaid – Charlotte Goodger; a nurse – Lydia Jones; an under-nurse – Anne Wyeth; a footman – the quaintly named Henry Digweed; and for the outdoor department was only a single gardener. Mr and Mrs Lovell and their lodger George Palmer occupied the gate lodge, – the men acting as labourers on the farm.[7] The only other property on the estate was a cottage, home to Mr Brown, also a farm labourer, and his wife. At the time of the Census the Wights' two year old grand-daughter Lucy Adelaide Rosa, daughter of their eldest son James, was staying with them.

By the time of the 1871 Census even the small staff of 1861 had been reduced to a cook, two live-in women domestics, and two agricultural labourers, one doubling as gardener, and of these only the Browns at the lodge were the same as ten years previously.[8] This reduction could merely reflect the fact that the children had grown up, but the loss of the footman hints at retrenchment. Or perhaps merely that Rosa, Augusta and the by now 75 year old Wight were leading quieter lives. They were, however, still entertaining members of the family and Alexandrina ('Zena') was staying with her children John and Mary. Zena was married to Thomas MacKenzie, and was Wight's niece, being a daughter of his sister Marion who had married Peter Murray, a doctor in Jamaica.

THE CHILDREN

The Wight children were evidently sent away to school, as in either 1857 or 1858, Wight had referred to the house being 'cleared of juvenile holiday company'.[9] The eldest was James, who in 1852, aged 13, was sent to 'Arnott … as a pupil for this season. I hope the youngster will get on well under his tuition and take kindly to scientific pursuits, as I can't bear the idea of his looking to either Army or Navy for his daily bread'.[10] The father's fears on this count were to be spared. In 1858, aged only 19, he married Mary Adelaide Lloyd, daughter of Edward Watson Lloyd, a 'Clerk of Assize, and Clerk of the Crown, North Wales and Chester Circuit'.[11] Given James's age, and the fact that their first child Lucy Adelaide Rosa was born in Liverpool the following year – as the father was on his way to America, one suspects that the marriage might have been a necessity. It is not known if Mary went to America, where James stayed for eighteen months, but certainly two years later (at the time of the Census) their two year old daughter was being looked after at Grazeley with her coeval Uncle Ernest. In 1862 James joined the Money Order Department of the General Post Office in London,[12] and in 1871 was head of the issuing and payment section of the Money Order Office, and Postmaster of the West Central district of London. One of his notable acts in the Post Office, in 1881, was to issue the very first Postal Order. James was helped in his career by the Controller of his department, a Mr Jackson, who evidently shared some of Wight's interests as James asked if his father could obtain permission for Jackson's daughter Emily 'who paints flowers splendidly' to paint at Kew. Some vestige of James's childhood interest in natural history evidently lingered on, as James had also given the Jacksons tickets for a 'Microscopical Soirée'.[13] James ended his career as Postmaster of Birmingham, but died in 1896, aged only 57. James and Mary had two daughters – the elder, Lucy, married William Cosens, a union that (despite Wight's eight children) is the origin of all of Wight's living descendents. The younger daughter, Florence Amy Alice, was described in her father's will as 'crippled and helpless', and died unmarried in 1917.

From her nickname Augusta would seem to have become the disgruntled spinster daughter, as she was known to younger generations of the family as 'Aunt Disgusta'. From photographs she inherited her mother's plain looks and her fate was the common one of

unmarried daughters – to be the companion of her parents' old age. Augusta was certainly the only one of the children still at home in 1864,[14] and after Wight's death and the sale of Grazeley she went with her mother to live at Westholme, Staines where she died in 1903, aged 60.

The fate of the middle two boys seems little better, and both would appear to have suffered from their disrupted childhood. Like his father, the younger Robert sought a career in India, and his unfortunate period as a cinchona planter has already been described (see p.70). As the only alternative to the Nilgiris had been a desk job as a clerk Robert would appear to have had nothing in the way of qualifications. According to Wight although 'no botanist' young Robert was a 'born naturalist',[15] and in a letter from the Nilgiris he reported back on 'a curious transformation in the Indian corn' – exactly the sort his father had observed in the pawpaw years before, where some female flowers had appeared among the normally entirely male terminal inflorescence. The interest was casual and papa's comment was 'what a pity he did not collect the seed and sow them again & in that way secure a new & curious variety'. Wight attributed the transformation to 'excess moisture & … vigour of the plant', but if, as it would appear, he thought this could be transmitted to the next generation then he still clearly held Lamarckian views.[16] As already noted, Robert moved on to the Bengal forest department, but this seems to have been no more successful than

the Nilgiri experience. Instead he turned to another of the new plantation crops and in October 1871, after a visit to Grazeley, Robert was about to return 'to look after his Tea Plantation in Darjeeling'. On the way he intended stopping off at Kew to see if Dr Hooker could 'in any way aid him towards enriching his plantation', though he never got to Kew, being confined to bed in London for three or four weeks with Typhoid fever.[17] As his father had interceded on his behalf with McIvor, then with Anderson, he now told Joseph Hooker he would 'esteem it a great kindness if the "rules of service"' permitted him' to help his son more 'efficiently' than he was able to.[18] Robert's time in Darjeeling was to be short, for according to the family monument in Grazeley churchyard he 'died on his passage from Calcutta to England, March 19th 1873', so at 28 outlived his father by only a year.

Charles Field, aged 20, decided to try his luck with his elder brother on the Darjeeling tea plantation. They sailed for Bombay on 22nd January 1872, but, with the opening of the Suez Canal three years earlier, the route was rather different from the one their father had last taken eastwards in 1834. The brothers reached Bombay in a month to the day, on 22 February, and as by now the railway was established, they disembarked and headed for Darjeeling. Here it was Charles's turn to fall ill and he contracted smallpox just as they were leaving ship.[19] Charles was later described by his niece Lucy Cosens as 'not a satisfactory member of the family' and she had lost

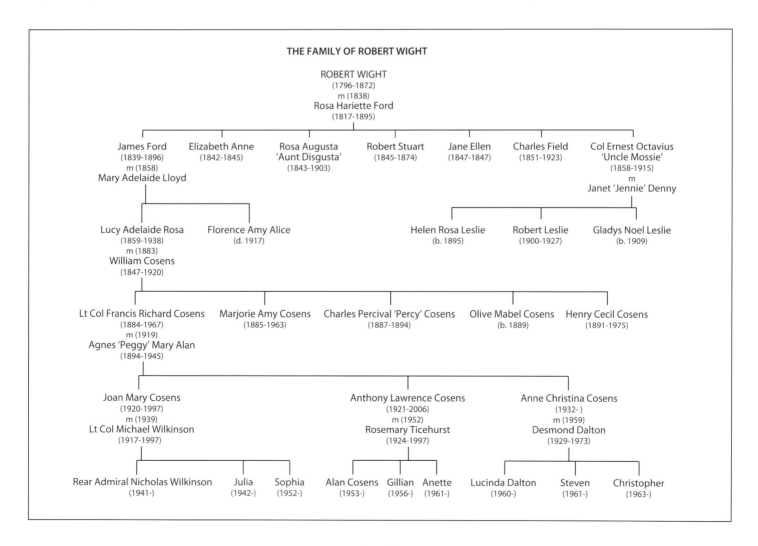

THE FAMILY OF ROBERT WIGHT

touch with him by the time of his death in 1923.[20] Evidently the poor boy never made good, though the nature of his unsatisfactoriness has to be left to the imagination – though his somewhat languid pose in the family photograph [fig.40] hints at one possibility. Whatever it was certainly did Charles no harm in terms of longevity – he was the only one of Wight's children to survive into his seventies, and their father's robust constitution was certainly not inherited by any of Charles's siblings.

In 1866 Wight wrote that 'we have been travelling very quietly down the stream of time with but little to disturb the smooth monotony of our course'.[21] Even given the contemporary reliance on nurses and nannies, the birth of Ernest Octavius on 29 May 1858 when Wight was 62 and Rosa 41 must have caused some ripple in the monotony. As with his older brother Charles's middle name, the Octavius again commemorates Wight's old friend Field. The elder boys escaped the military fate feared by Wight, so it is ironic that the youngest, doubtless a bright spot in Wight's old age, was the one to succumb and follow in his father's footsteps as an army doctor.[22] Ernest was sent to Wellington College,[23] and then undertook medical training at St Mary's Hospital, London.[24] He obtained an Edinburgh LRCP, and a London MRCS in 1881, and joined the Army Medical Service the following February. In 1892 Ernest Wight saw active service on the Lushai Expedition to Burma, reaching the substantive rank of Lieutenant Colonel in the Royal Amy Medical Corps in 1902, and retiring in March 1907, aged 49. Despite his family nickname 'Uncle Mossie' was clearly a man of great courage, morally and physically – he was decorated in Burma and seems to have had a curious affinity with water, receiving a bronze medal and two vellum testimonials from the Royal Humane Society for saving, on separate occasions, no fewer than three different individuals from drowning. After retiring from the army Ernest was involved with the medical branch of the Territorial Force, which explains his reason for joining up again, at the advanced age of 56, after the outbreak of the First World War, and in April 1915 he was made Assistant Director of Medical Services of the 49th Division. As a Colonel, Ernest served for only eight months and was killed 'by a shell whilst assisting to extricate some of his motor ambulances from a dangerous position' on the banks of the Yser Canal near Ypres in Flanders.

None of Ernest's three children left progeny – neither his daughters Helen nor Noel, nor his son Robert who disappeared in Shanghai in 1927. Ernest's widow Janet (née Denny) was still living at Newbury in the 1930s,[25] and it is unfortunate that the fate of her possessions is unknown as these included the portrait reputedly showing Alexander Wight in his militia uniform.

THE CHURCHWARDEN

It has been seen in the discussion of Wight's taxonomic work – and will again, when his views on evolution are discussed – that traditional Christian belief underpinned his science. It seems fairly certain that Wight was baptised into the Presbyterian Church of Scotland, but that he probably became an Anglican on his marriage. This episcopalianism continued in retirement and Wight took an active interest in his local church Holy Trinity, Lambwood Hill, a daughter church of the parish of Shinfield,[26] which had been opened only in September 1850 as a perpetual curacy worth £35 a year.[27] The curate was the Rev Freeman H. Bishop and the living was in the gift of the Bishop of Oxford, which, since 1845, had been 'Soapy Sam' Wilberforce, who in 1860 would gain notoriety as Huxley's adversary at the British Association meeting in Oxford. Wight had been an annual subscriber to the British Association since 1854, but it is not known if he attended the Oxford Meeting, though it would certainly be a possibility given the proximity of Reading to Oxford. Wilberforce was a High Churchman and the Grazeley Church, while simple, was designed by the architect Benjamin Ferrey on Tractarian principles, so the Rev Freeman Bishop is likely to have been of High Church bent. The congregation elected Wight as their Churchwarden on 15 April 1857, continued to do so every year until 1863, and gave him their thanks when he retired in 1864. The vestry minutes record the usual minutiae of a small church whose annual collections in 1859 amounted to only £11 12 4½d – in 1860 Dr Wight had to apply to the vestry of Shinfield for an iron chest in which to hold the church registers, and in 1862 the congregation raised a subscription to drain and fence the churchyard, and erect an iron gate in the porch so that the wooden door could be opened to air the church.[28] It would be just outside this wooden door that Wight was laid to rest in 1872.

Fig.41. The Wight memorial in Grazeley Parish Church.

The Final Years and Last Scientific Work

As Wight was one of the hundred 'scientists, reviewers and theologians' to whom Darwin sent a copy of Asa Gray's pamphlet 'Natural Selection not Inconsistent with Natural Theology' in 1860,[1] it seems likely that Darwin and Wight were acquainted and had perhaps even met through the Royal Society. Fortuitously we know something of Wight's views on Darwin's great theory due to the survival of copies of his half of a correspondence with a Dublin doctor and physiologist, perhaps not inappropriately, named Henry Freke written in December 1862.[2] Nothing is known of how this unlikely correspondence came about, though there is a curious coincidental connection with Wight's youth in that one of Freke's medical positions was in a fever hospital at Kilmainham. Wight's draft letters to Freke, and an 1861 pamphlet by Freke summarising his own book *On the Origin of Species by means of Organic Affinity*, were (and continue to be) preserved by Wight's family, and were published and discussed in an article in *Nature* by Thomas Edward Tucker Bond in 1944.[3] Bond worked at the Tea Research Institute of Ceylon, and had been shown the manuscripts by Henry Cecil Cosens, Wight's great grandson, and a Ceylon tea planter.

Freke claimed priority of publication (in 1851) of what he took to be Darwin's most important point – a common origin for all life.[4] In fact this is the only point of agreement between Darwin and Freke, and was not even original to the latter – for example Erasmus Darwin, in his *Zoonomia*, a work known to Wight, had speculated that at least 'all warm-blooded animals have arisen from one living filament'.[5] Freke must have challenged Darwin on this question of priority, as he is mentioned in the rather inadequate 'Historical Sketch' added by Darwin to the third edition of *Origin*, but Darwin's not even attempting 'the difficult attempt to give any idea of his [Freke's] views' is explained by Freke's periphrastic style, characterised by a plethora of parenthetical clauses, and excessive use of self-quotation and the personal pronoun, by which Bond was 'exasperated and amused in turn'. However, as Bond was prepared to admit, the 'apparent ingenuity and fertility' of Freke's imagination is not entirely without interest, though its abstract, almost mystical, character leaves it open to many interpretations. Freke was fascinated with the cyclical process of life and death and the increasing complexity of organisation from the inorganic to the organic; he was, however, a creationist, and attributed purpose to the 'organizing principles' that he thought acted on the 'embryo of all generations'. Freke provided a complex scheme of these 'organizing principles' acting at different levels from the inorganic upwards through plants and animals. Within plants and animals these acted at each of two levels – 'organizing atoms' with names such as 'georgat' and 'lignat', which produced 'organizing residual products' (i.e., tissues), such as lignin. The 'organizing atoms' of animals, including 'fibrinat' and 'musculat', which acted on the tissues to form muscular fibres and

so on, the whole being part of a cycle with death returning the organised structures to 'mineral atoms'.[6] Lindley's conclusions on this in a review in the *Gardeners' Chronicle* was a monosyllabic 'Pshaw!'; but this is not entirely fair and somewhere, heavily cloaked by the language, there *is* food for thought. When Freke stated that the primary organizing principle might have been 'a chain composed of perhaps but a few individual microscopic granules' Bond, writing in 1944, thought this could *almost* be seen as a 'foreshadowing of the discovery of the linear arrangement of genes in the chromosome', but how much more could one read into it a foreshadowing of the structure of DNA. Similarly when Freke wrote that 'the contents of a single Graffian vesicle could give origin to countless millions of the human race', totipotency and cloning come to mind.

Wight's acknowledgement in letters to Freke of the gifts of his books and pamphlets gave an excuse for a joint critique of both Freke's and Darwin's 'On the Origin of Species'. Despite Wight's comment on Darwin's 'peculiar style', he had clearly read the book with some care.[7] For Wight, and not least in comparison with Freke, these letters are unusually concise and closely reasoned showing that Wight had given the subject serious thought, and, if anything, was thinking more clearly than he, at times, had in India. Curiously the two 'Origin of Species' books were jointly reviewed in 1861 in the *Madras Quarterly Journal of Medical Science* by a 'distinguished contributor' who concluded that:

> the majority of readers will find in Dr Freke's remarkable production, an obscurity of style which will remind them of the "darkness which was on the face of the deep" in the chaotic period which preceded the time when the Creator called into being the "single primordial germ" in which Dr Freke believes.[8]

In a verbose, but heart-felt, pamphlet Freke objected to this and other antagonistic reviews of his works.[9] Given the Madras link one is tempted to wonder if Wight could have been the author of the anonymous review, but the style is not his, nor the grounds for rejecting Freke's theory, and such a communication would have been duplicitous given the tone of Wight's letters to Freke. Wight could not give up his conservative creationist beliefs, based on the Bible, and thought that as both Freke and Darwin admitted the need for the breathing of life into a primordial form, then nothing was gained by omitting a continued intervention on the part of the Creator in the development of life. As with many others since 1859, it was a failure of imagination on Wight's part, and perhaps a lack of a deep understanding of the process of natural selection, that meant he could not:

> with equal readiness comprehend how any amount of such shapeless vitalized atoms should so combine of their own accord, as to form even a mere lichen or puffball much less a sexual seed bearing tree. But having the aid of omnipotence to organize our first atom it behoves us

to return to the same source and solicit his inscrutable wisdom to superadd those laws of combination and arrangement which we find prevailing throughout organic existence thus providing for development and reproduction.[10]

As an example Wight could not see how, even with the passage of myriad years, 'a monocotydedonous grass [could change into] an umbrageous oak'. As he had in India, Wight still believed in fixed, but variable, species and that while a gardener was able to produce 'floral varieties in any number … he can't change an apple into a pear nor a cherry into a plumb [sic]'. Wight's final thoughts were summarised in the form of a rather charming trope – that of an Englishman, an Irishman and a Scotsman – used to compare his own thoughts and beliefs with those of Freke and Darwin:

> I am not by any means satisfied in my own mind that either of you have attained the desired goal [presumably an explanation for present diversity] though you attempt to reach it by such different routes. He [Darwin] starts from the present time and by a rigid process of induction argues that nature commenced her existing animal kingdom by the creation of some 4 or 5 forms her vegetable one by about as many primary vegetable forms thousands of ages ago. Such is the process by which the patient and laborious Saxon goes to work. The rapid thinking & impulsive Celt [i.e., Freke] on the other hand having caught sight of his Theory in the distance straightway bounds to prove by induction that it must be right. While the cautious Scotchman [Wight] looks first at the one & then at the other & right or wrong thinks both have missed the mark & concludes that Moses is the profoundest Philosopher of the three since he is content to take things as he finds them and in one word declares all we know or are ever likely to know by saying God Created without enquiring how.

PHARMACOPOEIA OF INDIA · 1865

In 1865 the Secretary of State for India appointed a 'Pharmacopoiea of India Committee', and in recognition of his enormous contribution to Indian botany Wight was invited to be a member. The committee met for the first time at the India Board Office, Canon Row on 15 March 1865. E.J. Waring, who had been a surgeon in Travancore, was to edit the planned book, and presumably did the bulk of the work – compiling literature and sending lists to medical officers in India for their comments – which came out under his authorship three years later. In addition to Waring the committee of eight included a younger generation of 'professionals': the pharmacologist Daniel Hanbury (1825–75), and two Scottish-Indian medics with strong botanical interests – Thomas Thomson (1817–78) and John Forbes Watson (1827–92), by now officially an economic botanist ('Reporter on Economic Products of India and Keeper of the India Museum'). Also represented was the group to which Wight belonged, a senior and extremely distinguished one of old Indian medical hands: Sir James Ranald Martin (1793–1874), one time Bengal surgeon, and pioneer of medical topography; another former Bengal surgeon, Sir William O'Shaughnessy Brooke (1808–89, Irish, but Edinburgh-trained), best known for his introduction of cannabis into western medicine and his pioneering work on introducing and establishing the Electric Telegraph in India; and Alexander Gibson (1800–68), Bombay surgeon, first Conservator of Forests for Bombay, and Superintendent of the Dapuri Botanic Garden (who like Martin had been in Burma in 1825). Wight had corre-

sponded with Gibson when at Dapuri over *Vogelia indica*, which they jointly described, but assuming that Gibson made the long trip from Auchenreoch, this was the only time they could have met, and Gibson died before the book appeared. If only this committee had been photographed, what a picture it would have been of old and new India, though one still with an overwhelmingly Scottish bias. Although the role of some of the old hands was probably largely advisory, Wight:

> from June 1865 to April 1868 … devoted a considerable portion of his time and attention to the work. He was rarely, if ever, absent from the meetings, though his attendance entailed a journey of sixty miles, and in the intervals he evinced his continued interest by frequent communications on various points.
>
> Although he naturally directed his attention principally to the botanical matter, he afforded much valuable information regarding the medical properties and uses of the plants of Southern India, the result of his own observation and experience. A long and interesting minute which he drew up had a great effect in determining the arrangement of the materials, and it was mainly owing to him and to Dr Thomas Thomson that the natural, in place of the alphabetical, arrangement was adopted. There were some points to which he devoted particular attention: of these may be mentioned the distinctive characters of the Genera *Holarrhena* and *Wrightia*, which up to this time had been involved in considerable confusion. His lucid remarks, the result of his personal examination of specimens in the Banksian, Wallichian, and Kew herbaria, will be found at p. 455 of the Pharmacopoeia of India. He endeavoured, also, to solve the question what plant yields the drug met with in the bazaars of India under the Persian name of Gouzaban … Another point to which he paid much attention, was aconite root, with reference to the period of growth at which it might be expected to yield the largest amount of its active principle aconitia … His interest in the work was sustained throughout, and on all occasions he displayed an untiring energy, clear judgment, and good sound sense, which are seldom found to be united with high scientific attainments such as were possessed by our lamented friend.[11]

Thus, far from being a sinecure, this job represented an Indian summer of Wight's botanical work, and even got him back into the herbarium. Aged 70, he was still fighting for the Natural System, and the experience must have rekindled memories of his work in the Madras Presidency – trying to fix the identity of the native medicines mentioned in Whitelaw Ainslie's by now long outdated *Materia Medica of Hindoostan*.

THE INTERNATIONAL
BOTANICAL CONGRESS, LONDON · 1866

Wight had been a corresponding member of the Horticultural Society of London since 1844,[12] and became a fellow of what by now was the Royal Horticultural Society some time after his return to England. In May 1866 the Society organised a spectacular, four-day International Horticultural Exhibition, held on the site of the 1862 Exhibition in South Kensington. 82,000 people attended, and John Gibson (who had collected orchids in the Khasia Hills for the Duke of Devonshire) landscaped the interior of the huge tent – 563 × 293 feet, covering 3½ acres.[13] This was a grand affair under the patronage of Queen Victoria and in many ways a forerunner of today's Chelsea Flower Show. The railway companies were approached to offer reduced fares for passengers and exhibits travelling to London,

and continental visitors were reminded that 'during Whitsun week unusual facilities will be afforded in the way of low fares by the Railway Companies'.[14] Like 'Chelsea' today tickets for the opening were at a premium and this is doubtless why Wight subscribed five guineas to ensure 'one personal non-transferable ticket, and three other tickets for the opening, and a card for two friends to the two conversazioni'.[15] Alongside the Exhibition was a two-day International Botanical Congress, only the third of its kind ever held. The purpose was 'to reciprocate as far as possible the courtesy and hospitality shown to British Botanists and Horticulturists by their continental brethren' at its predecessors in Brussels and Amsterdam, 'to promote mutual feelings of cordiality … [and] render service to Botany and Horticulture, by bringing [them] into more intimate communication than has hitherto been done in this country, the students of the one and the practitioners of the other, to the advantage of both'. The Congress secretary was Dr Maxwell T. Masters (1833–1907), editor of the *Gardeners' Chronicle* and lecturer in botany at St George's Hospital,[16] and there was a distinguished organising committee including James McNab and Dr Alexander Dickson, from Edinburgh; Charles Cardale Babington and Charles Giles Bridle Daubeny, Professors of Botany at Cambridge and Oxford respectively; Colonel William Munro, Wight's Nilgiri and Bangalore correspondent from thirty years earlier; J.J. Bennett, Robert Brown's friend and successor at the British Museum. The most surprising name on the list is Charles Darwin, and the penultimate one is Wight's – did they ever coincide at one of these meetings, and if so did Darwin quiz Wight about Indian botany?

The Congress meetings were held in the new and still far from complete South Kensington Museum. On 23 May, in the Raphael cartoon gallery (the great paintings had only recently been placed there on permanent loan by Queen Victoria), Wight would have heard Alphonse de Candolle's presidential lecture, which was circulated in French, German and English. Perhaps they reminisced about the work Candolle *père* had carried out on Wight's Indian Compositae in the 1830s. It was here that Wight met for the first time C.F. Meissner of Basle, also after a correspondence of thirty years, 'a striking proof of the value of such gatherings'.[17] The next day, in the Sheepshanks Gallery, Wight himself gave a talk 'On the Phenomenon of Vegetation in the Indian Spring', of which not so much as an abstract has survived. Two other items presented that day must have been of special interest to Wight – the German botanist Justus Karl Hasskarl's key to the plants of Rheede's *Hortus Malabaricus*, and a paper on the species of cotton given by the director of the Florence Botanic Garden, Filippo Parlatore. This was, however, probably the last of Wight's botanical activities, and although he received the prospectus for the International Congress to be held in Paris in August 1867 (and for which Alphonse de Candolle wrote the important '*Lois*' of botanical nomenclature) he did not attend it.

LAST BOTANICAL VISITORS

The most poignant botanical visit to Grazeley must have been that made by Arnott, his wife Mary, and their daughter Fanny, on 8 September 1866. Arnott was on his way home from Falaise in Lower Normandy, where he must have been visiting the algologist Louis Alphonse de Brébisson (1798–1872) – this was his first foreign trip since 1828, and would be his last. Though three years younger than Wight, and only 67, Arnott was 'terribly used up with Rheumatism in the knees & Legs'. Wight offered medical advice – 'try nux vomica in small doses as a "nervine tonic"', but was still disgusted with Arnott's 'trifling so much with his Diatoms'. The highlight of the visit was a day at Kew with Joseph Hooker and Thomas Thomson,[18] and what a meeting this must have been, the two veterans of Indian botany – 'Wight & Arnott', being shown round the garden by the leading lights of the new generation of Indian botanists – 'Hook. f. & Thomson'. Joseph Hooker was apparently 'still more or less an invalid', but was 'most assiduous in brushing up the Gardens which are decidedly improving under his direction' and Thomson seemed 'pretty well, but I understand there is room for improvement' – doubtless referring to his terrible procrastination over the writing of *Flora Indica*. The loss of friends is one of the many pains of growing old, and one that Wight's longevity did not allow him to escape. Wallich had died in 1854, Brown in 1858, William Hooker and Lindley in 1865, Greville in 1866, and Arnott followed them in 1868. It seems unlikely that Wight went north to Glasgow for the funeral, but he did (with Joseph Hooker) attend that of N.B. Ward at Norwood, which took place the same year, on 10 May.[19]

There was, however, a younger generation following, towards whom Wight had been notably generous and well disposed. Among these was Hugh Cleghorn who in 1868 retired as Inspector-General of Forests for India, and returned to his estate of Stravithie near St Andrews. Perhaps appropriately Cleghorn was the last of the recorded botanical visitors to Grazeley, and it is a possibility that it is due to him that the Wight drawings are in Edinburgh. Cleghorn visited the by now sick Wight in November 1870,[20] and as James Dorward (married to one of Rosa's sisters) was also a guest there must have been much reminiscing about Indian botany and the Madras Medical Service.

DEATH AND WILL

Wight was endowed with a tough constitution, and there were remarkably few bouts of illness whilst in India: the malarial episodes at Seringapatam (1824) and Courtallum (1836), and a fever when in Coimbatore in 1844.[21] In 1849 he was able to write that 'my health is as good as when I left home [30 years previously]'.[22] This health continued in what was to be a long retirement, and his first serious illness was not until April 1869;[23] a year later he was 'still very seedy & so shaky that I can't manage a pen & have not yet been out of the house'.[24] Reichenbach referred to bladder problems. A further attack of some sort occurred in February 1871 when Wight was 'so floored that I can neither sit nor stand for half an hour continuously',[25] and yet by October that year he was sowing winter wheat. On 17 March 1872 Wight, however, had felt 'much out of sorts for the last four days',[26] and on 26 May he 'passed away without suffering',[27] aged 76, a surprisingly good age considering his arduous life in India. There is no surviving record of his funeral, which took place in the graveyard at Grazeley, but in view of Wight's generosity to Kew Joseph Hooker must surely have been there. Obituaries appeared in the botanical journals – of these Cleghorn's for the Botanical Society of Edinburgh is by far the most thorough; others were published in the *Gardeners' Chronicle*,[28] the *Journal of Botany*, *Nature*, and the *Proceedings of the Linnean Society*. He was also remembered in the medical press, with two obituaries in the *Medical Times & Gazette*, the second, curiously, appearing next to that of his old friend the ornithologist T.C. Jerdon. The Royal Society did not, however, deem him worthy of the biographical memoir usually

accorded to its Fellows. German-speaking botanists learned of the death through a charming reminiscence by H.G. Reichenbach in the *Botanische Zeitung*. Several of the obituarists commented on Wight's incredible tenacity of purpose including the *Medical Times* which noted that his books were 'compiled under circumstances which would have appalled a less energetic man'. Rosa raised a handsome, if, by 1872, decidedly old-fashioned, black and white marble monument on the chancel wall of Grazeley Church, to which her own name and that of their eldest son James were added in due course.

Wight had made his will on 3 September 1861, naming Rosa, his brother-in-law James Dorward, and Octavius Adolphus Field as his trustees.[29] The contents of the house, including her own clothes and jewellery, the wine, carriages and horses, any cash, or outstanding payments from his pensions, were left to Rosa. His 'Library of Books and … Collections in Natural History' were left to Rosa and the two other trustees, and these, along with the real estate were to be sold (though in the case of the property this could be delayed until after Rosa's death), and the money invested, with the interest going as life rent to Rosa, and after her death to be divided among the children. This is slightly curious, though it should be remembered that by the time Wight died the major part of the collections, the herbarium, had been disposed of. The library was no doubt valuable, but when the estate was proved on 18 June 1872, the effects were valued at 'under £2000'. Although at the time the will was made Ernest was only three years old, by 1872 he was 14 and doubtless away at school, so only Augusta would have been living at Grazeley with her mother. Rosa must have decided that she did not want to go on living there, or could not afford to, and the executors lost no time in putting the house and estate on the market, as it was advertised in *The Times* of 18 July (and in the local press two weeks later) as the home of 'the late Dr Robert Wight, the celebrated Indian Botanist'.

Grazeley Lodge and its small estate was auctioned by Messrs. Haslam and Son at the George Hotel, a sixteenth century coaching inn on the High Street of Reading, on Wednesday August 7th, 1872 'at Two for Three o'clock in the afternoon punctually'. Wight's widow and spinster daughter removed to Staines, and by the time Rosa died twenty-three years later, aged 78, only four of her children were still alive. Of these James survived his mother by only a year, and Augusta by eight, leaving, the 'unsatisfactory' Charles and the youngest, Ernest, who presumably shared what was left of the estate. Charles was unmarried, but Ernest had three children – Robert whose distinguished career in the Royal Navy ended abruptly when he disappeared in Shanghai in 1927, and two daughters, who are not known to have married. The only line to be carried on, therefore, was that of James, the Birmingham Post Master, through his elder daughter Lucy and her marriage to William Cosens.

WIGHT'S CHARACTER

> When in the future it falls to the lot of some historian to sketch the history and progress of Indian Botany, there will be few names worthy of being placed in the same rank with Robert Wight.[30]

Without getting into speculative realms unwarranted from the surviving evidence it would be unwise to attempt to say much about Wight's character and personality. The only contemporary accounts, by people who knew him, are in the obituaries of Cleghorn and

Reichenbach, which, by their very nature would incline towards the flattering. Nonetheless an entirely credible picture emerges from these of someone extremely hard working in the face of adversity, and also kind and generous – which rings true in view of the enormous achievements of his publications and his generosity in the distribution of herbarium specimens. Wight was certainly proud of these achievements and that he had paid for his botanical works himself. The falling out with Wallich in 1845 was a storm in a teacup (and there were faults on both sides): Indian botany is liberally strewn with such flare ups, and can be explained in a large part to difficulties in communication, a sense of isolation, difficult climate and illness. Having said this, Wight does seem to have been abnormally sensitive to criticism, and quick to imagine that he must have caused offence. He could be assertive, even, perhaps, cussid, such as in his protests when he believed that Governors or Governments had treated him unfairly. Such was the case with Lushington in 1828, again when he felt he had been unfairly treated by the Government of India over his economic work in 1837, and ten years later when firstly Tweeddale, then Pottinger, tried to stop the cotton experiments. However in all except the first of these he was backed by the Court, which allowed him to stay on in his final post until he reached the seniority that allowed a very substantial pension. Nothing is known of Wight's politics, though he was certainly conservative in terms of religion and in his unwillingness to take Darwin's evolutionary theory on board. However, there is much in his surviving work that suggests that he was far more of a Whig than his Edinburgh solicitor father is likely to have been, and the arch-Tory that Arnott certainly was. These include the sympathy he often expressed for the Indian *ryot*, his schemes for training of youths of mixed race, and of training convicts in useful skills. The fact that he wrote about his cotton work (against Company rules) to the *Morning Chronicle*, well known as a Whig newspaper, is also suggestive.

Hooker's criticisms of Wight's lack of literary style go rather deeper than they seem, and having waded through his works one does detect a rather slow mind stumbling to express itself in clumsy, repetitive prose. This could account for Wallich's patronising appellation as 'old Wight', when in fact he was ten years his junior. On the other hand, a teacher with whom I discussed this matter suggested that Wight could, perhaps, have been slightly dyslexic.

Rather than speculate on the basis of inadequate evidence, it seems preferable to quote the two contemporaries who gave the most detailed pictures, though these are slight enough considering how well Cleghorn must have known him. Reichenbach's is perhaps the more interesting, being not only by a complete outsider, but one who was not known for generosity of spirit! It was Reichenbach who banned access to the type specimens of his new orchid species until 25 years after his death, something that would have mortified Wight.

H.F.C. Cleghorn:

> To conduct the great works by which Wight's name will ever be remembered, required, in a tropical climate, qualities of no ordinary stamp. In addition to an extensive knowledge of botany, Wight possessed extraordinary industry, with great physical power of endurance; difficulties did not easily thwart him, and he laboured steadily from early morning till late at night with few intermissions …
>
> Allusion has already been made to his great liberality in collecting and distributing duplicates for botanical friends; and good evidence is

afforded of his public spirit and ardent love of his favourite science by his incurring heavy pecuniary risk in the publication of costly illustrated works …

In private life Dr Wight was a man of great generosity and cordiality. Throughout his career he was most liberal and kind in communicating information and rendering assistance to young students of his favourite science; he thereby endeared himself to many, and proved a fast and firm friend.

When failing health precluded him from working, he was always eager to help anyone who wished to avail themselves of the use of his herbarium, and was more anxious for the promotion of botany than for his own celebrity in connection with it. He was an early riser, and of regular and abstemious habits, and he was always anxious to give no trouble of anxiety to any one.[31]

H.G. Reichenbach:

Dr. Wight was of tall stature. His head was the most genuine Celtic head imaginable. The liveliness of his facial expression, his expression of kind-heartedness and intelligence made an immediately favourable impression. He was the experienced, mature man of the world, who was aware of standing beyond all ordinary petty matters. When I knocked at his door for the first time, an imposing gentleman appeared, who could only be Dr. Wight. He immediately put aside my card and guided me as a "friend" to a wide circle of guests from England, India and the Scandinavian Islands sitting at breakfast, to whom he introduced me briefly. After everyone had dispersed in the garden after a long, cheerful chat, he took my card out again and recognized my name with an inevitable "oh, indeed".

Wight's kind-heartedness was extraordinary. It was a pleasure for him to distribute plants – but one was obliged to take them personally. He wanted only the happy face of the recipient as compensation. Yet, Wight was capable of iron strictness. He was one of those who instigated the stepping down of R. Brown from the Presidency of the Linnean Society. Wight sincerely respected R. Brown's merits, but the Scotsman Wight had, together with Englishmen, to oppose his eminent countryman. His sense of justice won out in the heavy struggle …

One may consider who of the splendid phalanx of Indo-British botanists deserves the greatest merit. Nobody should neglect that, under the most difficult conditions, in a spiritual desert, Dr. Wight achieved the feasible with touching compassion. We, who were so lucky to get closer to him and meet him more often, will never forget his dear image.[32]

SIGNIFICANCE AND LEGACY

Wight belongs to an interesting cross-over period, born and raised in Edinburgh at the very end of the Scottish Enlightenment, but lasting long into the period of high Victorian imperialism – when he went to India in 1819 he was blown there by the wind in an East Indiaman, but when he returned in 1853 it was by a P & O steamship. He retired four years before the Mutiny, so his time in India belongs entirely to the Company period, and to one in which the Scots were particularly important in the Madras Presidency. His economic botany work was underpinned by belief in the Enlightenment principle of improvement, and among his last works in India were to send material for the Great Exhibition and advise on timber suitable for railway sleepers.

The Company to varying degrees and at different times believed that the scientific investigation of natural resources could result in financial benefits, and led to Wight's employment first as Madras Naturalist (1826–8), then with a more roving brief on economic botany (1835–42), and finally on cotton (1842–52). There was always a tension in such work between the applied and the abstract, and in the Introduction a criticism was made of historians who consider the motivation for such work solely as a means of political control, or financial gain. Wight (from comments made by himself), and his contemporaries J.F. Royle and R.C. Cole saw no conflict between taxonomic and applied work, but given the personal time and money he put into the former, it seems unduly cynical not to allow that this was something Wight undertook largely from a love of the subject in itself. It should be pointed out that of more than a thousand new species that he 'discovered' and described,[33] only the merest handful have been found to be useful to man.[34] While the motivation of 'pure' science should not be underestimated in Wight's work, neither should the humanitarian vein that runs through the Scottish Enlightenment tradition, identified by Richard Grove.[35] This was given as an explicit inspiration for Sir John Sinclair's pioneering and influential *Statistical Account of Scotland*, and Wight gave the 'alleviation of human suffering' as a reason for investigating medicinal plants; it is also evident in his plans for the instruction of boys of mixed race, and the more useful employment of convicts – both for their own benefit and that of the community.

Wight was wholeheartedly behind the Company's agenda to develop natural resources for export, which he believed would benefit both India and Britain. He also enthusiastically used or recommended new technologies – including lithography, railways, improved ploughs, and the fly shuttle in weaving. The cotton work that occupied him for more than ten years was the culmination of this. The cotton experiment was largely a failure, and while the methods were rather amateur and empirical, and Wight's interpretation of them highly selective and wildly over optimistic, the failure was largely due to factors outwith his control (world trade and Company economic policy).

When Wight did attempt to theorise, such as in his homöothermal and morphological papers, he was decidedly wide of the mark. But he seems to have been aware of his limitations in such matters, and repeatedly stated that he was merely raising issues that he felt unable to pursue, but which others could. In the *Illustrations*, the *Spicilegium*, and many of his papers he showed skill as a synthesiser from a huge variety of sources, for the purpose of educating and disseminating information, and for which he had a missionary zeal. His most significant and lasting work, however, was as what would now be called a documenter of biodiversity: a collector, cataloguer and describer in the eighteenth-century statistical, Roxburghian tradition (though Wight was quick to see the advantages of the Natural System for organising this material, and which he actively promoted). Wight happened to find himself stationed in an area that still had great need of such primary work, the Western Ghats being a 'hotspot of biodiversity', and he was the first to describe and document its Flora on any significant scale using Western taxonomic methods.[36] Wight added hugely to our knowledge of the South Indian flora, describing 1266 new species and 110 new genera, many of which have stood the test of time and are still recognised. The herbarium collections were on an unusually vast scale (several hundred thousand), conforming with H.C. Watson's racial-phrenological stereotype of Scottish botanical collectors. Through

Wight's strenuous efforts at distribution these were made available to botanists worldwide – even in his working life they were dispersed from Boston to St Petersburg, and after his retirement as far afield as Melbourne, South Africa and Calcutta. New species continue to be based on Wight's collections to this day, including many that have been named after him.

However, perhaps Wight's most lasting achievement was his role in aiding identification by means of the publication of illustrations based on the works of his Indian artists. This also followed in the Roxburghian tradition, but was carried on with much greater determination, so that, unlike Roxburgh's, a large proportion of the illustrations Wight commissioned were published within his lifetime. Wight himself was conscious of this when he stated with justifiable pride that by the time he left India, it was the best illustrated flora of any British territory outwith Britain, and he had published illustrations of almost 3000 species. Noteworthy too was his use of lithography so that his artists' work could be disseminated as cheaply as possible. Another of his major services to India after his return from furlough in 1834 was his desire to publish articles and books in India, and establish a tradition there independent of Europe.

It is unfortunate that so little is known of the last 19 years of his life. For someone so hardworking it seems scarcely credible that his family and 66 acres could have occupied his whole energies, either mental or physical, so what did he do? Were there, for example, travels of which no record has survived? Or writings, or unpublished memoirs? This last period is therefore problematic, but only partly due to the lack of documentation. Despite initial intentions to the contrary, and the ultimate accolade from his botanical peers – election to FRS – he did no more botany in his surprisingly long retirement, other than attending the odd meeting, helping others by means of his specimens, and his contribution to the *Pharmacopoeia of India*. By this time, however, the primary descriptive phase for Indian botany was over, and what was required was the synthesis achieved by a younger generation, notably Joseph Hooker. Wight very probably knew Darwin and certainly read the *Origin of Species*. He did believe that species were variable, but only within certain limits, and he also believed in the inheritance of acquired characters. However, his age, conservative nature and religious beliefs precluded his espousal of the theory of natural selection. Neither was he persuaded by the desiccationist theory of deforestation and climate, but it is not given to all to devise new theories or recognise the significance of those provided by others.

Something should, perhaps, be said about this scientific conservatism, which contrasts with Wight's love of new technology. This, perhaps, is to be traced back to his school and university days in Edinburgh, from which he seems never to have broken free. In his time the Royal High School was notoriously old-fashioned, to the extent that only ten years after Wight left it a group of leading intellectuals founded the Edinburgh Academy as a rival.[37] University teaching in Wight's time was also still rooted in the eighteenth century and deeply conservative, using natural theology to justify the existing order. Culturally Wight may to some extent have escaped this, betraying the odd influence of Romanticism in unguarded moments in his appreciation of landscapes, and in his retirement he was still reading Walter Scott. But in his science, with the single exception (under the influence of William Griffith) of trying to use the Quinarian method of classification, he remained a traditionalist, still applying 'vital principles' common to animals and plants in inappropriate places, and the Brunonian concept of irritability, in the mid 1830s. While he was no innovator, Wight can be seen as one of the foot soldiers of early nineteenth century botany, both pure and applied. His greatest legacy lies in his descriptive works, the specimens he amassed, and the drawings he commissioned that will be the subject of Book 2.

Acknowledgements

The author has been helped by a very large number of individuals during the preparation of this book and its companion volumes. He is profoundly grateful to all of them, and offers apologies to any whose names have been inadvertently overlooked.

Firstly to colleagues at RBGE especially the Regius Keeper, Professor Stephen Blackmore and the Director of Science, Professor Mary Gibby, who appreciate the value of this type of work – bringing new life to old collections for the benefit of a wider audience than the taxonomists who have played them close to their chests for so long. Also to those who have provided practical assistance, information or advice: Dr Geoffrey Harper, Dr Mark Hughes, Dr David Long, Tony Miller, Dr Richard Pankhurst, Dr Colin Pendry and Dr Mark Watson. Duncan Reddish and Dr Kerry Walter for computing help; Jane Hutcheon, Graham Hardy, Leonie Paterson and other members of the library staff; Caroline Muir for help with graphics; Hamish Adamson for advice and help with publication; Paul Nesbitt for designing, and Graham Domke for assistance with, the exhibition 'Rungiah & Govindoo: South Indian Botanical Drawings, 1826–1853', held in Inverleith House, April–July 2006.

Secondly to Fram and Avi Dinshaw, friends and generous sponsors, for supporting and encouraging the work in memory of their parents.

To colleagues at the 'other' RBG – Kew. In the herbarium: Dr Nicholas Hind and Dr Dick Brummitt. In the library and archives: John Flanagan, Kate Pickard, Michele Losse, Sylvia Fitzgerald (who first drew my attention to Wight's letters to the Hookers), Marilyn Ward and especially to James Kay for answering numerous requests for information, especially over the watermarks of paper used by Wight and his artists. Also to staff of the Museum of Economic Botany.

Staff of the incomparable Oriental & India Office Collections of the British Library: Graham Shaw, Nalini Persad, Shashi Sen and Andrew Cook, and especially to Drs Savithripreetha Nair and Richard Axelby for providing unpublished information from their project cataloguing natural historical items in the Board's Collections, and for supplying answers to numerous queries.

For continued help and advice: Professor Anna Dallapiccola and Dr Richard Blurton (on matters Indological), and Professors David Mabberley and John McNeill (on matters botanical and nomenclatural).

For reading drafts of Book 3 and making helpful comments: Robert Duncan, Professor Theresa Kelly, the Rt Rev Dr Richard Henderson, Professor Veena Oldenburg and Julian Spalding.

Staff of the following Libraries & Archives: Berkshire Record Office, Reading; Court of the Lord Lyon, Edinburgh (Elizabeth A. Roads, Lyon Clerk and Keeper of the Records, for information on Wight's fake arms); Edinburgh City Archives (Jo Peattie); Edinburgh City Library (Edinburgh Room); Linnean Society of London (Gina Douglas); National Library of Scotland; Natural History Museum (Malcolm Beazley and Chris Mills for lending the NHM Wight collection to the author in Edinburgh for study and cataloguing); Reading Central Library, Local Studies Section (Mr Games); Royal College of Physicians of Edinburgh (Estella Dukan); Royal College of Surgeons of Edinburgh (Marianne Smith); Royal Society of Arts (Lara Webb for information on the medal awarded to Nubboo Comar Pal); Royal Society of London; Special Collections Departments of the Universities of: Edinburgh, Glasgow and St Andrews; University of Birmingham (Philippa Bassett for information about the Rev E. Johnson in the Church Mission Society papers); Worshipful Company of Apothecaries (Dee Cook for information about Wight's Pharmaceutical Medal)

Staff of the following Museums & Galleries: British Museum (Philip Attwood for information on Wight's medals); Liverpool Museums (Dr John Edmondson for information on Wight's copy of Dillwyn's commentary on the *Hortus Malabaricus*); National Museums of Scotland (Alison Taubman for information on Ruthven printing presses); Natural History Museum Birdroom, Tring (Dr Robert Prys-Jones, Mark Adams and Mrs F.E. Warr); Royal Pharmaceutical Society of Great Britain (Briony Hudson); Scottish National Portrait Gallery (James Holloway, Stephen Lloyd and Shona Corner).

Wight's descendants: Gillian Moore and her family for access to papers and artefacts belonging to Wight; Mr & Mrs Charles Maconochie-Welwood for showing me Meadowbank House; Rear-Admiral Nicholas Wilkinson for answering numerous queries and for hospitality on a memorable visit to see the conversation piece of Rosa Wight and her children.

On particular topics: Professor David Arnold for drawing my attention to some of the more scattered items of the Wight correspondence at Kew and helpful discussions on India, the EIC and historiography, and helpful comments on Wight's cotton work; Dr Zoe Badcock who discovered Wight's letters to Thomas Anderson at RBGE; Diane Baptie for undertaking the genealogical research on Wight's forebears; Anne Buddle for information on Tipu; Michael Bury for advice on printing techniques; Professor J.W. Cairns for information about Allan Maconochie; Professor Kurt Fagerstedt for comments on Wight's physiological work; Christopher Fraser-Jenkins for bringing to my attention the Wallich material in the Calcutta Botanic Garden, and for many useful (electronic) discussions; Dr Andrew Grout for making available his notes on Wight's 1835/6 appointment from the National Archives in Delhi; Dr Mark Harrison for commenting on Wight's doctoral thesis; the Hon Launcelot Henderson for translating Bentham's comments on Wight & Arnott's legume work; Niall Hobhouse for information on his ancestor Sir M.E. Grant Duff; Dalya Islam of Sotheby's for attempting to track the fate of Rungiah Raju's albums; the late Christine Mackay for information on the Bengal scroll painters; Dr

Kamakshi Matribhutam for translating the Telugu annotations on the drawings; Dr Sabine Miehe for translating Reichenbach's obituary; Dr Alison Pearn, University of Cambridge, for references to Wight in the Darwin correspondence; Professor Nicholas Phillipson for comments on Wight's economic work; Alan Robertson for information on Frederick Cotton; Allan & Denny Russell for showing me the Old Manse of Blair; Greg Scott for translating Wight's doctoral dissertation; the late Cecil Sinclair for deciphering Wight's will; Professor Peter F. Stevens for comments on the chapter on Wight's taxonomy; Dr Charles Waterston for showing me the Maconochie bust at the Royal Society of Edinburgh.

On two field trips to India invaluable help was provided by the following:

In Calcutta (Kolkata): Aditi Nath Sarkar for information on a wide range of topics, and company on a memorable, if unintentional, trip to the dissection hall of the Medical College, in search of Nubboo Comar Pal. Dr M. Sanjappa, Director of the Botanical Survey of India and his staff at the Indian Botanic Garden, especially Dr H.J. Chowdhery. Mrs Usha Sanjappa, Dr P.V. Prasanna, Dr Sampat Kumar and and Dr Lakshmi Subramanian for translating the Telugu inscriptions on the drawings. Mrs Alka Bangur, President, and Mr Deepak Erasmus, Secretary, (Royal) Agri-Horticultural Society of India.

In Coimbatore: Dr P. Daniel (Botanical Survey of India); Dr T.P. Rajendran and Dr K.N. Gururajan (Central Institute for Cotton Research) and Dr V. Santhanam.

In Delhi: V. Chandranna (for xeroxes of letters between Wight and J.A. Stewart-Mackenzie in TNA).

In Karnataka: Mr C.T.M. Kotraiah (Mysore for help with the Telugu annotations); Dr K.P Ramesh (National Dairy Research Institute, Bangalore); S.S. Nayak (Tipu Sultan Museum, Srirangapattana); J.C. Dasa (Hare Krishna Nature Farm, Mahadevapura)

In Kodaikanal: Bob Stewart and Tanya Balcar (Vattakanal Conservation Trust).

In Madras (Chennai): Staff of the: Botany Department of Presidency College; Government College of Arts and Crafts; Roja Muthiah Research Library (G. Sundar & A. Ganasekar); Tamil Nadu State Archives and the British Council (especially Eunice Crook). And the following individuals without whom I could have achieved nothing in Madras: S.T. Baskaran; K. Dhanavel (Director of Horticulture and Plantation Crops, Tamil Nadu Government); Dr Nanditha Krishna; P.T. Krishnan; S. Muthiah; N. Ram; Rear-Admiral Mohan Raman; O.T. Ravindran; Mrs Annamma Philip; V. Sundaram.

In Ootacamund (Udhagamandalam): R. Lingaraj and family (at Wight's house, Bellevue); H.B. Ramakirhnan and Dr V. Ramsundar (Government Botanical Garden);

Staff of the Nilgiri Library; the Rector of St Stephen's Church and Tarun Chhabra.

In Tanjore (Thanjavur): P. Perumal (Sarasvati Mahal Library)

In Trichy (Tiruchirapalli): the late Father K.M. Matthew SJ

Finally to Robert Dalrymple and Nye Hughes for designing and producing the books with their usual flair and efficiency, and to Fiona Barr for compiling the index.

References to Manuscript Sources

AGRI-HORTICULTURAL SOCIETY OF
INDIA, CALCUTTA (AHSI)
Minute books

BERKSHIRE COUNTRY RECORDS
OFFICE (BCRO)
Grazeley Vestry Book 1854 (D/P/124B/8/1)
Census records, Parish of Shinfield, 1861
(RG 9/751)
Census records, Parish of Shinfield, 1871
(RG 10/1287)

BRITISH LIBRARY (BL)
Egerton Correspondence

ORIENTAL & INDIA OFFICE
COLLECTIONS (OIOIC)
Board of Control's collections (B)
EIC Correspondence (E)
India Office Military Dept records (L/MIL)
India Office Marine records (L/MAR)
Proceedings and Consultations of Madras
Presidency (P)

CALCUTTA BOTANIC GARDEN (CBG)
Wallich Correspondence (WC)

EDINBURGH CITY ARCHIVES (ECA)
Royal High School of Edinburgh: Student
Library Subscription Register 1806–1819
(SL)

LINNEAN SOCIETY OF LONDON
Election certificates of fellows
Miscellaneous MSS

NATIONAL ARCHIVES OF INDIA,
DELHI (NAI)
Land Revenue Records (LRR)

NATIONAL ARCHIVES OF SCOTLAND
(NAS)
Edinburgh Sasine Abridgements

Ormiston Old Parish Registers (OPR)
Ormiston Kirk Session Minutes (CH)

Register of Deeds:
Court of Session & Edinburgh
Commissary Court (RD)

Register of Sasines:
General & Particular for Edinburgh,
Haddington & Linlithgow (RS)

Register of Testaments:
Edinburgh Commissary Court (CC)
Edinburgh Sheriff Court (SC)

MOORE FAMILY
Copy of the Rev J.S. Roper's pedigree of the
Wight family (1936) and related
correspondence between Roper, Lucy
Cosens and Janet Wight
Wight MSS relating to cotton and evolution

NATIONAL LIBRARY OF SCOTLAND
(NLS)
Saltoun Papers

PROBATE SEARCH ROOM, PRINCIPAL
REGISTRY OF THE FAMILY DIVISION,
LONDON
Wight's will – proved 18 June 1872

ROYAL BOTANIC GARDEN EDINBURGH
(RBGE)
Correspondence of T. Anderson (AC)
Correspondence of J.H. Balfour (BC)

ROYAL BOTANIC GARDENS KEW (RBGK)
Correspondence of George Bentham (BC)
Director's Correspondence (DC)
Herbarium Presentations to 1900 (HP)
Correspondence of J.D. Hooker (JDH)
Correspondence of John Lindley (LC)
Correspondence of William Munro (MC)
Correspondence of Nathaniel Wallich
(1841–9) (WC)
Museum Donation Books (MDB)

ROYAL COLLEGE OF SURGEONS,
EDINBURGH (RCSE)
Records 1810–22

ROYAL SOCIETY OF LONDON
Election certificates of Fellows

TAMIL NADU ARCHIVES, CHENNAI
(TNA)
Board of Revenue Proceedings (BRP)
Miltary Dept. Consultations (MDC)
Public Dept. Despatches to England (PDD)
Revenue Dept. Consultations (RDC)

UNIVERSITY OF EDINBURGH
University Matriculation Rolls, 1804–16,
1816–28
Medical and General Registers

WILKINSON FAMILY
Photographs of the Wight family and
miscellaneous letters
Copy of James Ford Wight's will

Bibliography

I. WIGHT'S PUBLICATIONS

(only ones referred to in the text are cited here, a full bibliography is given in Noltie, 2005).

WIGHT, R. (1818). *Dissertatio Medica Inauguralis: De Febrium Natura, Scalpello Quaesita*. Edinburgh: Neill & Co.

WIGHT, RICHARD (SIC) (1831). *Illustrations of Indian Botany; Principally of the Southern Parts of the Peninsula* (ed. W.J. Hooker). Glasgow: Curll & Bell.
Note. This consists of reprints and preprints of articles published by Hooker in the *Botanical Miscellany* and is not to be confused with the later work of the same title published in Madras 1838–50.

WIGHT, R. (1834c). *Contributions to the Botany of India*. London: Parbury, Allen & Co.

[WIGHT, R.] (1834d). [Review of] Illustrations of the Botany and other branches of the Natural History of the Himalayan Mountains and of the Flora of Cashmere. By John F. Royle, F.L.S. and G.S.M.R.A.S. &c. *Madras Journal of Literature and Science* 1: 316–329.

WIGHT, R. (1835a). Observations on Mudar (*Calotropis procera*), with some remarks on the medical properties of the natural order Asclepiadeae [prefaced, pp. 69–70, with letter to editor]. *Madras Journal of Literature and Science* 2: 70–86 + plate.

WIGHT, R. (1835b). Observations on the nuth grass [*Ischaemum pilosum*] of the Ceded Districts. *Madras Journal of Literature and Science* 2: 138–145 + plate.

WIGHT, R. (1835c). Observations on the flora of Courtallum. *Madras Journal of Literature and Science* 2: 380–391.

WIGHT, R. (1836a). Suggestions for a new application of grafting. *Madras Journal of Literature and Science* 3: 26–32.

WIGHT, R. (1836b). On the cause of the land winds of Coromandel. *Madras Journal of Literature and Science* 3: 32–35.

WIGHT, R. (1836c). Observations on the flora of Courtallum. *Madras Journal of Literature and Science* 3: 84–96.

WIGHT, R. (1836d). Some account of a botanical excursion, made in the neighbourhood of Courtallum, and in the adjacent mountains. *Companion to the Botanical Magazine* 1: 326–32.

WIGHT, R. (1836e). Observations on the flora of Courtallum. *Madras Journal of Literature and Science* 4: 57–66.

WIGHT, R. (1836f). On the tree which produces the gamboge of commerce. *Madras Journal of Literature and Science* 4: 300–304 + t. 9.

WIGHT, R. (1836g). An account of the harbour of Tuticoreen. *Madras Journal of Literature and Science* 4: 305–308 + t. 10.

WIGHT, R. (1836h). [Letter about the Pulney Mountains]. *Madras Journal of Literature and Science* 4: 431–432.

WIGHT, R. (1837a). Contributions to Indian botany – No. 1. On the genus *Impatiens*. *Madras Journal of Literature and Science* 5: 1–15 + t. 1–9.

WIGHT, R. (1837c). On the homöothermal method of acclimating extra-tropical plants within the tropics. *Madras Journal of Literature and Science* 5: 39–43.

WIGHT, R. (1837d). Statistical observations on the Vurragherries, or Pulney Mountains. *Madras Journal of Literature and Science* 5: 280–289.

WIGHT, R. (1837e). Further observations regarding the homöothermal method of acclimating extra-tropical plants within the tropics. *Madras Journal of Literature and Science* 5: 290–300.

WIGHT, R. (1837f). Contributions to Indian botany – No. 2. [*Dictyocarpus, Nimmoia*]. *Madras Journal of Literature and Science*. 5: 309–313 + t. 19, 20.

WIGHT, R. (1837g). [Addenda to article on *Cassia Lanceolata* by N. Wallich] 'Being practical remarks on the culture and preparation of senna in the Madras Territories'. *Madras Journal of Literature and Science* 5: 358–362.

WIGHT, R. (1837h). Postscript [to article on gamboge]. *Madras Journal of Literature and Science* 5: 428–429.

WIGHT, R. (1837i). Directions for preserving plants. *Madras Journal of Literature and Science* 5: 429–431 [prefaced by a letter to R. Cole].

WIGHT, R. (1837j). Notice (with a plate) of the Cassia Burmanni, with remarks on the Materia Medica of India. *Madras Journal of Literature and Science* 6: 71–75 + t. 5.

WIGHT, R. (1837k). Remarks on the culture of cotton; principally with reference to the finer foreign varieties. *Madras Journal of Literature and Science* 6: 79–111.

WIGHT, R. (1837l). Proposed new work on Indian Botany. *Madras Journal of Literature and Science* 6: 469–473 + plate.

[WIGHT, R.] (1838a). [A plate of lichens drawn by Rungiah, lithographed by Wight, issued to accompany: authors various, 'XL. Lichens. Communications from the Royal Asiatic Society of Great Britain and Ireland, and from the Asiatic Society of Calcutta, on the importance of drawing general attention to the subject of lichens']. *Transactions of the Agricultural and Horticultural Society of India* 5: 86–94.

WIGHT, R. (1838c). On the tree which produces the gamboge of commerce by Robert Wight, M.D. [reprint of article in *Madras Journal of Literature and Science* 4: 300–304 (1836)]. With remarks by Dr [R.] Graham. *Edinburgh New Philosophical Journal* 24: 106–111.

WIGHT, R. (1838e). *Illustrations of Indian Botany; or Figures Illustrative of Each of the Natural Orders of Indian Plants, Described in the Author's Prodromus Florae Peninsulae Indiae Orientalis; with observations, on their botanical relations, economical uses, and medicinal properties; including descriptions of recently discovered or imperfectly known plants*. Vol. I, parts 1–6, pp. 1–130, tt. 1–45. Madras: For the author by J.B. Pharoah.

WIGHT, R. (1838f). *Icones Plantarum Indiae Orientalis, or Figures of Indian Plants*. Vol. I, No. 1, p.[1], tt. 1–20. Madras: For the author by J.B. Pharoah.

WIGHT, R. (1838i). *Illustrations of Indian Botany* …. Vol. I, part 7, pp. 131–144, tt. 46–53. Madras: For the author by J.B. Pharoah.

WIGHT, R. (1839b). *The Mauritius Sugar Cane*. Directions for the cultivation drawn up and circulated by the Agri-Horticultural Society of Madras at the latter end of 1839. No copy of this pamphlet seen, but reprinted in Wight (1842) and in *The Madras Almanac and Compendium of Intelligence for 1842*, pp. 136–2–136–4. Madras: Asylum Press.

WIGHT, R. (1839c). *Illustrations of Indian Botany* …. Vol. I, parts 8–12, pp. 145–198, tt. 54–84. Madras: For the author by J.B. Pharoah.

WIGHT, R. (1839d). Remarks on Gambogia Gutta Linn., – Stalagmites Gambogioides, Murray; and Laurus Cassia Linn. *Madras Journal of Literature and Science* 9: 121–135.

WIGHT, R. (1839f). *Icones Plantarum Indiae Orientalis* …. Vol. I, No. 7, p.[1], tt. 122–141. Madras: For the author by J.B. Pharoah.

WIGHT, R. (1840a). *Illustrations of Indian Botany* …. Vol. I, part 13, pp. 199–218, tt. 85–95. Madras: For the author by J.B. Pharoah.

WIGHT, R. (1840e). *Icones Plantarum Indiae Orientalis …* . Vol. 1, No. 16, p.[1], tt. 299–318. Madras: For the author by J.B. Pharoah.

WIGHT, R. (1840g). Remarks on the fruit of the Natural Order Cucurbitaceae. *Madras Journal of Literature and Science* 12: 43–54 + plate.

WIGHT, R. (1840h). On the separation of the pomegranate as a distinct Natural Order from Myrtaceae. *Madras Journal of Literature and Science* 12: 254–260 + t. 8.

[WIGHT, R.] (1840i). Recent botanical letters of Dr Robert Wight, addressed to G.A.W. Arnott, Esq., LL.D. *Journal of Botany (Hooker)* 3: 156–201, [with Portrait].

WIGHT, R. (1841a). *Illustrations of Indian Botany … .* Vol. 2, part 1, pp. 1–67, tt. 96–119. Madras: For the author by P.R. Hunt, American Mission Press.

WIGHT, R. (ED.) (1842). *Proceedings of the Agricultural and Horticultural Society of Madras.* Madras: Spectator Press.

WIGHT, R. (1843a). Suggestions for the better transmission of plants from one part of India to another. *Journal of the Agricultural and Horticultural Society of India* 2(1): 85–86.

WIGHT, R. (1843f). *Icones Plantarum Indiae Orientalis … .* Vol. 2, Part 4, pp.[1–]2–7, tt. 632–736. Madras: For the author by J.B. Pharoah.

WIGHT, R. (1844a). Extract notes on American cotton agriculture, as practised on the Government Cotton Farms in Coimbatore. *Journal of the Agricultural and Horticultural Society of India* 3 (Correspondence & Selections): 126–139.

WIGHT, R. (1844b). *Icones Plantarum Indiae Orientalis … .* Vol. 3, Part 1, pp.[1–]2–7, tt. 737–815. Madras: Athenaeum Press, for the author, sold by Messrs. Franck and Co.

WIGHT, R. (1844–5). *Icones Plantarum Indiae Orientalis … .* Vol. 3, Part 2, pp.[1–]2–12, tt. 816–930. Madras: Athenaeum Press, for the author, sold by Messrs. Franck and Co.

WIGHT, R. (1845a). Remarks on the cultivation of American cotton in India, deduced from experiments conducted in Coimbatore. Forming pp. 18–27 of *Report of Proceedings of the Madras Chamber of Commerce, in continuation of last report published in 1841.* Madras: Athenaeum Press.

WIGHT, R. (1845c). Extract of a letter from R. Wight [on the subject of William Griffith's papers]. *Calcutta Journal of Natural History* 6: 300–306.

WIGHT, R. (1845d). *Spicilegium Neilgherrense or a Selection of Neilgherry Plants. Drawn and coloured from nature, with brief descriptions of each; some general remarks on the geography and affinities of natural families of plants, and occasional notices of their economical properties and uses.* Vol. 1, part 1, pp.[1–]2–42, tt. 1–50. Madras: For the author, sold by Franck & Co.

WIGHT, R. (1845f). Notes on Indian Botany. 'On the structure of the ovarium and generic character of Viburnum' and 'Description of some new species of Loranthus'. *Calcutta Journal of Natural History* 6: 357–363.

WIGHT, R. (1845g). *Icones Plantarum Indiae Orientalis … .* Vol. 3, Part 3, pp.[1–]2–17, tt. 931–1046. Madras: Athenaeum Press, for the author, sold by Messrs. Franck and Co.

WIGHT, R. (1846a). Notes on Indian Botany. 'On the genus Lasianthus, Jack'. *Calcutta Journal of Natural History* 6: 494–518.

WIGHT, R. (1846b). Letter to editor of the *Morning Chronicle* (no. 23, 831), 13 March 1846, p. 5.

WIGHT, R. (1847a). *Spicilegium Neilgherrense … .* Vol. 1, part 2, pp. 43–85, tt. 51–102. Madras: For the author, sold by Franck & Co.

WIGHT, R. (1848a). *Spicilegium Neilgherrense … .* Vol. 2, part 1, pp.[1–]2–44, tt. 103–151. Madras: Printed for the author, by P.R. Hunt, American Mission Press.

WIGHT, R. (1848b). On the culture of American cotton in India, and the proper time for sowing it in various localities. *Journal of the Agricultural and Horticultural Society of India* 6(1): 118–122.

WIGHT, R. (1848c). Further remarks regarding the cultivation of the Mexican cotton plant in India, and the proper season for sowing. *Journal of the Agricultural and Horticultural Society of India* 6(3): 189–196.

WIGHT, R. (1848d). An improved machine for divesting indigenous cotton of its seed. *Journal of the Agricultural and Horticultural Society of India* 6 (Proceedings): 20–21.

WIGHT, R. (1848e). *Icones Plantarum Indiae Orientalis … .* Vol. 4, Part 1, pp.[1–]2–17, tt. 1163–1282. Madras: For the author, printed by P.R. Hunt, American Mission Press.

WIGHT, R. (1848g). *Illustrations of Indian Botany … .* Vol. 2, part 2, pp. 67(bis)–108, tt. 122–134. Madras: For the author by P.R. Hunt, American Mission Press.

WIGHT, R. (1849b). *Illustrations of Indian Botany … .* Vol. 2, part 3, pp. 109–173, tt. 135–156b. Madras: For the author by P.R. Hunt, American Mission Press.

WIGHT, R. (1850a). Further observations regarding the cultivation of American Cotton in India, and the most suitable season for sowing. *Journal of the Agricultural and Horticultural Society of India* 7: 20–30.

WIGHT, R. (1850b). [Letter with comments on a Report on the cultivation of Mexican cotton in India]. *Journal of the Agricultural and Horticultural Society of India* 7: 211–214.

WIGHT, R. (1850c). Replies from Coimbatore [in response to questionnaire 'on the mode and cost of separating cotton-wool from the seed in various parts of India']. *Journal of the Agricultural and Horticultural Society of India* 7: 249–50.

WIGHT, R. (1850d). *Illustrations of Indian Botany … .* Vol. 2, part 4, pp. 174–230, tt. 157–181. Madras: For the author by P.R. Hunt, American Mission Press.

WIGHT, R. (1850f). *Observations on the Forest Trees of Southern India.* Madras: Fort St George Gazette Press.

WIGHT, R. (1851a). *Spicilegium Neilgherrense … .* Vol. 2, part 2, pp. 45–94, tt. 152–202. Madras: Printed for the author, by P.R. Hunt, American Mission Press.

WIGHT, R. (1852). *Icones Plantarum Indiae Orientalis … .* Vol. 5, Part 2, pp. 1–35, tt. 1763–1920. Madras: For the author, printed by P.R. Hunt, American Mission Press.

WIGHT, R. (1853b). *Icones Plantarum Indiae Orientalis … .* Vol. 6, pp. 1–44, tt. 1921–2101. Madras: For the author, printed by P.R. Hunt, American Mission Press.

WIGHT, R. (1854a). Further remarks respecting the naturalization of the American Cotton plant in India. *Journal of the Agricultural and Horticultural Society of India* 8 (Correspondence & selections): 27–35.

WIGHT, R. (1854b). Dr Wight's remarks on Mr McIvor's report on the Horticultural Gardens [of Ootacamund]. *Journal of the Agricultural and Horticultural Society of India* 8 (Correspondence & selections): 107–115.

WIGHT, R. (1861). Cotton Cultivation in India. *Gardeners' Chronicle* 1861: 946; 967–8; 985–6; 1007; 1027; 1047–8; 1093; 1116.

WIGHT, R. (1862). *Notes on cotton farming, explanatory of the American and East Indian Methods, with suggestions for their improvement.* Reading & London.

1.2 JOINT PUBLICATIONS

INGLEDEW, W. [& WIGHT, R.] (1837). Treatise on the Culture of the Red Rose, Strawberry, Brazil Gooseberry, Peach, Mango, and Grape Vine. Published under the direction of the Madras Agricultural and Horticultural Society. With Notes by R. Wight, M.D. F.L.S. pp.[i–]iv–xxvii; [1–]2–40; Frontispiece. Madras: For the Society at the Asylum Press.

WIGHT, R. & GARDNER, G. (1845). Observations on the structure and affinities of the genus "Azima" of Lamarck. *Calcutta Journal of Natural History* 6: 49–56; t. 1.

[WIGHT, R. & WALKER-ARNOTT, G.A.] (1833b). [*Wight's Catalogue*, part 1, pp. 1–64]. [Edinburgh].

WIGHT, R. & WALKER-ARNOTT, G.A. (1834a). *Prodromus Florae Peninsulae Indiae Orientalis.* London: Parbury, Allen & Co.

[WIGHT, R. & WALKER-ARNOTT, G.A.] (1834b). [*Wight's Catalogue*, part 2, pp. 65–112]. [Edinburgh].

[WIGHT, R. & WALKER-ARNOTT, G.A.] (1836d). [*Wight's Catalogue*, part 3, pp. 113–128]. [Edinburgh].

[WIGHT, R. & WALKER-ARNOTT, G.A.] (1837e). [*Wight's Catalogue*, part 4, pp. 129–144]. [Edinburgh].

2. GOVERNMENT PUBLICATIONS (RELATING TO WIGHT'S COTTON WORK)

Papers by Wight are published in the following volumes of Parliamentary Papers (abbreviated in the text as PP1, PP2, FRIT):

PP1: 1847 volume XLII (439). Accounts and Papers (9 of 37) Cotton (India). Papers … showing what measures have been taken since 1836 to promote the cultivation of cotton in India … London: House of Commons, 21 May 1847, ed. J.C. Melvill.

PP2: 1857 VOLUME XXXI (i). (296) Accounts and Papers (7(1) of 21) East India (Cotton). Selection of papers, showing the measures taken since 1847 to promote the cultivation of cotton in India. London: House of Commons, 24 August 1847, ed. J.C. Melvill.

Note. PP1 & PP2 both include more than one pagination sequence. The copies belonging to the author (ex Home Office Library) have been annotated in MS with a unique sequence from the start of the volume – as other copies have probably been similarly annotated these MS numbers have also been given: non-unique printed page number/unique MS page number.

FRIT: Fourth Report from the Select Committee on Indian Territories. London: House of Commons, 30 June 1853.

A fourth volume of Parliamentary Papers (PP3) is relevant to Wight's cotton work (especially the evidence by J.F. Royle, J. Petrie and J. Sullivan), though does not contain any of his own papers:

PP3: Reports from Committees, 1847–8. Vol.x (511). Report from the Select Committee on the Growth of Cotton in India. London: House of Commons, 17 July 1848.

3. PERIODICALS CONSULTED

The East India Register & Directory for … [1819–53]. Published in London, with two editions each year, by Cox & Baylis (1819–26), J.L. Cox (1826–40), W.H. Allen (1841–53) [consulted at OIOC, OIR 354.54].

EDINBURGH & LEITH DIRECTORY. CONSULTED FROM 1796 EDITION (T. AITCHISON). Continued from 1805 as *Post Office Annual Directory* [consulted at Edinburgh Room, City of Edinburgh Library].

Fort St George Gazette [consulted at OIOC, V/11/1590–1607].

The Madras Almanacs [1819–53]. Two different publishers produced these, for which typical publication details are:

i) *The Madras New Almanac, General Directory and Register for 1841.* Madras: J.B. Pharaoh, Mount Road. [consulted at TNA]

ii) *The Madras Almanac and Compendium of Intelligence for 1842.* Madras: Edmund Marsden, Asylum Press, Mount Road. [consulted at OIOC, OIR 954.8]

4. BOOKS CONSULTED

AIYAPPAN, A. (1999). Hundred years of the Madras Government Museum (1851–1951), in *Madras Government Museum Centenary Souvenir*, ed. Anon, pp. 1–58. Chennai: Government Museum.

ALLAN, M. (1967). *The Hookers of Kew, 1785–1911.* London: Michael Joseph.

ALLEN, L.L. (2000). *The World's Show: Coincraft's Catalogue of Crystal Palace Medals and Tokens 1851–1936.* London: Coincraft.

ANON (1816). *Laws of the Royal College of Surgeons of Edinburgh.* Edinburgh: J. Hay & Co.

ANON (1861). [Joint review of 'On the Origin of Species by means of Natural Selection' by Charles Darwin, Third Edition & 'On the Origin of Species by means of Natural Affinity' by H. Freke]. *Madras Quarterly Journal of Medical Science* 3: 370–385.

ANON (1868). *Edward Cassy and Co.'s History, Gazetteer, and Directory of Berkshire and Oxfordshire.* London: Thomas Danks.

ANON (1872/3). Robert Wight. *Proceedings of the Linnean Society of London* 1872–3: xliv–xlvii.

ANON (1896). People we know [James Ford Wight]. *Our City* [Birmingham] 1 (n.s.): [1].

ANON (1912). Sir Joseph Dalton Hooker 1817–1911. *Kew Bulletin* 1912: 1–34.

ANON (1913). The Wallichian Herbarium. *Kew Bulletin* 1913: 255–263.

ANDERSON, R.D., LYNCH, M. & PHILLIPSON, N. (2003). *The University of Edinburgh: an Illustrated History.* Edinburgh: Edinburgh University Press.

ARCHER, M. & LIGHTBOWN, R. (1982). *India Observed: India as viewed by British Artists 1760–1860.* London: Victoria and Albert Museum

ARNOLD, D. (2005). *The Tropics and the Travelling Gaze.* Delhi: Permanent Black.

BAIKIE, R. (1834). *Observations on the Neilgherries, including an account of their Topography, Climate, Soil & Productions, and of the effects of the climate on the European Constitution: with maps of the hills and the approaches to them, sketches of the scenery, drawings of the principal buildings, tables of routes, &c.* Calcutta: Baptist Mission Press.

BALASUBRAMANIAM, R. (1965). *Monograph on Cotton in Madras State.* Madras: Government of Madras.

BALFOUR, E.[G]. (1862). *The Timber Trees, Timber and Fancy Woods, as also, the Forests, of India and of Eastern and Southern Asia.* 2nd ed. Madras: Printed at the Union Press, by Cookson and Co.

BARKER, G.F.R. (1909). Miller, Sir William, Lord Glenlee (1755–1846) in *Dictionary of National Biography* (ed. Sydney Lee) 13: 426–7. London: Smith, Elder & Co.

BENTHAM, G. (1837). *Commentationes de Leguminosarum Generibus.* Vienna: J.P. Sollingeri.

BOND, T.E.T. (1944). Robert Wight (1796–1872), Dr. Freke and the "Origin of Species". *Nature* 154: 566–9.

BOOTT, F. (1844). On a species of Carex allied to C. saxatilis, Linn. *Transactions of the Linnean Society* 19: 215–20.

BRANDON-JONES, C. (2004). Blyth, Edward (1810–73) in *Oxford Dictionary of National Biography* (ed. H.C.G. Matthew & B. Harrison) 6: 362–3. Oxford: Oxford University Press

[BROUGHAM, HENRY LORD] (1845). A Memoir of Allan Lord Meadowbank. *The Law Review and Quarterly Journal of British and Foreign Jurisprudence*, 2: 72–80 [also reprinted as a pamphlet with introduction by Alexander, 2nd Lord Meadowbank. In neither form is Brougham's name given as author, though it is revealed by the statement that the author 'held the highest legal office under the Crown' – Brougham was Lord Chancellor 1830–4].

BROWN, R. (1818). *Observations, Systematical and Geographical, on the Herbarium Collected by Professor Christian Smith, in the Vicinity of the Congo … in the year 1816.* Quoted from *The Miscellaneous Botanical Works of Robert Brown, Esq., D.C.L., F.R.S.* Vol. 1 (ed. J.J. Bennett, 1866). London: Ray Society.

BROWNE, J. (2003). *Charles Darwin: Voyaging. Volume 1 of a Biography* [first published 1995]. London: Pimlico.

BURKE, J.B. (1852). *A Genealogical & Heraldic Dictionary of the Landed Gentry of Great Britain & Ireland for 1852.* 2 vols. London: Colburn & Co.

BURKILL, I.B. (1965). *Chapters on the History of Botany in India.* Calcutta: Botanical Survey of India.

BURTON, R.F. (1851). *Goa and the Blue Mountains; or, Six Months of Sick Leave.* London: Richard Bentley.

BYROM, C. (2005). *The Edinburgh New Town Gardens.* Edinburgh: Birlinn.

CAIRNS, J.W. (2004). Maconochie, Allan, Lord Meadowbank (1748–1816) in *Oxford Dictionary of National Biography* (ed. H.C.G. Matthew & B. Harrison) 35: 975–6. Oxford: Oxford University Press.

CAIRNS, J.W. (2005). The first Edinburgh chair in Law: Grotius and the Scottish Enlightenment in *Ex Iusta Causa Traditum: Essays in Honour of Eric H. Pool*, ed. R. van der Bergh, pp. 32–58. Pretoria: Unisa.

CANDAUX, J.-D. & DROUIN, J.-M. (2004). *Augustin Pyramus de Candolle, Mémoires et Souvenirs (1778–1841).* Genève et Paris: Bibliothèque d'Histoire des Sciences.

CANDOLLE, R. DE & RADCLIFFE-SMITH, A. (1981). Nathaniel Wallich … and the Herbarium of the Honourable East India Company, and their relation to the de Candolles of Geneva and the Great Prodromus. *Botanical Journal of the Linnean Society* 83: 325–348.

CASSELS, W.R. (1862). *Cotton: an account of its culture in the Bombay Presidency, prepared from Government records and other authentic sources in accordance with a resolution of the Government of India.* Bombay: Bombay Education Society's Press.

CHOISY, J.D. (1833). Convolvulaceae Orientales. *Mémoires de la société de physique et d'histoire naturelle de Genève* 6: 383–502; tt. 1–6.

CHRISTISON, R. (1837). On the sources and composition of gamboge, with an examination of some analagous concrete juices. *Companion to the Botanical Magazine* 2: 233–245.

[CHRISTISON, SIR R.] (1885). *The Life of Sir Robert Christison, Bart.* Edited by his sons. 2 vols. Edinburgh: William Blackwood & Sons.

CLARK, A. (1992). *An Enlightened Scot. Hugh Cleghorn, 1752–1837.* Duns: Black Ace Books.

CLEGHORN, H.[F.C.], ROYLE, [J.]F., BAIRD SMITH, R. & STRACHEY, R. (1852). Report of the committee appointed by the British Association to consider the probable effects in an œconomical and physical point of view of the destruction of tropical forests. *Report of the Twenty-first Meeting of the British Association for the Advancement of Science; held at Ipswich in July 1851.* London: John Murray.

CLEGHORN, H.[F.C.] (1853). *Hortus Madraspatensis. Catalogue of Plants, Indigenous and Naturalized, in the Agri-Horticultural Society's Gardens, Madras.* Madras: Printed for the Society at the American Mission Press.

CLEGHORN, H.[F.C.]. (1861). *Forests and Gardens of South India.* London: W.H. Allen & Co.

CLEGHORN, H.F.C. (1868). Biographical notice of the late Dr Walker-Arnott, Regius Professor of Botany in the University of Glasgow. *Transactions of the Botanical Society [of Edinburgh]* 9: 414–426.

CLEGHORN, H.F.C. (1873). Obituary notice of Dr. Robert Wight, F.R.S. (with portrait). *Transactions of the Botanical Society [of Edinburgh]* 11: 363–388.

COCKBURN, H. (1910). *Memorials of his Time.* Edinburgh & London: T.N. Foulis.

COTTON, J.J. (1905). *List of Inscriptions on Tombs and Monuments in Madras.* Madras: Government Press.

CRAWFORD, D.G. (1930). *Roll of the Indian Medical Service, 1615–1930.* London: W. Thacker & Co.

DARWIN, C. (1868). *The Variation of Animals and Plants under Domestication.* 2 vols. London: John Murray.

DARWIN, E. (1791). *The Botanic Garden.* 3rd ed. 2 vols. London: J. Johnson.

DARWIN, E. (1801). *Zoonomia; or, the Laws of Organic Life.* 3rd ed. 4 vols. London: J. Johnson.

DESMOND, R. (1982). *The India Museum 1801–1879.* London: Her Majesty's Stationery Office.

DESMOND, R. (1982). *Victorian India in Focus.* London: Her Majesty's Stationery Office.

DESMOND, R. (1992). *The European Discovery of the Indian Flora.* London: Royal Botanic Gardens [Kew] and Oxford University Press.

DESMOND, R. (1994). *Dictionary of British and Irish Botanists and Horticulturists.* London: Taylor & Francis, and The Natural History Museum.

DESMOND, R. (1995). *Kew: the History of the Royal Botanic Gardens.* London: Harvill Press.

DESMOND, A. & MOORE, J. (1991). *Darwin.* London: Michael Joseph.

EDWARDS, [W.F.] & COLIN, [?] (1836). Mémoire de physiologie agricole sur la végétation des Céréales sous de hautes températures. *Annales des Sciences Naturelles*, sér. 2, 5: 5–23.

EGERTON, F.N. (2003). *Hewett Cottrell Watson: Victorian plant ecologist and evolutionist.* Aldershot: Ashgate.

EISENDRATH, E.R. (1961). Portraits of Plants: a limited study of the "Icones". *Annals of the Missouri Botanical Garden* 48: 291–327.

ELLIOTT, B. (1993). The origins of floral diagrams. *The Garden* 118: 24–7.

FILIPIUK, M. (ED.) (1997). *George Bentham: Autobiography 1800–1834.* Toronto: University of Toronto Press.

FORD, A. (1967). *The 1826 Journal of John James Audubon.* New York: Abbeville Press.

FRASER-JENKINS, C.R. (2006). *The First Botanical Collectors in Nepal – The Fern Collections of Hamilton, Gardner and Wallich – lost herbaria, a lost botanist, lost letters and lost books somewhat rediscovered.* Dehra Dun: Bishen Singh Mahendra Pal Singh.

FREKE, H. (1862). *An Appeal to Physiologists and the Press.* Dublin: Fannin and Company.

FRYXELL, P.A. [1979]. *The Natural History of the Cotton Tribe (Malvaceae, Tribe Gossypieae).* College Station: Texas A & M University Press.

GAGE, A.T. (1938). *A History of the Linnean Society of London.* London: Printed for the Linnean Society by Taylor & Francis.

GARDNER, G. (1845). Notes of a botanical visit to Madras, Coimbatore, and the Neilgherry Mountains. *London Journal of Botany* 4: 393–409; 551–67.

GARDNER, G. (1846). Observations on the structure and affinities of the plants belonging to the Natural Order Podostemaceae. *Calcutta Journal of Natural History* 7: 165–189.

GARDNER, G. (1847). Description of a new species of Anemia from the Neelgherry Mountains. *Calcutta Journal of Natural History* 7: 8–10; t. 1.

GLEESON, J.M. (1898). *Catalogue of the Trees, Shrubs and Herbaceous Plants in the Gardens of the Agri-Horticultural Society of Madras and in the Neighbourhood.* Madras: Higginbotham and Co.

GRAHAM, R. (1831). Notice of plants observed in an excursion made by Dr Graham with part of his botanical pupils, accompanied by a few friends, in August last. *Edinburgh New Philosophical Journal* Jul–Sep 1831: 373–6.

GRAHAM, R. (1832). Notice by Dr Graham of botanical excursions into the Highlands of Scotland from Edinburgh this season. *Edinburgh New Philosophical Journal* Oct 1832: 350–7.

GRANT, SIR A. (1884). *The Story of the University of Edinburgh.* 2 vols. London: Longmans, Green, and Co.

GREUTER, W. (ed.) 2000. *International Code of Botanical Nomenclature (Saint Louis Code).* Being *Regnum Vegetabile.* Vol. 138. Königstein: Koeltz Scientific Books.

GREVILLE, R.K. (1821). On the leaves, capsule and root of *Buxbaumia aphylla. Memoirs of the Wernerian Natural History Society* 3: 442–8.

GRIFFITH, W. (1848). *Posthumous Papers bequeathed to the Honourable, the East India Company, and printed by order of the Government of Bengal. Vol. II. Itinerary Notes of plants collected in the Khasyah and Bootan mountains, 1837–8, in Affghanisthan and neighbouring countries, 1839 to 1841.* Ed. J. M'Clelland. Calcutta: J.F. Bellamy.

GRIGG, H.B. (1880). *Manual of the Nilagiri District of the Madras Presidency.* Madras: Government Press.

GROUT, A. (1995). *Geology and India 1770–1851: a Study in the Methods and Motivation of a Colonial Science.* Unpublished Ph.D. dissertation. School of Oriental and African Studies, University of London.

GROVE, R.H. (1995). *Green Imperialism.* Cambridge: Cambridge University Press.

HARRIS, S. (1996). *The Place Names of Edinburgh: their Origins and History.* Edinburgh: Gordon Wright Publishing.

HENREY, B. (1975). *British Botanical and Horticultural Literature before 1800.* London: Oxford University Press.

HOCKINGS, P. (1996). *Bibliographie générale sur les Monts Nilgiri de l'Inde du Sud, 1603–1996.* France: Dymset, T. Alence.

HOME, R.W. ET AL. (EDS) (2006). *Regardfully yours: selected correspondence of Ferdinand von Mueller.* Vol 3 1876–96. Bern: Peter Lang.

[HOOKER, J.D.] (1848). Extracts from the private letters of Dr Hooker, written during a botanical mission to India. *London Journal of Botany* 7: 297–321.

HOOKER, J.D. (1851). *The Rhododendrons of Sikkim-Himalaya* [t. 27, *R. wightii*]. London: L. Reeve & Co.

HOOKER, J.D. (1853). *The Botany of the Antarctic Voyage … II. Flora Novae Zelandiae. Part I. Flowering Plants.* Vol. 1. London: L. Reeve & Co.

HOOKER, J.D. & THOMSON, T. (1855). *Flora Indica: a systematic account of the plants of British India, together with observations on the structure and affinities of their natural orders and genera.* London: W. Pamplin.

HOOKER, W.J. (1821). *Flora Scotica.* London: for A. Constable & Co. and Hurst, Robinson & Co.

[HOOKER, W.J.] (1853). Dr. Wight's return to England. *Journal of Botany & Kew Garden Miscellany* 5: 247–9.

[HOOKER, W.J.] (1854). Dr. Wallich. *Journal of Botany & Kew Garden Miscellany* 6: 185.

HUMBOLDT, A. VON (1817). *De Distributione Geographica Plantarum Secundum Coeli Temperiem et Altitudinem Montium, Prolegomena*. Paris: Libraria Graeco-Latino-Germanica.

HUTCHINSON, J.B. & GHOSE, R.L.M. (1937). The composition of the cotton crops of Central India. *Indian Journal of Agricultural Science* 7(1): 1–34.

JENKINS, D. & VISOCCHI, M. (1978). *Mendelssohn in Scotland*. London: Chappell & Company.

JERMY, A.C., CHATER, A.O. & DAVID, R.W. (1982). *Sedges of the British Isles*. London: Botanical Society of the British Isles.

KERR, J. (1998). *Church and Social History of Atholl*. Perth: Perth & Kinross Libraries.

KNIGHT, D.M. (2001). High Church Science: William Swainson and William Kirby. *Paradigm* 2: 23–28.

KOSTERMANS, A.J.G.H. (1980). Clusiaceae (Guttiferae) in *A Revised Handbook to the Flora of Ceylon* (ed. M.D. Dassanayake) I: 72–110. New Delhi: for the Smithsonian Institution and the National Science Foundation by the Amerind Publishing Co.

KUMAR, DEEPAK (1997). Science in agriculture: a study in Victorian India. *Asian Agri-History* I: 77–103.

LAMOND, J.M. (1970). The Afghanistan collections of William Griffith. *Notes from the Royal Botanic Garden Edinburgh* 30: 159–175.

LAWSON, P. (1993). *The East India Company: A History*. London: Longman Group UK Ltd.

LINDLEY, J. (1836). *A Natural System of Botany; or, a systematic view of the organisation, natural affinities, and geographical distribution, of the whole Vegetable Kingdom; together with the uses of the most important species in medicine, the arts, and rural or domestic economy*. 2nd ed. London: Longman, Orme, Brown, Green, & Longmans.

LINDLEY, J. (1839). *School Botany; or, an explanation of the characters and differences of the principal Natural Classes and Orders of plants belonging to the flora of Europe, in the botanical classification of De Candolle*. London: Longman, Orme, Brown, Green, & Longmans.

LINDLEY, J. (1841). *The Elements of Botany, structural, systematical, and medical; being a fourth edition of the Outline of the First Principles of Botany*. London: Taylor & Walton.

LINDLEY, J. (1846). *The Vegetable Kingdom; or, the structure, classification, and uses of plants, illustrated upon the natural system*. London: for the author by Bradbury & Evans.

LINDLEY, J. (1851). Notices of Books. A Volume of Figures and Descriptions of Indian Orchids. By Robert Wight … being Part I., Vol. V., of his Figures of Indian Plants. *Gardeners' Chronicle* 23 viii 1851: 535.

[LINDLEY, J.] (1861). 'On the Origin of Species by means of Organic Affinity. By H. Freke, A.B.' [book review]. *Gardeners' Chronicle* 1861: 99–100.

LOCKHART, J.G. (1838). *Memoirs of the Life of Sir Walter Scott*. 4 vols. Paris: A. & W. Galignani & Co.

LONG, D.G. (1979). The Bhutanese itineraries of William Griffith and R.E. Cooper. *Notes from the Royal Botanic Garden Edinburgh* 37: 355–368.

LUDDEN, D. (1985). *Peasant History in South India*. Princeton: Princeton University Press.

MABBERLEY, D.J. (1985). *Jupiter Botanicus: Robert Brown of the British Museum*. Braunschweig: J. Cramer & London: British Museum (Natural History).

MACDONALD, H. (2004). Thomas Claverhill (sic) Jerdon (1811–72) in *Dictionary of Nineteenth-Century British Scientists*, ed. B. Lightman 2: 1073–4. Bristol: Thoemmes Continuum.

MARGADANT, W.D. (1968). *Early Bryological Literature*. Pittsburgh: Hunt Botanical Library.

MARSHALL, H. (JAN 1840). Observations on cinnamon. *Edinburgh New Philospohical Journal* 28 [no. 55]: 27–32.

MARTINE, J. (1883). *Reminiscences of the Royal Burgh of Haddington and Old East Lothian Agriculturists*. Edinburgh & Glasgow: John Menzies & Co.

[?MASTERS, M.T.] (1868). Nathaniel Bagshaw Ward, F.R.S., F.L.S. [Obituary]. *Gardeners' Chronicle* 1868: 655–6.

[?MASTERS, M.T.] (1872). The Late Dr. Robert Wight, F.R.S. [Obituary]. *Gardeners' Chronicle* 1872(22): 731–2.

MCCURDY, E.A. (c. 1830). *Views of the Neilgherries or Blue Mountains of Coimbetoor, Southern India. Drawn from Nature and on Stone*. London: Smith, Elder & Co.

MCWILLIAM, C. (1978). *Lothian* [Buildings of Scotland series]. Harmondsworth: Penguin Books.

MEDLICOTT, J.G. (1862). *Cotton Hand-book for Bengal: being a digest of all information available from official records and other sources on the subject of the production of cotton in the Bengal Provinces*. Calcutta: Savielle & Cranenburgh.

MILLAR, G.F. (2004). Maconochie, Alexander, Lord Meadowbank (1777–1861) in *Oxford Dictionary of National Biography* (ed. H.C.G. Matthew & B. Harrison) 35: 972–4. Oxford: Oxford University Press.

MORSE, E.J. (2004). Pillans, James (1778–1864) in *Oxford Dictionary of National Biography* (ed. H.C.G. Matthew & B. Harrison) 44: 337–9. Oxford: Oxford University Press.

MUDALIAR, C.R. (1954). Growth of the Madras State herbarium: a short account, in *The Madras State Herbarium: Centenary Souvenir* pp. 11–21. Madras: Agriculture Dept., Government of Madras.

MUTHIAH, S. (1999). *Madras Rediscovered*. Chennai: Eastwest Books (Madras) Pvt. Ltd.

NAIR, S.P. (2005). Native collecting and natural knowledge (1798–1832): Raja Serfoji II of Tanjore. *Journal of the Royal Asiatic Society of Great Britain and Ireland*, series 3, 15, 3: 279–302.

NICOLSON, D.H. (1991). A history of botanical nomenclature. *Annals of the Missouri Botanical Garden* 78: 33–56.

NOLTIE, H.J. (2002). *The Dapuri Drawings: Alexander Gibson and the Bombay Botanic Gardens*. Edinburgh: Royal Botanic Garden Edinburgh.

NOLTIE, H.J. (2005). *The Botany of Robert Wight*. Ruggell: A.R.G. Gantner Verlag.

PANDIAN, M.S.S. (1998). Hunting and colonialism in the nineteeth-century Nilgiri Hills of South India. In *Nature and the Orient: the Environmental History of South and Southeast Asia*, pp. 273–97; eds. R.H. Grove, V. Damodoran and S. Sangwan. Delhi: Oxford University Press.

PANIGRAHI, G. (1977). Central National Herbarium (CAl) – past, present and perspectives for the future. *Bulletin of the Botanical Survey of India* 19: 212–24.

PIDDINGTON, H. (1839). A chemical examination of cotton soils from North America, India, the Mauritius, and Singapore; with some practical deductions. *Transactions of the Agricultural and Horticultural Society of India* 6: 198–226.

PREBBLE, J. (1988). *The King's Jaunt: George IV in Scotland, August 1822: 'One and twenty daft days'*. London: Collins.

PRESTON, C.D., PEARMAN, D.A. & DINES, T.D. (2002). *New Atlas of the British & Irish Flora*. Oxford: Oxford University Press.

PRICE, F. (1908). *Ootacamund: A History*. Quoted from the 2002 paperback edition – Chennai: Rupa & Co.

PRIOR, K. (2004). Lushington, Stephen Rumbold (1776–1868) in *Oxford Dictionary of National Biography* (ed. H.C.G. Matthew & B. Harrison) 34: 795–6. Oxford: Oxford University Press.

RAMESHA, K.P. & REDDY, O. (c.2002). Amritmahal Breed. Part of unpublished report on cattle submitted to Dept. of Biotechnology, Govt. of India (copy at RBGE).

RATNAM, R. (1966). *Agriculture Development in Madras State Prior to 1900*. Madras: New Century Book House Private Ltd.

REICHENBACH, H.G. (1872). Personal-Nachrichten. *Botanische Zeitung* 30(44): 785–8.

RICHARDS, F.J. (1918). *Madras District Gazetteers. Salem*. Vol I(2). Madras: Government Press.

ROBINSON T.F. (2003). *William Roxburgh (1751–1815), the Founding Father of Indian Botany*. Unpublished Ph.D. dissertation. University of Edinburgh.

ROTTLER J.P. (1803). Botanische Bemerkungen auf der Hin-und Ruckreisse von Trankenbar nach Madras vom Herrn Missionair Rottler zu Trankenbar mit Anmerkungen von Herrn Professor C.L. Willdenow. *Neue Schriften der Naturforschender Freunde zur Berlin* 4: 18–224.

ROY, K. & HARDIE, T.L. (1974). *The Kirknewton Story*. Kirknewton: Kirknewton Story Committee.

ROYLE, J.F. (1833–40). *Illustrations of the Botany and Other Branches of the Natural History of the Himalayan Mountains, and of the Flora of Cashmere.* London: W.H. Allen & Co.

ROYLE, J.F. (1840). *Essay on the Productive Resources of India.* London: W.H. Allen and Co.

ROYLE, J.F. (1851). *On the Culture and Commerce of Cotton in India and elsewhere, with an account of the experiments made by the Hon. East India Company up to the present time.* London: Smith, Elder & Co.

SANGSTER, THE REV. H. (1796). Parish of Pencaitland in *The Statistical Account of Scotland* (ed. Sir John Sinclair) 17: 33–44. Edinburgh: William Creech.

SANGWAN, S. (1997). The strength of a scientific culture: Interpreting disorder in colonial science. *Indian Economic and Social History Review* 34: 217–250.

SANGWAN, S. (1998). From gentlemen amateurs to professionals: reassessing the natural science tradition in Colonial India 1780–1840. In *Nature and the Orient* pp. 210–236, ed. R.H. Grove, V. Damodaran & S. Sangwan. Delhi: Oxford University Press.

SANTHANAM, V. & HUTCHINSON, J.B. (1974). *Cotton, in Evolutionary Studies in World Crops,* ed. Sir J. Hutchinson pp. 89–100. Cambridge: Cambridge University Press.

SANTHANAM, V. & SUNDARAM, V. (1997). Agri-history of cotton in India: an overview. *Asian Agri-History* 1: 235–251.

SCHRADER, H.A. (1838). Reliquiae Schraderiana. III Cucurbitaceae. *Linnaea* 12: 401–423.

SCOTT, H. (1923). *Fasti Ecclesiae Scoticanae 4. Synods of Argyll, and of Perth and Stirling.* Edinburgh: Oliver & Boyd.

SILVER, A.W. (1966). *Manchester Men and Indian Cotton 1847–1872.* Manchester: Manchester University Press.

SINCLAIR, SIR J. (1798). History of the origin and progress of the Statistical Account of Scotland in *The Statistical Account of Scotland* 20: [ix–]x–cxv. Edinburgh: William Creech.

SMALL, J. (1883). *The Castles and Mansions of the Lothians* [article on Meadowbank House]. Edinburgh: William Paterson.

STAFLEU, F.A. & COWAN, R.S. (1976–88). *Taxonomic Literature.* 7 vols. Utrecht: Bohn, Scheltema & Holkema.

STANSFIELD, H. (1957). The missionary botanists of Tranquebar. *Liverpool Libraries, Museums & Arts Committee Bulletin* 6: 18–42.

STEARN, W.T. (ED.) (1999). *John Lindley, 1799–1865, Gardener-Botanist and Pioneer Orchidologist.* Woodbridge: Antique Collectors' Club in association with The Royal Horticultural Society.

STEVEN, W. (1849). *The History of the High School of Edinburgh.* Edinburgh: Maclachlan & Stewart.

STEVENS, P.F. (1994). *The Development of Biological Systematics: Antoine-Laurent Jussieu, Nature, and the Natural System.* New York: Columbia University Press. (Reprinted Bishen Singh Mahendra Pal Singh, Dehra Dun, 2003).

STEVENS, P.F. (1997). J.D. Hooker, George Bentham, Asa Gray and Ferdinand Mueller on species limits in theory and practice: a mid-nineteenth century debate and its repurcussions. *Historical Records of Australian Science* 11: 345–370.

STEWART, J. (1830). 'Musci' in *Edinburgh Encyclopedia,* ed. D. Brewster 15(1): [1] – 36; tt. CCCI–CCCIII. Edinburgh: William Blackwood.

STRICKLAND, H.E. [AND OTHERS] (1843). Report of a committee "to consider of the rules by which the nomenclature of zoology may be established on a uniform and permanent basis". *Report of the Twelfth Meeting of the British Association for the Advancement of Science held at Manchester in June 1842;* pp. 105–121 [report signed by Charles Darwin, and J.S. Henslow, the other ten being primarily zoologists]. London: John Murray.

SWAINSON, W. (1834). *A Preliminary Discourse on the Study of Natural History.* London: Longman, Rees, Orme, Brown, Green, & Longman, and John Taylor.

SYMES, P.J. (1998). James Alexander Stewart-Mackenzie: portrait of a private note issuer. *International Bank Note Society Journal* vol. 37(1) [consulted electronically].

THOMSON, REV T. (1875). A Biographical Dictionary of Eminent Scotsmen. Vol. 2. [Article on George Gardner pp. 87–9]. London: Blackie & Son.

THOMSON, T. (1857). Notes on the herbarium of the Calcutta Botanic Garden, with especial reference to the completion of the Flora Indica. *Journal of Botany and Kew Garden Miscellany* 9: 10–14; 33–41.

THURSTON, E. & RANGACHARI, K. (1975). *Castes and Tribes of Southern India* (7 vols). First published 1909. Delhi (reprint).

[WALKER, A.M.] (1835). Journal of an ascent to the summit of Adam's Peak, Ceylon (ed. W.J. Hooker). *Companion to the Botanical Magazine* 1: 3–14.

WALKER-ARNOTT, G.A. (1831). Botany, in *Encyclopaedia Britannica,* ed. 7 (ed. Macvey Napier) 5: 30–141; tt. CXII–CXXVI. Edinburgh: Adam & Charles Black.

WALLACE, E.C. (1975). Carex L. in *Hybridization and the Flora of the British Isles* (ed. C.A. Stace), pp. 513–540. London: Academic Press in collaboration with The Botanical Society of the British Isles.

WALLICH, N. (1820). Descriptions of some new Indian plants. *Asiatick Researches* 13: 369–415.

WALLICH, N. (1829–32). *Plantae Asiaticae Rariores.* 3 vols. London: Treuttel & Würtz.

WALLICH, N. (1853). Initiatory attempt to define the species of Hedychium, and settle their synonymy. *Hooker's Journal of Botany and Kew Gardens Miscellany* 5: 321–329; 367–377.

WARD, N.B. (1836). Letter from N.B. Ward, Esq. to Dr Hooker, on the subject of his improved method of transporting living plants. *Companion to the Botanical Magazine* 1: 317–320.

WARING, E.J. (1868). *Pharmacopoiea of India.* London: W.H. Allen & Co.

WATSON, C.B.B. (1929). *Roll of Edinburgh Burgesses and Guild-Brethren, 1406–1700.* Edinburgh: Scottish Record Society.

WATSON, C.B.B. (1930). *Roll of Edinburgh Burgesses and Guild-Brethren, 1701–1760.* Edinburgh: Scottish Record Society.

WATSON, H.C. (1832). Observations of Mr Hewett Watson [on altitudinal distribution of plants]. *Edinburgh New Philosophical Journal* Oct 1832: 357–61.

WATSON, H.C. (1833). On the relation between cerebral development and the tendency to particular pursuits; – and on the heads of botanists. *Phrenological Journal and Miscellany* 8: 97–109.

WATSON, H.C. (UNDATED, [C. 1846]). *Testimonials in favour of Hewett Cottrell Watson, as a Candidate for a Chair of Botany in Ireland.* London: A. Spottiswoode. [Copy presented to J.H. Balfour with extensive MSS annotations by Watson in RBGE library].

WATT, G. (1890). *A Dictionary of the Economic Products of India.* Article on *Gossypium* 4: 1–173. London: W.H. Allen & Co.

WATT, SIR G. (1907). *The Wild and Cultivated Cotton Plants of the World. A revision of the genus Gossypium, framed primarily with the object of aiding planters and investigators who may contemplate the systematic improvement of the cotton staple.* London: Longmans, Green, and Co.

WEBB, J.L.A. (2002). *Tropical Pioneers: Human Agency and Ecological Change in the Highlands of Sri Lanka, 1800–1900.* Athens: Ohio University Press.

WHEELER, J.T. (1863). *Hand-book to the Cotton Cultivation in the Madras Presidency.* London: Virtue Brothers and Co. [Madras edition, 1862].

WILL, R.K. (ED.) (1983). *Register of the Society of Writers to Her Majesty's Signet.* Edinburgh: Clark Constable.

YARRINGTON, A., LIEBERMAN, I., & POTTS, A. (1994). *An edition of the Ledger of Sir Francis Chantrey, R.A., at the Royal Academy, 1809–1841.* London: the Walpole Society.

YULE, H. & BURNELL, A.C. (1903). *Hobson-Jobson. A Glossary of Colloquial Anglo-Indian Words and Phrases, and of Kindred Terms, Etymological, Historical, Geographical and Discursive.* Reprint New Delhi: Munshiram Manoharlal Publishers, 2000.

Notes and References

INTRODUCTION

1 (Noltie, 2005)
2 (Ingram & Noltie, 1981: 205)

CHAPTER I

1 Martine, 1883: 329 *et seq.*
2 Note. MP for East Lothian, or Haddingtonshire as it was then known
3 NAS Ormiston Kirk Session Minutes CH 2/292
4 NAS Ormiston OPR 715
5 Watson, 1930: 216
6 NAS Edinburgh Commissary Court Register of Testaments – CC 8/8/124, 10 ix 1778
7 Roper Genealogy
8 NLS MS 17150 f.268
9 Note. A district near the Poterrow Port, Harris, 1996
10 NAS Particular Register of Sasines for counties of Edinburgh, Haddington & Linlithgow – RS 27/242 f.64
11 NLS MS 17150 f.263 and MS 16697 f.226
12 NLS MS 17151 f.98
13 Note. Now Crown Place, Harris, 1996
14 NAS Edinburgh Sasine Abridgements no 1655, 11 iii 1786
15 NAS Register of Deeds of the Court of Session RD 5/5 f.405
16 Will, 1983: 341
17 NAS Edinburgh Sasine Abridgements no 1636
18 Sangster, 1796: 33 *et seq.*
19 Note. These two closes, at 44 Cowgate, were where William Maconochie had a shop and yard at some date prior to 1763 – see Harris, 1996
20 Note. Alison's Close was opposite the Magdalen Chapel – Harris, 1996. Now buried beneath the City Library
21 Note. Now Old Fishmarket Close (Harris, 1996); in Wight's time the site of Patrick Neill's printing works
22 NAS Edinburgh Burgh Sasines –

B 22/4/42 f.47 1833. Note. None of these buildings survives, having succumbed to nineteenth century improvements of the Old Town
23 Note. The spelling varies, but has been standardised here
24 Edinburgh Marriage Register, 1595–1700
25 Watson, 1929: 324
26 Brougham, 1845; Burke, 1852; Small, 1883
27 Note. This Highland origin has been omitted from more recent editions of Burke, but lingers on in the kilted supporters of the Maconochie-Welwood arms
28 NAS General Register of Sasines RS 3/64 f.116; 67 f.219; 69 f.263; 74 f.468
29 NAS Particular Register of Sasines for Edinburghshire RS 27/65 f.419
30 Canongate Register of Marriages
31 NAS Particular Register of Sasines for Edinburghshire RS 27/133 ff.247 & 250
32 Brougham, 1845
33 Aitchison, 1796 onwards
34 Clark, 1992:2
35 Byrom, 2005: 187. Note. The reference to the role of an advocate called Alexander Wight, along with David Hume, in trying to prevent building on what would become Princes Street Gardens in 1770, l.c. p.79, must refer to a different individual, perhaps the writer on Scottish parliamentary history
36 NAS RD 5/31 f.82–21
37 NAS RD Court of Session recorded, 24 i 1809
38 NAS RD 2/255 f.411
39 NAS RD 5/168 f.660
40 NAS RD 5/52 f.542
41 Note. Edinburgh lawyers were in a position to buy up property in Ayrshire cheaply in the aftermath of the great Ayr Bank crash of 1772
42 Quoted in Barker, 1909
43 NAS SC 70/1/40 f.181
44 NAS CC 8/8/152, SC 70/1/40
45 E.A. Roads, pers. comm.

46 Wilkinson papers
47 RBGK DC 53/165
48 NAS Edinburgh Sasine Abridgements no 3200
49 NAS RD 5/532 f.372 1835. Note. W.H. Campbell would become Secretary of the Botanical Society of Edinburgh; his brother James was a Madras friend of Wight's who married his niece Rebecca Stewart. James was recommended for the EIC by Hugh Cleghorn senior OIOC L/MIL/11/43 f.311
50 NAS Edinburgh Burgh Sasines – B 22/4/42 f.47 1833
51 Sangster, 1796
52 OIOC L/MIL/9/371 f.285
53 Moore family papers: Roper Genealogy
54 Cairns, 2004
55 Cockburn, 1910 ed: 129 *et seq.*
56 Cairns, 2005
57 Cockburn, 1910 ed: 129 *et seq.*
58 Brougham, 1845
59 Charles Waterston, pers. comm.
60 Roy & Hardie, 1974: 29
61 McWilliam, 1978: 275
62 Millar, 2004
63 Lockhart, 1838, 4: 107
64 Quoted in Roy & Hardie, 1974: 31

CHAPTER 2

1 RBGE BC 12 f.83
2 ECA SL 137/15/4
3 Steven, 1849
4 Christison, 1885. Note. Christison (1837) undertook chemical analyses of gamboge, a subject in which Wight was interested as a result of his trip to Ceylon in 1836
5 Steven, 1849: 191
6 Ibid. p.173
7 Ibid. p.180
8 RBGK MC f.234. Note. Wight was contrasting his own efforts with those of Nathaniel Wallich
9 Filipiuk, 1977: 161
10 Wight, 1848a: 27
11 Wight, 1849b: 148
12 Steven, 1849: 101

13 Ibid. p.158
14 Morse, 2004
15 RBGE BC 12 f.85.
16 Desmond & Moore, 1991: 26
17 RBGE BC 12 f.83
18 Roll of Edinburgh Burgesses 1761–1841

CHAPTER 3

1 Grant, 1884; Anderson *et al.*, 2003
2 Christison, 1885
3 Anderson *et al.*, 2003: 90. Note. The beard was evidently deciduous – see Fig. 5
4 Note. For example Adam's two quadrangles became one large one
5 Grant, 1884 1: 330 *et seq.*
6 Browne, 2003: 51/2
7 Grant, 1884 1: 332
8 Christison, 1885: 157
9 Note. One of the others may be the Robert Wight (1798–1861) who became a surgeon in the Bombay Presidency (Crawford, 1930: 432), who might also be the one Grout (1995) recorded as undertaking geological work in Gujarat
10 Anon, 1816
11 RCSE Records 1810–22
12 Browne, 2003: 52
13 electric scotland.com – significant scots
14 Greville, 1821
15 Christison, 1885: 57 *et seq.*
16 Ibid. p.75
17 Ibid. p.76
18 Ibid. p.78 *et seq.*
19 Brougham, 1845
20 Christison, 1885: 85 *et seq.*
21 Ibid.
22 RBGE BC 12 f.83
23 Hooker, 1821: 139
24 Greville, 1821
25 Stewart, 1830
26 Christison, 1885: 53–6
27 Note. Later to be built on by Rowand Anderson's Italian Renaissance-style Medical School
28 Robinson, 2003: 105

29 Mabberley, 1985: 19; pers. comm.
30 Noltie, 2002: 25
31 Christison, 1885: 39
32 Cleghorn, 1868
33 Note. For example of Wight's near contemporary Indian naturalists Alexander Gibson, William Griffith and T.C. Jerdon
34 Note. 'Brown was a pupil, and later a critic of Cullen whose teaching proved popular with a sizable and vocal minority of army, navy and EIC surgeons, because it attempted to go back to basics, stripping away the edifice of learned medicine' Mark Harrison, pers. comm.
35 *Zoonomia*, ed. 4, pp.331–464 (1801)
36 Note. This approach was presumably what lay behind Wight's appointment to investigate diseased cattle in Mysore in 1824, but which malaria probably prevented him from carrying out
37 Christison, 1885: 142
38 Ibid. pp.117, 149

CHAPTER 4

1 OIOC L/MIL/9/371 ff.285–92
2 Note. 62 Assistant Surgeons were appointed in 1820
3 Note. The venue later moved to Greenwich
4 Note. He was later made a baronet, and was Chairman of the EIC in 1820–1 and again in 1826–7
5 OIOC L/MAR/B/243A
6 OIOC L/MIL/11/72
7 Note. The Lichfield botanical society comprised Erasmus Darwin, Brooke Boothby and John Jackson – Henrey, 1975 3: 75
8 Wight, 1840i
9 Noltie, 2005
10 RBGK DC 7/14
11 Wight, 1840i
12 OIOC P/246/4 f.1307
13 Ramesh & Reddy, unpublished
14 Quoted in TNA MDC 1824 vol. 837 f.3860 *et seq.*
15 TNA MDC 1824 vol. 850A f.300
16 TNA MDC 1824 vol. 839 f.4421
17 TNA MDC 1825 vol. 862 f.5371
18 Ibid. f.5399
19 EI *Register & Directory* for 1825
20 Wight, 1840i
21 RBGK DC 52/108

CHAPTER 5

1 Stansfield, 1957; Desmond, 1992; Burkill 1965, Grout, 1995
2 Robinson, 2003
3 Rottler, 1803. Note. Almost 40 years later, when the plot belonged to a General Campbell, it was still sometimes known as the 'Botanical Garden', as recorded on Thomas Hill's map of Madras OIOC X/2413/1
4 Archer, 1962: 28, but giving no source for the information
5 RBGK DC 52/120
6 OIOC P/246/4 f.1307
7 Note. For further information on Cleghorn senior, see Clark, 1992
8 Matthew, 1993
9 RBGK DC 52/113
10 RBGK DC 52/116
11 RBGK DC 52/122
12 Wight & Arnott, 1834a: xix
13 Nair, 2005: 287
14 Crawford, 1930: 289
15 OIOC P/245/19 f.49
16 Ibid. f.51
17 Ibid. f.63
18 OIOC P/245/19
19 OIOC P/245/20 f.1042
20 OIOC P/245/28 f.429
21 Ibid. f.432
22 OIOC E/4/935 f.846
23 Grout, 1995
24 OIOC P/245/28 f.426–9
25 OIOC P/245/30 f.1174
26 OIOC P/245/31 f.1729
27 OIOC P/245/30 f.1338
28 Note. Also spelt 'picottah' (Port.): 'a long lever … pivotted on an upright post, weighted on the short arm and bearing a line and bucket on the long arm' for raising water from wells Yule & Burnell: 704
29 OIOC P/245/37 f.4894
30 OIOC P/245/64 f.1564
31 OIOC P/245/52 f.769
32 OIOC P/245/23 f.2381–8
33 RBGK DC 52/108
34 RBGK DC 52/113
35 Note. His date of birth is erroneously given as 1795 in Crawford 1930: 308
36 OIOC P/245/71 f.372
37 OIOC P/245/56 f.2683
38 OIOC E/4/935 f.846
39 OIOC P/246/3 f.500
40 Note. Madras Naturalist's drawing number 370, now at Kew, it was referred to by Wallich (1853) in his revision of the genus
41 Note. The name, correctly spelt 'Pichai', is Tamil-Portuguese, and he probably belonged to the fishing community – Preetha

Nair, pers. comm.
42 OIOC P/245/76 f.2407
43 Ibid. f.2421
44 Ibid. ff.2415–22
45 Wallich, 1832
46 Cleghorn, 1872
47 OIOC P/246/3 f.500
48 Ibid.
49 RBGK DC 52/108
50 OIOC P/246/3 f.497
51 Ibid. ff.503–6
52 RBGK DC 52/108
53 Prior, 2004
54 OIOC P/246/4 f.1307
55 RBGK DC 52/108
56 Ibid.

CHAPTER 6

1 *Madras Almanac* 1829
2 RBGK DC 52/110
3 RBGK DC 52/129
4 Note. 'Upwards of 2000 plants', by which Wight probably meant different species, by 1828 – RBGK DC 52/108. Graham would later similarly ignore the important specimens sent from Ceylon by Colonel & Mrs Walker
5 RBGK DC 52/111
6 RBGK DC 52/110
7 RBGK DC 52/108
8 RBGK DC 52/113
9 RBGK DC 52/111
10 RBGK DC 52/113
11 RBGK DC 52/119
12 RBGK DC 52/113
13 Ibid.
14 RBGK DC 52/120
15 RBGK DC 52/113. Note. The printer of this work is C. Stewart – could there be a connection with John Stewart?
16 e.g. Sangwan, 1998: 225
17 Note. Expense approved OIOC E/4/935 f.846
18 OIOC P/246/21 f.4466
19 Ibid. f.4468
20 RBGK DC 52/112
21 2 vols, 1805–7. Note. It was probably the portability of these tiny sexto-decimo volumes that appealed to Wight – the two volumes together measure a mere 15 × 9.5 × 7.5 cm, but within their covers contain descriptions of over 20,000 species!
22 RBGK DC 52/112
23 RBGK DC 52/108
24 RBGK DC 52/112
25 RBGK DC 52/122
26 RBGK DC 52/113
27 RBGK DC 52/110
28 RBGK DC 52/119
29 RBGK DC 52/120

30 RBGK DC 52/107
31 Ibid.
32 RBGK DC 52/115
33 RBGK DC 52/111
34 RBGK DC 52/112
35 RBGK DC 52/113
36 RBGK DC 52/111
37 RBGK DC 52/114
38 RBGK DC 52/107
39 RBGK DC 52/120
40 Ibid.
41 RBGK DC 52/112
42 RBGK DC 52/113
43 RBGK DC 52/116
44 RBGK DC 52/117
45 RBGK DC 52/113
46 Ibid.
47 RBGK DC 52/120
48 Wight, 1837i
49 RBGK DC 52/111
50 Wight, 1844–5: t. 889
51 Wight, 1852: t. 1849
52 Wight & Arnott, 1834a Preface p.xxviii
53 Note. Wight must later have known Elliot in Madras as he was secretary (and cousin) to Lord Elphinstone; Elliot sent specimens of Indian pigeons to Charles Darwin
54 Wight, 1838e: ii
55 Ibid.
56 Wight, 1834d
57 RBGK DC 52/115
58 RBGK DC 52/112
59 RBGK DC 52/116
60 RBGK DC 52/109
61 Note. K. Sprengel's 16th edition of Linnaeus's *Systema Vegetabilium*, 5 vols, 1824–8. RBGK DC 52/112
62 RBGK DC 52/108
63 RBGK DC 52/113
64 RBGK DC 52/117
65 RBGK DC 52/118
66 RBGK DC 52/107
67 Note. This remained an interest of Wight's and much later he estimated that the world total would prove to be over 200,000: Linnaeus had known about 8000, Sprengel in 1828 about 60,000, and in 1845 'not fewer than 100,000 are scattered through our Botanical literature' with about 20,000 undescribed in European herbaria. Wight, 1845d: 28. Wight's guess was a lucky one, as his other figures are exaggerations of the sort to which he was prone – there are 5900 species in Linnaeus' *Species Plantarum* and only an estimated 97,205 in Bentham & Hooker's *Genera Plantarum* (1862–83) (Stevens, 1994: 208)

68 RBGK DC 52/116

69 RBGK DC 52/108. Note. Wight here attributed this estimate to Robert Brown and repeated this in the *Illustrations* (1838e: 56) stating that Brown based it on Roxburgh. Elsewhere Wight (1835c: 390) attributed the statistic to 'Humboldt and Brown'. In Humboldt's work, the size of various floras at first sight appear to be attributed to Brown, but this is not the case, and is his own work, probably based on Roxburgh. Brown is notorious for having been given a copy of Roxburgh's MS *Flora Indica* (in which *c.* 3139 species are described), with which he did nothing save impede its publication (Mabberley, 1985: 227). Brown did cite the proportions of Dicots to Monocots inferred from the MS in his work on the Congo (Brown, 1818: 102), but did not give numbers

70 Wight, 1834d

71 RBGK DC 52/108

72 RBGK DC 52/120

73 RBGK DC 52/112

74 RBGK DC 52/108

75 RBGK DC 52/113

76 RBGK DC 52/118

77 RBGK DC 52/120. Note. Wight later (RBGK DC 53/175) stated that his salary at this time was 'under £600 per annum', i.e., under Rs 500 per month

78 RBGK DC 52/112

79 RBGK DC 52/116

80 Note. In 1832 Wight helped Wallich with sorting the Euphorbiaceae of the EIC herbarium – RBGK DC 53/160

81 RBGK DC 52/121

82 CBG WC 1818 part 2

83 OIOC L/MIL/11/72

84 CBG WC 1818 part 2

85 RBGK DC 52/122

86 CBG WC 1818 part 2

87 RBGK DC 52/123

88 OIOC L/MIL/11/72

89 RBGK DC 105/380

90 EI *Register* 1832

91 Note. Named for the warrior princess of Palmyra who styled herself 'Queen of the East' and held sway over Egypt and Asia Minor until being captured by the Emperor Aurelian in 273 CE

92 RBGK DC 53/156

93 Wight, 1841a: 43

CHAPTER 7

1 CBG WC – Index

2 RBGK DC 52/123

3 RBGK DC 52/125

4 Note. This contains many botanical descriptions by J.E. Smith

5 RBGK DC 52/124

6 Candolle & Radcliffe-Smith, 1981; Desmond 1992: 88 et seq., Sangwan, 1997, Fraser-Jenkins, 2006

7 RBGK DC 52/119

8 Sangwan, 1997: 240

9 Candolle & Radcliffe-Smith, 1981: 341

10 Sangwan, 1997: 240

11 Mabberley, 1985: 300

12 Note. A list of recipients is given in Fraser-Jenkins, 2006: 53–6

13 Anon, 1913: 258

14 Thomson, 1857: 13

15 Panigrahi, 1977

16 Originating in Anon, 1912

17 Fraser-Jenkins, 2006: 49

18 Filipiuk, 1997: 301

19 Note. It has six storeys rather than the four or five of the rest of the street. Andrew Berry, who had charge of the Nopalry in Madras in the 1790s, was a neighbour at no 52, though died at his country house Newton, near Doune, in 1833: it is fascinating to think that he and Wight might have met and discussed the garden where they both worked

20 Filipiuk, 1997: 302

21 Ford, 1967: 343

22 Graham, 1831

23 Note. Son of William Macnab, whom he later succeeded as curator of RBGE

24 CBG WC pkt 48. Note. This is ironic: palms, being synonymous with the tropics, were hardly to be expected in the Himalaya, but Wallich had discovered a new one in Nepal, now known as *Trachycarpus martianus*

25 RBGK DC 53/126–7

26 RBGK DC 53/172

27 Filipiuk, 1997: 174

28 RBGK DC 53/160

29 Filipiuk, 1997: 175

30 Note. In 1844 he went to Bengal as a surgeon where he died soon after; curiously on his voyage out he was joined on the boat from Ceylon to Madras by George Gardner. a pupil of Hooker's on his way to visit Wight at Coimbatore

31 Allan, 1967

32 RBGK DC 55/401

33 Note. August 1831; December/January 1831/2; June 1833; ?November 1833 to March 1834

34 Note. In August 1829, see Jenkins & Visocchi, 1978

35 Stewart, 1845

36 Note. Elliot had died in 1823 and is better known for the suave classical style he used for example in Edinburgh's Waterloo Place and the Regent Bridge admired by George Bentham (Filipiuk, 1997: 160)

37 Kerr, 1998

38 Stewart, 1845

39 Prebble, 1988: 31, 38

40 Stewart, 1845

41 Preston *et al.*, 2002

42 RBGK DC 52/128

43 Scott, 1923, 4: 145

44 Note. The spelling of the surname was changed in this generation to the more archaic form, doubtless thought more distinguished

45 Scott, 1923

46 RBGK DC 3/44

47 RBGK DC 3/94. Note. The plant was then known as *Menziesia caerulea*, a genus named by J.E. Smith for Archibald Menzies, who was one of Wight's proposers for the Linnean Society

48 Kerr, 1998

49 RBGK DC 52/128

50 Note. J.P. Rottler had charge of its sister institution

51 RBGK DC 52/128

52 See Stearn, 1999

53 See Filipiuk, 1997: 383

54 Gage, 1938

55 Note. Letter from Wight to Edward Forster dated 21 October 1838 (Linn Soc). However there was a later hiatus; the Society stopped sending him the *Transactions* in 1843 and by 1849 thought he owed them five years' worth of subscriptions; Wight wrote an indignant letter and the offender was found to be Francis Buchanan White, author of the *Flora of Perthshire*. Letter from Wight to Bennett dated 8 August 1849 and reply, Linn. Soc.; see also RBGK DC 54/548

56 Note. Probably the young Edward Blyth (1810–73), at this stage apprenticed to a druggist in St Paul's Churchyard, before becoming more famous as a zoologist, curator of the Asiatic Society's museum in Calcutta (1841–62), and as one of Darwin's most important correspondents – Brandon-Jones, 2004

57 RBGK DC 53/154. Note. Klotzsch described six other species of fungi based on Wight collections in vols 7 and 8 of the German periodical *Linnaea*

58 RBGK DC 53/157

59 Note. For a list of botanists who received specimens see Noltie, 2005

60 RBGK DC 53/158A

61 RBGK DC 53/159

62 RBGK DC 53/160

63 RBGK DC 53/154

64 RBGK DC 53/156

65 RBGK DC 53/159

66 RBGK DC 53/159. Note. It was possibly on this trip that Wight admired the beauty of *Polygala* (presumably *P. calcarea*) on 'the dry chalk hills of Kent', Wight, 1838e: 47

67 RBGK DC 53/160

68 CBG WC pkt 18, 16 i 1832

69 CBG WC pkt 18, 28 v 1832. Note. Treatment for the disease in India was no less bizarre; after an attack in June 1840 Wallich wrote to Wight that he had received '20-pounders, with mustard plaster, opium, hot pans, & I know not what else administered promptly by my kind medical attendant' (CBG WC pkt 47)

70 Graham, 1832

71 Watson, 1832; Egerton, 2003. Note. A sensitive barometer invented by the Scottish medical instrument maker Alexander Adie

72 Watson, 1833. Note. Curiously Watson's sister Caroline was aunt of Mary Lloyd who would later marry Wight's eldest son James

73 Graham, 1832

74 Boott, 1844

75 Jermy *et al.*, 1982

76 Wallace, 1975: 523

77 CBG WC pkt 18, 8 viii 1832. Note. That this must have been a top-of-the-range instrument is shown by the fact that Wight bought a microscope in London for W.H. Harvey, who was then staying with Hooker, for £3 9/- (RBGK DC 53/162)

78 RBGK DC 53/161

79 RBGK DC 3/29

80 Quoted in Cleghorn, 1868

81 CBG WC pkt 18, 21 ix 1832

82 Wight to Henslow, 15 xi 1832

83 RBGK DC 53/163

84 RBGK DC 53/162

85 RBGK DC 53/163

86 Wight to Henslow, 15 xi 1832
87 Note. See also the Wallich portrait Fig.17
88 See Noltie, 2005
89 RBGK DC 53/165, 166
90 RBGK DC 53/165. Note. Doubtless the ones inherited from his mother in the old town of Edinburgh, and by this time probably little better than slums
91 RBGK DC 53/265, 166
92 Note. A conspicuous exception being the account of his bryological work in the outstanding bibliographic study by Margadant, 1968
93 Cleghorn, 1868
94 Burke, 1852
95 Filipiuk, 1997: 213 *et seq.*
96 Note. A carnivorous Egyptian quadruped allied to the mongoose
97 Filipiuk, 1997: 159, 165
98 Note. Now Tartu, Estonia
99 Stevens, 1994
100 Stafleu & Cowan, 1976
101 RBGK DC 3/18
102 Filipiuk, 1997: 304
103 RBGK BC 1 f.64
104 Filipiuk, 1997: 304
105 Noltie, 2005
106 RBGK DC 53/167
107 RBGK BC 1 ff.76–7
108 RBGK DC 53/167
109 RBGK DC 53/169
110 RBGK DC 53/160
111 EI *Register* 1833, ed. 2: 98
112 OIOC L/MIL/11/71 f.158
113 Note. He had named the specimens of this family in the EIC herbarium for Wallich
114 RBGK DC 53/171. Years later, shortly before Graham's death, Wight would write of him to Hooker: 'Graham as a teacher was never great and now poor fellow labouring under disease of the heart and broken in spirit under the pressure of contracted [financial] circumstances at home it is not to be expected he can now come up to what he was (RBGK DC 52/552)
115 RBGK DC 53/171
116 RBGK DC 53/170
117 RBGK BC 1 f.76–7
118 Bentham, 1837
119 Note. 16 species and one variety of *Sargassum*, and two of *Caulerpa* in the *Annals and Magazine of Natural History* in 1848/9 and 1853
120 RBGK DC 53/171. Note. Wight later on elaborated his views on the use of spirits in comparison with opium: 'used moderately

and with due discrimination, neither are so bad as extreme moralists would have us believe, while both are in particular circumstances necessary to our welfare … Used to an injurious excess, language does not possess terms strong enough to portray the horrors which both induce, and … none but the confirmed inebriate can adequately describe'. Wight was also concerned that a ban on opium production would 'inflict ruin and destruction on thousands of persons engaged in the growth and traffic of this much coveted drug', especially following the Chinese ban on importation of Indian opium (Wight, 1838e: 29)
121 RBGK DC 53/171
122 CBG WC pkt 19, 17 iii 1834
123 CBG WC pkt 18
124 RBGK DC 53/170. Note. 'So then because thou art luke-warm, and neither cold nor hot, I will spue thee out of my mouth' Revelation 3:16
125 OIOC E/4/943
126 RBGK DC 53/171
127 RBGK DC 53/173
128 Cleghorn, 1872
129 RBGK DC 53/174
130 RBGK DC 3/61
131 RBGK DC 3/62
132 NAS RD 5/532 f.372
133 Note. Adam had botanical interests and would send Hooker specimens from Madras
134 RBGK DC 3/66
135 OIOC E/4/944
136 Noltie, 2005
137 RBGK DC 3/73
138 Note. The cryptogams, edited by Griffith, not until 1844
139 Thomson, 1855: 48

CHAPTER 8

1 CBG WC pkt 19
2 Ibid.
3 RBGK DC 3/66
4 RBGK DC 53/175. Note. About Rs 750 per month
5 RBGK DC 53/175
6 Wight, 1840i
7 Wight, 1834d
8 Wight 1840i: 171
9 Ibid. p.160
10 Ibid. p.179
11 Note. He later illustrated one of these, *Linaria ramosissima*, to draw attention to it with a view to testing its reputed properties as a remedy for diabetes (Wight,

1850d: 192, t. 165)
12 Wight, 1840i
13 Wight, 1835a. Note. Emphasis added
14 Note. Interestingly this was the species Griffith first studied on his arrival in Madras, writing on its pollination (or lack thereof) to Robert Brown, the great expert on the family – see Mabberley, 1985: 295
15 Wight, 1835b
16 Ibid. Note. This example of what would now be called 'Biological Control' was also quoted by Swainson, 1834: 145
17 Wight 1840i: 160
18 Ibid. p.169
19 Ibid. p.170
20 Cleghorn, 1873
21 Wight, 1840i: 167
22 RBGK DC 53/175
23 RBGK DC 3/101, Arnott to Hooker, 19 Dec 1835
24 Wight 1840i: 172
25 Note. The first haul sent November 1835, and a second in January 1836
26 Wight, 1835c; 1836c, d, e; 1840i: 176–8
27 Wight, 1836d: 330
28 Wight, 1835c: 390
29 Humboldt, 1817
30 Wight, 1836b
31 Note. This became an important issue in the cotton experiments – see p.140
32 Wight, 1836d: 327
33 Wight, 1840i: 179. Note. Garrison appointments were better paid, and provided more opportunities for non-military work
34 Ibid. p.181
35 Wight 1836d: 331
36 Cleghorn, 1873

CHAPTER 9

1 RBGK DC 3/51
2 Wight, 1840i: 200
3 RBGK DC 54/549
4 Shaw, 1877: 3
5 Wight, 1836a
6 Note. 'Omnis Feret Omnia Tellus' – Virgil, Eclogue 4
7 Wight, 1840i: 194
8 RBGK DC 53/177
9 Note. At the British Library – classmark 7078.de.14. See Bibliography in Noltie, 2005, with details of Wight's articles therein
10 Shaw, 1877
11 Note. This was at

Nungambakkam, on the south side of the Cooum River, adjacent to the site of James Anderson's botanic garden, now the site of the Women's Christian College
12 Note. These had been printed for members before this date, as shown by copies received by the Calcutta Society – AHSI Minute Books
13 Gleeson, 1898
14 AHSI Minute Book 1843–8
15 Wight, 1852
16 Note. The spelling of his name is inconsistent, it was often spelt 'Jaffray' and it is not known which is the more correct. He later played a role in transferring cinchona plants from the Nilgiris to Darjeeling, see Burkill, 1965
17 Shaw, 1877: 31
18 *Madras Almanac* 1841 pp.M to O
19 From Shaw, 1877
20 Note. Elsewhere Wight pointed out that in India this plant was a roadside weed in the Hills, but 'immediately it found its way into English gardens it took its place among the choice prize flowers of their exhibitions' – a perfect demonstration of the definition of a weed as the 'right plant in the wrong place'. Wight 1851a: 75
21 Wight, 1851a: 63
22 Wight 1848a: 2
23 Wight 1845d: 3
24 Wight, 1840a: 212
25 Wight, 1841a: 7
26 Wight 1837c, e
27 Note. Wight was 'most partial' to lettuce and asked William Munro for seeds of it from Bangalore as 'they grow admirably in my garden [at Madras]' (RBGK MC f.234). On the cultivation of strawberries in the Nilgiris, where they are still grown, Wight (1847a: 52) noted that in order to get fruit 'something approaching to European perfection', it was necessary to grow the plants as annuals.
28 Note. This had been sent to the Society of Arts in London by Wallich in 1821
29 Note. It is perhaps not insignificant that Brown could only lecture after taking a mixture of opium and whisky
30 AHSI Minute Book 1835–7bis p.328. While respectful, Bell was clearly less than convinced by Wight's paper more generally: 'If the Doctor's deductions are valid … [Wight] … endeavours to show that the analogy of the law which

governs the principle of animal and vegetable life is more decided than heretofore imagined … It is impossible to give even an outline of the Doctor's scientific dissertation'

31 Linn Soc MS 325.45

32 Ward, 1836

33 Linn Soc MS 325.45

34 Edwards & Colin, 1836. Note. In the title both authors are prefixed with 'M.' for Monsieur, but this seems to have confused Wight, who in some places refers to 'Milne-Edwards'. Henri Milne-Edwards was zoological editor of the *Annales des Sciences Naturelles*, but the author of this paper was William Frederick Edwards (1776–1842), a plant physiologist who lived in Paris

35 Darwin, 1868 2: 313

36 Wight, 1841a: 54

37 Wight, 1836e

38 Darwin, 1868: 169

39 Note. Referred to again in Wight, 1838e: 57

40 Ingledew [& Wight], 1837

41 Note. 300 copies printed, sold for Rs 1 each. Wight's own copy is at BL-7078.de.14

42 Ingledew [& Wight], 1837. Note. Emphasis added

43 Wight, 1838e: 31

44 Griffith, 1848: liii

45 Knight, 2001

46 Griffith, 1848: liii

47 Note. 'A red, loose-skinned orange, which arrives at so great a perfection in the alpine tracts of the Circars … is so very tenacious of an alpine country, that it has in the Circars received the name of *hill orange*' Wight, 1838e: 105

48 Note. Described by Wight as *Mucuna utilis* in 1840; its pod was eaten as a kind of mangetout, and it was probably introduced to Madras from Mauritius (Wight, 1839c: 192)

49 Shaw, 1877: 19

50 Wight, 1838e: 96

51 CBG WC MS pkt 47

52 Ibid.

53 Wight, 1843a

54 Griffith, 1848: xxxi

55 Ibid. p.xl

56 RBGK DC 157/644

57 Griffith, 1848: l

58 Ibid. p. xlix

59 Note. Proposed by Wallich and the Society's Secretary John Bell. AHSI Minute book 1835–7 bis

60 Desmond, 1992: 106

61 CBG WC pkt 50, letter from Munro to Wallich, dated 24 July

1836

62 Note. The MS is at Kew

63 CBG WC pkt 47

64 Wight, 1844–5: t. 872

65 Wight, 1847a: 49

66 Wight, 1854b

67 Price, 1908: 238–44

68 Grigg, 1880: 571 *et seq.*

69 Burton, 1851: 293

70 Note. Built in 1827–8 by Charles May Lushington, Governor S.R. Lushington's brother

71 RBGK DC 54/547

72 TNA BRP 2336 ff.9042–58

73 Price, 1908: 243

74 TNA BRP 2336 ff.9033–42

75 Ibid. ff.9042–58

76 RBGK DC 55/476

77 Ibid.

78 Kurt Fagerstedt, pers. comm.

79 TNA PDD 60B ff.355–62, 1852/3

80 RBGK DC 55/481

81 RBGK DC 38/620

82 RBGE AC f.251

83 Note. Rosa Wight's step-mother (i.e. Lacy Gray Ford's second wife) was still living at Ooty, and acted as a 'second mother' to Robert

84 RBGE AC f.249

CHAPTER 10

1 R.C. Cole in Wight, 1837k

2 RBGK DC 53/176

3 Note. Malcolmson (1802–44) became a Madras Assistant Surgeon in 1823, Surgeon 1836, and retired in 1838. He published on beriberi (1835), rheumatism (1835) and 'On the effects of solitary confinement on health of soldiers in warm climates' (1837) (Crawford, 1930). Wight recommended him to Hooker during a home leave in 1836 (RBGK DC 53/176). During this leave he became known as a geologist: in 1839 he visited Agassiz in Switzerland, and back in Scotland looked for traces of glaciation, and worked on fossil fish of the Old Red Sandstone. He was elected FRS in 1840, the year he returned to Bombay, where he worked for the house of Forbes & Co., and continued his geological work

4 Cole in Wight, 1837k: 97

5 Wight, 1836g: 305

6 OIOC F/4/1701 no. 68781 f.51

7 *Fort St George Gazette*, 5 March 1836 pp.140–141

8 Royle, 1840: 366

9 It is curious that none of this type

of plant was finally included in the *Icones*, but in the NHM collection are pencil drawings of this sort of plant, which must have been made at this time: *Sinapis juncea* (no 20), *Raphanus sativus* (no 21), *Vitis vinifera* (no 90), *Fragaria cf.ananassa* (no 171), *Capsicum annuum* (no 380), *Rumex vesicarius* (no 476); and three native cereals – *Pennisetum americanum* (no 682), *Brachiaria cf.ramosa* (no 683) and *Paspalum scrobiculatum* (no 684)

10 NAI LRR 14–12–35 ff.3–36; Royle, 1840: 363–70

11 *Fort St George Gazette* 5 Mar 1836: 140

12 OIOC E/4/950 f.702

13 Wight, 1840i: 183

14 Note. Almost nothing is known of Huxham: Wight, in connection with trials on annatto, described him as 'a talented and enterprising merchant on the Malabar Coast' (Wight, 1838e: 39); Huxham also corresponded with Wallich and in 1838 listed the plants he was growing: mainly coffee, nutmeg, cinnamon and sappan [*Caesalpinia sappan*, a dye plant], but also cloves, cocoa, South American arrowroot, annatto, senna, mulberry, pimento and cottons 'in different situations in the hills, from 25 to 50 miles from the sea east of Quilon' – (CBG WC pkt 50)

15 Ratnam, 1966: 318

16 Wight, 1838e: 75

17 Ibid. p.115

18 Wight, 1841a: 7

19 Wight, 1840i: 184

20 Note. Hugh Cleghorn, the botanist's grandfather, having played a significant role in its transfer from Dutch administration by persuading the Swiss mercenaries, who formed the majority of the garrison, to defect – see Clark, 1992

21 Quoted in Desmond 1992: 163. Note. James Watson was previously employed at Calcutta, and accompanied Wallich to England in 1828 to help with the sorting of the EIC herbarium; from London he was posted to the Ceylon job. CBG WC pkt 48

22 Wight, 1840i: 185–6; RBGK DC 7/35

23 Walker, 1835. Note. This was accompanied by a print from a drawing made by Mrs Walker, one of Hooker's earliest uses of

lithography in a publication, made by the Glasgow firm of Allan & Ferguson

24 Wight, 1840i: 173

25 Note. The Kingdom of Kandy was taken over by the British in 1815; the highway from Colombo to Kandy completed in 1825, and the bridge over the Mahaweli, allowing easy access to Kandy, made only in 1832. The road to Nuwara Eliya, started in 1827 was only completed in 1837 – see Webb, 2002 for an account of the results stemming from this opening up

26 Note. Paton is a Scottish name, and perhaps their families knew each other in Edinburgh

27 RBGK DC 7/17

28 RBGK DC 10/12. Note. This would have required visits to London, and such was the dire state of Arnott's finances, that such visits were unthinkable

29 Wight 1836f, 1837h, 1838c, 1840i: 193

30 Griffith 1848: xxiii

31 Kostermans, 1980: 79

32 Christison, 1837

33 Wight, 1838e: 114–20

34 Note. Whence he sent Royle a set of specimens representing four species (Royle, 1840: 366)

35 Wight, 1839d

36 Wight, 1839f

37 Quoted in Marshall, 1840

38 Symes, 1998

39 CBG WC pkt 47

40 TNA BRP vol. 1671 ff.577–82

41 Gardner, 1845: 393

42 CBG WC pkt 50

43 RBGK DC 53/135, 177

44 See Thomson, 1875

45 RBGK DC 54/165

46 Gardner, 1845: 394

47 RBGK DC 54/161

48 Gardner, 1845: 398

49 RBGK DC 54/548

50 Gardner, 1845: 398

51 RBGK DC 54/545

52 RBGK DC 55/476

53 TNA RDC vol. 427 f.6159 *et seq.*

54 Ludden, 1985

55 Note. While on leave Wight had learned of these from Griffith

56 PP2: 154/654

57 Note. Also expressed in his article on the harbour of Tuticoreen: Wight 1836g

58 Wight, 1838e: 87

59 Wight, 1840i: 197

60 RBGK DC 9/24

61 Wight, 1840a: 207

62 Wight, 1840i: 186

63 Noltie, 2002: 35

64 Wight, 1840i: 192
65 Note. Copies of the MS are in TNA: RDC vol. 427 ff.6201–22, and OIOC F/4/1701 no 68781 ff.38–58, but are almost exactly as later printed
66 Wight, 1840i: 184
67 Wight, 1837d. Note. He had earlier published a preliminary letter: Wight, 1836h; a letter to Arnott on the same subject was also published: Wight, 1840i pp.194–201
68 Sinclair, 1798: xiii
69 Note. The air was said to be 'more salubrious than might be expected in a situation so low, with the Tyne, a muddy slow running water, passing through the middle of it' but where 'after a late or wet harvest, putrid fevers, indeed, are prevalent'. This link between climate and health became the subject of investigation in India in the 1820s under the name 'medical topography'
70 Note. A bleachfield for linen; one flax and one thread mill, four barley and four corn mills; there was also a paper mill just over the burn in the Parish of Saltoun
71 Note. Landowner with responsibility for upkeep of the parish church
72 TNA RDC 422 f.4202
73 Wight, 1840i: 198
74 Wight, 1846a
75 See Cleghorn, 1873
76 Wight, 1840i: 197
77 Note. Wight was keen to increase production of coffee, which by the late 1840s became well established as a plantation crop in the Nilgiris, to enable it 'to superseded the deleterious [alcoholic] Toddy [fermented palm sap], so generally consumed by nearly all the lower classes of Hindoos'. Wight, 1847a: 83
78 Wight, 1838e: 3
79 TNA RDC vol. 427, ff.6199–6201
80 Griffith, 1848: xi
81 CBG WC. Note. There were other links: Auckland's first cousin, Dorothy Eden, was married to R.K. Greville; his mother Eleanor was brother of Hugh Elliot, Governor of Madras when Wight first went to India in 1819, another brother was Gilbert Elliot, Governor General of India and first Earl of Minto
82 OIOC F/4/1701 no. 68781. Note. This makes one wonder if Madras failed to send a copy of

the 'Means of inducing' report to Calcutta. Could it, in fact, have been withheld by the Madras Board of Revenue and be the origin of Wight's comment on good suggestions being strangled by the Board – see p.79
83 NAI LRR 19–12–36 No 4–6, ff.43–6
84 OIOC F/4/1701 no. 68781. Note. This annotation was copied and sent to India, as it is also on the copy in NAI LRR 19–12–36 no 4–6 f.9

CHAPTER 11

1 RBGK DC 53/177
2 OIOIC F/4/1701 no. 68781 ff.64–9
3 City plan in Marsden's *Madras Almanac* for 1839; reprinted in the 1840 edition with an incorrectly numbered key. Note. Wight probably rented this house, and it is shown as belonging to a 'Mr Disney' in Thomas Hill's detailed map of Madras corrected 'to the end of 1842' OIOC X/2413/1
4 Note. Those on cotton will be described on p.120
5 Ingledew & Wight, 1837
6 CBG WC pkt 50
7 Wight, 1851a: 80
8 OIOC E/4/950 f.360
9 OIOC E/4/951 f.300
10 OIOC F/4/1755 no. 71755 ff.27–37
11 Ibid. f.91. Note. Although when in Calcutta the Governor General was the President of the Council in Bengal, if the Governor General was travelling, sick or had resigned Sir Charles Metcalfe was authorised 'to act provisionally as governor general' (EI *Register*, 1838 (ed 1). Given the use of the title 'President' here and that he is not referred to as 'His Lordship', it would seem that Wight's antagonist was Metcalfe (or some other deputy) rather than Auckland
12 Ibid. ff.105–17
13 Ibid. ff.95–101
14 TNA RDC 427 ff.6018–23
15 Robinson, 2003: 208–20
16 Note. This is an exact parallel with native and introduced cottons, where it was hoped that the exotic would grow on the less heavily assessed red soils
17 Note. Also, of course, a grass

18 TNA RDC vol. 427 ff.6023–5
19 Wight, 1839b
20 Ratnam, 1966: 302
21 CBG WC pkt 47
22 Ratnam, 1966: 310
23 Royle, 1835 1: 188
24 Wight, 1837g, j
25 Royle, 1835: 187. Note. There is a drawing at Kew of a specimen of Hughes's senna, painted by Rungiah perhaps on the 1826 expedition
26 Wight, 1837j
27 Wight, 1837g
28 Wight, 1838a: 89
29 OIOC F/4/1755 no. 71755 f.85
30 TNA PDC vol. 674 f.6210
31 TNA RDC vol. 437 ff.3276–82
32 TNA RDC vol. 440 ff.4355
33 Ibid. ff.4358–79
34 RBGK DC 53/179
35 OIOC F/4/1815 no 74864
36 Note. These must have included specimens and notes made by Alexander Moon – see under *Eugenia sylvestris*, Wight, 1841c
37 RBGK MC ff.226–236
38 Ibid. f.228
39 Royle, 1840: 369

CHAPTER 12

1 Linn Soc MS 325.45
2 ?Masters, 1868: 655
3 RBGK DC 54/545
4 RBGK DC 54/554
5 CBG WC pkt 18, letter to Wallich
6 OIOC N/2/17 ff.263–4
7 OIOC N/2/6 f.266
8 CBG WC pkt 50, Cole to Wallich, 15 iii 1838
9 Moore family MSS, J.S Roper to Marjorie Cosens
10 RBGK MC f.228
11 CBG WC pkt 50, Cole to Wallich, 15 iii 1838
12 *Fort St George Gazette* 1838: 152
13 *Fort St George Gazette*, 27 xii 1839
14 RBGK DC 54/553
15 RBGK DC 54/551
16 RBGK DC 54/554
17 Griffith, 1848: xliv
18 RBGK DC 54/182
19 RBGK DC 54/178, 192
20 *Fort St George Gazette* 1846: 1031, 1063
21 Note. Now Chapelside Place
22 RBGK DC 54/551. Note. Even the previous year, September 1847, Gardner had told Hooker 'I suspect Wight will go home soon' RBGK DC 54/187
23 *Fort St George Gazette* 1849: 491
24 RBGK DC 54/549

25 Note. The second name was for Octavius Adolphus Field, who would be one of Wight's executors; a surgeon, but not an Indian one
26 RBGK DC 3/50
27 Moore family MSS, J.S. Roper to Lucy Cosens 7 ii 1931
28 Wight, 1838e: 57
29 Ibid. p.37
30 RBGK DC 54/551
31 Gardner, 1845: 395
32 Hooker, 1848: 317

CHAPTER 13

1 Wight, 1834d
2 Ibid.
3 Swainson, 1834: 399
4 Wight, 1837l
5 OIOC F/4/1755 no 71755 ff.105–17
6 Note. The EIC had also subsidised publication of Wallich's *Plantae Asiaticae Rariores*, and in helping Wight with these two works made up for their lack of support for the *Prodromus* in 1834. That Elphinstone had serious artistic interests is shown by the fact that in 1842 he had employed a 'Mr F. Lewis', a 'painter of repute … recently arrived at Madras' to restore the portraits at Government House. TNA PDD Index 18 Feb 1842. This is Frederick Christian Lewis Jr. (1813–75), brother of the more famous Orientalist painter John Frederick Lewis – see Archer & Lightbown, 1982: 107.
7 RBGK DC 54/547
8 Noltie, 2005
9 Note. A copy was in Wight's library by 1829
10 Wight, 1850d: 212
11 Wight, 1847a: iii
12 Stevens, 1994: 93
13 Wight, 1841a: 2
14 Stevens, 1994
15 Griffith, 1848: xxiii. Note. The source of Griffith's information is unfortunately not recorded
16 Stevens, 1994: 48
17 Ibid. p.84
18 Ibid. p.64
19 RBGE BC 12 f.81, letter to Arnott, 1846
20 Wight & Arnott, 1834a: 178
21 Walker-Arnott, 1831: 30
22 RBGK DC 52/113
23 Wight, 1834c
24 Stevens, 1994: 99
25 Wight, 1851a: 50

26 Ibid. p.100. Note. H.C. Watson (in a letter to Alphonse de Candolle in 1869, quoted by Egerton, 2003: 224) gave a brilliantly bitchy description of Hooker's intellect: '[W.J.] Hooker was a Describer and Depicter, and nothing more. He was incapable of methodizing or classifying details – incapable of connecting ideas in the way of cause and effect – incapable of bringing out any third idea or conclusion from two or more simple facts brought into relation with each other – in short, utterly incapable of ratiocination. It was impossible to converse with him on any matter of mental science or moral philosophy. In describing and depicting plants, he was a genius; in almost all else, in all that required thought and reason, he was much below mediocrity. He was not a 'Homo sapiens', but nearer to a Simia intellectualis. He had the curiosity of a monkey in finding and examining objects: that was his genius, with a training of it for science'

27 Wight, 1850d: 218

28 Wight, 1839c: 189. Note. Wight mislaid the letter and replied only when packing up to leave India in 1853. RBGK BC 10 f.4199

29 Bentham, 1837, translated by L.D.J. Henderson. Note. The use of 'he', rather than 'they', is, perhaps, significant, and suggests that Bentham was aware that this was to all intents and purposes Arnott's work. The legumes were written in December 1833–January 1834 while Wight was bogged down with Asclepiadaceae, and panicking about his imminent return to India RBGK DC 3/59

30 Filipiuk, 1997

31 Lindley, 1836

32 Stearn, 1999: 57

33 Quoted in Stevens, 1994: 107

34 Lindley, 1846

35 Wight, 1848g: 74

36 Note. Lindley sent him a copy of the book (via J.F. Royle), and in Wight's letter of acknowledgement from Coimbatore, 8 March 1847, he challenged Lindley's placement of Vaccineaceae, and told him he had sunk all Indian members of the family (including Lindley's Gaylussacia serrata) under Vaccinium. RBGK LC L–Z f.920.

In a letter to Hooker referring to this work he wrote of it as 'a brilliant work and combines striking usefulness as a Botanical work, but in spite of these recommendations I seldom consult it without feeling dissatisfied with his groups … I doubt not, perfect as it now seems to be, his next edition will introduce a new set of changes as in all previous ones'. RBGK DC 54/551

37 Note. Only a single example has survived, from Wight to Arnott, written from Coimbatore in September 1846, with a detailed discussion of Oleaceae. RBGE BC 12 f.81

38 Note. The tone is uncharacteristically good humoured; on returning to Scotland he seems to have bowed beneath a weight of Presbyterian gloom and duty, at times plunging into deepest depression

39 RBGK DC 3/52

40 Candaux & Drouin, 2004: 456

41 Griffith, 1848: xxv

42 Griffith, 1848: xxviii. Note: This was unfair on Arnott, the division was actually Schrader's

43 Note. J.D. Hooker accused Griffith of turning the garden into a textbook, while Wallich's planting had been more picturesque – see Desmond, 1992: 94–6. Interestingly Candolle had used the planting scheme of a botanical garden as a means of demonstrating his natural system (Stevens, 1994: 87), and Griffith's 'Natural garden' reflecting his interest in Macleay was arranged in 'a large circle or ellipse – with interior circles or ellipses'. Griffith 1848: xxxii

44 Desmond, 1992: 96–7

45 Arnold, 2005: 174–5

46 Griffith, 1848

47 Griffith, 1848: xxix

48 Ibid. p.xxx

49 Walker-Arnott, 1831: 30

50 Note. The analogy is extended to the classification of botanical science itself – medical botany is not part of botany, but a 'mere connecting link between botany and materia medica'!

51 Walker-Arnott, 1831: 60

52 RBGK DC 1/8

53 Wight, 1840a: viii

54 Ibid.

55 Wight, 1839c: 160

56 Wight, 1840a: iii

57 Wight, 1838e: 30

58 Wight, 1848g: 89

59 Wight, 1841a: 6

60 Wight, 1838e: 65

61 l.c. p.78

62 Wight, 1838i: 142

63 Wight, 1839c: 159

64 Stevens, 1994: 185

65 Ibid. p.186

66 Note. Wight's correspondent Thomas Caverhill Jerdon was another convert to the Quinarian system in the Madras Presidency at this time, who used it for classifying birds, Macdonald, 2004: 1073

67 Griffith, 1848: xv

68 Wight, 1847a: iii et seq. Note. Stevens, 1994: 187, drew attention to this aspect of Wight's work, but was incorrect in stating that he was directly influenced by Fries

69 Lindley, 1841: 197, 225

70 Note. 'Have you read Swainson's works, especially his Preliminary Discourse on the Classification of Animals? Unpopular as they are, they are most philosophical, and ought to be learnt by heart; when I begin my real work I shall certainly have a table of his rules framed for constant reference'. Griffith to Wight, 6 March 1839 (Griffith, 1848: xviii). The reference is to one of the eleven volumes written by William Swainson for the Cabinet Cyclopedia, a series edited by the Rev. Dionysius Lardner

71 Wight, 1847a: viii

72 Ibid. p.iii

73 Knight, 2001

74 Quoted by Stevens, 1994: 187

75 Wight, 1841a: 56

76 Wight, 1849b: 109

77 Wight, 1841a: 17

78 Wight, 1850d: 219

79 Wight, 1847a: vii-viii. Note. This is a modification of a scheme given by Lindley, 1841: 225, but for Lindley's 'Acrogens' Wight has substituted Podostemaceae

80 Wight, 1841a: 37

81 Note. Griffith wrote of Bentham 'he is debarred the use of minute characters, which are often most valuable' Griffith 1848: xviii

82 Wight, 1839c: 166

83 Wight, 1841a: 6

84 Ibid. pp.48–9; 53–4

85 Wight, 1849b: 131

86 Wight, 1850d: 209

87 Wight, 1847a: ii

88 Wight, 1849b: 169

89 Wight, 1850d: 200

90 Griffith, 1848: xviii. This slightly patronising comment, doubtless intended to be reassuring, suggests that Griffith was fully aware of Wight's strengths and weaknesses

91 Note. Griffith was the first to undertake such studies in India, and Wight (1847a: 63) reported the light it threw on just such a sterile argument over the flower of Passiflora: what are petals, what are sepals, and are the coronal filaments modified stamens, or outgrowths from the corolla or calyx? Griffith showed that the filaments developed after the stamens were fully formed, so couldn't be androecial; they also developed after the petals, and at the same time as the calyx tube, so concluded that they were outgrowths of the latter organ, though they are now thought to develop from the corolla

92 Wight, 1841a: 40

93 Wight, 1848a: 29

94 Wight, 1838e: 110, 120. Note. These two families are no longer considered distinct and are now known under the name Clusiaceae

95 Wight, 1839c: 150

96 Wight, 1848a: 20

97 Ibid. p.28

98 Wight, 1852: 8

99 See Noltie, 2005: 238

100 Wight, 1852: 19

101 Stevens, 1994: 90

102 Wight, 1841a: 49. Note. When it suited his purposes Wight, like every other systematist of the time, was capable of inconsistency in such matters: in Rubiaceae, for example, he quite happily ignored the variable fruit characters, defining the group on what elsewhere he would denounce as less important vegetative ones (Wight, 1841a: 74), though he later (Wight, 1849b: 121) made out that this leaf character was a 'physiological' one

103 Wight, 1841a: 8

104 Note. Wight did not always stick to this principle, as can be seen from the casualty rate among his new genera

105 Wight, 1838e: 2

106 Wight, 1841a: 25

107 Ibid. p.81

108 Wight, 1850d: 213

109 Wight, 1840h

110 Wight, 1840g

111 RBGK LC L–Z f.920

112 RBGE BC 12 f.81
113 Wight, 1845f
114 Wight, 1841a: 33
115 Wight, 1838e: 48
116 Wight, 1841a: 25
117 Wight, 1838e: 64
118 Ibid. p.79
119 Wight, 1850d: 219
120 Wight, 1848e: 12
121 Wight, 1838e: 41
122 Wight, 1839c: 161
123 Wight, 1853b: 20
124 Wight, 1838e: 103
125 Ibid. p.57
126 Wight, 1848a: 35
127 Wight, 1853b: 14
128 Stevens, 1994: 83
129 Ibid. p.133
130 Quoted in Stevens, 1994: 149
131 Wight, 1838e: 67
132 Ibid. p.104
133 Wight, 1849b: 179
134 Note. It was certainly never then used in the modern sense of an individual specimen as a 'voucher' or 'standard' for a species name – these Wight and Arnott referred to as 'authentic' specimens, Wight & Arnott, 1834a: xxiii
135 Wight, 1845d: 27
136 Letter to C.P. von Martius quoted in Cleghorn, 1873
137 Hooker, 1853: 249. Emphasis added
138 Wight, 1844–5: 1
139 RBGK DC 7/15
140 Note. These have got progressively longer and harder to understand: the latest *International Code of Botanical Nomenclature* (Greuter, 2000) extends to 474 pages!
141 Wight, 1853b: 23–5
142 Strickland *et al.*, 1843
143 Noltie, 2005
144 Wight, 1853b: 25
145 Note. Works like Steudel's *Nomenclator Botanicus* (first edition 1821–4) helped Wight and his contemporaries greatly, but it was for this reason, and in a spirit of great scientific generosity, that Charles Darwin gave Joseph Hooker a large amount of money to compile *Index Kewensis*, the official list of all published botanical names that is continually being added to and updated – it can now be consulted electronically on 'www.ipni.org'
146 Note. For names of new taxa published since January 1958, an individual 'type' specimen has had to be designated, and the

herbarium in which it is deposited, included with the description
147 Wight, 1853b: 24
148 Note. Today the general ruling on this subject, orthography, is that the spelling of the original author should be respected
149 Note. According to contemporary rules of transliteration Wight was actually wrong! Horace Hayman Wilson, Boden Professor of Sanskrit at Oxford, whom Wallich (1853) consulted over the matter, agreed with Zenker's spelling
150 Note. For a discussion of this subject see Nicolson, 1991
151 Stevens, 1994: 206
152 Wight, 1840i: 179
153 CBG WC pkt 19
154 Griffith, 1848: xxiii, xxvii
155 Wight, 1838e: 120
156 Hooker, 1853: xiii. Note. For a more detailed discussion of the fascinating, but much neglected, topic of differing practices of species delimitation between field and herbarium botanists, see Stevens, 1997
157 Griffith, 1848: liii. Note. The Linnean Society had neglected to publish Griffith's paper on Assam mosses, though it had been read to them in March 1838. CJNH 2, no. 8 January 1842. This may have been because in it Griffith had been critical of Lindley
158 Note. For example when he was concerned about generic limits in Oleaceae Wight asked Arnott to 'dip into the subject by having a dig at both American and New Holland species to ascertain whether the subordinal character of *Chionanthus* can be thereby improved'. RBGE BC 12 f.81
159 Stevens, 1994: 207
160 Ibid. p.475
161 Wight, 1837a
162 Griffith, 1848: xv
163 Note. Much later Wight entertained such a possibility for cotton – 'may not the cotton plant … poison the ground for itself – long before it has exhausted the inorganic constituents on which it lives' Wight 1862: 36
164 Wight, 1851a: 61
165 Ibid. p.47
166 Wight, 1844b: 5
167 Note. In the case of *S. kunthiana*, the '*kurinji*' it is 12 years, and flowered in 2006
168 Arnott, 1831: 59
169 Wight, 1841a: 11

170 Wight, 1843f: 6
171 Wight, 1837l
172 Wight, 1840e: ii
173 Note. Greville & Hooker's projected *Filices Asiaticae*, intended as a supplement to Wallich's work, had to be abandoned for lack of subscribers: Greville told Wallich in 1834 'there is a stagnation among illustrated Nat. History works [in Britain]. We must attack them in a less ostentatious shape'. CBG WC pkt 19
174 Wight, 1840a: ii

CHAPTER 14

1 RBGK DC 54/554
2 The Nilgiris have been described as 'perhaps the most intensively studied part of rural Asia between Japan and the Holy Land'. Hockings, 1996: v
3 Price, 1908
4 Burton, 1851: 277
5 Note. By Wight's time in the Nilgiris Sullivan was back in Madras, in the Revenue Board. Their only direct contact so far discovered concerns Assam tea (CBG WC pkt 47). Sullivan retired to Britain in 1841, and more about him and his liberal views will be found in Chapter 15
6 McCurdy, c.1830. Note. In August 1847 there were 104 officers, from Bombay as well as Madras, on sick leave in Ooty. Burton, 1851: 276
7 Note. A drawing by Rungiah at Kew of *Osmunda regalis* from the Nilgiris dated 1 October 1827 does not necessarily mean that Wight was there himself on that date, though his collectors and/or artist must have been
8 Note. The first acacias came, probably from Tasmania, before 1825 and the first eucalyptus in 1843 (Price, 1908: 248–9). Extensive plantations of acacias started with E.B. Thomas in 1849, and eucalyptus slightly later. Deborah Sutton, pers. comm.
9 Munro quoted in Price, 1908: 75. Note. Interestingly this year was one in which *Strobilanthes kunthiana* was flowering 'the sides of the hills are at present covered with a purple flower, of the size of your [Lady Munro's] Bangalore geraniums, which makes them look as if they were covered with

heath'
10 Note. Variously spelt in Wight's time – also Toders, Todavers, Tandawars
11 Note. By 1847 the European population, including children, was 5–600. Burton, 1851: 276
12 Trevelyan on Macaulay, quoted in Price, 1908: 130
13 McCurdy, c.1830
14 Wight, 1848a: 20
15 Burton, 1851: 267–8
16 Note. Probably from March to November. RBGK DC 54/553
17 RBGK MC f.236
18 Wight, 1842: 238
19 Wight, 1842: 238–9
20 RBGK MC f.236
21 Gardner, 1845: 407
22 Note. There are illustrations of those marked * at RBGE
23 Letter to C.P. von Martius quoted in Cleghorn, 1873
24 Burton, 1851: 288
25 RBGK DC 54/554
26 Wight, 1848a: 23
27 Wight, 1851a: 49
28 Wight, 1845g: t. 938
29 Burton, 1851: 285
30 McCurdy, c.1830
31 Burton, 1851: 329
32 Pandian, 1998
33 Burton, 1851: 296
34 Price, 1908: 342. Note. It is recorded here that Mrs Jerdon was niece of General L.W. Watson
35 Baikie, 1834
36 CBG WC pkt 19, 27 iv 1835
37 CBG WC pkt 50, 28 xi 1836
38 CBG WC pkt 50, 23 ii 1838
39 CBG WC pkt 19. Note. She was a friend of Goethe, and is commemorated in Siebold & Zuccarini's genus *Paulownia*
40 RBGK DC 7/28 – a letter to Hooker from Arnott, quoting Wight
41 CBG WC pkt 2, Schmid to Wallich, 25 viii 1845
42 Note. This is betrayed in an amusing comment in a letter of Arnott's to Hooker in 1833: 'What an enormous labour you must have had in the division [of Drummond's plants]. It really was too bad in Dr Greville and his friend Mr Knobb (whether Botanist or Missionary – I hope the latter from the uncouthness of the name) – but I forgot you and I are not at one on these points' RBGK DC 3/41
43 CBG WC pkt 2, Schmid to Wallich, 30 xii 1845
44 CBG WC pkt 50

45 Information from CMS archives provided by Philippa Bassett
46 Letter on specimen of *Dalzellia ramosissima* at Kew
47 Price, 1908: 249
48 Alan Robertson, pers. comm.
49 RBGK DC 157/644
50 Gardner, 1845
51 RBGK DC 54/552. Note. This, strikingly, is a repeat of the Arnott story of 13 years previously
52 Note. For many of which there are drawings at RBGE – marked*
53 Note. The early Courtallum papers do not approach it in terms of detail or interest
54 Note. This betrays Gardner's Brazilian experience
55 Note. Spelt variously by the British as Burghers, Bargars, Badagas, the ancient, but probably not aboriginal, group of cultivators of the Nilgiris
56 Note. Wight later described this as two distinct species under the names L. *neilgherrense* and L. *tubiflorum*, but the original identification was correct and all three are now know as L. *wallichianum*. When Burton visited the falls two years later, in July, when there would have been more water than in February, he was typically unimpressed: the 'thin stream … dashes over a gap in the rock, and disperses into spray before it has time to reach the basin below. As usual with Neilgherry cascades they only want water'. Burton: 1851: 269
57 Gardner, 1847
58 Note. *The Chinese War: an Account of all the Operations of the British Forces from the Commencement to the Treaty of Nanking*. London: Saunders & Otley, 1844
59 Note. Gardner later took out a patent 'for preparing coffee leaf, so as to afford a beverage, by infusion, "forming an agreeable, refreshing, and nutritive article of diet"' Thomson, 1875: 89
60 OIOC E/4/964
61 Cleghorn, 1873: 26
62 OIOC E/4/959
63 OIOC E/4/959
64 OIOC E/4/961. Note. In 1846/7 an observatory was built on the summit of Dodabet by T.G. Taylor, the Company's Astronomer. Price, 1908: 456
65 Wight, 1843f: [index] iii
66 RBGK DC 157/644
67 Price, 1908: 293
68 Note. Wight mentioned its

change of name to Bellevue on the last page of the *Illustrations*
69 Burton, 1851: 287
70 RBGK DC 55/476

CHAPTER 15

1 Darwin, 1791 2: Canto 2, lines 85–90. This refers to the machine spinning of cotton wool using Arkwright's machinery driven by the River Derwent in Matlock, Derbyshire
2 Note. The EIC hierarchy from Wight upwards went: District Collector, Madras Revenue Board, Madras Governor and Council, Government of India in Calcutta, Court of Directors in London
3 PP3: 24
4 Note. Wheeler (1824–97) was a considerable scholar who wrote on a wide range of historical topics, not only Indian, but Biblical and Classical. He went to India as editor of the *Madras Spectator* in 1858, then taught at Presidency College before undertaking historical research firstly for the Madras Government (such as this book) then for the Government of India
5 Note. The date is significant, the start of the American Civil War and worry about its effects on cotton imports from that predominant source
6 Note. The gilt stamp on the front board of the English version rather oddly depicts a nutmeg not a cotton plant! The other handbooks are Medlicott (1862) for Bombay, and Cassells (1862) for Bengal
7 Wight, 1362: 5
8 Silver, 1966
9 Hutchinson & Ghose, 1937
10 Balasubramaniam, 1965
11 Ratnam, 1966
12 Royle, 1851: 1
13 Quoted in Santhanam & Sundaram, 1997
14 PPI: 42/52
15 Royle, 1851: 127
16 Royle, 1851: 86–90
17 Note. Hughes obtained 100lbs/acre of wool, i.e. about 300 lbs/acre of seed cotton, which cost 12d/lb to produce, and sold in London for over 2s/lb. Royle 1851: 228. Hughes (c. 1770–1835) was an interesting entrepreneur who also grew senna, see Cotton, 1905: 332

18 Note. Heath, d. 1851, was appointed Commercial Resident of Salem and Coimbatore in 1820, and was somewhat enterprising, setting up the East India Steel & Iron Company in Salem in 1830. www.mynet.in/salem2 consulted 3 May 2006
19 PPI: 6/16
20 Wight, 1836e: 62–3
21 Ibid.
22 OIOC F/4/1701 no. 68781
23 Wight, 1837k
24 Note. Fischer was the only European Zemindar in the Madras Presidency, which seems doubly odd given that this was the very area where Munro developed the ryotwary system. He purchased the zemindari in May 1836 and paid the EIC Rs 10,000 p.a. (Richards, 1918: 244)
25 Wight, 1837k
26 AHSI Minute Book 1835–7 f.490
27 CBG WC pkt 50, letter dated 8 Aug 1837
28 PPI: 42/52
29 AHSI Minute Book 1835–7 f.490
30 Ibid. Note. See also Watt, 1907: 220
31 AHSI Minute Book, 10 Jan 1838
32 Note. Not published until 1839, but evidently circulated earlier. Piddington was based in Calcutta and did important geological and meteorological work, and coined the word 'cyclone'
33 Wight, 1838e
34 Wight, 1838f
35 OIOC F/4/1833 no. 76037
36 Wight, 1838e
37 Note. In the south of the present state of Maharashtra
38 PPI: 3/13–9/19
39 PPI: 20/30
40 PPI: 40/50
41 PPI: 52/62
42 PPI: 22/32–24/34
43 PPI: 24/34–28/38
44 Note. Brunel's first steam ship that travelled between Bristol and New York from 1838 to 1846, taking 15 days
45 Note. Some work on rice was also intended; Morris undertook some at Errode, see OIOC E/4/959, 961
46 OIOC E/4/957, PPI: 323/341. Note the New Orleans seed had apparently been purchased at Rodney and Natchez, see Ratnam, 1966: 205
47 PPI: 305/323–312/330
48 PPI 312/330
49 PPI: 314/332
50 Note. As at Tinnevelly, there had

been earlier American cotton experiments at Coimbatore: the Collector William Garrow had tried Bourbon cotton there as early as c.1804 [perhaps with seed from Anderson?] (Ratnam, 1966: 141); and it was one of the sites of a 400 acre experimental farm in 1819 under J.M. Heath, who showed that good Bourbon could be grown, and persuaded the ryots to do so on a considerable scale (Ibid. 153; 500 bales were produced in 1823–4. Royle 1851: 229) – as they were still doing in Wight's time. Some of the Upland Georgian and Sea Island seed imported into Madras in 1831 was sent to Coimbatore, but as reported in 1833 was largely unsuccessful, and the Collector had urged remission on land assessment to encourage the growth of American cottons (Ibid. p.172)
51 PPI: 317/335
52 Note. by this time the post took only 6 to 8 weeks. One of the Directors who signed this letter was J. L. Lushington! On the copy of this letter retained in London an anonymous contemporary annotation reads 'Much ado about nothing I apprehend'. OIOC E/4/956
53 Translation reproduced in Ratnam, 1966: 205
54 Royle, 1851: 473
55 Letter of 10 January 1842, quoted in Royle, 1851: 184
56 OIOC E/4/958 f.149. Note. In some documents this is given as Rs 300
57 Ratnam, 1966: 208
58 PPI: 328/346
59 PPI 330/348–334/352
60 PPI: 335/353
61 PPI: 323/341
62 Note. In 1845 Hawley was at Dharwar in the Southern Mahratta country
63 PPI 331/349
64 PPI: 338/356
65 Note. the Court had hoped for 100 bales per planter, i.e., 300 from Coimbatore
66 PPI: 336/354
67 PPI: 337/355
68 PPI: 339/357
69 PPI: 340/358
70 PPI: 340/359. Note. In fact it was allowed for the whole course of the experiment, i.e. until 1853
71 Royle, 1851: 475
72 PPI: 347/365
73 Filipiuk, 1997: 168

74 PP3: 176

76 PPI: 335/353

77 PPI: 341/359. Note. A further Rs 2420/2/5 was spent completing the gin house in July 1845. OIOC E/4/965

78 Wheeler, 1863: 17

79 PPI: 342/360

80 PPI: 359/377

81 Wight, 1844a

82 Note. A native plough cost only 12 annas and the 'small country cattle' required to pull it Rs 10–15 a pair, while the heavier cattle required to pull the American plough cost Rs 70–80 for the whole 'turn-out' (PPI: 354/372); in February 1843 Wight asked for from 20 to 30 pairs of country cattle to plough 300 acres PPI: 356/374. It is not possible to go into details of the costs cultivation here, but for those interested copious details are supplied in PPI, e.g., pp. 357/375

83 Wight, 1844a: 129

84 PPI 1: 373/391. According to J.C. Wroughton, who described native cotton cultivation as 'peculiarly a family undertaking', sowing always took place in October, mixed with two or three grain crops and harvested by little children. Ibid. 410/428. Picking took place in February and March PP2: 28/518

85 PPI: 363/381

86 PP2: 185/685. Note. Oxygenation is, of course, important in soil preparation, but this process added nothing in the way of minerals, and atmospheric nitrogen cannot be taken up by plants directly from the soil

87 Wight, 1844a: 136

88 PPI: 355/373

89 Note. It has been reckoned that today 22.5% of all the world's insecticides are used on cotton, that grows on only 2.5% of Agricultural land – quoted in the *Church Times* 20 Jan 2006

90 Wight, 1844a: 137. Note. Wroughton gave drought and an insect called the 'grate' [perhaps what is now called a 'jassid', an hemipteran] as the two biggest threats to cotton cultivation PPI: 410/428

91 PPI: 355/373

92 Wight, 1862

93 PPI: 365/383

94 PPI: 360/370–365/383

95 Note. Wight at this point realised that a realistic aim to match was

the 5–600 lbs/acre of Georgia, rather than the 1200–1400lbs/acre achievable in the Mississippi valley PPI: 364/382, though he never quite got over hankering after 1000 lbs/acre

96 Note. They each received a gratuity of Rs 500 in 1844 or 1845. OIOC E/4/964

97 PPI: 369/387

98 OIOC E/4/961

99 PPI: 372/390. Note. Emphasis added

100 PPI 374/392

101 Note. The price of oopum was Rs 10–14 per candy. Wight later (September 1845) dropped the price offered for American to Rs 15 per candy, PPI: 392/410

102 OIOC E/4/964. Note. Continuance of this practice beyond the three years was later allowed; it was not officially stopped until July 1853. OIOC E/4/978

103 PPI: 378/398

104 OIOC E/4/962

105 For report see PPI: 400/418–406/424

106 PPI: 391/409

107 Wight, 1844a: 138

108 Ibid.

109 PPI: 390/408

110 Wight, 1862: 38

111 PPI: 363/381

112 PPI: 346/328

113 OIOC E/4/961

114 Shaw, 1877: 19

115 PPI 390/408; Wight, 1845a

116 Note. It was sown in July 1844, and picking was continuous from December to the following July

117 PPI 401/419

118 PPI: 409/427. The sw monsoon can penetrate the Western Ghats from the Malabar Coast, by means of the Palghat gap

119 Royle, 1851: 95

120 PPI: 378/396–381/399

121 Note. The censure was later approved by the Court. OIOC E/4/964

122 PPI: 381/399

123 Ratnam, 1966: 217

124 Ibid.

125 PPI: 385/403–389/407

126 PPI: 387/405

127 PPI: 395/413–396/414

128 Note. Sent from London on 26 November 1845

129 PPI: 398/416

130 OIOC E/4/965

131 PPI: 401/419

132 PP2: 186/686

133 Note. By 1849 Wight had changed his mind about the

advantages of 2–monsoon areas; the idea that they were better being 'most erroneous'. PP2: 209/709

134 PPI: 403/421

135 PPI: 401/419

136 PP2: 186/686

137 PP2: 186/686

138 PP2: 152/652

139 PP3: 176–98

140 Wight, 1848d

141 Note. Expenses of Rs 200 were allowed by the Court for this in July 1847 PP2: 150/650

142 PPI: 407/425. Note. Coimbatore to Madras was 320 miles by road, taking a bullock cart 23 or 24 days: cost Rs 20. Coimbatore to Cochin 90 miles of road and 60 of backwater taking 7 days: cost Rs 6¾ per cartload PP3: 176–98

143 PP2: 219/719

144 PPI: 424/446

145 PP2: 151/651

146 PP2: 166/666

147 PP2: 166/666. Note. Locations of these unknown, but presumably near Ootakalmund; the first and last were said to be 20 miles apart, but it appears that the last is not Pollachi, where some of the earlier experiments had taken place

148 PP2: 182/682–183/683

149 See also Wight, 1848b

150 PP2: 186/686

151 Royle, 1851: 107

152 PP2: 400/902

153 Note. Sent from London on 14 July

154 Note. They would have received the answer in January 1848: Rs 245,034/14/10, less Rs 16,409/4/10 for the proceeds of sales of cotton in England PP2: 140/640

155 PP2: 149/649

156 PP2: 29/519

157 PP2: 183/683. Note. In January 1847 Wight stated he could gin about 600 bales per year, and assuming the same was produced in Tinnevelly the most that could be produced would be 1200 per year, so the Court's order would take 5 years to complete (PP2: 349/849). However, the rate must have increased as almost nothing came from Tinnevelly, and yet by May 1849 the order had 'been about half executed'. PP2: 212/712

158 PP2: 156/656

159 See Ratnam, 1966: 172, 187

160 PP2: 153/653

161 PP2: 159/659

162 Note. These had by now been worked out at Rs 245,034, and appear to have incensed Tweeddale, but the implied slur against Wight is surely unjustified

163 PP2: 159/659

164 PP2: 169/669–171/671

165 Note. Wight did have appreciative supporters in the Madras Government, such as Henry Chamier the Secretary, who in 1845 paid tribute to Wight's 'care, scientific acquirements and deep interest in the experiment' PPI: 395/413

166 PP2: 153/653

167 Note. It would have the effect of 'forcing a factitious cultivation', as Sir Henry Montgomery, Secretary to the Madras Govt. put it. PP2: 32/522

168 Note. This had first been given, to a limited extent, in 1842; again in October 1845 for three years; and it was allowed again in September 1849 – summary in PP2: 245/745; it was not finally stopped until July 1853. OIOC E/4/978

169 PP2: 179/679

170 OIOC E/4/968

171 Silver, 1966: 22

172 PP3

173 PP3: 396–406

174 Ibid.

175 Silver, 1966: 24

176 PP2: 209/709

177 PP2: 185/685

178 Note. These included lack of rotation and manuring, that Coimbatore was not the best place for the experiments, and wrong sowing times

179 PPI: 424/446

180 Wight, 1848b

181 Copy published in Wight, 1848c

182 PP2: 186/686

183 Ibid.

184 PP2: 221/721, republished as Wight, 1850a

185 FRIT: 65

186 Note. See Ratnam, 1966: 251–7 for an account of Lawford's laudable efforts from 1848 to 1850

187 PP2: 212/712

188 PP2: 143/643

189 PP2: 189/689

190 PP2: 209/709

191 Note. The MCA was happy to give advice and receive the results and produce of the Court's expensive experiments, but was notably unwilling to put its hand into its collective pocket.

Eventually in 1850 they sent a cotton planter and merchant called David Lees, who, with his nephew Arthur, started farming in the coastal region near Tinnevelly, though apparently without success

192 PP2: 216/716

193 Note. Pottinger perhaps did not fully understand the principles of ryotwary, and in his long justification Wight pointed out that there was no option but to pay compensation for the use of land for Government purposes, as in effect the *ryots* owned the land so long as they paid their annual assessment

194 OIOC L/MIL/11/72; *Fort St George Gazette* 1849: 808

195 RBGK DC 54/545

196 FRIT: 63

197 Royle, 1851: 109

198 RBGK DC 54/545, letter to Hooker, 8 March 1850

199 PP2: 226/726

200 Note. The rise was about Rs 3612 p.a., giving him a total annual salary of about Rs 18,480

201 PP2: 221/721

202 FRIT: 65

203 Wight, 1850b: 212 – emphasis added

204 PP2: 406/908

205 Wheeler, 1863: 169

206 Wight, 1850c: 250. Note. Equivalent to 3 to 4 shillings

207 PP2: 384/886

208 Wight, 1850b: 212

209 Ibid.

210 PP2: 113/613

211 PP2: 236/736

212 Wight, 1854a: 28

213 PP2: 113/613

214 Wheeler, 1863; 168

215 Wight, 1850b: 214

216 Ibid. p.213. Note. Tweeddale had suggested to E.B. Thomas that increase in staple-length of Native cotton could be achieved by selecting seeds with longer staple. In 1861 this was brought to the attention of a later Governor, Sir William Denison, who recommended it as part of his experiments between 1861 and 1866. See Ratnam, 1966: 245; Wheeler, 1863: 151

217 *Fort St George Gazette* 1851: 295

218 RBGK LC L–Z f.921

219 RBGK DC 55/475

220 OIOC E/4/974

221 Wight, 1854a: 28

222 Ibid.

223 PP2: 133/633

224 PP2: 250/750

225 PP2: 244/744

226 PP2: 235/735

227 FRIT: 64

228 PP2: 235/735

229 PP2: 139/639–149/649

230 Note. Moore family MSS. Wight evidently kept in close touch with Petrie after his retirement and in his will of 1861 Wight recommended that Petrie be asked to be one of his Trustees should a vacancy arise – presumably through the death of either Dorward or Field

231 Wight, 1861, 1862. Note. The spectacles had by this time become positively carmine, when he felt able to refer to '13 years of invariable success'

232 PP1: 24/34. Note. The Madras Agri-Horticultural Society offered prizes, paid for by the Madras Government, for cotton improvement in the 1840s. Fischer scooped up most of these, but Soobah Singh of Coimbatore won Rs 300 for the best crop grown from imported seed in 1849, see Ratnam, 1966: 257–68. Singh was the 'duffadar' on the Collector's (i.e. Wroughton's) farm at Coimbatore PP2: 308/808

233 PP2: 242/742

234 PP2: 243/743

235 Ibid.

236 See PP2

237 Note. See PP2: Bengal for extensive documentation; Finnie appears to have worked considerably harder there than he would in Madras

238 PP1: 393/411

239 PP1: 394/412

240 PP1: 395/413

241 PP1: 417/435–420/438

242 Wheeler, 1863: 81

243 PP2: 171/671–178/678

244 PP1: 420/438

245 PP2: 264/764

246 PP2: 279/779

247 PP2: 273/773

248 'He had no sooner planted his cotton last year [presumably in September/October] than he went off to Courtallum and stayed away till March (and I believe intends doing the same this year [1848]' PP2: 183/683

249 PP2: 200/700

250 Note. When this letter was printed, it was presumably Royle who added an interesting explanatory note that for hybridisation to be possible in cotton it was necessary to

emasculate a flower in bud, and then cross pollinate it, PP2: 200/700

251 PP2: 292/792

252 PP2: 193/693

253 PP2: 165/665 – emphasis added

254 PP2: 200/700

255 Wheeler, 1863: 164

256 Ibid. p.111

257 PP2: 281/781

258 Ibid.

259 PP2: 295/795

260 PP2: 285/785

261 PP2: 282/783

262 PP2: 296/796

263 PP2: 195/695

264 PP2: 193/693. Note. In benign old age Wight would admit that 'the churka is superior to the saw gin in everything but speed'. Wight, 1862: 23

265 PP1: 417/435

266 PP1: 421/443

267 Ibid.

268 PP1: 422/444

269 PP1: 35/45 – emphasis added

270 Note. On starting in Madras Finnie's monthly salary, including expenses, was Rs 530–535 and Tweeddale recommended raising this by Rs 200 in September 1847 (PP2: 259/279) which was duly allowed by the Court (quoted in PP2: 182/682)

271 PP2: 150/650, 262/762

272 PP2: 270/770

273 Note. Since the renewal of its charter in 1813, when its monopoly on trade, other than tea, was removed, and opened up to private enterprise

274 PP2: 266/766

275 Wheeler, 1863: 83

276 PP2: 348/848

277 RBGK DC 54/192

278 PP2: 165/665

279 PP2: 276/776

280 PP2: 277/777

281 Note. Wight had written (PP2: 164/664) to the Government about the American's report to Manchester, but made no suggestion of a conspiracy

282 PP2: 204/704

283 PP2: 211/711

284 PP2: 226/726

285 PP2: 304/804

286 PP2: 304/804

287 Wheeler 1863: 164

288 RBGK DC 54/545

289 PP2: 238/738

290 PP2: 254/754

291 PP2: 131/631

292 PP2: 235

293 PP2: 247/747

294 PP2: 312/812

295 Wheeler, 1863: 235–237

296 PP2: 113/613

297 PP2: 133/633

298 President in Council's recommendation that Wight's employment on economic botany be terminated

299 Tweeddale's recommendation of scrapping of the Cotton farms

300 Pottinger's sending Wight back to military duties

301 Pottinger's attempt to block Wight's promotion

302 RBGK DC 55/475

303 Note. The main exception being the American cotton that continued to be grown in the Southern Mahratta country around Dharwar. Note. At the time of the American Civil War, the (by now British) Government again interested themselves, offering prizes for improved cultivation. In Madras between 1861 and 1866, under the Governor Sir William Denison, some experiments were again undertaken at Coimbatore; at this time there were attempts to introduce Peruvian cotton – see Ratnam, 1966: 242 *et seq.*

304 Note. The first working mill in India was in Bombay in 1854, that in Madras in 1874, and one was being built at Coimbatore in 1890 – see Watt: 1890

305 Account summarised from Hutchinson, 1974

306 Note. Coimbatore is now home to one of 11 main centres of the All India Co-ordinated Cotton Improvement Project (AICCIP), and a regional centre of Central Institute for Cotton Research (CICR)

307 Santhanam & Sundaram, 1997: 250

308 Balasubramaniam, 1965: 66

309 Ibid. p.71

310 www.ikisan.com, consulted 6 December 2005

311 *The Week* 29 December 2002; *The Express*, Coimbatore edition, 11 January 2003

312 Yule & Burnell, 1903: 486

313 Balasubramaniam, 1965: 61

314 FRIT: 67

315 Balasubramaniam, 1965: 62

316 Ibid. p.61

317 Yule & Burnell, 1903: 980

CHAPTER 16

1 Burton, 1851: 250
2 RBGK DC 54/545
3 RBGK DC 54/548
4 Note. A palanquin had to be purchased for the journey at a cost of Rs 85. OIOC F/4/1825 no. 75395 f.7
5 OIOC L/MIL/11/72
6 Shaw, 1877: 20
7 Hooker, 1848
8 Hooker, 1848
9 RBGK DC 54/547. Note they continued corresponding while Hooker was in Sikkim, and in 1849 his father sent Wight a copy of the lavish *Sikkim Rhododendrons*, in which he must have been thrilled by the dedication of *Rhododendron wightii*. When Wight acknowledged receipt of the book he pointed out to Hooker (senior) that it was Bentham who had concluded that the Nilgiri and Himalayan *R. arboreum* were conspecific and that he had merely followed this decision
10 Cleghorn, 1873
11 Noltie, 1999
12 RBGK BC 4 f.1516
13 Letter to Martius dated 14 vii 1844, quoted in Cleghorn, 1873
14 Wight, 1845c: 304
15 Reichenbach, 1872
16 Note. In the discussions over the mounting Griffith's specimens he recommended laid demy paper 'about sixteen by ten inches', which is closer to the size used by Arnott and Hooker
17 Cleghorn, 1873
18 Gardner, 1845
19 Note. Wight described this later this year as *Loranthus euphorbiae*, now *Helixanthera elastica*
20 Wight 1850d: 215
21 Cleghorn, 1861
22 Ibid. p.307
23 Note. Although this has uncanny resonances with the homöothermal method, the similarity is coincidental, and the ends in view very different
24 Kjaer, Kaosa-ard & Suangtho – http://www.dfsc.dk/imp_con_teak.htm, consulted 2 Oct 2005
25 Wight, 1850f
26 Note. Tamil and Telugu were then both commonly spoken in the area, and such problems are encountered on many of the Wight drawings – Tamil names being written by the artists in Telugu script
27 Note. As Petrie left Coimbatore in 1847, Wight's interests in timber must long predate Balfour's request, perhaps going back to the 1836 brief
28 Balfour, 1862: 9
29 RBGK MDB 1872 f.307
30 Cleghorn, 1852
31 Ibid. p.87
32 Muthiah, 1999: 314
33 TNA PDC vol. 902 ff.1559–71
34 Balfour, 1862: 9
35 Royle, 1851: 594–607
36 OIOC E/4/976
37 Allen, 2000: 32
38 OIOC F/4/2492 no. 141183
39 Balfour, 1862
40 Note. Three editions 1857 (1 vol), 1871–3 (5 vols), 1885 (3 vols)
41 Desmond, 1995: 191. Note. This building at the northern end of the Order Beds is now used as the School of Horticulture
42 RBGK MDB 1849 f.53

CHAPTER 17

1 Note. He returned to it after retiring to London, helping Bentham with the distribution of the final parts of the EIC herbarium, and in a creditable monograph of the genus *Hedychium* (Wallich, 1853)
2 Arnold, 2005: 155
3 Note. Half of Sir William Hooker's (1854) brief notice immediately following Wallich's death is devoted to this aspect of his work: 'but for his munificent contributions of Palms and other glories of tropical vegetation, the great conservatory of the Duke of Northumberland, at Syon, would never have been required…'
4 Note. As Calcutta was the capital, this could be seen as in some ways a 'national herbarium', though such a designation was never used
5 The original daguerreotype, which unfortunately can no longer be found at Kew, must have been taken in Calcutta, and therefore represents an extremely early Indian example of the technique. It is known that one M.L. Montairo advertised the taking of daguerreotypes in Calcutta in 1844 (Desmond, 1982), so perhaps this is his work. The Morton lithograph is reproduced in Desmond, 1992: 114. The photograph testifies to Griffith's immense physical and intellectual vigour, which has been massively tamed in both the prints, to make an image perhaps thought more suitable for posthumous reproduction
6 Note. The longest being a monograph of Indian palms
7 Griffith, 1848: v
8 Reported in December 1845 as '5 or 6 years ago' by Arnott to Hooker, RBGK JDH 1 f.177
9 CBG WC pkt, 24 ix 1845
10 RBGK WC 22 xi 1845
11 See Desmond, 1992: 95–7; Sangwan, 1997: 227; Arnold, 2005: 175
12 See Sangwan, 1997: 225–7
13 McClelland, 1846
14 Note. Though all his travels Griffith remained on the payroll of the Madras Medical Service
15 CJNH 6: 306
16 Ibid. p.294. Note. That this was not an exaggeration on the part of McClelland is shown by the fact that Auckland personally wrote a biographical memoir of Griffith, read to the Asiatic Society in London in May 1845
17 Wight, quoted in McClelland, CJNH 6: 'Notice'
18 CJNH 1: 2, 1840
19 Note. Wallich, probably not unreasonably, took this to be 'systematically'. The first occasion was in a review of Speede's *Indian Hand Book of Gardening* (CJNH 1: 302, July 1840); secondly in a review of Wallich's Report on the garden for the years 1836–40, when McClelland ended with a poison-barbed rhetorical question relating to one of Wallich's own discoveries, the Burmese lacquer tree, and the title of Wallich's most famous publication: 'Is *Melanorrhoea* still one of the *Plantae Asiaticae Rariores*; or are cabinet-makers likely to be able to avail themselves of its beautiful varnish?' CJNH 2: 288, July 1841
20 & 21 CJNH 6: 'Notice'
22 Wight, 1845c: 302
23 Quoted in Desmond, 1992: 115
24 Wight, 1845c: 301
25 & 26 Ibid. p.303
27 Ibid. pp.304–5 emphasis added. Note. Wight had been made aware of this (and, perhaps, egged on) by Griffith, who had discovered the absence of any specimens when trying to write up Roxburgh's cryptogams – see CJNH 3(16): 466
28 RBGK DC 54/550
29 Note. 21 of the 30 had done nothing, and most of the rest only a small proportion of their families, and these mainly in large, or inaccessible works
30 RBGK WC, Wallich to Hooker, 8 iii 1846. Note. Some Roxburgh material was included in Wallich's great distribution of the EIC herbarium, but this was material that was already at India House
31 Note. This is discussed by Sangwan, 1997. Wight was astute enough to avoid such disputes by keeping his art-commissioning and plant collecting activities after 1828 strictly separate from his professional ones
32 Thomson, 1857
33 Note. In McClelland's attack on Wallich's running of the garden he was incorrect in saying there was no herbarium
34 Desmond, 1992: 87
35 Thomson, 1857: 34
36 Desmond, 1982: 63–4; 1992: 191
37 Note. Cantor was Wallich's nephew
38 Desmond, 1982: 63
39 & 40 l.c. p.64
41 www.madrasmedicalcollege.edu – consulted 22 Oct 2005
42 OIOC F/4/2492 no. 141183
43 Quoted in Aiyappan, 1999: 6
44 Mudaliar, 1954: 11. Note. Drew (1826–57) had only two years in India between becoming an Assistant Surgeon and his death at Vellore
45 RBGK DC 54/548
46 CBG WC pkt 2, letter to Sir J.W. Hogg Bart., MP dated 19 Oct 1846 – emphasis added
47 CBG WC pkt 2, 30 viii 1848
48 RBGK DC 54/547. Note. Bentham lived at Pontrilas House near Hereford, and this visit concerned the long delayed final distribution of the EIC herbarium
49 RBGK DC 55/401
50 Referred to in RBGK BC 10: f.4079
51 RBGK BC 10 f.4084
52 RBGK DC 55/429
53 RBGK DC 55/476, 3 July 1852
54 Cleghorn, 1873
55 OIOC L/MIL/11/72
56 RBGK DC 54/548
57 EI *Register* for 1853
58 *Fort St George Gazette* 1853: 238

CHAPTER 18

1 RBGK DC 55/477
2 RBGK DC 55/478
3 FRIT. Note. See also Silver, 1966: 70 et seq. Note. Curiously Wight had also been Britain at the time of the previous charter renewal – that of 1833, which had removed the last of the Company's trading monopolies
4 Silver, 1966: 71
5 Sale Advertisement in *Reading Mercury, Oxford Gazette, Newbury Herald, and Berks County Paper* 150: 3, 3 August 1872
6 Ibid.
7 BL Egerton MS 2851 f.159
8 RBGK DC 55/479
9 RBGK DC 55/480
10 Wight, 1850d: 197
11 RBGK DC 34/308
12 Note. He is on the earliest surviving list of 1860 – Brent Elliott, pers. comm.
13 RBGK DC 55/480
14 RBGK DC 34/308
15 BL Egerton MS 2851 f.159. Note. It was Weddell who in 1868 published the English translation of Alphonse de Candolle's 'Lois' of botanical nomenclature, the origin of the present 'Code'
16 RBGK DC 34/308
17 Reichenbach, 1872
18 RBGK DC 54/551
19 RBGK BC 10 f.4200
20 Hooker, 1853
21 Arnold, 2005: 175
22 RBGK DC 33/439, and 55/479 & 480
23 RBGE BC 12 f.82
24 RBGK DC 55/481
25 RBGK DC 34/308
26 Note. A reference to Sir Walter Scott's *Guy Mannering*
27 RBGK DC 157/650, i.e. A.P. de Candolle
28 RBGK DC 157/647
29 Home *et al.*, 2006: 379
30 RBGK DC 55 f.429
31 RSL Wight's Election Certificate
32 RBGK DC 157/650
33 RBGK BC 10 f.4201
34 RBGK JDH 21: f.122
35 RBGK DC 42/502
36 RSL Election Certificates – various
37 RBGK MDB 1854 f.274
38 RBGK DC 37/654
39 Noltie, 2005
40 RBGK DC 157/647
41 RBGK DC 157/646
42 RBGK DC 157/649
43 RBGK HP to 1900 2 f.732
44 RBGK DC 105/375
45 RBGK DC 105/377
46 RBGK DC 105/376
47 RBGK DC 105/378
48 RBGK JDH 21 f.121
49 RBGK DC 105/380
50 Note. These were of 17, 12, 6 and 3 acres, and two of 5 acres
51 RBGK DC 55/481
52 Reichenbach, 1872
53 RBGK DC 157/646
54 RBGK DC 105/376
55 Wight, 1862
56 Note. *The Agricultural Gazette*, Liebig's *Letters on Modern Agriculture*, Johnston's *Lectures on Agricultural Chemistry* are quoted
57 Reichenbach, 1872
58 RBGK DC 37/649
59 Note. One of the drafts of his letters to Henry Freke is written on the back of a circular from the firm dated December 1862 notifying a change of address of their London premises
60 RBGK DC 38/620
61 RBGK DC 105/373
62 *Berkshire Chronicle* 37(1742): 6, 16 June 1860 & *Reading Mercury, Oxford Gazette, Newbury Herald & Berks County Paper* 138: 8, 16 June 1860
63 RBGK DC 37/649
64 Note. Macnee (1806–82) was by now a successful portrait painter; in 1876 he was knighted and succeeded Sir George Harvey as President of the Royal Scottish Academy
65 RBGK DC 37/649
66 RBGK DC 157/648. Note. She must have pulled through as she lived for another nine years
67 RBGE BC 12 f.85
68 Anderson *et al.*, 2003: 126

CHAPTER 19

1 RBGK DC 157/647
2 RBGK DC 157/646
3 RBGK DC 157/648
4 RBGK DC 157/647, 649
5 RBGE BC 12 f.84
6 RBGK JDH 1 f.183
7 BCRO RG 9/751 f.99
8 BCRO RG 10/1287 f.74
9 RBGK JDH 21 f.121
10 RBGK DC 55/476
11 Watson, undated. Note. Mary's uncle was John Horatio Lloyd, a wealthy barrister and MP, grandfather of Oscar Wilde's wife Constance. J.H. Lloyd's wife was Caroline Watson, sister of the botanical phrenologist H.C.

Watson who explored Glen Clova with Wight in 1831
12 Anon, 1896
13 RBGK DC 105/374
14 RBGK DC 42/502
15 RBGE AC f.253
16 Ibid. f.250
17 RBGK DC 105/378
18 RBGK DC 105/375
19 RBGK DC 105/378
20 Moore family MSS, draft letter Lucy Cosens to the Rev J.S. Roper, c.1931
21 RBGE AC f.249
22 Obituary, *The Times*, 18 December 1915
23 Note. Opened by Queen Victoria in 1859 on a bleak site at Crowthorne in Berkshire as the national memorial to the Duke of Wellington, initially for the sons of British and EIC army officer's sons. It was a charitable institution, with army orphans paying reduced fees of £10–20 per year, and perhaps Ernest benefitted from this after Wight's death
24 Obituary, *The Lancet*, 22 Jan 1916 p.220
25 Moore family, Cosens letters
26 Note. Later to become the parish church of Grazeley
27 Anon, 1868
28 BCRO, Shinfield Vestry Minutes

CHAPTER 20

1 Alison Pearn, pers. comm.; Desmond & Moore 1991: 502
2 Moore family MSS
3 Bond, 1944
4 Note. Neither Freke nor Wight were unusual among their generation in failing to see that it was the mechanism of natural selection that was Darwin's most important contribution
5 Darwin, 1801 2: 240
6 Note. Bond (1944) detected an influence from the French physician and pathologist Xavier Bichat (1771–1802)
7 Note. There is no mention of Wight in the *Origin*, though people well known to him in India or Ceylon are credited as supplying information: Sir Walter Elliot, George Gardner and G.H.K. Thwaites
8 Anon, 1861
9 Freke, 1862
10 Moore family MSS
11 Waring quoted in Cleghorn, 1873

12 Cleghorn, 1873
13 Elliott, 2004: 120
14 *Gardeners' Chronicle* 24 March 1866: 266
15 *The Times*, 11 April 1866, p.5
16 Note. Now the Lanesborough Hotel. Later he would write accounts of several large families, including Malvaceae, for J.D. Hooker's *Flora of British India*, for which Wight's collections were invaluable
17 ?Masters, 1872
18 RBGE AC f.249
19 ?Masters, 1868: 656
20 RBGE BC 12 f.86
21 Cleghorn, 1873
22 RBGK DC 54/548
23 Cleghorn, 1873
24 RBGK HP 2 f.732
25 RBGK DC 105/373
26 RBGK DC 105/378
27 Anon. 1872/3: xlvii
28 ?Masters, 1872. Note. Most probably by M.T. Masters, the joint editor, whom Wight must have known through the 1866 Congress
29 Copy of will from Probate Search Room, Principal Registry of the Family Division. Probate granted 18 June 1872
30 Anon. 1872/3
31 Cleghorn, 1873
32 Reichenbach, 1872, translated by Sabine Miehe
33 Note. Some in the herbarium rather than in the field, and most of the latter were actually found by his Indian collectors
34 Note. E.g. *Euphorbia cattimandoo* and *Hydnocarpus wightiana*
35 Grove, 1995
36 Note. His use of old literature, and identifying South Indian plants in the seventeenth and eighteenth century literature, especially Rheede and Plukenet, was also noteworthy and in the tradition of Francis Buchanan
37 The founders were Henry Cockburn and Leonard Horner; Sir Walter Scott and Robert Dundas were among its first Directors

Index

NOTE: Page references to figures are in *italic* type.

Abelmoschus angulosus, 112
Abercromby Place, Edinburgh, 147
Aberdeen, Lord, 161
Aberdeenshire, Graham's excursion to, 46
acacias in Nilgiris, 196n
Academy of Physics, Edinburgh, 23
Acanthaceae, 43, 56, 99, 106, 113
Achillea Ptarmica, naturalised at Ooty, 111
Acorus calamus, 114
Acotyledones, 98, 99
Adam family of Blair Adam, 55
Adam, Sir Frederick, 57, 59, 64, 71, 73, 76, 77, 85, 87, 157
Adam, R.M., photographer, 54
Adam, Robert, architect, 21
Adam, William, architect, 21
Adam, William (MP), 57
Adam's Peak, Ceylon, 74
Aden, 159
Adenanthera pavonia, 151
Adie sympiesometer, 51, 191n
Aerides lindleyana, 114
affinities
 circles of, 98–9
 how Wight inferred, 99–101, 102
Agapetes arborea, 110
— *rotundifolia*, 110
Agardh, Jacob Georg, 38, 61
Agri-Horticultural Society of Madras, 63–5, 77, 110, 120, 138, 155
 farewell to Wight, 158–9
 garden of, 68
 office bearers (1841), 64
 prizes offered by, 199n
 Proceedings, 64, 67, 110
 seal, 62
 Wight as secretary, 64, 85
agricultural botany, 10
Agricultural and Horticultural Society of India, 65, 68–70, 86, 120, 125, 137, 155
agricultural revolution, in Scotland, 13
agriculture, 71, 84
 American system, 123, 125–6
 cotton experiments, 117–45
 school for, 86–7
 use of convicts in 87, 176, 177
 Wight's later activities, 166–7
 Wight's report on (1836), 17

Ailanthus malabarica, 152
Ainslie, map of Edinburgh (1804), 17
Ainslie, Sir Whitelaw, 60
 Materia Medica of Hindoostan, 174
Alabama, USA, 122
Albert, Prince Consort, 48
albumen (as taxonomic character), 100, 101
Alchemilla vulgaris, 114
— *zeylanica*, 114
Aldershot, Hampshire, 166
algae, 42, 56, 175
Allan & Ferguson (lithographers and engravers), 57
allelopathy, 106
Allepey, 35, 112
Allison's Close, Cowgatehead, Edinburgh, 15, 189n
alpine plants, 10, 46, 48, 52, 114
America
 reducing dependence on cotton from, 117
 southern states, 121
American Civil War, 197n, 199n
American cotton
 drawings, 89
 pruning to convert from annual to perennial, 120, 124, 127
 seed, 122
 sowing time, 120, 126, 127, 130, 131, 133–4
 see also Bourbon cotton; New Orleans cotton; Sea Island cotton; Upland Georgia cotton
American cotton trials, 10, 13, 71, 72, 73, 78, 85, 86, 117–45, 176, 177
 aims, 118
 areas of conflict, 118
 causes of failure, 143–4
 costs, 127–8, 129–30, 138
 evaluation of, 117, 121, 123–4, 143–5, 177
 Finnie's story, 139–43
 glossary, 145
 Report (1849) by Wight, 133–4
 results (1842), 123–4
 results (1843), 126–7
 results (1844), 127–8
 results (1845–8), 128–31
 results (1849), 134
 Wight's final report (1852), 137–8
American Planters, 117, 121–4, 128, 134, 138, 139–43, 161
Amorphophallus campanulatus, 106
Ampelideae (now Vitaceae), 100

Amrit Mahal cattle, 30, 87
Amsterdam (Horticultural Conference), 175
Amyris Gileadensis, 148
Anagallis arvensis, 100
— *caerulea*, 100, 112
— *latifolia*, 100
anatomy, 21, 22, 23
 comparative, 23, 30
Andaman Islands, 157
Anderson, James, 31, 60, 119, 164, 170, 192n
Anderson, Rowand (architect), 189n
Anderson, Thomas, 70
Anderson, William, 65
Andhra Pradesh, 29, 41
Anemia wightiana, 115
Anemone wightiana, 65
Angus, county of, 10, 46
animals
 game in the Nilgiris, 111
 Quinarian classification of, 98
 products for exhibition, 151
Annales des Sciences Naturelles, 19
Annals of Natural History, 43, 63, 192n
Anson, Lord, 13
Antonio, Peechee, 32, 34, 190n
Aponogeton natans, 19
apple, Golden Pippin, 69
aquatic flowering plants, 40, 101
archaeology, 33, 41, 114
Archer, Mildred, 32
Archer, Thomas Croxon, 167
Arcot, 31, 147, 151
Areca palm, 152
Arenga wightii, 113
Argyll, Archibald, Marquess of, 15
Argyreia speciosa, 84
Arlary, Kinross-shire, 52, 54, 55–6
Armstrong, Adam, 17
Armstrong, William, 17
Arnold, Professor David, 97, 153, 164
Arnott, David Walker-, 55
Arnott, Fanny Walker-, 175
Arnott, Jane Walker-, 55
Arnott, Mary Walker-, 175
Arnott, Robert Walker-, 54
Arnott, George Arnott Walker-, 20, 24, 25, 26, 36, 40, 43, 48, 50, 51, 61, 63, 94, 95, 102, 103, 105, 114, 164, 167, 169, 176
 biography, 54–5
 correspondence with Wight, 74, 79, 81, 153
 death (1868), 175

influence on Wight, 96, 97–8, 106
 letter to Hooker re A.P. de Candolle, 96–7
 portrait, 54
 Pugillus Plantarum Indiae Orientalis, 74
 role in distributing Wight's specimens, 57, 73, 165–6
 visit to Grazeley (1866), 175
 on Wight, 56–7
 see also Wight & Arnott
Aroopoocottah (now Aruppukkottai), 140, 141
Arthur's Seat, Edinburgh, 19
Asclepiadaceae 43, 49, 52–3, 57, 59, 92, 100, 106, 113, 195n
Aspidium anomophyllum, 112
Assam, 60, 75, 97, 196n
 Wallich, Griffith and McClelland (1835 tea mission), 97, 148, 153
Astragalus alpinus (*Phaca astragalina*), 46
Atholl, 4th Duke of, 47, 48
Atholl, 6th Duke of (earlier Lord Glenlyon), 47–8
Auckland, Lord, 79–80, 81, 86, 121, 125, 153, 154, 194n, 200n
Audubon, John, ornithological artist, 46
Augusta Place, Weymouth, 169
Aurantiaceae, 103
Australian plants in Wight's herbarium, 148
 trees, 109, 149
Avalanche Bungalow, Nilgiris, 113, 114
Ayr, Burrowfield of, 17
Ayrshire, 17, 189n
Ayrton, Acton Smee, 166
Ayyar, Ramanathat, 145
Azalea [Loiseleuria] procumbens, 48
Azima tetracantha, 76
Azimaceae, 76
Azolla (water fern), 40

Babington, Charles Cardale, 175
Babington, Major D., 69
Baikie, Robert, 15, 115
 Observations on the Neilgherries, 111–12
Baird, George Husband, 21, 22
Balasubramaniam, R., 118, 145
Balfour, Edward Green, 144, 149, 151, 152, 157
 Cyclopaedia of India, 152

Timber Trees, 152
Balfour, James 18
Balfour, John Hutton, 19, 20, 22, 24, 25, 29, 48, 150, 164, 165, 167
Balsaminaceae, 56, 98
balsams, 81, 115
 aquatic, 63
 paper on (1837) (Wight), 87
Baluain, Blair Atholl, 47
bamboos, 113
Bangalore, 32, 35
 Lal Bagh garden, 31, 68, 87, 109
Banks, Sir Joseph, 31, 49, 74, 75, 144
banyan (*Ficus benghalensis*), 150
Baptie, Diane, genealogist, 13
Barber, C.A., 157
Barber, Thomas, engraver, *16*, 22
Barclay, Arthur (Arnott's father-in-law), 54
Barclay, John, 22, 23, *23*, 24, 30
Barclay, Mary Hay (later Mrs Walker-Arnott), 55
Barclay, Robert, 30
Baring, Thomas, 161
Barleria (Acanthaceae), 43
barometer, 32
Barry, Martin, 46
Bassia longifolia, 151
Bath Street, Glasgow, 47, 57
Bauer, Ferdinand, botanical artist, 49
Bayles, Thomas, 121, 122, 142, 161
Baynes, Mr, 64
Beck, Catharine, 169
Beddome, R.H., 157
Begoniaceae, 100
Beinn a' Ghlo, Blair Atholl, 48
Bélanger, Charles, 35
Bell, the Rev Andrew, 48
Bell, Charles, 13
Bell, John, 66, 121, 192n, 193n
Bellary, 59–62, 129
Ben Laoigh, 52
Bengal, 29, 59, 65, 68, 78, 81, 139, 156, 170, 174
Benne Chavadi *see* Amrit Mahal
Bennett, J.J., 165, 175, 191n
Bentham, George, 19, 45, 46, 47, 49, 50, 53, 54, 55, 56, 57, 95, 96, 99, 102, 103, 105, 124, 158, 163, 165, 200n
 Commentationes de Leguminosarum Generibus, 95, 195n
 Genera Plantarum (with J.D. Hooker), 190n
 Griffith on, 195n
Bentham, Jeremy, philosopher, 49
Bentinck, Lord William, 60, 109
Bentinckia condappana, 68
Berkshire Chronicle, 167
Berry, Andrew, 32, 191n
Best, A.E., 30
Best, Captain S., 150
Betula nana, 48
Bevan, Major, 89
Beveridge family, 15
Bhuj (Kutch), 133

Bhutan, (Griffith's visit), 97
Bichat, Xavier, 201n
Bidie, George, 157
Bignonia, 152
Bignoniaceae, 99, 165
biodiversity, 10, 177
Biophytum, 103
Birmingham (James Wight, Postmaster of), 169
Bishop, the Rev Freeman H., 171
Blackfriar's Wynd, High Street, Edinburgh, 15
Blair Atholl, 16, 18, 46, 47–8, *47*, 52, 54, 56
Blair Castle, 47
blood-letting, 24, 27
bloodsucker, 66–7
Blyth, Edward, 49, 191n
Bollgard GM cotton, 145
Bolumputty, near Coimbatore, 148
Bombax 103
Bombay, 9, 64, 79, 123, 129, 137, 163, 170
 Conservator of Forests, 149
 cotton mill, 10, 144, 199n
Bond, Thomas Edward Tucker, 173
Boothby, Brooke, 190n
Boott, Francis, 10, 49, 52
Borragineae, 99, 100
Borthwick, Samuel John, 26
Boston (USA), 52, 178
Boswells Bogg, near Edinburgh, 17
Botanical Congress
 London (1866), 174–5
 Vienna (1905), 104
Botanical Society of Edinburgh, 92, 175–6
Botanical Survey of India, South Indian Circle, 157
Botanische Zeitung, 176
botany, 175
 at Edinburgh University, 21, 22, 23, 24–6
 descriptive, 9, 106–7, 117
 floristic studies, 43
 geographical, 73
 history of Indian, 45
 of Madras Presidency, 29–30
 modern, 104–6
 monographic studies, 43
 philosophical, 94, 95, 97
 relations between Europe and India, 45
 systematic, 93, 97–8
 taxonomic, 37, 42–3, 93–107
 Wight's abandonment of, 163–5
 see also agricultural botany; economic botany; medical botany
'Botany Peak', Courtallum, 61
Bourbon cotton, 72, 78, 119, 120, 121, 124, 126, 136, 197n
Brachiaria cf. ramosa, 193n
Braemar, Aberdeenshire, 46, 51
Brand, William, 46
Brandis, Sir Dietrich, 164

Brazilian plants, 148
Brébisson, Louis Alphonse de, 175
breeding, 66, 106
 selective, 126, 166
 see also pollination biology
Brewster, Sir David, 150
 Edinburgh Encyclopaedia, 25
brief, of Madras Government (1836) to Wight, 71–3, 86, 109, 120, 144, 149
Bright, John, 133
British Association for the Advancement of Science, 57, 103, 124, 150, 163, 171
British Government, and American cotton trials, 117–45
British Museum, 175
Brooke, Sir William O'Shaughnessy, 174
broomrape seed, 106
Brough, John, Edinburgh builder, 16
Brougham, Henry, Lord, 15, 18, 23
Broun of Coalston, George, 13
Brown, John (1735–88), 26
Brown, John (medic), 65
Brown, Joseph, engraver, *119*
Brown, Mr and Mrs, 169
'Brown or Nankeen' cotton, 121
Brown, Robert, 25, 43, 45, 49, 50–1, 57, 59, 75, 103, 105, 154, 163, 165, 175, 177, 191n, 192n
 death (1854), 175
 Prodromus Florae Novae Hollandiae, 39, 95, 98
Brown, Thomas, 23, 24, 32
 Lectures on the Philosophy of the Human Mind, 23
Browne, Professor Janet, 21
Brussels (Horticultural Conference), 175
bryology, 192n
bryophytes, 37, 99
Buccleuch Place, Edinburgh, 16
Buchanan, Francis (Buchanan-Hamilton), 10, 40, 43, 46, 55, 103, 109, 121, 156, 201n
 "Travels in Mysore", 36, 109
Buckton, George Bowdler, 165
Bullock, George, cabinet maker, 47
Bulsumdrum, 73
Burchell, W.J., 165
Burke, William, body snatcher, 18, 20
Burlington House, London, 165
Burma, 52, 97, 157, 174
 Lushai Expedition (1892), 171
Burman, N.L., *Flora Indica*, 39
Burmese lacquer tree, 200n
Burns, Robert, 47
Burton, Decimus, architect, 152
Burton, Richard, 68, 110–11, 115, 147, 197n
Buxbaumia aphylla, 25
Byron, Lord, 74

cacti, 32

Caesalpinia sappan, 193n
Cairngorm Mountains, 51
Caithness, Scotland, 51
'Calacca', 111
Calcutta, 25, 29, 45, 64, 65, 67, 68, 79, 81, 84, 111, 137, 178
 Asiatic Society Museum, 33
 ban on import of salt to, 78
 Botanic Garden, 31, 32, 39, 45–6, 53, 68, 81, 85, 97, 153, 156–7, 195n
 connections (Wight's with), 153–7
 Medical College, 157
Calcutta Journal of Natural History, 63, 76, 154–5
Caledonian Horticultural Society, Edinburgh, 24, 54, 64
Callander, Perthshire, 46
Calophyllum inophyllum, 63
Calotes versicolor (bloodsucker lizard), 66–7
Calotropis gigantea, 59
— *procera* ('mudar'), 41, 59–60
Calysaccion (*Mammea*), 103
'Cambodian' cottons, 134, 144, 145
camels, 30
Campanula rotundifolia (harebell), 110
Campanulaceae, 100
Campbell, Captain J., 128
Campbell, Catherine, 17
Campbell, Sir Colin, 76
Campbell, D., 137, 139
Campbell, Dougall (alias Maconochie of Inverawe), 15
Campbell, the Rev Duncan, 48
Campbell, James, 47, 48, 92, 189n
Campbell, Rebecca (née Stewart), 92
Campbell, William Hunter (WS), 18, 46, 47, 57, 92, 189n
Campbellia (Orobanchaceae), 92
Canaries, the (lichen source), 86
candles, import duties in Britain, 79
Candolle, Alphonse de, 95, 103, 175
 Lois (1867), 103, 104, 175, 201n
Candolle, Augustin-Pyramus de, 39, 42, 45, 54, 57, 97, 102, 103, 105, 106, 113, 121, 148
 Natural System, 39, 42, 54, 61, 94–5, 96–7, 98, 99, 101
 Prodromus Systematis Naturalis Regni Vegetabilis, 95, 97
 Théorie Elémentaire de la Botanique 38, 39, 42, 95
 on types, 103
Candolle, Roger de, 45
cannabis, 174
Cannanore, 79
Canning, Lord 'Clemency', 117
Canonmills Lodge, Edinburgh, 54
Cantor, Theodore, 157
Cape Comorin, 34, 35, 61
Cape of Good Hope, 30, 43, 68, 86, 147
Cape Verde Islands (lichen source), 86
Capsella Bursa Pastoris, naturalised at

Ooty, 111
Capparis divaricata, 41
Capsicum annuum, 193n
Carex, 49
— *pulla*, 52
— *saxatilis*, 52
— *vesicaria*, 52
— × *grahamii*, 10, 52, 106
Carey, the Rev William, 64
Carica papaya, 102
Carissa carandas, 111
Carlisle, 15
Carlyle, Jane Welsh, 27
Carnatic plains, 73, 134, 150
Carrick, Robert, topographical
 artist, 57
'carua', 75
Casearia elliptica, 41
Cassia, 75, 152
— *Burmanni* (now *Senna italica*), 85,
 86
— *lanceolata* (now *Senna alexandrina*),
 85
Cassine albens, 68
Castleton of Braemar,
 Aberdeenshire, 52
castor oil, 148
Catalogue of Wight's herbarium, 55
cataloguing, 10
Catesby, Mark, *Natural History of
 Carolina*, 39
cattle, 73, 87
 veterinary research Mysore, 30,
 190n
cattle fodder, 72, 121
Caulerpa, 192n
Cavery River, 113
celery, 65
Census (of England, 1861 & 1871),
 169
cereals, European, 66
Ceropegia, 68, 106
— *mysorensis*, 60
— *pusilla*, 113
Ceylon, 32, 39, 40, 67, 71, 87, 90, 114,
 141, 142, 165
 Royal Botanic Garden, 74
 Tea Research Institute, 173
 tea and taxonomy of, 75–7
 timbers from, 150
 Wight's 1836 trip, 74, 105, 189n
Chalmers, James, 15, 18
Chambers, W.F., 29
Chamier, Henry J., 66, 71, 73, 84,
 139, 198n
Chapel Terrace, Petersburg,
 London, 90
Charles Street West, Westbourne
 Terrace, London, 161
Chelsea Physic Garden, 65, 89
chemistry, 21, 22, 23
Chidambaram, 35
China, 16, 86, 119, 157
 tea plants from, 67
Chingleput, 85
Chionantheae, 100

Chionanthus, 196n
Choisy, J.D., 34, 100
cholera, 51, 52, 90, 191n
cholum (*Sorghum bicolor*), 67, 134
Christison, Professor (father of Sir
 Robert), 32
Christison, Sir Robert, 19, 20, 21, 23,
 24, 25, 26, 27, 75, 189n
Christisonia, 65
Christy, William, 46
Church Mission Society, 111, 112
churka, 118, 119, 124, 125, 130, 139,
 140–1, 142, 199n
 Mather's improved, 137
Cicero, 19
cinchona, 70, 73, 170, 192n
Cinnamomum, 75
— *aromaticum*, 75
— *verum*, 75
— *zeylanicum*, 75
cinnamon, 73, 74, 75
 Chinese, 75
 seed, germination of, 149
cladistic analysis, 101
Clarke, C.B., 164
classification,
 alternative placements in different
 schemes, 100
 circles of affinity, 67, 98–9
 continuity versus discontinuity,
 94–5, 97–8
 history of natural, 94–5
 influences on Wight, 95–9
 Linnaean sexual system, 30, 36,
 42, 93, 94, 102
 Natural System of, 25, 39, 42, 43,
 54, 55, 61, 93–4, 98–9, 101, 174,
 177
 phylogenetic, 101
 Quinarian method, 98, 178, 195n
 size of groups, 94, 98
 symmetry of groups, 94–5
 tension with identification, 101
 see also taxonomy
Cleghorn family, 16
Cleghorn, Hugh, senior, 32, 48–9, 92,
 189n, 193n
Cleghorn, Hugh Francis Clark, 16,
 49, 68, 70, 129, 152, 157
 as biographer, 26, 55, 56, 60, 115
 Conservator of Forests (Madras),
 149, 150–1
 friendship with Wight, 147–8, 175
 Hortus Madraspatensis, 64
 obituary of Wight, 22, 29, 54, 148,
 158, 167, 175, 176–7
Cleghorn, Patrick, 147
'Clematis Cadmia Hamilt.', 68
Cleyera gymnanthera, 110
climate, 63, 72, 73, 110, 131, 133–4, 143
 deforestation and change, 149,
 150–1, 178
 rainfall data for Florida and
 Madras, 134
 versus soil, in cotton cultivation,
 118, 123, 126, 128–9

clinical medicine, 21, 22, 24
clinical surgery, 21, 22, 24
Clive, 2nd Lord (Governor of
 Madras 1798–1803), 32
Clive, Edward, 1st Earl of Powis, 161
Clive, Robert Henry, 161
cloves, 74
Clusiaceae, 195n
Cocanada, 29
Cochin, 115, 131, 132, 134
 Wight's 1847 trip, 147
cochineal insect, 32
Cochlospermum gossypium, 113
Cockburn, Henry, 17, 18, 201n
Cockburn of Ormiston, Adam, 13
Cockburn of Ormiston, John, 13
Cockerell, C.R., architect, 46
cocoa, 63, 74
Coffea alpestris, 110
coffee, 72, 73, 79, 81, 83, 115, 194n,
 197n
Coimbatore, 35, 68, 69, 72, 76, 84,
 90, 109, 110, 115, 175
 All India Co-ordinated Cotton
 Improvement Project (AICCIP),
 199n
 Central Institute for Cotton
 Research (CICR), 199n
 cotton experiment, 117–45
 cotton gin house, 122, 131, 135,
 137
 description of, 147
 life in (1842–53), 147–52
 Wight's herbarium at, 148, 157
Cole, Robert C., 63, 71, 89, 177
Coleroon River, 113
collections
 Natural History, Wight's disposal
 of, 176
 Wight's from Vellore and Madras
 (1825–6), 30
collectors, Wight's use of, 40, 61, 63,
 73, 76, 148
Colombo, Ceylon, 74, 75, 115
 EIC cinnamon gardens, 75
Committee for the Revision of Civil
 Establishments, 36
Compositae, 57, 65, 94, 95, 98, 175
conifers, 99
Conolly, Henry Valentine, 149
conservation, 52
continental drift, 115
Contributions to the Botany of India
 (Wight & Arnott), 43, 52, 55, 57, 95
convicts, use in agriculture, 87, 176,
 177
Convolvulaceae, 84, 92, 99, 100
 named after Shuter, 34
 paper on (1837) (Wight), 87
Coonoor (or Nellitorai) Ghat,
 Nilgiris, 109, 110, 113
Coorchee (now Kurichi), 124, 126,
 127, 128
Coorg, 79
Copenhagen, University of, 32
corallines, 42

Corchorus, use in native medicine, 41
Cordiaceae, 100
Coromandel Coast, 37, 38, 42, 61
 illustrated work on plants of, 31
Coromandel land winds, Wight's
 paper (1836), 115
Cosens, Henry Cecil (great
 grandson), 76, 173
Cosens, Lucy (née Wight) (grand-
 daughter), 169, 170, 176
Cosens, Marjorie, 17
Cosens, William, 169, 176
Cotman, John Sell, artist, 38
Cotoneaster buxifolia, 114
cotton, 10, 68, 79, 83, 148
 adulteration of, 141
 breeding, 144, 145
 cleaning, 117, 118, 120, 122, 124–
 5, 129, 140–1
 climate – 1849 circular on
 (Wight), 134, 136
 climatic effects on, 123, 126, 128–
 9, 131, 133–4, 135, 143
 cultivating by American methods,
 117, 118, 124–6, 129–30, 140
 different staples of, 116
 exports, 77, 117, 119
 extension system of cultivation,
 118, 130, 134, 138, 139
 *Extract Notes on American Cotton
 Agriculture* (Wight), 125, 126
 genetic modification (GM), 145
 germination experiments, 120
 history of cultivation in India, 119
 hybridisation, 140, 145, 199n
 improvement of quality of
 imports from India, 117, 118,
 119, 120, 123, 139, 140–1, 143
 long-staple, 10, 89, 119, 131, 144,
 199n
 Madras Experiment, 117–45
 pamphlet on (1862) (Wight), 166
 pests, 120, 123, 126, 145, 198n
 pressing (Atlas and Colaba
 presses), 125, 131
 prices, 121, 122, 127, 139, 143
 processing, 124–5
 'Remarks on the culture of …'
 (Wight), 120
 Report (1837) on senna and
 (Wight), 84
 seed deterioration, 137
 seed 'fur', 120
 seed for trials, 76, 120
 soil effects, 120, 123, 126, 128,
 128–9, 131, 135
 sowing times, 1848 circular on
 (Wight), 134
 species or varieties, 103
 taxonomy, 121
 Wight's early interests in, 119–21
 yields from various types of seed,
 84, 121, 127, 128, 129, 137
 see also American cotton;
 'Cambodian' cotton; Egyptian
 cotton; oopum

cotton brokers, 122, 124, 127, 141
cotton cloth, export and import of, 119–20
cotton farms (Government), 119, 121, 132, 139
 abolishing of, 134–6
Cotton, Frederick Conyers, 68, 113, 149–50
Cotton, Joseph, 29
Cotton, Sir Arthur, 113
Cotton Supply Association of Manchester, 138
'Country Cotton' (Indian), 121
Court of Directors of EIC, London, 84
 and Madras cotton experiment, 117–45
Courtallum 32, 35, 40, 60–1, 66, 79, 105, 175
 EIC spice gardens, 73, 74
 Finnie's cotton experiment, 140
 Paper on flora of (Wight), 120
Cousland Park, Cranston, 17
creationism, 173–4
Crewe, Major, 109, 110
crop rotation, 106, 118, 126, 127, 128, 167
cropping, repeat, 126, 127, 128
crops, mercantile increased over food, 78, 120
Crotalaria, 56, 114
— *longipes*, 41
Cruciferae, 96, 97
cryptogams, 25, 37, 38, 40, 42, 49, 102n
Cubbon, General Mark, 147
Cucurbitaceae, 68, 92, 97, 98, 100–1, 102, 165
cucurbitaceous pepo, 102
Cuddalore, 35
Cuddapah, 59, 60
Cullen, William, 24, 26, 190n
 Synopsis Nosologicae Medicae, 26
cultivars, production of, 65
cumboo (*Pennisetum americanum*), 67, 134
Cupressus, in Ooty garden, 69
'Curmurdah' (*Terminalia glabra*), 151
currency, Scottish paper, 79
Cursetjee, Ardasser, 161
customs duties
 on East and West Indian sugar imported into Britain, 84
 on import of candles, 79
Cuxton, R.N., 132, 135, 143
cyclone, 197n
Cyperaceae, 57, 99

daguerreotype, 154, 200n
dahlia, 65
Dalbergia latifolia, 151
— *sissoo*, 68
Dalhousie, Christian Lady, 13, 90
Dalhousie, Lord (James, 1st Marquess of), 147
Dallapiccola, Professor A.L., 80

Dalmahoy, Sir Alexander of that Ilk, 15
Dalrymple, Sir Hew, 13
Dalzellia ramosissima, 197n
dammer tree resin, 79
Dance, George, artist, 31
Daniel, Mr (on wood for railway sleepers), 151
Daniell, Thomas, artist, 61
Daniell, William, artist, 31, 61
Dapuri Botanic Garden, 9, 10, 174
Darjeeling (tea plantation), 170
Darwin, Charles, 10, 21, 63, 66, 105, 175, 178, 190n, 196n
 On the Origin of Species, 173, 178
 reference to Wight, 100–1
 Wight's views on, 173–4, 176, 201n
Darwin, Erasmus, 65, 190n
 theory of fever, 26
 Zoonomia, 23, 173
Daubeny, Charles Giles Bridle, 175
'dawal kurundu' tree, 75
De Alwis Seneviratne, Harmanis, 74, 75–6
De Febrium Natura, Scalpello Quaesita (Wight), 26–7
Dean Bridge, Edinburgh, 46
Decaschista crotonifolia, 68
deforestation, and climate change, 149, 150–1, 178
Delessert, Baron Benjamin, 54, 96
Denison, Sir William, 199n
Desmodium rufescens, 114
Desmond, Ray, 97
Devonshire, 6th Duke of, 174
Dharwar, 142, 197n, 199n
diatoms, 56, 167, 175
Dichrostachys cinerea, 68
Dickson, Alexander, 175
Dicotyledones, 98, 99, 101
Dictyocarpus, 87
Digitalis, 26
Digweed, Henry, 169
Dimhutty, Nilgiris, 109
Dindigul, 34, 35
Dinshaw, Mrs Mehroo, 10
Dipterocarpeae, 68
disease, miasmic theory of, 79
Disperis neilgherrensis, 110
DNA, structure of, 101, 173
Dodabet, Nilgiris, 114, 197n
Don, David, 49, 52
 Prodromus Florae Nepalensis, 39, 43
Don, George, 45, 52
Dorpat (Estonia), 54
Dorpoory, 73
Dorward, James (brother-in-law), 92, 175, 176
Downshire, Marquess of, 167
Drew, Charles, 157, 200n
drill cultivation, 13, 120, 125
Drum, Gilmerton, 17
Drum Coal Company, 17
Dryas octopetala, 48
drying of plants, 40–1, 85

Dublin Street, Edinburgh, 16
Dunal, M.F., 96
Dunbar (East Lothian), 22
Duncan, Andrew, 23, 23, 24, 26
Duncrahill (East Lothian), 15
Dundas, Henry, 1st Viscount Melville, 18
Dundas, Robert, 2nd Viscount Melville, 201n
Dundee, 48
dye plants, 68, 72, 74–5, 86, 151, 193n
dysentery, 60

East India Company (EIC), 9, 10, 18, 26, 29, 93, 117, 177
 Charter renewal (1813), 78, 123, 199n
 Charter renewal (1833), 36, 201n
 Charter renewal (1852), 161
 cotton experiment, 117–45
 criticism of policies, 161
 distribution of the herbarium by Wallich, 45–6, 49–50
 forestry concerns, 149
 herbarium collections, 36, 49, 52
 hierarchy, 197n
 policy on export of raw materials from India, 77–8, 177
 rules on trade, 78, 142
East India Register, 29, 56
East Indians, 86–7
East Lothian, 13, 18, 19, 22, 64, 124
East Mains, Ormiston, 13
ebony, 76
ecology, 51, 97, 106, 113
economic botany, 61, 68, 71–81, 109–15, 120, 153, 177
economic plants 83–7
 illustrations of, 72, 93
Eden, Dorothy, 194n
Edgeworth, Michael Pakenham, 90
Edinburgh, 10, 13, 15, 16, 16–17, 19, 29, 35, 46, 55, 57, 86, 147, 150, 167
 cholera epidemic (1832), 51
 fever epidemic (1817–20), 27
 middle classes, 13
 Town Council, 21
 Wight's return to (1831), 21
Edinburgh Academy, 178
Edinburgh Museum of Science and Art, 167
Edinburgh New Philosophical Journal, 24
Edinburgh Review, 23
Edinburgh University, 18, 19, 21–7, 32, 46, 54, 167, 178
 Library, 21, 26
 Museum, 21
education
 agricultural school, projected (Pulicat), 86–7
 of native boys, 112, 152, 176, 177
Edwards, William Frederick, plant physiologist, 193n
Edye, J., 150
Egypt, 85, 90, 121, 134

Egyptian cotton, 116, 120–1, 124
Ehretiaceae, 100
elephantiasis, 59
elephants, 30, 114, 115
Elettaria (now *Amomum*) *cannicarpum*, 110
Elliot, Archibald, architect, 47, 191n
Elliot, Gilbert (1st Earl of Minto), 161, 194n
Elliot, Hugh, 161, 194n
Elliot, John, MP, 161
Elliot, Walter, 152, 157, 159, 190n, 201n
 Flora Andhrica, 41
Elphinstone, Lord (John, 13th), 84, 86, 93, 94, 110, 114, 118, 190n, 194n
 and the cotton experiment, 119–24
 minute on experimental cotton farms, 122
Elphinstone, Mountstuart, 133
empiricism, 26
Encyclopaedia Britannica, 54–5, 95
England, 31
 cotton exports to, 117, 119
 Rosa's trip home (1846), 111, 115
Entada pods, 152
Eria reticosa, 114
Erigeron alpinus, 52
Eriobotyra japonica, 68, 74
Erode, 122, 197n
Etang de St Gracieu (Jussieu's last expedition), 54
ethnobotany, 41
ethnography, 33, 41
Eucalyptus, 69, 113, 196n
eudiometer, 32
Eugenia montana, 114
— *sylvestris*, 194n
Euphorbia Antiquorum, 148
— *cattimandoo*, 152, 165, 201n
— *Tirucalli*, 92, 148
— *tortilis*, 148
Euphorbiaceae, 43, 54, 101, 165, 191n
evolution, 95, 101, 106
 convergent, 100, 101
 Wight's views on, 173–4, 176, 178
Exacum wightianum, 114
'excitability', and 'excitement', 65, 178
Exogens, 99
experimental work, 10, 26, 63, 85
export duties, 77
exsiccata, 25
extension system of cotton cultivation, 118, 130, 134, 138, 139

Faed, James, artist, 94
Fagerstedt, Professor K.V., 66, 193n
Falconer, Hugh, 46, 153, 157, 158, 164
Falls of Fender, Perthshire, 48
families (plant)
 character combinations as 'basal' or 'derived', 101

formation by natural method, 94, 98, 100, 103
monogeneric, 98
new, described by Wight, 76
Farmer's Club
Ormiston, 13
Reading, 13, 167
Fern Hill school, Ooty, 111
ferns, 37, 40, 56, 99, 112, 115
Feronia, 75
Ferrey, Benjamin, architect, 171
'fever zone', 81
fevers, 21, 24, 26–7
choleric, 51
dissection of victims, 27
environmental factors in, 27
epidemic in Edinburgh (1817–20), 27
inflammatory, 26–7
taxonomy, of 26–7
treatments of, 24, 27, 51
typhoid or putrid, 26–7
Ficus benghalensis, 150
Field, Octavius Adolphus, 161, 171, 176, 194n
field studies, 79–81, 104–5
Fife, 15, 29
figs
illustrated by Rungiah, 68
wild, 92, 115, 148
Finnie, Thomas James, 118, 122, 125, 131, 132, 135, 139–43
Fischer, F.E.L. von, 54, 96
Fischer, G.F. (Zemindar of Salem), 120, 122, 141, 143, 197n, 199n
Fishmarket Close, Edinburgh, 15
Fitch, Walter Hood, botanical artist, 47
Fitzgerald family, 92
Flacourtia sapida, 92
— *sepiaria*, 92
flamboyant, or gulmohur (*Delonix regia*), 68
flax, 13, 73
Fletcher of Saltoun, Andrew, 13, 15
Flinders, Matthew, 105
Flora of British India (J.D. Hooker), 106
floral diagrams, 103
Florence Botanic Garden, 150, 175
Ford, Helen Julia (later Wight), 89, 90, 92, 115
Ford, Lacy Grey (father-in-law), 89, 193n
Ford, Mrs Lacy Grey (mother-in-law), 159
Ford, Rosa Harriette *see* Wight, Rosa (wife)
forestry, 10, 18, 79, 149–50
Forfar, Angus, 51
Forster, Edward, 191n
Fort St George, Madras, 33, 48, 64, 89–90
College of, 157
plan of, 91
Fort St George Gazette, 71, 83, 90, 147

Fowke, Francis, architect, 167
Fragaria cf. ananassa, 193n
— *indica*, 112
— *nilagirica*, 112
— *nilgherrensis*, 114
France
grants for publication of scientific works. 93
natural classification method, 93–4, 96
Fraser-Jenkins, Christopher, 43, 191n
Frederick Street, Edinburgh, 18
Free Church of Scotland, 48
free trade, 78
freemasonry, 55
Freke, Henry, *On the Origin of Species*, 173, 174
French, 19, 66
Fries, E.M., 195n
Frith Street. London, 49
fruits, 66, 69, 111, 192n
character of ovary and placentation, 102
'fuci' *see* seaweeds
Fumaria (fumitory flower), 67
Fumariaceae, 98
fungi, 39, 49, 99

Gaelic, 48
Gaertner, J., 75, 100
De Fructibus et Seminibus Plantarum, 39
Galen, 26
gamboge, 74–5, 189n
ganiometer. 32
Ganjam, 134
'ganjam' *see* sugar, Indian
Garcinia, 74
— *mangostana*, 63
— *morella*, 75
— *quaesita*, 75
— *spicata*, 75
— *xanthochymus*. 75
Gardeners' Chronicle, 49, 165, 166, 173, 175
Gardiner, William, 48
Gardner, George, 63, 76–7, 90, 92, 105, 111, 142, 148, 155, 165, 191n, 194n, 201n
patent for preparing coffee, 197n
visit to Nilgiris (1845), 113–15, 148
Gardneria wallichii, 46
garlic, 81
Garrow, William, 197n
Garstin, Major Robert, 147
Gauci, Maxim, lithographer, 46
Gaylussacia serrata, 195n
Gayton Park, Ooty, 113
genera
characters to delimit, 101
descriptions of, 9
formation by natural method, 94–5, 98
rule of priority in nomenclature, 104

subdivision by analytical methods, 97, 102
Wight's new, 87, 95, 177
General Election of 1868, 167
genetic modification (GM) of cotton, 145
Geneva, 45, 46, 54, 94, 95, 96
Gentiana nivalis, 52
geology, 32, 42, 73, 79, 80–1, 157, 193n, 197n
George Hotel, Reading, 176
George Street, Edinburgh, 16
Georgia, USA, 122
Geraniaceae, 98
German, 104
Germany, 80, 112
Gesner[i]aceae, 99
Gibson, Alexander, 9, 10, 79, 137, 149, 174, 190n
Hand-Book to the Forests of the Bombay Presidency, 150
Gibson, John, collector and garden designer, 174
Gilchrist, John Borthwick, 29
Gillies, John, 55
Gilmerton, near Edinburgh, 17
gin house (cotton), 122, 124, 131, 135, 137, 141, 143
Gingee, 35
ginger, 68, 110, 113
Gladstone, William Ewart, 161, 167
Glasgow, 10, 30, 37, 42, 43, 46, 47, 52, 53, 55, 56, 89, 155, 164, 167
'new town', 57
Glasgow University, 47
Gleeson, J.M., 64
Glen Callater, Aberdeenshire, 52
Glen Clova, Angus, 46, 51, 61
Glen Fee, Angus, 10, 49, 52
Glen Isla, Angus, 52
Glen Tilt, Perthshire, 46, 47, 48
Glenlee, Lord *see* Miller, Sir William, Lord Glenlee
Glenlyon, Lord (later 6th Duke of Atholl), 47–8
Gloriosa, nomenclature of, 103, 104, 164
glumaceous plants, 99
Godaveri River, 29, 92, 113
Goethe, Johann Wolfgang von, 196n
Goldney, Captain, 68
Gomphandra polymorpha , 103
— *tetrandra*, 103
Gondwanaland, 115
Goodger, Charlotte, 169
Gossypium, 103, 116, 117, 120
— *arboreum*, 119, 144
— — var. *obtusifolium*, 116, *see also* oopum
— *barbadense*, 116, 145
— — var. 'Suvin', 145
— *herbaceum*, 119, 144
— *hirsutum*, 116, 119, 144, 145, *see also* New Orleans cotton
— — race *latifolium*, 144
— *indicum*, 116

— *Peruvianum*, 116, 199n
Gouzaban, Indian drug, 174
Govindoo, 9, 41, 89
grafting, 63, 69
Graham, Robert, 10, 25, 37, 38, 40, 45, 46, 49, 50, 51, 52, 56, 74, 100, 105, 147, 149, 153, 167
gamboge source of, 74–5
specimens sent to (1832), 30, 190n
as teacher, 192n
Gramineae, 57, 89, 99
Grammitis cuspidata, 112
grasses, 54, 56, 72
Gravesend, Kent, 29, 51
Gray, Asa, 'Natural Selection' pamphlet, 173
Gray, John Edward, 165
British Plants, 39
Grazeley Church, 171, 175
monument to Wight, 31, 170, 172, 176
Grazeley Lodge, 16, 17, 128, 161–3, 162, 164, 165, 166, 168
botanical visitors to, 175
garden, 167
household, 169
plan of estate, 166
sale of, 176
Great Exhibition (1851), 144, 149, 150, 151–2, 157, 177
medal for Wight, 152
Great King Street, Edinburgh, 46
Greek, 19
Greene, Benjamin Daniel, 52
Greenfoot, Lasswade, 17
Gregory, James, 23, 23, 24
Greville, R.K., 23, 25, 26, 45, 46, 49, 51, 52, 54, 56, 59, 61, 86, 89, 105, 167, 175, 194n
projected *Filices Asiaticae*, 196n
Griffith, Emily, 154
Griffith, William, 45, 56, 60, 63, 67, 68, 81, 90, 94, 105, 106, 113, 164, 190n, 200n
on Bentham, 195n
Calcutta Garden, 97, 195n
daguerreotype of, 154
death of, 97, 154–5
influence on Wight, 97, 98–9, 100, 153, 178
McClelland and Wallich, 97, 148, 153, 154, 158
monument to, 154, 156
paper on Assam mosses, 196n
posthumous publication of papers, 155
specimens, 153, 155–7
Grigg, H.B., 68
Grout, Andrew, 189n
Grove, Richard H., 177
Gudalur, 114
Guettarda speciosa, 68
Gujarat, 189n
gulmohur, or flamboyant (*Delonix regia*), 68

gums – Keekur and Tragacanth, 151
 see also resins
Guntoor, 150
Gurruckpore, Bengal, 68
Guttiferae, 63, 100, 105
Gymnogens, 99

habitat forms, leading to species
 proliferation, 102–3
Haddington, East Lothian, 92
Haddingtonshire, 18, *see later* East
 Lothian
Haldwell, George, 34
Hale, Miss, 111
Halle, University of, 31, 32
Hallett, Major Frederic F., wheat
 breeder, 166
Hallikar tribe, 30
Halpin, Captain, 115
Hamilton, Francis, *see* Buchanan,
 Francis (Buchanan-Hamilton)
Hamilton, James, 23, 24
Hamilton, Thomas, 46
Hanbury, Daniel, 174
Hanover Street, Edinburgh, 17
Harappan (Indus Valley) civilization,
 119
Hare, William, 18, 20
harebell, 110
Harris, Lord, 36
Harrison, Dr Mark, 27, 190n
Harvey, Sir George, 201n
Harvey, W.H., 191n
Haslam & Son, Reading
 auctioneers, 176
Hasskarl, Justus Karl, 175
Havestries, East Lothian, 15
Hawley, Q.N., 122, 123, 124, 197n
Hay, George *see* Tweeddale, 8th
 Marquess of
Heath, Josiah Marshall, 119, 197n
Heber, Reginald, Bishop of Calcutta,
 35
Hebradendron cambogioides, 75
Hedychium, 200n
— *flavescens*, 34
Hedyotis verticillaris, 114
Helensburgh, Dunbartonshire, 52
Helfer, Johann Wilhelm, 157
Helixanthera elastica, 200n
Helmont, J.B. van, 26
hemp seed, 68
henbane, 25
Henderson, Jean (grandmother of
 Wight's mother), 15
Henslow, the Rev J.S., letter to, 53, 53
herbarium (Wight's), curation and
 distribution, 10, 49–50, 55, 148,
 156, 163–4, 165–6, 176, 177–8
Heriot Row, Edinburgh, 16
Heriot's Hospital, Edinburgh, 16, 17
Hermann, Paul, 74, 75, 104, 164
herpetology, 31
Hexacentris mysorensis, 65
Heyne, Benjamin, 31–2, 36, 38, 68
Hibiscus, splitting of large genera, 98

High School, Edinburgh (*later* Royal
 High School), 19–20, 20, 54, 178
High Street, Edinburgh, 15, 20
Hill, David Octavius, artist, 47
hill oranges, 67, 193n
Hill, Thomas, 194n
Himalaya, 52, 147, 157
Hindi, 139
Hippocrates, 21
Hodson, Captain, 67
Hoffmann, Friedrich, 26
Holarrhena, 174
Holl, William, engraver, 25
Holland, 13
Hollingshead, Tetley & Co, 124
holly tree, 20
Home, Ann (grandmother of
 Wight's father), 15
Home, James, 24
Home of Whitfield, George, 15
Homogens, 99
'Homöothermal Papers' (Wight),
 65–6, 85, 177
Honolulu, 92
Hood, Lady (married J.A. Stewart-
 Mackenzie), 75
Hood, Sir Samuel, 75
Hooker, Joseph D., 10, 45, 47, 65, 77,
 92, 97, 103, 105–6, 147, 155, 157,
 164, 165, 166, 167, 170, 175, 178,
 195n
 Flora of British India, 57, 164, 201n
 Flora Indica (with T. Thomson),
 57, 157, 164, 165, 175
 Genera Plantarum (with G.
 Bentham), 190n
 Index Kewensis, 196n
 and Kew, 165–6
 *Rhododendrons of Sikkim-
 Himalaya*, 200n
Hooker, Lady (wife of W.J.), 165
Hooker, Maria, 47
Hooker, Mary Harriet (d. 1841), 89
Hooker, William Jr. (d. 1840), 47, 89,
 92
Hooker, William Jackson (later Sir),
 10, 30, 32, 34, 36, 37–9, 38, 40, 49,
 50, 51, 52, 53, 54, 55, 56, 57, 63, 74,
 76, 95, 97, 112, 113, 115, 142, 152,
 153, 155, 156, 163, 165, 167, 200n
 Botanical Miscellany, 38, 42–3, 47,
 50, 52
 Botany of Captain Beechey's Voyage
 (with Arnott), 55
 *Companion to the Botanical
 Magazine*, 43
 correspondence with Wight, 10,
 37, 39, 41, 42, 43, 45, 48, 51, 53,
 54, 56, 60, 63, 69, 70, 83, 87, 90,
 95, 111, 113, 144, 147, 158, 164,
 169, 200n
 death (1865), 175
 description of by H.C. Watson,
 195n
 family of, 47, 89
 Flora Scotica, 25, 95

Icones Filicum, 38
Illustrations of Indian Botany
 (editor of Wight's), 47, 50
Journal of Botany, 43
 meeting with Wight, 47
 'Species Plantarum' (unrealised),
 96
hop roots, 67
Hope, John, 23, 49
Hope, Thomas Charles, 23, 23
Hopetoun, Earl of, 13, 15
Horace, 19
Horner, Francis, 23
Horner, Leonard, 201n
Horsfield, Thomas, 157, 165
Horticultural Society of London *see*
 Royal Horticultural Society
Horticultural Society of Mysore, 68
horticulture, 63–70, 84, 166–7, 175
 and translocations, 66–8
House of Commons, Parliamentary
 Paper on cotton (1847), 117
Howe Street, Edinburgh, 16
Hughes, George Arthur, 85, 119,
 194n, 197n
Hughes, J. Victor, 122
Hugonia, 102
Hugoniaceae, 98
Hullicul Droog, Nilgiris, 110
Hullmandel, C., lithographer, 47
Humboldt, A. von, 42, 50, 61, 66,
 109
Hume, David, 189n
Hume, Joseph, 121, 161
Hunter, Dr Alexander, 151
Hutchinson, Joseph, 117, 145
Huxham, William, 67, 73, 193n
Huxley, T.H., 171
hybridisation, 65, 106
 of cottons, 140, 145, 199n
Hyder Ali, 30, 68, 110
Hydnocarpus wightiana, 201n
Hydrocera triflora, 63
Hydroleaceae, 99
hydrology, 33
hygrometer, 32
Hymenocalyx variabilis, 112
Hyne, George, 32
Hyoscyamus niger, 25
Hypericineae, 100
Hypericum hookerianum, 114
— *mysurense*, 114

Icones Plantarum Indiae Orientalis
 (Wight), 25, 41, 43, 59, 68, 74, 75,
 76, 84, 93, 104, 113, 114, 121, 144,
 148, 152, 159, 164
 dedication of, 93
IKISAN website, 145
Ilex, 103
— *denticulata*, 110
— *wightiana*, 110
illustrations
 by Rosa, 89
 of economic plants, 72, 93
 importance of, 107, 156, 178

of Indian flora, 9, 39, 42–3, 50–1,
 178
of Indian medicinal plants, 59, 85
of trees, 73
Illustrations of Indian Botany (Wight),
 41, 43, 61, 65, 74, 75, 79, 81, 84, 90,
 95, 97, 100, 102, 104, 106, 107, 112,
 121, 148, 149, 162, 177
 dedication of, 93
immune system, 26
Impatiens, 106
— *munronii*, 115
"improvement", 10, 13, 18, 48, 80, 83,
 109, 124, 177
 in cotton trials, 120, 122, 139, 144
India
 as consumer of British cloth, 77–8
 cotton statistics, 145
 industrialisation, 144
 internal market for cotton, 78,
 119
 national herbarium, idea of, 156
 northern, 52
 partition (1947), 145
 role as producer of raw material,
 77–8, 144
 Wight's first period (1819–31),
 28–43
 Wight's second period (1834–53),
 58–159
 see also South India
India Bill (1853), 161
India House, London, 39, 45, 155,
 157
India Office, 117, 174
Indian artists and collectors, 10, 31,
 40, 41–2, 75–6, 90, 178
Indian botanists
 compared with European, 105
 maps of journeys (Wallich), 35
Indian Central Cotton Committee
 Conference (1937), 144–5
Indian tenant farmers *see* ryots
Indian Territories Select Committee
 (1853), 138, 161
indigo, 86, 151
Indigofera pulchella, 114
— *tinctoria*, 151
Indo-China, 144
Indore, 145
Indus Valley (Harappan) civilization,
 119
Infirmary Street, Edinburgh, 19
Inga dulcis, 92
— *koenigii*, 104
Ingledew, W., *Treatise on the Culture of
 Several Plants*, 66–7
insect damage to herbarium
 specimens, prevention of, 148, 155,
 198n
Inverleith, Edinburgh, 46
Inverleith House, Dapuri exhibition
 (2002), 10
Inverleith Row, Edinburgh, 20
Iris, naturalised at Ooty, 111
irrigation, 113, 118, 134, 136, 143,

143–4, 144, 145
Ischaemum pilosum ('nuth or couch grass'), 60, 126
Isle of Wight, 162, 163, 169
Iyamally Hills, near Coimbatore, 148

Jack, Dr William, 155
Jackson, Emily, 169
Jackson, John, 190n
Jaffna, Ceylon, 76
Jaffrey, Andrew T., gardener, 64, 192n
Jamaica, 16, 169
Jameson, Professor Robert, 21, 23, 24, 32, 81, 155
Jasminum, 112
— *myrtifolium*, 103
— *rigidum*, 102–3
— *tetraphis*, 103
Jeffrey, Francis, 23
Jena, Germany, 112
Jerdon, Thomas Caverhill, 90, 111, 175, 190n, 195n, 196n
Jobbins, John Richard, lithographer, 125
John, the Rev C.S., 31
Johnson, Eliza, 113
Johnson, the Rev Edmund, 112–13, 169
Johnson, Robert, 23
Johnston, John, 109
joint stock company, 138, 142
Jones, Lydia, 169
Journal of Botany, 43, 175
judiciary, 13, 18
Jumla rice, 65–6
Juncus spp., 81
Jussieu, Adrien de, 101
Jussieu, Antoine-Laurent de, 54, 93, 96, 106
 Genera Plantarum, 39, 93, 94
 natural classification, 94–5, 97, 98, 99, 101
Jussieu, Bernard de, 94

Kaitee Falls, Nilgiris, 113, 114
Kaiti, Nilgiris, 109, 110
Kalanchoe grandiflora, 114
Kambam, 35
Kandy, Ceylon, 102, 193n
Karnataka, 30, 59
Karur, 85
Kashgar, 157
Kay, John, etcher, 16, 22, 23, 23, 24
Keelpaukam (now Kilpauk), Madras, 84
Keithbank, East Lothian, 15
kelp industry, Scotland, 75
Kelso Cottage, Ooty, 110–11, 115
Kelso, Major, 109
Kenathkovadoo, 131
Kerala, 113
 Pooram temple festival, 115
Kerr, William, 74
Kew Gardens, London, 10, 25, 32, 37,

53, 55, 60, 63, 76, 90, 157, 158, 162, 175
 and the Hookers, 165–6
 Madras Naturalist's collection of drawings, 32
 Museum of Economic Botany, 150, 152
Kew Palace, former kitchen garden (1847), 152
'Kew Rule' (1877), of nomenclature, 104
Khasia Hills. NE India, 174
Killiecrankie, Perthshire, 48, 162
Killin, Perthshire, 46
Kilmainham, Dublin, 173
Kilpauk (Keelpaukam), Madras, 84, 120
King's College, London, 32
Kirknewton. Midlothian, 15
Kirkton of Clova, Angus, 52
Klein, J.G., 32, 36
Klingemann, Carl, 47
Klotzsch, Friedrich, 47, 49, 191n
Knight, Professor David M., 67, 99
Knox, Robert, 18, 20
Kodaikanal, Palni Hills, 81
König, J.G., 31, 32, 74, 75, 104
'Koondahs', Nilgiris, 114
Kotagherry (Kotagiri/Kotergherry), Nilgiris, 109, 110, 113, 115
Kottayam, 112
Kumar, Professor Deepak, 138

Labiatae, 49. 56, 95, 99, 102
Labouchère, Henry, 161
Laing, Alexander, 19
Lamarck, Jean-Baptiste, 101
Lamarckism, 66, 85, 100, 126
Lambert, A.B., 49
 Description of the Genus Pinus, 49
Lancashire, 10, 119
land assessment, 132, 133, 143
land tax, 77, 85, 121
larch, European, 47
Lardner, the Rev Dionysius, *Cabinet Cyclopaedia*, 99, 195n
Lasswade, Midlothian, 17
latex, 148, 165
Latin, 19, 21, 26, 39
Lauraceae, 56, 75, 163
Laurus cassia, 75
Lawford, Edward, 134, 198n
Lawson, Peter, Edinburgh seedsman, 167
Lawsonia inermis, 92
Leadenhall Street, London, 36
Ledebour, C.F. von, 54
leeches, 81
Lees, Arthur. 199n
Lees, David, 199n
Lees, James, 133–4, 143
Leguminosae, 55, 56, 57, 92, 95, 97
 genus named after Shuter, 34
Leith Walk, Edinburgh, 15, 17
 Botanic Garden at, 23, 25, 46
'Leopoldina' (Academia Caesareae

Leopoldina-Carolinae Naturae Curiosorum), 52, 74
Leschenault de la Tour, Jean-Baptiste Louis Claude Theodore, 109
Leslie, John, 26
lettuce, 192n
Lewis, Frederick Christian, Jr. (artist), 194n
Lewis, Isle of, Seaforth estates, 75
liane, 65
libraries, copyright, 93
lichens, 39, 40, 42, 49, 86, 86, 99
Lichfield Botanical Society, 190n
 translation of Linnaeus' *Genera Plantarum*, 29
Liliaceae, 99
Lilium longiflorum, 114
— *neilgherrense*, 103, 197n
— *tubiflorum*, 103, 197n
— *wallichianum*, 197n
Linaria ramosissima, 192n
Lindley, John, 45, 49, 52, 56, 95–6, 97, 99, 100, 101, 103, 105, 137, 154, 156, 165, 166, 173
 'Acrogens', 195n
 death (1865), 175
 Elements of Botany, 98
 Natural System of Botany, 95
 Vegetable Kingdom, 96, 195n
Lineae, 98
Linnaean tradition, 30, 36, 37, 42, 106, 111
Linnaeus, Carolus von, 25, 31, 32, 74, 75, 99, 103, 159
 Genera Plantarum, 29
 Hortus Cliffortianus, 39
 Species Plantarum, 75, 104, 190n
 Systema Vegetabilium, 190n
Linnaeus, Carolus (filius), 31
Linnean Society of London, 45, 49, 52, 53, 95, 156, 165, 177, 191n, 196m
 Proceedings, 175
lithography, 40, 45, 50, 56, 72, 73, 84, 86, 107, 177, 178, 193n
litmus, lichen dye, 86
Liverpool, 47, 56, 124, 129, 139, 169
 Museum, 32
lizard, 66–7
Lloyd, Caroline (née Watson), 201n
Lloyd, Edward Watson, 169
Lloyd, John Horatio, 201n
Lloyd, Mary Adelaide (James Wight's wife), 169, 191n
Loch Katrine, 46
Loch Lomond, 46
Loch Tummel, 48
London, 31, 36, 39, 40, 43, 45–6, 52, 55, 56, 57, 60, 81, 165, 169
 Rosa in, 90, 147
 Wight's return to (1853), 158
 Wight's stay of 1831–2, 48–51
 see also Court of Directors
London Mail, 130
London Street, Edinburgh, 16
Longwood, St Helena, 43

Lonicera ligustrina, 110
loquat, 68, 74
Loranthus euphorbiae, 200n
lotus, sacred, 101
Loudon, John Claudius, 66
Louisiana, USA, 122
Lovell, Mr and Mrs, 169
Ludden, David, 77
Ludwig, Baron, 68
Lush, Charles, 121
Lushington, Charles May, 84, 109, 122, 193n
Lushington Hall, Ooty, 109, 110
Lushington, J.L., 197n
Lushington, Stephen Rumbold, 36, 39, 43, 84, 109, 110, 144, 176
Luxmi cotton, 145
Lysimachia leschenaultii, 114

Mabberley, Professor D.J., 45
Macaulay, Thomas Babington, 109, 161
McClelland, John, 60, 63, 76, 154, 155, 156, 164, 200n
 Griffith and Wallich, 97, 148, 153, 154, 157
McCurdy, E.A., topographical artist, 108
McDonald, Duncan, 20
Macfarlane, A.J., 46
McIvor Report on Horticultural Gardens, Ooty (1852), 69
 Wight's comments on, 69–70
McIvor, William Graham, 65, 68, 69–70
 employment of Robert Wight Jr., 170
McKellar, Captain, 67
Mackenzie, Colin, Mysore survey, 31
Mackenzie, John, 169
Mackenzie, Kenneth, 20, 26
Mackenzie, Mary, 169
Mackenzie, Thomas, 169
Mackenzie, Zena (Alexandrina née Murray) (niece), 169
Maclean, Charles, 29
Macleay, W.S., 98, 195n
Macleod, Flora (later Jerdon), 90
McNab, James, 46, 52, 175
McNab, William, 25, 46, 191n
McNaghten, E., 137
Macnee, Daniel, 53, 53, 56, 167, 201n
Maconochie, Alexander, 2nd Lord Meadowbank (second cousin), 18, 24, 29, 48
Maconochie, Alexander (b.1711), 15
Maconochie, Allan, 1st Lord Meadowbank, 15, 18
Maconochie family, 15, 17
 family tree, 14
Maconochie of Inverawe (Dougall Campbell), 15
Maconochie, James, 15, 18
Maconochie, Jean (mother), 13, 15, 16–17
Maconochie, Robert (second

cousin), 29
Maconochie, William (maternal
 grandfather), 15, 16, 18
Maconochie's Close, Cowgatehead,
 Edinburgh, 15
Macrae, James, 74, 76
Madagascar, 68
madder, 73
Madeira, 86
Madras, 9, 16, 32, 38, 42, 43, 48, 57,
 59, 63, 65, 79, 81, 90, 110
 botany of Presidency, 29–30
 Chamber of Commerce, 86, 128–
 9
 Conservator of Forests, 149
 Cotton Experiment, 117–45: map
 of sites, 118
 description of city, 92
 Economic Botanist (1835–6), 71–
 81, 83–7, 177
 famines, 77, 78
 Government brief (1836) to
 Wight, 71–3, 86, 109, 120, 144,
 149
 herbaria, 157
 Mandapam Road, 82, 84
 Naturalist and Botanist (1826–8),
 31–6, 177
 plan of city (1840), 82, 194n
 Revenue Department, 71–81
 Wight's visits to, 147
Madras Almanac, 29, 30, 82, 85, 91,
 194n
Madras (Tamil Nadu) Archives, 117,
 118
Madras Army, 16, 29
Madras Cambodia cottons (MCU),
 145
Madras Club, 64
Madras Journal of Literature and
 Science, 59, 61, 63, 71, 75, 87, 120
 'Statistical Observations on the
 Vurragherries or Pulney
 Mountains', 80
'Madras landing', 29, 92
Madras Literary Society, 38, 155, 157
Madras Medical Board, 30, 32, 36, 39
 Museum of natural curiosities, 33
 rules for the Naturalist, 33
 Wight's letter re 1826 expedition,
 34–5
Madras Medical College, 157
Madras Medical School, 152
Madras Military Orphan Asylum, 48
'Madras Museum', 33–4, 152, 157
Madras Native Infantry
 6th regiment, 43
 13th regiment, 37
 21st (later 42nd) regiment, 29–
 30, 92
 33rd regiment, 30, 59
 40th regiment, 90, 137
Madras Quarterly Journal of Medical
 Science, 173
Madras Railway Company, 151
'Madras system' in Scottish schools,

48
Madura(i), 35 73, 138, 139, 145
Magnoliaceae, 97
Maharashtra Hybrid Cotton Seeds
 Company (MAHYCO), 145
Mahaweli Ganga, Ceylon, 74
Mahonia leschenaultii, 110
Mail Koondah, 70
Malabar, 60, 72, 74, 75, 79–81, 149,
 150, 190n
Malabar Coast, 35, 40, 43, 61, 67, 73,
 75, 79, 112, 114, 115
Malacca, 97, 154
malaria, 30, 51, 74, 76, 113, 175
Malay Peninsula, 52
Malcolmson, John Grant, 60, 61, 71,
 73, 193n
Malta, 119
Malvaceae, 201n
Mammea, 103
Manantoddy (now Manantavadi), 30
Manchester, 117, 124, 133, 135, 138
Manchester Commercial
 Association, 130, 131, 132, 135, 138,
 141, 142, 143, 144, 198–9n
mangel wurzel, 67
Mangles, Ross Donnelly, 84, 161
mangosteen (Mangostana morella),
 63, 74, 75, 79
mangroves, 79
Manjacamund, 110
Manu Smriti, 119
manure, 115, 118, 126, 128, 145, 167
maps, of Indian botanists' journeys
 (Wallich), 35
Margadant, W.D., 192n
Maria Paulowna of Russia, Grand
 Duchess of Saxe-Weimar, 112,
 196n
Marshall, Captain, 159
Marshall, Henry, 75
Martin, Sir James Ranald, 174
Martius, Carl Philipp von, 46, 50,
 148
mass flowering, 106
Masters, Maxwell T., 175, 201n
Masulipatam, 29, 119
Materia Medica, 21, 22, 24
Maull & Co, photographers, 89, 162,
 164
Mauritius, 85, 119, 121
Mayaverum (now Mayiladuthurai),
 112
Meadowbank, Midlothian, 15, 18
Meadowbank, 1st Lord (Allan
 Maconochie), 15, 18
Meadowbank, 2nd Lord (Alexander
 Maconochie), 18, 24, 29, 48
mechanisation, 119, 124–5
medical botany, 195n
Medical Physical Society of Calcutta,
 Transactions, 85
Medical Times & Gazette, 175, 176
medical topography, 174, 194n
medicinal plants, 41, 59, 174, 177
medicine, 20, 21–4, 26, 83

Brunonian system, 65, 178
Mehta, Sir Homi, 10
Meisner, C.F., 46, 175
Melanorrhoea, 200n
Melastomataceae, 98
Melcombe Regis, Dorset, 113, 169
Melianthus major, naturalised at
 Ooty, 111
Melville Monument, Edinburgh, 16
Mendelian segregation, 66
Mendelssohn, Felix, 47
Menzies, Archibald, 49, 191n
Mesembryanthemum, 43
Metcalfe, Sir Charles, 194n
meteorology, 33, 73, 109, 115, 197n
Methonica (v. Gloriosa), 103, 164
Mettupalayam, 109, 148
Metz, F., 40
Mexican cotton see New Orleans
 cotton
Meyer, Henry Hopper, engraver, 34
miasmic theory of disease, 79
Michelia Nilagirica, 104, 111
microscope, 32, 52, 53, 56, 97, 100,
 164, 191n
Midlothian, 22
midwifery, 21, 22, 23, 24
Miers, J., 165
Mill, John Stuart, 117
Mill of Kevock, Lasswade, 17
Miller, Sir William, Lord Glenlee, 16,
 17
Millhaugh, 17
Millingtoniaceae, 98
Milne-Edwards, Henri, 193n
Milton, Pencaitland, 13, 15, 16, 18
Milton, Lord see Fletcher of Saltoun,
 Andrew
Mimosa nitida, 104
Minchin, Major F., 69
mineralogy, 33, 81, 151
Ministerial Whitebait Dinner, 29
missionaries, 111, 112
 American, 81
 Tranquebar, 31, 32, 45
Mississippi, USA, 122, 128, 141
mistletoes, 148
Mitchell, William Somervell, 32
monkey-puzzle, Chilean, 49
Monocotyledones, 98, 99, 101
monocultures, 150
monoecy, 101
Monosis wightiana, 113
Monro, Alexander, tertius, 18, 23, 23
Monsanto, 145
Montague House, Bloomsbury,
 London, 49
Montairo, M.L., Calcutta
 photographer, 200n
Montgomery, Sir Henry, 134, 135,
 157, 198n
Montpellier, 96
Moon, Alexander, 74, 76, 194n
 Catalogue of Ceylon Plants, 39, 74,
 76
'Mooniapillay's' see Nopalry

Moore, J.A., 137
Moore, Lindsey, 10
moral philosophy, 22, 23
Morning Chronicle, 130, 142, 176
morphology, general laws of, 102,
 177
Morris, James, 122, 123, 124, 126,
 127, 128, 129, 132, 197n
Morris, J.C., 63
Morton, Edward, lithographer, 154
mosses, 25, 39, 40, 42, 49, 54, 192n,
 196n
Moulin, Perthshire, 48
Mucuna utilis, 193n
mudar (Calotropis procera), 41, 59–60
Mueller, Sir Ferdinand von, 164, 165
Muirhouse, Ormiston, 13
mulberry, 114
'Mulls', 29, 111
Munro, Sir Thomas, 30, 32, 33, 34,
 34, 36, 109
Munro, William, 87, 89, 90, 110, 115,
 175, 192n
 'Hortus Bangalorensis', 68
muriate of lime, as fertiliser, 115, 128
Murray, J.A., 75
Murray dukes of Atholl, 47–8
Murray, Marion (née Wight), 169
Murray, Peter, 16, 169
Murrays (farm), Ormiston, 13
Musa, 66
— Paradisiaca, 152
'Musci' see mosses
muscles, 26, 27
museum, functions, 33
Museum of Scotland, Edinburgh, 16
mycology, 47
Myrtaceae, Wight's taxonomic
 treatment of, 99, 101–2
Myrtus communis, 65
— tomentosa, 114
Mysore, 32, 35, 60, 68, 74, 129, 147,
 190n
 Public Cattle Depot, 30
Mysore survey, Colin Mackenzie's,
 31

Napier, Macvey, 54
Napier, Sir Charles James, 90
Napoleon Bonaparte, 43
Napoleonic Wars, 46, 79
National Monument to the
 Napoleonic Wars, Edinburgh, 46
Native cotton see oopum
'Native Draftsman', 30
natural history, 9–10, 21, 24, 31, 32,
 36, 98–9, 152, 157, 176
natural selection, 173–4, 178, 201n
Natural System of classification, 25,
 39, 42, 43, 54, 55, 61, 93–4, 98–9,
 101, 174, 177
natural theology, 10, 21, 60, 67, 94,
 100, 173, 178
naturalists, field or closet, 104–5
Nature, 173, 175
nature

Candolle's view of, 94
 continuity in, 94–5, 97–8, 103
 Griffith's view of, 98
 Wight's view of, 97–8, 100
Nawab of Arcot, 31, 147
Neddawattum (Neddawuttum),
 Nilgiris, 114, 115
Nees von Esenbeck, Christian G.D.,
 46, 50, 54, 56, 57, 75
Negapatam, 19, 34, 37–43, 45, 46, 47,
 48, 50, 86, 92
Neilgherry Hills *see* Nilgiri Hills
Neill, Patrick, 26, 54, 57, 189n
Nelumbium, 151
Nelumbonaceae, 101
Neolitsea cassia, 75
Nepal, 65
nettles, 113
New Orleans cotton, *116*, 117, 118,
 120, 122, 123, 124, 125–6, 127, 128,
 129, 131, 132, 135, 136, 139, 140,
 142, 144
New Statistical Account (1838), 48
New Town, Edinburgh, 46
Newbury, Berkshire, 17, 171
Niddrie Street, Edinburgh, 17
Nilambur, 149
Nilgiri Game and Fish Preservation
 Act (1879), 111
Nilgiri ('Neilgherry') Hills, 35, 40,
 43, 66, 67, 68, 70, 74, 76, 87, 104,
 105, 106, 148, 170
 botanical trips (1839–42), 109–15
 description of, 109–10
 view of, *108*
Nimmoia, 87
nitrogen, 25
nomenclature
 Candolle's *Lois* (1867), 103, 104,
 175, 201n
 changes in rules of, 104
 International Code of Botanical,
 196n
 'Kew Rule' (1877), 104
 Linnaean, 94
 priority principle, 103–4, 164
 valid publication principle, 104,
 155
 Wight's, 103–4
Nopalry, Madras, 31–2, 33, 68, 191n
Norrie, George, 15
North Hanover Street, Edinburgh,
 16, 18
North St David's Street, Edinburgh,
 15
Northern Circars, 29–30, 31, 152
Northumberland, Duke of, 200n
Norway spruce, 47
Nundydroog, 32
Nungambakkam, Madras, 192n
nut trees, 67
Nuwara Eliya, Ceylon, 74, 114, 193n
Nymphaea, 151
Nymphaeaceae, 101

Oakes, Partridge & Co., 64

*Observations on the Forest Trees of
 Southern India* (Wight), 149–50
Odina Wodier, 92
Œnothera biennis, naturalised at Ooty,
 111
Ogilvie, W.C., 122
oils
 Gingelly, 151
 Illiepie, 151
 Sesamum, 151
Old Fishmarket Close, Edinburgh,
 26, 189n
Old Greyfriars Church, Edinburgh,
 15
Old Town, Edinburgh, 46
Oleaceae, 102, 113, 195n, 196n
Oleineae, 100
Oliver, Daniel, 165
'On the means of inducing the
 Native of India ..to devote more
 time ... to the culture of
 commercial or mercantile produce
 ...' (1836) (Wight), 77–8
Oodoomulcottah (Ootamulcottah),
 123, 124, 126, 127, 128
oopum (native Indian cotton), 10,
 116, 117, 118, 123, 124, 126, 128,
 129, 131, 132, 136, 137, 139, 144
Ootacamund ('Ooty'), 68, 74, 109–
 13, 115, 147, 155
Ootakalmund (now
 Ottaikalmandapam), 126, 128–9,
 130–1, 148
Ooty *see* Ootacamund
Ooty Club, 111, 115
Ooty Horticultural Garden, 65, 68–
 70, 76, 109, 112, 115
 Report on (Wight), 144
opium, 192n
Opuntia, 32, 92
orchids, 49, 51, 56, 65, 68, 74, 90, 95,
 110, 113, 174, 176
Ormiston, East Lothian, 13, 22
Ormiston Wights, 13–15
 family tree, *14*
ornithology, 20, 46, 47, 90
Orobanchaceae, 65, 92, 99, 103, 106,
 113, 115, 148
Orobanche nicotianae, 106, 152
orthography, 104, 196n
Osbeckia gardneriana, 114
— *hispidissima*, 148
— *wightiana*, 114
Osmunda regalis, 114, 196n
Otteri Nala, Madras, 84
Ouchterlony, John, 115, 151
ovary, 102
Oxalideae, 98
Oxalis, 43
Ozodia (= *Fœniculum*), 165

pacottah (picottah), 33, 190n
Palamcottah, 35, 60–1, 73, 77, 79, 85,
 122
Palani ('Piney'), 35
palankeen (palanquin) journeys, 30,

76, 147
Palatchee, 131
Palghat, 35, 115
Pallavaram, 35
Palmer, George, 169
Palmerston, Lord, 161
palms, 99, 113, 148, 152, 191n, 200n
Palni (Pulney) Hills, 35, 42, 65, 73,
 79, 80, 81, 105, 106
pampelmousse, 133
Panigrahi, G., 45
Papaveraceae, 97
paper, 37–8
 drying, 40–1
 Indian, 29, 38
Paracelsus, 26
parasites, 99, 115, 148
Parbury & Allen, London
 publishers, 38, 50–1, 53, 57
Paris, 54, 175
 Jardin du Roi, 94
 Wight's visit (1861), 169
Park Place, Edinburgh, 25
Parkinson, John, 52
Parlatore, Filippo, 150, 175
Parliamentary Papers on Indian
 cotton experiment (1847), 117
Parliamentary Report on Indian
 cotton experiments (1857), 139
Parliamentary Select Committee,
 Report on Indian cotton
 experiments (1848), 133, 161
Parnassia Schmidii, 112
— *Wightiana*, 112
Paspalum scrobiculatum, 193n
Passiflora, 195n
— *Leschenaultiana* (= *leschenaultii*)
 112, 114
Pathanapuram, 73
Paulownia, 196n
Pautchoor, 80
pawpaw, 102, 170
Peakeshole, near Edinburgh, 17
Pedaliaceae, 99
pelargoniums, 111
Pencaitland, East Lothian, 13, 15, 22,
 80
Penicuik, Midlothian, 125
Peninsular & Oriental Navigation
 Company, 90
Pennisetum americanum, 193n
— *glaucum*, 67, 145
Peradenyia, Ceylon, 74, 76
Permamallie, Palni Hills, 81
Pernambuco cotton, *116*, 121
Perrottet, George Samuel, 149
Perryur, 80
Persoon, C.H., *Synopsis Plantarum*,
 29, 39, 42
Perthshire, 15
Peruvian cotton, *116*, 199n
pesticides, 145
Pestonjee, Jevanjee, 161
petals, lack of 101, 195n
Petrie, James, 124, 125, 131, 132, 133,
 138, 141, 149, 199n

'Petty-gulph' cotton, 136
Peyton, Thomas, 111
Phaca astragalina (=*Astragalus
 alpinus*), 46
Pharaoh printers, Madras, 117
 Mr Pharaoh's Library, 64
pharmacopoeia, Native Indian, 85
Pharmacopoeia of India, 164, 165, 174,
 178
Philanthropic Association [of
 Madras], 87, 124
Philippines, 144
philosophy, 120
Photinia notoniana, 114
phrenology, 51–2, 177
Phyllanthus, 43
Phyllodoce caerulea, 48
Physalis peruviana (Brazil
 gooseberry), 66–7
physic, practice of, 22, 23, 24, 26
Physico-chirurgical Society *see* Royal
 Physical Society, Edinburgh
Piddington, Henry, 121, 197n
pignuts, 19
Pillans, Dr James, 19, *20*
Pillay, C. Parasooramah, 33
Pillay, C. Senevassa, 33
Pimenta dioica, 74
Pimpinella leschenaultii, 114
placentation, 102
plane tree, 101
plant geography, 106, 115
plant pathology, 69–70
plantains, 66, 152
plants
 acclimatization, 65–6, 70, 112
 analogies with animal
 classifications, 99
 breeding, 66
 changing phenotypes of, 65–6, 85
 description, limitations of, 106–
 7, 117
 difficulties of identifying Indian,
 30, 39, 85, 101
 drying, 40–1, 85
 geographical distribution of, 115
 inferring affinities, 99–101
 limitations of words in
 describing, 98, 106–7
 possibility of alteration of
 sexuality by climate, 103, 170
 possibility of extinction, 100–1
 variation with time, 100–1
Playfair, John, 23
Playfair, Lyon, 167
Playfair, W.H., architect, 18, 21, 46
'plietesial flowering cycle', 106
plough
 American, 122, 125, 177, 198n
 Indian, 126, 198n
 light, 83
 Wilkie's improved friction wheel,
 87
Plukenet, Leonard, *Phytographia*,
 148, 201n
Plumeria, 66

Podostemaceae, 99, 113, 195n
Podostemon, 114
Poinciana [now *Delonix*] *regia*, 68
Point de Galle, Ceylon, 76, 159
'Pois noire', 67, 193n
political economy, 77–9
Pollachi, 123
pollination biology, 40, 106
Polygala, 102, 191n
Polygonatum verticillatum (whorled
 Solomon's Seal), 48
polyploidy, 106
Polyporus (now *Hexagona*) *wightii*, 49
pomegranate, 102
Pondicherry, 35, 144
Poona, 133
Portsburgh, Edinburgh, 15
potatoes, 79
Pottinger, Sir Henry, 69, 113, 118,
 119, 137, 142–3, 151, 157, 199n
 and the cotton experiment, 133–
 9, 144, 176
 Minute on scrapping of cotton
 farms (1849), 135
 response to Wight's final report
 (1852), 138–9
Pouzolzia, 98, 113
Prek Chu valley, Sikkim, 10
Presbyterian Church of Scotland, 48
Prescott, J.D., 54
Preston, Sir Charles, 29
Preston, Sir Robert ('Floating Bob'),
 29
Price, Sir Frederick, 68, 109
primrose, 19
Prinsep, H.T., 121, 143
printing, 93
*Prodromus Florae Peninsulae Indiae
 Orientalis* (Wight & Arnott), 36, 41,
 43, 53, 55, 56, 57, 95, 96, 106, 164
 incomplete second volume, 74
 inscription in Cleghorn's copy,
 148
 Preface, 156
Prosopis spicigera, 150
proteas, 101
Prunella vulgaris, 114
Prunus lusitanica, 167
Pseudocotyledonous plants, 99
Pterocarpus marsupium, 152
— *santalinus*, 151
publication projects (Wight's)
 illustrated Floras, 42–3
 Indian medical botany, 59
 monographs, 43
 projected local Indian Flora, 43,
 52
publications (Wight's), 50–1
 horticultural papers, 63
 of illustrations, 178
 in India, 59, 63, 83, 93, 105, 144,
 153, 155, 178
 priority of, 103–4, 155
 valid, of names, 104, 155
Pulicat Farm (projected), 86–7, 121
Pulicat Lake, 86

Pulney Hills *see* Palni Hills
Punjab, 144, 145
Pussellawa, Ceylon, 74
Pycarrah (Pykara) Bungalow,
 Nilgiris, 114
Pyrenees, 54, 95, 96
'Pyrexia', 26

Queen Street Gardens, Edinburgh,
 16–17
Queen Street, London, 45, 49, 54
Queensberry House, Edinburgh, 27
'Qui-hi', 29
Quilon, 32, 35, 43, 73, 79, 102
Quinarian method of classification,
 98, 178, 195n
Quisqualis indica (Rangoon creeper),
 65

Radcliffe-Smith, Alan, 45
Rafflesia, 99
railways, 78, 79, 149, 151, 170, 177
Rajahmundry, 29, 92
Ramboda, Ceylon, 74
Ranunculaceae, 81
Raphanus sativus, 193n
Ratnam, R., 85, 118
rattan, 113
Ravenshaw, William, 33
Reading, Wight's retirement to,
 161–7
Reading Farmers' Club, Wight's
 address to, 167
Reading Mercury, 167
Redouté, Pierre Joseph, 99
 Les Lilacées, 36
Rees, Abraham, *Cyclopaedia*, 45
Reichenbach, Heinrich Gustav, 148,
 163, 166, 167, 175, 176
 obituary of Wight, 177
Reid, Francis A., 64, 158
Repton, Humphrey, Scottish
 garden, 29
Requien, E., 96
resins, 79, 152
Retose families, 99
Retzius, A.J., 31
Rheede, Hendrik van, *Hortus
 Malabaricus*, 36, 39, 40, 60, 75, 175,
 201n
Rhizanths, 99
Rhododendron, 106, 110, 114
— *arboreum*, 112
— *nilagiricum*, 112
— *wightii*, 10, 65, 200n
rice, 197n
 acclimatization, 65–6
 costs of production, 78
 Jumla, 65–6
Richmond, John, 90
Rigg, the Rev Mr (Ooty), 111
Ritchie, William, 19, 20, 54
road-building, 113, 122, 150
Robertson family, 47
Robertson, William (Principal of
 Edinburgh University), 15, 18

Robertson's Close, Cowgatehead,
 Edinburgh, 15
Robinson, George Abercrombie, 29
Robinson, T.F., 25, 31
Rodrigues, E.A., 82
Roeper, J.A.C., 54
Rohde, John, 150
Rolfe, I.W.J., 23
Romanticism, 178
Roper, the Rev J.S., 17, 18, 92
Roscoe, William, *Monandrian Plants*,
 39
Rose Street, Edinburgh, 15
Ross, Andrew, 52
Roth, A.W., *Novae Plantarum Species
 Praesertim Indiae Orientalis*, 32, 38
Rottler, J.P., 32, 36, 39, 43, 166, 191n
 library, 38
Routledge, Jane Sophia, 89
Roxburgh, John, 154
Roxburgh, William, 10, 25, 29, 31,
 59, 60, 85, 93, 115, 121, 177, 178
 Flora Indica, 36, 39, 50, 57, 191n
 Hortus Bengalensis, 39
 Icones (unpublished at Calcutta),
 153, 155, 156
 Plants of the Coast of Coromandel, 31,
 38, 60, 107
Royal Academy, London, 89
Royal Asiatic Society of Great
 Britain, 86
Royal Botanic Garden Edinburgh
 (RBGE)
 at Leith Walk, 23, 25, 46
 Indian botanical drawings
 collection, 9, 10
 Indian tropical plants, 25
 library, 9, 16, 148
 move to Inverleith, 46
 Regius Keepers, 23, 30, 37, 167
Royal College of Surgeons,
 Edinburgh, 18, 22, 22, 24
Royal High School, Edinburgh, 46,
 178
Royal Horticultural Society,
 Exhibition (1866), 174–5
Royal Humane Society, 171
Royal Infirmary, Edinburgh, 21, 24
Royal Physical Society, Edinburgh,
 25
Royal Scottish Academy, Edinburgh,
 46
Royal Society of London, 18, 158, 173
 Wight's Fellowship, 163, 165, 178
Royapuram, Madras, 151
Royle, John Forbes, 49, 52, 73, 87,
 119, 121, 124, 129, 133, 142, 151,
 153, 157, 165, 177, 193n, 199n
 *Illustrations of the Botany of the
 Himalayan Mountains*, 59
 *On the Culture and Commerce of
 Cotton in India and elsewhere ...*,
 117
Rubiaceae, 195n
Rubus arctica , 48
Rumex, 81

— *vesicarius*, 193n
Rumphius, G.E., *Herbarium
 Amboinense*, 36, 39, 60
Rungiah, 9, 34, 40, 41, 42, 43, 46, 47,
 50, 76, 86, 97, 148, 194n, 196n
 illustration of lichens, 86
 letter to Wight, 51, 56
Russell, James, 24
Russell, Lord John, 161
Russell, Patrick, 31, *31*, 36, 45, 60
Rutherford, Daniel, 24, 25, 25, 30,
 39, 46, 49, 93
ryots (Indian tenant farmers), 10, 60,
 139, 176
 agreements to rent land from,
 123, 126, 130, 131, 134, 135,
 199n
 beliefs about American cotton,
 139, 143
 deforestation problems, 151
 introducing mercantile crops to,
 72, 77–9, 86–7, 120, 121, 145
 method of cultivation, 128, 140
 poverty of, 77, 78, 81, 113, 120
 preference for churka, 125, 129–
 30
 proposed agricultural school for,
 86–7
 purchasing cotton from (Finnie's
 agency), 141–2
 remunerating prices for their
 cotton, 122, 127, 135, 141, 143
 sugar cultivation, 85
 views on irrigation, 136

Saccharum officinarum (sugar cane), 85
— *sinense*, 85
Sachs, Julius von, 95
Saharunpur Botanic Garden, 165
Saidapet, Madras, 33
St Andrews, Fife, 48–9
St Andrew's Church, Edinburgh, *16*,
 18
St Catherine's Falls, Nilgiris, 113
St George's Cathedral, Madras, 64,
 147
 monument to Griffith, 154, *156*
St George's Hospital, London, 175
St Helena (Island of), 43
St James Square, Edinburgh, 20
St Mary's Hospital, London, 171
St Petersburg, Russia, 54, 178
St Stephen's Church, Edinburgh, 46
St Stephen's Church, Ooty, 109, 111
Salem (Tamil Nadu), 68, 81, 84, 85,
 120, 122, 124, 197n
salt, 78
Saltoun, East Lothian, 13, 15, 194n
saltpetre, 73
Salvadoraceae, 76
Salvia pratensis, 51
Samulcottah, 29, 31, 68, 85
Sanders, James, 22, 24, 26, 27, 30
 De Hernia Crurali, 26
Sangster, the Rev Henry, 80
Sangwan, Satpal, 45

sappan, 193n
sapromyophily, 106
Sardinia (lichen source), 86
Sargassum, 192n
satinwood, 76
Saunders, W.W., 165
saw-gin (cotton)
 small, 129, 131, 139, 140–1
 Whitney's, 118, 120, 122, 124–5,
 125
Saxifraga oppositifolia, 48
Schenck, Frederick, (lithographer),
 38
Schlagintweit brothers, 157
Schlechtendal, D.F.L. von, 98
Schmid, the Rev Bernhard, 59, 68,
 76, 104, 111–12
Schrader, H.A., 195n
Schrebera (?= *Cassine albens*), 68
Scot, William, 30
Scotland, 46–8, 51–2, 53, 56–7, 167
 agricultural revolution, 13
 inflation, 79
 poor harvests (1810–12), 79
Scott, Sir Walter, 16, 18, 178, 201n
Scottish Enlightenment, 10, 18, 36,
 77, 93, 144, 177
Scottish Highlands, 37, 46, 51, 52,
 167
 depopulation, 48
Scrophulariaceae, 49, 99
Sea Island cotton, *116*, 120, 121, 122,
 123, 134, 136, 197n
Seaforth Mackenzies, estates of, 75
seaweeds, 39, 40, 49, 56, 61, 99, 175
sedges, 10, 52, 54
seed characters, 99–100
seed collecting, 63, 64, 67–8
Seegoor Ghat, Nilgiris, 115
Selkirk-shire, Scotland, 25
Senecio wightianus, 114
senna, 72, 84, 85–6, 194n, 197n
 papers on (1837) (Wight), 84, 85
 seed, 68
Senna alexandrina, 85, 194n
— *italica*, 85
Serfoji II, Raja of Tanjore, 32, 35
Seringapatam, 30, 35, 111, 175
Seringe, N.C., 96–7
serpentine, 47
Sevacausey (now Sivakasi), 140, 141,
 143
Shackel, G. (farmer), 167
Shanghai, 171, 176
Shank, H.H., 137
Shaw, J., 64
Shee, Martin Archer, portrait
 painter, *34*
Shembaganur, Palni Hills, 81
Shepherd, T.H., *16*, 22
Sherman, Henry, 124, 127, 128, 129,
 131–2, 135
Shevagury Hills *see* Sivagari Hills
Shevaroy Hills, 71, 79, 81, 105
Shewarries *see* Shevaroy Hills
Shinfield, Berkshire, 171

shola forests, 109, 110
Shorea robusta (sal), 68
Shuter, James, 30, 32, 32–4, 36, 39,
 42
Sikkim, 65, 77, 200n
Silene acaulis, 48
Silver, A.W., 117
silviculture, 149–50
Simla, 90, 147
Simpson, Samuel, 122–3, 124, 126,
 127, 128, 129, 130, 139
Sinapis juncea, 193n
Sinclair of Broomrig, John, 15
Sinclair, Sir John, *Statistical Account
 of Scotland*. 80, 177
Sind, 90, 163
Singapore, 121, 150
Singh, Ram, 78
Singh, Soobah, 199n
Sirsi, 129
Sirumugai, 109
Sispara, Nilgiris, 113, 114
sissoo, 68
Sivagari Hills (Shevagury), 79, 80,
 81, 106
slave plantations in USA, 140
smallpox, 26, 170
Smith, Adam, 18, 77
Smith, James (Leith merchant), 17
Smith, Sir James Edward, 39, 55, 159,
 191n
Smith, Marjorie, 15
Smith, Sydney, 23
Smith of Woolston, steam cultivator,
 166–7
Smoult, W.H., 111
Society of Apothecaries, London
 garden of, 89
 medal given to Wight, 89, 152
Society, Edinburgh, 16, 17
Society for Promoting Christian
 Knowledge, 32
Society of Writers to His Majesty's
 Signet *see* 'ws'
Soho Square, London, 49
soil, 63, 67, 72, 80, 83
 black, 78, 85, 123, 124
 chemical analyses 121
 effects in cotton trials, 120, 123,
 126, 128–9, 131
 oxygenation in preparation of,
 126, 198n
 quality, 151
 red, 78, 85, 123, 124, 145
 versus climate, 118, 128–9
Solanaceae, 56, 99
Somerset House, London, 165
Sonchus (Cicerbita) alpina, 52
Sonerila speciosa, 114
sorghum, 128
Sorghum bicolor, 67, 145
South Africa, 178
South America, 86, 115
South Arcot, 85
South Carolina, USA, 122
South India, 32, 42

Botanical Survey of India, 157
 improvement in sugar
 cultivation, 85
 introduction of American cotton
 to *see* American cotton trials
 introduction of tea to, 67
 land tenure and agricultural fiscal
 systems, 124
South Kensington Museum,
 London, 175
Southampton, England, 161
Southern Mahratta country, 121, 129
Sowerby, James (with J.E. Smith),
 English Botany, 159
Spathodea, 148
species
 Candolle's concept, 95, 96
 definitions in terms of characters,
 98
 descriptions, 46, 97–8
 different delimitation practices,
 196n
 difficulties of identifying, 39, 49
 distinguished from varieties, 103
 epithets, 104
 with epithets commemorating
 Wight, 9, 178
 habitat forms leading to artificial
 proliferation of, 102–3
 need for broader concepts, 105
 nomenclature, 42
 number in Wight's herbarium, 10
 possibility of mutability of, 100
 preventing artificial proliferation
 of, 102, 107
 total number in India, 42, 61,
 190n
 use of field characters in
 delimiting, 106
 Wight's belief in fixed but
 variable, 174, 178
 Wight's diagnoses of, 95, 99, 106
 Wight's new, 177
specimens (in Wight's herbarium)
 donated to Kew, 165
 duplicates, 157
 insect damage to, 148
 localities given on, 113
 need for good, 98
 'type', 196n
 voucher, 39, 149, 196n
speculation, 79, 121
Speculative Society, Edinburgh
 University, 18
Speede, G.T.F. (*Indian Hand Book of
 Gardening*), 65, 200n
Spence, W., 165
spices, 73, 74
Spicilegium Neilgherrense (Wight), 43,
 61, 65, 93, 98, 99, 112, 113, 144, 177
spinal cord, 27
spinning (cotton), 119, 121
 Arkwright's machine, 197n
sponges, 42, 166
Sprengel, K.(C.)P.J., 32, 38, 39, 42,
 43, 95, 190n

Spring, the Rev F., 89
Sri Lanka *see* Ceylon
Srirangam, 134
Stahl, Georg Ernst, 26
Staines, Middlesex, 176
Stalagmitis, 74, 100
— *cambogioides*, 75
Stanhope Terrace, Hyde Park
 Gardens, London, 161
Stanley, Lord (later 13th Earl of
 Derby), 49, 161
star anise, 101
Statistical Account of Scotland, 15, 80,
 177
 methodology, 80
statistical accounts in India, 79–81
"Statistical" tradition, 10
Statuta Solennia, medical curriculum
 at Edinburgh University, 21
steam ship, I.K. Brunel's first, 197n
Stearn, W.T., 95
Stent, J., 64
Steudel, E.G. von, 32
 Nomenclator Botanicus, 196n
Stevens, Peter F., 94, 95, 98, 101, 105
Stevenson, Robert Louis, 16
Stewart, Alister (nephew), 92
Stewart, Anne *see* Wight, Anne
 (sister))
Stewart, Atholl, 48
Stewart, C., 190n
Stewart, Dugald (philosopher), 23
Stewart, Emilia, 54
Stewart, Jane McConochie, 48
Stewart, John, 22, 23, 24–5, 26, 50,
 54
 Hortus Cryptogamicus Edinensis, 25
Stewart, the Rev John (brother-in-
 law), 16, 18, 46, 47–8, 57
Stewart, Rebecca (niece), 48, 92,
 189n
Stewart-Mackenzie, James
 Alexander, 67, 75–6
Stocks, John Ellerton, 163
Stonehouse, bungalow in Nilgiris,
 109
Strathgarry, Perthshire, 48
Stravithie, Fife, 49
Strobilanthes kunthiana, 106, 196n
strontia (strontium), 23
Struan church, Perthshire, 47, 48
Stuart, John Ramsay, 48
Stuart, the Rev H.W., 111
Suez, 159
 Canal, 170
sugar, 83, 84–5, 151
 boiling apparatus, 83
 Chinese, 85
 East and West Indian, 84
 Indian, 84–5
 Palmyra, 151
sugar cane, 73, 77, 81
 pamphlet on cultivation (Wight),
 85
 varieties of, 85
Sullivan, John, 109, 121, 122, 133,

143, 196n
Surgeon's Square, Edinburgh, 22
surgery, 21, 22, 24
Sutton, Deborah, 196n
Swainson, William, 67, 93, 98, 99, 195n
Swan, Joseph, engraver, 42
Syzygium aromaticum (clove), 74

tamarind, 148
Tamil language, 41, 124, 150, 200n
Tamil Nadu, 145, 148
Tamil Nadu Archives, 77, 149
Tanjore, 26, 32, 35, 37, 40, 134
tartar emetic, 27
'Tartarous Moss' (lichen), 86
taxonomy, 9, 10, 21, 37, 42–3, 49, 87, 177
 circles of affinity, 98–9
 of cotton, 121
 and religious belief, 67
 Wight's, 98–101
 Zenker's, 112
 see also classification
Taylor, T.G., 197n
tea plants, 60, 67, 73
 Assamese, 67, 75, 196n
 Darjeeling, 170
 introduction to Ceylon, 75–6
 introduction to South India, 67
 seed, 67
teak, 10, 149, 151
 seed germination, 149
telegraph, electric in India, 174
Telford, Thomas, 46
Telugu language, 29, 41, 200n
Tennaserim, Burma, 157
Tennent, Sir Emerson, 76, 77, 165
Terence, *Andria*, 19, 26
Terminalia glabra, 151
Tetley, J.R. & Sons, 127
Thailand, 149
Thailentadopsis nitida, 104
Theobroma cacao, 74
thermometer, 32
Thespesia populnea, 66, 92
Thistle Street, Edinburgh, 16, 17
Thomas, E.B., 68, 136, 137, 141, 143, 151, 196n, 199n
Thomas, J.F., 138–9
Thomson, Gideon, 76
Thomson, James ws, 18
Thomson, the Rev John, of Duddingston, 20
Thomson, Thomas, 20, 45, 57, 76, 157, 174, 175
 Flora Indica (with J.D. Hooker), 57, 157, 164, 165, 175
Thomson, Thomas (chemist), 20, 76
threshers (cotton), 118, 122
Thunbergia grandiflora, 68
— *mysorensis*, 65
Thwaites, G.H.K., 77, 165, 201n
tigers, 79
timber, 73, 111, 113, 144, 149–50, 177, 200n

felling times, 149
methods for testing strength, 149–50, 151
 for railway sleepers, 151
Times, The, 138, 166, 176
Tinnevelly (Tirunelveli), 35, 40, 68, 72, 77, 78, 79, 85, 119, 121, 135, 136, 138, 145
 Finnie's cotton experiment, 122, 139–43
Tipu Sultan, 30, 68, 111
tobacco, 72, 73, 78, 83, 86, 148, 151
 export, 77
 seeds, 68, 71
 Wight on, 162
Todas (inhabitants of Nilgiris), 109, 110, 112
toddy tapping caste, 40
Topinpollium, 131
Torenia asiatica, 65
Tournefort, J. Pitton de, 104
Trachycarpus martianus, 191n
Tranquebar, 31, 32, 35, 45, 112
'transformed leaves', theory of, 102
transit duties, 77, 78
transplantation experiments, 103
transport improvements, 78, 79, 121
Travancore Mountains, 40, 174
trees, 69, 101
 Australian, 109
 effect on runoff and climate, 113, 149, 150–1
 European, 111, 114
 flowering, 110
 planting, 150
 seeds, 67–8, 111
 Wight's interest in, 148, 149–50
 see also timber
Trichinopoly ('Trichy'), 35, 51, 150
Trichur, 35, 115
Trivandrum, 35, 67
Troughton & Simms, instrument makers, 115
Tullibardine, Marquess of, 47
Turner, Charles, engraver, *20*
Turner, Dawson, 49, 158
Turner, Eleanor, 47, 89, 158
Turner, Gurney, 47, 76
Turner, James Aspinall, 141
Turner, Mary Dawson, etcher, *38*
turnips, 13, 15, 125
Turpinia nepalensis, 110
Tuticoreen, port of, 61, 73, 74, 79, 142
 paper on (1836) (Wight), 149, 151, 193n
Tweeddale, George Hay, 8th Marquess of, 64, 68, 119, 147, 167
 and the cotton experiment, 118, 124–33, 135, 139, 142, 144, 176, 198n, 199n
 daughter Susan, 147
 minute on cotton (1845), 130
 minute on cotton (1847), 132
Tylophora asthmatica, 60
'type'

concept, 39, 196n
 Wight's use of the word, 99, 103
typhoid, 26–7, 170

Umbelliferae, 99
'Unio Itineraria', 40
'United Brethren' (Tranquebar), 31
Upland Georgia cotton ('Uplands'), 120, 121, 122, 144, 145, 197n
Ure, Andrew, *The Cotton Manufacture of Great Britain*, 121
Urtica acerifolia, 112
— *heterophylla*, 112
Urticaceae, 163
Usnea florida var. *strigosa*, 86, *86*
usury laws, 77, 78
utilitarianism, 77

Vacciniaceae, 102, 195n
Vaccinium, 67
— *leschenaultii*, 111
Vachellia farnesiana, 68
Vahl, Martin, 104
Valleyfield, Fife, 29
Vallisneria alternifolia, 40
— *octandra*, 40
— *spiralis*, 40, 148
Vancouver, George, 49
Vandendaelen, T., lithographer, *154*
variability, Wight's views on, 102–3, 106
Vateria indica, 79
vegetation
 altitudinal zonation of, 113
 effects of muriate of lime on, 115
 influence on climate, 150–1
'Vegetation in the Indian Spring', Wight's paper on, 175
Vellore, 30, 34, 35
Vepery Mission, Madras, 32
Veragoo, 61
Verbenaceae, 99, 102
vernacular plant names, 40, 41, 72, 149, 150
veterinary research, Mysore, 30
Viburnum, 102
— *hebanthum*, 110
— *Tinus*, 167
Vicajee, Rustomjee, 161
Victoria, Queen, 48, 90, 152, 174, 175, 201n
Vijayanagar viceroys, 30
Viola patrinii, 103
Virtue Brothers, London, 117
Virudunagar, 144, 145
Viscum, parasitic on *Euphorbia*, 148
— *moniliforme* var. *coraloides*, 114
Vitaceae, 56, 100
viticulture, 84
Vitis vinifera, 193n
Vizagapatam, 119, 152
Vogelia indica, 174
Vriese, Willem Hendrik de, 163

Walker, Ann Maria (née Paton), 74, 90, 113, 190n, 193n

Walker, David, 54
Walker, George Warren, 74, 75, 90, 113, 190n
Walker, Mary, 13
Walker-Arnott, George Arnott, *see* Arnott
Wallace, Alfred Russel, 99, 105
Wallace, E.C. 52
Wallajahbad, 34, 35
Wallich, Nathaniel, 35, 36, 39–40, 46, 47, 49, 51, 52, 56, 59, 60, 67, 81, 83, 89, 112, 156, 189n, 191n
 Calcutta Botanic Garden, 45, 153, 154, 156
 correspondence with Wight, 39–40, 43, 45, 67–8, 84, 87, 120, 153, 156
 death (1854), 175
 Griffith and McClelland, 97, 148, 153, 154, 200n
 Numerical List of EIC herbarium, 36, 45, 50
 paper on senna, 85
 Plantae Asiaticae Rariores, 38, 40, 46, 107, 194n, 200n: maps 35, 109
 portrait, *53*
 relations with Wight (post-1846), 158, 164, 176
 tea plants for Ceylon from, 75, 97
 Tentamen Florae Napalensis, 39, 43
 visit to Madras (1844), 147
Walton, W.L., lithographer, *108*
Ward, Benjamin Swain, 80, 81
Ward, Charlotte, 89
Ward, Nathaniel Bagshaw, 66, 89, 165, 175
 family, 89
'Wardian Case', 66, 89
Waring, E.J., 174
water-lilies, 101
Waterston, Charles, 189n
Watson, Caroline, 191n
Watson, Hewett Cottrell, 46, 51–2, 61, 177, 195n, 201n
Watson, James George, 74, 193n
Watson, John Forbes, 174
Watson, Colonel L.W., 69, 196n
Waugh, Colonel, 68
weaving, 119–20
 fly shuttle, 78, 177
Weddell, Hugh Algernon, 163, 201n
Wellclose Square, London, 89
Wellington College, Berkshire, 171
Welsh, Benjamin, 27
Welwood, Elizabeth (Lady Meadowbank), 29
Wendlandia notoniana, 114
West Bank, Edinburgh, 15
West Byres, Ormiston, 13
Western Ghats, 35, 40, 42, 74, 79, 109, 120, 177
Western Himalaya, 157
Weymouth, Dorset, 113, 162, 169
wheat, 66, 73, 167
Wheeler, James Talboys, 139, 140,

141, 143, 145, 197n
Hand-book of the Cotton Cultivation in the Madras Presidency, 116, 117, 118
White, Francis Buchanan, *Flora of Perthshire*, 191n
White, Gilbert, of Selborne, 95
Whitefield, Leith, Edinburgh, 15
Whitehill, in Burrowfield of Ayr, 17
Whitelaw family (arms), 17
Whitfield, 15
Whitney, Eli, 125
Wight & Arnott, 24, 26, 34, 45, 52–6, 93, 112, 175
see also Prodromus Florae Peninsulae Indiae Orientalis
Wight, Alexander, of East Mains (great-grandfather) (d.1778), 13, 15
Wight, Alexander (advocate c.1770), 189n
Wight, Alexander (father) (d.1829), 13, 15, 16–17, 19, 26, 46, 79
Wight, Alexander (father of Robert Wight c.1698), 13
Wight, Alexander (nephew), 37, 92
Wight, Alexander (schoolmate), 19
Wight, Alexander (son of Robert Wight c.1698), 13
Wight, Allan (brother), 16
Wight, Andrew (1719–1792), 13
Wight, Andrew (schoolmate), 19
Wight, Anne Brown (sister) (later Mrs Stewart), 16, 17, 18, 46, 47–8, 53, 92, 158, 162, 163
Wight, Arthur Cleghorn (nephew), 16, 89, 92
Wight, Catherine (née Campbell) *see* Campbell, Catherine
Wight, Charles (brother), 16, 43
Wight, Charles Field (son), 69, 90, 115, 159, 166, *168*, 170–1, 176
Wight, David, 13
Wight, Eliza Anne (daughter), 90, 111, 114
Wight, Ernest Octavius (son), 17, *168*, 169, 171, 176
Wight family, fake coat of arms, 17
Wight, Florence Amy Alice (grand-daughter), 169
Wight, Helen (grand-daughter), 171
Wight, Helen Julia (née Ford), 89, 90, 92, 161
Wight, James (brother), 16, 17, 29, 92

Wight, James Ford (son), 90, 111, 114, *168*, 169, 176
Wight, James (grandfather) (1725–1785), 13–15
Wight, James (nephew), 92
Wight, James (schoolmate), 19
Wight, Jane Ellen (d.1847) (daughter), 90
Wight, Jane (later Fitzgerald) (niece), 92
Wight, Janet ('Jenny') (née Denny), 17, 171
Wight, Jean (née Maconochie) *see* Maconochie, Jean (mother)
Wight, Louisa (great-niece), 89, 111
Wight, Lucy Adelaide Rosa (grand-daughter), 169, 176
Wight, Marion (sister), 16, 17, 18, 169
Wight, Mary Adelaide (née Lloyd), 169, 191n
Wight, Mary Ann (née Fitzgerald), 92
Wight, Noel (grand-son), 171
Wight, Robert
American cotton trials, 117–45
Assistant Surgeon with the EIC, 29–43
attitude to the 'natives', 40–1
baptism, 13, 15, 18, 29
birth, 13, 16, 18
character, 40, 60, 83, 124, 176–7
as Churchwarden, 171
correspondence with Arnott, 74, 79, 81, 153
correspondence with J.D. Hooker, 166
correspondence with W.J. Hooker, 10, 37–8, 41, 42, 43, 45, 48, 51, 53, 54, 56, 60, 63, 69, 70, 83, 87, 90, 95, 111, 113, 144, 147, 158, 164, 169, 200n
correspondence with Wallich, 39–40, 43, 45, 67–8, 68, 84, 87, 120, 153, 156
death and will, 171, 175–6, 199n
doctoral thesis, 21, 24, 26–7, 54
domestic life and family, 169–71
as economic botanist (1835–6), 71–81, 144
family portraits, 88, 90, *168*
family tree of descendants, *170*
Fellow of the Royal Society, 163, 165, 178

final years, 173–8
finances, 30, 34, 36, 40, 51, 54, 69, 79, 83, 90, 115, 133, 144, 153, 159
first Indian period (1819–31), 17, 28–43
forebears, 13–18
furlough (1831–4), 44–57
Garrison Surgeon of Fort St George (1838), 89–90
Garrison Surgeon of Negapatam (1828–31), 37–43
handwriting, 53, 89
as horticulturist, 63–70
inheritance, 17–18, 29, 46, 49
later years (1853–72), 160–78
legacy (scientific), 177–8
Madras Naturalist and Botanist (1826–8), 34–6
marriage and family (1838), 89–92, 148
military service, 29, 43
obituaries of, 22, 29, 54, 148, 158, 167, 175–7
parents, 16–17
politics of, 130, 161, 176
portrait, 53, 56, *163*, 167, *168*
retirement (1853), 93, 158–9, 161–7, 175, 178
school, 19–20
second Indian period (1834–53), 17, 58–159
social life and sport, 90–2, 111–13, 166, 169–71
as Superintendent of the Cotton Planters (1842), 115, 117
the Taxonomist, 93–107, 144
university, 16, 21–7
veterinary research in Mysore (1824–5), 30
Wight, Robert (1798–1861) (Bombay surgeon), 22, 189n
Wight, Robert (from Dunbar c. 1813), 22
Wight, Robert (from Midlothian c. 1813), 22
Wight, Robert (grandson), 171, 176
Wight, Robert (son of Alexander c.1698), 13
Wight, Robert Stuart (son), 70, 90, 166, *168*, 170
Wight, Rosa Augusta (daughter), 90, 114, *168*, 169–70, 176

Wight, Rosa (née Ford) (wife), 88, 89, 90, 92, 111, 114, 115, 147, 158, 159, 161, *163*, *168*, 169–71, 176
Wight, Zena (niece), 16
Wightia gigantea, 46
'wightii' specimens, 36, 46, 49, 65, 113, 114, 115, 178
Wilberforce, 'Soapy Sam', Bishop of Oxford, 171
Wilde, Oscar, 161, 201n
Wilkinson, Joan, 17
Wilkinson, Rear-Admiral N.J., *88*, 163
Willdenow, C.L., 60, 106–7
Grundriss der Kraüterkunde, 39
Species Plantarum, 29, 30, 32, 36, 39
Willis, Thomas, 26
Wilmot-Horton, Anne, Lady, 74
Wilmot-Horton, Sir Robert, 74, 76
Wilson, Horace Hayman, 196n
'Winchester' (lithographer), 86
Winter, Thomas, 29
Wodeyar rajas of Mysore, 30
Wood, Sir Charles, 161
Woodcot, Ooty, 113
woodpeckers, 60
Woodside Crescent, Glasgow, 57
Woodside, Ooty, 111
World War I (1914–18), 171
Wrightia, 174
— *tinctoria*, 68, 151
Wroughton, J.C., 126, 127, 128–9, 130, 132, 198n
'ws' (Writers to the Signet), 13, 15, 16, 113
Wyeth, Anne, 169
Wynaad, 72
Wyon, William, medallist, 89, 152

Xanthochymus ovalifolius, 74, 75
Xanthomonas spp. (apple canker), 69

Yester, Haddington, 124
Yser Canal, near Ypres, Flanders, 171

Zenker, J.C.(K.), 104, 112
Plantae Indicae …, 112
zoology, 90, 114
classification, 99
nomenclature, 103
specimens, 42
zoophytes, 97